Albert Pinkham

Ryder

With catalogue by Eleanor L. Jones, Matthew J. W. Drutt,
Sheri L. Bernstein, and Elizabeth Broun

Published for the National Museum of American Art
by the Smithsonian Institution Press
Washington and London

Albert Pinkham
Ryder

Elizabeth Broun

Published on the occasion of the exhibition *Albert Pinkham Ryder,* organized by the National Museum of American Art, Smithsonian Institution, and shown at

National Museum of American Art, Washington, D.C.
6 April–29 July 1990

The Brooklyn Museum
14 September 1990– 8 January 1991

Edited by Kathleen Preciado
Designed by Janice Wheeler
Production management by Kathleen Brown
Typeset by Monotype Composition, Baltimore
Printed by South China Printing Company,
Hong Kong

Cover: detail of *The Flying Dutchman.* National Museum of American Art, Smithsonian Institution, Washington, D.C., gift of John Gellatly (cat. 14).

Library of Congress Cataloging-in-Publication Data
Broun, Elizabeth.
 Albert Pinkham Ryder.
 Catalogue of the exhibition held at National Museum of American Art, 6 Apr.–29 July 1990; The Brooklyn Museum, 14 Sept. 1990–8 Jan. 1991.
 Bibliography: p.
 Includes index.
 1. Ryder, Albert Pinkham, 1847–1917—Exhibitions. I. Ryder, Albert Pinkham, 1847–1917. II. Jones, Eleanor L. III. National Museum of American Art (U.S.) IV. The Brooklyn Museum. V. Title.
ND237.R8A4 1989 759.13 89-600053
ISBN 0-87474-328-1
ISBN 0-87474-327-3 (pbk.)

The paper used in this publication meets the requirements of the American National Standard for Permanence of Paper for Printed Library Materials Z39.48.1984.

For permission to reproduce illustrations appearing in this book, please correspond directly with the owners of the works, as listed in the individual captions. The Smithsonian Institution Press does not retain reproduction rights for these illustrations or maintain a file of addresses for photo sources.

Contents

Preface and Acknowledgments

Research for this book and accompanying exhibition began in 1985. A generation had already passed since the last book and exhibition on Albert Pinkham Ryder, and although people still talked about him regularly, neither art professionals nor the public had a clear or specific understanding of his work. Since the National Museum of American Art has the finest and largest collection of Ryder's paintings, assembled by John Gellatly early in the century as the centerpiece of his gift to the nation, it seemed natural to undertake this project in Washington. Fortunately, while this special opportunity was obvious from the start, the difficulties in finding primary documents, understanding the artist's working methods, and sorting out forgeries emerged only after I had gone far enough to be completely captivated by the subject. The problems could never have been resolved without the collaboration of many others, who provided expertise far beyond my own experience and who generously contributed ideas as well as effort.

Four gifted researchers made essential contributions to the project, each working six months or more on the full range of issues encompassed by this study. The discussions and arguments generated by this research team gave birth to the best ideas in this book; working with these graduate students was without question the most rewarding part of the project for me. Eleanor L. Jones established the initial bibliography and files on all the paintings and was first to pursue serious laboratory study of the paintings. Matthew J. W. Drutt was in-house expert on provenances, patronage, and analysis of Ryder's subjects. Sheri L. Bernstein and Leigh Culver extended the work on these subjects and followed a variety of research leads while shouldering many aspects of the exhibition organization and book preparation.

Many National Museum of American Art colleagues and interns as well as Smithsonian Fellows and Research Associates made important contributions, including Elizabeth Anderson, Andrew Connors, Anne Edwards, Charles C. Eldredge, Lois Fink, George Gurney, Susan Hobbs, Tonia Horton, Brinah Kuss, Karol Lawson, Virginia Mecklenburg, Colonel Merl Moore, Richard Murray, Wendy Owen, Margy Sharpe, Annie Storrs, Grey Sweeney, William H. Truettner,

Gary Wright, and Saul Zalesch. The staffs of the museum's Photographic Services Office, Research Resources Office, Registrar's Office, and Library provided invaluable assistance throughout the preparation of the book. Chief Designer Val Lewton has demonstrated great sensitivity to Ryder's art in his plans for the exhibition installation, which are still on the drawingboard at this writing.

It would have been impossible to reconstruct the provenances of Ryder's paintings or the history of his career without the exceptional resources of the Smithsonian Institution's Archives of American Art, and I am grateful to all Archives staff in Washington, especially Arthur Breton, Garnett McCoy, and former director Richard Murray. Outside the Smithsonian, important documents and references were made available by Kathryn Caldwell, John Driscoll of Babcock Galleries, David Henry of Ira Spanierman Gallery, Helena Pappenheimer and Gilder Palmer of the Gilder Archive, and Robert C. Vose of Vose Galleries.

Curators, registrars, librarians, and archivists across the country provided information and access to paintings. It would be impossible to list all who helped, but I particularly want to mention a few who went far out of their way to provide assistance: Nancy Anderson of the National Gallery of Art, Washington, D.C.; Judith Barter of the Mead Art Museum, Amherst, Massachusetts; Peter Blodgett of the Henry E. Huntington Library, San Marino, California; Doreen Bolger and Jeanie James of the Metropolitan Museum of Art, New York; William Colvin of the Cornell Fine Arts Center of Rollins College, Winter Park, Florida; Daniel DuBois of the New Britain Museum of American Art, Connecticut; Linda S. Ferber and Barbara Gallati of the Brooklyn Museum; Joseph Holbach of the Phillips Collection, Washington, D.C.; Patti Junkers of the Memorial Art Gallery, Rochester; Nancy Rivard Shaw of the Detroit Institute of Arts; Marc Simpson of the Fine Arts Museums of San Francisco; Clyde Singer of the Butler Institute of American Art, Youngstown, Ohio; Theodore Stebbins of the Museum of Fine Arts, Boston; and Susan

Strickler of the Worcester Art Museum, Massachusetts.

Private collectors often went to considerable trouble to answer my questions and requests and to them I am deeply indebted: Mr. and Mrs. Leonard Baskin; Mr. and Mrs. Daniel W. Dietrich II; Thomas Fidelo; Mrs. Daniel Fraad; Willard B. Golovin; Mr. and Mrs. George D. Hart; Mr. and Mrs. Alastair Bradley Martin, Mr. and Mrs. Robin B. Martin; Mr. and Mrs. Meyer Potamkin; Elton B. Stephens, and collectors who wish to remain anonymous.

The deterioration and frequent restoration of Ryder's paintings as well as the existence of innumerable forgeries made essential a technical study, which helped form my own understanding of Ryder's technique. The Smithsonian's Conservation Analytical Laboratory (CAL) undertook a major technical analysis of Ryder's paintings that provided much new information about his materials and methods. It was fortunate that several paintings could be autoradiographed at the National Bureau of Standards, for this unusual and revealing analytic process is not generally available to researchers. Jacqueline Olin and Ingrid Alexander of CAL each played a major part in coordinating the technical analysis. Other CAL scientists who made essential contributions include Tony Cheng, Ron Cunningham, Marion Mecklenburg, Edward Sayre, and Lambertus Van Zelst. National Museum of American Art conservators Quentin Rankin and Stefano Scafetta coordinated the museum's part of the technical study while independently examining and X-raying many Ryder paintings in the museum's laboratory. The results of these technical studies will be published separately.

Conservators in many museums were generous with time and ideas, allowing me to examine paintings in their laboratories and answering my questions: Arthur Beale of the Museum of Fine Arts, Boston; Paul F. Haner, formerly of the Worcester Art Museum; Kenneth Katz of the Detroit Institute of Arts; Bruce Miller of the Cleveland Museum of Art; Ken Moser of the Brooklyn Museum; Will Real of the Carnegie Museum of Art, Pittsburgh; Robert Sawchick of

the National Academy of Design, New York; Rosalind Westmoreland, at the Los Angeles County Museum of Art; and Jim Wright of the Fine Arts Museums of San Francisco.

Sheldon and Caroline Keck, conservators who examined more than fifty paintings attributed to Ryder during the past five decades, generously shared files, early photographs, and their extensive accumulated wisdom about Ryder's method. Perhaps this is the place also to credit them for daring to treat Ryder's paintings after carefully studying his unconventional technique, while more conservative conservators preferred to watch the paintings deteriorate rather than attempt treatments that could not be guaranteed. Without the Kecks' unusual nerve, the idea of an exhibition of Ryder's art in 1990 might well have been moot.

For the editing of this book, I thank Gaye L. Brown and Kathleen Preciado; for her excellent design, I am indebted to Janice Wheeler; and for coordination of production, Kathleen Brown. I am particularly appreciative of the efforts of Acquisitions Editor Amy Pastan of the Smithsonian Institution Press for her oversight of all aspects of the publication.

For financial support of the book and exhibition, I am deeply grateful to the Smithsonian's Scholarly Studies Fund and Special Exhibitions Fund. I wish also to thank an anonymous donor whose belief in Ryder's art is a source of inspiration.

Finally, heartfelt gratitude goes to my husband, Ron, and daughter, Katie, for their enthusiasm and encouragement.

Elizabeth Broun
National Museum of American Art

Albert Pinkham
Ryder

An Old Master
in the Modern Movement

The organizers of the famous 1913 Armory Show were mostly young, independent artists—independent of the conservative National Academy of Design, which consistently rejected their work from its annual exhibitions, and independent of patrons as well. But they felt themselves to be alive to a new spirit in art, open to new currents of life in America and influences from abroad.

"International Still Stirs the Public," wrote critic Charles Caffin five days before the show's close, as more and more people crowded in each day to see the bewildering things on view.[1] The shocking colors and fractured compositions sent by Europe's radical artists managed to make America's most avant-garde offerings look sweetly reasonable—or almost; but clearly a new age had dawned. In his review Caffin ignored changes in composition and palette to speak about the way "the old ideas of religion have been gradually supplanted by the new idea of the religion of science."

Curiously for a group bent on discovering the new, the organizers built into the exhibition the first beginnings of a modernist history by includ-ing the giants who had inspired their new ideas. A sprinkling of paintings by Ingres, Delacroix, Goya, Corot, Daumier, and Manet and large numbers of canvases by Gauguin, Cézanne, Puvis, van Gogh, and Redon hung in the four center galleries of the armory—the heart of a tradition whose pulse circulated throughout the fourteen peripheral galleries. The only American so honored was Albert Pinkham Ryder, ten of whose paintings were shown in the center galleries along with the foreign masters. " 'Old Man Rider [sic]' An Old Master," began a section of Caffin's article:

"Old man Ryder," he is apt to be called by the young generation of painters, yet in the quality of his work he is much nearer to the modern expression of intellectualized emotion than all but a few of the young men. In his unobtrusive sincerity he, in fact, anticipated that abstract expression toward which painting is returning and may almost be said to take his place as an old master in the modern movement.

At first it seems odd that the artist chosen as the spiritual father of this progressive group was Ryder, whose romantic, dreamy subjects and

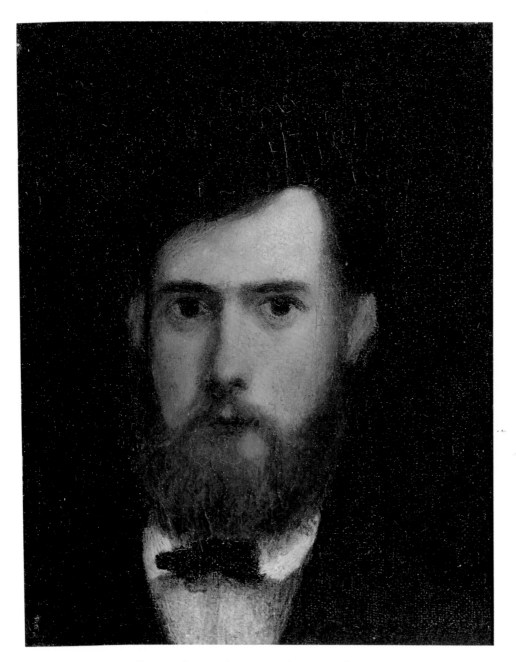

Fig. 1. *Self-Portrait*. Collection of Mr. and Mrs. Daniel W. Dietrich II (cat. 55).

withdrawn manner were far from the vigor of life as it appeared in the streets of New York and in the art of younger artists. Eakins would have been the logical choice. His career formed a bridge between European classicism and American empiricism, and besides, he had taught several younger artists in Philadelphia—yet no Eakins paintings were shown at the armory.

For more than a generation American artists had been criticized for ignoring native culture and adopting the subjects and styles of the European academies—a forgivable impulse, perhaps, as American paintings sold in New York for a fraction of what comparable European paintings brought. But imitating foreign styles had not brought success; Armory Show organizers George Bellows, Arthur B. Davies, Robert Henri, George Luks, and Walt Kuhn were after an art that struck closer to home. They wanted to engage the "large masses of people" that Caffin promised were "keenly interested in the expressions and manifestations of life."

It may be that Arthur B. Davies, president of the association that organized the exhibition, suggested Ryder be given a place of honor. Alone among the members of that group, Davies created mystical, romantic fantasies inspired by Ryder's work. Walt Kuhn later described how Ryder was led through the exhibition on Davies's arm: "He looked around at the paintings, grunted a few times, and nodded his head. . . . We got to the center of the Armory, where there were the cubicles in which Ryder was the only American honored with Cézanne, van Gogh, and Gauguin, and he just nodded some more."[2]

But it was not Davies's favoritism that prevailed. Kuhn remembered that Luks, Henri, and Sloan among the younger men praised Ryder's art, and he joined in the general homage, saying: "There's only Ryder in American painting. He's not my type, but I know he's one of the great ones. Eakins' paintings are dry prose; Ryder's sing."

Ryder's ascendancy depended on a close conjunction of life and art, as Caffin implied in his review. Admirers and critics alike had difficulty separating Ryder's art from the unconventional way he lived. By the time of the Armory Show he was known in art circles as a recluse, a man of "unobtrusive sincerity," a naïf, fond of children and courtly with women, uncorrupted and driven by an inner vision, like van Gogh. He seemed to be aloof from the world but vulnerable to it, a casualty from the material point of view but a spiritual survivor.

If Ryder's life was fascinating, his paintings were equally important to the evolving Ryder myth for the way they "anticipated . . . abstract expression," pointing past the "dry prose" of realism toward an art grounded in expression. He was as indifferent to the facts of representation as to the necessities of living. And his bizarre technique was a subject of horrified fascination—certainly no model for the coming generation but still a point of departure for modernists, who began to emphasize process over subject.

At the Armory Show, Ryder's status as an American "old master" and the only native prophet of modernism was officially recognized. He has maintained this reputation steadily ever since, despite extreme shifts in the styles and intentions of American artists. For many, he is the very archetype of the artist, whose life and work bear witness to the power of art.

The anointing of an American "old master" at the Armory Show was one more turn in the familiar circle that had plagued American art from its infancy. Since the time of Thomas Cole, American artists had wanted to create a native style that would express the special opportunities for art in a democracy. Yet patrons continued to prefer European art, so American artists had little choice but to mimic foreign examples, if only to demonstrate competency; this made them merely imitators, and their works were priced accordingly. However much Americans might talk about a native art, most still felt an imported canvas had more the aura of culture.

Ryder's reputation was intimately bound up in this dynamic. Traditionalists saw him as the last romantic, using literary and narrative themes that were honored staples of romanticism since

the 1830s. The avant-garde championed his tendencies toward abstraction and his unconventional stance as an artist. Everyone made political capital from the idea that Ryder was naive, a "visionary," for this was tantamount to saying that his achievement was natural and true, dredged from some deep current of character that was part of the American patrimony. The long years Ryder worked to bring a painting to perfection—endlessly rubbing out and reworking a tiny canvas only to have the entire paint surface slide on its oily foundations and puddle at the bottom of the frame—were the birth pains of a new native vision. He endured his struggles for those who came after him, like a Christ whose suffering expiated the sins of others. There are striking parallels between this aspect of Ryder's myth and that of van Gogh, Matthijs Maris, Henri Rousseau, and Ralph Blakelock, as if their generation required martyrs.

The Ryder myth has grown to even greater proportions since the artist's death and is now thoroughly integral to our understanding of modernism and the American spirit in art. Can we still see the insubstantial armature of fact beneath the elaborate structure it supports? Even the most cherished assertions about Ryder have less to do with history than with its reshaping by those who were strategically repositioning American art.

The legends that began to appear even before Ryder's death are like the thick varnishes that often cover his paintings. Once they added a touch of mystery, but they have grown cloudy with age, making the man and his work seem remote. By going back to the facts and looking closely at Ryder's world, we can penetrate the opacity a bit and perceive the remarkable composition and color of his career.

Was Ryder self-taught? Was he oblivious to other artists' work? Was he always a recluse? Was he ignorant of the technical formulas for painting? Is his work more American than that of his contemporaries? Was it based wholly on imagination? Was he neglected by critics and patrons? Did he live in poverty? And if the answer to each of these questions is no, what have we lost? Emerson cautioned, "The unities, the fictions of the piece it would be an impertinence to break."[3]

Ryder made an enormous impression on those who knew him, but even so, little reliable information about him survives. After his death in March 1917 there was an outpouring of reminiscences, mostly from people who met him late in life when his creative work was done. His letters generally record day-to-day events rather than aesthetic theory, and only a few paragraphs about his theory of art were published during his lifetime. His poems offer insight into his thoughts, but for the most part our picture of the artist remains fragmentary, based on incomplete and sometimes contradictory evidence.

The most telling evidence is found in his own works of art, but these conceal a trap, for Ryder—like his contemporary Blakelock and his great hero Corot—is among the most widely forged artists in history. Many misconceptions have grown up about the artist because conclusions have been drawn from paintings that cannot be substantiated as his. It is rather demoralizing to come to terms with the level of skepticism that is required in the study of Ryder's art. The nature of his mythology—that he was a "divine innocent"—lulls us into believing his world was free of treachery. But Ryder's seemingly simple paintings were easily copied, and his audience, then and now, is easily tricked. Only those paintings that look right to trained eyes, that follow a familiar pattern in laboratory analysis, and that present a straightforward provenance can be considered absolutely secure. One of the hardest lessons to learn is that Ryder painted few works and most were exhibited during his lifetime, mentioned in letters or commentaries published during his lifetime, or otherwise documented before his death in 1917.

While it may never be possible to establish a firm chronology for Ryder's life or art, we can place him among colleagues and friends, review his training, trace the evolution of his subjects

and style, examine his technique, chart the rise
in his reputation, and in other ways sketch the
shape of his career. Two cautions must be kept
in mind: critics and collectors presented Ryder's
work with an eye to advancing their own ideas
and agendas, and many of those who claimed to
be close with him were not. The reassuring news
is that while Ryder may not be exactly the figure
who has been handed down to us through
history, he is just as intriguing, his art just as
remarkable, as any of the myths have
suggested. ᚱᚨ

PART ONE

The Early Years

The Ryders
of Massachusetts

Albert Pinkham Ryder's ancestors, the Cobbs and the Ryders, were among the earliest settlers of Cape Cod. Samuel Rider (as the name was often spelled) left Plymouth Colony with a group that founded Yarmouth, Massachusetts, in 1639, the same year that Henry Cobb helped establish neighboring Barnstable.[1] Yarmouth and Barnstable youth often intermarried, and the Rider and Cobb names have intermingled for more than two centuries.

The artist's parents, Alexander Gage Ryder of Yarmouth and Elizabeth Cobb of Barnstable, had three sons in quick succession: William Davis (1836), Edward Nash (1837), and Preserved Milton (1839).[2] Sometime around 1840 they moved from the cape to New Bedford, where Alexander Ryder is listed in the city directory for 1841 as a laborer. During the next twenty-six years Alexander moved from job to job, working as a hackman, boatman at the customhouse, boarding officer, and finally as a dealer in prepared fuel at Ryder's Granulated Wood Company. He may also have worked for a time as an undertaker's assistant. Five different New Bedford addresses are recorded, suggesting Alexander's fluctuating fortunes.[3]

On 19 March 1847 Elizabeth gave birth to her fourth and last child and named him Albert Pinkham Ryder. Pinkham was a family name on the Cobb side, and Albert was called Pinkie by all the children at school and by his closest friends throughout his life. Elizabeth Ryder was a strong influence on her youngest son, and Albert always spoke of her with affection and admiration. After he became an artist and people began to inquire about his family, his mother was described in terms that might have been used for her son: "distinguished for benevolence, self-sacrifice and sympathy—others' troubles she made her own—a beautiful woman with a beautiful character. It has been said of Albert Ryder's genius that he owed it to his mother, a passionate lover of flowers and beautiful things."[4]

In the time of Albert Ryder's birth, New Bedford was the most active whaling port in the world, busy with men unloading barrels of spermaceti, hawking exotic wares, and building fine homes for the rich sea captains. The smell of candlemaking and fish drying filled the air as the city grew on the proceeds of the whaling industry.

Herman Melville had shipped out of New Bed-

8

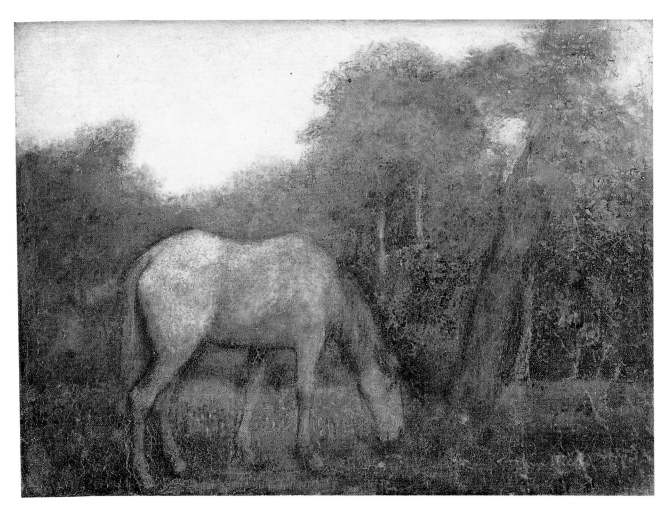

Fig. 2. *The Grazing Horse*. The Brooklyn Museum, Graham School of Design Fund (cat. 19).

ford on a whaler in 1840, about the time Ryder's family moved there, and included his impressions of the town in *Moby-Dick*. In the beginning of the novel Ishmael wanders through the city on a cold December night searching for a place to stay. The Crossed Harpoon and Sword-Fish Inn are jolly enough, but inns closer to the docks are gloomy and rough, just right for a poor seaman who is not "too particular." "Such dreary streets! blocks of blackness, not houses, on either hand, and here and there a candle, like a candle moving about in a tomb."[5] The mystery of such a town, alternately expansive and forbidding, was fertile to the imagination.

With New Bedford ships calling at the farthest points of the globe, the rich captains' wives were remarkable for their elegant finery, but some women of New Bedford wore the plain clothing of the pietist sects that sprang up after the Great Awakening of the 1820s and 1830s. Ryder's paternal grandmother and mother adopted this simple dress and may have belonged to such a sect, perhaps one of the numerous Methodist groups in the area. The splintering of religious groups during the Great Awakening may have led to the Ryders' move from Yarmouth to New Bedford.[6]

In the North these fervent religious groups were allied with the antislavery movement, which was given a boost in New Bedford when the escaped slave Frederick Douglass came to live and work in the city from 1838 to 1841. Douglass's impassioned speeches strengthened the already intense abolitionist sentiment in Massachusetts. When Civil War broke out two decades later, all of Albert Ryder's brothers went to war; the two middle brothers served on ships, while the oldest, William, enlisted as a private in the artillery.[7]

There is little record of how Albert Ryder spent his childhood, except that he attended the Middle Street Grammar School, an all-male school of about two hundred pupils and the largest in New Bedford. Conditions at the school were overcrowded in the 1840s and 1850s, with frequent turnover in teachers and principals, but much of the trouble was laid to the students'

"most disorderly and turbulent character." "Truancy and moral obtuseness, generally, have characterized the school," judged the New Bedford School Committee in 1855.[8] There were seven grammar schools in New Bedford, but only one high school; Ryder, like most students, concluded his formal education in grammar school.

Ryder had trouble with his eyes, a condition attributed to a faulty vaccination, and for the rest of his life he suffered intermittently from inflammation and eyestrain, which often interfered with his painting.[9] But even as a child he easily became absorbed in books and pictures, if the stories told of his childhood after he became a famous artist can be trusted. One of Ryder's seafaring brothers, for instance, is said to have brought back to New Bedford old art magazines full of reproductions of pictures in the Louvre and portraits of artists, which Ryder pored over, writing the names of the artists in his school copybook.[10]

Many have imagined how New Bedford influenced the future marine painter, but Ryder was silent on this subject, as on so much else. With two seafaring brothers, Albert could scarcely have missed knowing the seaman's life, even if secondhand. He recalled seeing his brother kiss the family pig for joy after a particularly difficult voyage, and later in life he liked to sing chanties with friends over beer. But he was almost a decade younger than his brothers—the baby of the family, with more interest in drawing than adventure.[11] Even fishing did not appeal to him; he wrote decades later to his close friend J. Alden Weir, "Catching mice is more in my line, and they are shivery looking enough for me."[12]

One of Ryder's few published comments about art credits his father and the "great masters" for encouraging his early interest. He seems to have felt none of the conflict either with his own father or with artistic ancestors that many young artists experience:

When my father placed a box of colors and brushes in my hands, and I stood before my easel with its square of stretched canvas, I realized that I had in my possession the wherewith to create a masterpiece that would

Fig. 3. *Summer's Fruitful Pasture*. The Brooklyn Museum, Museum Collection Fund (cat. 65).

Fig. 4. *The Pasture*. North Carolina Museum of Art, Raleigh, gift of the North Carolina Art Society (cat. 46).

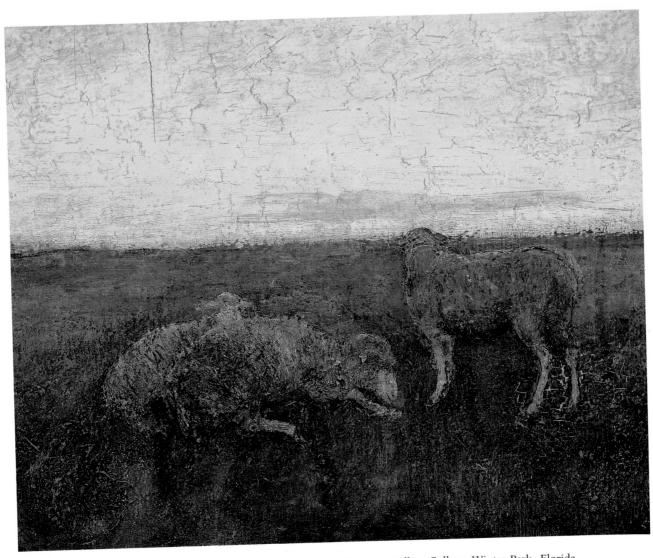

Fig. 5. *Landscape with Sheep,* oil on canvas. The Cornell Fine Arts Museum, Rollins College, Winter Park, Florida.

live through the coming ages. The great masters had no more. I at once proceeded to study the works of the great to discover how best to achieve immortality with a square of canvas and a box of colors.[13]

A supposed coincidence of history holds that Albert Pinkham Ryder was born in a house on Mill Street just across from the home of New Bedford's most famous artistic alumnus, Albert Bierstadt, who is said to have encouraged his young friend to draw. But the Ryders did not move to Mill Street until the end of the 1850s; Bierstadt had left New Bedford earlier to teach and travel. Bierstadt and the eleven-year-old Ryder could have become acquainted in 1857–58, when the older artist returned briefly to give lessons in New Bedford, but as neither mentioned such an encounter the possibility remains remote.

Even without Bierstadt, New Bedford offered opportunities to an aspiring artist. The city boasted several marine painters like Benjamin Russell, son of a whaling merchant, known for the accuracy of his delineations of naval vessels, or William A. Wall, who specialized in scenes of maritime history. William Bradford, native of nearby Fairhaven, took up painting around 1854 and invited a Dutch marine painter, Albert Van Beest, to set up a studio in Fairhaven, which he did that same year. Van Beest introduced drama and romanticism into Massachusetts marines, adding to "accuracy" other criteria for success.

Closer to Ryder in age, R. Swain Gifford was a New Bedford marine painter with high aspirations. Gifford and Van Beest established a studio in New York in 1857, but Gifford soon returned to New Bedford where he remained until 1864. If Ryder sought serious instruction during this period, he could have done no better than to work with Gifford, who was even then experimenting with advanced ideas on art. One of Gifford's friends, who was studying in France, sent him artists' materials in 1857, along with a description of Thomas Couture's painting method. Gifford immediately adopted the technique, which he thought superior to other methods for clarity and luminosity of color. Couture's methods were widely influential after they were pub-

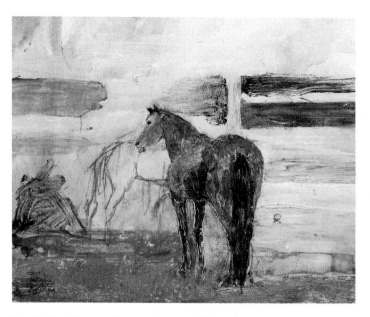

Fig. 6. *Two Horses,* oil on canvas. Hirshhorn Museum and Sculpture Garden, Smithsonian Institution, Washington, D.C., 1966.4432.

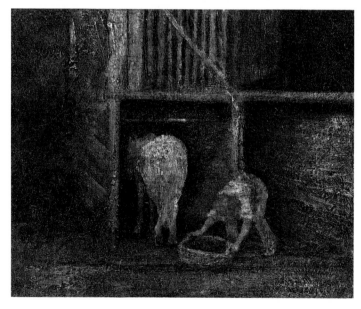

Fig. 7. *The Stable.* The Corcoran Gallery of Art, Washington, D.C., gift of Mabel Stevens Smithers, 1949, the Francis Sydney Smithers Memorial (cat. 63).

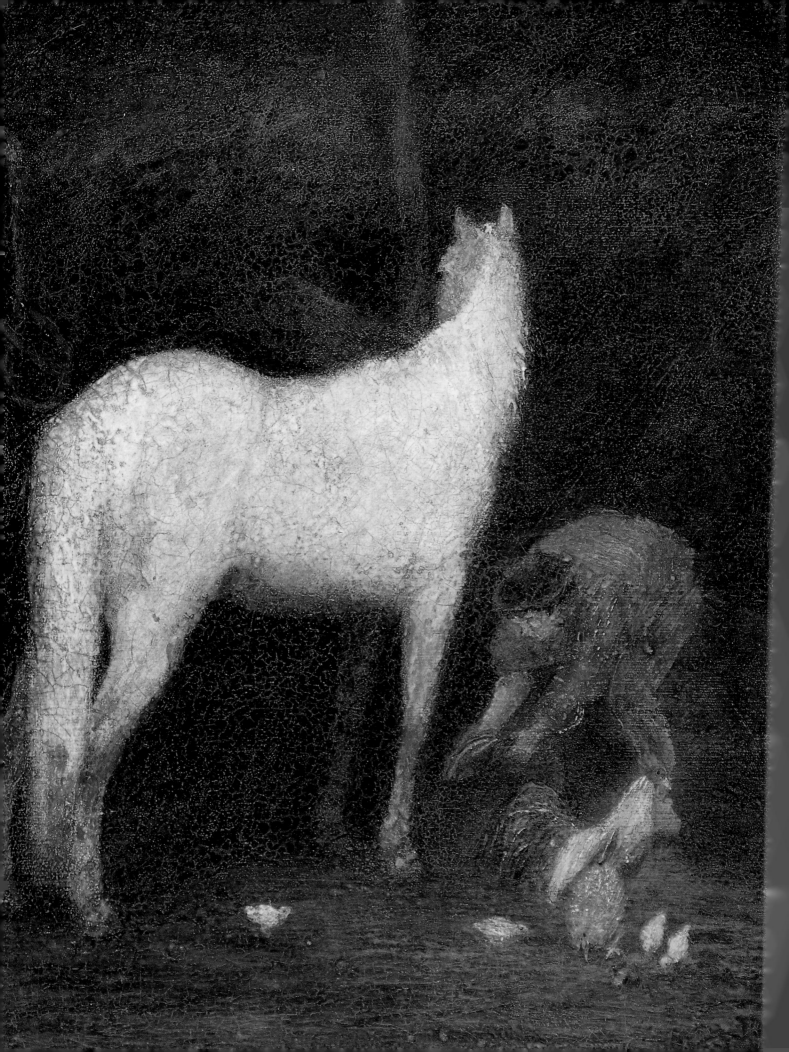

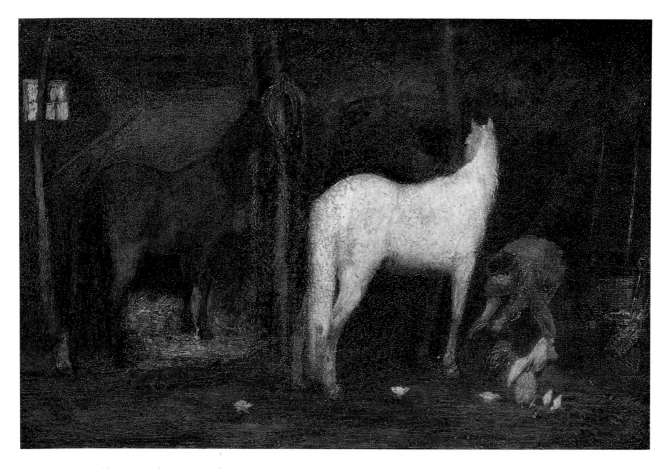

Fig. 8. *In the Stable*. National Museum of American Art, Smithsonian Institution, Washington, D.C., gift of John Gellatly (cat. 22).

lished in 1867 in France, but Ryder could have learned of them a decade earlier in New Bedford.[14]

It is not at all clear if Ryder received formal art instruction in New Bedford. We know little about his life after the Middle Street Grammar School and before his move to New York. With three brothers at war, he probably was needed at home, perhaps to help deliver fuel for his father. For a time he was a boarding officer at the customhouse.[15] If he took lessons from one of New Bedford's artists, he never acknowledged this during his subsequent career Ryder's sister-in-law remembered that his first lessons were from an artist named Sherman on William Street, perhaps the amateur painter and tannery

superintendent who was said to have first put a brush in Ryder's hand.[16]

Ryder's early interests centered on horses and farm animals rather than marine views. Horse-drawn carts were essential to the family business, and so he was familiar with stableboys and blacksmiths. When a blacksmith rendered a special service, Ryder gave him a small painting in gratitude.[17] He owned a white horse named Charley—the humble prototype for all the white horses that appear in his paintings, including the winged Pegasus. Although Ryder was constantly criticized for weak drawing, his animal subjects reveal a good understanding of animal anatomy, with excellent proportions and a firm grasp of musculature (figs. 2–9). Perhaps some instructor

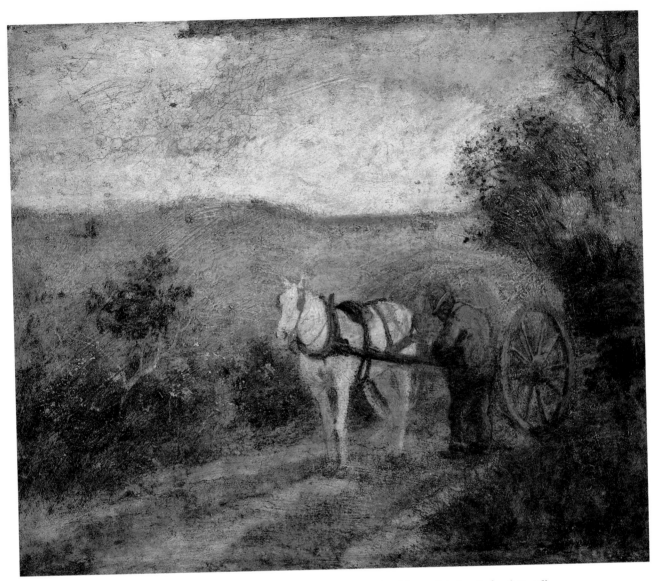

Fig. 9. *Mending the Harness*. National Gallery of Art, Washington, D.C., gift of Samuel A. Lewisohn (cat. 36).

in New Bedford taught this to Ryder, but concentrated attention and study from life may have sufficed. Later, in New York, he would visit racetracks and carbarns to make studies of horses, a practice probably begun in New Bedford.[18]

In addition to animals, portraits offered the young artist a chance to try his skills and prepare for a career. Visitors to his New York studio in later years commented on a life-sized portrait of a man in uniform that may date from this early period. The figure had intense, staring eyes that seemed "as if a soul were bursting from them"—perhaps one of Ryder's brothers in Civil War uniform or "Halpine," a war casualty whose funeral cortege inspired one of Ryder's earliest poems.[19] The portrait has disappeared, but the poem's insistent rhymes and intense feeling reveal a fervent young artist contemplating death within the romanticized context of war. Fife and drums are heard from afar, then gather force; stanza after stanza marches toward a climax as the cortege approaches the poet.

> Roll the muffled drum
> Wail the shrieking fife
> Halpine's in his home
> Only his remains come . . .
>
> And we hold the breath
> In the presence of death
> And we hold the breath
> For men who faced death
> Veterans every one.
>
> Now bursts the awful chime
> As they pass in line
> Shoulder to shoulder
> As they sway together
> As they vibrate together.

> With music weird and strange
> As sounds that range
> Along the billowy shore
> When storm rules the hour
> Alas! Alas!
> As they pass
> As they pass.
>
> Wakes within the brain
> Ah so dull a pain
> Wakes within the frame
> Both a chill and pain
> Ah so dull a pain.

The device of the cortege growing louder and then fading away as it passes is borrowed from funeral marches, and although the poem rambles and lacks subtlety, these early verses show Ryder to be an artist of the emotions, eager to convey the full force of experience. He returns to certain words and phrases as he would later go over a ship's sail or floating cloud with layer upon layer of glaze, heightening the emphasis until it transcends the literal meaning of the image. "Music weird and strange" is a personal note, one that would be heard in Ryder's most beautiful paintings.

In 1868 New Bedford erected a soldiers and sailors' monument to commemorate its Civil War dead—then tried to go on about its business. But the war had changed life in this port city by interrupting the supply of whale oil so that people learned to substitute coal oil in their lamps. Gradually, whaling began to be supplanted by cotton weaving and factories competed with the sea for the city's young workers. As the Industrial Revolution arrived to replace the romance of regiments and whaling ships with long, tedious hours at the looms, many, like the Ryder boys, left New Bedford in search of opportunities elsewhere.

Student Life
in New York

When Albert Ryder's brothers returned from war, the burden of family responsibilities that rested so uneasily on their father's shoulders gradually shifted onto theirs. William moved to New York by 1865, married, and established a restaurant on Broadway with his father-in-law. The business prospered, and around 1878 William became proprietor of the Hotel St. Stephen on East Eleventh Street in Greenwich Village. Five years later, the Hotel Albert opened next door, at the corner of Eleventh and University Place, on the site of a former coal yard. The Hotel Albert was often said to have been built by William and named for his artistic brother, who is supposed to have painted murals in the dining room or lobby. But while the St. Stephen and the Albert both seem to have been under William Ryder's management, the Hotel Albert was owned by Albert S. Rosenbaum and undoubtedly was named for him.[1]

Edward Ryder married a New Bedford girl and moved to New York by 1866. Albert and his parents followed the older boys to the city sometime between 1868 and 1870; the whole family was reunited in a small house on West Thirty-

fifth Street by 1871.[2] Alexander Ryder tried several new jobs over the next few years—restaurateur, milkman, church sexton—but as William prospered his father was persuaded to give up supporting himself. Albert Ryder probably took what jobs he could find or helped William in his business.[3] A career in art was one of many possibilities but perhaps not the most likely, for such a career demanded serious training, and Ryder had failed the entrance examination at the National Academy of Design.

The academy exam required that he submit for review a drawing of an antique cast. If, as seems likely, he had no formal training in draftsmanship, he could scarcely have satisfied a jury of academicians looking for firm contours and competent modeling. Before attempting the examination a second time, Ryder sought out the portrait painter and engraver William E. Marshall and asked for help. Marshall had studied with Asher B. Durand, who was among the founders of the National Academy and its president, but he had also studied in Paris under the unorthodox academician Couture, who counseled a free and individual approach. Couture's 1867 treatise on

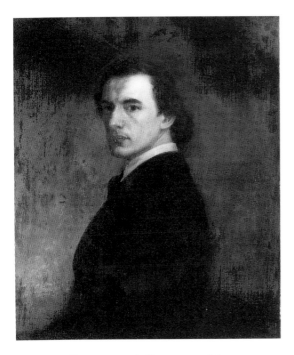

Fig. 10. William E. Marshall, *Portrait of the Artist, Age Twenty-three,* ca. 1860, oil on canvas. National Museum of American Art, Smithsonian Institution, Washington, D.C., gift of William T. Evans, 1909.7.43.

of the 1870s he began a colossal head of Christ in charcoal, ten by seven feet in dimension. Critics remarked on the strongly Semitic characteristics of this Christ and on his intense expression, and Marshall gained a reputation as a spiritualist, capable of plumbing the deepest mysteries of character.[5] Even in Marshall's celebrity portraits, a fixed stare expressive of the "fire within" occasionally overrides the subject's stilted demeanor.

Marshall is almost forgotten today, but he would have been a logical mentor for an aspiring artist around 1870, with his link to Durand and Couture and his studio for making portraits of great Americans. But Marshall was more than an instructor to Ryder: he was a kindred spirit, with a gentle manner masking a passionate inner life and a conviction that painting expressed spiritual truths only partially revealed to the eye. Ryder's deep regard for Marshall illustrates one of the characteristics that set him apart from other artists: he valued expression over style and technique and would praise even a clumsy painting that touched the emotions over a skilled but

art began by confessing that he had been unable to learn through academic teaching and had found his way only by experimenting without rule:

Rebellious against all science, it has been impossible for me to learn by academic means. . . . The sight of nature, the eager desire to produce that which captivated me, guided me better than the words which seemed useless. . . . This independence has cost me dear; I have often mistaken the way, sometimes entirely lost myself; but there has come to me from these failures great results, great light.[4]

Couture's seemingly paradoxical stance would have appealed to Marshall, who combined a career as a formal portraitist with an ardent commitment to the expression of the soul. He returned to America in 1865, soon after Abraham Lincoln was assassinated, to make portraits of the martyred president and then likenesses of Longfellow, Cooper, Beecher, Grant, Sherman, Garfield, Harrison, McKinley, and Roosevelt. But in addition to official portraits, at the beginning

Fig. 11. William E. Marshall, *Portrait of Asher B. Durand,* ca. 1867–73, oil on canvas. National Academy of Design, New York, 826-P.

uninspired effort. After Marshall's death in 1906, Ryder wrote to his widow:

[Marshall's] Durand portrait [fig. 11] is in my mind; and I can see it as clearly or more so than any portrait I have ever seen. . . . In fact I think if it could be placed in company with the finest portraits of any period, the Durand would have to be acknowledged the superior in the sense of the soul showing in the face.

Nor is it strange that it should be so; great as Rembrandt and the others are, they were painters and delighted in painting. Marshall's gift for portraiture was more phenomenal, keener in his insight into the character of his sitters, in the Durand portrait making him live as Shakespere [*sic*] would have done in a word portrait.

It is convincing; one feels in its presence, here is the man.[6]

Ryder's drawings must have improved (Marshall is said to have introduced Ryder to erasers), for when he applied again to the academy school, he was admitted.[7] He enrolled in four antique-drawing classes between 1871 and 1875 and a life-drawing class in 1871. By mortgaging its building the academy had raised enough money in 1870 to hire its first paid instructor, Lemuel Wilmarth, who had studied in Munich under Wilhelm Kaulbach and in Paris with Gérôme. Through careful attention to the academy's collection of casts, Wilmarth's students could hope to master academic style secondhand and earn a reputation for themselves and for American art.

Somewhere an undiscovered cache of sketches after antique casts may exist to testify to Ryder's several years' study with Wilmarth, but until such a trove is found we can only wonder that such a long apprenticeship left so little impression on his art. Although Ryder could draw a figure to proportion when necessary, he demonstrated no interest in drawing for its own sake. His mature art depended greatly on boundaries— the places where shapes meet—but it owed almost nothing to line in the classical sense.

Even Ryder's attention to the human figure was perfunctory compared with the intense study of anatomy and expressive gesture taught in nineteenth-century academies. Basing their philosophy on humanist traditions of the Renais-

sance, academicians praised the human figure as God's highest creation and the most worthy subject of art. Raphael and Michelangelo symbolized the ideal; academicians vied to reinterpret their work in a higher moral or emotional key or— failing that—at least to imitate these masters correctly. One Frenchman spent more than ten years making a full-sized copy of Michelangelo's Sistine Chapel ceiling![8]

Against this record two or three partially nude classical figures are all that appear in Ryder's oeuvre of the tradition that Wilmarth taught (see figs. 39, 87).[9] Occasionally, the gesture of a blessing Christ or a noblewoman in antique costume faintly echo academy traditions, but the sound is distant and sweetly magical. Although the paintings are often richly pictorial, with glowing landscape vistas providing a resonant background for narrative incident, the action of the figures is rarely heroic.

The formative experiences in Ryder's early training came not in Wilmarth's classroom but in the fields around Yarmouth, where Ryder spent the summer with an aunt and uncle after his first year at the academy.[10] Working directly from nature, Ryder felt overwhelmed, "lost in a maze of detail." When his aunt once asked to see the results from his daily excursions, he despaired of having anything worthy to show and felt the need for some dramatic breakthrough.

Try as I would, my colors were not those of nature. My leaves were infinitely below the standard of a leaf, my finest strokes were coarse and crude. The old scene presented itself one day before my eyes framed in an opening between two trees. It stood out like a painted canvas—the deep blue of a midday sky—a solitary tree, brilliant with the green of early summer, a foundation of brown earth and gnarled roots. There was no detail to vex the eye. Three solid masses of form and color—sky, foliage and earth—the world bathed in an atmosphere of golden luminosity. I threw my brushes aside; they were too small for the work in hand. I squeezed out big chunks of pure, moist color and taking my palette knife, I laid on blue, green, white and brown in great sweeping strokes. As I worked I saw that it was good and clean and strong. I saw nature springing into life upon my dead canvas. It was better than nature, for it was vibrating with the thrill of a new creation. Exultantly I painted until the

sun sank below the horizon, then I raced around the fields like a colt let loose, and literally bellowed for joy.[11]

Ryder abandoned the realistic depiction of nature that formed the basis of midcentury landscape painting in favor of a synthetic view that summarized experience and feeling in an image that was "better than nature." Ryder's revelation in nature inspired a radical shift in technical approach: "I threw my brushes aside. . . . Taking my palette knife, I laid on [color] in great sweeping strokes." From the beginning, Ryder's technical approach resulted from the search for an expression "vibrating with the thrill of a new creation." Style alone was never the issue; he required a method suited to his meaning. Technique was itself an expressive device—an end, not a means.

If Ryder received no strong impress from Wilmarth's lessons, the experience at the academy was still crucial, for his fellow students became lifelong companions. Chief among these was J. Alden Weir, who entered the academy school in 1870 and became Ryder's closest friend there,

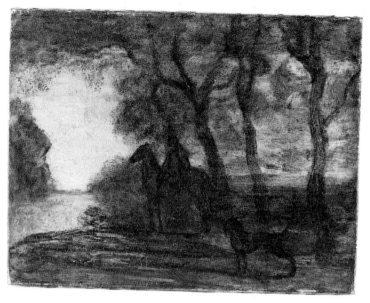

Fig. 13. *The Equestrian* (J. Alden Weir on Horseback). Portland Art Museum, Oregon, bequest of Winslow B. Ayer (cat. 13).

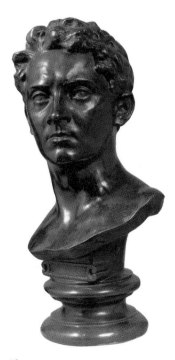

Fig. 12. Olin L. Warner, *J. Alden Weir*, 1880, bronze with black patina. The Corcoran Gallery of Art, Washington, D.C., gift of Ferargil Galleries, 25.3.

the one who more than any other sustained him. Weir's generous, gentle nature brought out Ryder's best qualities, which remained hidden before a more judgmental or impatient person. Weir was confident where Ryder was tentative; his father and older brother were professional artists and they had prepared him well for the academy program. Ryder's shyness masked an eager sociability; with Weir leading the way, Ryder enjoyed a large circle of friends loosely centered on the academy. Ryder's *Equestrian* (fig. 13) is said to picture Weir on horseback; Weir used Ryder as the model for his *Good Samaritan* (fig. 14), although most friends would have said it was Weir who did the ministering when it was needed.

An evening's discussion might be rounded out with any of a number of other people Ryder knew through the academy. J. Carroll Beckwith, George de Forest Brush, and Abbott Thayer were friends who became famous artists in their generation; numerous other chums took other paths after the academy experience, such as Joe Evans, who was president of the Art Students League in

Fig. 14. J. Alden Weir, *The Good Samaritan*, 1880, oil on canvas. Saint Paul's Episcopal Church, Windham, Connecticut.

the early 1890s. Three student colleagues—Frederick S. Church, Walter Denslow, and James Kelly—nursed Ryder through an attack of typhoid fever, and each received one of his small paintings in gratitude; another friend, Stephen Putnam, also was given such a souvenir (cat. 61).[12]

In addition to fellow students, Ryder apparently knew Louis Comfort Tiffany and by 1873 owned two of his watercolors of Moors.[13] R. Swain Gifford, Ryder's colleague from New Bedford who had come to New York several years earlier, may have introduced Ryder to Tiffany, for Gifford and Tiffany were close companions. Together they traveled to Europe and North Africa in 1870, where the brilliant sunlight and exotic life of the Arabs provided picturesque subjects for their watercolors and oils.

Tiffany and Gifford were among the earliest Americans to discover firsthand what French artists since Delacroix had known—that North Africa held exceptional charm for artists with a gift for color. Ryder must have found their talk very different from what he heard in Wilmarth's drawing classes. How could a plaster cast compete with mosques and market scenes as inspiration for artists? Wrapped in their desert robes, the Arabs were like toga-clad Greeks brought to vivid life—marble reserve transformed into warm-toned flesh. Tiffany's freely brushed sketches glowed with sunlight. They were the perfect expression of a painter enchanted by the possibilities of color and light.

Tiffany took photographs in North Africa that he later used, along with sketches, as studies for larger paintings.[14] One of these, *Market Day Outside the Walls of Tangier, Morocco* (fig. 15), appeared in the 1873 academy exhibition, to which Ryder sent his first submission, an unidentified landscape. From 1873 to 1878 Gifford also sent views of the Nile and Tangier to the National Academy exhibitions, capitalizing on the current fascination with the Near East.

Several years later Ryder turned his gaze to the East as well. In 1880 he sent *An Eastern Scene* (probably *By the Tomb of the Prophet*, fig. 16) to public exhibition, along with a literary

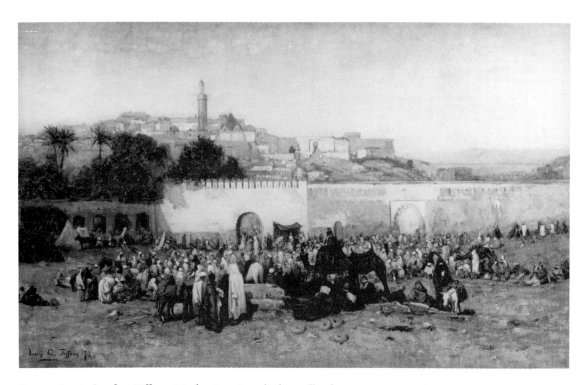

Fig. 15. Louis Comfort Tiffany, *Market Day Outside the Walls of Tangier, Morocco,* 1873, oil on canvas. National Museum of American Art, Smithsonian Institution, Washington, D.C.

subject, *Nourmahal,* based on Thomas Moore's romantic love poem set in India, *Lalla Rookh.* These two paintings, a reviewer noted, were enough "to satisfy one's self that he has the germ of greatness as a colorist."[15] The Near Eastern subjects that appeared before Ryder visited North Africa evoke the rich, deep color of Tiffany's Near Eastern oil sketches (fig. 17), suggesting that his early introduction into the exotic colorism of the East had a lasting impact.

Some orientalist painters worked almost like reporters, journeying far to record exotic monuments and customs for a stay-at-home public. Ryder's interest in this colorful tradition did not depend on travel but on a desire to explore neglected corners of his palette. When James Kelly complimented him by saying his work resembled George Henry Boughton's, he answered, "Yes, some people seem to think so, but I have more gold in mine."[16]

Two other Near Eastern subjects, *An Oriental Camp* and *The Lone Scout* (figs. 18–19), are close in style and mood and may have been done in the 1870s. *Oriental Camp* still retains a thick coating of luminous glazes and varnishes, now yellowed, adding to its mysterious allure, like the veil worn by an Arab maiden. These oriental subjects follow by several years those of Ryder's two well-traveled friends, but his early ownership of Tiffany's Arab watercolors suggests that even while attending to Wilmarth's instruction, he felt the pull of an alternative, colorist tradition originating with Delacroix. His sympathies ran against the grain at the National Academy, although they would have been more acceptable in the Paris Ecole des Beaux-Arts, where orientalism had long since taken root.

Women were admitted into the mens-club atmosphere of the National Academy School in the 1870s through an agreement with the Cooper-

Fig. 16. *By the Tomb of the Prophet.* Delaware Art Museum, Wilmington, bequest of George I. Speer (cat. 4).

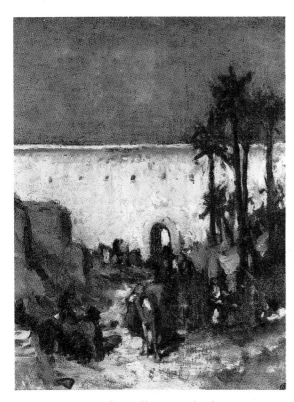

Fig. 17. Louis Comfort Tiffany, *North African Scene with City Wall,* exhibited 1873, oil on canvas. Charles Hosmer Morse Museum of American Art, Winter Park, Florida.

Union School that allowed as many as two hundred ladies to enroll each year. These were mostly amateurs, dismissed from serious consideration, but Helena de Kay—who would play an important role in Ryder's career—was an exception. She liked advanced ideas in literature and art and especially admired the sophisticated intellect of John La Farge, who seemed the very embodiment of the new art spirit, from his French upbringing and mesmerizing conversation to his fascination with exotic lands like Japan and Persia. An author, theorist, lecturer on aesthetics at Harvard, and an artist with novel approaches to murals, stained glass, and easel painting, La Farge had a following among the vanguard in New York and Boston. After a few lessons from La Farge, Helena de Kay sketched in her diary designs for decorative screen panels, with flowers asymmetrically arranged *à la japon-*

aise, in the manner introduced to America by her teacher. Her talent and beauty combined into a potent aphrodisiac, if we can believe the suggestion that she was the mysterious red-headed woman who haunted Winslow Homer's life and art and whose rejection caused him to retreat into a private communion with nature.

La Farge not only introduced Miss de Kay to the refined elegance of Japanese art but to the sensual, fatalistic world of Omar Khayyam. She copied La Farge's manuscript of the *Rubaiyat* by hand and shared it with a new acquaintance, an aspiring poet named Richard Watson Gilder, who would later become managing editor of *Scribner's.* "These marvellous quatrains were the litany—the tragic undertone to our courtship," wrote Gilder, who married Helena de Kay in 1874.[17] The Gilders' aesthetic curiosity and enthusiasms were magnets for artists seeking new expressions. Walt Whitman best described the fresh breeze that prevailed in their Fifteenth Street studio: "You must never forget this of the Gilders, that at a time when most everybody else in their set threw me down they were nobly and unhesitatingly hospitable. The Gilders were without pride and without shame—they just asked me along in the natural way. It was beautiful—beautiful. You know how at one time the church was an asylum for fugitives—the Church, God's right arm fending the innocent. I was such an innocent and the Gilders took me in."[18]

Ryder knew Helena de Kay Gilder through the academy school, and he too was taken into the Gilder circle for a time, where his acquaintance with the bright artistic minds of the day expanded. La Farge visited as did Will Low just back from painting at Grez, near Barbizon in France, where he had become friends with the young author Robert Louis Stevenson. Augustus Saint-Gaudens came with stories of study in Paris, while Stanford White, son of the great Shakespearean scholar, talked of taking up architecture. Also on hand were Madame Modjeska, the Polish tragedian who brought all New York to its hankies, Charles Dudley Warner, fresh from collaborating with Mark Twain on *The Gilded Age,* and many others.

Fig. 18. *An Oriental Camp*. Mead Art Museum, Amherst College, Massachusetts, gift of George D. Pratt, '93 (cat. 43).

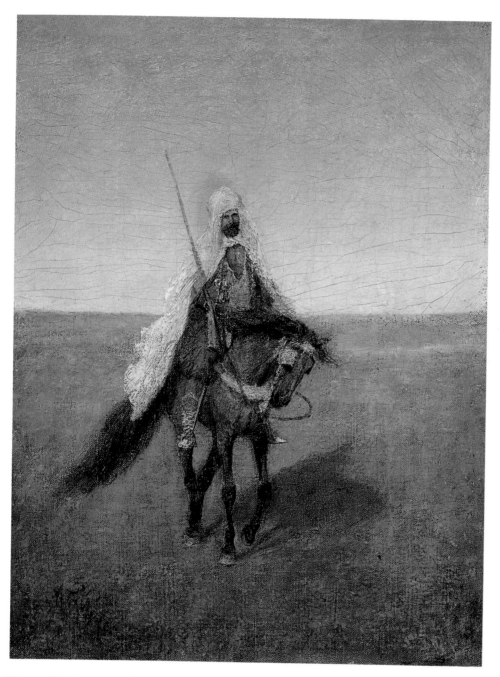

Fig. 19. *The Lone Scout*. The Fine Arts Museums of San Francisco, De Young Museum, gift of Mr. and Mrs. John D. Rockefeller III (cat. 31).

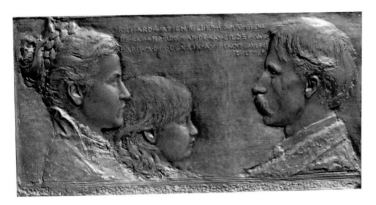

Fig. 20. Augustus Saint-Gaudens, *Portrait of Helena de Kay Gilder, Richard Watson Gilder, and Rodman Gilder,* 1878, bronze relief. Private collection.

Some evenings in the Gilder studio were spent discussing the tensions in the National Academy. A rumor had circulated in the spring of 1875 that the academy had no funds to rehire Wilmarth in the fall and that it would not open for classes until December. In response, about seventy students banded together to begin the first independent art school in America, the Art Students League, at Sixteenth Street and Fifth Avenue.[19] Even this did not sufficiently arouse the academicians to the need for change.

A number of older artists wanted to nurture native art by keeping foreign work out so that American artists could mature and find patrons. In 1867 more than seventy academicians petitioned Congress to tax foreign art entering America, but the protectionist legislation backfired, annoying collectors and outraging younger artists, who wanted no artificial encouragement that might later be said to compromise their achievement. They believed that success would come not by outlawing competition but by quickly mastering and surpassing it. Already several Americans had gone to Paris to study with Gérôme.

When the Metropolitan Museum of Art opened its doors in 1872 in the Dodsworth Building on Fourteenth Street in New York, its galleries full of foreign work, it was hard to know which side was served. Was this a threat to native growth or an incentive? Would the museum recognize American work in a spirit of fairness and national pride or ally itself with those who felt that American culture had not yet come of age?

In this climate the annual exhibitions of the academy inevitably became a political battleground. A committee of three academicians had full power to accept or reject work for the shows. Although younger artists with novel approaches were occasionally admitted, those who looked to foreign styles were offered little encouragement.

Ryder's case was fairly typical. He was accepted for the annual exhibition in 1873 with an unidentified landscape that a reviewer said showed promise even though it was "coarsely finished."[20] His work appeared again in 1876 but not in 1874 and 1875—although he must have submitted entries, for he had paintings in numerous other exhibitions at the time. Good visibility in the academy exhibitions was essential to establishing a reputation and securing commissions; repeated rejections could damage an artist's fledgling career. The new artists were incensed when the jurors rejected their canvases, but how could they protest a system so firmly in the hands of the conservatives? And how could Ryder—out of step with the academy's agenda, distracted from the study of plaster casts by color and romantic subjects—find a niche when even the most exemplary academicians lacked patrons?

The rejection of all of La Farge's submissions in 1874 produced consternation among his followers. Although he was a symbol of the new spirit in art, he was also a widely respected painter and teacher and a member of the academy, so that in refusing him the jury sent a clear message to those inclined to embrace his ideas. A host of other problems plagued the academy at this time, such that Helena de Kay Gilder wrote in her journal in April 1875: "They have determined that the new school shall have no chance.

. . . It was so wholesale—Lathrop, Ryder, Mrs. Carter, MRO [Maria Richards Oakey] and me. So we are conspiring! Cottier, through F. Lathrop, has offered his room. Mr. La Farge who was very angry, will countenance and admit. Lathrop will execute. R[ichard Watson Gilder] will send the press."[21]

The result was an exhibition of paintings by La Farge, William Morris Hunt, and several of their pupils—in the nature of a *salon des refusés*—which opened at Daniel Cottier's decorative-arts gallery during the run of the 1875 academy show. Half the exhibitors were women, and all were sympathetic to the ideas that Hunt and La Farge conveyed from their experiences abroad.[22] The press covered the exhibition approvingly, no doubt with some encouragement from Gilder at *Scribner's:* "These pictures cannot be lightly spoken of, and it is impossible to describe them as if they were an ordinary or even an extraordinary exhibition of common subjects, taken from a common standpoint."[23]

Among the works shown at Cottier's in 1875 were broadly brushed canvases by Hunt that revealed his closeness to the modern French style of Couture and Millet. La Farge sent to the exhibition three decorative panels painted in 1865 for the dining room of a private residence, their *japonaise* compositions and decorative gilding clearly distinguishing them from the conservative work shown at the academy. These directly influenced Ryder's later work, but his own entry in this seminal exhibition was a stable interior.[24]

Hunt's vigorous manner and La Farge's fascination with the decorative arts, Japanese design, and Persian poetry had more effect on the impressionable Ryder than the sum of Wilmarth's antique classes. If academic draftsmanship and technique had not been mastered, Ryder had found something far more valuable in his student years: a new direction for his art that felt fresh and forward-looking, fertile with ideas, exotic and challenging. In 1875 Ryder found himself exhibiting with the distinguished aesthetes Hunt and La Farge; sponsored by the ingenious and enterprising Cottier; and championed by powerful critics. The Cottier exhibition put Ryder squarely among the most avant-garde American artists; from this time on his name would be linked with progressive styles. By accident or design he was well positioned for an important career. ✤

A New Society for Art

The energy generated by the Cottier show in 1875 might have dissipated had the National Academy not tripped once more by rejecting Saint-Gaudens's work in 1877. His offense was the same as that of La Farge: he was too close to Europe and owed little to lessons learned at home. Seven years' residence in France and Italy had erased all evidence of his academy training from the 1860s. His sculpture was no longer a polished reinterpretation of the antique; he submitted instead a plaster "sketch," freely modeled in the French manner, contemporary in mood, with sensual surfaces alive to the changing effects of light and shadow. It seemed the very essence of an idea, still fresh with the artist's touch, but to the academicians it was merely unfinished and unconvincing.

Angry over this rejection, Saint-Gaudens, Wyatt Eaton, and Walter Shirlaw met with the Gilders to establish a new association "with the object of advancing the interests of Art in America."[1] First, they named their group the American Art Association but soon changed it to the Society of American Artists. Their intention was to hold annual exhibitions of the artists represent-

ing the new spirit so that audiences could see what was being rejected from the academy exhibitions, generally the work most inspired by foreign masters.

Without disclosing that a new society was being born in his sister's home, Charles de Kay used his position as *New York Times* art critic to call for a new artistic response to modern life.[2] He argued in a series of articles during the summer of 1877 that it was useless to talk of an American school since America was now part of an international art world. Saint-Gaudens obliged by marshaling support for the fledgling organization among Americans abroad, including John Singer Sargent, Mary Cassatt, Charles Sprague Pearce, Frederick Bridgman, Edwin Blashfield, and several others, who agreed to send paintings to the new society's exhibitions. Clarence Cook similarly promoted the interests of the new group in the *Daily Tribune*.[3] In the fall the organization was announced to the public.

The founders were divided over the election of Ryder. They needed strong men who could withstand the inevitable comparisons that would be made with the academicians, and everyone con-

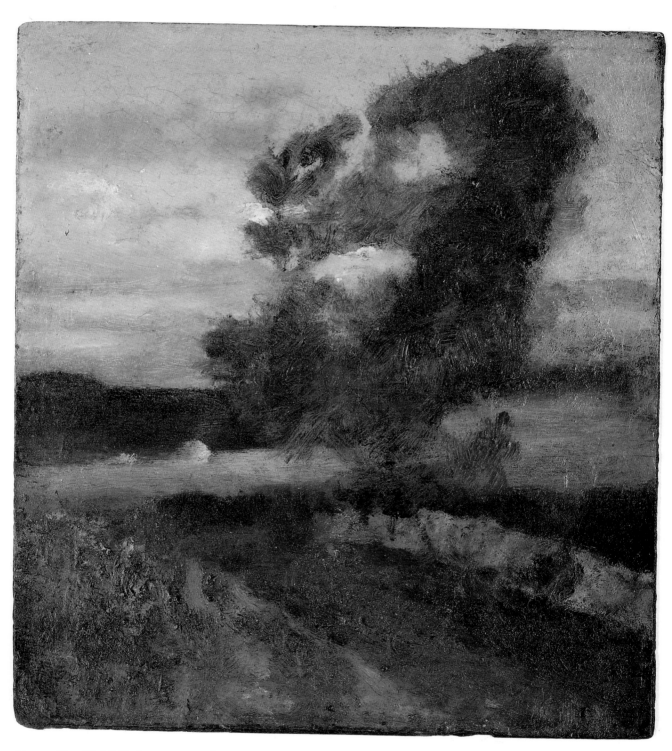

Fig. 21. *Near Litchfield, Connecticut.* Collection of Robin B. Martin, Washington, D.C. (cat. 42).

Fig. 22. *The Watering Place*. Private collection (cat. 72).

Fig. 23. *Landscape*. Collection of Rita and Daniel Fraad (cat. 27).

ceded that Ryder's drawing lacked confidence and his paintings, as noted by critics, were "coarsely finished." Including him would leave the group vulnerable to criticism. But some felt that this was mere carping; to reject him because he ignored drawing and finish was to adopt the standards of the academy against their own cause. The new society must take a larger approach. "If we know anything at all, we should know a work of art when we see it," some said.[4] Among the new members were Gifford, Olin Warner, Tiffany, and Francis Lathrop—natural allies of Ryder's. Already acknowledged as a special case, Ryder was elected in February 1878, shortly before the opening of the first exhibition of the society.[5]

The first exhibition of the Society of American Artists took on the atmosphere of a contest between the establishment and the avant-garde. Some of the society's members abstained from submitting work to the National Academy exhibition that year, heightening the contrast between the groups. As Ryder did not exhibit at the academy from 1877 to 1880 but did show at each of the new society's exhibitions from 1878 to 1884, he may have been among these "irreconcilables."

Ryder's landscape in the first Society of American Artists exhibition in 1878 has not been identified, but it must have been one of a type that we know he was doing at the time—small, thinly painted landscapes broadly composed in masses of rich color, the outgrowth of his experience in the Yarmouth countryside. Apart from one painting called *Market Horse* (unlocated), all of Ryder's entries to the society's exhibitions in 1878 and 1879 were landscapes, some with figures, so that he was considered to be primarily a landscapist. His works, however, looked entirely different from the magnificent, mammoth expanses painted by Thomas Moran in Yellowstone, Frederic E. Church in the Holy Land, or Albert Bierstadt in the Sierra Nevadas, which were then the passion of the public. Such glorious landscapes dazzled the eye and provoked the political senses as well, for they spoke to great national ques-

tions of eminent domain, foreign expansionism, and economic opportunity.

By comparison, the landscapes Ryder submitted for exhibition, such as *Near Litchfield, Connecticut* (fig. 21), are modest, only a few inches in each dimension. They appear unfinished, even by the standards of an oil sketch, with no detail and no careful plotting of space receding toward a distant horizon. Although Ryder's early landscapes are fairly small, he apparently did not consider them studies for more finished works but complete statements, that borrowed the looser aesthetic of the oil sketch.

In *The Watering Place* (fig. 22) the glow of the varnished panel is revealed along the edges of the pond, where Ryder left unpainted space between the pictorial elements. Ryder often painted on wood cigar-box lids—his brother's restaurants provided a steady supply—and the unpainted cedar of the panel gave a mellow warmth to the color ensemble.[6] Where the composition required an accent, a bit of agitated brushwork vaguely suggests vegetation without resolving into anything specific. There is little to draw attention from the subtle glow of light reflected off water.

Another small painting called simply *Landscape* (fig. 23) is brushed in thin washes without detail so that the composition is made of suggestive color shapes—a dreamscape of tree shadows reflected in a stream, lights and darks mirroring each other. The fabric has absorbed the paint in some areas so that the canvas weave is exposed, while other areas are covered by glossy glazes. Ryder was already playing with the media in which his pigments were suspended. Some say he would use pure alcohol as a medium, a volatile substance that evaporates without a trace, which could account for the way his pigments sink into the fabric like a stain.[7] Occasionally, a layer of pigment has puddled and dried on top of another, suggesting that the two layers had different and incompatible media.

Color and light made these small works delicious to their audience, although the range of hues is narrow—a few browns and blues, enliv-

Fig. 24. *Landscape*. Collection of Willard B. Golovin.

ened with touches of yellow and white or a glaze of red or green, mingled so that discrete or local color is submerged in an all-over harmony. The absence of incident brought forward the almost-abstract quality of the conceptions. Ryder ignored the traditional "view through a window," preferring an inner or mental image that owed as much to memory as to observation.

Several more small landscapes have survived (fig. 24), and we can find certain elements common to the group: an absence of drawing, reduction of the number of elements depicted (usually a tree or two with a bit of land or water), and the curious "unfinished" quality. But what really sets Ryder's landscapes apart is his refusal to treat landscape as an idiom for American nationalism. He did not depict the natural wonders of Niagara or Yellowstone, which Americans considered their divine endowment, or portray settlers populating an accommodating wilderness, as did the Hudson River landscapists, nor did he

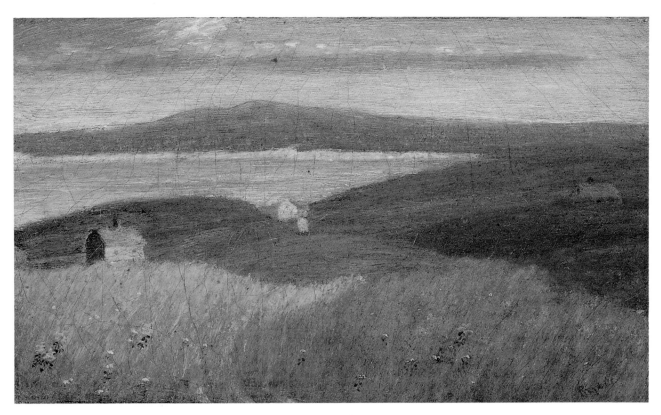

Fig. 25. *Gay Head*. The Phillips Collection, Washington, D.C. (cat. 17).

fuel economic ambitions for expansion and development with views of the West.

In America, landscape assumed roles assigned in Europe to history painting, for the virgin land had to substitute for a national history that was yet to unfold. But Ryder's landscapes played to no such national agenda. They were emblems of something private or internal, something that authors of the day liked to call "poetic" because it worked through analogy or reference. Ryder's landscapes evoke a state of mind, one that entered the American consciousness with the disillusionment that followed the Civil War and with the vague apprehensions that accompanied industrialization. If Bierstadt's and Moran's vistas trumpeting national opportunity represent one extreme—landscape as expansive, public declaration—Ryder's small nature notes seem to have imploded, leaving a small, silent, concentrated core.

Ryder's landscapes owe a debt to those of La Farge (fig. 26), whose influence among Ryder's friends can scarcely be overestimated. La Farge's small, vacant landscapes on wood from the late 1860s are the closest parallel to Ryder's work of the next decade. A single tree, broadly brushed in a restricted palette, with wood grain showing through from the support, must have moved Ryder deeply.

La Farge's revolutionary approach to landscape grew from a heightened sophistication and aestheticism, conceived during extensive travel abroad, nurtured in the studio of Hunt in Boston, and refined by a study of the arts of the Orient. Ryder's landscapes mirror La Farge's conception in a naive or intuitive way, without appealing to the intellectual theories that La Farge brought to his work.

Homer Dodge Martin's and George Inness's landscapes of the 1870s also took a poetic or suggestive turn in which the moods of nature were analogs for the inner life. Emotions mirrored in nature are a hallmark of romanticism, but Martin and Inness lent a more cerebral aspect to the formula by avoiding the old repertory of tempestuous storms and deluges by which an earlier generation had linked human crises to those of nature. Ryder borrowed the chill light and open, almost desolate composition of Martin's landscapes in a painting called *Harlem Lowlands, November* (fig. 27). Inness too preferred a "grey lowery day" of brooding stillness as a place for the mind and eye to dwell in quietude (fig. 28). Instead of evoking the Sublime in order to produce gasps of admiration, Martin and Inness held a moment in suspension, inviting contemplation.

Like La Farge, Inness took his cue from the modern movement in France, especially Corot and Millet and the painters associated with Barbizon, whose dreamy, synthetic landscapes and noble peasantry idealized the relationship of man and nature just as industrialization was rupturing this ancient rapport. By the 1880s Inness began to draw a veil over nature, floating hazy tree shapes against soft mists of color. The people in his landscapes halt their work as if transfixed, as much a part of nature as any tree or boulder. Ryder's work parallels Inness's in pastoral subjects such as *Spring* (fig. 29), shown in the 1879 Society of American Artists exhibition, and in *Autumn Landscape* (fig. 30). A similar mood suf-

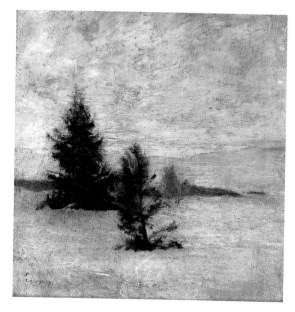

Fig. 26. John La Farge, *Snow Weather, Sketch,* 1869, oil on panel. The Art Museum, Princeton University, New Jersey, gift of Frank Jewett Mather, Jr., 51-8.

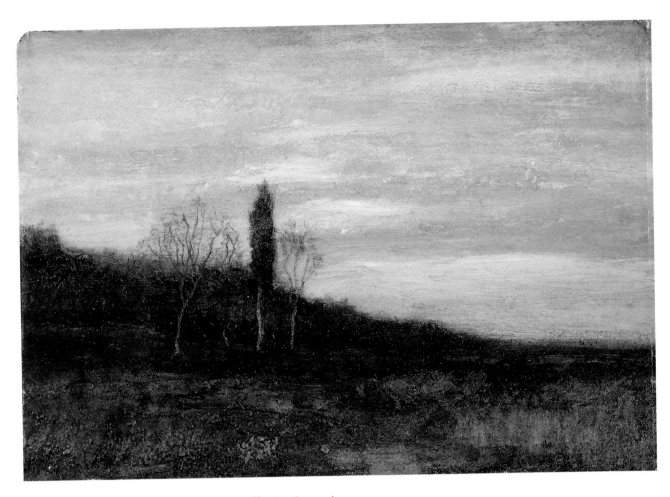

Fig. 27. *Harlem Lowlands, November*. Private collection (cat. 20).

fuses *The Golden Hour* (fig. 32), a perfect world
in which all nature glows with the sun's warmth.

Twilight reflected on a pond, the silhouette of
a single tree against the sky—such slight effects
were too insubstantial for an audience schooled
to expect landscapes on grand national themes.
It is hard to recapture today just how unusual
Ryder's little color notes appeared in the 1870s.
Most people dismissed them as clumsy and in-
significant, but those who enjoyed their simple,
open arrangements considered them sweetly na-
ive, evocations of an ancient rhythm in nature
that was somehow slipping away. Forms were
remembered rather than recorded and disagreea-
ble details forgotten in the harmonious glow of
these landscapes of the memory, abstracted in
time and place so as to escape the vice of
nostalgia.

The very awkwardness of Ryder's figures, con-
trasted with the elegance of academic art, was
proof of his sincerity. Appreciation of his clumsi-
ness is one of the first inklings of the attitude
that would later characterize folk-art collectors,
who also idealized the rapport with nature and
prized untutored work as more expressive of this
bond.

Ryder's closest friends often spoke of the diffi-
culty of putting into words the way his paintings
moved them and took refuge in analogies: "like
Japanese lacquer-work, or something just from
the Middle Ages"; "[His landscape] tells little
more than could a Deck plaque or a dainty bit of
faience"; "They belong to a world of their own,
and . . . they recall the visions conjured up in
old Italian epics"; "A daring picture, and one
which it is difficult to describe."[8]

Once in a while a voice spoke up to say
Ryder's paintings, like those of Blakelock, were
formless and vague, but de Kay had put himself
on the line by bringing Ryder into the Society of
American Artists, and he determined to provide
a friendly reception in the press. Sometimes de
Kay almost apologized on Ryder's behalf, saying
of *Spring:*

Mr. Ryder is another painter who often raises an in-
voluntary smile by the oddity and apparent naïveté of
his pictures; but for the close observer the smile is

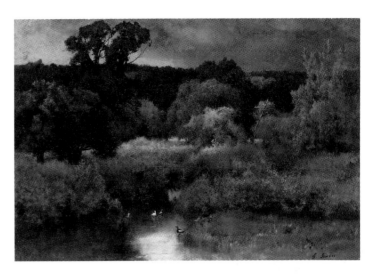

Fig. 28. George Inness, *A Grey Lowery Day,* 1877, oil on canvas.
Wellesley College, Massachusetts, gift of Mr. and Mrs. James B. Munn
in the name of the class of 1909.

sure to be more of pleasure than disdain. Probably no
pictures here, not even the broadest painted heads by
defiant impressionists like Whistler and Currier, will
rouse more diverse emotions than Mr. Ryder's work.
As to his one landscape here, called "Spring," it is
truly caviare to the multitude, and for the majority of
people it will seem wasted time to attempt to fix in
words its singular and fresh charm. Like many of the
modern painters, Mr. Ryder appears to be quite defi-
cient in knowlege of the figure. He is an impressionist
in so far as he strives for the "feeling" of a figure
rather than to express its anatomy in definite out-
lines.[9]

And so Ryder found himself taken up by the
avant-garde, a founder of the new association,
championed in the press as one of its most indi-
vidual members. Even his chief fault—weak
drawing—was a form of "naïveté" and a source
of "pleasure." In a bold move de Kay made Ry-
der's pictures a test of artistic sensibility: Who
was free enough in spirit to recognize these as
works of art, without fussing over matters of
drawing and finish?

One final aspect remains to be mentioned—
the part played by the artist's personality. It was

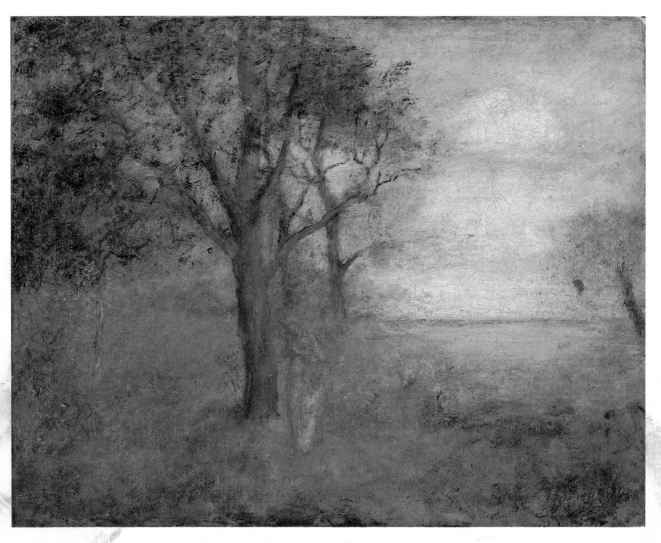

Fig. 29. *Spring*. The Toledo Museum of Art, gift of Florence Scott Libbey (cat. 62).

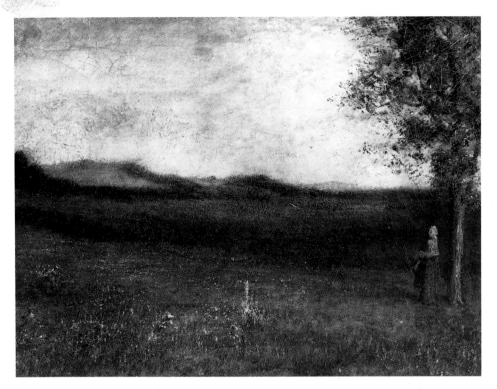

Fig. 30. *Autumn Landscape*. Private collection (cat. 1).

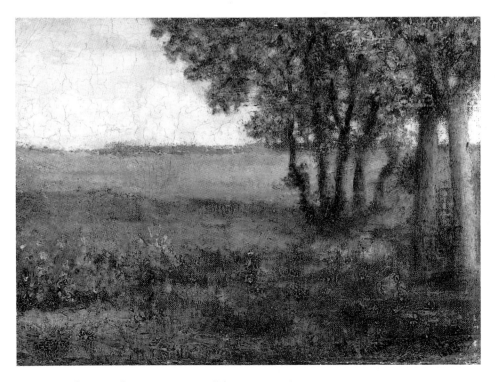

Fig. 31. *Landscape with Trees*. Private collection (cat. 28).

easy to see how a debonair man of the world and brilliant conversationalist like La Farge cut a swath through the rather narrow art circles of New York and Boston, but what of Ryder, with no money, little education, and no elegant speeches on art, only a curious, high-pitched giggle punctuating the art discussions over beer at Munschenheim's Arena Restaurant?

It was Ryder's luck to arrive in New York society at the moment that artists began removing themselves to bohemia. Absent social graces or weak art skills that would have disqualified an earlier artist for important commissions were now tolerated, even prized as demonstrating integrity. Although patrons were in no greater supply than before, the artist's relationship to his patron was quietly shifting, allowing greater latitude for individuality, even for eccentric behavior and unorthodox views. A number of the "new men" had been trained in Paris and took a broader view of the artist's role than was current in America, believing that he served his genius first and only later considered a collector's taste.

In 1878—the year of the first Society of American Artists exhibition—de Kay published a novel called *The Bohemian: A Tragedy of Modern Life,* set among a group of artists in Washington Square, curiously like the artists who frequented the Gilder home and Arena Restaurant. De Kay described their perplexity in the face of vanguard movements from abroad and gently satirized their timid attempts to break clear of philistine values:

"Ah," cried a young disciple of the brush, who, for reasons of his own, kept his hair at the traditional length, "what luck, what knack some of those Frenchmen have! There is Corot, for instance. Anybody can paint like Corot. He found that it paid to be singular, and so he went to work to paint with a feather duster. Do you call those cloudy things he paints, trees? And Millet! All you have to do is to make your landscape as bare as possible, exclude the light, put in some thick-legged, haggard peasants, doing nothing in particular—and there's Millet! . . . "Don't agree with you there," called out an art critic and picture reporter. "The Frenchmen are all right. What I can't stand is

the affectations of Americans. Look at Whistler, with his *nocturnes* in black, and *motifs* in blue, his peacock's feathers and frippery—La Farge, with his wabbly drawing and meaningless figures—Vedder, with his ugly grotesques!"

"You've picked out the very men who are really our strongest artists," piped up a little man, who blushed to hear his own voice. He was an insurance broker, who painted on the sly.[10]

In his criticism de Kay championed the idea that genius existed within an artist, almost independent of his work. Disregard of society's conventions, personal eccentricities, and refusal to conform were marks of character, and character—more than academic formulas—was the very stuff of the new art. Couture's departure from "rule" now became the standard. Of Inness, de Kay wrote: "There remains the personality behind the artistic product. A painter deserving the name of artist works, consciously or unconsciously, from inner rules which he has, as it were, invented for himself. It is easily conceiveable [*sic*] that he may be a great artist, and yet unequal in his work; a genius, and surpassed by lesser men in deftness of hand.[11]

This philosophy gained momentum in the decades coinciding with Ryder's career. The independent stance that inspired members of the Society of American Artists began as a reaction against the dismal patronage of American art, but what was forced on this generation as a necessity was quickly cloaked as a virtue. "The true use of art is, first, to cultivate the artist's own spiritual nature, and secondly, to enter as a factor in general civilization," declared Inness. "What [the true artist] hates is that which has evidently been painted for a market."[12]

As railroads, steel, cheap labor, and new banking structures transformed the American economy after the Civil War, money became almost an obsession. The general fixation on money and its curious relationship to art led William Harnett, John Haberle, Victor Dubreuil, and other artists to make trompe l'oeil paintings of paper currency—images brimming with paradox and

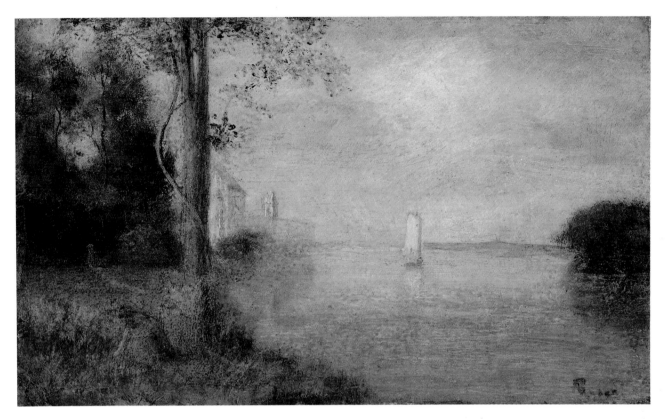

Fig. 32. *The Golden Hour*. Museum of Fine Arts, Boston, bequest of Hiram Hyde Logan (cat. 18).

irony. In a world where everything seemingly had a price, those qualities that could not be marketed ranked highest.

Ryder was the very archetype of "the true artist," pure in character, working without regard to the market. His indifference to money is perhaps the most enduring aspect of his legend.[13] As Walt Kuhn commented later, "[Ryder] had something behind the canvas."[14] That something could not be bought even by the richest captain of industry, who might, however, be privileged to own the by-product of genius. Heroism had been banished from the canvases of Inness, La Farge, and Ryder, but it reappeared almost magically in the artists themselves. The painted work was no longer a public representation designed to dignify the purchaser through association with noble deeds, magnificent vistas, and dynamic action. The new aesthetic associated the canvas intimately with its maker; it was a small, discreet window into the artist's soul, through which a viewer might glimpse greatness. ❧

Ryder and the
Decorative Movement

Most critics thought the first Society of American Artists exhibition showed "promise, not performance," but Daniel Cottier, the dealer who had offered his gallery for the landmark 1875 exhibition, bought canvases by Sargent, Low, William Gedney Bunce, and George Fuller out of the exhibition for his client Ichabod T. Williams.[1] Cottier never wavered in his support for the American vanguard; from the mid-1870s, when he first provided a platform for their views, until his death in 1891, he promoted their art and lent assistance in a hundred other ways. For Ryder, Cottier's support was crucial. He was dealer, friend, and mentor—providing introductions to clients and collectors, arranging Ryder's first two trips to Europe, and drawing him into the interior-decoration movement that swept America in the 1870s. The fifteen years of Ryder's association with Cottier were the most productive of the artist's life.

Cottier was born in Scotland in 1838, descended from French settlers on the Isle of Man, and was a glass stainer by trade.[2] He served an apprenticeship in Glasgow and studied in Dunfermline, Leith, and London, where he attended John Ruskin's lectures. During the 1860s he executed a number of glass commissions while working for the firm of Field and Allen in Edinburgh and then, by about 1865, established his own glass-staining company in Glasgow.

Cottier's most celebrated client was Dr. John Forbes White of Aberdeen, a collector of great importance for Scottish art, who commissioned Cottier to make nineteen stained-glass windows and other decorative furnishings for his villa, Seaton Cottage. These decorations were unusual in that they carried motifs from one part of a room to another in order to unify the whole; the decorative border on a piece of furniture, for instance, might be repeated as the pattern for wall stencils. A natural entrepreneur, Cottier liked to cross boundaries and build networks, whether between motifs in a decorative interior or between artists and clients who came to his gallery.

By 1867 Cottier had established a firm under his name in London; in 1873 he opened a branch in New York at 144 Fifth Avenue, managed by his Scottish colleague James (Jimmy) Smith Inglis, and another in Sydney, Australia,

co-owned and managed by a fellow glass stainer from Glasgow, John Lyon. On three continents Cottier promoted his own version of Ruskin's and William Morris's ideas on interior decoration, encouraging an eclectic appreciation of the best craftwork from around the world—silver and brasses from Spain, ebonized furniture in the Japanese style from England, embroideries from Austria, frames and mirrors from Holland, ceramics from the Mediterranean, scrolls and fans from the Orient, leather from Morocco, tapestries and silks from France, and his own stained glass. Each year Cottier traveled through Europe and beyond to find objects for wealthy clients who wanted to surround themselves with beauty as a respite from the cares of commerce and, as Thorstein Veblen was to reveal, as a way of displaying their riches in an era of expansionism and weak governmental regulation.

The 1872 American edition of Charles Eastlake's *Hints on Household Taste in Furniture, Upholstery, and Other Details* sparked a wave of interest in decoration. At the 1876 Philadelphia Centennial Exposition, exhibits of glass,

Fig. 34. Daniel Cottier, Cover Illustration for Clarence Cook, *The House Beautiful* (1878).

Fig. 33. Olin L. Warner, *Daniel Cottier,* 1878, bronze. National Academy of Design, New York, 128-S.

ceramics, rugs, fabrics, and other wares—many produced with new industrial technologies—spread the taste for interior design to millions of fairgoers. Cottier intended his custom interiors for the rich but gladly modified the designs for smaller purses.

To encourage the taste for decoration among the middle classes, Clarence Cook published eleven articles in *Scribner's* from 1875 to 1877, illustrating how even the most humble interior might be enlivened. These essays, collected and published in 1878 as *The House Beautiful: Essays on Beds and Tables, Stools and Candlesticks,* recommended Cottier and a few other designers as the best examples to follow. Cottier advised Cook throughout the preparation of these seminal articles and personally designed the cover for the volume of collected essays (fig. 34).

Fig. 35. Illustration from Clarence Cook, *The House Beautiful* (1878).

Americans aspiring to refinement in their lives soon began to realize the advantages offered by a cabinet in the Anglo-Japanese style (fig. 35) or chairs so elegantly designed that they were listed for sale by name: the Sir Walter Scott or the Hillingdon.[3]

Many of the items Cottier imported to America were damaged in transit and the harsh American climate split the fragile Anglo-Japanese furniture, which led Cottier to manufacture more of his wares in America. The lumber dealer Ichabod T. Williams, for whom Cottier had purchased paintings in the 1875 Society of American Artists exhibition, supplied the specialty woods needed by the artisans. An undated trade journal mentions that Cottier's factories and workshops provided "constant employment to 110 skilled hands and talented workmen."[4]

A man of tremendous force and ambition, Cottier could be counted on to get things done quickly. His closest friend wrote, "With his big head, his curly red hair, his shrewd and hu-mourous eyes, his strong Scots accent, his unaffected naturalness and *bonhomie*—[Cottier] was far more like an ideal coasting skipper than an artist."[5] Descended from generations of sailors, Cottier was in temperament the opposite of the Brahmin La Farge. Cottier had assisted La Farge on the decoration of Trinity Church in Boston—a spectacular project that dramatically advanced the cause of interior design in America—but the collaboration was not a happy one for the two men, and Cottier's contribution remains unidentified.[6]

Cottier was a craftsman and entrepreneur, able to handle several projects at once in his robust,

Fig. 36. Daniel Cottier, Window, ca. 1873–85, leaded and stained glass. Collection of Virginia Guard Brooks (courtesy of the Metropolitan Museum of Art, New York).

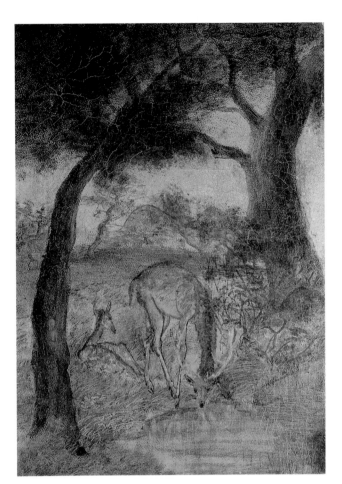
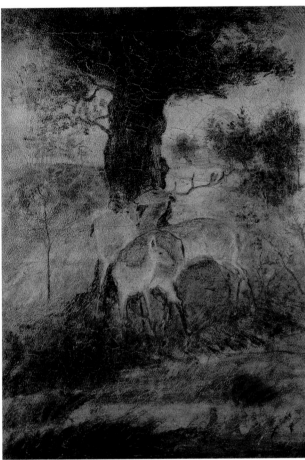

Fig. 37. Two Panels for a Screen: *A Stag Drinking* and *A Stag and Two Does*. Private collection (cat. 70).

Fig. 38. Dish with Decoration of Deer in a Landscape, Chinese, Ming dynasty, Jiajing period (1522–66), Jingdezhen enameled ware: porcelain with decoration in underglaze cobalt blue and overglaze yellow enamel. Harvard University Art Museums (Arthur M. Sackler Museum), Cambridge, Massachusetts, bequest of Samuel C. Davis, 1940.238.

exuberant manner, while La Farge, more the aesthete, sometimes struggled with commissions for years, not content until he had invented an entirely novel approach to his art. La Farge failed for more than five years to deliver the windows commissioned for Harvard's Memorial Hall, and so the board turned to Cottier, who obligingly produced the required glass. When La Farge finally completed a window for Memorial Hall in 1881—the striking Battle Window—it was a technical and artistic triumph, a landmark in American stained glass.[7] Cottier's glass stopped short of aesthetic breakthrough, but it was strong in color and generous in form (fig. 36). "Cottier as a colorist has a range of performance beyond that of any modern artist," wrote one critic.[8]

Nor was the decorative field left to Cottier and La Farge alone. With exquisite timing, Tiffany gave up painting in 1879 to found Louis C. Tiffany and Company Associated Artists, a group of designers offering the most fashionable textiles, glass, and other *objets de luxe*.[9] When that association dissolved, Tiffany went on to found other decorative-craft studios, including Tiffany Glass Company, Tiffany Furnaces, and Tiffany Studios.

By the end of the 1870s Ryder had some acquaintance or association with three of the champions of the American decorative-arts movement: Tiffany, La Farge, and Cottier. These three must be counted among the brilliant entrepreneurs who helped transform the American economy after the Civil War (albeit on a scale far below the railroad barons), for they pioneered a new enterprise and helped create new markets. All three joined art and commerce to varying degrees; Tiffany's business sense was keenest, La Farge's decidedly weak. Cottier was more involved with furniture production than the others, perhaps because his notions of interior design derived more from Morris and because he began his career as a craftsman while Tiffany and La Farge began as painters. But all were on the leading edge of the decorative movement, in the forefront of America's modern-art aesthetic.

Since Cottier helped orchestrate the crescendo of enthusiasm for domestic decoration, it is not surprising that he enlisted Ryder to paint artistic decorations for some of the interior furnishings made by his craftsmen. Ryder made a number of large paintings on gilded leather for folding screens and smaller ones as inserts in custom-designed furniture. Six large painted-leather panels are known, representing three different projects. *Diana* (see fig. 87) survives as a single panel and may have decorated a piece of furniture such as a firescreen or may have had side panels, now lost, to make a folding screen. One such folding screen was a collaboration, with two panels of deer by Ryder (fig. 37) flanking a panel of beeches by Homer Dodge Martin (unlocated). Ryder's quickly sketched deer and forest are adapted from very similar subjects often found on oriental scrolls and porcelains (fig. 38); such items were surely stocked regularly in Cottier's shop.

The only screen by Ryder for which all panels survive (although its wood armature is lost) is a three-panel ensemble of a woman with children, doe, and rabbits in a stylized landscape (fig. 39). Seated in a rocky grotto, cradling a deer on her lap, she recalls the legend of Genevieve of Brabant, a virtuous woman who was condemned to death by her wealthy husband on false charges of infidelity but was abandoned instead in the forest, where her child was nursed by a doe. The wrongly accused wife, infants, doe, and bunnies are all emblems of naive innocence, a theme that Ryder turned to often. Ryder placed two infants in the left and right panels, but other details, including the rabbits, closely follow the story as it was portrayed by German and American romantic artists (figs. 40–41).

While the Genevieve motif originated in Europe, the continuous landscape crossing all panels is in the tradition of oriental screens, and the asymmetrical flowering branches at left and right are strikingly Japanese. Ryder may have been inspired by the flood of oriental objects coming into America during the 1870s and 1880s, for they were already the passion of collectors, but he might as easily have caught an

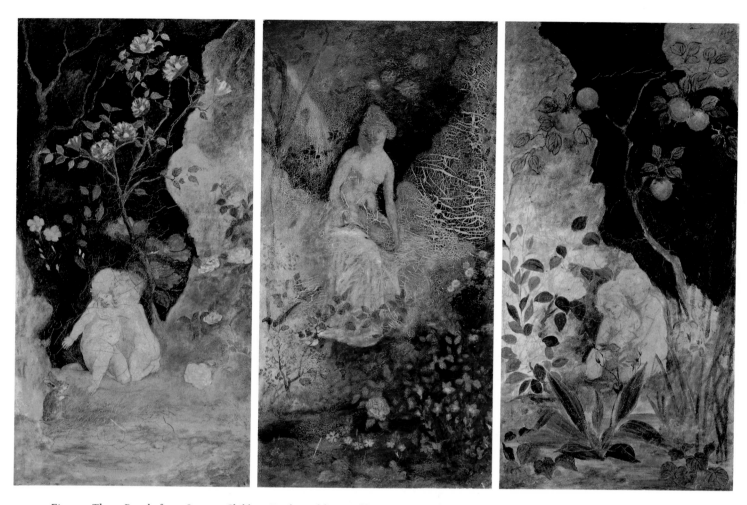

Fig. 39. Three Panels for a Screen: *Children Frightened by a Rabbit, Woman with a Deer, Children Playing with a Rabbit.* National Museum of American Art, Smithsonian Institution, Washington, D.C., gift of John Gellatly (cat. 68).

Fig. 40. Ludwig Richter, *Genoveva,* 1850, watercolor. Private collection, Leipzig (courtesy of Staatliche Kunstsammlungen Dresden, East Germany).

Fig. 41. George Bensell, *Saint Genevieve of Brabant in the Forest,* 1860–70, oil on canvas. National Museum of American Art, Smithsonian Institution, Washington, D.C., 1975.52.

aroma of orientalism from La Farge's designs or from the decorative patterning and fruit-and-flower motifs used in Cottier's furnishings and stained glass.[10]

Ryder painted the leaves and flowers of this screen in translucent green and red glazes on a gold background; light passes through the glazes to reflect off the gold. What inspired Ryder's use of leather and gold underpaint? Once again, La Farge's experimentations cannot be discounted. In the 1875 exhibition at Cottier's, La Farge had displayed decorative panels of flowers, vegetables, and fish, at least one of which has a gold underlayer.[11] La Farge also tried unconventional supports, such as Japanese lacquer trays, with their glossy surface and slightly translucent quality.

A number of smaller paintings on gilded leather by Ryder were probably intended as furniture inserts, perhaps for writing desks, cabinets, or clocks.[12] At least six small leather panels are known (two currently unlocated). All share the same broadly horizontal format—usually eight inches high by twenty or more inches wide—and all have landscape vistas or river scenes. One shows the tall arches of High Bridge spanning the Harlem River; one is an expansive marine view; and a third, more imaginary, presents a fanciful, canopied gondola floating past a turreted castle (figs. 42–44).

On two others, pirates scrape barnacles off a beached ship and tote booty to their homes tucked into rocky cliffs—charming vignettes of pirate life (figs. 45–46). Perhaps Ryder was recalling pirate tales from New Bedford or reading Robert Louis Stevenson's *Treasure Island,* serialized in the magazine *Young Folks* between October 1881 and January 1882. Both Ryder and Stevenson catered to the love of mystery and adventure shared by Americans and Scots. Stevenson wrote, "A Scottish child hears much of shipwreck, outlying iron skerries, pitiless breakers, and great sea-lights, much of heathery mountains, wild clans and hunted Covenanters."[13] His stories struck such a responsive chord with Americans that *Scribner's* and the *New York Sun* competed to publish his essays and novels in the 1880s.

Fig. 42. *The Bridge*. The Metropolitan Museum of Art, New York, gift of George A. Hearn (cat. 3).

Fig. 43. *Sunset: Marine,* gilded leather. Unlocated; formerly collection of Ralph M. Coe, Cleveland (courtesy of Babcock Galleries, New York).

Fig. 44. *Oriental Landscape,* gilded leather. Unlocated (courtesy of Babcock Galleries, New York).

Fig. 45. *The Smugglers' Cove.* The Metropolitan Museum of Art, New York, Rogers Fund (cat. 60).

Fig. 46. *Shore Scene.* Georgia Museum of Art, the University of Georgia, Athens, Eva Underhill Holbrook Memorial Collection of American Art, gift of Alfred H. Holbrook (cat. 58).

Ryder also painted mirror frames, one of which (unlocated) had a decorative rose motif.[14] The only mirror frame to survive occupies a special place in his oeuvre by virtue of its rococo charm (see fig. 48). Sixteen small painted vignettes decorate the wood frame, said to have been made by Stanford White, that encloses beveled mirror glass. The vignettes illustrate scenes from "The Culprit Fay," a poem of 1816 about Hudson River fairy sprites by Joseph Rodman Drake,

father of Janet Halleck de Kay and grandfather of Charles and Helena. Charles commissioned the mirror frame as a present for his mother; a portrait of the poet appears at right center, while the face of the Culprit Fay's earthly love (lower center) is modeled on that of Helena de Kay Gilder. Other scenes show a moonstruck world in which men ride frogs, evoking the light-hearted romanticism of Drake's era, when Mendelssohn composed magical fairy music for *A*

Fig. 47. *The Shepherdess*. The Brooklyn Museum, purchased through the Frederick Loeser Fund (cat. 57).

Midsummer Night's Dream. The vignettes are lightly brushed in yellow, blue, and white, with the varnished cherry wood lending a deep warm tone to the ensemble. In tender response to the poem and with a delicate touch and palette, Ryder evokes an earlier innocence. This affecting mood is found in another of his paintings, *The Shepherdess*, which has a similar blue and yellow palette, painted over a gold ground (fig. 47).

Ryder was not alone in turning his art to decoration. In England, Whistler painted the Butterfly Cabinet (fig. 49) and Morris persuaded artists to decorate functional objects. In America, Will Low and Charles Walter Stetson both painted furniture panels (fig. 50), and Cottier kept certain artists busy with such projects.[15] Cook encouraged fine artists to take up such projects in *The House Beautiful* but acknowledged, "Even if one be willing to pay for it, it is not easy to get decorative painting done. If it be

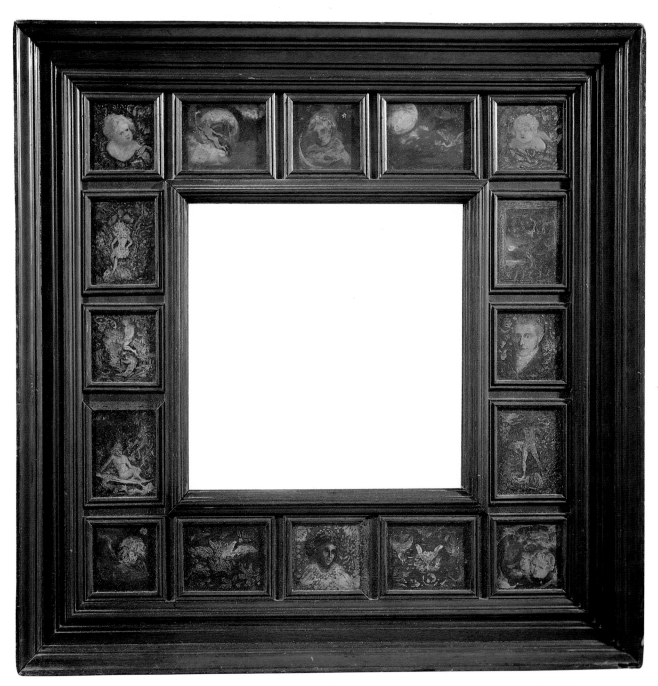

Fig. 48. *The Culprit Fay*. Whitney Museum of American Art, New York, bequest of Joan Whitney Payson (cat. 9).

Left detail of *The Culprit Fay* (cat. 9)

ordered from first-rate hands, it is expensive, and there is seldom any talent for this kind of work among our house-painters —even among those of the trade who add 'decorator' to their other titles."[16]

About the time Ryder was beginning his decorations Whistler's Peacock Room of 1876–77 created a sensation on both sides of the Atlantic, with gold decorations on painted-leather wall panels. Years later, Tiffany carried the idea to its extreme, placing gold and silver foils behind pieces of stained glass in his windows; when illuminated by exterior sunlight, these pieces appear opaque within the composition, but under artificial interior light they create glittering color patterns—an ingenious way to make stained glass effective both day and night.[17]

Fig. 49. James McNeill Whistler, *Harmony in Yellow and Gold: The Butterfly Cabinet*, 1878, mahogany, yellow tiung, glass, and brass. Hunterian Art Gallery, University of Glasgow.

Experimentation was in the air, each artist seeking an original way of harnessing light. Tiffany was quick to explore the possibilities offered by Edison's electric bulbs, working with the inventor in 1885 to introduce electric lights into the Lyceum Theater in New York and developing a few years later the stained-glass lampshade for which he is best known today. While Americans turned natural and electric light to decorative purposes, the French impressionist painters were developing a scientific approach, recording on their canvases the changing aspect of things under various kinds of light.

Ryder's translucent glazes over gold underlayers on his leather decorations differ from the French impulse toward an objective optical science; like Tiffany, La Farge, and Cottier, he preferred the magical, glittering luminosity of transmitted and reflected light. Such light conveys a spiritual quality and for centuries has been associated with religious decoration, especially Byzantine glass mosaics and medieval stained-glass windows. The American artists who were so fascinated with glowing color and gold grounds and foils were also, each in his way, at some point associated with religious commissions and subjects.

The year after publication of Cook's book, the Tile Club was formed by a group of painters caught up in the decorative movement who met on Wednesday evenings to paint and model ceramic tiles. Although Tile Club members claimed to see decoration mainly as an excuse for convivial get-togethers and tramps through Long Island, some of their splendid tile fireplace surrounds show a serious purpose.[18] Tiffany, with his keen business sense, saw great possibilities for decorated tiles and patented his own glass-tile process in 1881. The flowing rhythms and swirling colors of his tiles are like abstract versions of the small coloristic paintings by Ryder and others (fig. 51). Perhaps Ryder's unusual fondness for the square format derives from the popularity of ceramic and glass tiles.[19]

In the first years of his career, until the early 1880s, Ryder divided his time between landscape paintings, exotic "oriental" scenes, a few literary subjects, and decorative work. Although he sent

easel paintings to exhibitions and catalogues occasionally indicate that his work was in private collections, functional objects must have provided a steadier source of income. Many artists he knew or knew of—Tiffany, La Farge, Whistler, Lathrop, Low, Eaton, Helena Gilder, and others—found decorative projects as suited to their love of color and light as easel painting. And Ryder's relationship with Cottier was surely enhanced by his willingness to produce the fancy goods that made Cottier's furnishings exceptional in the marketplace.

The decorative movement did more for Ryder than just put coins in his pocket and cement a commercial relationship with a dealer, important as those things were. It expanded the framework for his evolving aesthetic, which moved from nature and view-painting toward an image constructed from memory and imagination. Experimentation with media and supports helped Ryder in his search for new visual effects. The square shape of a tile, light reflected off gold foil,

Fig. 51. Louis Comfort Tiffany, Tiles, pressed glass. The Chrysler Museum Institute of Glass, Norfolk, Virginia, gift of Walter P. Chrysler, Jr., 71.8009 (GAT.70.2) and 71.6240 (GAT.66.12).

Fig. 50. Will H. Low, Cabinet, 1882, ebonized cherry, painted panels. The High Museum of Art, Atlanta, gift of Virginia Carroll Crawford, 1982.

illuminated colors of stained glass—these were source materials for a fresh approach to oil painting. In one sense Ryder was the very antithesis of the decorator, for he preferred a condensed, intimate expression to the complex iconographies and vast public spaces of muralists. But decoration drew Ryder closer to the transformative visual experience that he had glimpsed earlier in nature and that had caused him then to "bellow for joy." The flash of color as transmitted light helped set Ryder on the path of a new vision. He would find ancestors in the great Venetians, the richly tonal Dutch masters, Delacroix, and a few others, but the original spark was struck in the American decorative movement of the 1870s and 1880s. ❧

Ryder, Cottier, and Modern Art

Given Cottier's love of color in stained glass and painting and his fiercely independent judgment, he naturally was attracted to the vanguard Americans who had shown in his gallery in 1875. His need for artists to decorate furniture probably led him to favor Ryder and Lathrop, who were amenable to this work, but he was equally supportive of Olin Warner, a talented but impecunious young sculptor. Cottier lent Warner studio space in an unused room on the gallery's second floor for a couple of years and did his best to secure portrait commissions for the young Paris-trained modeler.[1] In 1889 Warner submitted a bust of Cottier to the National Academy as his acceptance piece, conveying Cottier's bluff Scottish heartiness with a touch of Hellenistic heroism (see fig. 33). Given Cottier's help with the 1875 exhibition that led to the founding of the Society of American Artists, accepting the Cottier portrait must have been salt in the academy's wound.

Ryder met Warner around 1875, and they remained close friends until Warner's death in 1896.[2] Warner, Ryder, and James Inglis (manager of Cottier's New York gallery) were close bachelor buddies from the mid-1870s through the mid-1890s; even after Warner's marriage in 1886, they maintained their special friendship. Inglis loved music and had a box reserved at the Metropolitan Opera, often taking friends to hear his favorite singers, sometimes dropping in late to hear a single act or aria.[3] The friends referred to themselves as the "Menagerie"—a group that expanded easily to include congenial Cottier clients such as C. E. S. Wood of Portland, Oregon, and Sir William Cornelius Van Horne of Montreal, whenever they might be in town. Ryder was dubbed the "Reverend Referendum" or sometimes just the "Reverend," in recognition of his monklike habits, although he was as fond of oysters, wine, pipes, and cigars as any Menagerie member.[4]

Cottier's and Inglis's easy-going attachment to the Americans gave them something more, beyond even what the Society of American Artists could deliver: a forum where their work could be viewed, by discriminating clients, beside the best modern European painting. To be shown on a par with Daubigny, Theodore Rousseau, Diaz, or Corot was an opportunity for Weir, Bunce,

Warner, and Ryder to prove that they responded to an international current, more ideal in spirit than the home-grown realism of the academy.[5] Only at Cottier's or Samuel Avery's in New York or at Vose Gallery in Boston was such an encounter possible.

Unable to obtain life insurance after rheumatic fever weakened his health, Cottier began to collect paintings as financial security for his wife and children. In the spring of 1877 the second floor of his Fifth Avenue gallery was made into a painting showroom.[6] His taste ran to seventeenth-century Dutch masters and modern paintings of the Barbizon and Hague schools. As a Scot, he loved Raeburn's portraits, and with a decorator's fondness for color, he was passionate for Delacroix. But most of all, Cottier revered Corot, Millet, and the eccentric Adolphe Monticelli.

Of these three, Corot held highest honors as a modern master, for he revived the spirit of antiquity and of Claude. Seth Morton Vose had begun to buy Corot's paintings for his Boston gallery in 1852 and in twenty years assembled a collection of major paintings. But Corot found few buyers in America until after his death in 1875, when collectors suddenly realized that a master had been taken from their midst.[7] It was about this time that Cottier began buying Corots, both for resale in his galleries and for his own private collection. In 1880 a critic reviewing America's younger painters singled out Cottier's *Orpheus* by Corot (fig. 52) for praise and then named Corot as the "greatest painter of our time, because he best represents what the spirit of the time has to express in plastic art, without . . . the defect of material detail."[8] Corot symbolized the ascendancy of thought over fact and so was often invoked as a rebuke to the academic standards of "finish" and "observation": "Corot's work is the best he could do—far better than any finished painter ever did. It is best because it renders the best—the *idea*. The other is work like that of statisticians—facts and details which render the body of a thing, but do not touch the soul."[9]

Corot's idealized landscapes inspired a profound shift in Ryder's landscape conception,

Fig. 52. Jean-Baptiste Camille Corot, *Orpheus Greeting the Dawn*, 1865, oil on canvas. Elvehjem Museum of Art, University of Wisconsin, Madison, gift in memory of Earl William and Eugenia Brandt Quirk, class of 1910, by their children, 1981.136.

reducing still more the role of observation and direct experience of nature and filtering the whole through a collective artistic memory reaching back to Poussin and Claude. Ryder's *Dancing Dryads* (fig. 53) pays homage to this pastoral tradition and especially to Corot's numerous scenes of nymphs dancing in forest glades (figs. 54–55); many another painting by Ryder also borrows Corot's characteristic sinuous tree trunks, wispy leafage, and hushed idyllic mood.

More than any specific motif, Corot offered Ryder a link with the artistic past. While the European moderns wanted to cast off tradition in

Fig. 53. *Dancing Dryads*. National Museum of American Art, Smithsonian Institution, Washington, D.C., gift of John Gellatly (cat. 10).

favor of observation, Ryder and other Americans of his generation continued to search for ancestors among the old masters—for a tradition that would provide that sense of nobility and continuity so lacking in American culture. All his experimentation with technique and groping toward a new vision sprang from a desire to equal the masters without repeating their work. Ryder knew that nothing great comes from imitation: "The new is not revealed to those whose eyes are fastened in worship upon the old. . . . No two visions are alike, and those who reach the heights have all toiled up the steep mountains by a different route. To each has been revealed a different panorama."[10] But he also spoke clearly of the need to assess progress by comparing one's work to the greatest achievements of past masters, saying, "It's only when you see my pictures in company with the old masters that you really feel what they are. It takes fine quality to not seem out of place in such company."[11] And in the case of Corot, he cared deeply for the aura of something ancient in the paintings. He even prized the patina of age that linked them to the revered masters and once wrote to a dealer, "How Mr. Cottier was amused at the cleaned Corots that had been painted some years, made to look as if they were painted yesterday!"[12] With Corot as guide, Ryder recast his landscapes as pastoral idylls evoking the antique world first sketched in Virgil's *Eclogues*. No wonder Ryder is said to have spoken of Corot "as about a woman he loved."[13]

Next to Corot, Cottier's strongest support went to Millet, who had also died in 1875 and was suddenly hailed as a modern master. He was already somewhat known among American painters before Cottier took up his cause, for Hunt and Low had studied with the peasant painter in France and spread his influence among their colleagues.[14] Millet's admirers took on the aspect of a cult after the publication of Alfred Sensier's biography of the artist, which Helena de Kay Gilder translated for the American edition of 1881.[15] Artists on both sides of the Atlantic sought to absorb his sincerity by retracing his images; van Gogh, for instance,

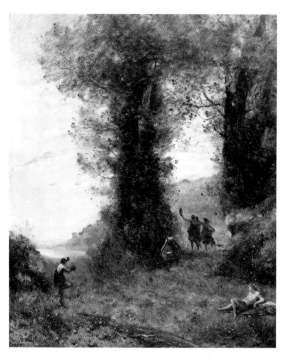

Fig. 54. Jean-Baptiste Camille Corot, *Pastorale—Souvenir d'Italie,* 1873, oil on canvas. Glasgow Art Gallery and Museum, Scotland.

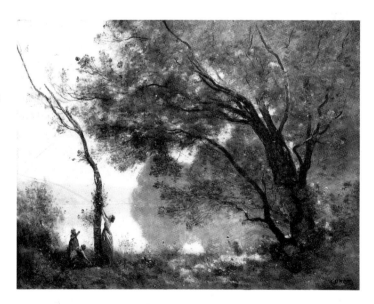

Fig. 55. Jean-Baptiste Camille Corot, *Souvenir de Mortefontaine,* 1864, oil on canvas. Musée d'Orsay, Paris.

painted twenty-one copies after Millet while at Saint-Rémy, saying, "Above all it sometimes gives me consolation."[16]

Millet's peasant origins held a special fascination, making his whole life seem an object lesson in sincerity and spirituality. If Corot was a link to a pastoral ideal, Millet symbolized the happy social contract between the laborer and the soil. Millet's genius was to portray humble peasants with all the dignity of academic figure painting; *The Sower* (fig. 56) imparts a nobility of character—previously reserved for gods, kings, and heroes—to a rough, untutored laborer who sprang from the soil like the grain he sows.[17] By focusing on the most negligible of God's children Millet addressed the universal human condition, as the introduction to Sensier's biography explained.

For Millet, the man of the soil represents the whole human family; the laborer gave him the clearest type of our toil and our suffering. The peasant is to him a living being who formulates, more strongly and clearly than any other man, the image, the symbolical figure of humanity. Millet, however, is neither a discouraged nor a sad man. He is a laborer who loves his field—plows, sows, and reaps it. His field is art. . . . Here is a painter who has given a place to the humblest; a poet who has raised to honor those whom the world ignores, and a good man whose work encourages and consoles.[18]

The appeal of Millet's work in France reflected concern over the disturbing degradation of rural life in the generation after 1848. The miserable state of the peasantry, consigned to live in conditions little better than that of their draft animals, was the subject of many government studies; as conditions worsened, peasants moved to the cities to seek low-wage jobs in the new industrial economy. Although America had not experienced the same class struggle or political upheaval, here, too, the countryside began to lose people to crowded city slums. As industrialism interrupted the established order, artists increasingly painted humble country life as a higher state of morality, closer to both God and nature. Millet was the greatest exponent of this view because he was himself of peasant stock. But it was not unusual for artists to paint the rural ideal from a city tenement. Ryder lived his entire professional life in Greenwich Village, experiencing the countryside only when he took long, moonlit walks along the Jersey shore or when he visited Weir at his farm, near Branchville, Connecticut. Such distance was probably helpful in maintaining a rosy view of country life.

Cottier purchased works with important provenances by both Corot and Millet, for their value increased when it could be shown that they had been cherished by distinguished owners. For instance, he bought Millets given by the artist to his friend and biographer Sensier, and he purchased Corot's large *Orpheus,* which was part of a decorative suite for Prince Demidoff's Paris town house. In the spirit of continuity, Ryder was given the original frame from *Orpheus,* which was intended for a large painting Ryder promised to Cottier.[19]

The third of Cottier's great passions, Monticelli, was still relatively unknown during the 1870s. Born in Marseilles of a Venetian father, Monticelli lavished thick, creamy colors on tiny

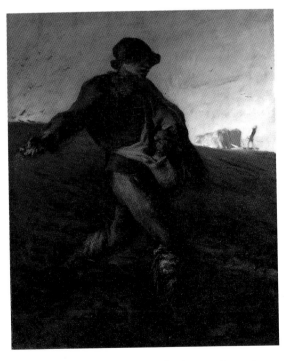

Fig. 56. Jean-François Millet, *The Sower,* 1850, oil on canvas. Museum of Fine Arts, Boston, gift of Quincy Adams Shaw, 17.1485.

panels with a Mediterranean light-struck lushness. With some persistence one can discern, in the dense impasto, images of elegant chatelaines, columned porticos, and greyhounds on leashes (fig. 57). These vivid courtly fantasies were usually dismissed by French critics as the pictorial ravings of a deranged or alcoholic man, but Cottier bought heavily and began to promote Monticelli to his clients: "I have great pleasure in drawing your attention to a grand work by the late Italian artist and nobleman 'Montecelli [*sic*],' the comrade of Diaz and the greatest colorist of our or any other time."[20]

Through Cottier, Monticelli's best works went into collections in Scotland, England, Canada, and America—along Cottier's circuit of collectors.[21] Cottier's personal vision dictated his choice of artists, but he specialized in bringing others around to his point of view:

At Cottier's one finds a collection of paintings which reflects exactly the taste of the owner. This art-inspired Scot is the only dealer of prominence, so far as I know, who allows his personal preferences to influence his selection of pictures. He can afford to do this, for his trade is not with the public, but with connoisseurs who, like himself, find no charm in the photorealistic school of Vibert, Gérôme, Meissonier, and the rest, but luxuriate in the air, the sunshine, and the sentiment of a Diaz, a Corot, or a Monticelli.[22]

Cottier championed artists who combined a passion for color with an otherworldly temperament. It is remarkable how his favorites resembled each other, inspiring the same following and outpouring of tribute, suffering the same indignities. After Monticelli's death in 1886, a fellow artist wrote,

Monticelli was the kindest, most inoffensive being I ever knew. Simple, naive, unperturbed, he seemed to ignore the rest of the world, its rules and laws as well as its dishonesty and trickery. He had detached himself from everything, had no home, family, or obligations. "For myself," he told me, "as long as I'm not hungry and my palette has paint on it, I'm not worried about anything. . . ." But what was truly unique about him was his total disregard for success or honors.[23]

A young poet named Paul Guigou also described Monticelli in terms that would later be used for

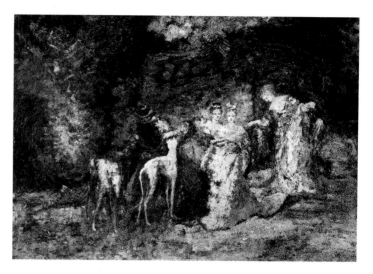

Fig. 57. Adolphe Monticelli, *The Greyhounds,* ca. 1871–72, oil on panel. The Toledo Museum of Art, gift of Arthur J. Secor, 33.24.

Ryder: "a handsome old figure whose face showed a majestic tiredness . . . large beard reaching to his chest, a peaceful expression and slow gestures gave him the appearance of an old monk . . . an Old Master of some previous age. . . . [He was] kind and without bitterness against anyone, living simply."[24]

Monticelli's most passionate posthumous admirer was van Gogh, who identified with the earlier artist almost to the point of obsession during his years in southern France. He talked with his brother Theo about doing a book on Monticelli and wrote about him in his letters:

I think of Monticelli terribly often here. He was a strong man—a little cracked, or rather very much so—dreaming of the sun and of love and gaiety, but always harrassed by poverty—of an extremely refined taste as a colorist, a thoroughbred man of a rare race, continuing the best traditions of the past. He died at Marseilles in rather sad circumstances, and probably after passing through a regular Gethsemane. Now listen, for myself I am sure that I am continuing his work here, as if I were his son or his brother. . . . Let us take up the same cause again, continuing the same work, living the same life, dying the same death.[25]

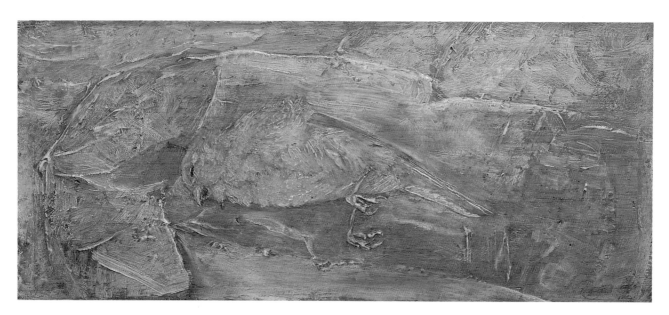

Fig. 58. *The Dead Bird*. The Phillips Collection, Washington, D.C. (cat. 11).

On occasion there are striking parallels between Monticelli's and Ryder's art, despite their very different techniques. Ryder's *Dead Bird* (fig. 58)—perhaps his single most affecting image—distills pathos to a monosyllable, a sacrifice on an altar similar to Monticelli's *Dead Hare* (fig. 59). The extreme isolation of the image demands the most intense concentration from the viewer. Such a device is less apt to be borrowed than rediscovered by an artist groping for an emblem of intense feeling; van Gogh projected the same pathos and emotion into a painting of a pair of shoes.

Ryder's friendship with Cottier must have been well advanced by the summer of 1877,

when the two traveled together to London. Using Cottier's house on Saint James's Place as a base, Ryder explored the city and its surroundings. He likely visited the National Gallery, with its extraordinary Renaissance masterworks, the Parthenon marbles at the British Museum, and the 1856 Turner bequest at the Tate—but no record survives to document his itinerary or tell of his reactions. Surely, there was news or scandal about Whistler, whose ripostes kept London critics in an irritable state and whose Peacock Room continued to provide copy for the press.

We know that Ryder traveled at least as far as Amsterdam, where he signed the guest book of the Rijksmuseum on 24 July 1877, along with

William Craibe Angus, a Glasgow dealer who often sold stock obtained from Cottier.[26] There Ryder's interest in stable subjects was reinforced by the Dutch masters. *In the Stable* (see fig. 8) includes light streaming in from a window at left—almost a trademark of Dutch painting. The geometrized interior spaces and wealth of genre details—stableboy, hay, barnyard fowl, harnesses—derive from seventeenth-century Dutch prototypes or their nineteenth-century English descendants.

More than any element of composition or subject, however, Ryder absorbed the radiant glow of Dutch painting, its chief attraction for nineteenth-century artists. He tried to reproduce this luminous tonal depth by glazing, with disastrous results. Instead of applying glaze thinly over opaque paint to give extra depth of tone, Ryder made *In the Stable* almost entirely of oil-rich tints, built up to an astonishing thickness. Such a paint film dries slowly, migrating while still viscous. Individual layers dry at different rates, producing tensions and eventually causing the paint to shrink into islands surrounded by networks of wide cracks. *In the Stable* has suffered grievously from this condition, known as traction crackle.[27]

The remarkable luster of Dutch art was appreciated by many nineteenth-century artists, but Ryder alone imitated the Dutch to the point of unbearable excess. His intuition was to seek expression through process, and although he pursued the idea to the point of destruction, it was a crime of passion, with its own terrible fascination. Ryder knew many of the accomplished painters of his generation, who would gladly have taught him formulas used in the Paris or Munich academies.[28] To regret that he did not know correct methods, as did many later critics, is to miss the search for the inner secret of great painting—not techniques that guaranteed longevity but mysteries that marked exceptional works as the product of genius.

Traveling with dealers like Cottier and Angus offered entrée to collections in England and Scotland and on the Continent as well. Their network was extremely broad. From 1874 to 1882 Cottier's London gallery was managed by Elbert J. Van Wisselingh, a Dutchman employed earlier by Goupil's in Paris. Van Wisselingh's contacts brought Cottier in touch with vanguard French and Dutch painters of the Barbizon and Hague schools—Daubigny, Diaz, Dupré, Theodore Rousseau, Troyon, Josef Israels, Anton Mauve, the Maris brothers, Jongkind, and many more. Before joining Cottier's firm, Van Wisselingh met van Gogh, also employed at Goupil's, and became acquainted with painters in his circle. Van Gogh visited Cottier's establishment in London in 1876 and later considered how his pen sketches might be used as decorative inserts in Cottier's furniture, although this idea came to nothing.[29]

Cottier's Dutch connection grew stronger when Matthijs Maris was drawn into his web.[30] The brothers Matthijs, Jacob, and Willem Maris were all painters associated with the Hague school that had reinvigorated Dutch tradition by blending it with a modern French sensibility. Van Wisselingh much earlier had admired Matthijs Maris's tiny fanciful conceits brimming with color and tried to persuade Goupil's to handle his work, but it was too eccentric to attract a wide audience. Unwilling to adopt the style of his brothers, Matthijs teetered on the brink of destitution before being rescued by Van Wisselingh, who arranged in 1877 for him to live in Cottier's London house and work for the firm. There the young Dutchman was set to

Fig. 59. Adolphe Monticelli, *The Dead Hare,* ca. 1875–77, oil on panel. Vidal Collection, Marseilles, France.

hand-painting glass globes and furniture panels, restoring damaged paintings (including many by Monticelli), and preparing designs for stained glass.[31]

At first Maris was grateful for Cottier's help. He picked up Cottier's Scottish sayings and fondness for Robert Burns, whose verses he declaimed with an exaggerated burr overlaying his Dutch accent. Cottier took Maris along to Paris, the Hague, and Germany, just as he brought Ryder on voyages to Europe. But eventually, Maris came to resent his employer for exploiting him as a decorator at the expense of his painting career. Their relationship deteriorated so that when Cottier visited London, Maris would avoid him by leaving town. In 1888, thoroughly embittered, Maris left Cottier's employ and moved into private quarters.

Ryder met Maris in his studio at Cottier's, probably just after Maris had moved to London, while his rapport with Cottier was still strong. Ryder always spoke of Maris as an artist he admired, and decades later he obtained Maris's address from a mutual friend and was urged to renew their contact.[32] In such charming Maris fancies as *The Little Shepherdess* (fig. 60), so similar in mood to his own *Shepherdess* (see fig. 47), Ryder found the work of a kindred spirit.

It is remarkable how accounts of Maris's character and art sound like Ryder. Maris's friend Ernest Fridlander wrote a lengthy description of the painter's artistic and personal life that is identical in almost every particular to the legend that grew around Ryder.

Great tenderness of conception and execution . . . loathe to wound the feelings of others . . . not aggressive, yet possessed courage . . . lenient of judgment . . . Spartan life of all possible integrity and purity . . . withdrew himself from the world . . . perfect delicacy and purity with women . . . strange sympathy with children . . . obstinate tenacity . . . averse to business matters . . . deep ideal faith . . . no inconsiderable reader . . . much admired handiwork of craftsmen of Old China and Japan . . . it was of Corot that he oftenest talked . . . his large unconscious memory stored with images . . . absolutely one with Nature's

inner spirit . . . strove ever to escape from the material . . . his landscapes are instinct with painter's poetry . . . glorified and intensified vision of a child.[33]

Was it coincidence that led Cottier to promote two such men, both more or less unable to manage their own affairs by conventional standards? How far did Cottier shape the myth that surrounded them and trade on it to create a market for their works? Did Ryder adapt his own stance to what he learned of Monticelli and Maris? Ryder never showed hostility toward Cottier, always speaking of him as a friend and mentor, yet the parallels between his and Maris's decorative work for Cottier suggest that self-interest was intermingled with Cottier's generosity.[34]

Both Ryder and Maris allowed others to press closely against their interests before taking steps to protect themselves, but neither man lacked will or judgment. Ryder asserted himself not through argument or action but by a stubborn refusal to be pushed where he did not want to go. In this, Ryder may have been stronger than Maris or perhaps Cottier used a gentler hand with him. In any case, Ryder performed for Cottier some of the same tasks that Maris did in London, although the dealer recognized that Ryder was not the person to undertake restorations, except occasionally of his own works.

In a way, Ryder, Monticelli, and Maris are late, accentuated manifestations of a cultural current that had reached its classical apogee in Corot and Millet. All three younger artists revered these masters of the "generation of 1830," each expressing his fervor through extreme measures, as if great excess demonstrated great homage. Ryder and Maris were just beginning their careers in 1875 when Corot and Millet died; the outpouring of adulation that ensued left no doubt that an artist could reach the pinnacle only by finding his own path, however difficult, leaving for others the straight road paved by the academy system.

In addition to these favorites Cottier collected and sold paintings by a great many artists—old masters as well as moderns. Then, in 1878, just

a few years after beginning his collection, Cottier held a closing-out auction, announcing that he was "intending to discontinue this branch of their business." More than 160 paintings by over seventy artists were offered, including ten canvases by Corot, eight by Mettling, six by Millet, five by Jacob Maris, four each by Diaz and Monticelli, three each by Dupré and Theodore Rousseau, and one each by Delacroix and Pissarro. Bidding was dull and spiritless; only 73 paintings sold and prices were low, with Corot's small *Destroying Angels* going for only thirty-five dollars.[35]

Perhaps because he would have taken a loss on the balance of his collection, Cottier held on to the rest of his paintings, continued to buy, and set out in earnest to make a market for the work he loved. His taste was extremely broad, embracing not only his favorite romantic artists but others, from Pieter de Hoogh to Manet.[36] At his death the sale of his collection was a vindication of his taste and judgment. William Ernest Henley, one of Cottier's closest friends, wrote in the auction catalogue of his estate:

He perceived, at a time when most critics were still cavilling or discussing, that the Nineteenth Century would be known, so far as art is concerned, as the century of that great school of painting whose finest and completest expression is the landscape of Corot; at a time when not many cared to invest in its output, he bought of that output whenever and wherever he could; at a time when few artists and still fewer art-critics in Britain suspected the existence of such a school, he was distributing the work of its greater masters—Corot, Diaz, Daubigny, Rousseau, Monticelli, Delacroix—wherever he could find a collector keen enough to believe or gifted enough to enjoy.[37]

Certainly one "gifted enough to enjoy" was Ryder, whose taste in painting coincided with Cottier's and must have been somewhat shaped by his. The experience of seeing so many splendid examples by foreign artists must be taken into account whenever we think about how Ryder's own aesthetic developed. It has suited some critics to accentuate Ryder's inner vision at the

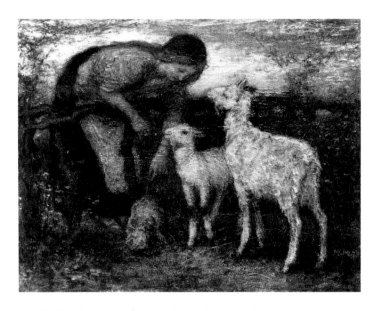

Fig. 60. Matthijs Maris, *The Little Shepherdess*, 1872, oil on canvas. Courtesy of Sotheby's, Inc., London.

expense of his awareness or to emphasize his Americanism by saying that he worked without reference to foreign styles. But his intimate association with Cottier's gallery, clients, and collections placed him firmly at a crossroads of the international art network. Far from being oblivious to foreign influences, he was immersed in work by modern artists and the old masters who inspired them. He may occasionally have borrowed a specific motif, but most of all he absorbed a foreign aesthetic—traditional and modern, French and Dutch. While not educated in the European academies, as were so many of his colleagues, through his privileged relationship with Cottier in the 1870s and 1880s he saw as much vanguard painting as any artist of his generation then living in New York. ❧

First Critics,
Early Patrons

In 1879, at age thirty-two, Ryder achieved a certain independence in his life by taking a private room at Canal and Broadway.[1] Two years later he moved again, into the new six-story Benedick (or Benedict) Building at 80 Washington Square East. Warner was already living there; Bunce, George Maynard, and Weir came in 1881; John Twachtman and Lathrop resided there by 1883.[2] A ready-made circle of colleagues had gathered, offering the camaraderie so valuable to an artist.

In 1882 Ryder went abroad again for five months with Cottier and his family, accompanied during most of the tour by Warner.[3] Part of the itinerary is recorded in a small account book kept by Warner, which gives dates, cities, and the allocations made to each traveler from a common fund for miscellaneous expenses.[4] The group visited Paris, where they saw the spring Salon just before it closed, then Madrid, Seville, Gibraltar, North Africa, Marseilles (where Cottier could find Monticelli paintings), Genoa, Rome, Naples, and Venice.[5] Returning by way of Switzerland and Germany, they traversed the Alps, then traveled back through Paris and Brussels to England and home to America. The path of this tour follows a route similar to Childe Harold's in Byron's poem, which provided the subject for an early Ryder canvas (see fig. 120). Ryder may have fancied himself, like Childe Harold, on a pilgrimage to the great cities and monuments to seek out the meaning of art and life.

While waiting for Warner in England, Ryder wrote to de Kay with all the enthusiasm of a tourist:

I think I wrote you about visiting Exeter and all those places. Since then I have been to Leicester, saw the Prince and Princess of Wales, took a run from there to Coventry, a delightful old place, so splendid and old that it is moldy.

There is an old Alms House for seven old women that is perfect in its architecture, a picturesque paved close, with these funny timbers let in with the plaster.

I want to visit these places again and have all the time I want.

We went to a circus at the Coventry Fair; entrance two pence. On a platform the stars were hopping about and cutting capers before the performance began.

Reminding me of Browning's lines that begin "O trip and skip Elvire."

Pushed on next morning to Stratford on Avon; what a delightful place.

Fine view of the castle at Warwick on our return.[6]

Fig. 61. *A Sentimental Journey*. Canajoharie Library and Art Gallery, New York (photograph from the 1918 memorial exhibition, the Metropolitan Museum of Art, New York; cat. 56).

The chance to see Venice with a dealer and Rome with a sculptor surely heightened Ryder's experience. Throughout the journey Ryder made quick sketches after paintings that interested him.[7] He must have loved Venice, the colorists' mecca, where resplendent Titians set the standard for richness of effect. Since the end of the eighteenth century English artists had periodically "discovered" the Venetian secret that produced the enviable luster of Venetian paintings—deep in tone like Dutch work but more colorful.[8] Cottier shared their admiration, taking the sumptuous Venetian aesthetic as a touchstone for his decorative schemes.[9] Ryder probably knew early Titian paintings from the National Gallery in London, but the late Titians, slowly built up in layers of glaze and thick, scumbled color, were the greater revelation for their sheer substance and almost palpable vibrancy. In them, paint and color assert a physical presence that speaks directly to the emotions.

Ryder's companions at the Benedick, the long journey abroad, and the activity at Cottier's all proved invigorating. Between 1879 and 1884 Ryder submitted numerous paintings to public exhibitions, which, along with the efforts of Cottier, de Kay, and others, established him as the premier imaginative painter and colorist of his generation. Critics supported him tentatively at first, apologizing for his weaknesses, but soon they were making sweeping and emotional claims about his genius.

In the 1879 Society of American Artists exhibition, Ryder showed five paintings. De Kay commented in the *Times* about "the oddity and apparent naïveté of his pictures" and said "there is plenty of scoffing at this sort of thing" but went on, "the artist is a colorist by nature, and in this country, that is a rare thing indeed." *Market Horse* "looks like an old Dutch master," and *The Chase* [is a] "singularly fascinating study of a twilight deer-chase . . . like Japanese lacquer-work, or something just from the Middle Ages."[10]

Ryder had another champion at *Scribner's*, which under Gilder's editorship was moving toward a more contemporary, less conservative

point of view. The reviewer of the 1879 show praised Martin and La Farge and wrote of Ryder:

Most people did not know what to think of Mr. Albert Ryder's mysterious pictures of horsemen following hounds through shadowy landscapes, of herdmen going home through the twilight, of a woman in a wood with children. They have been much praised and much laughed at. Mr. Ryder is evidently fully aware of his aim and of his own powers. If, in his passion for color, he neglects outline and drawing, it is not that he admires drawing less, but color more. His work is fascinating in the stricter meaning of the word, for it grows on the observer more and more, the oftener he sees it.[11]

By contrast, de Kay in the *Times* wrote that Eakins's *Gross Clinic* had "terribly overshot the mark," while *Scribner's* said "the horribleness taught nothing, reached no aim." Already Ryder and Eakins represented two poles: Eakins merged academic style and tradition with intense observation, while Ryder filtered tradition through imagination and memory. The press was often more sympathetic to Ryder.

The following year Ryder sent six paintings to the Society of American Artists exhibition. The *Times* said: "Mr. Ryder makes a sensation, although it is all very small in size. He is a colorist in the highest sense of the word. . . . [One work] has an antique flavor, as if it had been painted two centuries ago."[12]

The *Sun* went further, calling the small oriental painting *Nourmahal* "a deep unfathomable mystery": "But Mr. Ryder is already famous, soaring swiftly on the wings of the inexplicable far away from the merely human and commonplace into the happy realms of the wholly inscrutable, and he is safe there from all envious pursuit.[13]

Ryder's work seemed the more "inexplicable" and "inscrutable" in that it appeared to spring wholly from his imagination, without precedent, at least to New Yorkers just beginning to know contemporary foreign work. In 1880 the modern Barbizon and Hague school styles were only occasionally shown outside Boston; the French impressionists were still largely unknown outside Philadelphia. The stringer for Boston's *Daily Evening Transcript* clearly perceived the inspiration

for some of the Americans and followed his review of the 1880 Society of American Artists exhibition with a plea that Cottier lend Corot's "glorious and immortal" *Orpheus* to the Museum of Fine Arts in Boston to hang alongside Cottier's other great Corot, *Dante and Virgil*. But soon the New Yorkers caught on, and by 1883 they were commenting knowledgeably on the resemblance of Ryder's marines to those of Dupré.[14]

In the early 1880s Ryder suddenly found he was famous within a small circle of cognoscenti, with a reputation surpassing that of many more established artists. Reviews often noted in passing a dozen artists and then chose a few to discuss in detail, and Ryder was often among the select. In 1880 and 1882 Blakelock (Ryder's exact contemporary) was cited as a follower, "whose *raison d'être* is to give Mr. Rider [sic] the importance of having a school."[15]

Ryder's individual style impressed the critics, who outdid each other in describing his special charm: "a piece of supernatural scenery had been let down to earth," "a depth of tone and subtlety of expression not to be fathomed at the first glance," "a world of their own . . . like dream pictures," "little phantasmagories of color," "a fastidious morsel of color."[16] Occasional detractors took nature as the given in art and criticized any attempt to skirt it, saying: "[Ryder and Blakelock] will have to learn that if art is the end of the painter's effort, nature is the material of his study, and no such complete divorce as Mr. Ryder, especially, shows can lead to a permanent position. . . . Their art is a mistake and a needless sacrifice of qualities better than those they attain."[17]

But such old-fashioned stands reinforced the need for an American art that could escape description and open a window onto the imagination. It was time for American painters to look up from their nature studies and cast an eye over the whole history of the visual arts, including the aesthetic and religious objects of exotic places and times. The French academicians urged their American pupils to study the grand traditions of Renaissance and baroque art, and

they admired the liturgical and decorative objects made in the Near East and Orient. The taste for such objects spread among Americans as the best painting students returned from their studies in the late 1870s and early 1880s—many lured by new prospects for art following the establishment of the Society of American Artists.

Critics began at the same time to find new comparisons for Ryder's art in the "ancient Oriental rug scheme of color" and "prehistoric glaze."[18] His paintings left the domain of easel painting to live in the realm of precious things like gems and porcelains, oriental carpets and medieval manuscripts. Their small size made them seem fragile and highly prized; they never exhorted or postured or preached a lesson but existed for beauty alone, appealing to connoisseurs capable of discerning a rare, exquisite expression of human genius. The ability to perceive Ryder's greatness became proof of discrimination and refinement such as often went hand in hand with a taste for fine decorative art.

The records of Cottier's firm have not surfaced, so Ryder's early paintings are difficult to trace, apart from the few that went directly to de Kay and his mother. By the mid-1880s they began to change hands at auction, leaving a revealing if incomplete record. Mary Jane Morgan, a fabulously wealthy and profligate widow, amassed an unparalleled collection of European paintings and oriental porcelains, which was auctioned after her death in 1886—a week of sales covered in minute detail by the press. At $45,000, Jules Breton's *Communicants* brought the highest price among the 240 paintings auctioned, and a rare peachblow Chinese porcelain brought $18,000. Ryder's *Spring* sold for $225 and his *Resurrection* for $375 (see figs. 29, 92)—prices that seem low until we remember how abysmal the American art market was at this time; it was honor enough to be one of only six Americans among the one hundred and fifteen artists in this celebrated collection.[19]

Pockets of Ryder enthusiasts appeared in the 1880s, not only in New York but in Oregon, Montreal, and Great Britain. John Popham took the first Ryder to Canada—a marine called

Fig. 62. *The Lovers.* Vassar Art Gallery, Poughkeepsie, New York, gift of Mrs. Lloyd Williams in memory of her father, Daniel Cottier, 40.1.11 (photograph from the 1918 memorial exhibition, the Metropolitan Museum of Art, New York).

Moonlight on the Sea (see fig. 97); soon three other Montreal collectors had added Ryders to their holdings. One of these, E. B. Greenshields, wrote a book called *Landscape Painting and Modern Dutch Artists,* espousing a synthetic, subjective approach to landscape; he included chapters on each of the Maris brothers, Johannes Bosboom, Israels, and others and linked Ryder's

concept of nature to the modern Dutch movement.[20]

Greenshields admired not only landscapes but also the poetic dreamlands that Ryder had begun to paint. He bought *A Sentimental Journey* (fig. 61), based on Laurence Sterne's novel, which depicts a carriage with lovers pulled by teams of horses under a lunar light. The subject of the lovers' moonlit journey became a favorite, repeated with variations for several patrons in *The Lovers, The Lover's Boat, Lord Ullin's Daughter,* and *The Windmill* (figs. 62–65).

Another Montreal collector, R. B. Angus, bought Ryder's moonstruck *The Temple of the Mind* (see fig. 95), making it the only American painting in a collection that included Constable, Diaz, Fantin-Latour, Fromentin, Hoppner, Monticelli, Raeburn, Reynolds, Troyon, and old masters such as Hals and Rembrandt. In *The Temple of the Mind* intellect and imagination triumph over the baser realities; Ryder took his inspiration from Poe's "Fall of the House of Usher" but departed from the source to create a personal landscape.

By far the most distinguished of the Montreal collectors was Sir William Van Horne, one of the century's preeminent self-made men, who rose from a telegraph operator to become the multi-millionaire president of the Canadian Pacific Railway and developer of the Cuban railroad system. In an age of financial magnates, Van Horne was among the greatest, his name an omen of success in any enterprise. Like many captains of industry, Van Horne formed collections with the same voracity that he displayed in amassing wealth. He pursued a lifelong fascination with geology and accumulated extensive fossil specimens; his collection of ship models was the largest outside Holland; his vast holdings of Chinese porcelains and Japanese tea jars commanded international attention. Of Dutch ancestry, Van Horne loved and collected the art of old and modern Holland, along with English paintings and Greco-Roman antiquities. He was deeply interested in Spain and its influence in the New World; he spoke fluent Spanish (also Italian and Japanese) and bought works by El Greco, Goya,

Fig. 63. *The Lovers' Boat*. Guennol Collection (courtesy of Babcock Galleries, New York; cat. 34).

Fig. 64. *Lord Ullin's Daughter*. National Museum of American Art, Smithsonian Institution, Washington, D.C., gift of John Gellatly (cat. 32).

Fig. 65. *The Windmill*. Collection of Robin B. Martin, Washington, D.C. (photograph from the 1918 memorial exhibition, the Metropolitan Museum of Art, New York; cat. 75).

Fig. 66. Unidentified artist, *Portrait of R. B. Angus,* oil on canvas. CP Rail Corporate Archives, Montreal, Canada.

Fig. 67. Wyatt Eaton, *Portrait of William Cornelius Van Horne,* 1894, oil on canvas. CP Rail Corporate Archives, Montreal, Canada.

Velázquez, and Zurbarán. He acquired canvases by Cottier's favorite French modernists—Corot, Delacroix, and Monticelli—as well as Cézanne, Daumier, Degas, Pissarro, Renoir, Sisley, and Toulouse-Lautrec.[21]

An amateur artist, in his spare time Van Horne painted full-scale watercolors of each of his oriental ceramics and executed mural decorations at one of his three homes. He enjoyed the company of artists and fell in naturally with the Menagerie whenever business or the thirst for travel took him to New York. Over Scotch whisky and cigars, Van Horne talked shop with Ryder and Inglis. He eventually acquired *Siegfried and the Rhine Maidens* and *Constance* as well as John Popham's *Moonlight on the Sea* (see figs. 75, 85, 97). He paid for *Constance* when it was barely begun and watched it evolve endlessly over the

years, cursing Ryder's slowness but unable to force him to hurry.[22] In 1896 Inglis wrote that it was at last complete. With a painter's eye and the habit of command, Van Horne wrote back,

I am delighted to hear that the Constance is finished and that you think so well of it. I hope he put some stuffing into Constance and braced her up a little. She was dead as a mackerel when I saw her last, and considerably decomposed. And I hope he has widened out that boat forward a little so as to suggest that Constance might hope to drift ashore in it.[23]

Ryder's rapport with Van Horne—the most important industrialist to patronize his art—weakened when he learned that the railroad baron had reworked the clouds on *Constance* to suit his own taste.[24]

The route that took Ryder's paintings to En-

gland and Scotland is harder to trace, but as William Craibe Angus carried Cottier's stock in Glasgow and as Cottier had his own gallery in London, the overseas market may have been well supplied. Apart from Whistler's work, American painting held little interest for European collectors, but Cottier specialized in artists who were outside the mainstream, and a number of Ryder paintings may have crossed the Atlantic. Three were in the 1903 estate auction of R. T. Hamilton Bruce, the famous Scottish collector of Dutch and Barbizon painting. As if to confirm the migration, the dealer William Macbeth once asked Ryder why he had to go to England to buy his paintings. There are still many titles of Ryder paintings listed in the exhibition histories for which no work has been identified; it is tantalizing to imagine that one or more may languish, misattributed, in a British collection. Recently, a painting of a castle that appears to be by Ryder surfaced in Scotland at an estate sale, identified as "Scottish School" (fig. 68).

Another indefatigable collector of Chinese porcelains, Greek vases, and iridescent glass has been noted in history almost exclusively for his highly unusual interest in American paintings. Thomas B. Clarke saw that a double standard kept prices for American pictures well below comparable European ones. Anticipating a rise in their value, Clarke amassed more than four hundred American paintings between 1872 and 1899, including more than fifty by Inness and almost forty by Homer.[25]

Ryder and his contemporaries considered Clarke a beacon of hope—the first collector to promote parity with European artists through his purchases and loan exhibitions. To inspire American painters, in 1884 Clarke initiated a three-hundred-dollar prize, to be awarded annually for the best figure painting of an American subject by a non-academician at the National Academy's spring exhibition. Many artists drew Clarke's attention to their newest works, Ryder among them. In April 1885 he acknowledged payment for *Christ Appearing to Mary* and *The Temple of the Mind* (see figs. 93, 95), saying that he was pleased to be identified with Clarke's "mission,"[26]

and complimented Clarke as "one who has made such an impression on the art impulse of the country." At about the same time Ryder wrote Clarke a promotional line about *Jonah* (see fig. 105), then in progress, "I am in ecstasy over my Jonah: such a lovely turmoil of boiling water and everything. Don't you think we should try and get it in the A.A.A. If I get the scheme of color that haunts me: I think you will be delighted with it."[27] But Clarke did not buy *Jonah*, letting it go instead to Richard Haines Halsted. Clarke did, however, manage to add another Ryder to his collection by sawing in two the panel on which *The Temple of the Mind* was painted so that *Moonlight* on the verso could be separately displayed and later sold.

Fig. 68. *Scottish Castle*. Collection of Thomas Fidelo, Edinburgh, Scotland (cat. 54).

Clarke auctioned his collection in 1899, and the sale was promptly declared a success, proving his financial genius and the investment value of American art. After lively bidding, Ryder's dealer Inglis bought *The Temple of the Mind* for $2,250 (it had cost Clarke $500) and immediately resold it to R. B. Angus. Ryder was delighted with his four-figure sale, but the average price at the auction was only $630—well below that for European work—and Clarke's profit looked small when amortized over the period of his investment.[28] The sale was billed as a landmark opportunity for museums and collectors to acquire the finest American work, but the dealers stayed away and the market simply could not absorb more than four hundred paintings of a type not generally in great demand. Most disappointing of all, Clarke's passion for contemporary work evaporated after the sale. His crusade on behalf of his contemporaries looked like mere speculation when this "champion of the living artist" began to invest in colonial portraits.

The Ryder collectors on the Northwest Coast all sprouted from one exceptional seed, Colonel Charles Erskine Scott Wood, a man of far-ranging intellect, personal courage, artistic sensibility, and unfettered curiosity. Educated at West Point, he fought in the Indian wars from 1874 to 1877 but developed such a strong attachment to the vanquished Indians—especially Chief Joseph of the Nez Percé tribe—that he denounced the government's Indian policy. At twenty-six, Wood led an expedition to the North, becoming the first white man to discover Glacier Bay in Alaska. Like Sir Richard Burton of England, Wood was that rare exception among explorers—a man gifted with the ability to appreciate without condescension the foreign lands, peoples, and customs he encountered.

Redirecting his life, Wood enrolled in Columbia University's School of Law, graduating in 1883. During his years in New York he met some of the "new men" in art—Warner, Weir, and Childe Hassam. After law school Wood resigned his military commission and returned to Portland, Oregon, to a distinguished career as a maritime lawyer, but he did not neglect the art-

ists who represented, for him, the higher life. Usually short of money, he still managed to give commissions to his friends or convince the wealthier citizens of Portland to do so instead. Warner's bronze medallions of Indians, including one of old Chief Joseph, were done at Wood's initiative; Hassam painted murals in Wood's home. Wood accompanied his artist-friends on sketching trips, being himself an accomplished watercolorist and oil painter, and when they returned east, he sent them off with wolfskins, bear rugs, and the finest dried fruit from his orchards.

Wood wrote poetry, speeches, dramas, and satires and was a prolific correspondent. Of his many pursuits, poetry dominated first, then radical politics and social programs became more pressing. Among the many people profoundly influenced by Wood's anarchist writings and labor theories was young John Reed of Portland.

Warner introduced Wood to Ryder's art by sending to Portland on approval a small panel, probably the one known to Wood as *Geraldine* but now called *Woman and Staghound* (see fig. 70). No doubt Wood knew of Ryder's accelerating reputation among critics; perhaps he had met Ryder in a gathering of the Menagerie over oysters and wine at the Arena Restaurant. Wood's expectations were high, but the painting was not what he had anticipated. Unlike Van Horne, he did not alter or return it, but rather with uncommon intellectual honesty he tried to penetrate its mysteries without slighting his own misgivings. His letter to Warner reveals how Ryder's art required revision of attitudes, indeed re-vision of an entire aesthetic.

My first impression of it was disappointment. In the subject rather than the merits, for it certainly will impress anyone as a rich glowing piece of color, but I expected to see a figure very subordinate and unimportant, and a landscape full of color and aerial perspective. Somehow from your letters I had got such an idea, and you know how it is when one is expecting to taste milk and suddenly finds it is lemonade, one is shocked as it were. Well, I felt that sort of disappointment. Nor do I agree with you that one will either like it or dislike it promptly and decidedly. I think you speak from the point of view of one having an edu-

cated taste. Now my whole attitude to *every* work of art is at first *doubt*. I doubt myself. I refuse to give way to the impression "I *like* this picture" or reverse.

I am greatly prejudiced in its favor because you have written more enthusiastically of it than I ever heard you speak, and it seems to have a good pedigree. So I want to hang it up and let it work on me a few days. My present feeling is that it is certainly a deep, rich glowing piece of color but no more. I know that in itself is a great deal, and to a picture so insignificant in size perhaps no more was possible. Yet I confess in the great art of oil painting I like to see color associated with human thought and emotion of some kind. With stained glass, I am content to take color that is the limit of art, but in this picture there is a deliberate *seeking* of the same limitation as in stained glass or tapestry. It is this which I erroneously thought an affectation of Mr. Ryder's which irritated me against him and even now I think makes me unfit to do him justice. This picture seems striving for the accidental and annoying obscurity of the old masters. . . . It paints from the first the uniform brown of old

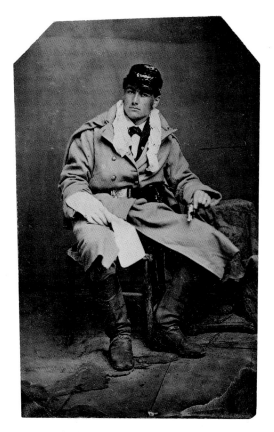

Fig. 69. Charles Erskine Scott Wood, ca. 1876, tintype. The Henry E. Huntington Library, San Marino, California.

pictures. Now I can't see a blessed thing in this picture in the brown background. There is a faint indication of the trunk of a tree which may have been visible once or be just as Mr. Ryder left it. (Don't you lose patience with me, wait till I get through.) Now this may be necessary to achieve the result the colorist hoped for, but not knowing that to be true it is irritating to me that there is not a depth to the picture. Let it be as deep and rich as possible but I think nature and the wonderful luminosity of Nature even where her shadows are the deepest ought to be suggested. It is a purely decorative panel to me, and suggests neither humanity from the figure, nor Nature from the landscape. It is like a great ruby or garnet, a pure piece of wonderful and enjoyable color and that is all. It makes everything else seem pale and shallow and thin and colorless. Yet it doesn't give me a dream and a rest as does Weir's Moon.

. . . I feel sorry that in this piece of color of Ryder's I am not stirred more than I would be by any other piece of mere color and have to turn to Weir to feel the poetry of Nature. It seems wrong, and as if something was wrong with me.[29]

"As if something was wrong with me" is the telling phrase, for those who saw nothing exceptional in Ryder's work came to feel incapable of attaining the summit from which they could glimpse genius. To remain unmoved was to admit insensitivity in a profound aspect of life. In this age when men joined (through nomination and secret ballot) as many as a dozen clubs, each an elite membership in some area of interest, being admitted to the unaffiliated but select group of Ryder admirers was a distinction. A false judgment could result in exclusion, comparable to blackballing in a club; Wood commented about one collector that he "doesn't know a Corot from a chromo."[30]

Ryder's art always asks a question: Does one believe in a reality beyond the visible? This was a difficult question about the soul in an age of failing faith. Wood, a doubter in art and religion, came to believe in Ryder's painting as more than just decorative color—as an expression of some inviolate, indestructible aspect of the human spirit. Decades later the artist Hans Hofmann made the same judgment in distinguishing between the "decorative creator" and the "cosmic creator" and named as the latter "Ryder the greatest of American artists."[31]

Wood, the explorer of Alaskan glacier fields, journeyed into another unmapped wilderness when he visited Ryder's Greenwich Village rooms. He noted Ryder's conversation in his diary as if recording the wisdom of a seer.

On one of our night walks alone Ryder talks of his own poetry and his dreams for pictures and tells me, "Everything has been done in art so all that is left to a modern man is to try and improve the medium. I have been working to get my paint less painty looking than any man who went before me, and it's only when you see my pictures in company with old masters that you really feel what they are. It takes fine quality to not seem out of place in such company." . . . He spoke of elm leaves drooping against the sky as "jewels pendant and trembling, giving value to the sky." His observation of the sea is minute, color, form, and liquidness.[32]

As Wood grew to love Ryder's works, he bought more for himself (*Guinevere, Jonah, Landscape, The Tempest*) and urged them on his friends. The Ladd family—Charles Ladd, William Ladd, and Helen Ladd Corbett—acquired a number of masterworks through Wood's efforts (*Christ Appearing to Mary, Desdemona, The Lorelei, Story of the Cross*).

In the 1890s Wood acted almost as an unpaid agent for Cottier on the West Coast. He obtained old master and modern paintings on consignment from Inglis and persuaded friends and business associates to purchase them at a time when economic depression threatened the dealership's survival. Wood also sometimes sold paintings directly for Weir, without using the gallery as intermediary. Although Inglis was grateful for Wood's assistance with numerous sales, he demanded commissions on all sales of gallery artists' works, even those obtained directly from the artists. Angered at this proprietary attitude, in 1899 Wood abruptly ended the correspondence with Inglis that had begun at Cottier's death in 1891. Ryder had begun some months earlier to negotiate directly with his patrons rather than wait for Inglis's monthly payments; about the time of Wood's rupture with Inglis, Ryder's exclusive relationship with Cottier's company came to an end.[33]

Although John Gellatly would later assemble more Ryders in a single collection, Wood was never surpassed in sympathy and understanding of his elusive art. Perhaps this is because Wood alone worried about the undercurrent of arrogance involved in "patronizing" an artist, especially one as vulnerable as Ryder. Cottier, Inglis, Weir, and other friends sometimes could not avoid teasing the artist for his slowness, strange giggle, peculiar clothes, endless night rambles, pack-rat habits, peculiar health regimens, and the thousand other eccentricities that were the outward manifestation of the "cosmic creator" they admired. Wood alone resisted the desire to be superior and chided himself if he joined the fun at Ryder's expense. Ryder attracted exceptional dealers in Cottier and Inglis and an exceptional critic in de Kay, but in Wood he found that rarest blessing, a patron fully in touch with the deepest mysteries of his work who felt no urge to rise above the artist who made it. ❧

PART TWO

Subjects, Style, Method

Courting the
Gentle Muse

Most of the paintings for which Ryder is celebrated were painted during the last two decades of the nineteenth century, known as the Gilded Age. Ryder's 1882 tour of Europe deepened his resolve to create something original that would withstand comparison with the great masters. His reputation as a landscapist receded as his "fantasies" captured the public imagination. Since Cottier had new clients for easel paintings, Ryder could afford to turn his attention to the subjects he increasingly preferred: nature and the simple life, the yearning for love, and literary and imaginative themes.

The small rooms Ryder called his studio became a haven and sanctuary, although those who saw the squalor there were more apt to call it a den. The more he confined himself, the farther his imagination ranged and the more he strayed from convention. In this as in so much else, his life was an inversion of the prevailing pattern, for the Gilded Age was a time of restless expansionism and travel, much of it for the purpose of extending the body of conventions called civilization into new territories. Ryder, however, believed that art expresses inner experience, not

the social will or a patron's plan, and he knew that only the artist who dared everything would be great. Like Constable, he felt that "every man who distinguishes himself stands on a precipice," and he determined to find his own way.[1] As inclination led him farther from the well-traveled path, this basically shy man chose to pursue his course rather than "correct" it. Naturally, he endured much teasing—good-natured but with a patronizing undercurrent—and occasional comments about his stubbornness. Ryder rarely argued or took exception to those who urged a different course but neither did he change.

After 1888 he sent no more paintings to the National Academy or the Society of American Artists shows.[2] In the early 1890s he left his companions at the Benedick for rooms at 308 West Fifteenth Street. Invitations were declined, unless they came from his small circle of friends; new admirers were put off for weeks on one excuse or another; even close companions understood that sometimes their knock would not be answered. Over the two decades in which he painted most of his masterworks he changed from a convivial young painter with wide ac-

quaintances into a recluse and finally an eccentric. Other artists also distanced themselves from Gilded Age materialism: Homer followed a similar progress into partial seclusion but maintained a measured life that could not be called eccentric; Blakelock went further, past eccentricity into insanity and delusion.

There is no journal such as Delacroix kept and no intimate correspondence like that between Theo and Vincent van Gogh to give Ryder's thoughts during lengthening periods of solitude. So with more than the usual curiosity, we turn to his paintings and poetry—keeping in mind that these are creative inventions rather than documentary evidence—to tell us of his interests and views. Charting the development of his work is difficult, as several paintings were in progress simultaneously and few can be dated. Some were sold, exhibited, and later reclaimed for reworking, so that even sale and exhibition records do not provide an absolute terminus ante quem. But if a chronology of his development is impossible, at least we can find certain threads that weave through his art, appearing sometimes on the surface and again below the warp.

Ryder drew many subjects from literature, and in this he was somewhat old-fashioned, closer to the early romantics than to his contemporaries.[3] He read the romantic authors, including Byron, Browning, Coleridge, Keats, Poe, Thomas Moore, Longfellow, Hugo, Scott, Thomas Campbell, Drake, Heine. He quoted them in letters and mined their verses and stories for subjects for his brush. From the romantic poets he took a sense of drama and foreboding, shadowed destiny, doomed passion, and fateful encounter. The brooding or ecstatic moonlight marines, defiant lovers of *Lord Ullin's Daughter,* siren's deathly allure in *The Lorelei,* outcast graces of *The Temple of the Mind*—these are the strange fruits of his romantic harvest (see figs. 64, 77, 95).

Another side of Ryder's work evokes the earlier, happier pastoral mode of British poetry. He knew James Thomson's "Seasons" from the eighteenth century, and he found a special kinship with the great poets of the sixteenth century. He adopted their charming conceits on love and nature, their courtly tone and archaic language. An Elizabethan formality prevails in such Ryder poems as "The Spirit of the Flowers": "What radiant passing is this / That gilds the sphere with summer bliss / And calls a race of gentle wonders / All born in beauteous splendors / To gem the warm zone of the world." Certain paintings, too, such as *The Shepherdess* and *A Country Girl* (see figs. 47, 74), owe more to the charming maids in Spenser's "Shephearde's Calender," Sir Philip Sidney's "Arcadia," or Robert Greene's "Shepherd's Ode" than to the quasi-religious, dull-witted peasants of Israels, Mauve, and Millet. There was a revival of the early English poets in the nineteenth century, enough that, when stained-glass windows were commissioned from Cottier for Harvard's Memorial Hall, one of the subjects specified was Sir Philip Sidney.[4]

The painting now called *Woman and Staghound* (fig. 70), which so perplexed Wood, offers the most direct link between Ryder and the early pastoral poets. Wood referred to the painting as *Geraldine;* as he was intensely respectful of Ryder's art we can assume the title was not Wood's invention but Ryder's intended subject. The name Geraldine resounds in English literature through the poems of Henry Howard, earl of Surrey, one of the first English poets to model his verses after Petrarch. Geraldine was to English poetry what Laura was to Italian verse—the embodiment of inspiration, the poet's muse.[5] The earl of Surrey's love of Geraldine was legend, the subject not only of his own verses but of a famous poem by Michael Drayton, whose lines seem almost to have inspired Ryder's painting:

Near that fair castle is a little grove,
. .
There the soft poplar and smooth beech do bear
Our names together carved everywhere,
And gordian knots do curiously entwine
The names of Henry and of Geraldine.
O! let this grove in happy times to come
Be called the lovers' blest Elysium;
Whither my mistress wonted to resort,
In summer's heat in those sweet shades to sport.
A thousand sundry names I have it given,
And called it Wonder-hider, Cover-heaven.[6]

Fig. 70. *Woman and Staghound.* New Britain Museum of American Art, Connecticut, purchased through the Harriet Russell Stanley Fund (cat. 77).

Ryder absorbed the Elizabethan pastoral style and tumultuous romanticism of his own century and turned both to account in his poetry and paintings. One of his untitled poems describes a grove of love, opening with, "these tended flocks and pastures green . . . these sylvan / bowers that range so wide around," calling to mind one of his most beautiful landscapes, *Pastoral Study* (fig. 71). As the verses unfold, however, a gloomier strain appears, and we learn that "Where yon

tree in sunlight stands / There us'd to be our trysting place." The poem moves into bittersweet reverie as "leafy memories" recall a former lover, and finally, the poet wishes for death and a return to sweet dreaming.

> And when in reverie appears
> Her face with same sweet smile of old
> Then ah then I lay me down in tears
> And sigh for cold cold death to fold
> In embrace of years
> This weary day
> Has gloomy fears

> And when And when sad beguiling
> I wake from dreams to conscious day
> Then ah then as her spirit smiling
> I would resolve in dreams away
> In dreams away
> I would resolve in dreams away.

Whether or not Ryder intended a correspondence between the poem and a specific painting, the verses express the fervor of his feelings for nature and describe the way landscape was, for him, charged with associations, awakening his most passionate emotions and desires. His painted landscapes brim with the intensity of hoarded emotions, released into nature like a pent-up flood. The massive trunks and spreading limbs of the two characteristic "Ryder trees" in *Pastoral Study* are almost animate, entwined like Philemon and Baucis in Arthur Golding's poem: "Phrygians in that park / Do at this present day still show the trees that shaped were / Of their two bodies, growing yet together jointly there." In a passage of one of Ryder's own poems, "The Voice of the Forest," Ryder speaks of trees as lovers:

> I will draw near to thee
> For thou can'st not to me
> And embrace thy rugged stems
> In all the transports of affection.
> Stoop and kiss my brow
> With thy cooling leaves
> Oh ye beautiful creations
> Of the forest.

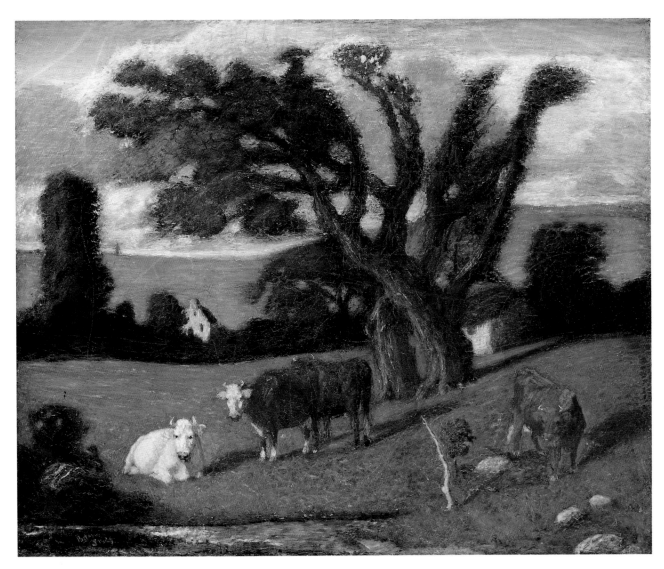

Fig. 71. *Pastoral Study*. National Museum of American Art, Smithsonian Institution, Washington, D.C., gift of John Gellatly (cat. 45).

Fig. 72. *Perrette*. Smith College Museum of Art, Northampton, Massachusetts (cat. 50).

This is the true spirit of pastoral romanticism, in which nature echoes human passions, absorbing joys and sorrows into a universe of bloom and decay. In painting, the pastoral tradition of Poussin and Claude was inherited by Constable, Corot, Blake (in his *Eclogues*), and Samuel Palmer. In poetry, the tradition was ancient, beginning with the Greeks and descending through Virgil to the Elizabethans and the nineteenth-century nature poets. Ryder began his career with such immediately perceived landscapes as

Near Litchfield, Connecticut (see fig. 21) but moved quickly into the imaginative world in which nature is not transmitted through the eye but transformed by memory and idea.

"Voice of the Night Wind" is Ryder's most explicit and passionate nature poem. Whitman's high-keyed language echoes in certain passages, but Whitman would not have recognized the Victorian combination of fascination and fear with which Ryder approached sexuality through the metaphor of the wind. "I am the wind, the wind, the wind," he declares, imagining how he will "caress" the flowers, and "shake [the trees] to their roots . . . And make them tremble to their sap."

> I'll away, I'll away to where maidens
> Are sighing for fond lovers,
> And softly coo and woo
> And whisper in their ears
> Making their hearts throb,
> Their bosoms rise
> Till I seem hardly from without
> Almost within the voice
> Of their soul's illusion.

But in the end he cannot be the lover who will "breathe upon those rounded bosoms." The last verses suggest melancholia, rejection, and wounded pride that seeks to conceal its pain.

> I'll away, I'll away to gloomy pools profound,
> And stir the silence
> Of their reflective depths
> With rippling laughter
> At my wanton freaks.
> And my fantastic wanderings
> Who can pursue, who comprehend?

With its note of wildness and desperation, the poem projects a profound yearning for sexual experience, mingled with frustration and fear. Longing and anxiety—at least partly sexual—were at the root of Ryder's way of painting, especially his seemingly endless striving toward perfection and insistence that each canvas needed just a few touches more. In response to an eager buyer he paraphrased Browning, saying

Fig. 73. *Little Maid of Acadie.* Collection of Mr. and Mrs. Daniel W. Dietrich II (cat. 29).

Fig. 74. *A Country Girl.* Maier Museum of Art, Randolph-Macon Woman's College, Lynchburg, Virginia (courtesy of Babcock Galleries, New York; cat. 8).

that the painting needed little to be complete, but "Oh, how much that little may be."[7] To a friend, he wrote, "I sometimes think, the smallest thing I do, it is as if my life depended on it; and then the great shadow, always, of the impossible and the unattainable."[8] Perfection that was worlds away, the shadow of the unattainable—in such passages we feel Ryder groping toward uncharted realms. "Have you ever seen an inch worm crawl up a leaf or a twig, and then clinging to the very end, revolve in the air, feeling for

something to reach something? That's like me. I am trying to find something out there beyond the place on which I have a footing."[9]

"The impossible and the unattainable" expresses Ryder's high ideals and apprehensions he felt about obtaining them—in love as well as in painting. Ryder's feminine ideal was the child of nature rather than the femme fatale. *Perrette, Little Maid of Acadie,* and *A Country Girl* (figs. 72–74) are guileless and open, no more capable of cleverness than flowers. Perrette is a figure

Fig. 75. *Siegfried and the Rhine Maidens*. National Gallery of Art, Washington, D.C., Andrew W. Mellon Collection (cat. 59).

from a fable included in Thomas Percy's *Reliques of Ancient English Poetry*, a dairymaid who daydreams of riches while carrying milk to market until she stumbles and spills it all. The poem underscores one of Ryder's favorite themes—that dreaming brings more pleasure than reality, that fancy holds more charm than fact.

Little Maid of Acadie (fig. 73) is from Longfellow's "Evangeline: A Tale of Acadie," which opens in a wailing and gloomy "forest primeval" and tells of love "that hopes, and endures, and is patient" despite the world's indifference. This is a story of devotion and deferred joy, of a wife who searches for years for her husband, only to find him dying. But this little maid and all the similar subjects Ryder painted—factual, fictional, allegorical—stand for simple virtue and constancy. Wordsworth's Lucy, Ivanhoe's Rowena, Hamlet's Ophelia, Othello's Desdemona, Dante's Beatrice, Petrarch's Laura, Astrophel's Stella, Coridon's Phillis, and myriad others combine in this image. These are women who wait—uncorrupted, selfless souls who are faithful despite fortune's vagaries, their constancy an inspiration to the poet.

In his life as in his art Ryder's manner with women was chivalrous. Retreating into his own world, he moved less in the circles of the beautiful Helena de Kay Gilder and other society women. He only reluctantly received women in his room, but when they came he made an elaborate show of removing the papers and books that littered his only armchair and spreading a small carpet before it as if preparing a throne for a queen.[10] Ryder's contemporaries thought him quaint in the way he greeted women with an exaggerated, old-fashioned courtliness, as if every female were Pastorella or Phillis—"In her hand a shepherd's hook, / In her face Diana's look."[11]

Ryder's formality with women also helped him enforce a certain distance. Raised by a mother who adopted Quaker dress, in a family of four sons, educated from age ten in a boy's school, temperamentally shy—Ryder probably knew little about women before he left New Bedford. No romantic attachment is recorded nor any courtship or companion mentioned until he was more than forty. In the 1890s a friend one day discovered an adolescent country girl in Ryder's apartment; Ryder had found her on the streets a couple of days earlier and moved her in, intending to care for her. She was soon whisked off to the police, and no further mention was made of Ryder's plan.[12] Is *A Country Girl* (fig. 74), the only one of Ryder's pastoral maidens to cast a coquettish glance, a memory of this experience?

Ryder almost escaped the fin-de-siècle fascination with femmes fatales—the sirens, sphinxes, mermaids, vampires, and other temptresses and alluring killers who populated so many canvases in the Gilded Age, sapping the strength of heroes.[13] It was hard for him even to conceive of a death-dealing seductress. The nixies in *Siegfried and the Rhine Maidens* (fig. 75) look ill at ease and almost frightened in their moonlit stream; the magnificent swaying tree undulates more alluringly. They are not agents of destruction but of destiny, warning the passing horseman of a curse woven in the "never-ending rope of time and fate." The Weird Sisters in *Macbeth and the Witches* (fig. 76) are also prophets, planting evil seeds in Macbeth's mind by foretelling his untimely ascent to the throne but avoiding wanton sexuality; worldly ambition here is treated as the root of tragedy.

Only once does Ryder link love and death in the way so intriguing to late nineteenth-century artists, poets, and musicians. In *The Lorelei* (fig. 77), based on Heine's famous poem, a sailor hears irresistible singing and tries to steer toward the nymph on the rock but is sucked to his death in whirlpools and rapids. The placement of the figure of the siren gave Ryder endless trouble. In the spring of 1898 Inglis wrote to Wood, who had paid for the painting, "Ryder's Lorelei is still in process of baking but he says it's near done."[14] Eight years later Ryder was still making adjustments, writing to Wood: "I am getting the Lorelei into shape. I think she was too perpendicular on the rock; reclining, more as I have her now, seems to help the feeling of the picture very much: of such little things painted dreams are made."[15] But Ryder's only lethal temptress proved impossible to settle once and for all. The painting still languished in Ryder's studio at his

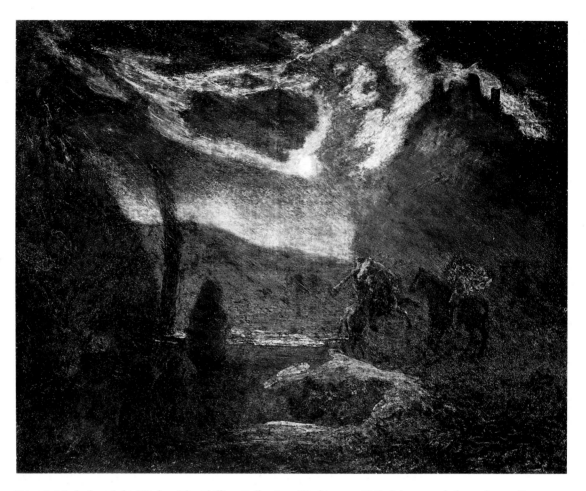

Fig. 76. *Macbeth and the Witches*. The Phillips Collection, Washington, D.C. (photograph from the 1918 memorial exhibition, the Metropolitan Museum of Art, New York; cat. 35).

death in 1917; today the golden-haired siren has completely vanished, the thin glazes of her figure obscured by the darker colors of the rock on which she reclined.

While laboring over *The Lorelei* Ryder made another small panel on a related theme, *Passing Song* (fig. 78).[16] Again a beautiful maiden sings irresistibly to a sailor, but in a poem of his own composition, Ryder made the grief of unattainable love into the agent of death. His maiden is no naked nymph luring men to destruction but a beautifully attired noblewoman holding a lyre and singing like Apollo's muse.

By a deep flowing river
There's a maiden pale,
And her ruby lips quiver
A song on the gale,
A wild note of longing
Entrancing to hear,
A wild song of longing
Falls sad on the ears.

The sailor longs to turn his ship to her shore, but the boat has no rudder and the current carries him out to sea, away from the maiden's song. Then,

Fig. 77. *The Lorelei*. Guennol Collection (cat. 33).

Fig. 78. *Passing Song*. National Museum of American Art, Smithsonian Institution, Washington, D.C., gift of John Gellatly (cat. 44).

Sweeter and fainter
the song cometh back,
And her brain it will bother
And her heart it will rack,
And then she'll grow paler
With this fond memory
Paler and paler
And then she will die.

Passing Song and *The Lorelei,* like *A Country Girl,* may hold some private meaning. In the mid-1890s Ryder committed an impulsive act that took all his friends by surprise. He heard beautiful singing coming through the apartment building where he lived, and tracking the sounds to their source, he introduced himself and proposed marriage to the singer. Alarmed and more than a little amused, his friends told him that the woman was of dubious character, unsuitable for him.

The Reverend has almost [illegible] making a fool of himself, proposing to a Prima donna for marriage. Heaven save us—Warner and all have sailed in & called her an adventuress & a hypocrit[e]—one with a past—& it was finer than the yacht races to hear Old Warner sail in and give him advice—he may have done wrong for who knows but that she might have been a worthy addition to the Menagerie—Pinkie though is up now early & works late & talks of enough pictures when sold to buy himself $4500 of Pullman stock—which would give him an annual income of $350—on which he says he can live—Bravo Pinkham.[17]

To distract himself from persistent lovesickness, Ryder went on a voyage to Europe, his fourth and last, in 1896. Afterward, he never spoke of the incident but twice painted the theme of the irresistible singer—once as he saw her, a beautiful maiden offering love, and again as his friends interpreted her, as a dangerous siren.

Like Odysseus, Ryder was saved from a singer by his friends, but in so doing did they not affirm that no romantic attachment could be countenanced for the "sweet minded philosopher Bishop Ryder"?[18] We can only wonder why the idea of a liaison or marriage seemed so absurd that they felt compelled to prevent it. And why did Ryder acquiesce in this intrusion? Whatever

the reasons, Ryder felt powerless to direct his own future. The rudderless (and often mastless) boat became a frequent symbol, expressing his inability to control his fate, inadequacy in love, and sense of drifting with the current, moving always farther from home shores to boundless, uncharted seas.[19] Although Ryder used the symbol with a special poignancy, the drifting boat was a universal emblem of man's helplessness in a world beyond his control.

The nineteenth century experienced a great rediscovery of Renaissance arts and letters. In the fine arts, academicians urged their students to study Florence and Venice like sacred texts; Raphael, Michelangelo, and Leonardo were again anointed as the eternal triumvirate of art. In music, Grieg, Brahms, and many others created suites "in the antique style" from archaic dance forms such as the gavotte and saraband. But the Renaissance Revival was manifested most clearly in the Shakespeare cult that emerged in all the arts, inspiring poets, painters, and musicians.

Shakespeare's plays had become subjects for history painters in the late eighteenth century, when John Boydell opened his Shakespeare Gallery in Pall Mall. A little later, Delacroix's *Hamlet* lithographs demonstrated how stage conventions of exaggerated gesture and facial expression could be abandoned for a painter's pictorial vocabulary of light and shadow. Soon Shakespearean subjects were staples in the romantic painters' repertory. Coleridge delivered dazzling lectures on Shakespeare's creative genius that were published and widely influential,[20] and other scholars—Stanford White's father among them—made the study of Shakespeare's plays into a new discipline. From Mendelssohn to Verdi and Tchaikovsky, composers translated Shakespeare's settings and characters into orchestral suites and operas.

The passion for Shakespeare was in full force from Ryder's youth through the end of the century. It is not surprising that he made a pilgrimage to Stratford-upon-Avon as part of his 1882 trip to Europe, for a visit to this hallowed site was de rigueur for cultured Americans. (In 1885 a group of Americans donated a stained-glass

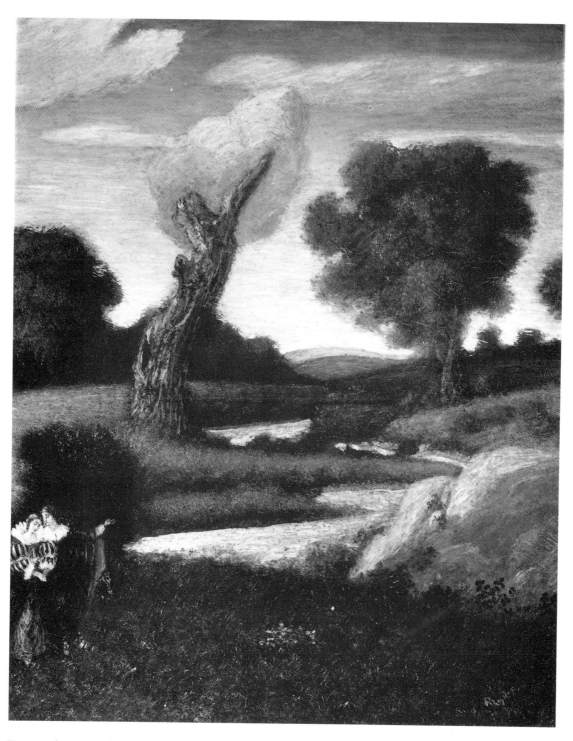

Fig. 79. *The Forest of Arden*. The Metropolitan Museum of Art, New York, bequest of Stephen Clark (photograph from the 1918 memorial exhibition, the Metropolitan Museum of Art, New York; cat. 16).

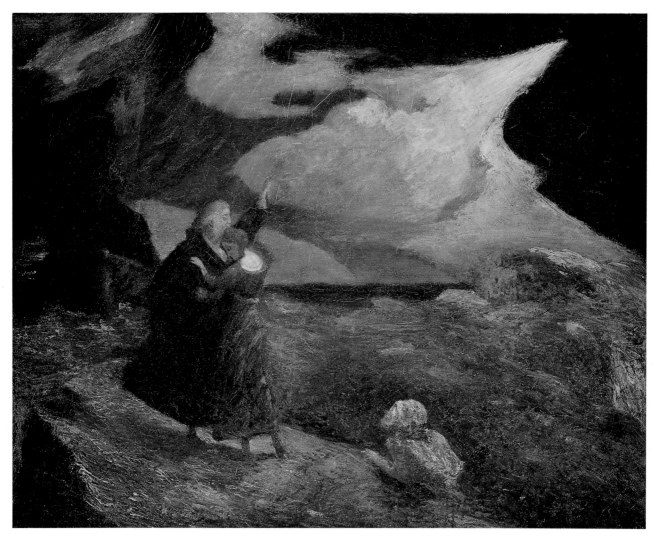

Fig. 80. *The Tempest*. The Detroit Institute of Arts, purchased through the Dexter M. Perry, Jr., Fund (cat. 66).

window representing the Seven Ages of Man to Stratford's Holy Trinity Church, which houses Shakespeare's grave.) At least seven of Ryder's paintings take subjects from Shakespeare's plays. In 1901 the critic Sadakichi Hartmann wrote an illustrated book entitled *Shakespeare in Art,* praising several of Ryder's paintings as being among the most evocative ever inspired by the Bard's themes.[21]

The Forest of Arden and *The Tempest* (figs. 79–80), two of Ryder's greatest Shakespearean subjects, depict enchanted realms far from the ordinary world. The dreams and illusions that Ryder loved find perfect settings here, where a pastoral magic rules. These temporary refuges have been compared to that in Spenser's "Faerie Queene"— a liberation from the mundane and a release into a world of art, where nature is not oppressed. "The truest poetry is the most feigning," says Touchstone in *As You Like It,* as if to sanction Ryder's faith in dreaming and the transformative power of art. In *The Forest of Arden,* Rosalind (disguised as a suitor) introduces Celia to a primeval Arcadia, in which a strong young tree with splendid foliage and an aged leafless stub flank a meandering stream, condensing man's seven ages into a single polar opposition. In this Arcadia the true identity and meaning of love is discovered.[22]

In *The Tempest,* Ryder moves the eye through the ascent of man—from the brute Caliban emerging from the sea to the ideal beauty Miranda, to the noble magician Prospero, and finally to Ariel, spirit of the air, floating in the storm.[23] Coleridge thought *The Tempest* to be one of Shakespeare's greatest plays and considered at length its appeal to the imagination. Ryder allowed himself one of his few moments of pride in discussing his *Tempest* with Wood, saying, "Judging from the work of Millet and others, it is so nice in colors and other good things."[24]

Ryder's favorite Shakespeare play was *The Winter's Tale,* about Prince Florizel's love for the beautiful peasant girl Perdita, a child of nature whose verses comparing crossbred flowers with natural blossoms are among Shakespeare's most

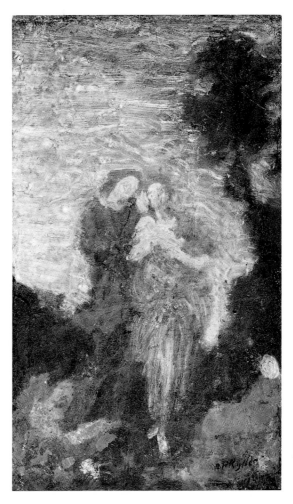

Fig. 81. *Florizel and Perdita.* National Museum of American Art, Smithsonian Institution, Washington, D.C., gift of John Gellatly, 29.6.94.

beguiling—an ingenious contrast of artifice and nature. In Ryder's small *Florizel and Perdita* (fig. 81), of which Hartmann wrote "the colours shine like ancient gems," blissful lovers stroll arm in arm.[25] But their love is threatened by their differing social stations, until Perdita is discovered to be the daughter of a king who had cast out his wife and infant daughter, believing his wife unfaithful. A nobleman's love for a virtuous woman beneath his social station is also the theme of *King Cophetua and the Beggar Maid* and may

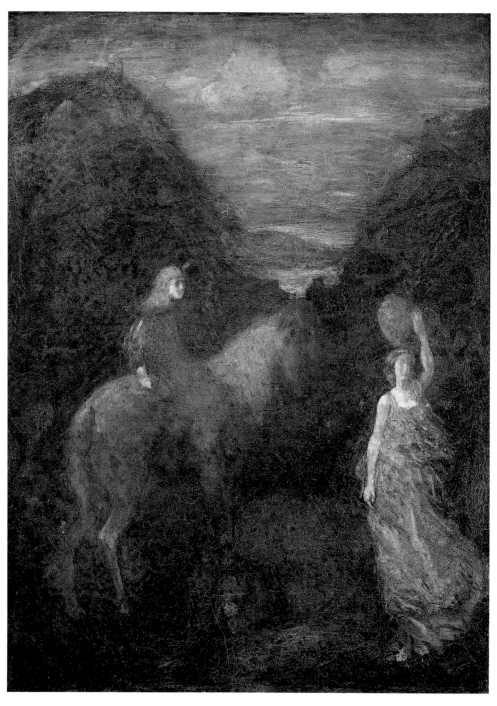

Fig. 82. *King Cophetua and the Beggar Maid*. National Museum of American Art, Smithsonian Institution, Washington, D.C., gift of John Gellatly (cat. 25).

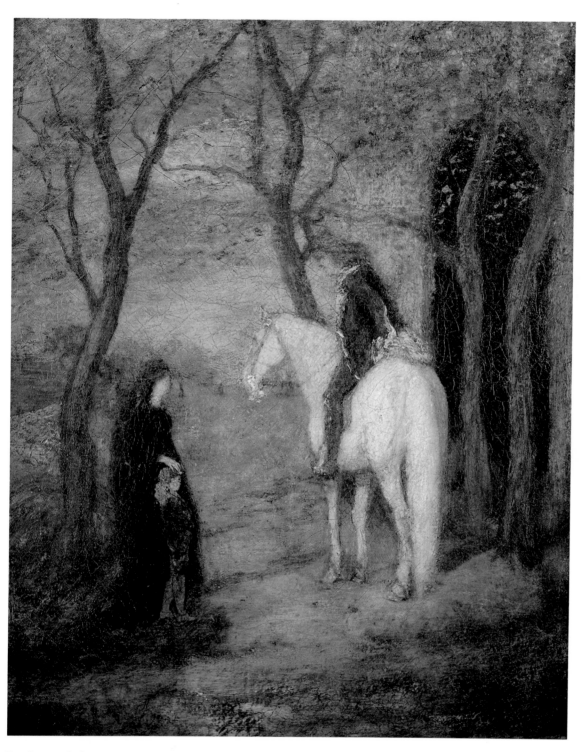

Fig. 83. *Roadside Meeting*. The Butler Institute of American Art, Youngstown, Ohio (cat. 53).

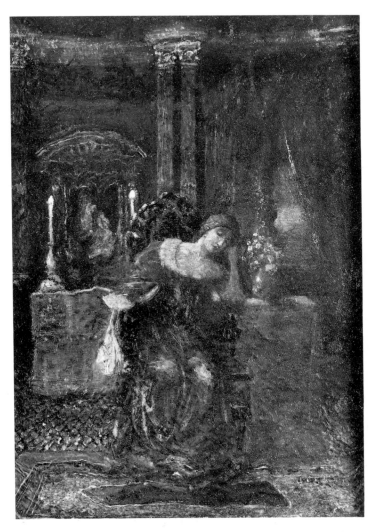

Fig. 84. *Desdemona*. The Phillips Collection, Washington, D.C. (early photograph).

perhaps be the theme of a similar composition known only as *Roadside Meeting* (figs. 82–83).

Ryder portrayed *Desdemona* (fig. 84)—another wrongly accused heroine—in enthroned, melancholy majesty; all her riches cannot restore her husband's trust and the exalted love they once enjoyed. This lovely, but now deteriorated, small painting, full of rich details of costume and setting, was one of Ryder's finest accomplishments. He wrote to Wood that he was delighted with his work,

It is very near my ideal and you know what that is. I am anxious you should see the flesh quality; I am greatly mistaken if it is not very beautiful; a charming kind of warmth yet rare and pale. Altogether it seems to me very strong and very delicate which I think you will agree with me is most desirable in a Shakespeare subject.[26]

Virtuous women falsely accused, innocent children reared in nature, long periods of rejection (sometimes followed by happy reunions)—these elements inspired several Ryder paintings. The similar story of Genevieve of Brabant was the source for his three-panel screen (see fig. 39), and Chaucer's *Canterbury Tales* provided yet another in the legend of Constance, the subject of one of Ryder's largest canvases (fig. 85). *Constance* presents a noblewoman and her child in a boat without rudder or sail, through treachery cast on the ocean to drift for more than five years. Sustained by faith in God, Constance and her child miraculously survive and are restored to the distraught husband and father.

Many of Ryder's protagonists are innocents in a private world, cast out, not confronting their accusers or protesting fate but submitting—powerless in argument but triumphant in patience and virtue. It matters little whether the ending is happy or sad, for in a fatalistic world, acceptance constitutes wisdom, not the ability to direct one's affairs. In Ryder's moral scheme, titled positions and wealth sometimes go hand in hand with intolerance and misjudgment, while innocence abides with those who have faith in God and live by nature's principles. In other compositions richly dressed noblemen recognize exceptional virtues in simple country women. But whether

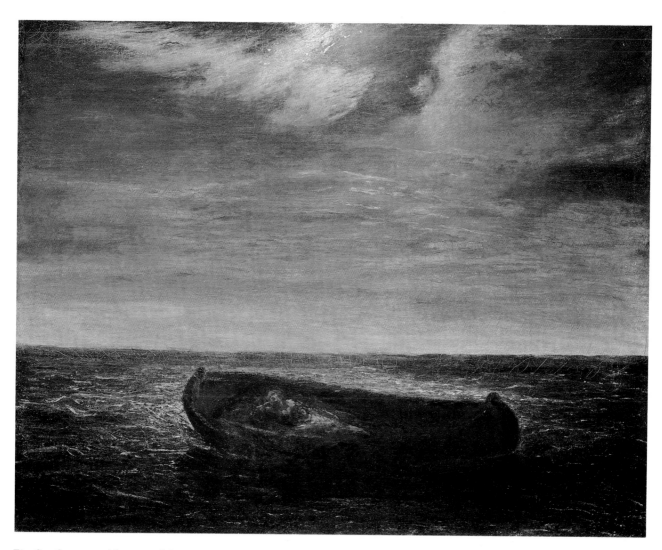

Fig. 85. *Constance*. Museum of Fine Arts, Boston (cat. 7).

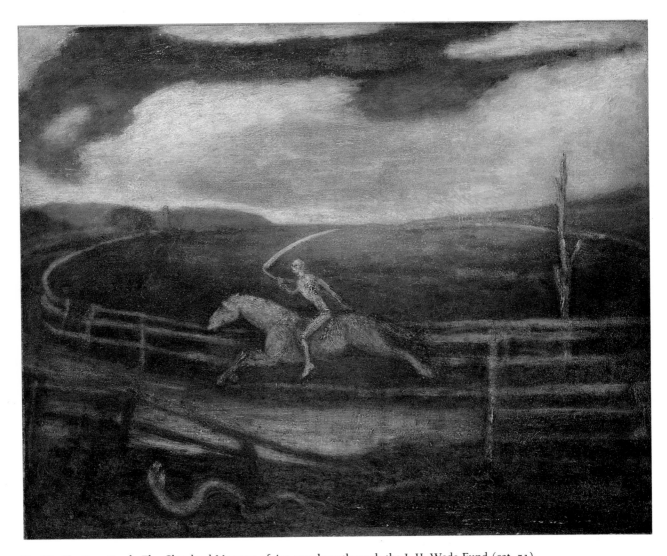

Fig. 86. *The Race Track*. The Cleveland Museum of Art, purchase through the J. H. Wade Fund (cat. 51).

the tale is hopeful or cautionary, the idea dominates that virtue flourishes in nature.

So many of Ryder's paintings and poems treat romantic love that we must recognize it as one of his major preoccupations. Although no strict chronology can be established, we can trace a shift from hope to despair in Ryder's approach. The blissful lovers of *Florizel and Perdita* were complete before the mid-1880s as were *The Lovers* and *The Lover's Boat*—both serene moonlit romances. In his thirties, Ryder must still have imagined that happiness would come to him, as it did to Warner, who married in 1886. In contrast, *Constance, Desdemona,* and *The Lorelei*—all begun in the 1890s—reveal the pain of love forsaken or denied. A profound sadness enters these works, the "wild note of longing" of his *Passing Song* poem.

Through paintings and poetry Ryder tried to assuage the longing and come to terms with grief and isolation. The difficulty he had in completing his pictures—a problem that began in the late 1880s—tells of his difficulty in accepting his situation as fate. He eventually arrived at resignation or acceptance, and with this, he essentially stopped painting. "Old Pinky seems to be as near content . . . as any man I know. He does not allow his work to trouble him and always rises superior to his surroundings," wrote Weir in 1906. "Although he is not a great producer, he has the philosophical air of content and I think his health is better than it has been in years."[27]

Ryder's deep knowledge of literature and art—his ability to live in that world and draw comfort from it—gives his paintings a resonance that no one of his generation could match. For him, literature was alive with emotion, providing not just a picturesque subject but joy and release from pain. Apparently, he painted only when in this state of emotional investment, unable to "go at a picture cold."

Ryder used literary characters and subjects but made no effort to retell the narrative. Most painters of literary or historical subjects were compromised from the beginning by undertaking to illustrate a single dramatic moment in the narrative, like a still from a movie. Crowding the canvas with principals and extras, props, scenery, costumes, and gestures, painters vainly tried to capture an unfolding story in a time-frozen matrix. But Ryder understood art as a poet does, not as narrative but as idea made concrete through imagery. Abstracting ideas from circumstances and condensing them into an image, he depicted only one or two actors, with limited interaction, minimal setting, no dramatic conflict, rarely any specific moment. His paintings are poetic, not because they borrow literary themes and titles or are accompanied by verses, but because they present images with a poet's eye and ear. Ryder apparently came by this gift by instinct; nothing in legend or life can explain the pure poetic grief over silenced singing in *The Dead Bird*. Robert Frost said that poetry is what evaporates from all translations, but Ryder, almost alone of his generation, moved from verse to painting without losing the essence. ❧

Fancy Endowed with Form

'Tis to create, and in creating live
A being more intense that we endow
With form our fancy, gaining as we give
The life we image, even as I do now.

Byron, *Childe Harold's Pilgrimage* (canto 3.6)

For an artist said to work almost completely from imagination, Ryder often repeated images from his own or others' repertory. Hartmann noticed one day a copy of his book *Shakespeare in Art* lying on Ryder's windowsill, open to the page illustrating a Macbeth by a German artist (cat. 35b); he immediately noted its resemblance to the painting on Ryder's easel.[1] Who could imagine this gray, grainy illustration inspiring the mysterious *Macbeth and the Witches?*

Instances abound to show that Ryder's style was patched together from things observed and filtered through his imagination. *The Temple of the Mind* (see fig. 95) takes Poe's "Fall of the House of Usher" for its subject and combines visual sources ranging from Turner to penny postcards. As with most artists, images and ideas provoked a profound excitement that ultimately found release in pictures. It was his fortune, not

his weakness, to respond so deeply to even mundane images, looking past their conventional technique or staginess to discover a personal meaning in the work.

The artist Marsden Hartley was amused to watch Ryder in art galleries, for he gazed long and hard at even pedestrian efforts, then singled out some insignificant aspect of a picture for special praise.[2] Friends considered this either naïveté or poor judgment, but in fact he was an omnivore who grazed on images wherever he found them, often in book illustrations.[3]

Until the impressionists and early modernists discarded tradition—replacing it with optics, formalism, or personal symbolism—originality in art consisted of reviving through some personal interpretation or accent the fresh, "original" vision underlying conventional representations. Standard compositions and poses descended from the Renaissance to the late nineteenth century, with reproductive engravings serving as aide-mémoire. In the decade of Ryder's birth, photography greatly expanded the possibilities for artists, but ironically the proliferation of images did not immediately expand the repertory of

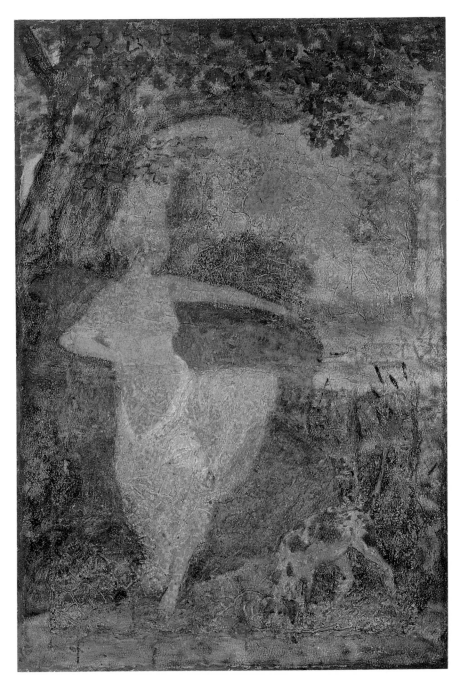

Fig. 87. *Diana*. The Chrysler Museum, Norfolk, Virginia, gift of Walter P. Chrysler, Jr. (cat. 12).

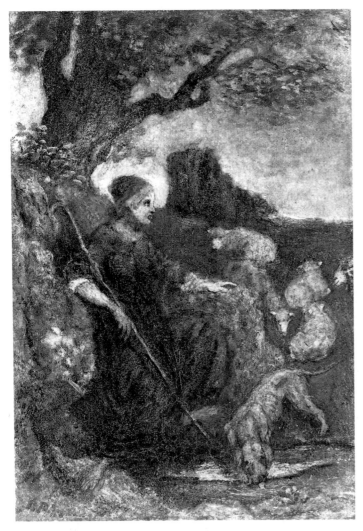

Fig. 88. *Joan of Arc.* Worcester Art Museum, Massachusetts, bequest of Theodore T. and Mary G. Ellis (1956 photograph; cat. 23).

imagery, for early photographic artists' aids merely reproduced the standard poses once again. Conventional poses, stock compositions, repertory subjects—these were the givens of art, which the artist animated with his touch and personality.

The rapidity with which the nineteenth century discovered and discarded period styles ("Gothick," Romanesque, Renaissance, rococo, Pre-Raphaelite, Greek, Egyptian, Islamic, Assyrian) suggests that the conventions had been slowly rising to the surface and now lay just beneath the veneer of style, which grew increasingly exotic in order to compensate for tired, worn-out subjects. In this world Americans fared pretty well; for them, traditions were not exhausted conventions but opportunities to converse in the noblest language of art. Eakins, with his steely observation, reinterpreted the anatomy lesson and the crucifixion with an unnerving attention to suffering and pain. Sargent chose a gypsy theme, long ago tamed into picturesqueness, and unleashed a torrent of bravura brushwork that made vagabond license almost irresistible. By treating common themes as living traditions and proving there was still passion to be found in them, these Americans became heroes of the Paris salons.

Ryder's academy experience was limited to Wilmarth's drawing classes—more likely to induce irregular attendance than a serious examination of tradition. But he contributed to the modernist push by using stock images as raw matter to be worked up into something highly personal. Some source, for instance, must have inspired his early *Diana,* which reappeared almost verbatim as *Joan of Arc* (figs. 87–88). Olympus became medieval France through a costume change, the whole mood transformed from a relaxed pastorale to a tension-charged alert, as Joan strains to hear the voices summoning her to war—all this without altering the composition!

Ryder cared little for antiquity or medieval France for its own sake. He did not use period styles or subjects to invoke high-toned references for his art, as did Puvis with his Italian primitive manner or Albert Moore with his Greek girls or

Saint-Gaudens with his Renaissance grandeur. These artists, and sometimes whole schools, defined artistic values through historical analogy. When Saint-Gaudens claimed that the 1893 World's Columbian Exposition represented "the greatest gathering of artists since the fifteenth century," he meant to imply that Renaissance virtue lived again in modern America, which was prepared to play a role in human affairs comparable to that of quattrocento Italy.

Ryder's art speaks to us more clearly across the generations because he took his personal concerns and made them universal, without setting out to represent his age. Often using illustrations or other paintings as a starting point, he worked an image until it became his alone—his most intimate dreams and thoughts given form. The small size of his canvases and panels, which rarely reached a yard in either dimension, declares immediately that this work is private. But within this compass, Ryder was an unerring judge of scale, enticing us close to the tiny panels so we see deeply into the glazes and accentuating pictorial structure in larger works to sustain the image from a greater distance. In this way he adjusted all aspects of his palette, composition, and brushwork.

In *The Poet on Pegasus Entering the Realm of the Muses* (fig. 89) Ryder transformed a conception that originated in literature. The muses are secure in their sanctuary, shielded from the world by a rocky enclosure, greeting the arrival of the poet on a gentle-eyed, vast-winged Pegasus. The central composition, valley formation, gravity of pose and gesture, and brilliant sky all make this an oasis of calm where inspiration dwells, evoking the lines of Drayton: "The Poets Paradise this is, / To which but few can come; / The Muses onely bower of blisse / Their Deare Elizium."[4]

Ryder completed *The Poet on Pegasus* during his deepening isolation from society. As he shifted attention from the outer world to an inner one his cluttered apartment served increasingly as his "Deare Elizium," in which art reigned supreme. Several of Ryder's paintings and poems allude to the power of inspiration and the search for an expression appealing to the mind through the eye. In one of his most beautiful poems Ryder compares thoughts to the morning mist, which alters form as it rises, following the shape of each object in its path:

> The mist soft molded to the cape
> Rises lightly on the morning air
> And shifts with every breeze its varying shape
> But ever graceful and ever fair
>
> The thought fits to the parent mind
> And lightly floats away
> But varies to each 'centric kind
> That grasp it on its way

These lines suggest, as well as words are able, the way Ryder's thoughts took form—"soft molded" by his "parent mind" but assuming a personal meaning, never concrete or finite. *The*

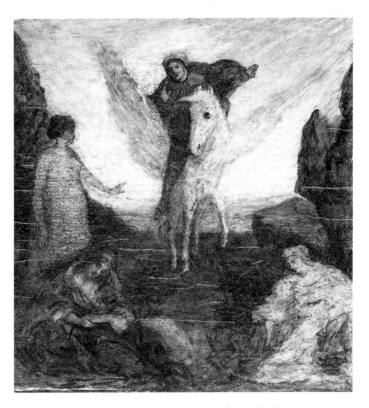

Fig. 89. *The Poet on Pegasus Entering the Realm of the Muses.* Worcester Art Museum, Massachusetts (photograph from the 1918 memorial exhibition, the Metropolitan Museum of Art, New York; cat. 48).

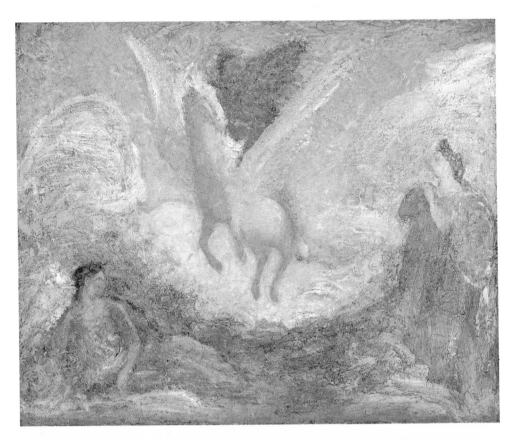

Fig. 90. *Pegasus Departing.*
National Museum of
American Art, Smithsonian
Institution, Washington,
D.C., gift of John Gellatly
(cat. 49).

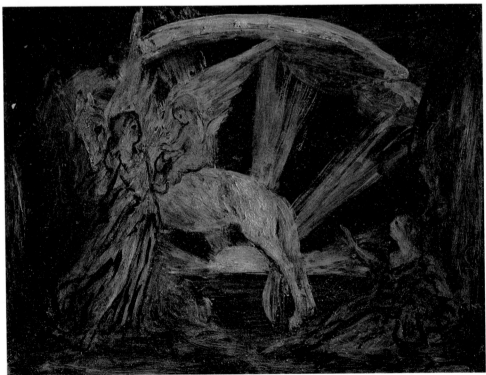

Fig. 91. *Pegasus.* Hirshhorn
Museum and Sculpture
Garden, Smithsonian
Institution, Washington,
D.C., gift of Joseph H.
Hirshhorn (cat. 47).

Lorelei and *Passing Song* (see figs. 77–78); *King Cophetua and the Beggar Maid* and *Roadside Meeting* (see figs. 82–83); *Diana* and *Joan of Arc* (see figs. 87–88)—each pair presents variations on an idea. In this, Ryder was closest to Whistler, whose paintings were similarly suggestive and open.

Seeing a half-nude Diana become Joan of Arc raises questions about Ryder's much-discussed religious works, especially the two paintings of Christ appearing to Mary after the Resurrection (figs. 92–93). Despite his background among New Bedford's Methodists and Quakers, Ryder was free of doctrinal or ideological views and did not attend church. Those who knew him made an important distinction, saying that he was spiritual but not religious. Spirituality animates many of his works, including landscapes, marines, and literary subjects.[5] What, then, should we make of those with a specific scriptural theme or text?[6]

Ryder's first religious images were painted when his ambitions were rapidly expanding. He had worked at decorative projects, landscapes, and Near Eastern subjects in the late 1870s and then added pastorals, moonlights, and marines to his repertory in the early 1880s. Open to new prospects, he also tried his hand at religious subjects, which had brought La Farge much recognition through his commissions for Trinity Church in Boston and the chancel of Saint Thomas Church in New York. La Farge's New York project included a mural, now destroyed, depicting the Noli me tangere scripture in which the resurrected Christ reveals his divinity to Mary Magdalen by saying, "Touch me not" (John 20:17).[7]

In choosing this subject Ryder paid homage to La Farge while piggybacking on his success. Since he twice painted the Noli me tangere theme while ignoring La Farge's companion subject in Saint Thomas Church, Three Marys at the Tomb, it may be that the unbridgeable distance between a spiritual male and a sensual female interested him personally.

Painted in the gemlike colors for which he was known, Ryder's two pictures were bought

for the important collections of Mary Jane Morgan and Thomas B. Clarke by 1885. By that year he also had begun *Jonah* (see fig. 105), hoping to sell it to Clarke as well. Apparently, Ryder's explicitly biblical subjects were painted not only to express his spirituality but to please a clientele.

Other artists were also discovering the vogue for religion. Tiffany worked busily to supply stained-glass windows for churches across America; Robert Loftin Newman, Horatio Walker, and Elliott Daingerfield (all acquaintances of Ryder) made the transition from Millet's pious peasantry to biblical subjects; Eakins strapped a student to a cross to paint a *Crucifixion,* and works by his pupil Henry O. Tanner also turned frankly religious. Thayer, George Hitchcock, de Forest Brush, and Cassatt all depended on the new climate to give their pictures of mothers, maidens, and children an air of sanctity. "Secular madonnas" were an immediate success, combining saintliness and contemporary life in a way that seemed both timeless and modern.

Curious paradoxes developed in the late nineteenth century: historicism was judged by the standard of originality and devotional images were made to look contemporary. These paradoxes demonstrate that an urge toward modernity was building, mostly underground and invisible, but enough to cause an occasional tremor or shift in surface formations. Many artists made some accommodation to ease the tension, confident that they stood on tradition's terra firma but keeping an ear tuned to the low rumble of change. Ryder's response was, as always, highly personal. He went against the grain by ignoring the urge toward a more contemporary look and instead pared his images to their most eternal elements. When the modernist cataclysm occurred, Ryder was one of the few to have something substantial to cling to through the upheaval.

Many Ryder paintings, especially those of boats and water, are distilled essences of a few simple forms. However poignant the early work, the paintings of the mid-1880s and after (when he ceased submitting to public exhibitions) resonate with a deepened concentration and gravity.

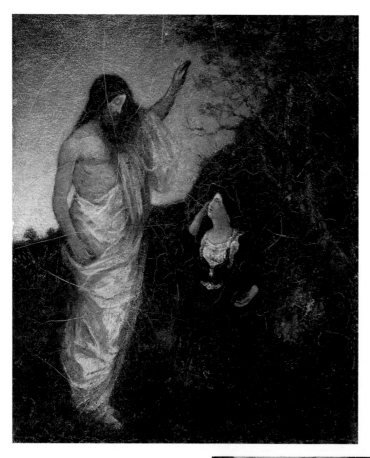

Fig. 92. *The Resurrection*. The Phillips Collection, Washington, D.C. (cat. 52).

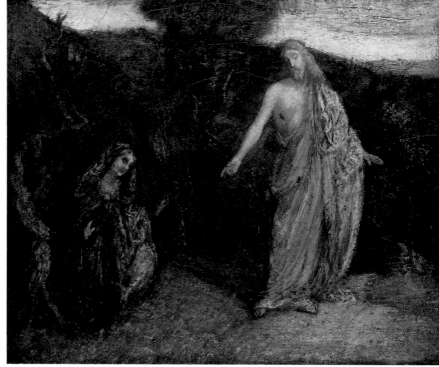

Fig. 93. *Christ Appearing to Mary*. National Museum of American Art, Smithsonian Institution, Washington, D.C., gift of John Gellatly (cat. 6).

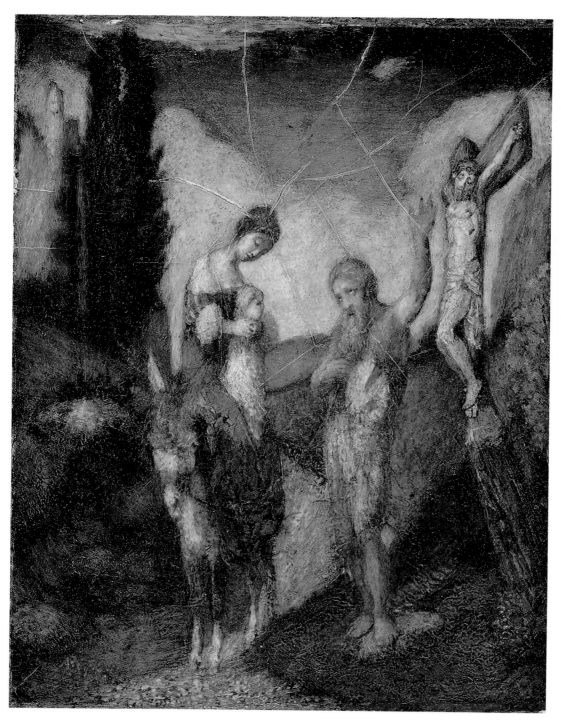

Fig. 94. *The Story of the Cross.* Guennol Collection (cat. 64).

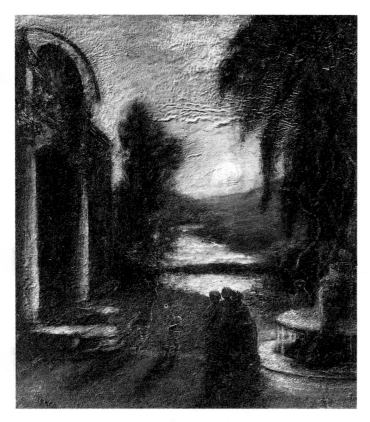

Fig. 95. *The Temple of the Mind.* Albright-Knox Gallery of Art, Buffalo, gift of R. B. Angus (photograph from the 1918 memorial exhibition, the Metropolitan Museum of Art, New York; cat. 67).

By the end of the decade Ryder's "glowing colour time" was waning and his paintings depended more on powerful light-and-dark contrasts that made compositions commanding and dramatic.[8] Everything temporal evaporated as Ryder worked over the image, sometimes for months or years. Layers of glaze accumulated as before, but now a dense, creamy white pigment full of coarse-ground crystals and lumpy impurities was liberally used as well. Forms took on palpable substance over a long period of work, so that even water and clouds present a sculptural aspect. Wherever a moon appears, it is a full moon and the thickest part of the paint film, projecting in relief as if modeled. Positive and negative shapes,

light and dark, balance each composition, like contending forces of good and evil. Ryder subverted traditional figure-ground relationships by eliminating linear contours; instead of the usual way of placing an object before a background, he negotiated boundaries as if trees and boats occupy their places by treaty with the surrounding space. He accentuated compositional rhythms—agitated zigzags rupturing *Lord Ullin's Daughter,* stately verticals and flattened curves in *The Temple of the Mind,* blissful rocking in *With Sloping Mast and Dipping Prow,* huge rolls and swells in *Jonah* (see figs. 64, 95, 101, 105). It was such devices that Caffin referred to when he said in 1913 that Ryder "anticipated that abstract expression toward which painting is returning."[9]

Ryder's ability to concentrate an image was not the result of naïveté, as critics have suggested ever since the discovery of folk art. Although he worked by instinct rather than theory, that instinct led to a sophisticated alliance of form, idea, and technique, untutored but scarcely naive in the sense of being unwilled. He was not without ambition or a sense of history, but these did not dominate his art. He began with an idea, a personal thought, that worked its way through to expression as a spring finally breaks through a rock. Well versed in literature and knowledgeable about foreign and domestic art, he was a genuine intellectual, but not a scholar. We cannot doubt that he consciously intended a new expression of abstract ideas; his poetry makes clear his belief in the power of an idea, as in the closing lines of "Joan of Arc": "Who knows what God knows / His hand he never shows / Yet miracles with less are wrought / Even with a thought."

One of Ryder's abstract thoughts is easily recaptured because the text on which it is based provides a clue. *The Temple of the Mind* (fig. 95) is related to Poe's "Fall of the House of Usher," which presents Usher's mind as a beautiful temple from which reason has been banished by evil spirits—an eloquent metaphor of depression and insanity. In his distracted state Usher improvised dirges and wild waltzes, but he sometimes also assuaged his gloom by painting:

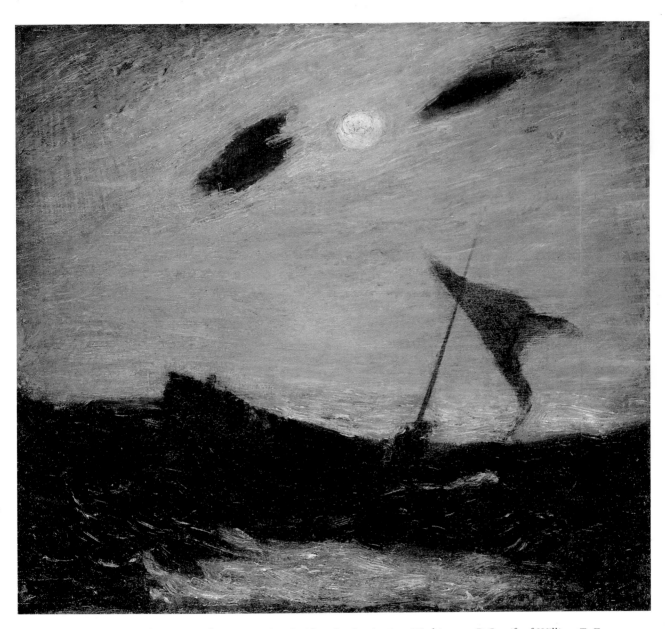

Fig. 96. *Moonlight*. National Museum of American Art, Smithsonian Institution, Washington, D.C., gift of William T. Evans (cat. 38).

From the paintings over which his elaborate fancy brooded, and which grew, touch by touch, into vaguenesses at which I shuddered the more thrillingly, because I shuddered knowing not why;—from these paintings (vivid as their images now are before me) I would in vain endeavour to educe more than a small portion which should lie within the compass of merely written words. By the utter simplicity, by the nakedness of his designs, he arrested and overawed attention. If ever mortal painted an idea, that mortal was Roderick Usher. For me at least—in the circumstances then surrounding me—there arose out of the pure abstractions which the hypochondriac contrived to throw upon his canvas, an intensity of intolerable awe, no shadow of which felt I ever yet in the contemplation of the certainly glowing yet too concrete reveries of Fuseli.[10]

This passage foretold Ryder's own move beyond "concrete" symbolism into "pure abstraction" as it was then conceived—abstraction of the idea through an utterly simple, naked composition beyond the compass of merely written words. The challenge was clear: how to "paint an idea," avoiding illustration, delving below narrative and even below consciousness. Yet *The Temple of the Mind* still clings to symbolism such as Fuseli used—in fact, Ryder's faun seems descended from the pointed-eared incubus that presides over Fuseli's great portrayal of intellec-

tual derangement, *The Nightmare*.[11] The fountain, graces, and temple all evoke a literary symbolism and an "obsession with mind" or "cult of intellect" like that in Vedder, Moreau, Redon, or other symbolists.[12] While Ryder's painting still orchestrates symbols in the familiar intellectual way, he, like Usher, was searching for a more direct visual expression.

Ryder worked on *The Temple of the Mind* in his cabin while sailing to Europe in 1887.[13] On the return voyage he began a marine on the back of the panel—a boat with single sail lashed by wind, floating on waters made iridescent by the light of a full moon (fig. 96). In this painting Ryder achieved the suggestive expression he was seeking. He was proud of this painting, writing that "a remarkable light shone out of it. . . . A light seemed to come through the sky from way back."[14]

The powerful effect of *Moonlight* depends on certain compositional elements, especially two dark clouds shaped by wind into eerie sentinels attending the moon, holding it prisoner like some captured majesty. Moon and clouds are swept into a long flattened arc that is echoed and inverted in the silhouette of the hull; between these precariously balanced forces of heaven and

Fig. 97. *Moonlight on the Sea*. Wichita Art Museum, Kansas, Roland P. Murdoch Collection (cat. 40).

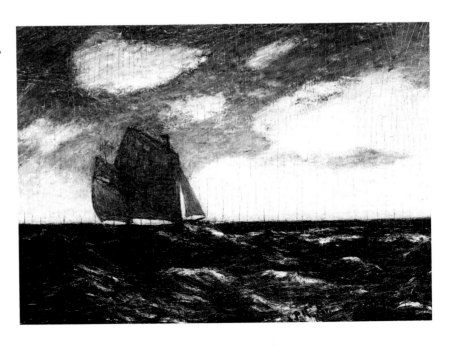

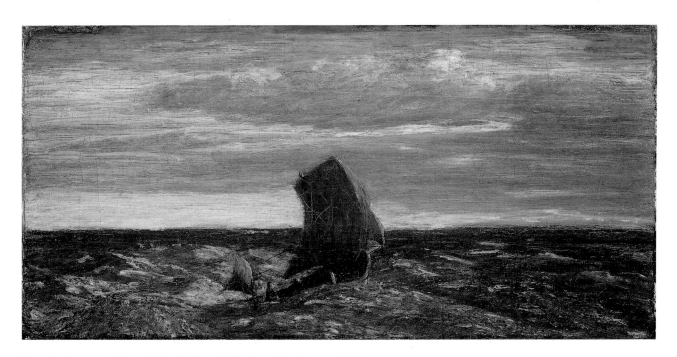

Fig. 98. *Homeward Bound*. The Phillips Collection, Washington, D.C.

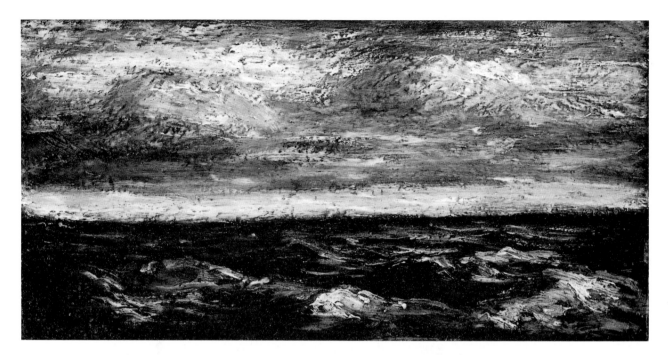

Fig. 99. *Marine*. National Academy of Design, New York.

earth the tilted mast with a shred of sail strikes a note of wild abandon. Phrases from Ryder's poems come to mind: "music weird and strange," "a wild note of longing." But even Ryder's own words do not fully seize the mood of this painted idea, full of the beauty and terror of life.

Collectors and critics have come to consider the moonlight marine as Ryder's personal emblem, although such paintings constitute only a small part of his oeuvre. They seem to predominate partly because of the dubious tribute of countless forgeries. But if they are few in number, they still hold a special place, for they are like conversations with the soul. The longing that permeates Ryder's paintings of women and his urge toward the unattainable become the yearning of the boat for the moon in *Toilers of the Sea* (fig. 100). *With Sloping Mast and Dipping Prow* (fig. 101) nestles the moon in the embrace of sails and hull as waves orbit gracefully around this center of gravity. Clouds swirl close around a deserted shore as if concealing a precious mys-

tery in *Moonlit Cove* (fig. 103). Most of these compositions place the boat almost at the center of a near-square, tugged or pressed by encircling forces, submitting or straining against them. The relationships within such compositions are intrinsic to our understanding. Mondrian, for instance, said that intersecting vertical and horizontal lines are like the moon's rays striking the earth's surface.

In Ryder's greatest paintings, themes interweave so that yearning and religion, destiny and salvation, symbol and idea, all become one. *The Flying Dutchman* (fig. 104), often said to derive from Wagner's opera of the same title, is probably based instead on an earlier version of the legend by Captain Frederick Marryat, called *The Phantom Ship*, which tells of the Dutch captain Vanderdecken, who tried in vain to round the Cape of Good Hope against adverse winds. Marryat tells how the angry captain swore upon the true cross that he would gain his point and was cursed for his blasphemy by the halt of time; he

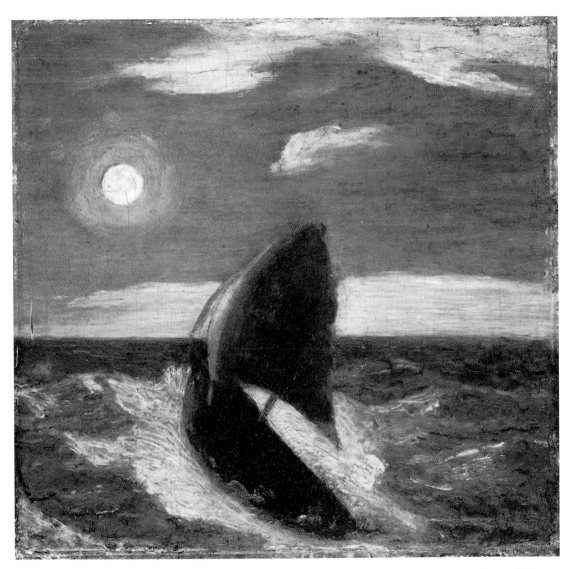

Fig. 100. *Toilers of the Sea*. The Metropolitan Museum of Art, New York, George A. Hearn Fund (cat. 69).

Fig. 101. *With Sloping Mast and Dipping Prow*. National Museum of American Art, Smithsonian Institution, Washington, D.C.; gift of John Gellatly (cat. 76).

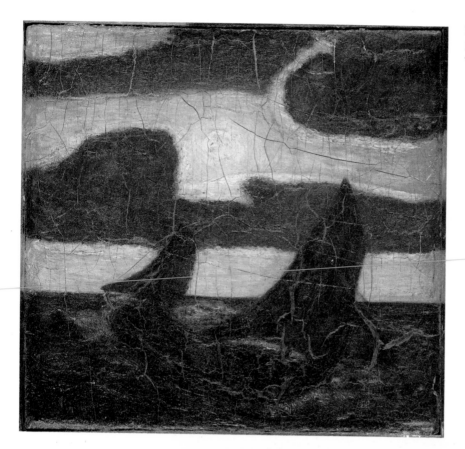

Fig. 102. *Moonlight Marine*. The
Metropolitan Museum of Art, New
York, Samuel D. Lee Fund (cat. 39).

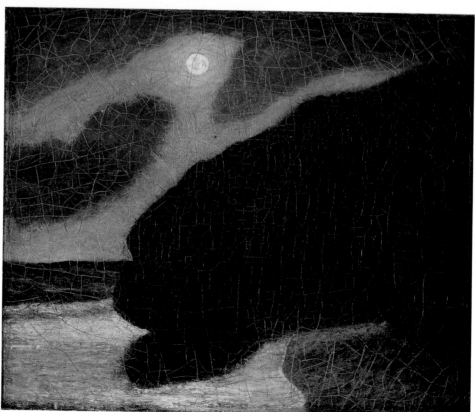

Fig. 103. *Moonlit Cove*. The
Phillips Collection,
Washington, D.C. (cat. 41).

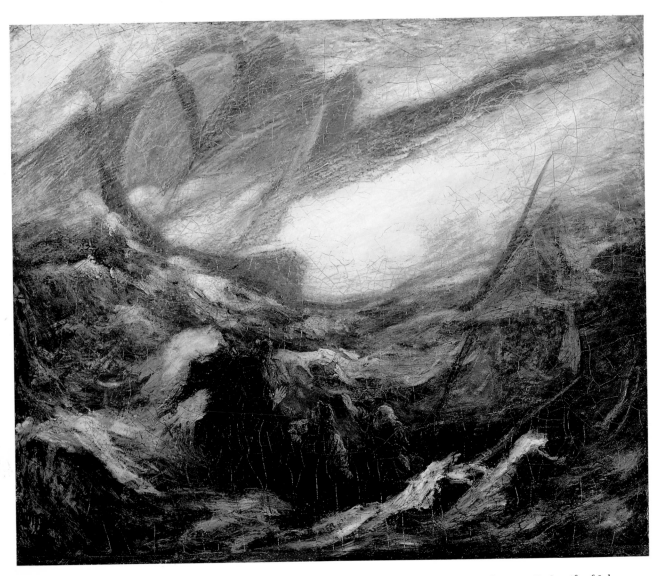

Fig. 104. *The Flying Dutchman*. National Museum of American Art, Smithsonian Institution, Washington, D.C., gift of John Gellatly (cat. 14).

could never reach port until his son should bring a fragment of the true cross for him to kiss.

Marryat combined adventure, love, philosophy, and religion in a rapidly moving story that was still popular decades after its first publication in 1839. (In 1887, the year that we first hear of Ryder's painting on this subject, Robert Louis Stevenson read the Marryat book for a third or fourth time, hoping to emulate it in *The Master of Ballantrae*.)[15] The phantom ship was an omen of disaster; whoever spied it was doomed to destruction. Vanderdecken's son Philip tried three times over many years to rescue his father, but each time his own ship foundered as he glimpsed the phantom ship, "in which his father's doom was being fulfilled."

Doom and destiny dominate the story as Philip tries to reach his father, only to be cast back by storms in which all his mates die—all save the fiendish Pilot Schriften, who escapes death to thwart each of Philip's attempts at saving his father. After many years an aged Philip forgives Schriften his vengeful course, saying, "I am now convinced, that you are as unhappy as myself, and that in what you are doing, you are only following your destiny, as I am mine. Why, and wherefore I cannot tell, but we are both engaged in the same mystery." With this forgiveness, the spell is broken, and Philip steers to the phantom ship and boards her, whereupon he gives his father the sacred relic to kiss, redeeming him. Defiance and repentance lie at the heart of the story, as Venderdecken defies his heavenly father and is in turn saved by his own son through the lesson of forgiveness.

Ryder's painting shows the son Philip as an old man, his ship's only sail in tatters and a stay torn loose as waves and wind threaten disaster; the fully rigged phantom ship appears on the horizon, its sails catching the colors of the setting sun. Ryder wrote a poem to accompany the painting, pitying the "hapless soul" consigned to roam the seas endlessly but also asking, "Or in the loneliness around / Is a strange joy found? / And wild ecstasy into another flow / As onward that fateful ship doth go." The poem concludes on a despairing note of eternal night and sleep-

ing secrets but not before hinting at the strange ecstasies of a terrifying solitariness, which Ryder also must have known. Like Emily Dickinson, Ryder watched himself becoming a recluse with full awareness of the costs and returns, and in this lies the origin of the artist's tragic vision. However different their temperaments, each was a "soul admitted to itself."[16]

When Ryder began his great *Jonah* in the mid-1880s (figs. 105–6), it was the largest painting he had attempted, the first to approximate the twenty-eight-by-thirty-six-inch dimensions that he chose when he was of a mind to paint a masterwork. (*Constance, Macbeth and the Witches, The Race Track,* and *The Tempest* are all approximately the same dimensions.) For the subject he turned to the most primal of all legends, the Old Testament, and selected the story that evoked defiance, damnation, salvation, and resurrection. La Farge had included a resurrected Jonah in a lunette of Trinity Church, and, of course, Melville had retold the Jonah story from several angles in *Moby-Dick*.

In every way *Jonah* extends Ryder's ambitions and symbols. The moon no longer presides over the scene; it is replaced by a celestial orb held by a blessing God made visible in a burst of light, his vast cloud-wings spread over the horizon, reminiscent of Blake's drawings. The endangered boat filled with terrified people—the largest crowd in any Ryder painting—descends from Rembrandt through Delacroix, whose *Christ on Lake Gennesaret* was the jewel of the Van Horne collection (fig. 107). A great fish equal in size to the boat approaches Jonah, who was cast overboard by the mariners for defying God and bringing on the tempest that threatens to destroy them all. The fish, the terror and ecstasy of the waves, and the exquisite blending of glazes are richly orchestrated, rather like Turner's *Slave Ship*, which was exhibited repeatedly in New York in the 1870s and much discussed by artists (fig. 108).[17]

But ultimately it is Ryder's imaginative portrayal that fascinates, apart from its sources in art and scripture. *The Flying Dutchman* and *Jonah* announced Ryder as a master mythmaker, with

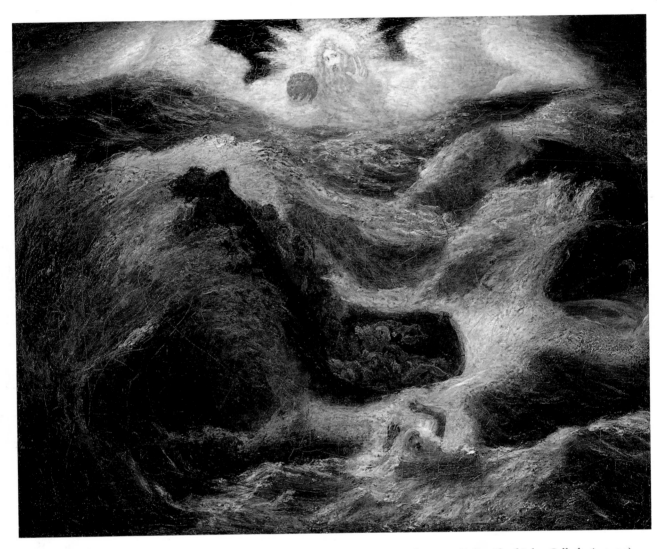

Fig. 105. *Jonah*. National Museum of American Art, Smithsonian Institution, Washington, D.C., gift of John Gellatly (cat. 24).

Fig. 106. Detail of *Jonah* (cat. 24).

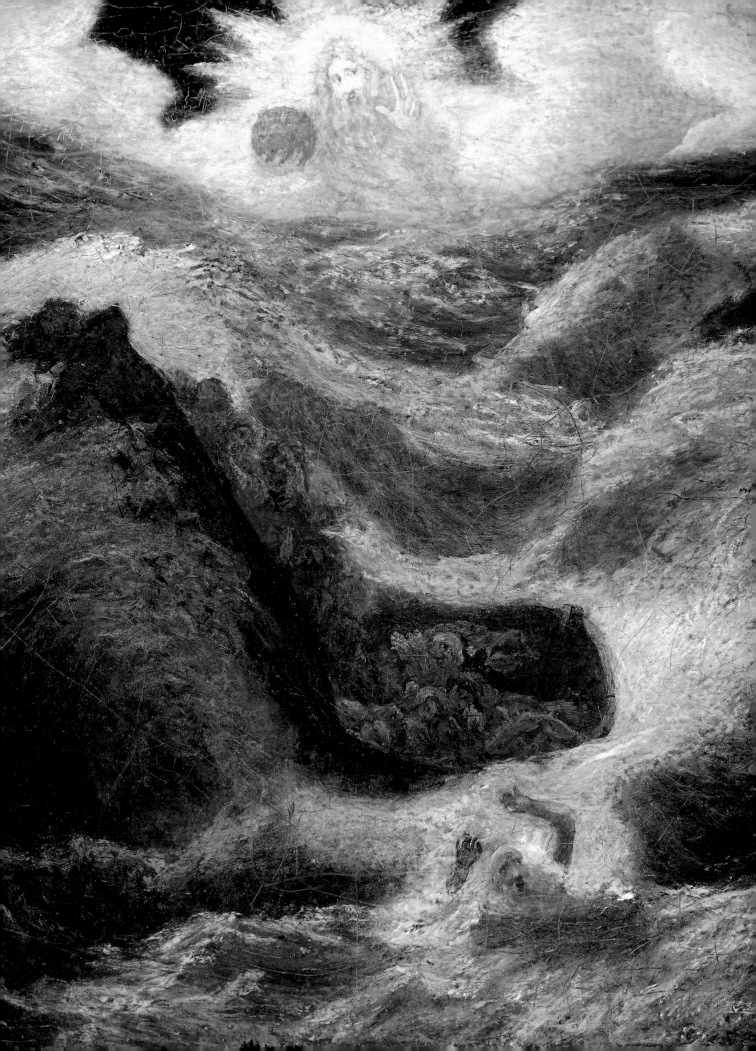

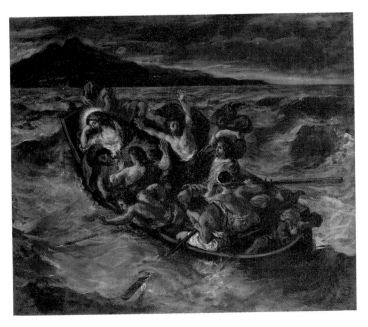

Fig. 107. Eugène Delacroix, *Christ on Lake Gennesaret*, oil on canvas. The Metropolitan Museum of Art, New York, the H. O. Havemeyer Collection, 29.100.131.

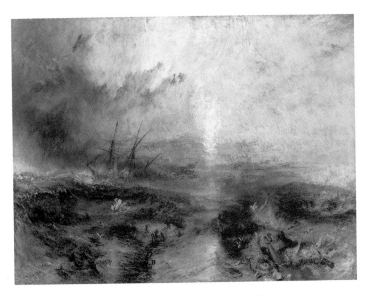

Fig. 108. J. M. W. Turner, *Slave Ship*, ca. 1840, oil on canvas. Museum of Fine Arts, Boston, Henry Lillie Pierce Fund, 99.22.

an approach to subject that was both theatrical and profound. At the beginning of his career he had depended heavily on other artists for his vision—Inness, La Farge, Tiffany, Corot, Monticelli, Dupré, and others of the Barbizon and Hague schools. From the mid-1880s through the end of the century Ryder left these influences behind and developed an art of archetypes, each painting passing through an evolutionary process that seemed almost aimless to those around him. Unable to "go at a picture cold," he retreated more and more into the muses' Elizium, preparing for inspiration to arrive on a white horse. When it did, the wait was rewarded.

Again one who paints not by rule but by inner promptings is thereby more or less a stranger to his talent whatever it may be; but there is a compensation in sometimes going "a mountain in a night." So we will hope for the night, and a day added may make a picture that is a song in paint.[18]

By seeking a timeless art Ryder moved against the impulse of his own century, which was dedicated to speeding time and dividing it into ever smaller, discrete units. The invention of photography froze a single moment, even though it might be a meaningless frame randomly fixed. Eadweard Muybridge extended the idea between the 1870s and 1900—exactly overlapping with Ryder's most fruitful years—by presenting motion as a sequence of frozen time slices. Trains and machine-made watches appeared at midcentury to speed up the pace of life; by the 1880s steamers could cross the Atlantic in just seven days. Illustrated daily papers appeared, putting snaillike wood engravers on the defensive; in the 1880s and 1890s penny-press artists invented a rapid-fire draftsmanship that could capture street life on the spot; new zinc-engraving techniques reproduced drawings in hours. Among fine artists, the impressionists transcribed each fleeting moment, changing canvases whenever a haystack darkened or lightened. The cubists presented several simultaneous views of an object; the futurists used stop-action images. Soon after the turn of the century Einstein announced that light did not arrive as a steady wave but as photons—

tiny, discrete energy particles moving at incredible velocity.

Yet against this tide other currents were felt. An openness to experience countered the ideas of progress and ambition in the Gilded Age, manifested in William James's philosophy, with its emphasis on personal, subjective views. Memory emerged as a force in art, as in the work of Homer Dodge Martin, who claimed as his eyesight failed that he could paint his inner vision from memory even if he were completely blind.[19] The most remarkable tribute to the power of memory is Proust's *Remembrance of Things Past,* written while he was an invalid and recluse. In the final volume Proust wrote movingly of how Time's "different planes" were required for the "resurrection of the past which my memory had evoked." His protagonist wanted to "extract the real essence of life in a book, . . . to give his volume the effect of a solid," which required a new approach, a new dedication akin to reverence that resembles Ryder's method.

[He] would need to prepare it with minute care, constantly regrouping his forces as if for an attack, endure it like an exhausting task, accept it like a rule of conduct, build it like a church, follow it like a regimen, overcome it like an obstacle, win it like a friendship, feed it intensively like a child, create it like a world, without overlooking those mysteries whose explanation is probably to be found only in other worlds and the presentiment of which is the quality in life and art which moves us most deeply.[20]

Ryder's deep affection for dreaming, shared by European symbolists, is an aspect of his art that moves against the idea of progress then dominating the nineteenth century. Dreams were not only pleasant but truer than other aspects of life. Freud's *Interpretation of Dreams* and *On Dreams* presented a model for the way dreams work that parallels the way Ryder's paintings function. Freud explained that dreams operate through compression or condensation and that every element in a dream opens out in several directions, leading to a highly suggestive vagueness. Different components of a dream overlap one another, so common elements stand out clearly, while contradictory details fade into insignificance. In this way each element is "overdetermined," building up a powerful intensity. He spoke of a dream's manifest content—its surface logic or image—as a "pictorial arrangement of the psychical material," under which lies a profound, concealed truth. He explained that adults, like children, project in dreams the fulfillment of wishes thwarted by the "long and roundabout path of altering the external world."[21] Above all, Freud made the point that all dreaming is purposeful and significant.

Just as the hallucinatory imagery of European symbolism anticipated Freud's discoveries, Ryder's art too suggests mental processes for which there were then no theories or words. For artists, eating from Freud's tree of knowledge could mean expulsion from paradise, for when psychiatrists explored the symbols of the subconscious, artists lost the freedom to use them unselfconsciously for private reverie. The surrealists in the 1920s and 1930s found that their awareness of psychological theory stimulated but also impeded their art; they developed techniques of automatism to recapture unpremeditated access to psychic undercurrents that had been lost. Ryder, standing on the dark side of Freud's enlightenment, painted the most urgent promptings of his psyche without losing his Edenic innocence. ❧

Chaos Bewitched

If Poe prefigured Ryder's essential form, Melville forecast his unusual and fascinating technique in *Moby-Dick*. Ishmael stays the night in the Spouter Inn in New Bedford, where the first thing that catches his eye is a painting,

so thoroughly besmoked, and every way defaced, that in the unequal cross-lights by which you viewed it, it was only by diligent study and a series of systematic visits to it, and careful inquiry of the neighbors, that you could any way arrive at an understanding of its purpose. Such unaccountable masses of shades and shadows, that at first you almost thought some ambitious young artist, in the time of the England hags, had endeavored to delineate chaos bewitched. . . .

But what most puzzled and confounded you was a long, limber, portentous, black mass of something hovering in the centre of the picture over three blue, dim, perpendicular lines floating in a nameless yeast. A boggy, soggy, squitchy picture truly, enough to drive a nervous man distracted. Yet was there a sort of indefinite, half-attained, unimaginable sublimity about it that fairly froze you to it, till you involuntarily took an oath with yourself to find out what that marvellous painting meant. Ever and anon a bright but, alas, deceptive idea would dart you through.—It's the Black Sea in a midnight gale.—It's the unnatural combat of the four primal elements.—It's a blasted heath.—It's a Hyperborean winter scene.—It's the breaking-up of

the ice-bound stream of Time. But at last all these fancies yielded to that one portentous something in the picture's midst. *That* once found out, and all the rest were plain. But stop; does it not bear a faint resemblance to a gigantic fish? even the great leviathan himself?[1]

Ryder's generation loved his glowing color and early modernists prized his compositional rhythms, but it is the "nameless yeast" of Ryder's painting that most intrigues us today. His colleagues and friends were inclined to see his strange technical methods as one more manifestation of his charming innocence and naïveté. Frustrated patrons who watched as their paintings began to crack and ooze shortly after purchase considered it a lamentable lapse of craftsmanship. Often critics opined that Ryder knew nothing of correct painting formulas, but today we recognize a fresh, intuitive intelligence in his approach and a whole new aesthetic that considered a painting to be a physical object with a life of its own, organic rather than fixed. Ryder's deep investment in the process of painting is one of the most forward-looking aspects of his art.

Since he left no treatise and apparently fol-

lowed no systematic plan, it has been easy to believe that Ryder was bewildered by technical processes. Stories abound telling how his more sophisticated colleagues tried to help. Groll claimed to have passed along the Munich Academy's formula for paint medium. Miller chided Ryder for melting wax into his paints, to which Ryder is supposed to have answered, abashed, "I only used one candle." Others simply reported with horrified amazement how Ryder used dirt from his boot to tone down an area or tobacco juice from a spittoon next to his easel or a hot poker from the fire to "draw" the lightning into one of his paintings, simulating nature's searing effect right on the canvas.[2]

Recent examination of a few of Ryder's paintings suggests that the techniques he used were experimental but not without intention. He consciously sought a new effect of color and surface, trying to "improve the medium" and get his paint "less painty looking," working like the inchworm groping into the place beyond where he has a footing. He wrote to an employee in Cottier's London gallery this enigmatic note: "I am treating the Lorelei in a way that I think will give you pleasure; . . . it may be interesting to you to know that the treatment I am adopting for the pictures is in a measure a kind of revelation for method to introduce in some stage of my future work."[3] The "revelation for method" remains a mystery and must be deduced from the physical evidence of the paintings themselves, which is often confused by the many restoration campaigns carried out on them over the decades.

In considering the paintings as physical objects it is useful to start from the back, with the support. About one third of Ryder's works are painted on wood panels; the rest are on canvas, except for the decorative paintings on leather, which constitute a distinct group. Some smaller panels are cigar-box lids, probably cedar, which has a warm tone.[4] Others are on boards half an inch thick or more. *Moonlight* was tested and found to be on mahogany, a wood frequently used for furniture, which lends some plausibility to the legend that Ryder sawed up the headboard

Fig. 109. Autoradiograph of *Jonah* (oriented vertically). Conservation Analytical Lab, Smithsonian Institution, Washington, D.C. (cat. 24).

of his bed to paint on; but it was also a commonly used painting support during the period.[5]

Ryder used a variety of canvases, including both coarse- and fine-weave fabrics. A few paintings have been identified as having preprimed commercial canvas supports. In at least one important instance, for *Jonah,* Ryder reused a canvas and painted over the earlier image—a seated, half-length portrait visible in autoradiographs (fig. 109).

Ryder's grounds were usually white, but cross-sections from some paintings show the presence also of a thick, gray, semitranslucent layer under

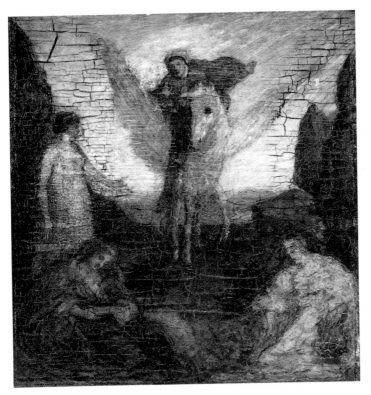

Fig. 110. *The Poet on Pegasus Entering the Realm of the Muses.* Worcester Art Museum, Massachusetts (1987 photograph; cat. 48).

often applied "wet-on-wet"—one laid directly over another and slightly mixed by the brush in the act of painting. Ryder's seas and skies are marvels of the wet-on-wet process—blues, dense whites, and yellows mingled in the most intricate ways, giving an effect of depth and richness. A much flatter quality results when colors are mixed on the palette and applied as a solid area, as in the foreground of *Pastoral Study* (see fig. 71). Cross-sections of paint samples taken from the wet-on-wet areas show how one color invades or overlays another in a marbleized swirl, giving each color a flickering shimmer, while large chunks of dry paint or foreign matter add bulk (fig. 112).

In addition to these paints Ryder applied glazes in sharper, brighter colors as accents—glowing crimson or bright green. All too often these glazes appear to have faded; *Dancing Dryads* (see fig. 53) was once described as a glowing bit of color, but it mellowed quickly to the point that some early restorer incised outlines around the figures so they could be distinguished from the ground. Many glazes, forming an opalescent rainbow of accents playing over the waters, remain on *The Flying Dutchman* and *Jonah* (see figs. 104–5).

To begin a painting Ryder attacked the canvas with an energy and freedom that can scarcely be imagined from the refined, "enameled" surface of the completed works. One unfinished canvas, *Harvest* (fig. 113), shows broad slabs of color swiftly laid down with the palette knife, very similar to Ryder's description of his early experience painting in nature: "Taking my palette knife, I laid on blue, green, white and brown in great sweeping strokes." Impulsive scribbling with the brush fills the sky; unresolved forms (proto-trees?) shoot upward in a dramatic gestural rush. Thick blobs of crusted paint, possibly intermixed with foreign matter for texture, are deposited irregularly over the surface. A stream is brushed in with a creamy white pigment so thick that the stiff bristles of the brush have left deep depressions in the paint. Overlaying this a thin gloss of blue (apparently in a medium different from that below) puddles and separates

the paint film. *In the Stable* was begun with a rich red-earth underpainting in the manner of the old masters. In *The Poet on Pegasus* deep cracks have filled with brilliant yellow and red pigments, leached from some underlayer and flowing in oil like silt in a river (figs. 110–11). *The Shepherdess* and *Woman and Staghound* (see figs. 47, 70) appear to have gold leaf under the paint film as do the paintings on leather.[6] These examples suggest that Ryder experimented with translucent or brilliantly colored preparations, perhaps in an attempt to increase the vibrancy of the upper pigment layers.

Given his reputation as a colorist, it is surprising to discover how frugal a palette Ryder used. A dense lead white, Prussian blue, Naples or lead chromate yellow, a red earth—the "colorist" mainly worked with primary hues.[7] Colors were

Fig. 112. Cross-section of paint from *The Story of the Cross*, showing multiple paint layers and the presence of large, irregular globs of pigment; magnified seventy times. Conservation Analytical Lab, Smithsonian Institution, Washington, D.C. (cat. 64).

Fig. 111. Photomicrograph of *The Poet on Pegasus* (cat. 48).

where it lies on the white, exposing the lower color and giving this passage a textured shimmer through the simplest of means.

Working out his composition directly on the canvas without benefit of studies, Ryder decided to reverse the direction of his haycart and switch from dray horses to oxen. Without scraping or sanding the surface, he brushed rough cart-wheels over the earlier design and reddish brown transparent glazes where the oxen were to be, heading left in the opposite direction from the horse, whose blocked-in form appears behind the wheels.

Harvest gives the impression of having been painted at a single go, seized in a moment of inspiration, then altered as the conception changed. This is a painter's way of working, far from the academic method that relied on draw-ing and preparatory studies. When Ryder needed to define a form with line, as for instance in the oxen, he used the butt of the brush to draw through the pigment, a sgraffito technique used

also by Blakelock and Inness. Only when posi-tioning the figure of a boy leading the oxen did Ryder draw contours with the brush, establishing proportions and gesture with a few lines placed directly over the landscape (fig. 114).

At this early stage of his work Ryder con-cerned himself with positioning broad masses and with essential color relationships, placing areas of blue, red, brown, and creamy white within the composition but not stopping to re-fine any passage. Ryder told critic Walter Pach that he first seized the design and only then began the endless, exacting work of building up the glowing color glazes.[8]

X-rays and autoradiography reveal that the ap-proach used in the unfinished *Harvest* is charac-teristic of much of Ryder's work. These two analytical techniques allow us to look below the surface by recording the presence of various in-organic elements such as lead (the primary ele-ment shown on an X-ray), antimony, barium, chrome, manganese, potassium, sodium, and

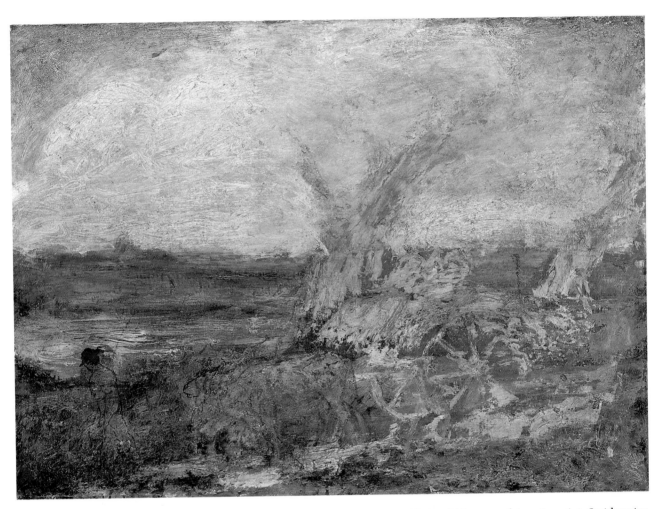

Fig. 113. *Harvest*. National Museum of American Art, Smithsonian Institution, Washington, D.C., gift of John Gellatly, 1929.6.96.

Fig. 114. Detail of *Harvest* (photographed under ultraviolet light).

many others (recorded on successive autoradiographs). These elements can be found in pigments, media, or grounds, so careful analysis is required to determine the methods and materials of the artist. Both techniques produce an image on film: X-rays give a negative image (lead and other heavy elements show as light areas on a dark ground), while autoradiography produces a positive image (elements show as dark areas on a light ground).[9]

By examining autoradiographs for several paintings we can establish a "fingerprint" of Ryder's technique and materials—a characteristic repertory of materials and brushwork that differs strikingly from other artists' work and from known Ryder forgeries. Brushwork, for instance, takes several forms. The agitated, rapid scribbling that underlies many paintings is rarely visible on the surface but evident in autoradiographs. Then there are regular, broad horizontal strokes used for skies; nervous flicks of a fine brush for details (chickens in *In the Stable*, God's aureole in *Jonah*); and irregular, overlapping short strokes where negative and positive shapes meet. The aspects of Ryder's art that recur from painting to painting include this distinctive handwriting as well as frequent adjustment of compositional elements, vaguely defined contours, restricted palette, coarse-ground crystals or foreign matter in the paint, figures or objects positioned with painted outlines. Sometimes a surprising derivation from Ryder's normal practice emerges, as in the unusually delicate silhouette drawing of Christ's body revealed by an autoradiograph of *Christ Appearing to Mary* (fig. 115).

By working so long on each picture Ryder built up the paint film to unprecedented thicknesses. Other artists—Monticelli, for instance—achieved heavy, textured surfaces through the use of impasto; Ryder wanted his work "less painty looking," which may account for the way he used dense paint for underlayers (and wherever he needed a white or light yellow that "covered") and then endlessly applied glazes to achieve a smooth, refined surface. This surface was usually compared to enamels, for it had a

Fig. 115. Autoradiograph of *Christ Appearing to Mary*. Conservation Analytical Lab, Smithsonian Institution, Washington, D.C. (cat. 6).

hard, vitreous, baked, or molten quality very different from the irregular relief of impasto or the slick finish of academic paintings.

From time to time it was noted that Ryder's surfaces resembled glazed ceramics. During the 1880s and 1890s the aesthetics of art pottery and of painting began to converge. Connoisseurs like Clarke, Morgan, and Van Horne collected Greek and oriental ceramics, while a broader public bought Rookwood underglaze ware, which developed in a manner somewhat parallel to Ryder's painting. In 1880 an author wrote that early Rookwood pottery "presents the appearance of a painting in oil, to which a brilliant glaze has been applied."[10] A few years later Rookwood artists experimented with a thick, lavalike slip to produce a glossy, dense, irregular surface not unlike some of Ryder's bulky paint films. In 1894, by which time several other art potteries were competing for the market, Rookwood introduced Sea Green—an opalescent blue green

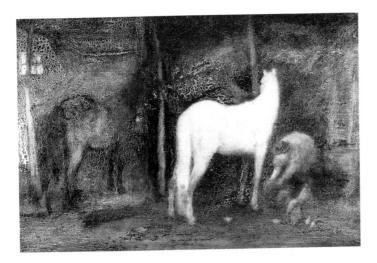

Fig. 116. *In the Stable* (pretreatment photograph; cat. 22).

Fig. 117. *Desdemona*. The Phillips Collection, Washington, D.C. (1985 photograph).

glaze often used for aquatic images, similar to Ryder's characteristic "water" color. In 1904 Rookwood introduced Vellum ware, with a soft, waxy texture that veiled the image in atmosphere, much like that created by Ryder's varnishes.

It is not necessary to suppose a direct influence between Ryder's work and that of the ceramicists to feel some common current between them. Pach was one of many who defined the distinctive quality of Ryder's paintings by invoking first the Venetian and Dutch masters, then saying: "It is intimately connected with the pigment, and the glow which he has again and again extracted from his material is such as potters and enamelers have striven for, and only attained at their best."[11]

Perhaps no aspect of Ryder's art caused more comment than his incessant reworking of his panels and canvases. In part, his slowness can be attributed to his laborious process of glazing. And, like Whistler, whose method also involved extensive reworkings and revisions, Ryder was intuitively searching for a new ideal. His constant reworking sorely tested the patience of collectors. Some thought him lazy to complete so few works; others, confused or naive. One frustrated patron claimed to have left instructions for his funeral procession to stop at Ryder's studio to obtain his painting, to which the artist supposedly replied, "I told him it couldn't go out then unless 'twas done."[12]

The critics, however, found beauty in this labored technique. Hartmann wrote,

He is really painting the same picture on the same canvas a hundred times. And the hundred pictures—many of them as beautiful as the final one—disappeared, were blotted out, as if destroyed by accident.

There is however . . . one decided advantageous merit in this nerve-racking and elusive technique. It not only heightens the capacity of expression, as one's brush is so familiar with the ground of operation, that one is justified to believe that one may get in some cases the hundredth time what one has missed ninety-nine times before, but it also improves the textural quality, the subtlety and vibrancy of the "grain" and color surface.[13]

Going over and over an image imparted a meaning beyond mere physical effects. An art of dreams and memories depends on a stretched and folded concept of time, not the straight, linear progression from which an impressionist snatches a fleeting instant. Ryder invested his innermost emotions in the work, so that each painting became the incarnation of an idea: "I like my slow dreamy way with a picture, fancying thereby they have a charm peculiar or like self creation."[14] The Russian mystic and painter John Graham had a similar habit.[15]

For Ryder, laying yet another glaze on a cloud or wave was a way of searching out the essential life concealed behind external appearance. Time, colorless and impalpable, assumed a physical presence through the accumulation of pigments and media.

In the temporal world the effect of this loading of the canvas was to create stresses within the paint film. The wet-on-wet technique meant that paint layers did not dry before being worked again. Wherever "lean" paint overlay "fat" (one richer in oily medium), the upper layer dried more quickly and cracked as it contracted, exposing the still-viscous layer below. Sometimes these traction cracks became so severe that they appear like a network of canals isolating small areas of paint—a condition known as alligatoring, which particularly affected *In the Stable* and *Desdemona* (figs. 116–17).

Problems were especially acute wherever Ryder used organic pigments to achieve a warm, rich dark tone. According to the literature, he frequently used bitumen, although it has not been found in laboratory tests so far. This unstable material, derived from coal tar, had been used by no less an authority than Sir Joshua Reynolds, but already by 1845 painting manuals warned that it was "a great resource" but one to be approached with "caution, even distrust . . . as one would a friend of doubtful faith," for it tended to darken into a glossy, black pitch.[16] It may be bitumen that has caused the deterioration of such favorites as *Toilers of the Sea* and *Moonlight Marine,* in which some areas have

gradually become tarry. The most extreme example of deterioration is *The Curfew Hour,* an ocean of glossy black on which float grizzled islands of paint (figs. 118–19).

Although Ryder restricted the number of his pigments, his affection for oils and other binding media was extravagant. He is said to have used excessive amounts of alcohol to thin his paints,

Fig. 118. *Curfew Hour.* The Metropolitan Museum of Art, New York, Rogers Fund, 09.58.1 (early photograph).

Fig. 119. *Curfew Hour* (recent photograph).

causing disruptions in the paint film. He sometimes used wax, which added bulk and sheen to his paints. Many visitors commented on his habit of pouring—not brushing—varnish over the surface of his paintings to keep them from drying at night or to give them a glow when showing them to friends.[17] After innumerable coatings the paint film became a slow-oozing goo, a conservator's nightmare, "a boggy, soggy, squitchy picture truly." The treatment report for one painting that resisted stabilization despite the most radical measures reads like a *cri de coeur*:

The structure was sadly typical; right below a blob of still soft paint would be a brittle layer of resin, full of pinholes and very fragile. There is absolutely NO way of guaranteeing the stability of this structure—it will never and can never dry out. It resembles shale interlaced with puddles of sticky oil. . . . It is bound to flow again.[18]

Such flowing often caused the paint film to sag and creep over the edge of the frame rabbet. Worse horrors were told by the collector Gellatly, who described a "varnish slide" on *The Flight into Egypt,* in which "the head of the infant suddenly began to move and wriggled downwards to abdominal regions."[19]

We know that Ryder was aware that his paint films presented special problems. Inglis explained to Wood when shipping *Jonah* to Portland that he was not sending along the glass sheet that Ryder always wanted over his works to protect their tacky surfaces from rubbing or touching.[20] That Ryder took steps to protect his paintings but did not give up his experiments for a simpler, more stable process tells us that he was not oblivious in technical matters, but daring.

Woman and Staghound (see fig. 70) has escaped cleaning and kept the full complement of varnish that so put off Wood when he first saw the painting. The varnish on this picture may be tinted with powdered yellow and red pigments, unifying the composition with a golden glow. But it also contains resins that yellowed with age, so that a veil of obscurity soon dropped over the image, giving it a yellow green cast and darkening the jewellike colors.

No doubt tinted varnishes were first devised to give newly executed works an old master mellowness. Wood criticized Ryder's striving for the "annoying obscurity . . . the uniform brown of old pictures."[21] But tinted varnishes were standard fare for many nineteenth-century painters, who accepted the darkening of the image as a desirable patina of age. Constable's shocking freshness is better understood if we remember that tinted varnishes and bituminous pigments were in general use among romantic painters of his age; the impressionists' burst of pure color must also be set against a backdrop of heavily varnished paintings. Museum collections were given an application of resinous "gallery varnish" whenever they were spruced up for exhibition. The Eastlake controversy at the National Gallery in London in the 1850s hinged on whether or not to clean accumulated varnishes off the old masters; many connoisseurs defended tinted varnishes for the way they softened too-harsh colors. A conservator explained that even if a Claude had no glazes on it when it was brought to him for work, "I should have put a coat of warmth over it; I would have tinted a coat of mastic varnish as [the painting] has such a very crude appearance."[22] There were arguments in favor of the "benefit of dirt"—the inevitable concomitant of heavy varnish, which remained tacky long enough to trap soot and dust from smoky Victorian interiors. In Scotland during the 1880s a school of painters was sometimes dubbed the "Magilp school" for the artists' love of the brown mastic varnish that imparted a mellow richness to "raw" color.[23]

Ryder depended on varnishes to complete and enrich his color, leading one wag to call his art "vagaries in varnish"; but other artists also unified their images this way, if more moderately.[24] In 1879 a critic described how Sanford Gifford "varnishes the finished picture so many times with boiled oil, or some other semi-transparent or translucent substance, that a veil is made between the canvas and the spectator's eye—a veil which corresponds to the natural veil of the atmosphere."[25] Daingerfield, Ryder's friend and colleague, used tinted varnishes to give his late

Barbizon-style paintings a unifying warm tone; when stripped clean, the paintings have the brighter palette of the Brittany artists.

The dilemma was clear long before Ryder's death: whether or not to repair disfiguring cracks and clean off darkened varnishes. When William T. Evans acquired *Moonlight* for the second time, in 1909, he was immediately contacted by Charles Melville Dewey, who had been a student with Ryder at the National Academy almost forty years earlier and who painted in a similar dreamy landscape manner. "Sooner or later your beautiful little Moonlight by Ryder will fall into the hands of the fatal restorers, so I am writing to ask you to let me do what it needs; just filling the large cracks and staining them," wrote Dewey to Evans.[26] Evans agreed and sent the painting for treatment. Ryder reviewed the repairs and approved Dewey's restraint, writing to Evans:

Mr. Dewey was in the other day to ask me to see the Moonlight you entrusted to him for doing some little mending; it is entirely satisfactory to me and I feel grateful to him for his kindly interest.

The tendency is to do so much that is unnecessary in these connections that it is refreshing to find a kindly soul do what he has with the aim of saving the color and character of the work. . . .

So I am indebted to you; and we both to Mr. Dewey that such a fine artist would give it his attention and do the work with such angelic reserve.

Trusting that you will be as pleased as I am with the result; and not desire any more; quoting from John Constable "that a picture can be so good that it is good for nothing."[27]

By 1911, when Ryder learned that the dealer Macbeth had acquired *In the Stable* (see fig. 8), he was intolerant of even limited treatment, saying, "I hope you will not have the picture cleaned; I am confident that the color is as perfect as when painted; if there are any cracks they count for little in this enlightened age. For myself I like the picture just as it is."[28] Macbeth indicated his intention of proceeding, spurring Ryder to his strongest assault:

You say nothing will be done to mar my beautiful color; and then you say the old varnish will be removed; that you cannot do without injuring the pic-

ture seriously; all it needs is to be washed and a thin coat of varnish if you like.

How Mr. Cottier was amused at the cleaned Corots that had been painted some years, made to look as if they were painted yesterday!

I refer you to the verdict in the English Court sustaining Whistlers [*sic*] contention that a man did not wholly own a picture by simply buying it.

Ergo, I have a right to protect my picture from the vandalism of cleaning; if it needed it I would not say a word. . . . It is appalling, this craze for clean looking pictures. Nature isn't clean, but it is the right matter in the right place, to paraphrase Faraday.

I can't remember that the picture was ever varnished.

Heed what I say.[29]

Despite Ryder's injunction, many of his paintings were cleaned, if not during his lifetime, then in time for the 1918 memorial exhibition of his work at the Metropolitan Museum. Since resinous varnishes discolor within a few years of application, we may suppose that Ryder's own varnishes—tinted or not—were often removed

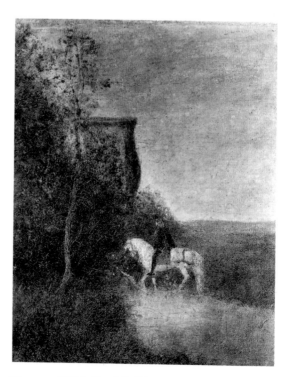

Fig. 120. *Childe Harold's Pilgrimage*. EBSCO Industries, Inc., Birmingham, Alabama.

and the yellowed surface we see today was applied by some early restorer. On *Childe Harold's Pilgrimage* (fig. 120) an early restorer removed the varnish in some areas but left the dark areas untouched, which may have contained resins and unstable paints that would have dissolved in the varnish solvent, leaving the partially cleaned painting with a peculiar tonal imbalance. It may never be possible to reconstruct the extent to which tinted or resinous varnishes were part of the Gilded Age aesthetic. The appeal of a unifying tone, however, was not limited to paintings and glazed ceramics. Stained-glass windows occasionally had a sheet of lightly tinted and textured "dispersing" glass placed over them to soften and diffuse the sun's rays.[30]

It is difficult to discuss Ryder's technique without mentioning Sheldon and Caroline Keck, conservators who are intimately bound up with the survival of Ryder's oeuvre. Together with the great Ryder scholar Lloyd Goodrich, the Kecks examined and X-rayed several dozen paintings attributed to Ryder, beginning in the mid-1930s, and they treated a fair portion of this number. With an inspired understanding of Ryder's approach, they left the surfaces of most paintings intact, only removing the topmost grime and skillfully filling and inpainting cracks. Caution joined with courage, however, as they worked from the back of many paintings to stabilize oozing, deteriorating paint films. Often this required radical steps, such as removing Ryder's original support (which yielded some intriguing discoveries, such as the large horse painted underneath *King Cophetua and the Beggar Maid* [cat. 25c]) and carefully scooping out the still-viscous materials below the paint surface, then mounting the paint film on a new support. Many of the paintings they treated have remained stable for two decades or more, while several untreated masterworks have suffered irreparable damage. The Kecks' ingenuity saved some of his greatest triumphs, preserving Ryder's art for another generation.

Even the works seriously affected by what conservators call "inherent vice" still have the power to move us. Like precious relics, they began as incarnations of an idea, and they demand that we recognize the idea embedded within, despite their imperfect condition, as we would recognize qualities of character in a body ravaged by time. Many artists have found inspiration not despite the condition of the works but because of it, for Ryder's paintings represent a willingness to risk everything for invention and a determination to push art beyond the limits of the physical. Ryder's art is not so much a bid for immortality as a metaphor of life and death. His paintings are organic, their physical existence moving toward destruction, while the thought remains clear. He knew they cracked and yellowed, yet he maintained, "When a thing has the elements of beauty from the beginning it cannot be destroyed"—invoking the Venus de Milo in defense of his own ravaged canvases.[31] He wrote: "In pure perfection of technique, coloring and composition, the art that has already been achieved may be imitated but never surpassed. Modern art must strike out from the old and assert its individual right to live through the Twentieth Century. . . . The artist of today must work with his face turned toward the dawn, steadfastly believing that his dream will come true before the setting of the sun."[32]

Legends and Legacies

First Citizen
of the Moon

The legends about Ryder have proved more durable than his paintings. None of the closest friends of his most productive years left a private account of the artist, but many who met him later were moved to record their impressions and the stories they had heard secondhand, especially after his death in 1917. Critics Henry McBride and Sadakichi Hartmann; young artists such as Marsden Hartley, Kenneth Hayes Miller, Philip Evergood, and Arthur B. Davies; and personal friends Charles Fitzpatrick and John Robinson all gave accounts of Ryder's later years. Acquaintances from student days such as Elliott Daingerfield, James Kelly, and William Hyde wrote about Ryder after his death, even though they had not stayed in touch much during the two decades when he produced most of his work.[1]

The several painted and written portraits of Ryder differ in character according to the portraitist, although all are sympathetic. Kelly's reminiscence, like Louise Fitzpatrick's painted portrait (fig. 121), describes a sweet and ingratiating soul—shy, pale, sensitive, and "artistic" in the dreamy feminine way that became fashionable by the end of the nineteenth century. Kelly remembered Ryder from the academy days:

He wore a slouch hat. His hair was light brown and straight—A high, delicately modeled forehead, very fair, almost pearly in effect. His eyes were inclined to be blue, lustrous, with a frank confiding look, like a fine child. His nose was straight and crisply molded, with sensitive nostrils. His face was pale, without much color. A light flossy beard, as though it had its own way. He at that time was very neat, with a New England regard for the proprieties. But, what made Ryder, was his sweet, refined voice and gentle smile.[2]

Kelly continues his narrative in a bemused, patronizing tone, recounting Ryder's decline: "His hair was scraggly, . . . his beard matted . . . he wore a night shirt instead of the conventional one . . . no collar—well-worn sack coat—his trousers hung low at the hips."

The contrasting view is given in prose and paint by Hartley (fig. 122), who in about 1909 sought Ryder out after seeing a moonstruck seascape at the Montross Gallery and came to consider him an artistic father-figure, a patriarch.

Hartley complained that neither Miller's stately portrait nor Alice Boughton's photographs of a dressed-up Ryder (figs. 123–27) showed the man he knew:

Ryder was so majestic in his grey wools, sweater, skull-cap to match, with a button of wool at the top, and this is the Ryder that we should have had completely recorded. This cap came down to his shaggy eyebrows which were like lichens overhanging rocks of granite, the eyes that they now tell me were brown I thought of course to be blue—thought them blue probably because blue eyes seem always to be looking over desperate horizons. . . .

Brown eyes then that seemed blue, skating on the far thin ice of labradorean visions.

Visionaries are nearly always summoned to the centers of revelation, and Ryder, being among the first citizens of the moon, became at once prince and serf of this exacting kingdom.[3]

This then is the "Job-like physiognomy" that Hartley painted in 1938.

The two aspects of Ryder's personality run side by side in the literature and often intermingle: the submissive, sensitive, naively sweet, feminine aspect and the complete-unto-himself, wise, masculine strain. De Kay noted in 1890 that "it is among women he always finds some of his warmest admirers,"[4] but by this time all of American culture was assuming a more feminine, aestheticized character, manifest especially in the decorative movement that centered in the home. Culture and art provided a release from the fiercely competitive, masculine world of commerce and offered a link to intuition and feelings that was very congenial to the busy man of affairs. Ryder mined this dualism, along with a number of other artists of the period including La Farge, Eakins, Homer, and Whitman.[5] Ryder's own sexuality remains in the background, blurred like the boundaries of his painted forms, perhaps more dream than definition, but his art evokes the late nineteenth-century construction of the feminine—an alluring combination of the physical and the ideal, appealing to the moral sphere through the senses.[6]

Whatever view predominated, the constant in every description is Ryder's unimpeachable char-

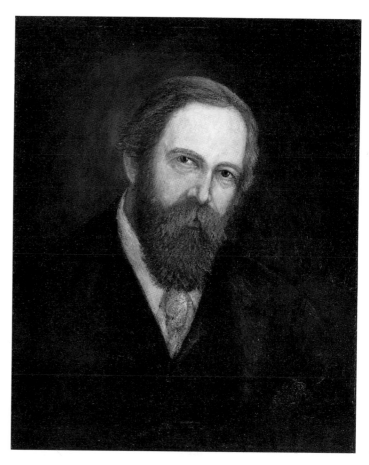

Fig. 121. Louise Fitzpatrick, *Albert Pinkham Ryder*, oil on canvas. National Portrait Gallery, Smithsonian Institution, Washington, D.C., 83.1.

Fig. 122. Marsden Hartley, *Portrait of Albert Pinkham Ryder*, 1938, oil on board. Collection of Mr. and Mrs. Edith and Milton Lowenthal, New York.

the line. These saintly sympathies emerge mainly in late reminiscences, while earlier accounts stress his sociability, delightful laugh, and love of pipes and beer.[7]

Ryder's enthusiasms were contagious, as conveyed by Inglis's letter to Wood just before an excursion to the races in 1895:

Wish you could see the Reverend this A.M. He is going to the Races with me—don't think he has slept all night with excitement—has picked out all the winners—and states that after all it wouldn't surprise him for any horse to win. His straw hat is older than G-D [goddamn] but his belief is that the old ones are the coolest—then he has a seersucker coat—some one must have left it in his Brother's Hotel—of light [illegible] colors—a flannel shirt he has washed himself— and with all his genial good nature—relieved by fearful perspiration and a promise that he will finish *Christ Appearing to Mary* before my return home from Europe. He says also how much you'd have enjoyed the Races if you were here. There is no man that will be there any happier and none with less in their pocket—but he'll have clam chowder and lots of beers and will [illegible] again someone he knows and talk Horses or Art whichever they want—and approve of whatever they select—in fact for Pinky it is a gala day.[8]

While worshiping the inner serenity, one might still deplore the outer squalor of Ryder's existence. Several reported that Ryder was very neat in the early years, but by the mid-1890s, while living at 308 West Fifteenth Street, he stopped throwing anything away. Debris inched upward toward a high-water mark as friends watched with appalled fascination. Charles Fitzpatrick, who with his wife, Louise, lived just below Ryder for many years and later moved him into their home on Long Island for his last years, gave the account with the strongest ring of authenticity:

His room was a mass of papers, pasteboard boxes, some with food, others, empty, piled high. He had old clothes piled high on the floor and chairs. He never threw away a string. He saved everything. In front of one window there was a carved chair and when any of his friends called he would brush off the chair and put a small Persian rug in front on the floor. There was a pathway from the door to this chair, or as I called it, "A trail through the hills," and he had another path-

acter. Befitting an American artist, he was democratic in his sympathies—hastening to comfort a cleaning woman who smudged a still-tacky painting with a feather duster and insisting that the bums and undesirables along the wharves were not so bad as people thought. Ryder moved out of his brother's hotel after arguments over his unseemly fraternization with the help; *The Race Track* (see fig. 86) commemorates a waiter's lost bet and suicide. When an old woman next door to Ryder's room became ill, he sat like a sentry outside her room at night so he would hear if she called for help. He even refused to continue flying kites after a gull was injured in

way to the grate. He slept on a cot, but not being able to keep it clean he abandoned it and slept on the floor. He had a fur rug given to him by Col. Wood which he slept on for some years until it was eaten up with the moths. He tried a number of times to clean the cot, and finally got some naphtha (which is dangerous stuff) and with the candle in one hand and the naphtha in the other, the place caught on fire. He tried to put it out with his hands, and as he saw it was gaining he knocked on the floor. I ran up, grabbed the fur rug and other things and smothered the flames. Poor Ryder's hands were like a piece of beef.[9]

When an agent came once a year to make repairs and clean, Ryder would refuse to admit him. But during one period when Ryder was ill and unable to protest, Louise Fitzpatrick took matters into her own hands and cleaned the apartment.

Finally she got the housekeeper's son and started to clean up. They cleaned out bags and barrels filled with paper, empty food boxes, ashes, old clothes, especially under garments, and about fifteen white shirts for evening wear, all soiled and in a fearful condition, mice that had decayed in traps, food in pots that had been laid [to] one side and covered with paper and forgotten. As he laid there helpless, he would accuse them of upsetting his room. When they got one side clean, they would drag him over on the rug to the other.

The state of Ryder's apartment struck his admirers most forcibly. Hartmann spoke of "this false note, ludicrous and sad" and asked, "How could a man of his mentality allow himself to be dragged down to the antics of a crank?" He even posited that Ryder was immune to bedbug bites, like a Jain philosopher![10] But however much it disturbed his friends and still disturbs us today, Ryder seems to have been more or less content with his rubbish.[11] William Macbeth once rented a nearby apartment and gave the keys to Ryder, inviting him to make a fresh start, but Ryder found one reason and then another not to move in.[12] He moved out of his rubbish-filled rooms only when forced by renovation plans for his building in late 1909, and then only a short distance, to the same address one block north, at 308 West Sixteenth Street.[13]

Ryder's world was physically confined, but he filled it completely, dissolving the boundaries between self and world to the extent that his apartment became an extension of his own being. His refusal to give up string and ashes puts into perspective his reluctance to hand over paintings even when they had been paid for years before. Feeling his surroundings and art to be an inseparable part of his being, he keenly protested any "de-parture." Through his labored technical process he effected a transference of self to the canvas or panel, loading the work until it became a precious reservoir of experience and feeling, the overflow of emotions too large for daily life.

Ryder generously gave money to the poor and special gifts to his friends, although he became increasingly stingy with the wealthy patrons who knocked at his door to ask for paintings. His Christmas gift list was long. One year he gave small china bottles filled with a perfume of his own brewing. Another year he bought sailors' wallets and placed a good-luck penny in each. Whether a lovely essence, a lucky charm, or a moonlit marine, Ryder's gifts always appealed to dreams beyond reality.

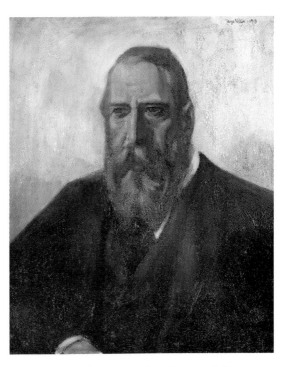

Fig. 123. Kenneth Hayes Miller, *Portrait of Albert Pinkham Ryder*, 1913, oil on canvas. The Phillips Collection, Washington, D.C.

That he chose to give out lucky pennies and wallets one year may say more about his material ambitions than all the stories of his generosity to beggars or ignorance about checks.[14] "The artist should not sacrifice his ideals to a landlord and a costly studio," wrote Ryder. "The artist needs but a roof, a crust of bread and his easel, and all the rest God gives him in abundance. He must live to paint and not paint to live."[15] This was the credo by which the bohemian artist lived, a distant echo of Millet's humility and a hedge against elusive worldly success. It is a statement of values surely not to be overinterpreted as a vow of poverty. We know that Ryder rejoiced when his pictures in the Clarke sale reached four figures and that he once announced with pride that he was doubling all his prices. Ryder could appear indifferent to money because, after the poverty of his student days, he always had means sufficient to his modest needs. Unlike Blakelock, who was driven insane by lack of appreciation and abject poverty, Ryder found ready buyers for his works even before they were far along on the easel. He could have sold many more paintings had he been willing to begin them, even if he lacked the ability to bring them to completion.[16]

The stories told about Ryder scarcely piece together the full fabric of his personality, but, individually, the fragments suggest that he found pleasures and satisfactions outside the conventions he had abandoned. He loved playing with his friends' children, who called him Uncle Ryder. Peggy Cottier ("Pedlums"); young Mary Fitzpatrick (an adopted niece of the Fitzpatricks), who sang and played the violin; the two nephews of Captain John Robinson; "little Elsie sweetheart," daughter of Harold Bromhead of Cottier's; young Inez Sanden, Rosalie Warner, and the Weir children were some of Ryder's best friends. He played Hunt the Slipper and Musical Chairs, and when a horse was required he was saddled and ridden. Ryder's childlike qualities assumed great significance for those who sought in the twenties and thirties to portray the artist as a naïf, but those qualities are too often confirmed to be ignored. An affection for fantasy and a distaste for grown-up conven-

tions naturally led Ryder to find allies among "the little folk."

Ryder loved oysters and baked beans, buttermilk, cereal, dried fruit, and other foods to the point that he earned through his bulk the nickname Santa Claus.[17] In the early days he was a regular at Ichabod T. Williams's weekend dinner parties, where he talked more than anywhere else, and at the Menagerie's evenings in the Arena Restaurant. Later, he loved to dine with Inglis and the Warners on Captain Robinson's ship, the *Minnehaha,* or prepare steaks in his room when his seafaring brother came to visit or even roast a Thanksgiving turkey over the fire. He patronized an English-style sailors' tavern at Thirteenth Street and Seventh Avenue; Kiel's Bakery, where he would sit for two or three hours over a meal; and an "oyster saloon" at Eighth Avenue and Horatio Street that offered "Oysters in Every Style, One Cent a Piece," hot codfish sandwiches, and lobster. For awhile he had a standing invitation for Friday dinner at the Sandens', and he usually was sent home with a large crock of baked beans. Like most men of the period, he could drink quantities of beer and whiskey and he loved to smoke cigars; in this, at least, he was wholly conformist.[18]

Ryder was often seen in Greenwich Village with a rope-handled, two-quart stoneware jug slung over his shoulder; sometimes twice a day he fetched fresh buttermilk, which he drank in enormous quantities.[19] He solved the problem of fixing meals in his room for a time by buying a small stove and keeping a stew kettle always simmering, adding apples, cereal, or meat whenever the supply seemed low. This timesaving but poisonous practice caught up with him and made him quite ill.

Ryder's long walks were legendary—up Eighth Avenue or through Central Park, along the Battery or the Jersey Palisades. The walks were mainly at night, when the soft light was easier on his eyes and when he could study the moon and cloud formations for his paintings. These midnight meanderings caught the fancy of those who knew his strange ways: "When New York slept and the Hudson was black with night, he

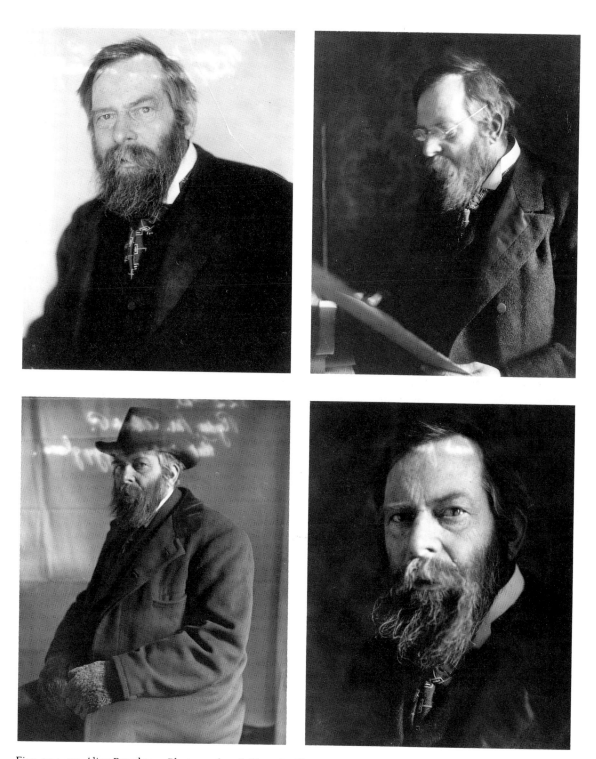

Figs. 124–27. Alice Boughton, Photographs of Albert Pinkham Ryder, 1905. Library of Congress, Washington, D.C., gift of Everett Boughton, LC-B7901-75, 74, 19, 21.

sought the Palisades and walked hatless, forgetful of self, seeking the revelation that is in moonlight. Christ on the mountain saw the same rays, fathomed the same message and derived from it the same strength."[20]

A deeper insight is given by another walking devotee, Robert Louis Stevenson, whose essay "Walking Tours" is among his most charmed pieces of writing: "It seems as if a hot walk purged you, more than of anything else, of all narrowness and pride, and left curiosity to play its part freely, as in a child or a man of science." The state of free association leads to "that kingdom of light imaginations, which seem so vain in the eyes of Philistines perspiring after wealth." Of course, one may wonder if the walker is "the wisest philosopher or the most egregious of donkeys," but "whether it was wise or foolish, tomorrow's travel will carry you, body and mind, into some different parish of the infinite."[21]

Long, solitary rambles allowed the recluse to maintain his special world outside the sanctuary. For all his shy geniality, Ryder's retreat from society was complete at least by 1905, when his only published statements appeared under the title "Paragraphs from the Studio of a Recluse." This writing refers to seeing "naught but the vision beyond" and to working out a painting with "prayers and fasting," placing the act of painting in a spiritual framework that recalls Gauguin's Christlike self-portraits or the emphatically religious autoportraits of F. Holland Day, another recluse, who in 1898 fasted literally to the point of emaciation in order to photograph himself as the crucified Christ.[22]

The materialism and sophistication of the Gilded Age brought a nagging fear of overcivilization; Brooks Adams proposed in *The Law of Civilization and Decay* that Western civilization had already begun to decline. Such thoughts were paralleled by artists and writers in a variety of ways—a search for primal purity in the South Seas, a curiosity about the matriarchal mythologies that preceded classical civilization, and a revitalization of Christianity as a means of personal transformation. The figure of Christ focused many of these feelings, as is evident in

Gauguin and Day, in the popularity of Ernest Renan's *Vie de Jésus* and William Dean Howell's *If Christ Came to Chicago*, and in the late nineteenth-century revival of Thomas à Kempis's *Imitation of Christ*. The idea of the artist as saviour and martyr in a world of Philistines and Pharisees affected Ryder no less than many others. His first serious critic considered him a paradigm of the American artist mocked by an unfeeling public, a Greenwich Village Man of Sorrows: "The parable fits to a young painter who slowly and with endurance of insulting pity, of ridicule and of inappreciation, has worked his way to a small but very enthusiastic practice."[23] Ryder's "Paragraphs from the Studio of a Recluse" are phrased with a biblical cadence that suggests he embraced a quasi-religious role, but whether these are his words or those of his amanuensis is not clear.

In Ryder's life and art, excess and experimental procedures led to deterioration. He suffered from rheumatism, or "poor man's gout," for many years, which he treated by taking walks with his feet caked in straw and cold oatmeal, covered by oversize brogans. Late in life he moved so slowly that he could scarcely avoid onrushing traffic while crossing the street.[24] He grew swollen and heavy and perspired profusely even in a cold room. His eyes continued to be a problem. The combination of symptoms including excessive thirst, swelling, overweight, and vision problems suggests some chronic disease, perhaps diabetes. For the last ten years of his life Ryder's condition was diagnosed as nephritis, or Bright's disease.

The art of healing brought out Ryder's inventiveness and love of unorthodox approaches. On a hot day he would light a fire in his studio to dry out the humidity, while in cold weather he opened the windows and went without socks. He once announced to Weir that he was following an Indian regimen of eating five meals a day. He was much attracted to the hydrotherapy of the German "water doctor," Father Sebastian Kneipp, who developed more than one hundred internal and external water treatments for ailments ranging from abscesses to worms.[25] Around 1898

Ryder became close friends with Dr. Albert T. Sanden, inventor of a famous cure-all electric belt; the artist did not hesitate to prescribe for the doctor his own "royal cure . . . the Salts and Oil."[26] As we can imagine that these regimens and treatments gave more mental than physical relief, Ryder must have endured much discomfort without complaint, for his friends always spoke of his sunny disposition. But in illness as in art, Ryder was a "treater," ever ready for a new remedy, attracted to eccentric procedures that appealed to his highly personal sense of logic.

In many ways Ryder's life and work manifest a reversal of the preceding generation's ideals. The Hudson River school painters, with their public ambitions and private transcendentalism, believed that nature revealed God's plan. While exercising the full quotient of artistic vision and judgment, they still sought to let nature speak in her own voice. It was a masculine, intellectual world in which the artist sought to portray the noblest ambitions of the age. Whitman marked a transition from this world to the new culture that dominated the end of the century, but his roots in the transcendentalist past were stronger than Ryder's. Despite his New England origin, Ryder's world was already very different, devoted to "feminine" emotions and intuition, to a private vision of which nature was only a kernel. By withdrawing from society he became "prince and serf" of his own kingdom, ignoring conventions and expectations. He insisted on speaking only for himself, not as an exemplar of his age. In part this was reticence, but it also derived from a vague perception that the age—despite its "quest for unity"—had shattered the old verities. Conventions and expectations no longer stood for values held in common but merely old habits of thought concealing a crumbling consensus. Discarding them as so many empty shells, Ryder maintained a cheerful equanimity by adhering to his own unities amid the general fragmentation. ❧

Later Critics,
New Patrons

Many of the "new men" of the 1870s had to wait decades for tensions with the academy to subside before they were taken into the rather stuffy bosom of the American art establishment. A few, like Warner and Saint-Gaudens, made the transition earlier by participating in grand schemes for exposition decoration, public monuments, or commissions for the wealthy. The "new men" and their champions took advantage of powerful connections when they were available. In 1893 Inglis wrote to Wood with an edge of jealousy about Warner's work for the 1893 World's Columbian Exposition, saying, "As for Warner he is now one of the McKim, Mead, and Century crowd—so I call him anyway to make him angry—but he is up to the eyes now in work and looks fat."[1]

Ryder was little suited to the public work that brought such recognition, so he remained largely unknown beyond the coterie of artists, dealers, and collectors who avidly pursued his work. Ryder's only official award came when his most productive years were over—a silver medal at the 1901 Pan American Exposition in Buffalo, where he was represented by *Siegfried and the*

Rhine Maidens and *The Temple of the Mind.*[2] The next year he was made an associate of the National Academy.

The critics had a lot of catching up to do. For many years the only in-depth article on Ryder's art was written by de Kay for *Century Magazine* in 1890 (signed with the pseudonym Henry Eckford), which firmly declared him a "modern colorist." De Kay voiced the judgment that Ryder was advancing the tradition of Titian, the Dutch and Flemish masters, Delacroix, Corot, and Dupré. But de Kay also saw something quintessentially American in Ryder that gave him hope for the ultimate triumph of a native art: "Perhaps American art, like American mechanics, literature, politics, has a mission of its own. Perhaps it may teach the great lesson in the fine arts which the United States is teaching in many other fields—individuality, freedom, rejection of the authority of any one school."[3]

With such a clear long-range agenda, de Kay naturally stressed Ryder's independence of Europe, even to the point of claiming, "it would indeed be difficult to find a more thoroughly native workman than Ryder." This theme became

a constant in Ryder commentaries, despite his knowledge of the old and modern European art that passed through Cottier's, his four trips to Europe, and his special appeal for collectors of international painting. For decades critics have loved to say that Ryder rejected all "alien" influence and only crossed the ocean to watch moonlight on the water, despite evidence to the contrary.

The contest between nativists and internationalists reached a remarkable pitch in 1904, when collector J. Harsen Rhoades headed a committee that staged the *Comparative Exhibition of Native and Foreign Art*. The show matched one hundred American paintings with an equal number of European examples selected from American collections "in order to quicken the public appreciation of the unquestionably meritorious work of American painters."[4] Native and foreign paintings hung side by side according to their strongest qualities; Ryder's color in *Constance, Flying Dutchman,* and *Siegfried* were judged—by none other than de Kay in the *Times*—to be "more varied and delicate than that of Delacroix, Diaz, and Monticelli. . . . [He is] more the poet than any of the three, despite the evidence that he struggles with his materials."[5] We wonder today that such judgments were taken seriously since the jury was formed wholly of American collectors and the critics were scarcely impartial.

The following year, in 1905, Ryder's "Paragraphs from the Studio of a Recluse" was published to accompany a mythologizing article by critic Joseph Lewis French entitled "Painter of Dreams." About the same time, the photographer Alice Boughton sought him out for several portrait photographs, in one of which he sports new spectacles (see figs. 124–27).

Having outpainted Delacroix in the eyes of some critics, Ryder was finally admitted to academician status in the National Academy in 1906. As his diploma piece, he submitted one of his most abstract marines—an uninterrupted expanse of sea and sky—which had probably been painted earlier, for it is inscribed "A mon ami Captain Robinson / A P Ryder" (see fig. 99). The academy also required a portrait of each mem-

Fig. 128. Rockwood Studios, *Portrait of Albert Pinkham Ryder,* inscribed by Ryder, "To Walter Percy Fearon, With happy wishes for his birthday, I look into the eyes of a friend." Archives of American Art, Smithsonian Institution, Washington, D.C., Sherman Papers.

ber, so Weir painted Ryder, looking every inch the academician (fig. 129).

About this time a new element crept into the longstanding debate about the American indebtedness to Europe, for this was the moment when the major Cézanne retrospective introduced a whole generation to new concepts of form, Max Weber penetrated Matisse's studio, and Leo and Gertrude Stein discovered Picasso and Matisse. In New York the radical developments were well represented at Alfred Stieglitz's gallery 291, which opened in 1905. The Englishman Roger Fry, one of the great champions of Cézanne and French postimpressionism, helped spread the new gospel during his tenure as paintings curator at the Metropolitan Museum from 1905 to 1910.

It seemed at first that the French would lead yet another generation of "new men" in America—unless, of course, it could be shown that an American painter (preferably one untouched by European influence) had pioneered these new directions. Fortunately, such an American prophet was at hand, although it took a European critic to anoint him.

In 1908 Roger Fry wrote an article placing Ryder squarely among the avant-garde, saying that he had "solved . . . the crucial problems of the modern painter." Fry saw nothing specifically American about Ryder: "[his genius] might arise almost at any moment, and in any circumstance; it does not belong particularly to its age or its place." Ryder was an "unexpected freak of his stock," and, to the extent that he had an artistic genesis, he could be considered "the last gleaning of the harvest of 1830," that is, part of a French tradition.[6] Fry compared Ryder to Poe (always popular with the French) and in other ways sought to fold him into a French-dominated evolution from romanticism to modernism. Fry's revisionist view of Ryder prevailed. When the Armory Show of 1913 presented the newest innovations against a historical backdrop of French precursors, there was Ryder's work nestled among the Gauguins, Cézannes, van Goghs, and Redons.

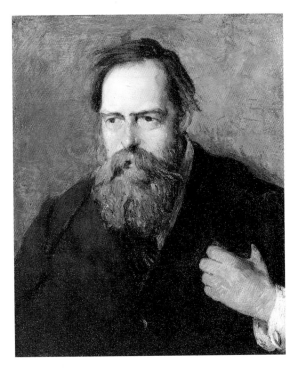

Fig. 129. J. Alden Weir, *Portrait of Albert Pinkham Ryder,* 1906, oil on canvas. National Academy of Design, New York.

In presenting Ryder's highly individual vision Fry stressed form and composition, using the typically modernist device of inverting the usual values of words. Ryder's genius lay in his "childishly simple" forms, in the placing and shape of the "ungainly mass" of a boat, and in the "willed awkwardness and *gaucherie*" of his silhouettes. Ryder's old bugaboo—lack of drawing skills, which de Kay had tried to explain away in Ryder's earliest reviews—became the standard under which he entered the avant-garde. His individualist technique and composition placed him outside tradition, so that he became the perfect contradiction to the overcivilized, overskilled conformity prevailing in academic circles. Ironically, in the immediate wake of his acceptance into the academy, Ryder was made over as a self-taught primitive—an American counterpart to Henri Rousseau, whose memorial exhibition at 291 in 1910 made an impression on many New York modernists. Ryder's art, too, seemed to em-

body some primal artistic current, as did African or Iberian sculpture.

The rise in Ryder's critical reputation parallels the heightened consciousness of an alternative, folk-art tradition in America. In the teens, the Ogunquit School in Maine was already searching out naive art as a new source of inspiration and Electra Havemeyer Webb was starting to collect Americana; in the twenties, Elie Nadelman opened a folk-art museum on his estate and the Whitney Studio Club held its first exhibition of early American art. In 1930–31 Holger Cahill's exhibitions of primitive painting and sculpture at the Newark Museum established non-academic art as the purest aesthetic vein of American art, linking good design and naïveté in American criticism.

The Museum of Modern Art in New York was the architect of modernist history, laying the foundations of formalism in folk art and tribal sculpture and tracing an alternative, non-academic lineage in a sequence of important exhibitions. Ryder was given an honored place as a progenitor within this lineage. In 1930 the museum presented *Winslow Homer, Albert P. Ryder, and Thomas Eakins*—each member of the triumvirate a solitary and, therefore, a symbol of dissent from the official progress of American culture. These three were paraded as the most "authentic" American painters, surpassed in integrity only by old New England folk carvers.[7] In 1935 the museum featured an exhibition on the tormented, misunderstood van Gogh, leading Hartley to open an essay on Ryder that same year by speaking of "van Gogh who like the Son of Man had not where to lay his head."[8] The pattern of criticism in the twenties and thirties—especially the idea that humble, naive work prophesied the modernist utopia—determined the way Ryder has been understood ever since.[9]

The critic Clement Greenberg made a useful distinction about Ryder's art when he said it had a manner but no clear style.[10] Ryder's art was never aligned so closely with any other that it had to be rejected when the next wave arrived. It offered something to the conservatives, the van-

guard, the nativists, the internationalists, the formalists, and the romantics. In the first decade of the twentieth century these groups—many of which had ignored Ryder during his productive years—laid claim to him as embodying their own position. We can gauge the ups and downs of the various factions by the tone of their arguments on Ryder's behalf—sometimes confident, sometimes strident and defensive.

The modernist bid that began with Fry was echoed in articles by Walter Pach (1911), Duncan Phillips (1916), and Leo Stein (1918). The most heated debates occurred after Ryder's death, in the 1920s and 1930s, when conservatives like Royal Cortissoz and Sadakichi Hartmann used Ryder as a foil for their own hostility to modernism, while Marsden Hartley cast him as the prototypical vanguard painter, scarcely disguising his personal identification with Ryder.[11]

Although Fry had dismissed Ryder's Americanism, native critics in both the conservative and radical camps emphasized the national aspect of Ryder's art. Frank Jewett Mather, Jr., sounded the theme when he wrote that Ryder, Fuller, and Blakelock were "the most American artists we have. Neither their minds nor their methods betray any alien tinge."[12] Even those artists whose style had little in common with his work—Henri, Sloan, Kuhn, Bellows—were pleased to claim one native ancestor who was so respected among the European cognoscenti. As early as 1895 Humphrey Ward of the London *Times* (an authority on the Dutch masters) had singled out Ryder's work as the best of the Americans. Later, not only Fry, but also Wilhelm R. Valentiner, decorative arts curator at the Metropolitan Museum, championed Ryder, while the arbiter of British taste and director of the Tate, Sir John Rothenstein, considered him "the sole imaginative painter of genius."[13]

While modernists pursued their advantage among the critics, conservatives dominated the marketplace. Dr. Albert T. Sanden collected eleven Ryders, a group that attracted special notice when five were lent to the Metropolitan Museum from 1918 to 1924. A wine merchant

named Alexander Morten also formed a collection of Ryders, prized especially because the artist had authenticated every painting in the group.[14]

Most patrons of Ryder's art in the early twentieth century were seeking the same spiritual and romantic qualities that attracted his first patrons in New York, Montreal, and Portland. It was truth and beauty more than formal design that moved John Gellatly to amass fifteen Ryders as the centerpiece of the huge collection that he gave to the nation in 1929.[15] At the peak of his collecting activity Gellatly wrote his testament of art:

Truly great Art is not the question of achieved ability to use the brush or chisel, it is the power to use such tools to portray emotional beauty found in the soul . . . and to me Botticelli might well be the keynote, and it is my thought that America in Thayer, Ryder and [George Gray] Barnard, growing in a virgin atmosphere untrammeled by all that has passed along since the days of the Italian Renaissance, approach more nearly in their achievement to the greatness and purity of the soul found in Botticelli and Fra Angelico

Fig. 130. *The Red Cow*. Freer Gallery of Art, Smithsonian Institution, Washington, D.C., 08.25 (photograph from the 1918 memorial exhibition, the Metropolitan Museum of Art, New York).

than is perhaps possible in the environments of European artists hampered by tradition. . . .

Truly great Art is a wonderful crystal enveloped in love. True love is the purest emotion known and the greatest power in existence. . . .

And Ryder's beautiful picture of our Saviour appearing to Mary after the resurrection in all the picture's crystalline purity and profound religious feeling, together with the Lincoln head by Barnard, represent the purity of the soul in art.[16]

It may be that Gellatly was swayed by Charles Lang Freer's decision in the first years of the new century to donate his collection to the Smithsonian.[17] Both men collected across national lines, considering that their refined taste would provide aesthetic definition to a collection of disparate objects. Freer's exquisite sensibilities found their deepest expression in oriental art, complemented by a few modern Americans—Whistler, Thomas Dewing, Dwight Tryon. Gellatly reversed the formula, collecting oriental and European objects to set off his modern Americans. Both collectors implicitly continued the idea of a "comparative exhibition" of American and foreign work. Both also bought directly from the artist when possible, enjoying the role of benefactor.

Ryder's reputation was such that no national collection of American painting would be complete without one of his works, so Freer acquired *The Red Cow* in 1909 (fig. 130). But his ultra-refined sensibilities must have rebelled at the experience of negotiating for paintings while surrounded by filthy debris. One Ryder sufficed for this man who collected Whistlers, Dewings, and Tryons by the score.

Gellatly, like Freer, was a self-made gentleman, fond of elegant gestures. He liked to wear a pure white suit that had once belonged to Mark Twain (fig. 131),[18] but he was less fastidious than Freer, scrapping and battling to get what he wanted. He preferred a bargain and would take advantage of an artist's financial straits to obtain a masterpiece on the cheap, as when he bought Ryder's *Flying Dutchman* for eight hundred dollars.[19] But when his mind was set on having something, he would if necessary pay more than anyone else.

Although Ryder disliked working on commission, he agreed to paint *King Cophetua and the Beggar Maid* and a version of *Pegasus* for Gellatly (see figs. 82, 90). As usual, the pictures languished for a long time, so Gellatly nudged Ryder by buying an elegant French gilt frame, but Ryder refused to be hurried.[20] By the fall of 1905 Gellatly became more demanding; he wanted the paintings for the new picture gallery he was building in his home at 34 West Fifty-seventh Street. Ryder wrote to explain that he was having difficulty with his eyes; fearing that Gellatly would not be mollified, he suggested that Mrs. Gellatly "understands possibly better than you or me the meaning of such a work and the difficulties and also the limitations pertaining to it."[21]

A more serious problem developed in the next few weeks, as Gellatly pressured Ryder to finish his commission. Finally, a painting was promised for a certain day. Soon after, Hartmann happened by the studio and recorded this remarkable scene:

One afternoon I found [Ryder] greatly excited, in a state of silent fury as it were. . . . Ryder had promised to deliver but now regretted having done so. His eyes gleamed ominously; rummaging about he tried to appear calm, but his hands shook and he kept up a stubborn silence after telling me in a few words what had happened. What Whistler had said playfully as a sort of sarcasm, "Madam, because you paid for a picture you do not believe you own it?" he was bent to carry out literally. There was a peculiar smell in the room, as if some metal was heated. . . . Somehow Ryder was in the possession of an old hairclipper. This he had thrust into the glowing coals, and before I realized what he was up to (not that I would have attempted to hinder him), he had run it criss-cross through the picture surface, leaving deep gashes as if made by the prongs of a rake. "He thinks he owns it (ha! unuttered!)! This will teach him who decides in such matters."[22]

Somehow Gellatly was confronted with the situation, but even then Ryder was unrepentant, writing to his patron:

As to your picture. The fact must be realized that it must be all felt out again. Can you wait? or do you wish to wait? If you have the patience and the desire to do so: I shall of course do all in my power to make

Fig. 131. Irving Ramsey Wiles, *Portrait of John Gellatly,* 1930–32, oil on canvas. National Museum of American Art, Smithsonian Institution, Washington, D.C., 1932.6.1.

Fig. 132. X-ray of *Pegasus Departing* (cat. 49).

it as good as before. Contrary: if you are tired of it all, I will cheerfully return your retaining fee. Allow me to say that I cannot in any sense accept a defensive position in the matter. The commission when taken was a compliment to you. The disastrous effort to finish it in a certain time was your suggestion; and I assure you the loss of all the previous work on it is by no means a light one. However I take it all lightly; as the fates decreed it so.

If you decide to wait you will surely have to wait as my obligations in other directions are really greater than in your case. If not: as I have said, I will cheerfully refund the $200—Two hundred dollars. . . .

With best wishes to Mrs. Gellatly and yourself and much pleasure to you in your new home.[23]

Eventually, the scratches were filled, the image repainted, and Gellatly took away his prize. Perhaps this was *Pegasus Departing*, whose bizarre X-ray reveals curious overall scorings—possibly the trail of the hairclipper's devastation, scars from the struggle between the artist and his patron (fig. 132).

Ryder had changed a great deal from the mid-1880s when he wrote flattering appeals to Clarke. His position vis-à-vis the patron had altered; he now dealt from strength, so that the purchaser counted himself lucky to carry away a finished painting, like a trophy from the hunt. While Ryder's manner was generally mild, a stubbornness underlay his refusal to be pushed and new patrons learned to be submissive and patient, like Mr. A. Ludwig, who wrote to Ryder in 1905:

I thank you for giving the size of picture—of course I shall order the frame and withall not get discouraged even if the picture is not in it; don't you believe in expectation and anticipation, and as Col. Wood says "Ryder always gets there sometime," so you will most assuredly get on with my picture, I am sure—if only I have patience enough—Is it not so?—So go ahead and do your best and that is all any body can do—But only one thing, my dear Mr. Ryder—Don't forget me for the others.[24]

Like Whistler, Ryder asserted control over his art even after it left his studio, prefiguring the battle over artists' *droits morals* that is just now coming to a head in America. The many stories of his bumbling slowness and saintly manner

obscure the extent to which he tacitly refused to acknowledge a patron's authority in any transaction involving a work of art. His tendency to cite Whistler in defense of his own views suggests that he took an interest in the flood of Whistler books and exhibitions unleashed at that artist's death in 1903. Not only would Ryder not be rushed, but he protested having his works cleaned and objected to the sale of reproductions. In 1906 he wrote to Wood to ask legal assistance in protecting his works,

I asked [William] Catlin to speak to you about an injunction on the copyright office in Washington, to restrain them from giving copyrights on my works except to me or by my consent. It seems self evident or common law that a person should not be obliged to copyright everything to protect it or to save his rights. Please tend to it as soon as you can as I want to head off somebody I suspect. To be paid for as a service rendered.[25]

At the turn of the century a contest of wills began between artists and patrons. If the artists considered themselves worthy descendants of Raphael or Michelangelo, their patrons and dealers claimed the prerogatives of a Leo X or Julius II. The question was one of authority: Would the patron or the artist dictate the subject and style of a picture? This conflict led Eakins to avoid commissions and turn increasingly to his family and friends for portrait subjects. Thayer, financially dependent on Freer, still argued that the artist and not the patron was the "true prince": "Look at the Japanese dukes, Da Vinci's noble patron, and the Medicis with Raphael and Michel Angelo. They all recognized that an artist in the full sense was the true prince and, lacking the painter's gift themselves, they painted by saying to these artists 'I long to feed on the fruit you can bear.'"[26]

This tension reflects the American artists' growing ambitions as well as the heightened respect for culture in the late nineteenth century— a respect sometimes won at the expense of commerce and industry. Henry Adams, for one, suggested that the 1893 world's fair artists would be remembered long after their politicians and millionaires were forgotten.[27]

Ryder was not financially secure enough to ignore patrons altogether. Late in life, when he had almost stopped working and had little to sell, Ryder was dependent on monthly payments from Sanden, just as he had earlier been dependent on Cottier. Charles Fitzpatrick told how he had led Sanden to believe another collector was about to buy *The Race Track* for $7,000, scaring Sanden into a speedy purchase at $7,500 and thereby freeing Ryder of his accumulated monthly debt to the collector, with cash to spare.[28] As far as we know, this is the highest price paid for a Ryder painting during the artist's lifetime, obtained through a ruse.

The record did not hold for long after Ryder's death, as Gellatly scrambled to acquire masterworks for the nation. He had wanted *The Temple of the Mind* since the 1899 Clarke sale, at which he was underbidder to Inglis, who sold the painting to Angus of Montreal.[29] When Gellatly learned almost two decades later that Angus was donating the painting to the Buffalo Fine Arts Academy, he made Angus and the academy an extraordinary offer: Gellatly would give the academy four Ryders, four Theodore Robinsons, and major canvases by La Farge and Thayer and donate fifteen thousand dollars to Angus's favorite charities in his name, all in exchange for *The Temple,* which had been insured at Buffalo for only $2,500. Angus was willing, but somehow the arrangement was never consummated, perhaps because Gellatly used too much muscle in threatening that the academy must comply or be publicly embarrassed for depriving the charities.[30]

Gellatly was equally determined to have *Jonah*. At the same time that he was pursuing *The Temple* he sent word to Wood through Louis Fitzpatrick that he might pay $5,000 or even $7,000 for such a prize. To this, Wood replied,

Of all the pictures I have it is the one that is nearest to my soul and the one I would most hate to give up, and I neither could afford nor would I give it up except for some such price as tempted me and made me feel I ought not to hold on to the picture. So far as my own valuation is concerned, I think the picture is worth just whatever the man is able to pay. For exam-

ple, if it was a multimillionaire, I think it is worth a hundred thousand dollars. The fact is, you cannot put a money-value on art, and while there always is, to a certain extent, a market value, I feel in Ryder's case that market-value is going to be very high the more he is understood as absolutely unique in the whole realm of art and painting so few pictures as he did. I don't think it would be any use for anybody to talk to me about the "Jonah" for anything less than twenty thousand dollars. I know that is above its present-day market-value, but it isn't above its value to me, and the only reason I would consider twenty thousand would be because I would feel I am too poor a man to afford to own a picture which would bring to me and my family so much money. If I were above all thought of money, neither fifty nor a hundred thousand would get it away from me.[31]

More than a year later Gellatly capitulated to Wood's terms, paying not only the twenty thousand but also the 10 percent luxury tax.[32] Ever after, he considered *Jonah* the greatest of the 1,640 objects in his collection.

What made Ryder the most sought after hero of both modern and traditional camps? In looking back at Ryder's art and patrons we see a clear cultural orientation. However unique or eccentric Ryder appeared, he fairly represented the shrinking world of the late nineteenth-century Anglo-Saxon, which slowly shifted its hopes for distinction from the business realm to the cultural arena. For the high-minded, self-conscious elite, the art museum was a haven and natural habitat, where an endangered code of values could be enshrined for posterity. The generation that hoped to revive Renaissance unities through the study of European culture watched as a polyglot pluralism flooded America, posing a threat to their most cherished traditions. Museums appeared to be islands of certitude in a sea of new populations and alien ideas. Both Freer and Gellatly encumbered their benefactions to the Smithsonian with stringent legal injunctions against the selling of works; the terms of Freer's donation stipulated that objects could not even leave the museum building for loan to another institution. The museums they endowed in the nation's capital were to be bastions strong enough to survive the onslaught of barbarian "taste."

If Ryder was first the favorite of a small cult of collectors, most of whom collected European art and admitted only an occasional American, in the early twentieth century he was championed by the fledgling museum complex, which found him an acceptable American exception to their European agenda. In 1914 the Brooklyn Museum purchased six Ryder paintings that came ultimately from Cottier's private collection, through the estate of his widow. And, in 1918, the Metropolitan Museum gave Ryder a one-person exhibition, the eighth artist thus honored there.[33]

Especially in the early years, Cottier and Inglis cultivated a genteel clientele, Anglo-Scottish by birth or extraction, in the British Isles, Montreal, and New York. For instance, Cottier placed three Ryders with R. T. Hamilton Bruce of Edinburgh, then the greatest of all Scottish collectors and a symbol of advanced Scottish culture. Hamilton Bruce organized the huge art exhibition at the 1886 International Edinburgh Exposition and wrote articles for the *Scottish Art Review,* a serious if short-lived journal that covered international culture, including American developments. Cottier similarly cultivated allies within Montreal's large Anglo-Scottish community, such as John Popham, Angus, and E. B. Greenshields. Subsequent dealers Macbeth and Newman E. Montross moved in the same circles. Even Gellatly fits the pattern; son of a Scottish father and Irish mother, he was raised by his Scottish uncle after both parents died. So many of Ryder's patrons and friends were of Scottish extraction that we may assume some of his paintings were intended for this market. Paintings of sheep, works based on Campbell's poetry and Shakespeare's *Macbeth,* and subjects echoing Stevenson's pirate adventures would have held special meaning for such audiences.

There was a self-conscious Anglo-Saxon or British accent to much late nineteenth-century American culture, revealed in innumerable ways. J. Alden Weir (of Scottish descent) recalled his family reading together the novels of Sir Walter Scott when he was a child. Will Low wrote in *A Chronicle of Friendships* about his summers at Grez as the "Advent of the Anglo-Saxon."

Charles de Kay (writing under the name of his Scottish grandfather, Henry Eckford) prepared an article on George Inness summarizing the artist's Gallic qualities and explaining, "The name Inness means 'island' in the Irish and Highland Scotch dialects of the Celtic. Mr. Inness is probably of comparatively pure Celtic blood."[34] A fascination with blood lines and racial qualities permeated the century; Scott's *Ivanhoe,* for example, elaborately contrasts the unsavory Norman type with the stalwart, honest Saxon temperament. After the turn of the twentieth century racial themes became pervasive and shrill, and the underlying fear of miscegenation surfaced.[35] While Ryder's subjects are not specifically about race, they evoke an Anglo-Saxon literary tradition and linger on matters of social caste that reflect a concern with "values" and "leveling."

Ryder's cultural message remained mild; he was less the darling of the Victorian elite than Thayer or Dewing, which helped his art survive the devaluing of Victorian culture in the wake of modernism and World War I as well as the embarrassment over all racial themes that ensued after World War II. His eccentricities and humble lifestyle kept him outside the circles of power and his art remained free of the meanspirited, manipulative undercurrent that crept into many paintings treating gender, race, or religion. Nonetheless, the Anglo-Scottish character of his work placed it within the close-knit intellectual world wherein Shakespeare reigned supreme. The debate that constantly swirled around Ryder's "American" qualities must be seen against this background, for it involved far more than simple native pride. The contest over Ryder's art was at bottom a struggle between competing concepts of American culture. ᙢᙡ

Fig. 133. *Weir's Orchard*. Wadsworth Atheneum, Hartford, the Ella Gallup Sumner and Mary Catlin Sumner Collection (cat. 73).

Disputed Spoils

If in the mid-1880s Ryder felt himself drifting with the current, he tried over the next decades to strengthen his grasp on fate. He hoped to escape the bondage of a monthly stipend from his dealer; he challenged collectors and dealers who reproduced or cleaned his paintings without permission; and—most of all—he reduced his needs until they were comfortably accommodated by the narrow means he could provide for himself. But age and illness undermined this independence, so that in his last years he was more reliant than ever on the well-meaning attentions of friends. Weir still came to check on Ryder, taking him for a few days to his farm in Branchville whenever recuperation was needed. Ryder's painting of the orchard on Weir's farm (fig. 133) conveys the sense of calm and beauty he found on these occasions, although he rarely stayed long. A number of younger artists also sought him out, especially Kenneth Hayes Miller, who more than the others felt responsible for Ryder's welfare. It was Miller who took Ryder to the Brooklyn Museum to sign the group of six paintings purchased in 1914 so that there could be no question of their authenticity. Miller often brought paintings for signature, for false pictures had begun to appear on the market about the time of his triumph at the Armory Show. Occasionally, Ryder would refuse to sign a work, shaking his head slowly but remaining silent as he contemplated it.

As Ryder's health declined the burden of caring for him fell mostly on Charles and Louise Fitzpatrick, the couple who lived for a time in the basement apartment below Ryder's on Fifteenth Street. Louise was artistic and something of a spiritualist. Ryder took an interest in her painting and bought a few works to give as Christmas presents. Gradually, Louise came to consider herself "Ryder's only pupil,"[1] and, indeed, her paintings are like sweeter, sentimental versions of his own, painted with a tighter, softer touch (fig. 134).

In 1915 Ryder collapsed and was found on the floor of his room. He spent three months in Saint Vincent's Hospital in Greenwich Village, where the nurses embarrassed him with their ministrations. Miller visited him in the hospital and wrote: "The old man is nearly done. . . . He is clean. The effect is rather striking. I am not

Fig. 134. Louise Fitzpatrick, *Evening,* oil on canvas. The Butler Institute of American Art, Youngstown, Ohio.

sure I like it better—Not in every way at least. Something seems wanting, I thought. It irks him to be kept so."[2]

Unable to take care of himself after three months in the hospital, Ryder moved into the Fitzpatricks' home in Elmhurst, Long Island.[3] Most of his relatives had died, and his niece, Gertrude Ryder Smith (Edward's daughter), was unwell or unwilling to help.[4] Poor health and the distance from the city meant fewer visits from friends, so that Ryder's isolation deepened still more. Miller described him after his release as "half in another world now . . . delicate and shrunken but impressive still." But there was another difficulty; Louise Fitzpatrick, like so many of Ryder's friends, was overly protective. By February 1916 Miller said: "I don't see Ryder any more. He is in the clutches of a woman—as most men desire to be. She is hostile to all his friends and has driven them away. . . . He has

fondly loved her daughter—a child—for several years."[5] The Lebanese poet and painter Kahlil Gibran also wrote that Ryder was "in the clutches of a woman who is afraid if anybody goes there . . . that they are trying to take him from her. Several people have told me that she takes his pictures out and sells them and is taking care of the money for him."[6]

As Ryder's health worsened in early 1917 Louise Fitzpatrick invited friends to send little remembrances for his seventieth birthday. Nine days later, on 28 March 1917, Ryder died of complications from a chronic kidney ailment.[7] Although he had asked to be cremated, Louise Fitzpatrick sent the body to New Bedford for burial in the family plot at Rural Cemetery, near his brothers and parents. On 30 March a special train took friends from New York to New Bedford for a quiet ceremony, and on Memorial Day an artist's palette made of flowers was left at the grave of the colorist (fig. 135).

The obituaries were effusive but inaccurate, repeating scraps of stories that had long since become legend. But even while newspapers gathered these precious fragments, Ryder's "friends" grabbed for the few tangible items in his estate. He had died intestate, so his niece was appointed executor by the court; but on the day after the funeral she signed over full authority to Charles Melville Dewey, the painter who had restored *Moonlight* for William T. Evans in 1909.[8]

An immediate conflict developed over two paintings that were for sale at Knoedlers at the time of Ryder's death. Louise Fitzpatrick made it known that Ryder had given these to her, although she had neglected to mention this when consigning the paintings. She felt that proceeds of the sale should go to her rather than to Dewey. "I had quite a time to explain my right," she wrote to Wood, but the claim was finally settled in her favor, allowing her to pay off two mortgages on the house and help her husband's business. "I am doing just what poor dear Ryder would wish me to do, so you see the bread cast on the water did return, but oh, Mr. Wood, for the voice that is stilled."[9]

The question of what remained in Ryder's es-

tate is puzzling. One painter wrote, "The four or five canvasses [sic] left by him after his death were merely fumbled painted surfaces, quite unfinished, which I saw at the time, and which Dewey destroyed." But Olin Warner's widow claimed that a number of unfinished works "had rather mysteriously disappeared in a comparatively short time" after Ryder's death. Louise Fitzpatrick believed that Gellatly had bought "several . . . [of] the pictures they took away" and explained that Dewey said the others "were not in a state to be sold yet."[10]

The groundswell proclaiming Ryder an "old master" of American art that had begun as early as 1906 resulted in a memorial exhibition at the Metropolitan Museum in the spring of 1918 (figs. 136–37). Forty-eight works were gathered together, many restored and reframed especially for the event. The exhibition curator, Bryson Burroughs, hoped *Jonah* or some other important painting could be acquired for the permanent collection. Unable to meet Wood's high price for the masterwork, Burroughs prevailed on Sanden to leave five of his Ryders at the museum as long-term loans.

While the memorial exhibition was much in the news, Dewey wrote to the Worcester Art Museum proposing purchase of a group of Ryders—including previously unknown versions of *Christ and Mary* and *Forest of Arden* that were then in his own studio—so the artist would be well represented in his home state. He explained that he was "administrator of the Ryder Estate, and more familiar with his art than any other painter."[11] At the same time that he made this offer he had two other paintings on loan to the Metropolitan's memorial exhibition, neither of which had been previously known. By 1920 Dewey boasted six Ryder paintings; two more were lent by him to a Ferargil Gallery exhibition in New York in 1932. In due time other paintings emerged from the Ryder estate and were sold, each quite complete, most of decent size (a foot or more in each dimension, some larger), all of familiar subjects. Several were alternate versions of paintings known during Ryder's lifetime, such as *Christ Appearing to Mary, The Forest of*

Fig. 135. Memorial Day ceremony at Rural Cemetery, New Bedford, Massachusetts, 1917, from *New Bedford Centennial*, 29 June 1947 (courtesy of *New Bedford Standard-Times*).

Figs. 136–37. Installation views of the 1918 memorial exhibition at the Metropolitan Museum of Art, New York (courtesy of the Metropolitan Museum of Art Archives).

Arden, Plodding Homeward, The Story of the Cross, and, of course, the popular moonlight marines.

Some skeptics saw the miracle of the loaves and fishes in this proliferation of paintings. Yet we have Louise Fitzpatrick's word that a number of paintings were carried away from the Elmhurst home, and Sylvia Warner's mention that many "disappeared," so at least a few of Dewey's Ryders must have been unfinished works that Dewey completed and sold. He may not have bothered with the tiny ones, four of which were found in the Elmhurst home after Louise Fitzpatrick's death in 1933.[12]

That Dewey fabricated some "Ryders" can scarcely be doubted. He sold several paintings said to be from the estate, including *Autumn Meadows* (fig. 138), a forgery derived from *The*

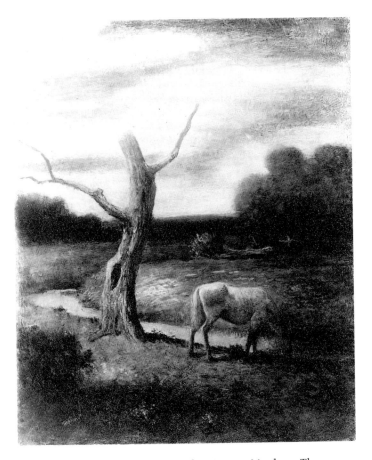

Fig. 138. Formerly attributed to Ryder, *Autumn Meadows.* The Metropolitan Museum of Art, New York.

Grazing Horse and *The Forest of Arden* (see figs. 2, 79).[13] His own Barbizon-style landscapes were rather similar to Ryder's; he was a friend of the artist and knew his method as well as anyone; his restorations allowed him to examine Ryders at close range and practice imitating their palette and brushwork. Separating his hand from Ryder's is a matter of judgment and connoisseurship, considerably affected by how one reads his intentions. Did he rush to snatch the estate because he feared leaving it with "Ryder's only pupil" or because he himself saw an opportunity for gain?

Meanwhile, Louise Fitzpatrick was enjoying new attention due to her friendship with Ryder. Gellatly, Weir, and Wood all took a kindly interest in the woman who had made Ryder's last years more comfortable. Burroughs asked her to help select the memorial exhibition and went to Elmhurst to admire her own work and encourage her to keep painting.[14] The Boston art dealer Robert C. Vose invited her to write biographical notes for a Ryder publication he was planning. Flattered, she invited Vose to Elmhurst, saying, "I own some other pictures by Mr. Ryder that I think you would like to see,"[15] including a picture she said Ryder had given her, a shepherd pointing at a wayside shrine, not unlike *The Story of the Cross* in the Ladd collection. She lent her version to the 1918 memorial exhibition.[16]

The Lorelei and *The Tempest* had been in Ryder's studio for decades, each advance and retreat reported to Wood in letters from Ryder and his friends, but in 1917 the two paintings were found in a wretched state. Wood asked Macbeth to sell them if possible; Macbeth answered they might find buyers if cheaply offered simply because of Ryder's name, but their condition was otherwise too poor to consider a sale.[17] Wood decided to let Louise Fitzpatrick restore them as she had asked to do, but before they were sent to her Weir did what he felt was necessary to *The Lorelei.* Fitzpatrick's additional work on *The Lorelei* angered Weir, so she wrote contritely to Wood that she had removed all her retouching.[18] Her extensive restoration of *The Tempest* went unchallenged. By then it was ru-

mored that she had mingled her own art too closely with Ryder's, signing his name to her own work. Some said that when Ryder was ill in his last years, she had prepared his palette and helped him paint and even made up "Ryders" from scratch.[19]

Louise Fitzpatrick's identification with Ryder had a mystical overtone. "I am very happy to hear about the Jonah, dear old Ryder is too," she wrote to Wood when he sold the painting after Ryder's death. As her health weakened over the next decade her obsession with spiritualism, painting, and Ryder grew.

Now I am working again with new hope and life—the picture that I started over twenty years ago but never even looked at for the ten years I am now finishing. I call it Dancers [?]. . . . I am now going to paint a "Christ Appearing to Mary" it shal have Light, Love, and Faith, for all who will look at it.[20]

As Ryder's so-called pupil, Louise Fitzpatrick began authenticating paintings that appeared on the market as early as 1918—paintings not previously known, somewhat sentimental and slack in execution.[21] She apparently also hoped to be paid as intermediary on sales. Although Gellatly arranged the purchase of Jonah directly by letter, Louise Fitzpatrick wrote Wood after the sale, implying that she was responsible for persuading Gellatly to his price and pointedly bringing up the matter of a commission:

I told [Gellatly] that it was no use to [offer less than twenty thousand dollars], that I know you well enough to feel sure that nothing les [sic] would get it from you, and to write to you himself at once or he might miss his opportunity alltogether as I knew some one else that wanted it; then he asked me if he might use my name saying that *I was willing to forego my commission* if you let him have the picture.[22]

After years of caring for Ryder during his illnesses and taking him into her home Louise Fitzpatrick no doubt felt entitled to whatever she could make from his work and reputation. But by falling under suspicion through her restorations, maneuvering for commissions, and authenticating questionable paintings, her opportunities drew quickly to a close. Long before her death in 1933, she was ignored and forgotten.

In 1920 the first book-length study of Ryder's art was privately printed in an edition of two hundred by Frederic Fairchild Sherman. Of Scottish heritage, Sherman was first introduced to literature through Sir Walter Scott's novels and was moved to write verse himself, leading eventually to a post at *Scribner's*. In 1911 Sherman began a decade as a private publisher with the new American Artists Series, and the following year he cofounded the journal *Art in America* with Wilhelm Valentiner, then curator at the Metropolitan Museum.[23]

The frontispiece for Sherman's Ryder monograph was *Sea Tragedy* (fig. 139), which he had purchased in September 1919 for $400 and sold two months later for $6,000. At the moment of this triumphant first sale Sherman purchased for $1,000 a second marine, *Homeward Bound* (see

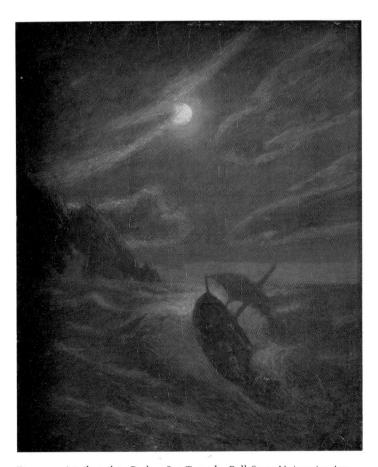

Fig. 139. Attributed to Ryder, *Sea Tragedy*. Ball State University Art Gallery, Muncie, Indiana, Frank C. Ball Collection, permanent loan from the Ball Brothers Foundation. L29.069.

fig. 98), which had belonged to Captain Robinson, then retired on a small pension in England. Sherman sold this painting to the Phillips Memorial Art Gallery in Washington, D.C., in early 1921 for $12,500, buying a cottage in Westport, Connecticut, and a touring car with his profit. Flush with success, Sherman became a professional art dealer in autumn 1921.[24]

Sherman's book was the first to list all known authentic paintings. He relied on the judgment of three painters who had known Ryder: Alexander Shilling, Albert Groll, and Elliott Daingerfield. The problem of forgeries did not daunt these connoisseurs or Sherman himself, who explained: "Of recent forgeries I have seen not more than six or seven and they were too poor to deceive anyone at all familiar with [Ryder's] work. The distinguishing marks of his hand are so unique in the painting of his time in this country that it is not really difficult to determine whether a picture is from his brush."[25] Sherman listed 130 paintings, several of which are today unlocated or disputed in authenticity. Many titles had never been mentioned in early articles, letters, or exhibition histories. Are these authentic paintings, renamed and thus disconnected from

their provenances? Or did they come forward from private collections only when the publicity over Ryder's death and memorial exhibition made them notable? Or do they bear witness to a rapidly accelerating market in forgeries? Most perplexing of all, what are we to make of the proliferating authentications by Shilling, Groll, and Daingerfield, some attached to paintings now identified as forgeries? Why did Sherman ignore Dewey's authority and Miller's obvious expertise? Publicly identified as "the best judges of Ryder's work," Shilling, Groll, and Daingerfield were invited to pen comments on many works that entered the market. Their three names do not appear among the scanty references to Ryder's early friends (except in Sherman's writings and their own accounts) nor did they often penetrate Ryder's deepening isolation late in life; yet they unconditionally authenticated many paintings, sometimes noting that they had personally seen the work in Ryder's studio.

Sherman was excessively gullible at best or culpable at worst. He acquired for his own collection paintings that did not stand the test of time, including *Dance of the Wood Nymphs* (fig. 140), a pastiche of *Dancing Dryads* and *The Poet on Pegasus* (see figs. 53, 89), and several others that he later publicly disparaged. One passage he wrote in his book reads like an announcement for a forgery:

Of one of [Ryder's] earlier works I have as yet been unable to find any trace, which is all the more regrettable as I cannot but believe that it would be likely to enhance our opinion of his ability. The picture to which I refer is the Nourmahal exhibited at the Society of American Artists in 1880. As it is not described in any of the newspaper notices of the exhibition one can only imagine its appearance, but the conclusion seems safe that when the canvas reappears, as it probably will some day, it will be found to belong with his few masterpieces.[26]

The certainty with which Sherman anticipated the reappearance of this undescribed masterwork was rewarded less than four years later when a painting turned up under the title *Oriental Scene,* quickly identified as a scene from Moore's *Lalla*

Fig. 140. Formerly attributed to Ryder, *Dance of the Wood Nymphs.* Private collection.

Fig. 141. Formerly attributed to Ryder, *Nourmahal*. The Metropolitan Museum of Art, New York, Morris K. Jesup Fund, 32.67.2.

Rookh, of which Nourmahal is the heroine (fig. 141). Daingerfield and Groll proclaimed its authenticity and quality, and several years later Shilling added his endorsement. As Sherman had noted, no contemporary descriptions existed, so the image could not be disputed, although one might wonder about the large size of the canvas—19½ by 28½ inches—considering that all Ryder's 1880 submissions for exhibition were reviewed as "very small." *Nourmahal* went first to a private collector but was purchased in 1932 for the Metropolitan Museum, fulfilling at last curator Burroughs's dream of owning a major Ryder painting.[27]

Burroughs had coveted *Nourmahal* since it first appeared in March 1924, and with good cause; just the month before he had learned that Sanden was removing the five major Ryders still on loan to the museum in order to sell them (along with another five or six) to Ferargil Gallery for thirty thousand dollars. Ferargil Gallery, co-owned by Thomas H. Russell and Frederic Newlin Price, thus gained the most important group of Ryders apart from the Gellatly collection and in a stroke became the best commercial source of

Ryder's art. Ryder had directed a number of unusually fine paintings to Sanden, who paid him a monthly stipend for many years: *Forest of Arden, Gay Head, Macbeth and the Witches, Night, The Race Track, Under a Cloud, Weir's Orchard, The Windmill,* and others.[28] Using these paintings as bait, Price wrote to collectors and museums around the country over many years, offering an ever-shifting stock of Ryders for the discriminating connoisseur. The fame of the Sanden collection was so great that Price could ask a much higher price for those works than for others that he acquired—most of which had only recently come to light, although they emerged from obscurity with impressive documentation, elaborate provenances, and sometimes a black oval "Cottier & Co." stamp on the stretcher.[29] Collectors and curators bought these less-expensive items, which were often, suspiciously, slightly larger than the Sanden paintings. Thus, while many "Ryders" were sold by Ferargil Gallery, several from the Sanden collection stayed in stock, bringing prestige to the firm.

Any commercial gallery dealing so heavily in Ryder's works needed a conservator's services,

Fig. 142. Horatio Walker, *Ave Maria,* 1906, oil on canvas. Art Gallery of Hamilton, Canada, gift of the Women's Committee, 1963.

Fig. 143. Horatio Walker, *The Smugglers (Contrebandiers),* 1928, oil on canvas. Musée du Quebec, Canada, 34-534-P.

even though collectors expected to find the works cracked and murky with varnish. Price was fortunate in this regard, for he also handled the paintings of Horatio Walker, a Canadian artist working in the Barbizon manner who claimed to have been the friend who taught Ryder how to cash checks. Known as the "American Millet," Walker painted large canvases of humble peasants laboring in fields or worshiping at wayside shrines (fig. 142), and he specialized in barnyard scenes of hogs.[30] In the 1920s, however, with modernism on the rise, the demand for spiritualized porcine subjects waned, and Walker found his indulgent, even lavish lifestyle somewhat constrained. By about 1927 he agreed to help with work on Ryders sent to him by Price.

Only one side of the correspondence between Walker and Price survives, but it shows a brisk traffic in Ryders between New York and Walker's home in Saint-Petronille, Canada. In 1928 Walker asked Price: "How about the Ryder you handed me on leaving. *Is it yours?* Will do anything *for you* in this line, but it *must be yours.* Have, I think, given you a short disertation [*sic*] on the subject." Several letters later he wrote Price an enigmatic note: "Did you ever receive the Ryder? Is there anything more of our friend, the lawyer? who evidently was trying to make a case."[31] Another intriguing letter reads: "Am going to Quebec in a couple of days, and will ship the Ryder. . . . Ran out of the magic stuff and only got some more a week ago. Had a hard time with it but it has [illegible] out in fine shape."[32] At the same time as this suspicious correspondence Walker turned to painting one of Ryder's favorite subjects—pirates smuggling contraband (fig. 143)—a strange choice that seems at once an ironic homage to Ryder and a sly acknowledgment of Walker's situation.

The pace quickened as Price planned a major exhibition and book on Ryder for 1932. As the depression deepened, spiritual values and self-sufficient, noble poverty held a special appeal, as Price surely recognized. His catalogue introduction for the 1932 Ferargil Gallery exhibition repeats the old myths with new embellishments and an elastic approach to facts. Price aimed at a

higher truth through style: "[Ryder] dreamed and dreaming dwelt with masters gone these centuries. . . . He rose among our arts a white, pure free flame, uninfluenced except by the sacred figures of his most devoted soul."[33] But the motto for this catalogue is caveat emptor. The frontispiece strikes the keynote—a self-portrait (fig. 144), unknown during Ryder's lifetime, showing the artist at his easel, silhouetted against a curtained window; near the window hangs the "masterwork" *Nourmahal,* purchased by the Metropolitan just in time for the museum to be credited as owner in the catalogue.

Two hundred and two panels and canvases were assembled for the 1932 Ferargil Gallery exhibition, yet almost immediately skeptics suspected that there were scarcely more original Ryders in this ensemble than in the 1918 Metropolitan memorial exhibition, which had numbered a mere forty-eight works. Dewey was outraged by both the show and catalogue; a list was made up of "right" and "wrong" paintings according to his judgment, the latter category vastly larger.[34] Rumors circulated about Price's curious knack for finding new Ryders, about employees who made paintings to order, about forgery "factories" in Philadelphia, Chicago, and elsewhere. Suddenly, there were simply too many moonlit marines and versions of other subjects. Price's merchandising of Ryder's integrity coincided with the opening of new Americana and folk-art markets, but in his greed he oversold Ryder's stock, triggering a strong backlash.

For twenty years Sherman had been steadily publishing articles on Ryder's art announcing newly discovered works, but in 1936–37 he reversed himself and published two articles listing forged and disputed paintings, including some in his own collection.[35] Sherman had seen the tide turning and joined the opposition, hoping perhaps to salvage his own reputation.

At about the same time a young friend and former student of Kenneth Hayes Miller at the Art Students League began to take an interest in the proliferation of Ryders. Lloyd Goodrich, then a curator at the Whitney Museum of American Art in New York, collected everything he could find about the artist, interviewing patrons and colleagues and canvassing dealers' files for letters, sales records, and photographs. He worked with Brooklyn Museum conservator Sheldon Keck to examine many paintings under the microscope and with ultraviolet light, refining their knowledge of Ryder's technique. Most significantly, they X-rayed many paintings—a procedure recently introduced into the study of art—and quickly discovered a curious thing: the compositions of original paintings were generally visible in the X-ray, while the films of forged works often showed only a blank, undifferentiated smear.[36] Apparently, the forgers simulated Ryder's heavy paint films by lathering a thick ground over the support, then painting the image in a single layer and covering it heavily with varnish. The image was simply too thin to register on an X-ray, especially when blocked by heavy elements in the thick ground. In his 1959 book on Ryder, Goodrich published this interesting diagnostic approach with illustrations.[37]

Fig. 144. Formerly attributed to Ryder, *Self-Portrait.* Unlocated (courtesy of Peter A. Juley & Son Collection, National Museum of American Art, Smithsonian Institution, Washington, D.C.).

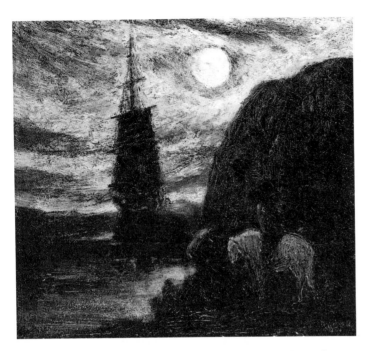

Fig. 145. Formerly attributed to Ryder, *The Smuggler's Ship*. Yale University Art Gallery, New Haven, Connecticut, bequest of Doris M. Brixey, 1984.32.71.

Goodrich's sleuthing was reported to Price, who was still smarting from having so many of his works appear on Sherman's published blacklists of dubious works. In 1938 curiosity and mounting apprehension led Price to write to Goodrich:

Words and words have come to me anent a Ryder book you are writing. As far as I can remember you have not troubled to see or inquire about my important collection of this American master. . . . Many people have advised me that you and your dealer group openly condemn many of my paintings, almost all of which have been expertised by Horatio Walker. . . . I believe that my opinion is quite as good as the next so-called expert.[38]

The correspondence continued through the spring and early fall, with Price alternately threatening and accommodating, still hoping to find out just what Goodrich knew and how he knew it. "I am still curious and deeply interested in your experiments. I would like very much to know what you find out and how you are arriving at decisions. Unfortunately, the only man I trusted on Ryder, Horatio Walker, has just passed away. Walker knew Ryder's art, pigment and process."[39]

As Goodrich continued to examine Ryder's art from every angle—technique, history, documentation, and connoisseurship—he developed an exceptional expertise, gradually introducing sound scholarship into the chaos that surrounded the Ryder name in the mid-1930s. For more than half a century until his death in 1987, Goodrich worked to extricate Ryder from the fakes and misinformation that had accrued to his reputation. Goodrich's 1947 Ryder centennial exhibition at the Whitney and his 1959 monograph on the artist went a long way toward clarifying the record.

What do we learn from the confusion surrounding questions of authenticity? It seems likely that when originals and forgeries are at last clearly separated, we will be able to trace the evolution of Ryder's reputation visually through the hundreds of forgeries as well as in the written record. The "sweet, gentle Innocent" comes

through in some early disputed works, the "fervent spiritualist" or "lush colorist" in others; the "modernist master of two-dimensional design" dominates sometimes or the "vigorous expressionist" or "awkward unskilled naïf." Like an ink blot, Ryder's myth assumed different shapes and meanings for different viewers, accounting in part for his continuing popularity.

It is tempting to believe that the inner quality of Ryder's paintings will somehow surface to shame the mediocre efforts of his imitators, but down this path lies a trap. Precisely because the forgeries were made to capture some deeply affecting aspect of the Ryder myth, many are convincing. Some forgeries are more satisfying, "more like Ryder" than certain difficult, but completely authentic, paintings, such as *The Story of the Cross,* with its curious figures and unusual coloring (see fig. 94). *The Story of the Cross* is an acquired taste, but once we learn to see its highly idiosyncratic beauty, we know something new about Ryder's search to equal the severe spirituality of the Sienese primitives.

The attraction of the forgeries lies more on the surface, appealing to what we expect and confirming what we know rather than teaching us something new; nonetheless, the appeal must be acknowledged. Clement Greenberg knew this when he wrote of one forgery:

[It] manages to be a rather good picture precisely because it takes nothing from Ryder except his manner, leaving out the difficult intensity and originality of emotion he could not realize often enough in his own work. While Ryder could not always meet the high terms he set himself, the forger, even though he was only a hack, could meet them when reduced.[40]

From the forgeries, we re-learn the lessons of many cautionary tales—that when something seems too good to be true, it probably isn't; that the experts are often wrong; that memory is fallible. Most of all, however, we learn a certain temperance in our own judgments. So many of the fakes based on other forgeries look blatantly wrong today (figs. 145–46) that we may imagine our eyes have learned to distinguish the true from the false in every case. But since forgeries were made even during the artist's lifetime by those who knew his method and materials, it may never be possible to sort them entirely through lab analyses, beyond the reach of any appeal or opinion. To decide whether Ryder painted a disputed work we will have to continue to ask the most important but difficult question—What man was he? ᔒ᙮ᖇᕱ

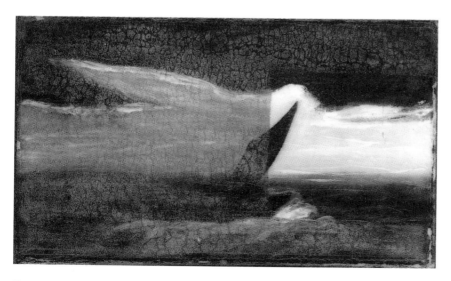

Fig. 146. Formerly attributed to Ryder, *Seascape with Sailboat* (partially cleaned). National Museum of American Art, Smithsonian Institution, Washington, D.C., 1964.16.1.

Converts to
the Imagination

Scores of young artists found Ryder's triumph at the 1904 Comparative Exhibition and the 1913 Armory Show inspiring, although few cared to follow his solitary and eccentric path. Different artists absorbed various aspects of his art into their own. Almost every American moonlit landscape or marine from the first decades of the century carried some overtone from Ryder, whose influence, according to one writer, was like "distant thunder."[1] Marsden Hartley commented at Ryder's death that he was "so much the legend among professional artists,"[2] and indeed the list of those whose style veered toward Ryder's for a while or who borrowed from his repertory includes many names both familiar and obscure in early twentieth-century painting, including Albert Bloch, Oscar Bluemner, Elliott Daingerfield, Arthur Dove, Rockwell Kent, Yasuo Kuniyoshi, Sydney Laurence, Ernest Lawson, John Marin, John Noble, B. J. O. Nordfeldt, Will Henry Stevens, Max Weyl, Marguerite and William Zorach, and many others. For a few artists, however, Ryder's art became a preoccupying ideal, a touchstone against which they measured their own efforts.

Ryder's funeral preceded by exactly one week America's entry into World War I; his declining years were almost a metaphor for the isolationism that ended so abruptly with that military intervention. Artists had experienced the period of isolation with a special sadness. Despite the best efforts of critics and a few dedicated collectors, no native artistic tradition had taken root in America. The generation of artists to which Ryder belonged, unable to escape European influence, moved from optimism about national culture to anxiety and depression. Even their triumph at the 1893 World's Columbian Exposition came to seem merely a moment of perfect imitation and futile ambition, a lovely flower that produced no seed. J. Alden Weir, deeply sensitive to America's mood, was one of several who became despondent and found it increasingly difficult to summon energy for work.

With hopes for a national school dimmed and a growing separation of the political and artistic spheres, some painters began to conceive of art as a private world of inner feelings and beautiful dreams, lacking reference either to nature or culture beyond that conjured by the artist in a

moment of reverie. Arthur B. Davies created just such an enchanted world, a never-never-land inhabited by dreamy maidens, children, white horses, and unicorns. His debt to Ryder is early and clear, although we know little of how the friendship between them began, nor can Davies's paintings be securely dated.

Davies paid direct homage to Ryder in his version of *The Flying Dutchman* (fig. 147), but for the most part he drew more subtle inspiration from Ryder's oeuvre. *Breath of Autumn* (fig. 148) shows how closely Davies observed such paintings as *Spring, Woman and Staghound,* and *Roadside Meeting* (see figs. 29, 70, 83). The mother and child, white horse, and massive, almost animate trees are quotations from Ryder, softened in mood. Davies carefully studied Ryder's style, particularly the intimate, small format, attention given to edges where positive and negative shapes meet, jewellike glazing, and expressive, unsystematic brushwork that conveys touch while disdaining skill.

Davies's *On the Road to the Enchanted Castle* (fig. 149) brings to the surface an escapism implicit in Ryder's art and life—a storybook "land of legend" and "hushed horizons."[3] By removing the literary references that gave Ryder license to portray knights on horseback and hilltop castles, Davies introduced a certain arbitrariness into his imagery. This could be any knight, any maiden, any enchanted forest—it matters little, as long as we recognize that they are not of our world but denizens of a better, golden realm of the imagination. Davies cut "fancy" adrift from the accumulated, real experience that grounds Ryder's literary sources and gives his images weight. Where Ryder drew on dramatic scenes from plays, books, and poems, Davies was distanced from literature, unwilling to link his art to specific narratives yet still nostalgic for the higher values they represented. Ryder presented fictions that distilled truth from experience, while Davies's fancies conveyed a bittersweet sense of loss.

Davies discovered his affinity with Ryder in the 1890s and met him soon after, when the older artist's reputation still rested on lush, gem-

Fig. 147. Arthur B. Davies, *The Flying Dutchman,* oil on canvas. Courtesy of Sotheby's, Inc., New York.

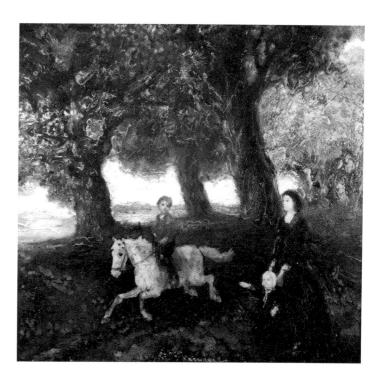

Fig. 148. Arthur B. Davies, *Breath of Autumn,* oil on canvas. Collection of Mr. and Mrs. Herbert Baer Brill, Brooklyn.

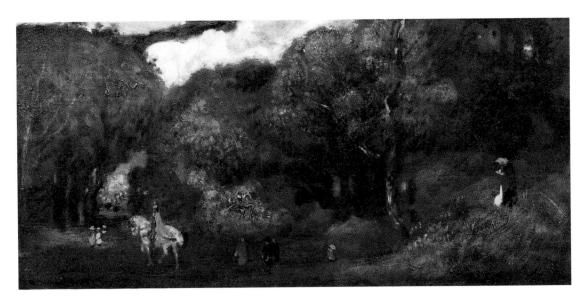

Fig. 149. Arthur B. Davies, *On the Road to the Enchanted Castle*, oil on canvas. Courtesy of Babcock Galleries, New York.

like colors and glowing surfaces. The affecting combination of innocence and delicate sensuality in Ryder's art attracted him especially. His early, Ryderesque work aimed for a similar richness and ideality, but it sometimes slipped into preciousness, dwelling on the past, opening no door to the future.

In the first decade of this century the innocence of Davies's early paintings gave way to a more overt sensuality, evident in his frequent use of nudes and in the vibrant colors of his oils and pastels. The change reflected his personal circumstances, for around 1905 he began to live a double life, one centered on his wife and the other on his mistress. For twenty-five years he maintained two residences and a remarkably compartmentalized existence, neither household knowing of the other. Each was a closed system focused on a sexual relationship and the children born of it, hermetic in its isolation. Privacy deepened into profound secrecy, yet to judge from his increasingly vague, etherealized art, Davies managed to reconcile in his own mind his profoundly sensual nature with an elevated, late-Victorian idealism and spirituality. In life as in art, he invented private, enchanted worlds, in which sensuality coexisted with innocence. Many

factors influenced the shift, but in Ryder's art and the privacy shrouding his late years Davies found a model for an existence removed from "real life," one that merged aesthetic philosophy and personal experience. Davies lived the sensuality that Ryder put into his art.

Through his organization of the Armory Show, Davies was among the first Americans to explore in depth the innovations of European modernism. There he found the ultimate escape into the "enchanted world" of pure color and composition that kept subject, narration, and personal disclosure at a safe distance. Yet even on this occasion he paid homage to Ryder by featuring his art in one of the central rooms of the armory reserved for patriarchs of the avant-garde. Modernist critics had recently claimed that Ryder's contribution lay not in sentiment or subject but in formal values; Ryder's "reassignment" from the ranks of the traditionalists to the avant-garde, although imposed on him by critics, reinforced Davies's own evolution. Davies redirected his vision but kept constant his hero. Leading Ryder on his arm slowly through the Armory Show, he managed—as would others in the future—to integrate Ryder into a new, shifting landscape of art rather than relinquish him to the past.

Davies is a crucial figure in tracing Ryder's impact. At the Armory Show he scripted Ryder's new role as a father of modernism, leading subsequent artists—even those like Kuniyoshi or Bellows, whose personal concerns were far removed—to link their aspirations to his struggle and achievement. This updating of Ryder's image happened not once but many times, as critics, artists, forgers, and restorers constantly adapted the Ryder story to suit changing needs. Forgers and restorers, always accentuating something emblematic or especially meaningful about his art, kept Ryder's influence current by inadvertently injecting their work with contemporary ideas about his art. Forgeries that today look wrong by virtue of their accentuated flatness and geometrization were, in their day, appealing to a generation of artists devoted to formal values and abstraction.

The repressed tension between men and women in Ryder's art—revealed in their differing social stations or in the unbridgeable gulf dividing divine and earthly beings—was profoundly sexual, although veiled in spiritual ideals. Davies was not alone in feeling this current of emotion in Ryder's works. Kahlil Gibran, a Lebanese painter in America suffering from an extreme case of repression that manifested itself as a "master-passion for the Great Reality,"[4] felt a special kinship with Ryder and wrote a prose poem hailing him as the prophet of "primal truth and unveiled visions," in which "souls of unborn worlds dance in rhythmic ecstasies." Walt Whitman was well known for inspiring free-thinking sensualists through his explicit poems and personal relationships, but, remarkably, Ryder, too, despite the chasteness of his art and apparent limitation of his own experience, also gave courage to those seeking the "primal truth" of a sexual awakening. Pinkney Marcius-Simons, Claude Buck, and other American symbolists occasionally borrowed a strain or two from Ryder, creating their own "enchanted worlds" of symbol and sexual longing.[5]

Another acolyte and friend during Ryder's last years was the young painter Kenneth Hayes Miller. Miller was born into the Oneida community in New York, a perfectionist religious group that believed the Second Coming had already occurred, opening paradise on earth for those who would live a sinless life. Within the Oneida community Miller enjoyed special status, for his father was a nephew of the founder, John Humphrey Noyes, and was chosen to look after Noyes in his last years. Although Miller left the community to become an artist and live in "the world," he carried with him the feeling of being chosen for distinction as well as an intense moral and ethical imperative.

When Miller met Ryder, the younger artist was deeply unhappy about his marriage to a woman who sought to perfect her own spiritual character by abstaining from sex. Miller divorced her in 1910 but spent years before and after anguishing over the situation. During this period his subjects varied from such Barbizon favorites as *Faggot Gatherers,* 1902 (unlocated), to symbolist themes such as the male and female principles embodied in *Two Figures* (fig. 150).

As Miller grew closer to Ryder's world he more directly linked his art to his mentor's. In 1913 he painted Ryder (see fig. 123) as a broad-shouldered patriarch, similar to his 1896 gouache portrait of one of the Oneida patriarchs, Theodore Noyes. And for four years he labored over *Christ and Mary,* known also as *Apparition* (fig. 151), restating the primal male and female relationship in a vocabulary specifically identified with Ryder.

Ryder embodied Miller's values; he was oblivious to possessions but not abstemious, wholly devoted to art, living somewhat apart from the world but still within it—a poet expressing the higher life. Just as Miller's father had ministered to the Oneida founder in his last years, Miller felt responsible for Ryder in his last decade, calling frequently to check on his needs.

Miller found in Ryder a patriarch or "founder," whose life in art was as principled and selfless as the vocations of those in the Oneida community. Ryder's tiny apartment was a kind of halfway house for Miller's entry into the secular world, where art was substituted for the religious commitment he could no longer sustain. Beginning

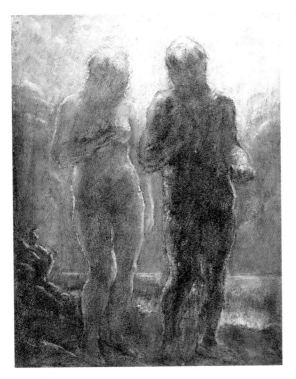

Fig. 150. Kenneth Hayes Miller, *Two Figures,* oil on canvas. Unlocated (courtesy of Peter A. Juley & Son Collection, National Museum of American Art, Smithsonian Institution, Washington, D.C.).

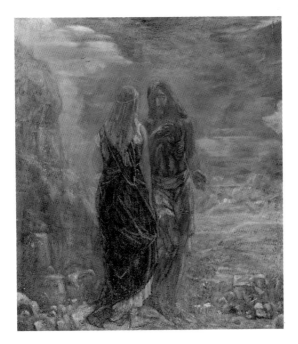

Fig. 151. Kenneth Hayes Miller, *Apparition,* 1913, oil on canvas mounted on cardboard. The Phillips Collection, Washington, D.C., 1923.

in 1916, however, influenced by the writings of two more "founders," Freud and Jung, Miller began to detach himself from both perfectionist religion and artistic spirituality. After Ryder's debilitating illness in 1915, Miller's quasi-religious devotion slackened, and he confided to Rockwell Kent, "Poor Ryder is himself an ancient ruined temple: the altar fire is out."[6] In April 1917, two weeks after Ryder's death, Miller reported an "expanded feeling, less restraint"; in late July he reported, "I have never enjoyed New York so much, nor sensed it so richly as I do now."[7] The result was a conversion to contemporary life, in which shoppers became the main source of inspiration.

In a long career as an instructor at the Art Students League, Miller translated his early attraction to Ryder's spirituality into something more concrete and easily taught. By rendering accessible Ryder's esoteric appeal, Miller brought this outsider into the very bosom of the academy, institutionalizing his influence. Miller excelled in teaching the formal and technical aspects of painting—how to achieve a dark, transparent veil of color like the Venetians or lodge figures securely within the middle planes of an image or clarify the architectural relationships within a composition. "Ryder had all sorts of ideas about poetry, sentiment, feeling; but what is really outstanding about his work is what you can grasp between thumb and forefinger," he wrote. "[Ryder] groped among the plastic fundamentals until he unearthed the foundation on which Giorgione and Titian built."[8] Whereas Davies considered Ryder a precursor of the modernists, Miller made him seem a successor to the Renaissance masters. Either way, Ryder was established as a leading American "founder" for generations of art students, both vanguard and traditional. Caught up in the twentieth century's discovery of formalist structure, neither Davies nor Miller acknowledged how much their first love of Ryder had depended on "poetry, sentiment, feeling."

One who fully acknowledged this attraction, feeling it even as a dangerous enticement or seduction, was Marsden Hartley, whose career

was precariously poised between the cerebral classicism engendered by cubism and a personal, symbolic expressionism.[9] Although his work and time were divided between the two impulses, the "objective" periods seem like long interludes interrupting the fundamental romanticism with which he began and ended his career. Cézanne's memory presided over the intellectual aspect of his art, leading Hartley to discipline his forms and colors and achieve a modernist style as advanced as any in his generation. But at key points in his career this progress was abruptly set aside as the tragic, brooding figure of Ryder—for so Hartley conceived him—became alter ego of his darker, solitary self.

Hartley told how he first saw one of Ryder's paintings in the Montross Gallery in 1909, an experience that he said "shook the rafters of my being":

This picture was a marine by Albert P. Ryder—just some sea, some clouds, and a sail boat on the tossing waters . . . and when I learned he was from New England the same feeling came over me in the given degree as came out of the Emerson's Essays when they were first given to me—I felt as if I had read a page of the Bible. All my essential Yankee qualities were brought forth out of this picture . . . it had in it the stupendous solemnity of a Blake mystical picture and it had a sense of realism besides that bore such a force of nature itself as to leave me breathless. The picture has done its work and I was a convert to the field of imagination into which I was born.[10]

Hartley began his "black landscapes" almost immediately, filling them with Ryder's peculiar "force of nature," Emerson's "biblical" Yankee qualities, Blake's "solemnity," and the mystical dualisms he discovered at Green Acre, a spiritualist community in Maine, where he had spent the summer of 1907. In this first wave of response to Ryder's art, Hartley felt a racial and regional kinship, a return to the original Yankee transcendentalism and to the traditions of Nordic spiritualism. He continued to express this urge throughout his career in paintings of such "magic mountains" as Mount Katahdin and Garmisch-Partenkirchen.

Although he lived just a few blocks from Ryder in Greenwich Village and sometimes saw the aging man shuffling through the neighborhood, Hartley did not wish to intrude on his privacy and so visited him only occasionally. Indeed, since Ryder was for Hartley the very embodiment of his own loneliness, a closer friendship would have been not only an intrusion but a violation of the symbol Ryder had become. Keeping his distance, Hartley also was able to maintain his own understanding of Ryder's intentions and art. While those who knew Ryder spoke always of his cheerful disposition and good nature, Hartley saw rather his own youthful despair grown more serene although no less acute—a fulfillment of the terrifying promise of a life lived solely for art.

In the landscapes such as *Deserted Farm* (fig. 152) that Hartley made after exposure to Ryder's works, the powerfully massed mountain forms, thick, undulating tree trunks, and dense clouds pressing against horizon and canvas edge all convey a sense of overwhelming physical weight and gravity, as if these landscape elements, bloated

Fig. 152. Marsden Hartley, *Deserted Farm,* 1909, oil on canvas. University Art Museum, University of Minnesota, Minneapolis, gift of Ione and Hudson Walker, 61.2.

Fig. 153. Marsden Hartley, *Gull,* 1942–43, oil on composition board. Collection of Edith and Milton Lowenthal, New York (courtesy of the Brooklyn Museum).

Fig. 154. Marsden Hartley, *Seahorse and Shrimp,* 1942, oil on canvas. Private collection (courtesy of Salander-O'Reilly Galleries, New York).

and heavy with accumulated emotion, would crowd each other out of the overburdened pictorial space. These are Ryder's concentrated, overdetermined forms carried almost to the point of excess, the artist's urgency investing every shape with painful majesty.

Against such tormented outbursts, the intellectual rigor of cubist formalism was tonic. Hartley's musical abstractions and military-emblem paintings made in Germany from 1913 to 1915 and the elegant Provincetown abstractions of 1916, composed of thin planes so different from the bulky Ryderesque landscape forms, all spoke a formalist language while voicing an expressive message. In the midst of developing his modernist vocabulary Hartley wrote to Franz Marc, "I am by nature a visionary," allying himself with

those who "go away into the interior (oneself)" to discover a "natural and genuine naïveté."[11] He listed those who had achieved true purity, who were "helpless before the vision," singling out Giotto and Fra Angelico, Rousseau, and the "fine American visionary Albert Ryder—who has spent his life following the dictations of his vision the results of which are so beautiful and so pure." In linking Ryder with Renaissance and modern primitives he continued an association begun as early as the 1890s.

By the early 1930s Hartley experienced periods of depression and persistent illness and was unable to sell his paintings. He was dependent on federal relief programs and once destroyed a hundred paintings that he had no room to store. Then, in 1935–36, he lived for a time in a Nova

Scotia fishing community with the Mason family, whose simple existence on the margin of land and sea restored his belief in life and friendship. Hartley's fragile emotional world was devastated by the drowning of the two Mason boys in September 1936, for their intimate affections had helped draw him out of persistent despair.

Resurrecting Ryder's memory at this moment of deep affliction, Hartley painted images of marine life isolated against vacant fields of color. As a group, these paintings recall Ryder's *Dead Bird* (see fig. 58), a relationship made explicit in several pictures of dead plovers and gulls (fig. 153). But the poignancy is even stronger in *Seahorse and Shrimp* (fig. 154) for being more transformed. Vulnerable despite their shells, these tiny creatures seem a fragmented memory of *The Dead Bird*—the two aligned shrimp tenderly recalling tiny lifeless bird legs and the coiled form of the seahorse evoking the enclosed, oval-coffin shape on which Ryder's dead songbird lies.

In 1936 Hartley also began a sequence of dark seascapes (fig. 155) in which jagged angles of rocks, waves, and clouds intrude on sea and sky—two gray blue infinities knit together by the sails of tiny drifting boats dredged from Hartley's memory of Ryder's marines. From the crisis of 1936 until his own death in 1943, Hartley explored the full range of Ryder's formats and symbolic language, from the direct expression of *The Dead Bird* and the marines to the formal, iconic symbolism of Ryder's literary subjects. Just as Ryder presented *The Poet on Pegasus* (see fig. 89) as his homage to creativity, Hartley painted a paean to spiritual inspiration in *Give Us This Day* (fig. 156), changing Ryder's mythological references into a Christian vocabulary more appropriate to the Masons' beliefs. As Ryder had transformed his earliest subject—the humble cart horse—into Pegasus arriving in the land of the muses, Hartley made over the common gull as the winged emblem of Christian inspiration—the Holy Spirit, arriving on earth to console and inspire. In such paintings Hartley showed himself to be Ryder's most sensitive and subtle heir, able to grasp the deepest resonances of his art, and the only painter to maintain exactly Ryder's

Fig. 155. Marsden Hartley, *Northern Seascape, Off the Banks*, 1936–37, oil on cardboard. Milwaukee Art Museum, bequest of Max E. Friedman, M1954.4.

Fig. 156. Marsden Hartley, *Give Us This Day*, 1938–39, oil on canvas. Shaklee Corporation, San Francisco.

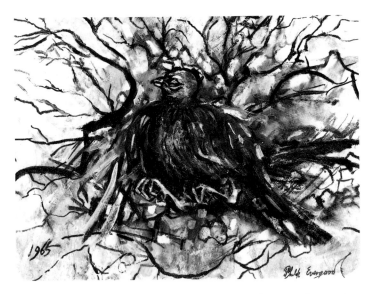

Fig. 157. Philip Evergood, *Dead Sparrow*, 1965, oil on panel. Collection of Lawrence P. Arine, Palm Springs, California (courtesy of Christies, Inc., New York).

Fig. 158. Morris Louis, *Bird*, 1941, oil on canvas. Private collection, New York.

delicate balance of subject and symbol, nature and spirit.

From 1936 until his death seven years later Hartley lived out his identification with his alter ego. He painted a memory portrait of Ryder in 1938 (see fig. 122), perhaps his first figure painting, inaugurating a sequence of imaginary portraits of heroes and mystics. The memory portrait of Ryder was related to a poem Hartley wrote called "Albert Ryder—Moonlightist," which identified him as an "ancient mariner," literally and figuratively as an outsider, gazing at a Christmas party through a window.[12]

Hartley's first literary homage to Ryder had appeared in 1917, a sympathetic appreciation of the artist's "incomparable sense of pattern and austerity of mood."[13] But in 1936, believing Ryder's sufferings wholly kindred to his own, he again set down in print his despair at the world's indifference and his reasons for believing that "if America is to have a great tradition, it will begin with the great and lasting name of Albert Pinkham Ryder."[14] Hartley began his reminiscence with a bitterly ironic statement about those who believe that "in order to produce good work, the artist must be all but throttled with poverty." Although he later admitted that "there is rumour that Ryder was not utterly poor, that there were checks lying about for months uncashed," he saw his own grinding poverty in the clouded mirror of Ryder's life, just as he saw his creative aspirations reflected there. His passionate description of Ryder's simplicity, poverty, naïveté, "Franciscan faith and purity," lovesickness, and "solid background of fishermen, carpenters, masons and such" tells even in its choice of words how intimately Hartley identified his own experience with Ryder's, conceiving him as the prophet whose martyrdom prefigured his own. Hartley's response to Ryder is extreme but paradigmatic, for it depends almost equally on Ryder's art and life, the first conceived as the perfect expression of the second. Undoubtedly, this perfect marriage accounts for the unparalleled influence that Ryder has had over painters of our century. Hartley's passion for Ryder affected others in the Stieglitz circle such as Dove and Bluemner,

Fig. 159. Andrew Wyeth, *Winter Fields*, 1942, tempera on canvas. Whitney Museum of American Art, New York, gift of Mr. and Mrs. Benno C. Schmidt in memory of Josiah Marvel, 77.91.

Fig. 160. Chaim Soutine, *Dead Pheasant*, 1926–27, oil on canvas. The Phillips Collection, Washington, D.C., 1950.

Fig. 162. Jackson Pollock, *Black and White Painting I*, ca. 1951, black paint on canvas. Copyright Artists Rights Society, Inc., New York, Pollock-Krasner Foundation, 1988.

Fig. 161. John Graham, *The Yellow Bird*, ca. 1930, oil on linen. Weatherspoon Art Gallery, University of North Carolina, Greensboro, gift of Jefferson Standard Life Insurance Company, 1970.1696.

whose glowing suns and moons remove their landscapes from the visible world to a higher transcendental plane.[15]

Ryder's motifs turned up far and wide, in the most stylistically diverse objects. Those Ryder paintings that were consistently on public view had the widest impact: *The Dead Bird* at the Phillips Collection, *The Flying Dutchman* and *Jonah* at the National Museum of American Art, *Moonlight Marine* and *Toilers of the Sea* at the Metropolitan Museum. The motif of the dead bird, to take one example, turns up in paintings by Hartley, Evergood, Morris Louis, Andrew Wyeth, Chaim Soutine, and—in a much transformed way—John Graham and Jackson Pollock (figs. 153, 157–62). This subject had a long history before Ryder's small panel, but his example was the most visible, and usually some direct connection to Ryder's example can be located.

Fig. 164. James Lesesne Wells, *Jonah and the Whale*, 1959, woodcut. National Museum of American Art, Smithsonian Institution, Washington, D.C., 1969.34.2.

Fig. 163. John Flannagan, *Jonah and the Whale*, 1937, cast stone. Virginia Museum, Richmond, gift of Curt Valentin, 46.15.1.

Graham, for instance, painted *Yellow Bird* in 1930, at the height of his friendship with the ardent Ryder champion Duncan Phillips, in the year following Graham's own one-person exhibition at the Phillips Collection (then the Phillips Memorial Art Gallery), where Ryder's *Dead Bird* was on view, and in the same year that it was lent to an exhibition at the Museum of Modern Art in New York.

In tracing such relationships the visual connection to Ryder can be stretched very thin without losing its poignancy: Pollock's abstraction of about 1951 (fig. 162) only resolves as a dead bird for those who bring to it a familiarity with Ryder's image, yet once recognized, we find the familiar points of reference—the fragile legs, semblance of skeletal structure and wing feathers, and, above all, sense of stilled life, a "gesture" forever fixed.

The subject of Jonah was also popular, appearing in John Flannagan's 1937 stone sculpture (fig. 163), which draws also on early Christian sculptures of this theme, and in James Lesesne Wells's 1959 wood engraving (fig. 164). Ryder's rhythmic, compositional energy sometimes displaced the motif itself as subject, as in Jacob Kainen's remarkable free aquatint *Marine Apparition,* 1949 (fig. 165), the first abstract expressionist print, which was made while Kainen was employed in the museum that owned Ryder's two "marine apparitions," *The Flying Dutchman* and *Jonah.* Pollock also made use of Ryder's overall rhythms in his marine *Ocean Greyness,* 1953 (fig. 166).[16] Kainen and Pollock no doubt had Melville in mind as well as Ryder; the most inspired borrowings are those based on imaginative assimilation rather than literal quotation.

That artists so diverse in approach all found something useful in Ryder's example shows that his work was supremely fungible, available to artists of every perceptual bias. Hartley had alluded to this in noting Ryder's "passivity of mental vision . . . that element outside the mind's jurisdiction."[17] His art seemed deeply rooted in the eternal verities but open-ended, appealing especially to artists of the forties and fifties fascinated with Jungian archetypes. Not the sad sweetness of a private world but the power of universal nature myths held sway over the abstract expressionist generation. Similarly, the predominant aspect of Ryder's life was again felt out and his celebrated saintly innocence subsumed into a new image of uncompromising artistic integrity, doomed to martyrdom by an indifferent world.[18]

In 1944 Pollock said, "The only American master who interests me is Ryder."[19] Like so much of Pollock's aesthetic, this debt was seeded by Thomas Hart Benton, his teacher at the Art Students League, whose own art is liberally sprinkled with quotations from Ryder's paintings.[20] When the seventeen-year-old Pollock arrived at the league in 1929, Ryder was among the most discussed artists in modernist circles, a role confirmed the next year by the Museum of Modern Art's exhibition featuring Homer,

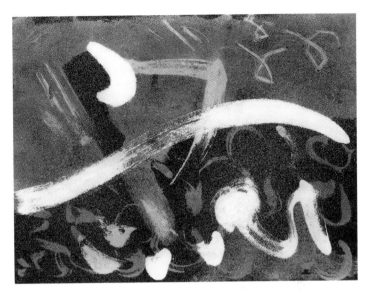

Fig. 165. Jacob Kainen, *Marine Apparition,* 1949, aquatint. National Museum of American Art, Smithsonian Institution, Washington, D.C.

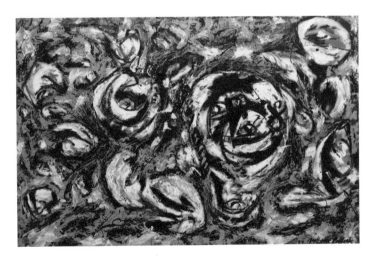

Fig. 166. Jackson Pollock, *Ocean Greyness,* 1953, oil on canvas. The Solomon R. Guggenheim Museum, New York.

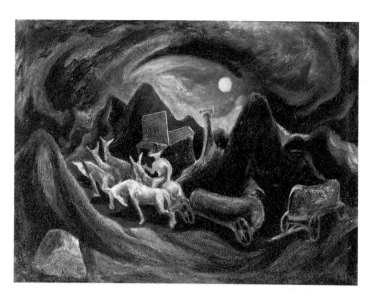

Fig. 167. Jackson Pollock, *Going West,* ca. 1934–35, oil on fiberboard. National Museum of American Art, Smithsonian Institution, Washington, D.C., gift of Thomas Hart Benton, 1973.149.1.

Eakins, and Ryder. Benton—and through him, Pollock—felt a special kinship through his association in the early 1930s with Ferargil Gallery, the gallery most strongly promoting Ryder's art during this period.[21]

Pollock's paintings from the early 1930s—rhythmic landscapes with white horses, an occasional marine—show him trying on Ryder's subjects and compositional devices to find a comfortable fit. *Going West* (fig. 167) is a close transcription of Ryder's *Sentimental Journey* (see fig. 61), perhaps commemorating Pollock's own "sentimental journey" in 1934 to visit his mother following his father's death.

Pollock's interest in Ryder was not confined to his student years; his famous tribute was made a decade later as he was beginning his mature work. Throughout Pollock's career he echoed Ryder's lyric-romantic nature subjects, as evidenced in the titles he chose: *Autumn Rhythm, Lavender Mist, Moon Vibrations, Ocean Greyness.* The surging, overall rhythms that so impressed modernist critics in Ryder's art were carried to

their logical extreme in such works as *Ocean Greyness,* where taut whorls of paint complete the circular wave-shapes of Ryder's oceans, trapping their force within enclosed cells.

Ryder was a legitimizing authority for Pollock's romantic response to nature, his restless overall rhythms, and even perhaps for certain innovations in palette.[22] But his greatest debt to Ryder is found in his elevation of the act of painting to supreme significance. Pollock saw that Ryder's obsessive working and reworking, so much a part of his legend, invested the painting with new emphasis and intensity. The notion that anyone could find a direction in Ryder's tangled technical methods was then almost beyond belief, but despite the disparity of their approaches—one all laborious glazing and the other spontaneous action—they were united in their faith in the very process of painting as a means of embodying the content of the work. Both artists went further than their contemporaries to assert the primacy of process and medium, making the very act of the painting supreme.

In his drip paintings Pollock's layered skeins of paint create a tension between plane and depth that is close to that in Ryder's heavily built-up, wet-on-wet paint films. One looks through Pollock's threaded webs into a mystical, invented space much like that seen under magnification in Ryder's layered glazes and marbled paint films. In both, the image emerges as a synthesis of the planes, not truly located in any one of them, and so the experience of seeing is also synthetic, vested in discovery rather than recognition. Ryder's peculiar approach served as an American analogue to surrealist automatism in that it was an art rooted in the process of painting rather than in a preconceived image.

For many artists since Pollock, Ryder's art has above all symbolized a commitment to painting as a physical, transformative process. Some feel this is a peculiarly American quality. Bill Jensen has described how, for him, modern art is an extension of European representational traditions reflecting intellectual movements, while American art—Ryder's in particular—takes its cues from the paint itself. What remains essential

about Ryder for Jensen and others is his own unorthodox method—the way he "allowed the images to be born in the paint."

Jensen has paid direct homage in such paintings as *Ryder's Eye* and *Room of Ryders* (figs. 168–69), this last made after he saw the Ryder gallery at the National Museum of American Art. Jensen's paintings are usually intimate in size, but with dynamic plastic forms pressing against the frame and powerful tonal oppositions richly shot through with vibrant color. They build on the formal strengths of Ryder's work, accentuating the role of raw paint. Forces gather around the edges and converge on a focal point in the same way that Ryder's compositions converge on a moon, anchoring an image that seems otherwise in danger of flying into fragments.

For each group or individual, Ryder's attraction varies a bit; artists of many styles and media have cited him as important for their work. A partial list of those recent and contemporary artists who have felt a serious affinity of spirit includes John D'Agostino, Milton Avery, Rudolf Baranik, Ronald Bladen, Carmen Cicero, Robert De Niro, Hans Hofmann, Basil King, Franz Kline, Rebecca Purdum, John Roloff, Clyfford Still, Jane Teller, and Ann Wilson as well as the English artists Hughie O'Donoghue and Paul Smith.[23]

And then there is another tradition or if not a tradition in the classic sense, then a lineage that stems from Ryder and from the other forces for naïveté current at the turn of the century. This is the "outsider" who will not adhere to instruction, preferring to carve his own channel along the margin of mainstream art. These artists are often reclusive, showing their work rarely but maintaining a reputation through the artists' underground. Myron Stout, pupil of Hans Hofmann, lived first in Cape Cod and after 1952 in Provincetown, producing a modest body of small paintings that give the feeling of irrevocable reality. He has been described as "endlessly turning the pebble of nature around in his hand . . . always concerned with the discovery and expressive weight of forms on our consciousness."[24]

Another such artist is Albert York, whose tiny pastoral landscapes distill Ryder's already re-

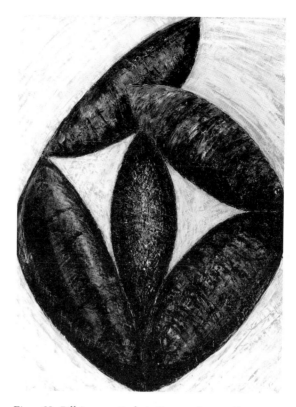

Fig. 168. Bill Jensen, *Ryder's Eye,* 1978–79, oil on linen. Collection of the Estabrook Foundation, Carlisle, Massachusetts.

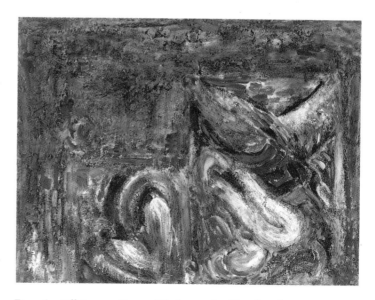

Fig. 169. Bill Jensen, *Room of Ryders,* 1987–88, oil on linen. Private collection.

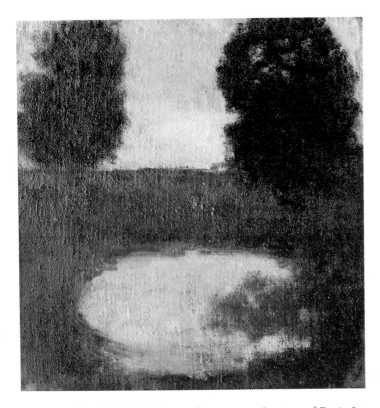

Fig. 170. Albert York, *Twin Trees,* oil on canvas. Courtesy of Davis & Langdale Company, Inc., New York.

duced romanticism to an ever more refined essence, as in *Twin Trees* (fig. 170), reminiscent of Ryder's *Landscape* (see fig. 23). York's paintings seem at first the simple utterance of a recluse, out of the habit of converse with society. But as with Ryder, the simplicity deceives; one writer has spoken of how in this landscape the brushwork "caresses the image," adding that "its authority is also a statement that looking and painting matter"[25]—just the message that Ryder's work so often inspires. York uses symbol and allegory with familiar ease, offering in still lifes and imaginative works alike an avowal of what Fairfield Porter has called "the mystery of the world that our civilization tries to keep us from being aware of."[26]

York first saw Ryder's paintings as reproductions in music books that he studied as a child; later, when Ryder was for a time his favorite artist, he went to see *The Forest of Arden* and *The Temple of the Mind.*[27] Like Ryder, York paints slowly and is often dissatisfied with the results, scraping out his work to begin again, producing no more than five to ten small paintings each year. The equation is familiar: time and effort over size and ambition equals intensity.

Forrest Bess, who died in 1977, carried some aspects of the equation to a painful point, following the example of Ryder, whom he revered, and of his own dangerously rigorous conscience.[28] A fisherman in Texas, he lived in an overturned barge accessible only by boat—the distance from society emphasizing his disregard of any audience. Conceding nothing to the art world, he refused to "lift vision up to aesthetics," disavowing all stylistic flourishes. His paintings were small so that he could keep them the same size as the image in his head, he said. Most were made of symbol-shapes, reduced to hieroglyphics, except when he made the painted image itself into a symbol, as in his small 1951 *Homage to Ryder* (fig. 171), with its dark brooding land mass and yellow-to-black color bands signifying emotions from hope to despair. (Another canvas pays a second debt: *Dedication to van Gogh.*) Just as Ryder's figure paintings project a sexual

yearning across unbridgeable distances, Bess's search for a universal absolute took him past androgyny to hermaphroditism, which he attempted to achieve through a series of surgical procedures, while filling his small panels with private markings signifying sexual wholeness. Excessive behavior and extreme statements in art can provide insight into the "normal" impulse that they exaggerate; thus, Bess's life and art provide a point of reference for aspects of Ryder's character and art.

Perhaps Ryder would be as little known today as York or Bess were it not for the fact that his closest lifetime friends, de Kay and Weir, were the *New York Times* art critic and the president of the National Academy, while his later champions, Davies and Miller, became proselytizers for modernism and tradition. Each of the four undertook in his way to prescribe the future of American art, including Ryder as a standard-bearer, just as the founders of the Society of American Artists had decided that his clumsy drawing and lack of finish distinguished their aims from those of the academy.

Ryder's work was the object of a cult during his lifetime, and his posthumous influence has similarly always carried with it an aura of self-selection and initiation into mysteries. He is an emblem of art as it has been conceived in the twentieth century—as a transcendent world of the most intimate expression of the imagination, made visible through a personal language, asserting a higher reality. Ryder has become for many the symbol of the artist's inner voice—alter ego, ancestor, authority, conscience, and catalyst. His influence moves from margin and mainstream and back again, but throughout this century it has proved a magically renewable resource.

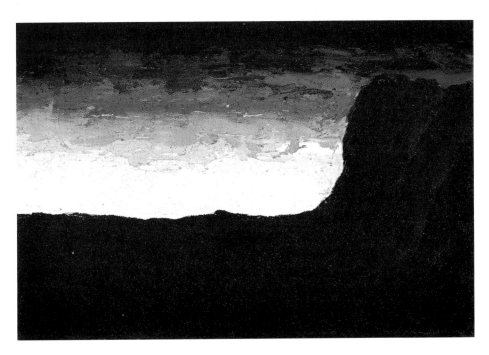

Fig. 171. Forrest Bess, *Homage to Ryder,* 1951, oil on canvas. Museum of Contemporary Art, Chicago, gift from the Mary and Earle Ludgin Collection, 81.22.

Notes

References included in the Bibliography are abbreviated in the Notes.

Introduction

1. Caffin, "International Still Stirs the Public," 8. I am grateful to Richard Wattenmaker for bringing this review to my attention.

2. Quoted in Louchheim, "Best American Painter's Largest Show," 28–31.

3. Ralph Waldo Emerson, "Illusions," 1860, in *A Century of the Essay: British and American*, ed. David Daiches (New York: Harcourt, Brace, 1951), 47.

The Ryders of Massachusetts

1. See Evelyn Eastwood, "In His Own Country: The Story of Albert Pinkham Ryder," 1947–49, Eastwood Papers, Archives of American Art. Eastwood based her essay on documents in New England collections and on interviews in the towns of Yarmouth, Barnstable, New Bedford, and elsewhere, but the sources are not noted. She has generously provided copies of Ryder's death certificate and other documentation about the Ryder genealogy for the present study.

Thomas Cyr, head of the Genealogy Room of the New Bedford Free Public Library, and his assistants, Elaine Silva and Maryann Maguire, also provided information on the Ryder family and New Bedford. The New Bedford Whaling Museum vertical file on Albert Ryder contains additional information.

2. The dates of birth of Albert Ryder's brothers are found in the Vital Records of Yarmouth, bk. 19, p. 275: William Davis, born 13 January 1836; Edward [Nash], born 23 July 1837; Preserved [Milton], born 4 April 1839.

Albert was born in New Bedford, where the family moved to in 1840, so he does not appear in the Yarmouth records. The New Bedford Census of 1850 names the four Ryder sons and their ages: Albert, age 3; Preserved, age 10; Edward, age 12; and William D., age 14.

3. New Bedford directories and files in the New Bedford Whaling Museum give the following occupations and addresses for Alexander Gage Ryder: 1841, laborer, with Samuel Rodman's house, 98 School; 1845, cabman, house 49 Mechanics Lane; 1849, hackman for E. Sampson, house 94 Elm; 1852, hack driver, 137 Purchase; 1855, customhouse boatman, house 16 Mill; 1856, customhouse boatman, house 16 Mill; 1859, boarding officer, customhouse, house 16 Mill; 1865, granular fuel, Court, house 3 Court; 1867–68, house 3 Court.

The 1850 Census lists Alexander Gage Ryder's occupation as "none." Albert Ryder's brothers are listed in the New Bedford directories twice: 1859, William D. Ryder, bookkeeper, N. Lewis, house 16 Mill; Edward N. Ryder, mariner, house 16 Mill; Preserved M. Ryder, mariner, house 16 Mill; 1865, Edward N. Ryder, ensign, U.S. gunboat Young Rover, inq[uire] 3 Court; William D. Ryder, New York, inq[uire] 3 Court; Preserved M. Ryder, master's mate, Constellation, inq[uire] 3 Court.

4. Quoted from "Notes on Albert P. Ryder, Obtained by G.C.B." (Love Papers, Archives of American Art). The same document describes Ryder's father rather improbably as "distinguished for his nobility of character and high order of courage and decision. . . . A Titan in strength and statue [sic], suggesting in his manly beauty the heroic characters of Titian's pictures."

5. Herman Melville, *Moby-Dick; or, The Whale* (1851; reprint, Boston: Houghton Mifflin, 1956), 28.

6. According to *History of the Churches of New Bedford* (New Bedford: Anthony, 1869), a Methodist revival began in New Bedford in 1823–24, when many were converted by the preaching of the "eloquent Maffit." Methodist Episcopal churches dominated New Bedford's religious life well into the 1860s. A second "memorable and mighty revival" began in the North Congregational Church in 1857.

7. Edward Ryder's Civil War experiences are described in "Papers Reveal Navy Duty of Cape Native," *New Bedford Sunday Standard-Times,* 26 October 1947, 20. I am grateful to Evelyn Eastwood for sending me a copy of this article.

8. School reports for 1840–59 are in the New Bedford Free Public Library. Quotations are from the *Report of the School Committee of the City of New Bedford for the Year 1851–52,* City Document No. 4 (New Bedford: Benjamin Lindsey, 1852), 29, and *Report of the School Committee of the City of New Bedford for the Year 1854–55,* City Document No. 7 (New Bedford: Anthony, 1855), 26.

9. Ryder's eye problems worsened with age. The condition may have begun concurrent with a vaccination but is unlikely to have resulted from it. His failing eyesight and other ailments may indicate a mild case of diabetes, for he manifested several symptoms of the illness later in life—a tendency toward obesity, chronic weakness, unusual thirst, dropsy (edema) that made walking difficult, and kidney disease.

10. "Albert P. Ryder: Poe of the Brush," 5.

11. See Cheney, "Painter of Dreams," 17. The information about his early life came from an interview with Mrs. E. N. Ryder, widow of Edward. When asked how Albert Ryder came to paint, she said: "The gift was born in him. When he was only four years old, he would be found lying on his stomach on the floor, lost to the world in his picture book. He did not care so much about drawing, as long as he had his colors."

Mrs. E. N. Ryder was born Jennie Keen, and she lived in New Bedford before her marriage in 1866, so she may have known Ryder as a youth. She admitted, however, that he was a mystery, that Edgar Allan Poe "was nearer to the painter than Edward, his brother." She mistakenly gave his birthplace as Mill Street and related the Gage ancestors directly to Thomas Gage, the British Revolutionary War general, for which there is no evidence. She was unable or unwilling to help care for Albert Ryder when he was infirm in his last

years and took no part in administering his estate, although she and her daughter, Gertrude Ryder Smith, were his only living relatives. Her information is not reliable and her motives may have been mercenary; she spoke of reproving Albert for carelessness in selling his pictures and liked to point out how much money they were worth after his death.

12. Ryder to J. Alden Weir, 23 September 1897, Weir Papers, Archives of American Art.

13. Ryder, "Paragraphs from the Studio of a Recluse," 10.

14. Thomas Couture's treatise was published as *Méthode et entretiens d'atelier* in 1867. R. Swain Gifford wrote the introduction to the English edition, *Conversations on Art Methods,* trans. S. E. Stewart (New York: Putnam's, 1879), in which he recounts his first exposure to Couture's method in 1857.

15. *Morning Mercury,* 31 March 1917, 4.

16. Mrs. E. N. Ryder, quoted in Cheney, "Painter of Dreams," 17. This Sherman may be the tanner mentioned in "Albert P. Ryder: Poe of the Brush," 5: "One day his father sent him to collect a bill due at a tannery. The superintendent of the tannery was an amateur artist, and the walls of his office were covered with pictures he had painted himself. The boy gasped at these entranced.

" 'Why,' " said he, " 'If I could paint pictures like that I'd never do anything else.'

" 'I'll tell you what we'll do,' " said he. 'I'll take a little studio downtown, and we'll go there and just paint all we please.'

"The tannery man kept his word. He was the first to put a brush in the boy's hand, and set him to copying pictures."

17. Cheney, "Painter of Dreams," 17.

18. According to an inscription on the back of *The White Horse* (The Art Museum, Princeton University, New Jersey), it was made at the carbarn at Thirty-third Street and Fourth Avenue.

A friend of Ryder's recalled: "I first remember Ryder about 1873 when I was a student in the schools of the N.A.D. Ryder came only a few times to draw there. He never was a school man. But he used to come in from time to time, smelling strongly of stables where he had been to make sketches of horses" (Hyde, "Ryder as I Knew Him," 596).

19. The first mention of this painting was in 1897 by Sadakichi Hartmann ("A Visit to Ryder," 1–3): "Looking about the room I suddenly saw from a corner a life size portrait gazing at me. The first glance told me that it was a man in United States uniform; after that I only saw the face: the tightened lips, *the eyes,* it was if a soul were bursting from them, and then it seemed to me as if Ryder, his soul was steadily gazing at me.

"This portrait immediately gave me a keener insight into his artistic character than any other picture. Everything was sacrificed to express the radiance of

the innermost, the most subtle and most intense expression of a human soul."

It is not clear if Halpine was real or fictional. No war casualty by the name of Halpine is recorded in *Massachusetts Soldiers, Sailors, and Marines in the Civil War* (1933).

Student Life in New York

1. The New York directory for 1878 gives William Ryder's address as the Hotel St. Stephen. This is the first year the St. Stephen is mentioned in the directories. About that time William moved to 16 East Twelfth, near the hotel, which occupied the lot now numbered 46–52 East Eleventh. Murphy's New York City Business Directory for 1888 lists William Ryder as owner of the St. Stephen.

The Hotel Albert was opened in 1883 in a new eight-story building by Henry J. Harkenbergh, at the corner of Eleventh and University Place. Albert S. Rosenbaum, a tobacconist, is listed in city records as owner. There was a close connection between the Albert and the St. Stephen; most likely, Rosenbaum capitalized the Albert and William Ryder managed it, along with the St. Stephen. After Rosenbaum's death, ca. 1894, William Ryder is no longer listed in the directories as proprietor of the St. Stephen. In the late 1890s the twelve-story New Hotel Albert opened next door to the original Harkenbergh building on University Place. Later, a third building was added, so the Albert stretched from Tenth to Eleventh to streets along University Place.

2. There is much confusion about the date of Albert Ryder's move to New York. Elwyn G. Campbell in "Artists of This Vicinity" says that Albert Ryder left New Bedford at twenty, which would place his departure in 1868. Dorothy Weir Young in *Life and Letters of Weir,* 13, claims that Weir met Ryder at the National Academy of Design in 1868. Mrs. E. N. Ryder (Albert's sister-in-law) emphasized that Albert's departure from New Bedford followed two years after her own (Cheney, "Painter of Dreams," 17). The date is confused by a misprint giving 1886 as the year of Mrs. E. N. Ryder's last residence in New Bedford. In fact, she left New Bedford at the time of her marriage in 1866; therefore, Albert's move "two years later" would have taken place in 1868. The critic Paul Rosenfeld claimed that Ryder moved to New York in 1867 (*Port of New York,* 297). Ryder's death certificate of 1917 gives "residence in City of New York" as "50 years."

There is no documentation of Albert Ryder in New York until 1871, when he registered a residence with his father at 348 West Thirty-fifth Street, so some have concluded that he arrived only at this time or a little earlier. Perhaps the strongest point in favor of a move in 1868 is that no member of Ryder's immediate family is listed in the New Bedford directories after 1867, although they are in every volume for two decades before.

3. A short biographical note for an 1899 auction catalogue mentions that Ryder "emerged into art from commercial life" (*Catalogue of the Private Art Collection of Thomas B. Clarke, New York,* auction cat. [New York, 1899], 99).

Charles de Kay reported in "Modern Colorist," 257, that Ryder had "some experience as a buyer and seller of pictures, in which he showed wonderful ability to pick out fine ones and little to sell them again." This experience as picture dealer is mentioned by no one else.

4. The quotation is taken from the preface of Couture, *Conversations on Art Methods.* Couture's possible influence on Ryder is considered in depth in Albert Boime, "Newman, Ryder, Couture, and Hero-Worship in Art History," *American Art Journal* 3, no. 2 (Fall 1971): 5–22.

5. In the "Art and Artists" column of the *Boston Daily Evening Transcript,* 11 August 1877, the head of Christ was described as "powerful as well as benevolent, . . . a manly man . . . half way between the Arab and Grecian types . . . with an absorbed expression that is too thoughtful to be dreamy." The work is currently unlocated. I am grateful to Colonel Merl Moore for bringing this article to my attention.

6. Two copies of this letter from Ryder to Mrs. William E. Marshall survive, both in Ryder's hand. One, dated 22 July 1909, is in the Love Papers, Archives of American Art, along with an earlier letter of consolation from Ryder to Mrs. Marshall on her husband's death. The second copy of the letter, which varies in only a word or two, is dated 5 August 1910 and is in the Evans Papers, Archives of American Art.

7. Artist Kenneth Hayes Miller told several times that Ryder was excited to learn that he was allowed an eraser, saying, "Can I use an *eraser?* Then, I can do anything" (Miller Papers, Archives of American Art).

8. The Frenchman Paul Baudry reproduced full-size more than thirty-five hundred square feet of the Sistine Chapel ceiling, requiring more than ten years of labor. He then painted in reduced scale all of Raphael's cartoons in the South Kensington Museum. See Will H. Low, *A Painter's Progress* (New York: Scribner's, 1910), 72–74.

9. Dorinda Evans proposed that the partial nude in the center section of Ryder's three-part painted leather screen (see fig. 39) is adapted and reversed from the academy's cast of the Venus de Milo (Evans, "Albert Pinkham Ryder's Use of Visual Sources," *Winterthur Portfolio* 21 [Spring 1986]: 22–23). The other partial nude recalling antique sculpture in both subject and pose is *Diana* (see fig. 87), also painted on leather.

10. "Albert P. Ryder: Poe of the Brush."

11. Ryder, "Paragraphs from the Studio of a Recluse," 10.

12. An academy colleague, James Edward Kelly, later wrote: "[Ryder] had an attack of typhoid fever. Denslow told us in the Academy; so Church, Denslow and

myself did what we could to comfort him during his sickness. I called one day after he had recovered. He said, 'I appreciate the kindness of you boys, especially Wallie Denslow. I feel that I owe you something.' Then he pointed to some of his paintings on cigar boxes. He said, 'I give that to Denslow, that to Church, and that to you'" (Kelly Papers, Archives of American Art).

One of Ryder's good friends from much later in his life wrote some of the stories he had heard from Ryder, including this one: "[Ryder] told me when he first came to New York and started to study at the Academy he did not have much money. His folks were fairly well off, but he wanted to get along by himself, and when he paid his tuition at the academy and a cheap room rent, there was very little to live on. Sometimes he had bread and milk and sometimes no milk. He kept this up so long he finally broke down, being taken sick with fever and exhaustion. He was found by someone in this state and his brother was notified who took him to his hotel until he recovered" (Charles Fitzpatrick, quoted in Taylor, "Ryder Remembered," 13).

For another personal account by one of Ryder's academy friends, see Hyde, "Ryder as I Knew Him," 596–99.

13. Two watercolors by Louis Comfort Tiffany, each entitled *Moorish Figure*, are listed in an 1873 exhibition catalogue as lent by A. P. Ryder. See *Catalogue of Annual Exhibition*, ex. cat. (New York: American Society of Painters in Water Colors, 1872–73), nos. 33, 37.

14. *Louis Comfort Tiffany: The Paintings*, ex. cat. (New York: Grey Art Gallery and Study Center, 1979), 15–20.

15. "One Day in the Gallery," 5.

16. Kelly Papers, Archives of American Art.

17. *Letters of Richard Watson Gilder*, ed. Rosamond Gilder (Boston and New York: Houghton Mifflin and Riverside Press, 1916), 58. Richard Watson Gilder's comments about the *Rubaiyat* reveal how daring it seemed in the 1870s: "Did I ever tell you H. de K., now Mrs. R. W. G., had a copy of the 'Rubaiyat' in her own handwriting, while 'The New Day' [Gilder's book-length poem] was being written? There may have been but one other copy in New York, Mr. La Farge's, which also was a manuscript. I thought of publishing the whole of it in [Scribner's] but realizing that Dr. Holland would never let it appear there on account of the *wine* therein, I gave up the idea" (ibid., 434).

18. Ibid., 66.

19. Marchal E. Landgren, *Years of Art: The Story of the Art Students League of New York* (New York: McBride, 1940). De Kay reported in "Modern Colorist," 257, that Ryder had a few lessons at the Art Students League, but he did not say when or with which instructor.

20. *New York World*, 15 April 1873.

21. Gilder Journal, Gilder Archive, Tyringham, Mass.

22. The invitation card, with a list of artists and titles, and several reviews of this exhibition are in scrapbook no. 1, Gilder Papers, New York Public Library. Artists included were Hunt, John La Farge, Maria Richards Oakey, Helena de Kay Gilder, Ryder, Elizabeth B. Greene, Helen M. Knowlton, S. Salisbury Tuckerman, Susan Minot Lane, Alice M. Curtis, Elizabeth Boott, Francis Lathrop, Adelaide E. Wadsworth, John W. Bolles, and Elizabeth Howard Bartol.

23. *Appleton's Journal*, 8 May 1875, Gilder Papers, New York Public Library.

24. Ryder's painting is listed as *Interior* on the invitation card in scrapbook no. 1, Gilder Papers, New York Public Library. An undated clipping in the scrapbook describes it as a stable interior.

A New Society for Art

1. From the resolution offered by Augustus Saint-Gaudens (quoted in Will H. Low, *A Chronicle of Friendships, 1873–1900* [New York: Scribner's, 1908], 234). For the most complete account of the founding of the Society of American Artists and its early exhibitions see Bienenstock, "Society of American Artists" (thesis).

2. See de Kay, "Art, or Business?" *New York Times*, 6 May 1877, 6, and "Protection in Art," *New York Times*, 17 June 1877, 6.

3. Clarence Cook, "American Art: Why There Should be a New Academy," *New York Daily Tribune*, 5 June 1877, 5.

4. Concern over admitting Ryder is discussed in Bienenstock, "Society of American Artists," 44–45, based on information in the manuscript of the Low autobiography, 172, Will H. Low Papers, Albany Institute of History and Art, New York, The debate over "finish" that raged during the late 1870s and was such a point of tension between academicians and younger artists is presented in detail in an unsigned article, "An Unfinished Discussion on Finish" (*Art Journal* 5 [1879]: 316–19). I am grateful to Richard Murray for bringing this article to my attention.

5. Other members of the society in 1878 were Samuel Colman, Frederick Dielman, Wyatt Eaton, Gifford, Helena de Kay Gilder, La Farge, Lathrop, Homer Dodge Martin, Thomas Moran, Saint-Gaudens, William Sartain, Walter Shirlaw, Tiffany, Olin L. Warner, and Weir.

6. See Hyde, "Ryder as I Knew Him," 598, and James Kelly's reminiscence of Ryder, Kelly Papers, Archives of American Art.

Michael Palmer, conservation scientist at the National Gallery of Art, Washington, D.C., studied wood supports used by American painters. He explained in a letter to the author, 1 March 1988, that most cigar boxes in the nineteenth and early twentieth centuries were made of Spanish or Central American cedar. The

heartwood darkens to a reddish brown as it dries; the sapwood is whitish gray to pink; the luster is medium to high. When varnished, cigar-box cedar would somewhat resemble mahogany in warmth of color.

7. "One day, in the course of a talk, [Ryder] told me that he sometimes used pure alcohol as a medium, more especially in the commencement of a picture. It worked smoothly and with transparency, he said. It is reasonable to suppose that the use of this spirit will account for some of his earlier works showing many cracks" (Robinson, "Reminiscences of Ryder," 183).

8. "The American Artists: Varnishing Day of the Second Exhibition," *New York Times*, 8 March 1879; *Boston Daily Evening Transcript*, 27 March 1883; *New York Tribune*, 1 April 1883; *New York Tribune*, 15 April 1883.

9. De Kay, "American Artists," 5.

10. Charles de Kay, *The Bohemian: A Tragedy of Modern Life* (New York: Scribner's, 1878), 28–29.

11. Charles de Kay (Henry Eckford, pseud.), "George Inness," *Century Magazine* 24 (May 1882): 62–63.

12. George Inness, "A Painter on Painting," *Harper's New Monthly Magazine* 56 (February 1878): 461.

13. Ryder's statement—"The artist needs but a roof, a crust of bread and his easel, and all the rest God gives him in abundance"—is repeated like an incantation throughout the Ryder literature. Other favorite stories include his giving scarce cash to street beggars, lack of understanding of how to cash checks, and reply to William H. Hyde, on being asked if Hyde's paintings would sell: "You bring that in like a twist in a pig's tail. I cannot sell my pictures. I had an auction once and they brought a dollar or two. And Homer had the same experience" (Hyde, "Ryder as I Knew Him," 598).

14. Quoted in Louchheim, "Best American Painter's Largest Show," 29.

Ryder and the Decorative Movement

1. Bienenstock, "Society of American Artists," 85–86.

2. The most complete information on Daniel Cottier is found in Hobler, "Daniel Cottier" (thesis). She includes an extensive bibliography. For a short biography and select bibliography on Cottier see *In Pursuit of Beauty: Americans and the Aesthetic Movement*, ex. cat. (New York: Metropolitan Museum of Art, 1986), 414–16. See also Brian Gould, *Two van Gogh Contacts: E. J. Van Wisselingh, Art Dealer; Daniel Cottier, Glass Painter and Decorator* (Bedford Park, England: Naples Press, 1969), 1. This text was published in an edition of one hundred; a copy is in the Metropolitan Museum of Art Library, New York.

3. *Illustrated Catalogue of the Artistic Property, Fine Antique and Modern Furniture, Important Flemish Tapestries, Stained Glass, Textiles, and Other Objects of Household Utility and Embellishment of the Well-known House of Cottier and Company of New York*, auction cat. (New York: American Art Association, 1913). This sale liquidated Cottier & Co. stock after the death of Mrs. Daniel Cottier. A copy of the catalogue in the Metropolitan Museum of Art Library is annotated with buyers and prices.

4. Photocopy of an undated, unattributed clipping, "The Metropolis of Today," 283, Cottier scholarship file, Department of Decorative Arts, the Metropolitan Museum of Art (quoted in Hobler, "Cottier," 64). George Gurney has traced Cottier and his business through New York directories. The first listing is in 1875, when Cottier & Co. is mentioned as "upholsterers." In 1876–77 the firm is listed as "decorators"; in 1878 (the year the firm began to promote paintings seriously) as "artists." In subsequent years the firm is identified as "decorators" or "fine arts," until 1888, when it changes to "furniture," which continues until after Cottier's death in 1891.

The address of the gallery showrooms remains constant at 144 Fifth Avenue. In 1880–87 the address 324 West Twenty-sixth is also given, probably to indicate the workshops. In 1888–90 the address changes to 223 West Twenty-eighth Street, and in 1891–93 the address changes again, to 191 Seventh Avenue.

5. William Ernest Henley, "Daniel Cottier, 1838–1891," in *Catalogue of Ancient and Modern Pictures; Important Works of the French, English, and Dutch Schools*, auction cat. (Paris: Durand-Ruel; and Edinburgh: Constable, 1892).

6. Clarence Cook, "Recent Church Decorations," *Scribner's Monthly* 15 (February 1878): 571. Cook complains that Cottier's contribution has been unfairly ignored. La Farge responded to this article with a long letter to Richard Watson Gilder, disparaging Cottier's work (Gilder Archive, Tyringham, Mass.).

7. Virginia Chieffo Raguin, "European Antecedents of American Stained Glass" (lecture, National Museum of American Art, Smithsonian Institution, Washington, D.C., 2 October 1987).

8. Quoted in Hobler, "Cottier," 12.

9. Tiffany's partnership included Candace Wheeler, Samuel Colman, and Lockwood De Forest. The association was responsible for the decoration of the Veterans Room of the Seventh Regiment Armory in New York, among other commissions.

10. On *japonisme* in America see Henry Adams, "John La Farge's Discovery of Japanese Art: A New Perspective on the Origins of *Japonisme*," *Art Bulletin* 67 (September 1985): 449–85.

11. Richard Newman, research scientist at the Museum of Fine Arts, Boston, confirmed in a letter to the author, 15 April 1988, that unburnished gold leaf covers most or all of the ground of La Farge's *Hollyhocks and Corn*, before 1875 (Museum of Fine Arts, Boston), which was conceived as a decorative panel for a dining room. The other panels from this ensemble have not been analyzed.

12. A letter Ryder wrote to de Kay, dated 12 February 1903, seems to refer to decorated clock panels (by Ryder?) owned by either Janet de Kay or Mrs. Charles de Kay. Ryder explains that a clock he was to claim on behalf of de Kay was taken away by two unknown men, then adds, "I will of course make good in the matter having seen sometime back in Bowles I think it was, identically the same clock, showing they are to be had. There is a fancier [clock at the] corner of 29th St. and 4th Ave. that the panels could be taken out of and yours substituted, which I saw this evening in the window. It does not seem necessary to alarm Mrs. de Kay as we can surely find a substitute" (Detroit Artists Association Records, Archives of American Art).

13. Quoted in David Daiches, *Robert Louis Stevenson* (Norfolk, Conn.: New Directions, 1947), 17–18.

14. Hyde, "Ryder as I Knew Him," 599. De Kay in "Modern Colorist," 257, mentions three painted mirror frames: "one now in Albany; another in New York owned by Mr. Thomas Williams; and a third for Mrs. Janet H. de Kay."

15. The sale liquidating Cottier company stock in 1913 included many pieces of furniture made of exotic woods with painted inserts, including music and curio cabinets, screens, stationery stands, and jewel cases (*House of Cottier*).

16. Cook illustrated a Cottier-designed movable cupboard with two painted panels by Lathrop (nos. 39, 105) and went on to "wish somebody had venturesomeness enough to design a cupboard, or wardrobe, or book-closet for Mr. Lawrence or Mr. Lathrop to decorate; but in these matters, there seems nowadays not only to be no venturesomeness, but no desire to get out of the comfortable ruts we are all jogging along in" (*The House Beautiful: Essays on Beds and Tables, Stools and Candlesticks* [New York: Scribner, Armstrong, 1878], 87, 250).

17. This effect is prominent in the Butterfly Window, which Tiffany made for the dining room of his Fifty-seventh Street mansion. It is now in the Charles Hosmer Morse Museum of American Art, Winter Park, Fla.

18. Ryder never joined the Tile Club, although a number of his friends were in the group, including Weir, William Gedney Bunce, Saint-Gaudens, Gifford, and White. See "The Tile Club at Work," *Scribner's Monthly* 17 (November 1878): 401–9; and "The Tile Club at Play," *Scribner's Monthly* 17 (April 1879): 457–78.

19. The significance of the square format for the development of modern art is considered in William H. Gerdts, "The Square Format and Proto-Modernism in American Painting," *Arts Magazine* 50 (June 1976): 70–75. Gerdts proposes that the square painting format may derive from tiles or from paintings by J. M. W. Turner, James McNeill Whistler, Jules Bastien-Lepage, and others; he explores its use by Ryder, John Singer Sargent, William Merritt Chase, John Twachtman, and Winslow Homer.

Ryder, Cottier, and Modern Art

1. Warner's studio was listed at Cottier's address in 1877–79. He moved when Cottier's business expanded and the room was needed. Many of Warner's sculptures from the late 1870s are portraits of people in Cottier's circle, suggesting that the dealer had a hand in arranging commissions (George Gurney, "Olin Levi Warner: A Catalogue Raisonné" [Ph.D. diss., University of Delaware, 1978]).

2. Ryder wrote a Christmas letter to Warner in 1875 expressing appreciation of his friendship. The formal tone of the letter ("May the rolling years be as the wheels of Apollo's car") suggests that they were new acquaintances at the time. Ryder included in the letter a poem, "Lines addressed to a maiden by request," but the maiden remains unidentified (Warner Family Papers, Archives of American Art).

3. Erskine Wood, *Life of Charles Erskine Scott Wood* (privately printed, 1978), 65. Several letters from James Inglis to C. E. S. Wood, a Cottier client and agent for the firm on the West Coast, discuss the New York opera and symphony seasons (12 December 1893; 25 May 1895; 15 November 1895; 30 November 1895; and 28 March 1896, Wood Papers, Huntington Library).

4. Many of Inglis's letters of the 1890s to Wood refer to the "Menagerie," "Rev. Ryder," "Rvd. Pinkham," or just "the Reverend." One of Ryder's letters to "Brother Wood," dated 4 March [1896?], has an addendum signed "The Reverend Referendum" (Wood Papers, Huntington Library).

5. Wood to Weir, 7 July 1899: "[Inglis] has only three living Americans he recommends, and he does intelligently and forcibly speak of them—Weir, Ryder, and Bunce" (Weir Papers, Archives of American Art). By the time this was written the fourth American championed by the firm, the sculptor Warner, was dead.

6. "The Fine Arts: Opening of the Cottier Gallery on Fifth Avenue," *New York Times*, 1 March 1877, 4.

7. Seth Morton Vose assembled a major collection of paintings by Camille Corot in the 1850s and 1860s for less than $25,000. He offered them at a large sale in 1873, with the highest price being $1,250, but found no buyers. In 1887, however, he realized $92,000 on just a small portion of his collection (scrapbook, Vose Gallery Papers, Archives of American Art).

8. Brownell, "Younger Painters—Second Paper," 326.

9. "An Unfinished Discussion on Finish," 316.

10. Ryder, "Paragraphs from the Studio of a Recluse," 10–11.

11. Quoted in Wood diary no. 6, August 1896, Wood Papers, Huntington Library.

12. Ryder to William Macbeth, 9 November 1911, Macbeth Gallery Papers, Archives of American Art.

13. This quote, ascribed to Miller, is in Lloyd Goodrich, "New Light in the Mystery of Ryder's Background," *ArtNews* 60 (April 1961): 51.

14. Low in *Chronicle of Friendships*, 78–95, tells of an emotional, almost mystical experience in viewing one of Jean-François Millet's canvases in the artist's studio and describes his fascination with the painter.

15. Alfred Sensier, *La vie et l'oeuvre de J.-F. Millet* (Paris: Quantin, 1881). The abridged American edition was published as *Jean-François Millet: Peasant and Painter,* trans. Helena de Kay Gilder (Boston: Osgood, 1881), after serialization in *Scribner's.*

16. Ronald Pickvance, *Van Gogh in Saint-Rémy and Auvers,* ex. cat. (New York: Metropolitan Museum of Art and Abrams, 1986), 155.

17. *The Sower* was purchased by William Morris Hunt in the 1850s and created a stir when it arrived on these shores. In an undated letter to Mrs. Van Rensselaer (probably December 1883 or early 1884), Ryder regrets that the current owner declined an invitation to lend it to the Metropolitan Museum's annual loan exhibition (The Metropolitan Museum of Art Library).

18. Sensier, *Millet,* xi–xii.

19. Ryder's painting for the *Orpheus* frame may never have been executed: "[Ryder] promised Cottier a large picture also in fact the same size as the Orpheus and was given its old frame, but Cottier is dead and the picture still [illegible] Scotland where it stood" (Inglis to Wood, 19 April 1892, Wood Papers, Huntington Library).

20. Cottier to Samuel Barlow, 9 February 1878, Barlow Papers, Henry E. Huntington Library, San Marino, Calif. Although Cottier refers to Adolphe Monticelli as the "late" Italian artist, he lived until 1886.

21. "An Impressionist's Work: The Pictures of Monticelli, Curious Works of Art at Cottier's," *New York Times,* 20 May 1879, 8. In 1895 Marion Hepworth Dixon in "Monticelli," *Art Journal* (July 1895): 214, credited Cottier and Paul Guigou with establishing Monticelli's reputation: "Thanks to the love and enthusiasm of these two men the world has lately had the means of coming to a better understanding of the master. Daniel Cottier's part in the enterprise is indeed no inconsiderable one. He spent half his life in pushing, and dogmatically pushing, Monticelli's claims, in buying his canvases, and finally, in his collection, gave Art lovers a glimpse of the painter in his soundest and less mannered achievements."

22. "Montezuma" [Montague Marks], *Art Amateur* 11 (April 1880): 91.

23. Etienne Martin, quoted in Aaron Sheon, *Monticelli: His Contemporaries, His Influence,* ex. cat. (Pittsburgh: Museum of Art, Carnegie Institute, 1978), 10.

24. Paul Guigou, quoted ibid.

25. Vincent van Gogh, quoted ibid., 84.

26. H. Nichols B. Clark discovered Ryder's and William Craibe Angus's signatures in the "Visiteurs du Musée 31/7/1874–31/5/1878," and this information was published in Evans, "Ryder's Visual Sources," 28 n. 11.

27. See pretreatment photograph in the Conservation Lab Files, National Museum of American Art. The painting was lined and restored at least once before coming to the museum and may also have been cleaned, so it is difficult to assess Ryder's glazing from the current condition of the painting.

28. One companion, Albert Groll, claimed to have given Ryder the formula for a medium that he learned in the Munich Academy and said that Ryder used it ever after (Groll interview, Eastwood Papers, Archives of American Art).

29. Vincent van Gogh's letter 76 to Theo van Gogh, 7 October 1876, describes his visit to Elbert J. Van Wisselingh. In letter 289, Vincent tells Theo that he wants to try to sell his drawings to Cottier as insets in woodwork and mantles (*The Complete Letters of Vincent van Gogh,* 3 vols. [Greenwich, Conn.: New York Graphic Society, 1958]).

30. Accounts vary as to the date (1877 is most likely, but it may have been earlier) and reasons for Matthijs Maris's move to London. Some say Maris followed Van Wisselingh when the latter was hired to manage Cottier's London gallery. Others say Maris was lured by Cottier's offers of financial support (Ann Wagner, *Matthijs Maris,* ex. cat. [The Hague: Gemeentemuseum, 1975], 21). For other accounts see D. Croal Thomson, *The Brothers Maris* (London and Paris: Offices of "The Studio," 1907). Thomson was the manager of Goupil's London branch from 1886 to 1897.

31. Maris's restorations of Monticelli's paintings led some of them to be given joint authorship. The two artists did not paint together, but Maris's reconstructions were at times so sweeping that acknowledging his part seemed prudent. Maris complained of having to do this restoration; it was a chief part of his grievance against Cottier in 1888 and contributed to his departure from the gallery that year (Wagner, *Maris,* 22–23).

32. "I think I gave you Mr. Maris's address. It is 18 Westbourne Square, Baywater, W. London. I hope you will write to him as I know it would give him much pleasure to hear from you after such a long time" (Frederick Lessore to Ryder, 25 January 1911, Love Papers, Archives of American Art). Maris painted a picture of Lessore, ca. 1879–80, when Lessore was less than a year old, on commission from the watercolorist Jules Lessore, his father.

33. Ernest D. Fridlander, *Matthew Maris* (London and Boston: Philip Lee Warner and Jonathan Cape, 1921), 91–128 passim.

34. When proofing a biographical entry about his own career, Ryder insisted that Cottier's support be emphasized: "It would perhaps be more complete if . . . reference were made to Cottier and Company, Daniel Cottier and Joseph [*sic*] S. Inglis, who were attracted to my work and made sterling efforts in the way of patronage and speech to make me understood and of course had a marked influence on my career.

"Mr. Cottier was a man of wonderful perception in all things; particularly in all art subjects" (typescript of Ryder's criticism of James T. White and Co.'s galley proof for the *National Cyclopedia of American Biography* [vol. 10, 1910], Love Papers, Archives of American Art).

35. *Fine Oil Paintings and Water-Color Drawings by the Great Modern Classic Painters,* auction cat. (New York, 1878), a copy of which is in the American Art Auction and Exhibition Catalogues, Archives of American Art.

36. Among the paintings by Edouard Manet that were sold into American collections through Cottier & Co. are *The Dead Toreador,* ca. 1864 (National Gallery of Art, Washington, D.C.), and *Woman with a Parrot,* 1866 (The Metropolitan Museum of Art, New York).

37. Henley, "Cottier," x–xi.

First Critics, Early Patrons

1. Kelly visited Ryder in a small room on the southwest corner of Ninth and Broadway while both were students at the National Academy (Kelly Papers, Archives of American Art). The address Ryder listed in the 1876 academy exhibition was 432 Broadway, the address of William Ryder's restaurant, suggesting that Albert had a room in the same building. Eastwood said Ryder moved to Canal and Broadway in 1879 (Eastwood Papers, Archives of American Art). Frank Jewett Mather, Jr., said that when William moved to 16 East Twelfth (near the St. Stephen Hotel) in 1879, Albert set up separate quarters (Mather, "Ryder's Beginnings," 122).

2. I am grateful to George Gurney for information on the residents of the Benedick Building.

3. Ryder sailed with Cottier and his family on the *Britannic* from New York to Liverpool on 6 May 1882. Cottier and Ryder stayed in England almost a month waiting for Warner to join them; Warner sailed on the *Ontario* on 27 May 1882. In June they began their tour through the Continent and North Africa. Ryder, Warner, and the Cottiers returned together on the *Republic,* which left Liverpool on 26 September 1882 and arrived in New York on 6 October 1882. I am grateful to George Gurney for this information.

 Weir to Anna Dwight Baker, 8 October 1882: "Mr. Warner and Ryder returned on Friday. They are full of the great art treasures that they have seen. They walked over the Simplon Pass in the Alps and had a grand time, yet they seem equally delighted to get back again, as do all" (Weir Papers, Archives of American Art).

4. A number of sheets in the notebook contain entries referring to accounts and expenditures of Warner, Cottier, and Ryder. For the period from mid-July through late September 1882, an itinerary lists Marseilles, Genoa, Rome, Naples, Venice, Chiogga, Milan, Lucerne, Cologne, Paris, and Brussels. Warner's account book also includes mention of Ryder after this

voyage. Notations for 1883–85 include five payments of fifty dollars each from Ryder to Warner; the last is noted "Ryder in full." I am grateful to George Gurney for sharing his copy of this account book with me.

5. William Merritt Chase to Weir, 1 July 1882, from Madrid: "I saw Warner, Ryder and Cottier at the Salon, just missed seeing Cottier & Ryder here, they left only the day before we arrived. I am sure they must have enjoyed the Gallery here, [Robert] Blum and Vinton are quite wild about it" (Weir Papers, Archives of American Art).

6. Ryder to de Kay, not dated, Frick Art Reference Library. The letter must date to the 1882 trip, as the visit to Exeter is mentioned again in a letter from Ryder to William R. Mead (also a resident of the Benedick Building), 27 May 1882, in which he describes visits to Salisbury, Sherbourne, and the horse races at Epsom. In this letter Ryder sends greetings to Mead's brother and to White, Charles Follen McKim, Maynard, Weir, Lathrop, (John George?) Brown, Saint-Gaudens and his brother, and Eaton—a useful index to his circle at this time (Weir Papers, Archives of American Art).

 I am grateful to Jacob Kainen for tracing the Robert Browning line to "Fifine at the Fair."

7. Conversation between Rudi Wunderlich (who had sold the sheets of sketches) and author, 4 September 1987. The sheets were purchased by Harold O. Love and are now in the Ryder Archive, University of Delaware.

8. John Gage, "Magilphs and Mysteries," *Apollo* 80 (July 1964): 38–41.

9. "As was to be expected of a man whose passion was the art of the great Venetians, [Cottier] cherished two ambitions: to be nothing if not decorative in design, to be nothing if not sumptuous in effect" (Henley, "Cottier," xi).

10. "The American Artists: Varnishing Day of the Second Exhibition."

11. "The Society of American Artists," *Scribner's Monthly* (June 1879): 311–12.

12. "One Day in the Gallery," 5.

13. *New York Sun,* 1880, Sherman scrapbook, Force Papers, Archives of American Art.

14. The Cottier reference is in "Third Exhibition of the Society of American Artists," *Boston Daily Evening Transcript,* 25 March 1880. I am grateful to Colonel Moore for bringing this review to my attention. Ryder is compared to Jules Dupré in a review of the 1881 National Academy exhibition in the *New York Evening Post* (18 March 1881) and in a *New York World* review of the 1883 Society of American Artists exhibition (25 March 1883).

15. "Art and Artists," *Boston Daily Evening Transcript,* 12 June 1880. In "The Season in New York," *Boston Daily Evening Transcript,* 28 October 1882, Ralph Blakelock is said to work "in the manner of Ryder." I

am grateful to Colonel Moore for bringing these reviews to my attention. A review in the *New York Tribune* of the Society of American Artists show (15 April 1883) noted another follower: "Mr. Grafflin comes with his well varnished farmyard scene to enlist under Mr. Ryder's banner."

16. *New York Evening Post*, 18 March 1881; *Boston Daily Evening Transcript*, 25 November 1882; *New York World*, 25 March 1883; *New York Times*, 1 April 1883; and *New York Times*, 4 November 1883 (typed excerpts, Sherman scrapbook, Force Papers, Archives of American Art).

17. J.M.T., "American Artists' Exhibition," 30.

18. "The Society of American Artists," 7.

19. The *New York Sun* reprinted several articles about the Mary Jane Morgan sale in 1886 that trace the history of similar auctions and comment on the relative values of the objects sold. The *Sun* was disdainful of the old-fashioned painting by Jean Meissonier that brought the highest price ($16,525) on opening night but expounded on the wise investment ($9,000) in a painting by Corot purchased that same evening (New York Public Library Papers, Archives of American Art).

The *Boston Daily Evening Transcript* covered the sale in twenty-four articles between 9 February and 20 March 1886. (I am grateful to Colonel Moore for bringing them to my attention.) One of these (11 February 1886) reported, "American art is almost unrepresented, there being only six artists, counting Boughton as one, who are so classed, the others being A. P. and P. P. Ryder, Joseph Lyman Jr., F. E. Church and F. A. Bridgman. On the other hand, French art is well represented, there being eight Corots, seventeen Diazes, five Duprés, eleven Millets, seven Rousseaus, and a like number of Troyons, besides examples of Meissonier, Jules Breton, Detaille, etc."

20. See E. B. Greenshields, *Landscape Painting and Modern Dutch Artists* (New York: Baker & Taylor, 1906), 56, 199.

21. On William Cornelius Van Horne's collections see the Jaccaci Papers, Archives of American Art; James Mavor, "Sir William Cornelius Van Horne," in *My Windows on the Street of the World II* (London and Toronto: Dent, 1923), 233–52; *A Selection from the Collection of Paintings of the Late Sir William Van Horne, K.C.M.G., 1843–1915*, ex. cat. (Montreal: Art Association of Montreal, 1933) [brought to my attention by Nancy Anderson]; and *Twenty Important Modern Paintings from the Collection of the Late Sir William Van Horne, K.C.M.G.*, auction cat. (New York: Parke-Bernet Galleries, 1946) [priced catalogue in the Frick Art Reference Library].

22. "Van [Horne] has been swearing at Ryder but the Reverend had Angus on his side and came out on top. They return [to Montreal] to night so we'll be lonely next Sunday, but have sent for Warner" (Inglis to Wood, 20 September 1895, Wood Papers, Huntington Library).

23. Van Horne to Inglis, 29 July 1896, Wood Papers, Huntington Library. In the same letter Van Horne responds to a false rumor he had heard of Ryder's death: "I am made happy again by your note of yesterday. The report about Ryder was confirmed by Howard Marrifield [?] and Shugio [?] and I have been wearing mourning in my heart for days. I thought he was surely gone and that we should see no more of his symphonies, nor hear that catching laugh of his, nor have anybody to keep the scotch and polly going. So convinced was I that I fear I shall look upon him as a sort of ghost for a while—until at least I see him handling the bottles.
"It is long since I had such a shock. . . .
"Tell Ryder I will want him at dinner. I wish to see him eat to be sure that he isn't an angel."

24. Miller recounted that Van Horne pointed at *Constance* and said to Ryder, "I thought the cloud too white, so I rubbed dirt off the sole of my shoe and rubbed it on the cloud to give it some tone" (quoted in Louchheim, "Best American Painter's Largest Show," 29). Van Horne was not the only one who knew how to "improve" Ryder's work: Kelly admired a figure in one of Ryder's landscapes and was told by the artist that it was not a figure but a drop of candle grease. He continued: "But I held my ground and answered, 'Well, if it is not a figure it ought to be one, because it adds to the weirdness of the scene—that lone figure crossing the moor. Now if you take out the candle grease and paint in the figure that it suggests, it will improve it.' [Ryder] studied it, and musingly said, 'I see what you mean. I will do that' " (Kelly Papers, Archives of American Art).

25. H. Barbara Weinberg lists fifty-one by Inness and thirty-eight by Homer as having been in Thomas B. Clarke's collection at some time or another ("Thomas B. Clarke: Foremost Patron of American Art, from 1872–1899," *American Art Journal* [May 1976]: 75–77). Some were disposed of before the large 1899 sale, in which there were thirty-nine Innesses and thirty-one Homers.

26. Quoted ibid., 59.

27. Ryder to Clarke, 9 April 1885, Detroit Artists Association Records, Archives of American Art.

28. Inglis to Wood, 25 July 1899: "The Clarke sale has come and gone and as you know Pinky Ryder and old Homer Martin came out on top—also George Fuller. Pinky should have been the highest, but he did well and is unable to do anything but talk of doubling his prices. The price for the Temple $2250.00 was big only relatively to what he had ever got but it made my heart glad to know that so many people wanted it. Gellatly who owns his Flying Dutchman bid up to $2200.00 and then I got it, but if people had been wise it should have gone for $5000.00 or any figure, the picture is a wonder—dreamland itself. . . ."

"One thing has been shown however and that is that those who have been abused and spit upon in the past are now to the fore and saved Clarke's sale from ruin—Coffin the artist who used to always write Pinky down in the Evening Post—had a picture there and it sold for $125.00 so Pink had his revenge. He takes his glories all very modestly and told Clarke he on his part had no hard feelings toward anyone. . . .

"Ryder has clients visiting him daily and offering him commissions and even money—so they may yet kill him with kindness" (Wood Papers, Huntington Library).

29. Wood to Warner, 17 March 1889, Warner Family Papers, Archives of American Art. I am grateful to George Gurney for bringing this letter to my attention.

30. Wood wrote this of Sam Jackson, owner of the *Portland Journal* (quoted in Young, *Life and Letters of Weir*, 247).

31. Hans Hofmann, "Lecture 5," 5, Knaths Papers, Archives of American Art.

32. Wood diary no. 6, August 1896, Wood Papers, Huntington Library.

33. Correspondence between Wood and Weir explains the break with Inglis (see letters from 6 May to 7 July 1899, Weir Papers, Archives of American Art). In the last of these Wood comments, "I have seen a little more of the shopkeeper and dealer in Inglis in this experience than I ever did before."

A letter from Warner's widow to Wood discusses Ryder's selling of his own work: "[Ryder] exercises quite a lot of good sense in his manner of living as well as in his work. It is a great matter of pride with him to prove that he can get along without a go-between, and deal with his clients directly, instead of having to go to Jimmy Inglis for a few dollars at a time. . . . They are mutually amiable, but I think Ryder has taken the right stand and one can't help respect him more now than a few years ago" (Sylvia Warner to Wood, 11 January 1899, Wood Papers, Huntington Library).

When Cottier & Co. sold a Ryder painting they did not immediately give over to Ryder his share in the sale but doled it out over time like a stipend. Inglis explained this in a letter to Wood when Wood bought *Jonah* (10 January 1895, Wood Papers, Huntington Library).

Courting the Gentle Muse

1. C. R. Leslie, *Memoirs of the Life of John Constable, Composed Chiefly of His Letters* (1843; reprint, London: Phaidon, 1951).

2. *Siegfried and the Rhine Maidens* was shown at the 1902 Society of American Artists exhibition but was lent by Van Horne, not by Ryder. Other lenders frequently submitted his work for public exhibition in New York, elsewhere in America, and abroad. Although Ryder did not seek out these opportunities, his art was not "undiscovered" during his lifetime, as is often said (see Appendix B).

3. Ryder's literary sources are discussed in Braddock, "Poems of Ryder" (thesis).

4. This window and a companion made by Cottier for Memorial Hall featuring Epaminondas were part of a series depicting soldiers and scholars in history. Cottier received the commission late in 1878, and he exhibited the two windows in his gallery in April 1879 ("Notes," *Art Interchange* 2 [30 April 1879]). They were installed at Harvard by May 1879. Lines from Sir Philip Sidney's popular poem "The Bargain" from *Arcadia* were included in the window (Hobler, "Cottier," 34–38).

5. In 1537 Henry Howard, the earl of Surrey, was inspired by the beauty of Geraldine (Lady Elizabeth Fitzgerald, youngest daughter of Gerald Fitzgerald), although she was only nine years old. Surrey wrote amatory verses that were published by Richard Tottel in "Songes and Sonettes written by the ryght honorable Lorde Henry Haward, late Earle of Surrey," including "A Description and Praise of His Love Geraldine." Surrey's Petrarchan sonnets and translation of Virgil's *Aeneus* influenced many other poets. Michael Drayton wrote "The Earl of Surrey to Geraldine" in *England's Heroical Epistles*. Petrarch's Laura was more directly memorialized by Thomas Campion, in his poem "Laura" in *Observations in the Art of English Poesy*.

I am grateful to Jacob Kainen for identifying Geraldine and for pointing out the link between Ryder's paintings and sixteenth-century English poetry. There is another Geraldine in English literature—the evil seductress "with sunken serpent's eyes" of Samuel Coleridge's long poem *Christabel,* but many aspects of Coleridge's poem are at odds with Ryder's image.

6. Michael Drayton, "The Earl of Surrey to Geraldine," 1602, *Oxford Book of Sixteenth-Century Verse* (Oxford: Clarendon, 1932), 628–29.

7. Browning's lines are: "Oh, the little more, and how much it is! / And the little less; and what worlds away!"

8. Ryder to Harold W. Bromhead, Cottier & Co., London, 20 March 1903, Sherman scrapbook, Force Papers, Archives of American Art.

9. Ryder, "Paragraphs from the Studio of a Recluse," 10.

10. Ryder's apprehensions and preparations for receiving a woman are revealed in his letter to Miller, 20 April 1910, when Miller wanted to bring his cousin Rhoda Dunn to Ryder's rooms: "I hope you and Mrs. Dunn will be able to make a day for your expected call. I would like to have been in better order for so sweet a lady but I will at least be able to spread a rug and keep the writer of 'The Aeronauts' out of the dust which I feared if you took me unawares.

"I think you misunderstood when I said not to bring the gifted lady into this dusty place.

"I didn't mean you were not to come, but to wait

until I could clean a space and as I have just said spread a rug down" (Miller Papers, Archives of American Art).

11. Robert Greene, "The Shepherd's Ode," 1589, in *Oxford Book of Sixteenth-Century Verse,* 369–70.

12. "On one occasion, [Albert] Groll found a 12-year-old girl, a simple country type, in Ryder's studio. He had found her in the street and was going to take care of her. Groll called Mrs. [Charles] Fitzpatrick [a neighbor]. The girl had been missing two days. Mr. Fitzpatrick took her to the police station. Nothing was mentioned of Ryder's connection" (Groll interview, Eastwood Papers, Archives of American Art).

13. See Bram Dijkstra, *Idols of Perversity* (New York: Oxford University Press, 1986).

14. Inglis to Wood, 25 May 1898, Wood Papers, Huntington Library.

15. Ryder to "Brother Wood," 9 February 1906, Love Papers, Archives of American Art. Ryder wrote an earlier letter to Wood about *The Lorelei,* dated 2 October 1899; it apparently was never sent, as it was found among Ryder's things after his death by Louise Fitzpatrick and forwarded to Wood only at that time: "I feel I must drop you a line to at least keep alive a last ray of hope that I trust lingers with you yet, that you will some day get the Lorelei and that like many things in life it may not be so late as to give no pleasure; it should not be so with pictures; for the patience to keep on and the possibility of retaining interest in the endeavor long sustained should be encouraged in proportion to our reverence and esteem or understanding of the gift that makes art and the makers thereof possible.

"It was not till this spring that I felt the witching maiden was placed where she should be.

"It is only now that I am convinced that a moonlight rare and pale will be the most beautiful and poetic treatment of the subject.

"An ounce of poetry added to a picture is worth many pounds of paint literally; and truly worth the doing and undoing of an hundred pictures to obtain."

I am grateful to Katherine Caldwell, Wood's step-daughter, of Berkeley, Calif., for permission to quote this letter, which is in her possession.

16. That Ryder was working on *The Lorelei* and *Passing Song* at the same time is indicated by his letter to Bromhead, 2 August 1901: "I lost both the Lorelei and the Passing Song but have them under way again" (Sherman scrapbook, Force Papers, Archives of American Art). Ryder's reference to having "lost" the two paintings probably refers to his having scraped or started over on the canvases, due to some dissatisfaction with them.

A third painting also dealt with a maiden's love-inducing song; *Nourmahal* (shown in the 1880 Society of American Artists exhibition, now unlocated) was based on Thomas Moore's *Lalla Rookh,* which tells how the heroine Nourmahal obtained a potion that

enabled her to play her lute and sing so well that she regained her lover's lost affections.

17. Inglis to Wood, 15 November 1895, Wood Papers, Huntington Library. Two weeks later, on November 30, Inglis wrote again to Wood: "Ryder has been a love sick man for a week—the Girl having given him the cold shoulder. No fool like an old fool" (ibid.).

18. Wood to Weir, 10 November 1902 (quoted in Young, *Life and Letters of Weir,* 217).

19. Gaye L. Brown, in "Ryder's *Joan of Arc:* Damsel in Distress," explores the way Ryder's poems and images of women and drifting boats express his powerlessness, unhappiness, and loneliness. The author traces this idea through a dozen images, finding strong thematic relationships between them, as, for instance, between *Constance* and *The Dead Bird.*

Occasional comments in the literature bear out the idea that Ryder was considered by some to be almost incompetent in managing his affairs: "[Walter P. Fearon, a Cottier employee] speaks of Ryder with great affection, yet with something of amused patronage, such as a keeper of a trained bear might indulge in" (McBride, "News and Comment," 12).

20. *Coleridge on Shakespeare: The Text of the Lectures of 1811–12,* ed. R. A. Foakes (Charlottesville: University Press of Virginia, 1971).

21. Sadakichi Hartmann, *Shakespeare in Art* (Boston: Page, 1901). Several of Ryder's subjects can be found both in Shakespeare's plays and in other sources, making a complete count of Shakespearean subjects difficult, but any list would probably include: *Desdemona,* from *Othello; The Forest of Arden,* from *As You Like It; Macbeth and the Witches,* from *Macbeth; Florizel and Perdita,* from *The Winter's Tale; The Tempest,* from *The Tempest; Launce and His Dog* (unlocated), from *Two Gentlemen of Verona; Ophelia* (unlocated), from *Hamlet.* Unfortunately, of these, the first three are seriously darkened or deteriorated, the next two are considerably overpainted, and the last two are unlocated.

Shakespeare's *King Henry VI* includes a role for Joan of Arc, and *Love's Labour's Lost* mentions the story of King Cophetua and the Beggar Maid, but both were more famous through other sources. Shakespeare's *Macbeth* and *Othello* were made into operas by Verdi; it is possible that Ryder knew them from performances heard with Inglis and drew his ideas for *Desdemona* and *Macbeth and the Witches* from the operas.

22. The disposition of elements in *The Forest of Arden*—a young woman introduced to an ideal or enchanted landscape by her would-be lover—is prefigured in *La Pêche* by Edouard Manet (The Metropolitan Museum of Art) and *Park at Steen,* ca. 1632–38, by Peter Paul Rubens (Kunsthistorisches Museum, Vienna).

23. One looks in vain today for the figure of Ariel in the clouds. He has disappeared, just as the Lorelei is gone from her rock. But a description of the painting in 1896 refers to the "remote, almost invisible Ariel

slanting out with the clouds" ("Genius in Hiding"). Perhaps Ryder made Ariel thinner because he is a spirit of the air, just as his phantom ship is thinly painted in *The Flying Dutchman*.

24. Ryder to "Brother Wood," 9 February 1906, Love Papers, Archives of American Art.

25. Hartmann, *Shakespeare in Art,* 199.

26. Ryder to Wood, 4 March 1896, Wood Papers, Huntington Library.

27. Weir to Wood, 16 December 1906 and late May 1907 (quoted in Young, *Life and Letters of Weir,* 224–25).

Fancy Endowed with Form

1. "One day I noticed a new outline drawing of Macbeth on a rearing horse, drawn in white chalk into the half dry paint. It was an exact copy from an illustration in my 'Shakespeare in Art' which was lying on the window sill open to the tell-tale page 225, a painting by Hafften that I was particularly familiar with" (Hartmann, "An American Painter," 15, Hartmann Papers, University of California Library). Hyde also reported that Ryder looked at portfolios of engravings and reproductions for ideas ("Ryder as I Knew Him," 596–99).

2. Hartley, "Ryder: Spangle of Existence," in *Hartley: On Art,* 260.

3. One of these is an illustration after Turner (cat. 33a) that inspired *The Lorelei.* See Evans, "Ryder's Visual Sources," 36.

4. "The Muses Elizium," 1630, in *Minor Poems of Michael Drayton,* ed. Cyril Brett (1907; reprint, Freeport, N.Y.: Books for Libraries Press, 1972).

5. Walter de S. Beck's comments in "Ryder: An Appreciation," 40, are fairly typical: "To Ryder a subject of a religious character was not necessary to express his religious sentiment. Acquaintance with his work shows that his *Pegasus* has as much of his 'God-spirit' as has his *Jonah;* his very trees are angels, his stones altars, his rivers are hallowed waters."

 The idea of a personal spirituality "more fundamental than either theology or ecclesiasticism" was explored in depth in William James, *Varieties of Religious Experience: A Study in Human Nature: The Gifford Lectures on Natural Religion Delivered at Edinburgh, 1901–1902* (1902; reprint, New York: Modern Library, 1929). James considered personal religion to mean "the feelings, acts, and experiences of individual men in their solitude, so far as they apprehend themselves to stand in relation to whatever they may consider the divine" (ibid., 31–32).

6. Of recent scholars, Elizabeth Johns has most seriously considered Ryder's religious and spiritual works and their relationship to social Darwinism and other intellectual currents of his time ("Ryder: Thoughts on His Subject Matter," 164–71).

7. H. Barbara Weinberg, *The Decorative Work of John La Farge* (New York and London: Garland, 1977), 146–66, 591–92.

8. Inglis wrote of *Resurrection:* "I have the other also—Christ and Mary—it is beautiful—& of magnificent color—done in his glowing colour time" (Inglis to Wood, 25 July 1899, Wood Papers, Huntington Library).

9. Caffin, "International Still Stirs the Public," 8.

10. Edgar Allan Poe, "The Fall of the House of Usher," 1845, in *Complete Stories of Edgar Allan Poe* (Garden City, N.Y.: Doubleday, 1966), 182–83.

11. Many scholars have found intriguing stylistic prototypes for various aspects of *The Temple of the Mind,* especially Robert Pincus-Witten ("Symbolist Roots of American Abstraction," 85), who suggests the Elgin Marbles and the work of J.-A.-D. Ingres and Auguste Rodin, among others.

12. Ryder's link to symbolist painters through the themes of mind and intellect is explored in detail in Charles C. Eldredge, "Temples of the Mind: Imaginative Imagery and Symbolist Thought," in Eldredge, *American Imagination and Symbolist Painting,* 55–61.

13. Robinson, "Reminiscences of Ryder," 180, 183.

14. Ryder to William T. Evans, 5 April 1910, Evans Papers, Archives of American Art.

15. James Pope Hennessy, *Robert Louis Stevenson* (New York: Simon & Schuster, 1974), 221. A link between Stevenson's interest in Marryat's *Phantom Ship* and Ryder's painting on the same subject is more likely than appears at first glance, for Stevenson had ties to Ryder's circle. Stevenson came to New York in September 1887 as the guest of his good friend Will Low, a painter known to Ryder. Acclaimed at the dock and in the papers as a celebrity, Stevenson stayed at the Hotel St. Stephen, of which William Ryder was proprietor. While Stevenson recuperated from illness at the St. Stephen, Saint-Gaudens came to model his famous relief of the author. On this same trip Stevenson contracted with *Scribner's* for twelve articles and with the *New York Sun* for serialization of his next novel. In April 1888 Stevenson returned to New York and stayed again a few days at the Hotel St. Stephen, and Saint-Gaudens again worked on a relief ("Hotel Harbored Noted Author," *Villager,* 10 August 1950, 11). Stevenson was best of friends and literary collaborator with the Scottish writer William Ernest Henley, an intimate of Cottier's. Henley wrote the catalogue introduction for Cottier's estate sale in 1892, and he reported meeting Ryder in England during Ryder's trip there in 1887.

16. "There is a solitude of space / A solitude of sea / A solitude of death, but these / Society shall be / Compared with that profounder site / That polar privacy / A soul admitted to itself— / Finite infinity (Untitled, in *Final Harvest: Emily Dickinson's Poems,* ed. Thomas H. Johnson [Boston: Little, Brown, 1961], 312).

17. Turner's *Slave Ship*, like Corot's *Orpheus*, was regarded as one of the great, controversial masterworks to arrive in America in the 1870s by which Americans could measure their sophistication. It was sold by John Ruskin to John Taylor Johnston in 1872 and shown in exhibitions at the new Metropolitan Museum of Art in 1873, 1874, and 1876. In 1877 it was purchased for an astounding ten thousand dollars by Miss A. Hooper of Boston. By 1899 it was in the Museum of Fine Arts, Boston. Opinions of the painting varied, but all were strongly held. De Kay noted in his article on Inness: "The so-called 'Slave Ship' is a bugbear. . . . [Inness's] contempt for [it] is so great that one is half persuaded that there is self-illusion at the bottom, and that some day Inness will awake to the fact that the picture which shocked him so much is just the picture he would prefer out of all the other eccentricities of Turner" (p. 63).

18. Ryder to Wood, 2 October 1899 [not sent], Katherine Caldwell collection, Berkeley, Calif.

19. "I have learned to paint at last. If I were completely blind now and knew where the colors were on my palette, I could express myself" (quoted in Donelson F. Hoopes, *The American Impressionists* [New York: Watson-Guptill, 1972], 28).

20. Marcel Proust, "The Past Recaptured," from *Remembrance of Things Past*, trans. Frederick A. Blossom (1928, reprint, New York: Modern Library, 1932), 382, 384.

21. Sigmund Freud, *On Dreams*, trans. James Strachey (1901; reprint, New York: Norton, 1980). For one of the early examinations in America of Freud's dream theories see Havelock Ellis, "Symbolism of Dreams," *Popular Science Monthly* 77 (1910): 42–55. I am grateful to Charles C. Eldredge for introducing me to this article. Ellis's 1910 article followed the first public recognition of Freud and Carl Jung's ideas, when they were invited to lecture at Clark University in Worcester, Mass., in 1909.

Chaos Bewitched

1. Melville, *Moby-Dick*, 31. My thanks go to Brian O'Doherty for calling this passage to my attention.

2. The artist Philip Evergood reported that Ryder would "chew tobacco, spit into a spittoon next to his easel and dip his brushes into the tobacco juice" (quoted in Taylor, "Ryder Remembered," n. 2). Hartley tells how Ryder used dirt on his paintings and ran a hot poker through the sky of *The Tempest* ("Ryder: Spangle of Existence," in *Hartley: On Art*, 263–64).

3. Ryder to Bromhead, 2 August 1901, Sherman scrapbook, Force Papers, Archives of American Art. In a letter to Dr. Albert T. Sanden, dated 12 August 1899, Ryder referred to "experiments which I hope will come out in your pictures as well as others later on" (Ryder Records, Babcock Galleries).

4. See here "A New Society for Art," n. 6.

5. In a letter to the author, 1 March 1988, conservation scientist Michael Palmer identified the support of *Moonlight* as mahogany.

Frederic Newlin Price tells how Ryder sawed up his headboard for painting supports, implying that he was too poor to buy canvas or panels (*A Study of Appreciation*, 20). This story cannot be confirmed.

6. The use of gold leaf under a painting has been noted in the work of La Farge (see here "Ryder and the Decorative Movement," n. 11). Constable and Leslie discussed the use of gold leaf as an underlayer by Correggio, as described in Leslie, *Memoirs of Constable*. Ryder apparently read this book and may then have been aware of Correggio's example.

7. Evidence of these inorganic pigments have been found in six Ryder paintings from the National Museum of American Art in a study of Ryder's art by conservation scientists at the Smithsonian's Conservation Analytical Laboratory in 1986–88.

8. Walter Pach in "On Ryder," 127, quotes Ryder: "I work altogether from my feeling for these things, I have no rule. And I think it is better to get the design first before I try for the color. It would be wasted, much of the time, when I have to change things about." This statement has sometimes been interpreted to mean that Ryder worked first in monochrome, but the evidence of *Harvest* and cross-sections of paint from other works suggest that this is not the case.

9. For radiography in paintings analysis, with special reference to Ryder, see Charles Bridgman and Sheldon Keck, "The Radiography of Paintings," *Medical Radiography and Photography* 37, no. 3 (1961): 62–65; and Goodrich, *Ryder* (1959). For an introduction to autoradiography with emphasis on paintings by Blakelock and Ryder see Cotter et al., "Study of the Nineteenth-Century Oil Painters by Means of Autoradiography," 163–203.

Another excellent introduction to autoradiography is *Art and Autoradiography: Insights into the Genesis of Paintings by Rembrandt, Van Dyck, and Vermeer* (New York: Metropolitan Museum of Art, 1982). All paintings attributed to Ryder in the Metropolitan Museum and several considered to be forgeries have been autoradiographed and the results briefly noted in Bolger-Burke, *American Paintings in the Metropolitan*, vol. 2. Seven Ryders in the National Museum of American Art have been autoradiographed at the National Bureau of Standards under the supervision of scientists at the Conservation Analytical Laboratory: *Christ Appearing to Mary, The Flying Dutchman, In the Stable, Jonah, King Cophetua and the Beggar Maid, Lord Ullin's Daughter,* and *Pastoral Study*.

10. M. Louise McLaughlin, *Pottery Decoration under the Glaze* (Cincinnati: Clarke, 1880), 41–42 (quoted in *American Art Pottery*, ex. cat. [New York: Cooper-Hewitt Museum, 1987], 33).

11. Pach, "On Ryder," 128.

12. McBride, "News and Comment," 12.

13. Hartmann, "An American Painter," 10, Hartmann Archives, University of California Library.

14. Ryder to Sanden, 12 August 1899, Ryder Records, Babcock Galleries.

15. John Graham describes in a journal entry how he worked on a portrait of his mother: "Today I painted on Eugenie's portrait. . . . I am already working two years on it. I always wanted to lead it to such perfection by constant going over it caressing with love its forms that it would say 'Mama.' Today, however, . . . when I worked especially assiduously all of a sudden to my surprise she shivered. . . . I was thrilled and frightened" (quoted in Eleanor Green, *John Graham: Artist and Avatar* [Washington, D.C.: Phillips Collection, 1987], 63).

16. Laughton Osborn, *Handbook of Young Artists and Amateurs in Oil Painting* (New York: Wiley & Putnam, 1845), 65, 87.

17. "[Kenneth Hayes] Miller was astonished to see [Ryder] pouring varnish back and forth over the surface on a work like collodion" (Lahey Papers, Archives of American Art). Hartmann wrote: "He seizes the canvas with one hand, and a varnish bottle in the other, steps nearer to the light and pours the entire contents over the pictures, a sluggish flow of which one half drips to the floor. He tests the stickiness with his fingers and replaces the canvas on the easel. A feeling of relief comes over him, and he stands there contemplating, making curious movements with his lips" ("An American Painter," 8, Hartmann Papers, University of California Library).

Weir wrote to Wood: "Every time I go [to Ryder's studio] he washes out his canvases with kerosene and they are as black as your hat" (25 January 1912 [quoted in Young, *Life and Letters of Weir*, 241]).

18. Caroline Keck, treatment report on *Story of the Cross* (title given in report as *The Way of the Cross*), March 1966, copy in curatorial files, National Museum of American Art.

19. Hartmann attributes this story to John Gellatly, in "An American Painter," 8, Hartmann Papers, University of California Library.

20. "Haven't sent the glass on the Ryder, because you don't like it and it looks so well without it—but the fellow thinks strangers are apt to go up and touch it or rub it—so in a way he thinks the glass is an advantage" (Inglis to Wood, 10 January 1895, Wood Papers, Huntington Library).

21. Wood to Warner, 17 March 1889, Warner Family Papers.

22. Martin Wyld, John Mills, and Joyce Plesters, "Some Observations on Blanching (with Special Reference to the Paintings of Claude)," *National Gallery Technical Bulletin* 4 (1980): 53. In 1846 Charles Eastlake, director of the National Gallery, London, had a number of the gallery's paintings cleaned, sparking a major controversy that led to his resignation the next year. His successor, Thomas Uwins, continued the cleaning, which led to an inquiry in the House of Commons in 1853. The transcript of the hearings is invaluable in explaining painting and cleaning practices at midcentury.

23. The Glasgow Boys were first recognized as a school in 1877, after exhibitions in London and Munich, and they continued to exhibit together until about 1900. In their subjects and style they were indebted to the Barbizon and Hague schools.

24. "Pictures at the New York Athletic Club."

25. George Sheldon, *American Painters* (1879), 18. I am grateful to William H. Truettner for bringing this reference to my attention.

26. Charles Melville Dewey to Evans, 8 November 1909, Evans Papers, Archives of American Art.

27. Ryder to Evans, 5 April 1910, Evans Papers, Archives of American Art. The quotation from Constable is found in Leslie, *Memoirs of Constable*, 186. Constable received "a great many suggestions from a very shallow source" and complied with a number of them but finally responded to the continuing criticism by saying, "Very true, but don't you see that I might go on, and make this picture so good that it would be good for nothing."

28. Ryder to Macbeth, 6 November 1911, Macbeth Gallery Papers, Archives of American Art.

29. Ryder to Macbeth, 9 November 1911, Macbeth Gallery Papers, Archives of American Art. A painter who shared Ryder's contempt for the restorers' heavy-handed approach was his friend Abbott Thayer. Thayer wrote on the back of the canvas of his large *My Children*, ca. 1897 (National Museum of American Art), "*Never to receive one pin point of retouching.*"

One critic asserted that Ryder restored his own paintings in an unconventional way: "Fissures appeared in the surfaces even before the works quit his room for the dealer's shop or the home of the rare patron. Ryder used to wave a heated poker close to the cracks; he had some theory to the effect that the red-hot iron would heal them" (Rosenfeld, *Port of New York*, 14).

Louise Fitzpatrick, who often watched Ryder paint, commented of *The Lorelei*: "But alas, in the making of the picture, the varnish, the oils, the wax, the heat, and his fear that it would not dry made him dig into it, and then the work of undoing started and it was put aside. He could no longer stand the strain of even speaking about it" (Fitzpatrick to Wood, 17 April 1918, Wood Papers, Huntington Library).

30. Art Femenella, stained-glass conservator, New Jersey, identified the purpose of the lavender-tinted dispersing glass that came with a La Farge window in the Metropolitan Museum. David Donaldson, curator of the Charles Hosmer Morse Museum of American Art, told the author that Tiffany also sometimes used a dispersing sheet to soften and unify the light striking his windows.

31. Sherman, *Ryder*, 43.

32. Ryder, "Paragraphs from the Studio of a Recluse," 10.

First Citizen of the Moon

1. The stories about Ryder discussed here are derived from the following accounts, unless otherwise noted: Daingerfield, "Ryder: Artist and Dreamer," 380–84; Evergood and Charles Fitzpatrick, both quoted in Taylor, "Ryder Remembered," 5–8, 8–15, respectively; Hartley, "Ryder: Spangle of Existence," in *Hartley: On Art*, 256–68; Hartmann, "An American Painter," Hartmann Papers, University of California Library; Hyde, "Ryder as I Knew Him," 596–99; Kelly Papers, Archives of American Art; McBride, "News and Comment," 12; Robinson, "Reminiscences of Ryder," 176–87.

2. Kelly Papers, Archives of American Art.

3. Hartley, "Ryder: Spangle of Existence," in *Hartley: On Art*, 261.

4. De Kay, "Modern Colorist," 258. Among Ryder's earliest patrons were Mary Jane Morgan, Mrs. Bickely, Helena de Kay, Mrs. W. C. Banning, Mrs. Middlemore of Philadelphia, and Mrs. Moore of Paris.

5. T. J. Jackson Lears, *No Place of Grace: Antimodernism and the Transformation of American Culture, 1880–1920* (New York: Pantheon, 1982), 247–51, 279–97. The same themes are expanded in Dijkstra, *Idols of Perversity*.

6. Paul Rosenfeld developed an elaborate theory about Ryder's sexual fears, equating his canvases with the trunk of a woman's body and analyzing how Ryder avoided the lower parts and concentrated interest in the middle and upper reaches of the canvases. "Ryder could not bring his whole man into entire contact with the object. The upper, spiritual regions of the body were singing flesh to him" (see *Port of New York*, 14–15).

7. Ryder's good works are discussed especially by Kelly, Robinson, and Charles Fitzpatrick.

8. Inglis to Wood, 15 June 1895, Wood Papers, Huntington Library.

9. Another eyewitness account is given in "Albert P. Ryder: Poe of the Brush," 5. Hartley, Hartmann, Kelly (repeating J. Carroll Beckwith's account), Robinson, and others give accounts of the clutter in Ryder's apartment. Henry McBride repeated Walter Fearon's assertion that the board of health got after Ryder more than once for the condition of his apartment.

10. Hartmann, "An American Painter," 23–24.

11. In correspondence to Sanden, Ryder showed some self-consciousness about his rubbish. In a typical letter he excused a delay in writing by explaining, "I presume it is the housekeeping that's the baleful course. I get so nervous from the time it takes, and hurried also by it; hoping all the time to find some way of simplifying" (2 September 1901, Ryder Records, Babcock Galleries).

12. According to Kelly, Ryder called this clean apartment his "receiving studio"—a place for guests who could not be invited to his home. It was at 152 West Fourteenth Street, in a modern studio building, "neat," furnished with a sofa, chair, and easel. In 1913 Ryder mentioned to Sanden that he had the room for "another year," adding that he was "busy planning to get as much good out of it as possible"; a subsequent letter noted that he had taken his best furniture and important pictures to the room (20 June and 5 August 1913, Ryder Records, Babcock Galleries).

13. In a letter to Sanden, dated 19 October 1909, Ryder explains that the tenants in his house must move by 1 November to permit remodeling (Ryder Records, Babcock Galleries). Ryder's letter to Gellatly, dated 26 March 1910 and written from the Sixteenth Street address, mentions that he had been unsettled since moving and had notified no one yet of his new address (Gellatly Vertical File, National Museum of American Art). A letter to Weir, dated 11 August 1911, gives a formula for remembering his address: "$16 \times 2 = 32$ there's your 3. $2 + 6 = 8$ threes [*sic*] your 8. 0 for the middle number gives you 308" (quoted in Young, *Life and Letters of Weir*, 232).

14. Both Kelly and Charles Fitzpatrick as well as others repeat the story that Ryder did not know how to cash checks or that "four-figure" checks were found uncashed among his effects at his death. Horatio Walker is said to have asked Ryder if he had any money for food, only to discover a number of checks from patrons that Ryder did not understand how to cash. After Walker took Ryder to a bank and showed him how to draw money on the checks, Ryder supposedly considered Walker a financial wizard.

15. Ryder, "Paragraphs from the Studio of a Recluse," 10–11.

16. De Kay, for instance, noted that Ryder declined a dealer's offer to purchase ten paintings over three years ("Modern Colorist," 258). An anonymous author wrote in 1906 that "for years every stroke of his brush has been sold before it is made. He paints only on commission now" ("Albert P. Ryder: Poe of the Brush," 5).

17. Charles Fitzpatrick said that Ryder worried he would sometime starve to death, a fear engendered by the extreme poverty of his days as an academy student (Taylor, "Ryder Remembered," 13).

18. Did Ryder drink? Critic Joseph Lewis French wrote, "He has never tasted spirits in his life" ("Painter of Dreams," 7). Frederic Fairchild Sherman said categorically, "He did not drink" (*Ryder*, 26). And one anonymous author insisted, "He never drinks anything stronger than chocolate" ("Albert P. Ryder: Poe of the Brush," 5). But his personal friends said otherwise. Evergood recounted how Ryder and Charles Fitzpatrick went on "beer drinking sprees together, going from pub to pub singing sea ditties. . . . Ryder . . . enjoyed a few beers, though on the whole he was pretty abstemious." Kahlil Gibran described meeting

Ryder outside a restaurant and walking home with him: "In a step or two we passed by a saloon and he said 'Will you have a drink?' I said No, but that I'd be glad to wait for him in his studio. He went in and took one. He went into two [more] on his way home. . . . He probably feels the need of the stimulant" (Hilu, *Beloved Prophet*, 244).

19. Ryder urged Sanden and his wife to "Get the habit of buttermilk; they claim all sorts of good from it" (15 March 1907, Ryder Records, Babcock Galleries).

20. Beck, "Ryder: An Appreciation," 37. The most romantic account of Ryder's walks is by Hartmann, who opened "The Story of an American Painter" with a reimagination of Ryder walking along an open road in New Jersey on an autumn moonlit night: "No Chaldean shepherd ever gazed with more reverence at the luminous firmament . . . a strange pilgrim who walks the lonesome country at night with such adoration."

21. Robert Louis Stevenson, "Walking Tours," 1876, in *A Century of the Essay*, ed. David Daiches (New York: Harcourt, Brace, 1951), 98–106.

22. The Boston photographer F. Holland Day secluded himself in order to fast and to allow his beard and hair to grow long; he made a crown of thorns, then photographed himself and mounted seven images for exhibition under the title *The Seven Words*. His eccentricities surpassed Ryder's, and in 1917 Day took to his bed in a state of ennui, where he remained until his death sixteen years later (Estelle Jussim, *Slave to Beauty: The Eccentric Life and Controversial Career of F. Holland Day—Photographer, Publisher, Aesthete* [Boston: Godine, 1981]).

23. De Kay, "Modern Colorist," 250–51.

24. Richard Lahey reported, "Toward the end of [Ryder's] life he suffered from hardening of the arteries—and was very slow walking. One day in Miller's company they were about to cross 6th Avenue at 42nd Street NYC and Kenneth looked up and down—there was a car several blocks away—but they ventured forth. He was only halfway across when the car was upon him. So excited was he that he kept stamping [?] his feet up and down—But they did not seem to go forward. However they finally got across the street without injury" (Lahey Papers, Archives of American Art).

25. Numerous authors report that Ryder wore no socks. This was apparently part of the regimen Ryder adopted from Father Sebastian Kneipp (Groll interview, Eastwood Papers, Archives of American Art). In 1891 Father Kneipp, a homeopath, authorized the manufacture and distribution of therapeutic and body-care products under the trademark "Kneipp." Father Kneipp's books were available in America during the 1890s and are still popular today in both America and Europe. I am grateful to Dr. Kurt Albert of the Kneipp Corporation of America, Inc., for providing information about the Kneipp system.

26. Ryder to Sanden, 17 May and 15 June 1912, Ryder Records, Babcock Galleries.

Later Critics, New Patrons

1. Inglis to Wood, 10 March 1893, Wood Papers, Huntington Library.

2. A copy of the award certificate is in the Love Papers, Archives of American Art.

3. De Kay, "Modern Colorist," 250.

4. *Comparative Exhibition of Native and Foreign Art*, ex. cat. (New York: Society of Art Collectors, 1904).

5. De Kay, "Comparative Art Exhibition," 1.

6. Fry, "Art of Ryder," 63.

7. Alfred H. Barr, Jr., wrote in the introduction to *Sixth Loan Exhibition: Winslow Homer, Albert P. Ryder, Thomas Eakins*, ex. cat. (New York: Museum of Modern Art, 1930), 6–7: "Homer, Ryder and Eakins seem of considerably more importance than they did in 1920. . . . Ryder, too, has a peculiarly contemporary meaning . . . the antecedent not of the cubists but of the more recent surrealists—artists intent upon realizing spontaneous images capable of evoking sentiment. . . . [T]he imaginative world of Albert Ryder need[s] no apology in 1930." In an essay in the catalogue, curator Bryson Burroughs wrote about Ryder's "lack of systematic instruction . . . heedless methods of painting . . . childish indifference to rationality and logic." Ryder was one of the "isolated phenomena in the arts, who happen unaccountably and have no generation" (ibid., 12, 14).

8. Hartley, "Ryder: Spangle of Existence," in *Hartley: On Art*, 256.

9. For the development of concepts of folk art in America see David Park Curry, "Time Line," in *An American Sampler: Folk Art from the Shelburne Museum*, ex. cat. (Washington, D.C.: National Gallery of Art, 1987), 184–207. I am grateful to William H. Truettner for his thoughtful ideas on Ryder's links to American folk art and to the development of a history of American art.

10. Greenberg, "Review of an Exhibition," 1947, in *Greenberg: Essays and Criticism*, 2:180.

11. Royal Cortissoz's *American Artists* (New York and London: Scribner's, 1923), 96, included a chapter, "Poets in Paint," that featured Ryder, opening with "Ryder wrote verses, and I can sniff the offense this circumstance would give to a certain type of artist." His discussion uses Ryder to refute the modernist hostility to the "taint" of literary subjects.

Hartmann's unpublished 1926 manuscript, "The Story of an American Painter," is the most extreme example of the conservative argument. The first twenty-eight pages present Ryder as the archetypal American artist—romantic, visionary, individual, literary. This section is followed by another twenty pages espousing Hartmann's elitist views of art: principles of beauty, the vulgarity of popular art, morality, the dif-

ference between ordinary and superior appreciation of art, marketing and patronage, the insufficiency of technique, and the general decline of painting since the advent of impressionism (Hartmann Papers, University of California Library).

Hartley wrote about Ryder in 1917, 1921, and most extensively in 1936. The last text dwells on Ryder's mysticism and poverty, closely reflecting Hartley's own concerns at the time.

12. Frank Jewett Mather, Jr., Charles Rufus Morey, and William James Henderson, *The American Spirit in Art* (New Haven, Conn.: Yale University Press, 1927), 59.

13. Inglis recounted Humphrey Ward's visit to the Cottier gallery to see the Dutch old masters there as well as the Americans: "The Reverend's pictures pleased him more than any American he has ever seen—who and where is he was his remark—but that was too difficult to answer" (Inglis to Wood, 18 March 1895, Wood Papers, Huntington Library).

Henry McBride discussed Wilhelm R. Valentiner's high opinion of Ryder in his obituary "News and Comment," 12. Sir John Rothenstein's comments were given in the catalogue for an exhibition of American painting shown at the Tate Gallery, London, in the 1930s, summarized in Edward Alden Jewell, "Our Tender 'Innocents Abroad'," undated clipping, Sherman scrapbook, Force Papers, Archives of American Art.

14. Ryder's authentication of Alexander Morten's paintings occurs in a letter written in November 1915, that is, after the serious illness that spring from which Ryder never completely recovered; this has led to some questions about the reliability of the authentications.

15. The Ryder group was said to be Gellatly's favorite, but he also formed in-depth collections of Thayer, Thomas Dewing, Frederick S. Church, Hassam, and Twachtman (see Seymour and Riggs, "Gellatly Collection," 109–25, 144).

16. Gellatly, "In the Year of Our Lord 1926," typescript, Wood Papers, Huntington Library.

17. Gellatly and Charles Lang Freer knew each other in the 1890s and traveled on the same ship to Europe in 1900. Freer began to explore a donation to the nation in 1901, and by 1906 his offer was accepted by the Smithsonian. (I am grateful to Susan Hobbs for this information.) Gellatly's gift to the nation finally occurred in 1929.

18. Gellatly's assistant, Ralph Seymour, commented on the portrait of the collector by Irving Ramsey Wiles, donated to the Smithsonian by the artist the year following Gellatly's death in 1931: "Dreaming perhaps of his treasures, Mr. Gellatly is shown as a pensive elderly gentleman dressed in white, entirely absorbed in something far removed from the beholder. The dark jewel on his right forefinger and the loosely held cigarette he has forgotten to light add their touches of character to this brilliant study of a man the workings of whose mind can best be understood by consideration of his devotion to the curious Ryders in the next room" (Seymour and Riggs, "Gellatly Collection," 118).

19. Hartmann makes veiled references to Gellatly's purchase of *The Flying Dutchman* for such a low sum, saying "He could have afforded a thousand, even if he had to borrow it from his wife" ("An American Painter," 25).

20. The story is told by Charles Fitzpatrick and Albert Groll, among others. Groll claims that Ryder threw the frame in the fire but that Groll withdrew it.

21. Ryder to Gellatly, 24 August 1905, Gellatly Vertical File, National Museum of American Art.

22. Hartmann, "An American Painter," 26–27. Hartmann does not name the picture that was attacked. Charles Fitzpatrick hints at Ryder's potential for violence to his own works: "[Ryder] told me how long Maris worked on his pictures and how hard it was for the dealers to get them and if they bothered him too much he would kick a hole in the picture. Maris had a large carving knife handy and I don't know whether it was by accident or not, but there were a few of Ryder's had holes in them. . . . Ryder also had a knife, but I don't think he ever had any ferocious intentions, altho at times I have seen him straighten up, throw his arms up and determine not to let anybody get the best of him, or to make him finish his pictures in a certain length of time" (quoted in Taylor, "Ryder Remembered," 11).

23. Ryder to Gellatly, 20 November 1905, Gellatly Vertical File, National Museum of American Art.

24. A. Ludwig to Ryder, 28 August 1905, Love Papers, Archives of American Art.

25. Ryder to Wood, 9 February 1906, Wood Papers, Huntington Library. It may be that Ryder wanted to "head off" Gellatly, who sometimes copyrighted works in his collection, or Newman E. Montross, a New York dealer who was passionate for his art, keeping *Forest of Arden, Moonlight Marine,* and others in his private collection, his "holy of holies," according to Charles Fitzpatrick (quoted in Taylor, "Ryder Remembered," 12). Montross copyrighted several Ryders in his collection and made reproductions of them, which were used in publications.

26. Thayer to Freer, 20 May 1893, Abbott Handerson Thayer Papers, Archives of American Art, reel D200.

27. Henry Adams, *The Education of Henry Adams* (1918; reprint, Boston: Houghton Mifflin, 1931), 341.

28. Charles Fitzpatrick, quoted in Taylor, "Ryder Remembered," 11. Fitzpatrick does not identify Sanden by name, but *The Race Track* entered his collection directly from Ryder's studio. Ryder's correspondence with Sanden includes acknowledgments of two five-hundred-dollar payments in 1899 and of regular, almost monthly payments from him up to the time of

Ryder's illness in 1915 (Ryder Records, Babcock Galleries).

29. Inglis wrote to Wood, 25 July 1899, that Gellatly had bid up to $2,200 for *The Temple of the Mind* at the Clarke sale and then Inglis prevailed on a bid of $2,250. After the sale Gellatly offered Inglis $3,000 for the painting, but Inglis refused him, saying he would sell only to Helen Ladd Corbett or R. B. Angus (Wood Papers, Huntington Library). Angus bought the painting and kept it until 1918, when he donated it to the Buffalo Fine Arts Academy (now Albright-Knox Art Gallery).

30. Correspondence in curatorial files, Albright-Knox Art Gallery.

31. Wood to Louise Fitzpatrick, 16 March 1918, Wood Papers, Huntington Library.

32. See Gellatly's letters to Wood, 9 October and 22 October 1919, Wood Papers, Huntington Library. Gellatly's price was enormously high for an American work but, surprisingly, not a record. The Toledo Museum of Art had paid twenty thousand dollars for Blakelock's *Brook by Moonlight* at auction in 1916, then the highest price paid for the work of a living American.

33. In its first decades the Metropolitan Museum generally exhibited mixed loan shows of European and American work. In 1874 it presented thirty-eight John Kensett paintings to honor the recently deceased artist and one Thomas Cole allegorical series. Memorial shows were held as well for Gifford (1881), Saint-Gaudens (1908), Whistler (1910), Homer (1911), Chase (1917), and Eakins (1917). Two one-person exhibitions were held of Europeans during the same decades: George Frederick Watts (1884–85) and Gustave Courbet (1919).

34. De Kay, "Inness," 64.

35. Hartley described Ryder as "our finest genius, the most creative, the most racial" ("Ryder," *Seven Arts,* 95). Rosenfeld is paraphrased as saying that "the suppression of racial traits in groups submerged in an alien environment results in divided personality and artistic sterility" (Daniel Gregory Mason, "Psychoanalysis and Music: The Submerged Anglo-Saxon," *Arts & Decoration* 13, no. 2 [25 June 1920]: 106). The literature on race frequently singled out the Scottish people as superior: "Almost the tallest stature in the world is found among the pure Nordic populations of the Scottish and English borders" (Madison Grant, *The Passing of the Great Race* [New York: Scribner's, 1916]: 26). For the best discussion of racial themes in late nineteenth-century Western culture see Dijkstra, *Idols of Perversity.* Several Ryder subjects (*Constance, Desdemona,* and *King Cophetua and the Beggar Maid*) present "heathen" or non-European men marrying white women—a manifestation of the concern over miscegenation.

Disputed Spoils

1. Louise Fitzpatrick to Robert C. Vose, 15 November 1917, curatorial file, Butler Institute of American Art, Youngstown, Ohio.

2. Miller to Rhoda Dunn, 21 September 1915 (quoted in "The Kenneth Hayes Miller Papers," *Archives of American Art Journal* 13, no. 2 [1973]: 21).

3. The Fitzpatricks first moved Ryder into a boarding house at 9103 Fiftieth Avenue in Elmhurst, where they were then living, but soon they purchased a small house at 27 Gerry Avenue.

4. Ryder's mother died on 19 June 1892; his father on 19 June 1900. His brothers died in 1879, 1898, and 1911. After Ryder's death his niece, Gertrude Ryder Smith, wrote to Louise Fitzpatrick: "I realize what an anxious and tiring time you have had during the past days of Uncle Albert's illness and passing away; and of course during the time he has been with you, when he has been so feeble. And although I may not have phoned or written often, it is only because I have been physically unable to attend to all the matters, both business and household, that daily seem to require attention" (30 March 1917, Love Papers, Archives of American Art).

5. Miller to Dunn, 29 October 1915 and 16 February 1916, Love Papers, Archives of American Art.

6. Gibran to Mary Haskell, 21 April 1916 (Hilu, *Beloved Prophet,* 255). Gibran and Ryder met in January 1915 after Ryder went to Montross Gallery to see an exhibition of Gibran's work. That same month, he wrote a prose poem, "To Albert Pinkham Ryder," which was privately printed: "Poet, who has heard thee but the spirits that follow thy solitary path? Prophet, who has known thee but those who are driven by the Great Tempest to thy lonely grove?

"And yet thou art not alone, for thine is the Giant-World of super-realities, where souls of unborn worlds dance in rhythmic ecstasies; and the silence that envelops thy name is the very voice of the Great Unknown.

"Thine is the Giant-World of primal truth and unveiled visions, whose days stand in awe of mystic nights, whose nights are big with high and lustrous days, whose hills relate the unrecorded deeds of unremembered races, whose seas chant the deep melody of distant Time, whose sky withholds the secrets of unnamed gods.

"O, poet, who has heard thee but the spirits that follow thy footprints? O, prophet, who has known thee but those the Tempest carries to thy lonely fields?

"O, most aloof son of the New World, who has loved thee but those who know thy burning love?

"Nay, thou art not alone, for we, we who walk on the flaming path, we who seek the unattainable and reach for the unreachable, we whose bread is hunger and whose wine is thirst, we know thee and we hear thee and we love thee and we hold thee high" (Jean

and Kahlil Gibran, *Kahlil Gibran: His Life and World* [Boston: New York Graphic Society, 1974], 280).

7. The death certificate lists uremia and pulmonary edema as the immediate cause of death, with chronic interstitial nephritis of ten years' duration as the contributory condition. I am grateful to Evelyn Eastwood for sending me a copy of the death certificate.

8. Dewey's petition to the New York State Surrogate Court, Borough of Manhattan, is dated 10 April 1917; it includes a witnessed letter to the court from Gertrude Ryder Smith, dated 31 March 1917, relinquishing her authority. The speed with which this transaction was completed suggests that the arrangement was planned sometime earlier. Dewey may have convinced Mrs. Smith and her mother, Mrs. E. N. Ryder, that all would profit more handsomely if affairs were left to an art professional like himself. The *New Bedford Standard-Times* obituary (quoted in Cheney, "Painter of Dreams," 17) is based partly on an interview with Mrs. E. N. Ryder, in which there is speculation about the high value of a small landscape still in her possession.

A letter from Mrs. Smith to Louise Fitzpatrick, 30 March 1917 (the day of Ryder's funeral), begins: "I have delayed writing to you for the reason that I hoped to see you in person to-day at Uncle Albert's funeral. But Mr. Dewey will probably tell you, it is impossible for either Mr. Smith or myself to make the trip over to-day. Naturally we feel sorry that circumstances have seemed to combine to prevent our going either to Elmhurst or down to New Bedford at this time. . . .

"We realize how near you and your husband have been to Uncle Albert, and how thoughtful you have been for his comfort. We cannot help but appreciate it, and we hope to be able to show our appreciation later, when his affairs have been adjusted."

9. Louise Fitzpatrick to Wood, 9 December 1917, Wood Papers, Huntington Library.

10. Thomas Casilear Cole, a friend of Dewey's, wrote that Dewey had destroyed four or five unfinished canvases ("Notes on Charles Melville Dewey's Comments on Price's Book," ca. 1932–37, Cole Papers, Archives of American Art). Sylvia Warner discussed in two letters to Cole how canvases disappeared from Ryder's room when she brought her friend Marian Y. Bloodgood there to select a work. It is not clear whether this was just before Ryder's death or after (11 and 15 March 1933, Cole Papers, Archives of American Art). In the earlier letter she wrote: "[Ryder] had been much run after within the preceding two or three years by certain dealers and amateurs, and, in his increasingly sickly condition, may have weakened in his resolve to hold on to a number which he had wanted to keep until better able to perfect them." I am grateful to Garnett McCoy for bringing these letters to my attention.

Louise Fitzpatrick's assertion that Dewey felt that the remaining paintings were not ready for sale is in

her letter to Wood, 9 December 1917, Wood Papers, Huntington Library.

11. Dewey to Raymond Wyer, director, Worcester Art Museum, not dated [April 1918], curatorial files, Worcester Art Museum, Mass. The *Christ and Mary* offered by Dewey is now called *Noli Me Tangere* (Carnegie Museum of Art, Pittsburgh). *Forest of Arden* is in a private collection; this is not the work of the same title in the Metropolitan Museum of Art.

As for Dewey's closeness to Ryder, Sylvia Warner wrote years later to Thomas Casilear Cole, "With all due respect to Mr. Dewey, and between ourselves, Ryder saw him but very seldom after he, R., had merged into the Cottier crowd, which included Julian Weir and Olin Warner" (15 March 1933, Cole Papers, Archives of American Art).

12. Evergood, whose mother was a close friend of Louise Fitzpatrick's, carried away four small paintings and some poems and documents pertaining to Ryder when Mary Fitzpatrick prepared the house for sale. Three of the paintings found their way into the Hirshhorn Museum and Sculpture Garden; the original documents are in the Harold O. Love Papers, Ryder Archive, University of Delaware; most were microfilmed by the Archives of American Art in 1960.

13. *Autumn Meadows* was sold by Dewey to John F. Braun of Philadelphia in 1917. It was published as a forgery in Bolger-Burke, *American Paintings in the Metropolitan*, 3:29–30. Donald Kellogg of Buffalo mentioned in a letter to Burroughs that he had recently purchased two Ryders from Dewey (9 June 1919, 1918 memorial exhibition file, the Metropolitan Museum of Art Archives).

14. Burroughs to Louise Fitzpatrick, 22 November 1917, 1918 memorial exhibition file, the Metropolitan Museum of Art Archives.

15. Louise Fitzpatrick to Robert C. Vose, 15 November 1917, curatorial file, Butler Institute of American Art.

16. "I will show you a picture that Mr. Ryder gave me when I was ill last year. I hope that I will never have to part with it. It is not much more than a sketch, a shepherd pointing up to a wayside crucifix; one of the things he did not finish, perhaps you remember it?" (Louise Fitzpatrick to Wood, 9 December 1917, Wood Papers, Huntington Library). Ryder's famous painting on this theme, *The Story of the Cross,* was in Helen Ladd Corbett's collection by 1907.

17. Macbeth to Wood, 5 February 1918, Wood Papers, Huntington Library.

18. Louise Fitzpatrick to Wood, 17 April 1918 and undated [1920], Wood Papers, Huntington Library.

19. "When [Ryder] was too old and feeble to paint alone, [Louise Fitzpatrick] would help him at the easel. She would prepare his palette and would sit for hours at his side, ever ready to steady his hand when he needed support, sacrificing her own desires to paint in order to perform the menial chores and enable him

to live and breathe. . . . It is a sad commentary on the small meanness of the timid and commercially minded men that she was so completely neglected both before and after Ryder's death. I don't think she sold more than a couple of paintings in her life, but I heard the implication breathed in hushed tones a couple of times in later years that she painted so like Ryder that her work might be mistaken for his. When a lot of obvious and vile fakes of Ryder's work started to seep into the market after his death, even a faint shadow of suspicion was cast onto this beautiful and saintly soul, I am told, by some whispering commercial voices looking for a whipping boy" (Evergood, quoted in Taylor, "Ryder Remembered," 7).

Elbridge Kingsley, who had engraved Ryder's paintings for the 1890 Century Magazine article, also reported that Ryder let others paint on his works: "He seemed to invite friends to help him paint. I have seen other artists take his brushes and paint for him, and when they were done he took hold himself and it would all come out a 'Ryder' after all. I can only account for it by saying that the artist could absorb the ideas of other minds and use them for his own ends" ("Life and Works of Elbridge Kingsley, Painter-Engraver," typescript, 191, Sherman scrapbook, Force Papers, Archives of American Art).

20. Louise Fitzpatrick to "Friend" [Sara Bard Field], 19 June 1928, Wood Papers, Huntington Library. Evergood described Louise Fitzpatrick as "pure as the driven snow. A kind of Saint whose fervor and love for humanity was completely tied up in her fervor and love of the master. She would speak of Ryder and Christ in the same breath" (quoted in Taylor, "Ryder Remembered," 7).

21. See, for example, Moonrise, no. 6 in the American Art Association sale of 7 February 1918, listed in the catalogue as "Authenticated on the back of canvas by Louise D. Fitz Patrick."

22. Louise Fitzpatrick to Wood, not dated [1920], Wood Papers, Huntington Library.

23. "Biographical Notes," typescript, Sherman Papers, box 1, not microfilmed, Archives of American Art.

24. Ibid., 3–4. A correspondence developed in 1919–20 between Sherman and Bromhead, formerly of Cottier & Co., London, and by 1919 head of his own dealership, Bromhead, Cutts & Co., Ltd. It was Bromhead who offered the chance to purchase John Robinson's marine, and this led to further correspondence about Ryder and finally to Bromhead's advising Sherman on how they might cooperate to sell paintings in America (box 1, Sherman Papers, Archives of American Art).

In February 1925 Sherman wrote to his former Art in America colleague, Valentiner, then director of the Detroit Institute of Arts, offering two Ryders that had come to light in 1923. Valentiner purchased Summer Night, Moonlight—"the larger but the cheaper one"—now acknowledged to be a forgery derived from The

Barnyard (correspondence between Valentiner and Sherman, curatorial files, Detroit Institute of Arts).

25. Sherman, Ryder, 66–67.

26. Ibid., 46. While writing these words, Sherman was in correspondence with Bromhead in England about how the two might collaborate on selling paintings in America.

27. Nourmahal has been published as an elaborate forgery in Bolger-Burke, American Paintings in the Metropolitan, 3:31–32.

28. This list is given in a letter from Thomas H. Russell, co-owner of Ferargil Gallery, to Margaret Evans of the Butler Institute, 5 February 1924, announcing purchase of the Sanden collection. Two other paintings had been lent by Sanden to the Metropolitan Museum exhibition but are not mentioned in Russell's letter: A Bit of Holland and Moonrise Marine. Frederic Newlin Price, the other co-owner of Ferargil Gallery, later said that there had been eleven paintings in the Sanden purchase, so these two must have been part of the set, along with one other (Ferargil Gallery Papers, Archives of American Art).

29. One undated, priced list of Ryders in the Ferargil Gallery includes twelve paintings, mostly new discoveries after Ryder's death. Of the twelve, ten are priced between $1,200 and $4,500. The other two, both from the Sanden collection, are priced at $9,000 (Night) and $26,000 (Macbeth) (Ferargil Gallery Papers, Archives of American Art).

30. Cottier & Co. held one exhibition of Walker's works in 1897, as reported by Inglis to Wood (24 March 1897, Wood Papers, Huntington Library): "Our Exhibition of Horatio Walker things has been successful in bringing lots of people around—but being mostly women they haven't proved lucrative—Walker isn't a powerful man at all—but refined and above the average—He's a friend of Pinky's and I promised him long ago to give the exhibition and have now carried it out."

31. Walker to Price, 3 April 1928 and 13 December 1929, Price Papers, Archives of American Art. I am grateful to David Karel for calling this correspondence to my attention. Notice of this correspondence is included in Peter Bermingham, "Horatio Walker: The Celebrator of Ile d'Orleans," in Horatio Walker, ex. cat. (Montreal: Musée du Quebec, 1986), 71 n. 13. In addition to working on the paintings, Walker occasionally wrote authentications for the Ferargil Gallery Ryders.

32. Walker to Price, "about the 20th Feb." [no year], Price Papers, Archives of American Art.

33. Price, A Study of Appreciation, 9, 12.

34. Cole, "Notes on Price's Book," Cole Papers, Archives of American Art. Dewey's comments as transcribed by Cole are full of obvious errors and self-serving interpretations; Sylvia Warner disputed a num-

ber of his assertions in her letters (11–12, 15, and 24 March 1933, Cole Papers, Archives of American Art).

35. Sherman, "Paintings Erroneously Attributed to Ryder," 24:160–61, and 25:87–89.

36. Many of the X-rays made by Sheldon Keck during this important period of research remain at the Brooklyn Museum; I am grateful to Ken Moser, Brooklyn Museum conservator, for making them available for this study. Others are in the Ryder Archive of the University of Delaware and were not available for study.

37. Goodrich, *Ryder* (1959). Neither X-rays nor any other single technique is sufficient by itself to distinguish original paintings from forgeries. Ryder's painting method changed over his career, and the paint films vary from quite thin to extremely thick; the X-rays differ accordingly. The technique is, however, useful in conjunction with other analytical techniques.

38. Price to Goodrich, 24 March 1938, Ferargil Gallery Papers, Archives of American Art.

39. Price to Goodrich, 14 October 1938, Ferargil Gallery Papers, Archives of American Art.

40. Greenberg, "Review of an Exhibition," 1947, in *Greenberg: Essays and Criticism,* 2:180.

Converts to the Imagination

1. Miller said, "Ryder wasn't so much thought of when he was alive. But he somehow always seemed present, like distant thunder" (quoted in Lincoln Rothschild, *To Keep Art Alive: The Effort of Kenneth Hayes Miller* [Philadelphia: Art Alliance Press, 1974], 27).

2. Hartley, "Ryder," *Seven Arts,* 95.

3. Hartley, *Adventures in the Arts.*

4. Jean and Kahlil Gibran, *Gibran,* 274. For Gibran's poem "To Albert Pinkham Ryder" see here "Disputed Spoils," n. 6. In 1915 Gibran also drew a pencil portrait of Ryder, looking very much the prophet (The Metropolitan Museum of Art).

5. Eldredge, *American Imagination and Symbolist Painting.*

6. Quoted in David Traxel, *An American Saga: The Life and Time of Rockwell Kent* (New York: Harper & Row, 1978), 86.

7. Miller to Dunn, 14 April and 30 July 1917 (quoted in Rothschild, *To Keep Art Alive,* 33).

8. Ibid., 74–75, 88.

9. Many books have been written about Hartley's interest in Ryder, among the most helpful being Barbara Haskell, *Marsden Hartley,* ex. cat. (New York: Whitney Museum of American Art, in association with New York University Press, 1980); Ronald Paulson, *Marsden Hartley and Nova Scotia,* ex. cat. (Halifax: Mount Saint Vincent University Art Gallery, 1987); and Hartley, *Hartley: On Art.*

10. Quoted in *Feininger/Hartley,* ex. cat. (New York: Museum of Modern Art, 1944), 61.

11. Hartley to Franz Marc, 13 May 1913, Germanisches Nationalmuseum, Nuremberg. I am grateful to Patricia McDonnell for alerting me to this correspondence.

12. "Albert Ryder—Moonlightist" by Marsden Hartley (quoted from Marsden Hartley, *Selected Poems* [New York: Viking], 945, 111):

Moonlight severing his ancient mariner's beard
and falling over the cliffs of his eyebrows,
his lips fearing to touch what was no
longer available,
night streaming through his listless fingers
with the texture of impassable days to come
hanging like limpid moss from his prophetic
shoulders—
this beautiful man, suffering from the weight
of majesty of dream
because he had been denied substance of
any other truth—dream so sumptuous—heavy
with failures of death, radiant with shimmer
of new belief:
I am speaking of Albert Ryder moonlightist
as I knew him—
"I asked him to Christmas dinner," the lady
said to me, who had a long time known him;
"he said he would come; we waited two hours
for him, the party eager to see him; he did
not come."
Next time she saw him—"O we were so
disappointed you did not come."—
"I was there," said Ryder, "I looked through the
window—saw the lovely lights. It was very
beautiful."

13. Hartley, "Ryder," *Seven Arts,* 96. An early draft of this article is dedicated "For Alfred Stieglitz, Marsden Hartley, Nov. 2, 1916," indicating that Hartley began his tribute before Ryder's death (Alfred Stieglitz Papers, Beinecke Rare Book and Manuscript Library, Yale University, New Haven, Conn.).

14. Hartley, "Ryder: Spangle of Existence," in *Hartley: On Art,* 268. Yasuo Kuniyoshi echoed this comment in 1947, when he told Aline B. Louchheim, "If America is to have a great tradition, it will begin with the great and lasting name of Albert Pinkham Ryder" (quoted in Louchheim, "Best American Painter's Largest Show," 31).

15. The German-born Oscar Bluemner knew Hartley through the Stieglitz group and would have known of Hartley's regard for Ryder's art. Bluemner was susceptible to Ryder's influence after the death of his wife in 1926, when he retired into an isolated existence in South Braintree, Mass. In his diary for 1927 Bluemner compared his musical conception of painting to that of Ryder and noted his interest in Ryder's moons. Bluemner's celestial orbs may have in turn influenced Arthur Dove, perhaps reinforcing his interest in Ryder (Jeffrey R. Hayes, "Oscar Bluemner's Late Landscapes: 'The Musical Color of Fateful Experience'," *Art Journal* [Winter 1984]: 355).

Hartley may have shared his passion for Ryder with Albert Bloch, an American painter who lived in Germany from 1908 until 1922 and who was a close friend of Marc's. Bloch admired Ryder's work and felt he shared an "affinity of spirit" with him (letters from Anna Bloch to the author, 1986–87).

16. Henry Sayre, in a talk on Jackson Pollock at the College Art Association meeting in New York, February 1986, discussed whether another of Pollock's paintings, *Out of the Web*, 1949 (Staatsgalerie, Stuttgart), contained the figure of a whale hidden in the gestural skeins of paint at left. This suggestion was said to have first been made by Charles Stuckey.

17. Hartley, "Ryder," *Seven Arts*, 93.

18. Typifying the early view, Hartmann examined Ryder's palm and noted primarily that the "circle of Venus" was greatly defined ("An American Painter," 12, Hartmann Papers, University of California Library). In the early 1950s Nathaniel Pousette-Dart, an artist and handwriting authority, analyzed a small sample of Ryder's handwriting and found evidence of "great tenacity . . . an uncompromising attitude towards the world . . . extreme sensitivity . . . a spirit of striving . . . disability to adapt himself to circumstances . . . a strong, driving will" (Love Papers, Archives of American Art).

19. "Jackson Pollack [*sic*]," *California Arts and Architecture* (February 1944): 14.

20. Peter White, curator and director of the Dunlop Art Gallery, Regina, Canada, wrote a seminar paper at the University of Delaware in 1984 entitled "Thomas Hart Benton, Jackson Pollock, and the Influence of Albert Pinkham Ryder," advancing intriguing hypotheses about the relationships of these three painters. He notes, among other comparisons, that Benton's *Shallow Creek*, 1939 (private collection), is dependent on Ryder's *Forest of Arden* and that the drowning figure in Benton's *Flight of the Thielens*, 1938 (estate of the artist), is quoted from the figure of Jonah by Ryder. I am grateful to him for sharing his paper with me.

21. Benton showed his own art at Ferargil Gallery in the early 1930s, and although Pollock was not formally affiliated there, he named Ferargil as his dealer in the catalogue of a 1935 Brooklyn Museum exhibition (ibid., 16).

22. Does Pollock's affection for shiny Duco enamel reflect an interest in Ryder's bituminous paints, which, by the 1930s, were already darkening into a glossy pitch, creating an eerie shimmer across such paintings as *Moonlight Marine* and *Toilers of the Sea?*

23. This is not a definitive list but only some of those who have been specifically interested in Ryder's motifs or technique. The quote about "common ground" is from Paul Smith, in a letter to the author, 13 June 1988.

24. Judith Rothschild, "Myron Stout at the Whitney," *Art World*, 15 February 1980.

25. Michael Brenson, "Albert York Abides in His World with Grand Aloofness," *New York Times*, 20 March 1988, 35.

26. Fairfield Porter, introduction to *Albert York*, ex. cat. (New York: Davis & Langdale, 1974), n.p.

27. Melinda Kahn Tally, Davis & Langdale Company, New York, to the author, 28 June 1988.

28. See John Yau, introduction to *Forrest Bess*, ex. cat. (New York: Hirschl & Adler Modern, 1988); and Michael Brenson, "Forrest Bess: Desire Ruled His Vision," *New York Times*, 1 May 1988, 35.

Catalogue

The catalogue includes entries on each of the paintings in the current retrospective exhibition. It does not discuss the several authentic Ryder paintings in the sections of the exhibition devoted to his technical method, nor the forgeries. Many authentic paintings exist that could not be shown in the exhibition; this is not a catalogue raisonné of all known original Ryder paintings.

Entries were compiled by three accomplished young scholars and are initialed to indicate authorship. Eleanor L. Jones (ELJ) is a Ph.D. candidate at Yale University, focusing on nineteenth-century American painting; Matthew J. W. Drutt (MJWD) is also in the Ph.D. program at Yale, studying Russian and American modernism; Sheri L. Bernstein (SLB) is a graduate student in the history of modern art at Harvard University. The texts were written individually, but each author was involved in researching all aspects of Ryder's life and art.

The information here presented was drawn from published and unpublished sources cited in the notes but cannot be considered definitive as it was not possible to consult the Ryder Archive at the University of Delaware, which includes many unique documents.

Because of the difficulty in establishing a chronology for Ryder's oeuvre, entries are arranged in alphabetical order by the most common title of each work, with alternate titles given in parentheses. Documents and inscriptions that help determine when Ryder was working on a painting are cited. Where two works are clearly linked in subject, they are discussed together.

Since all works but one (cat. 15) are painted in oil, only the supports are identified in the entries. Dimensions are in inches and centimeters, with height before width. Provenances—so crucial in tracing the history and authenticity of Ryder's works—have been reconstructed from many sources; gaps in the record still exist, and, occasionally, conflicting information is noted. To illustrate the paintings in a condition close to that in which Ryder left them, early photographs have sometimes been reproduced rather than more recent images; where this is done, that fact is noted in the caption.

Elizabeth Broun (EB)

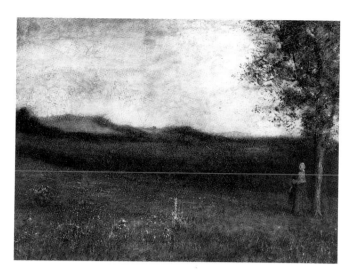

1 ***Autumn Landscape***

canvas; 18 x 24 in. (45.7 x 61 cm)
Private collection
See also figure 30

Autumn Landscape emphasizes warm harmonies of gold, brown, and red while simplifying subject matter. Largest of the several landscapes that Ryder painted in this manner, it is the most daring—the entire center of the composition is left vacant for the play of color effects. Ryder's high regard for Corot and the Barbizon painters is readily apparent in the synthetic approach and seasonal reference of this work. The woman and child in *Autumn Landscape,* similar to those in *Roadside Meeting* (cat. 53), impart a mood of innocence and reverie.

In *Autumn Landscape* the relief image of a large horse can be faintly seen in raking light, oriented upside down to the current image. Ryder painted out a similar profile horse under *King Cophetua and the Beggar Maid* (cat. 25).
ELJ

Provenance: William T. Evans, New York; purchased for $235 by Cottier & Co., New York, from William T. Evans Collection Sale, American Art Association, Chickering Hall, New York, lot no. 42, 31 January–2 February 1900; J. G. Shepherd; purchased for $2,500 by George S. Palmer through Macbeth Gallery, New York, 2 December 1912; consigned to Macbeth Gallery, valued at $7,500, 17 January 1921; returned to Palmer, 1 June 1921; Neva Palmer Johnson (Palmer's daughter) by 1957; consigned to and purchased by Alastair Bradley Martin, New York, from E. & A. Milch, Inc., New York; private collection.

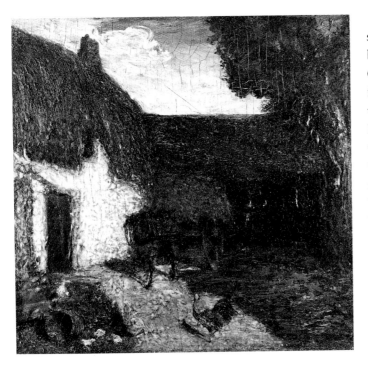

2 **The Barnyard**

mahogany panel; 11⅝ x 12¼ in.
(29.5 x 31.1 cm)
Munson-Williams-Proctor Institute,
Utica, New York; 57.39

The Barnyard is a variation on Ryder's theme of
pastoral labor, exemplified by the horse-drawn
haycart, and is related to the sketch *Mending the
Harness* (cat. 37), which establishes the central
elements of horse and cart. In both these paint-
ings the bay horse seems almost asleep in the
traces; in *The Barnyard* it stands unattended in
the yard.

The Barnyard, particularly with its thatched-
roof architecture, recalls scenes from European,
British, and Canadian art.[1] This atmosphere pre-
vails in another canvas of similar size, *The Red
Cow* (see fig. 130), the cottage closely resembling
that in *The Barnyard*. According to the Ichabod
T. Williams auction catalogue, *The Barnyard* was
purchased from "the late Daniel Cottier," sug-
gesting that it was completed before Cottier's
death in 1891. The catalogue described *The
Barnyard* as "almost in the values of rich enam-
els," extolling "the opulent coloring which the
artist has given to this painting."[2]

The Barnyard embarked on an unusual ody-
ssey in December 1920, after its purchase in 1919
by Duncan Phillips. En route to New York's
Century Club as part of an exhibit of works
from the Phillips Memorial Gallery, the painting
was stolen.[3] During the next few years a reported
half-dozen similar paintings attributed to Ryder
were taken to the Phillips Gallery, but none were
the missing work. On 9 April 1926 *The Barnyard*
resurfaced in the hands of a New York collector,
Wilbur J. Cooke.[4] Claiming that the painting had
belonged to his mother since 1911, Cooke took
the panel to Frederic Fairchild Sherman, offering
it for sale; Sherman recognized the work and
alerted the police.[5] *The Barnyard* was confiscated,
and Phillips filed suit to reclaim the painting.
Supported by testimony from Knoedler's, who
had handled the painting's sale to Phillips in
1919, *The Barnyard* was returned to the Phillips
Gallery. The controversy fanned speculation con-
cerning reasons for the theft of such a well-
known painting, including the following com-
ment in the *Sun*:

In the case of an American dealer who was charged
with forging pictures attributed to various painters
still living the artists were unable to swear they had
not executed the work. All were typical of the style
and subjects of the painters, who had turned out
examples of their facility so abundantly that they
could not recall whether the particular works so clev-
erly executed were from their own brushes or not. It
is asserted by the authorities that Ryder painted sev-
eral subjects closely resembling the picture in
dispute.[6]

In 1940 the painting was back in the news as
the Phillips Gallery exchanged *The Barnyard* and
the smaller *Macbeth* (cat. 35a) with the Ferargil
Gallery for the large *Macbeth and the Witches*
(cat. 35).[7] After passing through several hands,
The Barnyard was purchased by the Munson-
Williams-Proctor Institute.

ELJ

Provenance: Daniel Cottier, New York; Ichabod T.
Williams, New York; purchased for $1,400 by M.
Knoedler & Co., New York, from Ichabod T. Wil-
liams, Esq., Sale, American Art Association, Plaza Ho-
tel, New York, no. 9, 3 February 1915; A. H. Cosden,
Southold, New York, February 1915; returned to

Knoedler, March 1918; purchased by Duncan Phillips, Washington, D.C., November 1919; traded (along with the small *Macbeth*) to Ferargil Gallery, New York, 1940; C. J. Robertson, Pelham Manor, New York, by 1946; Mrs. Richard L. Hacke, California (Robertson's daughter); consigned to Macbeth Gallery, New York, 29 January 1957; Hirschl & Adler Gallery, New York, 1957; Munson-Williams-Proctor Institute, Utica, New York, 1957.

Notes

1. An undated wood engraving by Elbridge Kingsley bears a nominal resemblance to *The Barnyard*. Set in similar surroundings, a horse cart appears with figures wearing Dutch dress and wooden shoes. Kingsley's engraving may reproduce an early stage of the painting or a forgery. As no X-ray of *The Barnyard* was available for study, it is impossible to determine if Ryder made changes in the composition.

2. *Notable Collection of Valuable Paintings Formed by the Late Ichabod T. Williams, Esq.,* auction cat. (New York: American Art Galleries, 1915), no. 9 (American Art Auctions and Exhibition Catalogues, Archives of American Art, reel N162).

3. "A Ryder Strangely Lost," *American Art News* 19 (25 December 1920): 3.

4. See "Seize Ryder Canvas; Ownership in Doubt: Sheriff Takes 'The Barnyard' from W. J. Cooke as Phillips Sues to Recover It," *New York Times*, 17 April 1926, and "Disputed Ryder Art Returned to Cooke," *New York Times,* 18 April 1926, Sherman scrapbook, Force Papers, Archives of American Art.

5. "Ryder's 'Barnyard' Comes to Light," *ArtNews,* 17 April 1926, Sherman scrapbook, Force Papers, Archives of American Art.

6. *New York Sun,* 26 April 1926, Sherman scrapbook, Force Papers, Archives of American Art.

7. Curatorial files, the Phillips Collection, Washington, D.C.

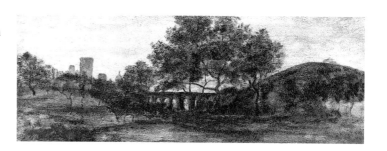

3 *The Bridge*

gilded leather; 10 x 26¾ in.
(25.4 x 67.9 cm)
The Metropolitan Museum of Art, New York, gift of George A. Hearn, 09.72.8
See also figure 42

The Bridge is one of at least six narrow, horizontal gilded leather panels painted by Ryder, probably during the 1870s.[1] Their oblong format makes them likely candidates for decorative insets made for cabinets, writing desks, chests, and other furnishings. Ryder's dealer Daniel Cottier traded extensively in such objects, and Ryder is known to have painted panels for cabinet doors as well as for screens and mirrors.[2]

Lloyd Goodrich identified the scene in *The Bridge* as a composite of the skyline of New York viewed from Central Park and the High Bridge over Harlem River, several miles north.[3] High Bridge was a subject popular with Ryder's contemporaries, perhaps for its similarity in appearance to Roman viaducts, so often found in Italianate landscape paintings.[4] Ryder's thin, delicate handling of paint against the gilded surface lends the work an exotic air enhanced by its Mediterranean overtones.[5]

Two of Ryder's other horizontal paintings on leather, *The Gondola* (private collection) and *Oriental Landscape* (see fig. 44), depict gondolas being poled along rivers with castles along the banks. Exports from the East influenced aesthetics in most European countries, readily apparent in the decorated furnishings from France, Italy, Britain, and the Netherlands appearing in American homes during the nineteenth century. Such furniture often included gilded, carved, or painted panels.[6]

Ryder's horizontal paintings like *The Bridge* were probably sold after having been removed from their armatures.[7] As his popularity grew it is likely that Ryder's panels were more highly prized as paintings than as furniture decoration, encouraging buyers to frame them individually and hang them on their walls. An additional possibility is that the panels, intended as decoration for furniture, were never actually used this way but immediately sold by Cottier as paintings.

ELJ

Provenance: James S. Inglis, New York; purchased for $525 by George A. Hearn, New York, from James S. Inglis of Cottier & Co. Estate Sale, American Art Association, Mendelssohn Hall, New York, no. 68, 12 March 1909; gift of George A. Hearn to the Metropolitan Museum of Art, New York, 19 April 1909.

Notes

1. The five other panels known to exist are *Sunset: Marine* (see fig. 43), *Oriental Landscape* (see fig. 44), *Shore Scene* (cat. 58), *The Smugglers' Cove* (cat. 60), and *The Gondola* (private collection).

2. James S. Inglis sent to C. E. S. Wood a drawing for four leather panels to be set into a cabinet. Inglis proposed that Wood's carpenter would cut the leather, Inglis would stain the panels, rub them with gold powder, and surround the pieces with tacking nails (Inglis to Wood, 9 July 1896, Huntington Library). See also de Kay, "Modern Colorist," 257.

3. Goodrich, quoted in Bolger-Burke, *American Paintings in the Metropolitan*, 3:10.

4. Among the artists who painted views of High Bridge are John William Hill (1848), David Johnson (1860), R. Swain Gifford (1890), and Ernest Lawson (n.d.).

5. Doreen Bolger-Burke suggests that Ryder may have been influenced by Piero di Cosimo's *Hunting Scene*, ca. 1505–7, exhibited at the Metropolitan Museum in 1874 and acquired by the museum in 1875 (*American Paintings in the Metropolitan*, 3:9).

6. Frida Schottmueller, *Furniture and Interior Decoration of the Italian Renaissance* (New York: Brentano's, 1921), xvii–xix, 47.

7. By the time of the first known description of this work, *The Bridge* and its companion, *The Smugglers' Cove* (cat. 60) were listed as paintings (*James S. Inglis of Cottier & Co. Estate Sale* [New York: American Art Association, 1909], no. 68).

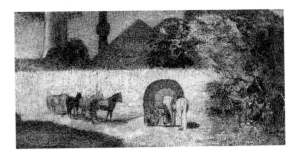

4 **By the Tomb of the Prophet**
(By the Tomb of the Saint; Oriental Scene)

panel, cradled; 5 3/16 x 11 7/16 in.
(14.8 x 29.1 cm)
Delaware Art Museum, Wilmington, bequest of George I. Speer, 68-17
See also figure 16

By the Tomb of the Prophet is one of several paintings of Near Eastern subjects that Ryder painted early in his career. The first mention of an orientalist subject is an entry for *At the Gates—Cairo* by A. P. Ryder in the Charles Loring Elliott Estate Sale in 1876.[1] If the pyramid shape in *By the Tomb of the Prophet* indicates a pharaoh's tomb and an Egyptian subject, this painting could perhaps be the same as *At the Gates—Cairo,* although it is unlikely that Elliott would have acquired a Ryder painting before his death in 1868, as Ryder had not then begun his career. Two of Ryder's leather decorations have orientalist subjects—*The Gondola* (private collection) and *Oriental Landscape* (see fig. 44)—and probably date from the mid- or late 1870s when Ryder was producing such decorations for Cottier's firm.

In 1880 Ryder exhibited at the Society of American Artists a work entitled *An Eastern Scene.* A review describing the painting suggests that this was *By the Tomb of the Prophet:* "One has only to look at . . . the Oriental scene as No. 89, consisting of Arab horses outside a long wall, in which a gateway shows a glimpse of a garden, to satisfy one's self that he has the germ of greatness as a colorist."[2]

American artists began to travel to the East by the late 1860s, with Louis Comfort Tiffany and R. Swain Gifford following Frederic E. Church's

lead.[3] Tiffany and Gifford exhibited their impressions of the Orient in the early 1870s at the National Academy. *By the Tomb of the Prophet* resembles in point of view Tiffany's *Market Day Outside the Walls of Tangier, Morocco* (see fig. 15), exhibited at the National Academy in 1873. Ryder's interest in Tiffany's oriental subjects is revealed by his ownership of two Tiffany watercolors depicting Moorish figures.[4]

Eastern subjects were common in the works of Delacroix, Fromentin, Gérôme, and Gros; by 1875 Cottier & Co. was handling Delacroix's art as well as paintings by the celebrated orientalist Adolf Schreyer.

In September 1879 an important exhibition of Monticelli's Near Eastern subjects was held at Cottier & Co. A critic entitled his review of the exhibition, "Dreams of the Orient—A Tapestry in Paint" and alluded to Ryder as Monticelli's "singular parallel in an American [artist]."[5] In emphasizing the imaginative and decorative qualities of these paintings, the critic distinguished them from orientalist works by painters like Gérôme, which were received as documentary images from far away lands, despite their now obvious fictional embellishments.

Although Ryder's orientalist subjects derive from European and American precedents, his color effects were unusual, leading Charles de Kay to write in 1890: "After the hackneyed pictures of the Orient, this charming mosaic of colors [has] a most original effect."[6]

The earliest known owner of *By the Tomb of the Prophet* was Louis A. Lehmaier (later changed to Lemaire), a master printer and businessman from New York, who acquired it around 1905. He was a friend and patron of American artists, establishing a fund to aid the family of the destitute painter Ralph Blakelock and cofounding the National Arts Club with Ryder's friend Charles de Kay.

MJWD

Provenance: Louis A. Lehmaier (Lemaire), New York, about 1905; purchased for $800 by Lawrence A. Fleischman, Detroit, through Macbeth Gallery as agent from Estate of Albert K. Schneider & Others Sale (Lemaire collection), Parke-Bernet, New York, no. 15,

14 October 1953; to Hirschl & Adler Galleries, New York; purchased by Alastair Bradley Martin, New York, 1959; Hirschl & Adler Galleries; purchased by Delaware Art Museum, Wilmington, through bequest of George I. Speer, 1968.

Notes

1. The painting is lot no. 112 (American Art Auction and Exhibition Catalogues, Archives of American Art, reel N308, frame 1057). There were few orientalist subjects painted by Americans before 1868 when Elliott died; it is possible that this entry refers to a painting by P. P. (Platt Powell) Ryder, with whom A. P. Ryder is sometimes confused early in his career, although no such orientalist subject by P. P. Ryder has been identified.

2. "One Day in the Gallery," 5.

3. See John Davis, "Frederic Church's 'Sacred Geography,'" *Smithsonian Studies in American Art* (Spring 1987): 79–96.

4. On orientalism see Edward Said, *Orientalism* (New York: Vintage, 1978), and Gayatri Chakravorty Spivak, "Can the Subaltern Speak?" in *Marxism and the Interpretation of Culture,* ed. Cary Nelson and Lawrence Grossberg (Urbana and Chicago: University of Illinois Press, 1988), 271–313.

5. "The Cottier Gallery—Monticelli and His Friend Diaz—Dreams of the Orient—A Tapestry in Paint," *New York Times,* 1 September 1879, 5.

6. De Kay, "Modern Colorist," 255.

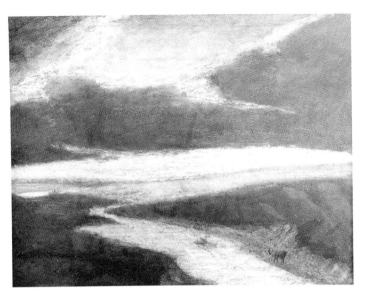

5 *The Canal*

canvas; 19 x 25 in. (48.2 x 63.5 cm)
Arizona State University Art Museum, Tempe,
Oliver B. James Collection of American Art, 50.14

Kenneth Hayes Miller called *The Canal* "one of
the most admired and coveted of all those
[paintings] which were in Ryder's possession in
his late years."[1] In fact, the painting was pur-
chased out of Ryder's studio by Alexander Mor-
ten in 1915.[2] Closely linked to seventeenth-
century Dutch themes, *The Canal* reflects Ryder's
ability to borrow from the canon of Dutch pano-
ramic landscapes and apply familiar visual para-
digms to suit his purpose. His interest in Dutch
subjects was manifest also in his pictures of
windmills, stable scenes, and rural landscapes.

Balancing sweeping curves with angular paths
of light and dark paint, Ryder established a
rhythm repeated in *Gay Head* and *Landscape*
(cat. 17, 26), giving each canvas a different scale
and mood. Adopting the high, distant vantage
point strongly associated with the works of Jacob
van Ruisdael and Philips Koninck, Ryder has
pulled back from the intimate perspective more
common to his work and commanded a broader
view. Dark cloud masses tipped by light frame
the patch of open sky above; in the distance
below, the curved shoreline gives way to a nar-
row, winding waterway that broadens in the

foreground, its banks recalling the dunes com-
mon to the Dutch landscape.

Ryder's forms resonate across the undulating
horizon in dynamic equilibrium—the abstract
pattern of light and shadow becoming earth and
sky with the placement of two diminutive
horses, harnessed one behind the other, invisibly
linked to a barely discernible barge. The painting
achieves its scale from those tiny forms that
draw the eye like a magnet as we seek to estab-
lish our place in the composition. Describing
Ryder's landscapes, Marsden Hartley wrote, "they
suggest Michel's wide wastes of prodigal sky and
duneland with their winding roads that have no
end, his ever-shadowy stretches of cloud upon
ever-shadowy stretches of land that go their aus-
tere way to the edges of some vacant sea."[3]

Ryder painted a second canal subject in *Essex
Canal* (cat. 5a), once owned by Gellatly and now
in the Art Institute of Chicago. Its title presumes
an English setting, recalling the work of another
artist strongly affected by Dutch art, John
Constable.

ELJ

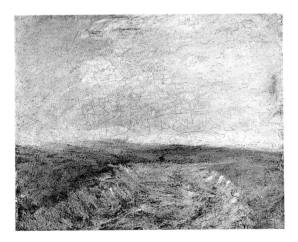

Cat. 5a. *Essex Canal*. The Art Institute of Chicago, gift
of Mr. and Mrs. Herbert Geist, 1980.279.

Provenance: Alexander Morten, New York, 1915; consigned by Marjory (Mrs. Alexander) Morten to Frank K. M. Rehn, Inc., New York; purchased by George Dyer, Norfolk, Connecticut, 16 February 1924; purchased by Milch Galleries, New York, 1940; purchased by Oliver B. James, 1940; gift of James to the Arizona State University Art Museum, Tempe, September 1950.

Notes
1. Miller to Milch, 8 May 1934, copy in curatorial files, Arizona State University Art Gallery, Tempe.

2. Marjory Morten to Ryder, 29 February 1924, Arizona State University Art Gallery; Miller to Milch, 8 May 1934, copy in curatorial files, Arizona State University Art Gallery.

3. Hartley, "Ryder," *Seven Arts*, 93.

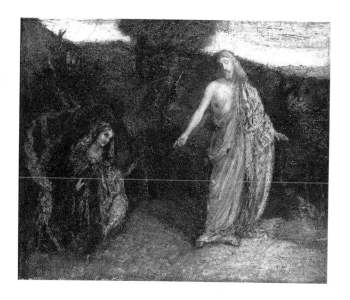

6 *Christ Appearing to Mary*

canvas mounted on fiberboard; 14¼ x 17¼ in. (36.1 x 43.8 cm)
National Museum of American Art, Smithsonian Institution, Washington, D.C., gift of John Gellatly, 1929.6.92
See also figures 93, 115

And when she had thus said, she turned herself back, and saw Jesus standing, and knew not that it was Jesus.

Jesus saith unto her, Touch me not; for I am not yet ascended to my Father (John 20:14, 17).

Christ Appearing to Mary shares the same subject as *The Resurrection* (cat. 52).[1] Considered in the context of nineteenth-century culture, this theme can be understood beyond its religious significance as emblematic of codes of behavior between men and women, in which Christ represents the male as an image of dignified spirituality presiding over Mary Magdalen, a repentant prostitute, dressed in the blue garb of holy women. The Magdalen is more than merely respectful; she is a symbol of "the submission of obedience to Divine command."[2] In contrast to Christ, whose demeanor is that of an intellectually superior being, Mary crouches in the mouth of the tomb like a creature of the earth.

The canvas was purchased in April 1885 by Thomas B. Clarke, the foremost New York collector of American art during the late nineteenth century.[3] Pleased to be represented in so important a collection, Ryder wrote to Clarke: "I can

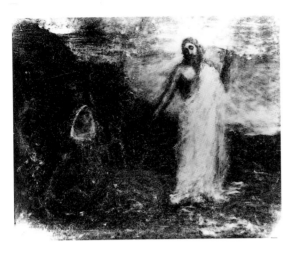

Cat. 6a. X-ray of *Christ Appearing to Mary*.

Cat. 6b. Titian, *Noli Me Tangere*, ca. 1508, oil on canvas. National Gallery, London.

Cat. 6c. Line engraving of Duccio's *Christ Appearing to the Magdalen* (from Anna Jameson, *History of Our Lord* [1864]).

not but feel in some way that in both the Temple [*The Temple of the Mind* (cat. 67)] and the Religious picture [*Christ Appearing to Mary*] I have gone a little higher up on the mountain and can see other peaks showing along the horizon."[4]

An X-ray of the painting (cat. 6a) reveals that Ryder made several important compositional changes: an aureole glows resplendently around the head of Christ; his left arm is raised in a gesture of blessing; the contour of his right arm is of varying thicknesses; his garment does not extend as far to the right; and the horizon line slopes downward in a manner reminiscent of landscape conventions in seventeenth-century northern European art.[5]

An autoradiograph of the painting (see fig. 115) confirms the changes revealed by the X-ray and shows more clearly the path on which Christ stands, dividing the two realms occupied by Christ and Mary. The contours of Christ's torso and arms are delicately drawn, and his right hand forms a pronated blessing gesture. Charles Fitzpatrick's account of this picture may explain Ryder's changes to the torso of Christ:

When he was painting the Christ Appearing to Mary picture, he asked me to pose for him to get some lines in the drawing. I was working hard on the building at that time and was rather stout and muscular, so I remarked to him that the figure would look rather healthy for a man that had been in the grave three days, but he said the figure should show power as well as spirituality.[6]

Ryder's excursions to Europe in 1877 and 1882 may have encouraged his move into religious subject matter. Along with numerous other religious works, Titian's celebrated *Noli Me Tangere* (cat. 6b) would have been seen by Ryder when he visited London's National Gallery, which acquired it in 1859. In *Christ Appearing to Mary*, Ryder adopted the convention of dividing the domains of Christ and the Magdalen with a tree, as in Titian's example.

It is also likely that Ryder's painting was influenced by Anna Jameson's *History of Our Lord as Exemplified in Works of Art,* a vital source for religious iconography in the nineteenth century.[7] Titian's painting was illustrated in this book, but even closer to Ryder's composition is that of Duccio's *Christ Appearing to the Magdalen,* which was rendered as a schematic line engraving (cat. 6c). Jameson's interpretation of the theme reads like a script for Ryder's early version of the painting as revealed in the autoradiographs: "On the one side, dignity and beneficence, on the other, grace and beauty, and sorrow emerging into sudden joy."[8]

Other American examples germane to a history of typologies include John Quidor's *Two Marys at the Tomb,* 1845 (private collection), which portrays Christ's tomb as a rocky grotto, and Robert Loftin Newman's two versions of *Christ and the Magdalen* (private collection), one of which shows a submissive Magdalen at Christ's feet.[9] The subject frequently appeared in American and European art, for it celebrated a nineteenth-century conception of woman as sensual, earthly being, submissive to a more spiritual or intellectual man.

In 1966 the painting was conserved by Sheldon and Caroline Keck. Restorations around the head of Mary and right eye of Christ were noted as well as overpainting of the original glazes. The reverse of the canvas was cleaned, coated with wax resin, and mounted on a honeycomb support. The painting was cleaned of darkened varnish and reglazing, at which time it was noted that "the original surface seems abraded, rubbed and cracked."[10]

MJWD

Provenance: purchased by Thomas B. Clarke, New York, April 1885; purchased for $1,000 by Cottier & Co., New York, from Thomas B. Clarke Sale, American Art Association, Chickering Hall, and American Art Galleries, New York, no. 349, 17 February 1899; to William Ladd, Portland, Oregon, through Wood as agent, by 1907; to Macbeth Gallery, New York, through Dr. W. S. Ladd, 11 March 1919; R. C. and N. M. Vose Galleries, Boston, date uncertain; purchased for $7,500 by John Gellatly, New York, 13 March 1919; gift of Gellatly to National Museum of American Art, Smithsonian Institution, Washington D.C., 1929.

Notes

1. The Carnegie Museum of Art, Pittsburgh, owns a painting of the same subject entitled *Noli Me Tangere,* originally in Charles Melville Dewey's collection, which is attributed to Ryder.

2. Catalogue entry, *Thomas B. Clarke Collection of American Pictures,* ex. cat. (Philadelphia: Pennsylvania Academy of the Fine Arts, 1891).

3. The painting may have been commissioned by Clarke. In an undated letter to Mr. and Mrs. Richard Watson Gilder, Ryder wrote: "Ah, dear—I am so busy. Christ and Mary at the tomb, a marine, The King & Beggar Maid and a maiden reading—all these I have to put through on commission—and others I must do for myself" (Gilder Archive, Tyringham, Mass.). Ryder, however, may have been referring to *Resurrection.*

4. Quoted in Sherman, *Ryder,* 24. H. Barbara Weinberg reports that Clarke's typescript copy of this letter is in *U.L.C.: Early American Portraits, 1921–1926; Century Association,* bound catalogues and scrapbook in the possession of Mrs. Thomas B. Clarke, Jr. (H. Barbara Weinberg, "Thomas B. Clarke: Foremost Patron of American Art, from 1872–1899," *American Art Journal* [May 1976]: 59).

5. Sadakichi Hartmann commented that " 'Christ and Magdalene' displays a strange resemblance to one of Rembrandt's etchings" ("An American Painter," 15, Hartmann Papers, University of California Library). This could also refer to *The Resurrection* (cat. 52), which has a landscape configuration similar to that revealed in the autoradiograph of *Christ Appearing to Mary.*

6. Charles Fitzpatrick, quoted in Taylor, "Ryder Remembered," 9.

7. "Art can do no more in the delineation of an earnest, impetuous, and most beautiful woman" (Anna Jameson, *The History of Our Lord as Exemplified in Works of Art* [London: Longman, Green, Longman, Roberts, & Green, 1864], 284). In *Sacred and Legendary Art* by Anna Jameson the painting is reproduced and noted for its "beauty and truth of expression" (1848; rev. ed., Boston: Houghton Mifflin, 1899), 364.

8. Jameson, *History of Our Lord,* 278–79. Barbara Weinberg, in *Decorative Work of John La Farge,* cites a medieval carved ivory, *The Marys at the Sepulchre,* as a source for La Farge's mural of the subject in Saint Thomas's Church. This ivory is also reproduced in Jameson, *History of Our Lord,* 264.

9. Ryder and Robert Loftin Newman both lived at the Benedick Building on Washington Square in the 1880s. For a discussion of their friendship see Landgren, *Newman,* 61–70, and Boime, "Newman, Ryder, Couture, and Hero-Worship in Art History," 5–22.

10. Sheldon and Caroline Keck, condition and treatment reports, Conservation Lab Files, National Museum of American Art.

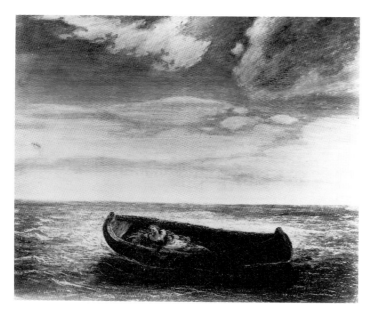

7 *Constance (Custance)*

canvas; 28¼ x 36 in. (71.7 x 91.4 cm)
Museum of Fine Arts, Boston, 45.770
See also figure 85

The most ambitious of Ryder's images of women, *Constance* treats themes of fidelity and false accusation while expanding them to include faith and redemption. Because of its simple forms, *Constance* has also become for many a testament to Ryder's modern vision.

Sir William Van Horne commissioned the painting in the mid-1880s but did not receive it for a decade, despite repeated attempts to hurry Ryder.[1] The artist was paid thirteen hundred dollars for *Constance* in the mid-1890s, at a time when he was raising his prices and painting larger works.[2]

Ryder damaged his first *Constance* in 1895 and had to begin again on a new canvas. Charles Fitzpatrick recalled that "There were a few of Ryder's [paintings that] had holes in them. One of these was the original of the Constance picture now in the Van Horn [sic] collection."[3] Although perhaps an accident, Ryder's destructive act may have been provoked by his patron's impatience or by his own dissatisfaction with his work. Inglis wrote Wood of the arrival at Cottier's gallery of a beautiful painting by Delacroix, which may have stirred self-doubt in Ryder:

"[The Delacroix] will please you immensely. Ryder has promised to write you about it. . . . He is very pleased over it. Don't know whether its arrival had anything to do with it or not but he knocked a hole in Van Horne's picture yesterday letting it fall through some chair or something."[4] Van Horne wanted both versions of *Constance* but whether he ever received the first remains uncertain.[5]

Ryder's literary source for *Constance* was "The Man of Laws Tale" from Chaucer's *Canterbury Tales*. Constance (sometimes spelled "Custance" in Old English),[6] the daughter of a Roman emperor, was set adrift with her son in a boat with no sail or rudder as punishment for infidelity, of which she was innocent. Miraculously, she survived the journey through faith in divine protection and was reunited with her husband, King Allah of Northumberland. The association of a heathen king and a Christian woman occurs also in Ryder's *Desdemona* (see fig. 84) and *King Cophetua and the Beggar Maid* (cat. 25).

The image of a sleeping figure in a boat on a desolate sea derives in part from traditions of religious painting, exemplified by Delacroix in *Christ on Lake Gennesaret* (see fig. 107), in which Christ sleeps in a boat, unaware of a gathering storm, while an orb of light surrounds him. Another compelling comparison with *Constance* is offered by John La Farge's *Lady of Shalott* (cat. 7a), which depicts a stately woman floating

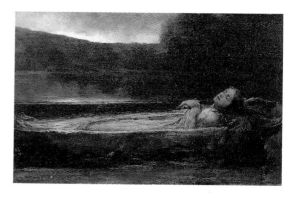

Cat. 7a. John La Farge, *Lady of Shalott,* ca. 1862, oil on canvas. The New Britain Museum of American Art, Connecticut, H. R. Stanley Fund, 1945.2.

in a boat; shown in the 1875 Cottier exhibition in which Ryder also participated, *Lady of Shalott* would certainly have been familiar to Ryder.

Constance was one of three Ryders included in the 1904 *Comparative Exhibition of Native and Foreign Art,* which won the artist great acclaim: "Perhaps no one emerges from the comparative test more brilliantly than Albert P. Ryder, who stands head and shoulders above his contemporaries in the splendor of his imagination and the power of his individuality."[7] For this critic and others, *Constance* exemplified Ryder's rejection of realistic painting in favor of internal visions rendered in simplified, abstracted forms. In 1908 Roger Fry wrote:

It might be dangerous to hazard a guess as to which way the boat is moving, or how it is constructed or can float at all; but there can be no doubt that it is moving forward by some magic spell. . . . And all this, so comparatively easy to poetry, so difficult to painting with its more specialized vision, is given by . . . a most elaborate and hyper subtle simplification. The actual forms are almost childishly simple, but they have a mass and content essential to the effect they produce.[8]

While *Constance* was said to have rivaled Delacroix's paintings in color, the palette is now restricted to cool greens and blues in the sea and sky and browns in the figures and boat. *Constance* lacks the glazes of *The Flying Dutchman* and *Jonah,* perhaps because Ryder never applied them or because they were removed in an early cleaning.

SLB

Provenance: commissioned by Sir William Van Horne, Montreal, Canada and received by 3 August 1896; Lady Van Horne, Montreal, after 2 September 1915; purchased by Museum of Fine Arts, Boston, from Van Horne Sale, Art Association, Montreal, 16 October–5 November, 1933.

Notes
1. "Sir William Van Horne waited ten years for 'Constance'" ("Albert P. Ryder: Poe of the Brush"). An undated article includes this account: "The painting is scarcely nearer completion than it was five years ago, when I saw it first. 'It was finished once,' the painter explained, 'but I scraped it out last month to change that shadow under the boat. The man who wanted it was angry, but I think I had the right to do it. You

can't get the tone without working a thing over and over.' Mr. Inglis, at Cottier's gallery, pronounced the act a shame, a vandalism. He had the most beautiful light in that picture—I doubt if he ever gets it back" ("Genius in Hiding," *Chicago Times-Herald,* 24 March [year unknown]).
 "Van [Horne] has been swearing at Ryder but the Reverend [Ryder] had [R. B.] Angus on his side and came out on top" (Inglis to Wood, 20 September 1895, Wood Papers, Huntington Library).

2. Wood diary, ca. 1895–96, Wood Papers, Huntington Library.

3. Charles Fitzpatrick, quoted in Taylor, "Ryder Remembered," 8.

4. Inglis to Wood, 28 June 1895, Wood Papers, Huntington Library. Inglis may have been referring to one version of Delacroix's *Christ on Lake Gennesaret,* acquired by William Ladd of Portland, Oregon. This version, showing Christ reclining in a mastless boat, is related in composition to Ryder's *Constance.*
 Van Horne also owned a version of the Delacroix by 1892, which one critic compared to *Constance* in 1898: "In another part of the house was a superb Delacroix—Lake Genesaret, also bluish in tone. The two were put together for comparison, and my informant assures me that in color the Ryder was easily superior. It really hurt the Delacroix. Of course the comparison was solely in color, without consideration of the dramatic charms of Delacroix ("The Critic's 'Albert P. Ryder,'" *Art Collector* [1 December 1898],

5. "Pinky has finished his 'Constance.' It is lovely and old Van Horne is delighted. He thinks it finer in many ways than the first but wants both of them—tells Pinky to get the hole plastered up and go ahead and finish" (Inglis to Wood, n.d. [after July 1896], Wood Papers, Huntington Library). Another canvas entitled *Constance* has sometimes been attributed to Ryder. The Addison Gallery purchased the work in 1929 from N. E. Montross, who acquired it from Louise Fitzpatrick (Lloyd Goodrich to W. G. Constable, 16 October 1945, curatorial files, Museum of Fine Arts, Boston).

6. The discrepancy between "Constance" and "Custance" has led to confusion over the title of the painting. According to Goodrich, all modern language versions of Chaucer have modernized the old English name to "Constance," although de Kay referred to the painting in his 1904 *New York Times* review as "Coustance." "Coustance" was the spelling in the 1918 memorial exhibition, but there is no authority for this spelling (Goodrich to Constable, 14 October 1947, curatorial files, Museum of Fine Arts, Boston).

7. Meyer, "Exhibition of American and Foreign Art," 1841.

8. Fry, "Art of Ryder," 63.

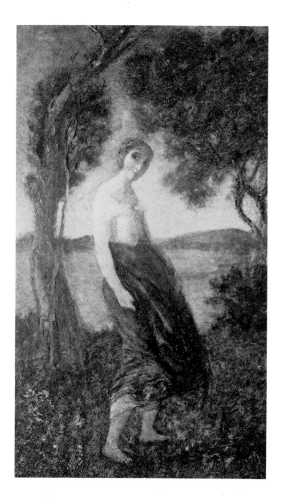

Scottish lays and ballads. *A Country Girl* is linked perhaps to sixteenth-century verses such as "The Nutbrown Maid," a tale of tested love:

> Record the Nutbrown Maid,
> Which from her love, when, her to prove,
> He came to make his moan,
> Would not depart, for in her heart
> She loved but him alone.[2]

ELJ

Provenance: consigned by Ryder to Macbeth Gallery, New York, 1903; purchased by William S. Hurley, Brooklyn, 1905; consigned to Babcock Galleries, New York, 1937; purchased by Dr. L. Pierce Clark, New York; inherited by Mrs. Clark and Mrs. T. D. Cairns, Chicago, and Mrs. Frederick L. Strong, New York (Clark's daughters); consigned by Mrs. Cairns to Macbeth Gallery, 28 November 1945; purchased by Randolph-Macon Woman's College, Lynchburg, Virginia, 10 March 1947.

Notes
1. Robert McIntyre to Dr. Herbert C. Lipscomb, 10 March 1947, curatorial files, Maier Museum of Art, Randolph-Macon Woman's College, Lynchburg, Va.

2. "The Nutbrown Maid," in *Oxford Book of Sixteenth-Century Verse* (Oxford: Clarendon), 14.

8 *A Country Girl (An Idyll; Spring Song)*

canvas; 9½ x 5¾ in. (24.1 x 14.6 cm)
Maier Museum of Art, Randolph-Macon Woman's College, Lynchburg, Virginia, 1947
See also figure 74

A Country Girl surfaced in a Valhalla, New York, roadside inn during the 1920s. Robert McIntyre, president of Macbeth Gallery, had sold the work to William S. Hurley in 1905 and had not seen it since. Stopping at the inn for dinner, he scanned the pictures on the walls. "In one room I was quite startled to see this Ryder and asked the proprietor how she came by it. Then she told me how Mr. Hurley helped her start the restaurant and gave, or lent, her pictures to decorate the rooms."[1]

The gently swaying rhythms of *A Country Girl* echo those of pastoral poetry, which enjoyed a resurgence during the late nineteenth century. Ryder's heroines were often those of English or

9 *The Culprit Fay*

cherry frame for glass mirror; overall, 20¼ x 20¼ in.
(51.4 x 51.4 cm)
Whitney Museum of American Art, New York,
bequest of Joan Whitney Payson, 76.13
See also figure 48

The Culprit Fay is one of Ryder's early works, a
decorative commission dating from 1879.[1] Ryder
painted three mirror frames; *The Culprit Fay,*
with sixteen panels, is the only one known to-
day.[2] The mirror frame is said to have been
designed by Stanford White.[3] This commission
was intended as a Christmas gift from Charles de
Kay to his mother, Janet Halleck Drake de Kay,
the only child of Joseph Rodman Drake, whose
poem of the same name inspired the painted
vignettes.

Ryder's miniature paintings refer to episodes
in Drake's popular poem, "The Culprit Fay,"
written in 1816 and first published in complete
form in 1835.[4] By the 1880s at least six separate
editions of the poem had been published, many
illustrated. Drake wrote the poem on a bet to
prove that the Hudson River could provide a
setting as suitable as the Rhine for fanciful
poetry.[5]

The poem recounts the punishment of a fay,
or fairy, who falls in love with a mortal woman.
Summoned before a moonlight council, the cul-
prit receives his penance: first, he must cleanse
his wings with the spray left by the sturgeon
when he leaps from the water in the moonlight;
then, he must relight his flame-lamp with a
spark from a falling star. Fay departs and in the
face of extreme difficulties completes his trial by
water. Ascending to the stars, he meets the Syl-
phid Queen, who offers him the chance to re-
main with her, but he resists, recalling the
woman he left behind:

> [The Queen] was lovely and fair to see
> And the elfin's heart bent fitfully;
> But lovelier far, and still more fair,
> The earthly form imprinted there,
> To clasp her in his reverie,
> To think upon his virgin bride,
> Was worth all heaven and earth beside.[6]

Buoyed by his remembrance of her beauty, the
fay completes his arduous tasks and returns to
earth, where other fairies welcome him in a
moonlight dance around the wild witch-hazel
tree.

Ryder's individual scenes do not all represent
recognizable moments in the poem, but each is
in the spirit of the verse. In the corners are small
cherubic fays; among the other scenes is a por-
trait of Joseph Rodman Drake (middle, right
side), based on a miniature done by Elias Metcalf
in 1819, and another of Helena de Kay as the
fay's earthly love.[7] Clockwise from the upper left,
the scenes are: a fay's head; fay relighting his
flame-lamp from a falling star; man in the moon;
moon and large crane flying; another fay; fays
dancing around the witch-hazel tree; portrait of
Drake; fay traveling to the river; male and female
fays; owl, birds, and water creatures; portrait of
Helena de Kay; owl (?) flying; fay looking out-
ward; Sylphid Queen with dancing figures; fay
riding the spotted toad; monarch fay on his
throne.

Ryder could not have chosen a more suitable
poem to echo the romantic side of his character.
"The Culprit Fay" takes place by moonlight, for
the fays lose their powers with the rising of the
sun. The fay's love for a pure but mortal woman,
from whom he must be rescued, parallels stories
of Ryder being "rescued" from a woman to
whom he had proposed (see here "Courting the

Gentle Muse"). *The Culprit Fay* may also commemorate Ryder's deep regard for Helena de Kay.

The condition is excellent; the lower-left panel has been slightly abraded. In technique *The Culprit Fay* resembles *The Dead Bird* and *The Lovers' Boat* (cat. 11, 34), in which areas of unpainted mahogany panel provide a deep, warm color.

ELJ

Provenance: commissioned by Charles de Day for Janet Halleck Drake (Mrs. George C.) de Kay, New York; Phillis de Kay (Mrs. John Hall) Wheelock, New York; Ira Spanierman, Inc., New York; Joan Whitney (Mrs. Charles Shipman) Payson, New York; bequest of Payson to Whitney Museum of American Art, New York, 1976.

Notes
1. "I am going to give mother at Christmas a square mirror with broad cherry frame, 16 panels, all painted by Ryder with decorative allusions to the 'Culpritt Fay' [*sic*]. Mum's the word! . . . Ryder is putting a head of H[elena] on one panel of mirror. Has a good likeness at the first chalk sketch. He wants to be remembered to you both" (Charles de Kay to Richard Watson Gilder, 29 November 1879, Gilder Archive, Tyringham, Mass.). *The Culprit Fay* hung on the walls at Cottier's during an exhibition of Monticelli's work earlier that fall ("Cottier Gallery," 5).
2. De Kay, "A Modern Colorist," 257. Hyde, "Albert Ryder as I Knew Him," 599. Hyde mentions a mirror decorated with roses by Ryder.
3. Goodrich's notes, curatorial files, Whitney Museum of American Art (courtesy of Ira Spanierman, Inc., New York).
4. "Note by the Printer," *The Culprit Fay and Other Poems by Joseph Rodman Drake* (1835; New York: Grolier Club, 1923), ix.
5. Drake, the naturalist James de Kay, and author Fenimore Cooper would row up the Hudson River talking poetry. The bet arose from one of these trips.
6. *The Culprit Fay*, stanza 33.
7. Ibid., frontispiece illustration. The miniature is in the Museum of the City of New York.
 "Did I tell you that Ryder made a sketch of you from memory for the mirror? As finished it no longer is a good likeness. This is your reward for meanness with photographs! Had you remembered your own brother he would have supplied Ryder with one. As it was the photographs of the family were in unknown quarters of trunks—and now it is too late" (Charles de Kay to Helena de Kay Gilder, March 1880, Gilder Archive, Tyringham, Mass.).

10 *Dancing Dryads (Landscape with Figures)*

canvas mounted on fiberboard; 9 x 7⅛ in.
(22.8 x 18 cm)
National Museum of American Art, Smithsonian Institution, Washington, D.C., gift of John Gellatly, 1929.6.93
See also figure 53

Cat. 10. Photograph from the 1918 memorial exhibition, the Metropolitan Museum of Art, New York.

Dancing Dryads has often been described in terms such as those used by Frederic Fairchild Sherman in 1920: "Siegfried and the Rhine Maidens and the Dancing Dryads are the most rhythmical and musical of his works, the former dramatic, the latter lyric in intention. . . . Hardly more than a single color chord suffices for that approximation of melody which in each is palpably the basic element of beauty."[1]

Dancing Dryads dates to the late 1870s or early 1880s, a period in Ryder's work dominated by pastoral subjects and idealized views of nature. Such themes also emerge in his poems; Ryder wrote a short couplet for this small "lyric of

dawn,"[2] which was inscribed on an earlier frame: "In the morning, ashen-hued, / Came nymphs dancing through the wood."

In 1879 Charles de Kay wrote to Richard Watson Gilder, his brother-in-law, that he had "a group of dancing Nayads [sic] which is exquisite in tone and full of lovely lines in the figures."[3] As this is Ryder's only known authentic work on such a subject, this letter is the first indication that the picture had an owner prior to Stanford White, the celebrated American architect who also owned *The Poet on Pegasus* and *The Stable* (cat. 48, 63).[4] White was an enthusiastic collector of oriental carpets and objets d'art and was concerned about decorations for the buildings he designed. His taste for such works may be reflected in this painting by Ryder, the colors and textures of which resemble ceramic glazes.

Arcadian imagery is widespread throughout the history of Western painting; a classical subject revived during the Italian Renaissance, it dominated French painting beginning in the seventeenth century. The nineteenth century saw a flood of arcadian landscapes in Europe and America. Whirling or dancing woodland nymphs were frequently portrayed in Corot's works, which were widely exhibited in this country. Furthermore, Ryder's dealer Cottier collected and sold major Corot paintings. In his *Dancing Dryads*, Ryder was responding to a market for this idyllic genre.

While the painting clearly evokes early morning dawn, the season has been variously identified. De Kay wrote in 1890 that it was "a very blonde picture. . . . The trees are springlike, not over-leafy, and the whole picture is in keeping with the joyous, cool freshness of dawn in April.[5] By 1919 it was said to be "autumnal, for the bare trees have shed their leaves and the hillside is leaf brown."[6] Are these simply differing opinions or had the painting darkened or been overpainted to produce such opposing descriptions?

When it was relined and cleaned in March 1966 a preliminary examination confirmed earlier findings that the canvas had been cut down along the right edge but whether by Ryder or a restorer could not be determined. Overpainting

was found in the sky, right and lower-left landscape, and around the hair of the reclining naiad. Two sets of outlines around the dancing figures, one red and the other incised in dark green, had been added to the composition, perhaps to define the figures more clearly from their background. An X-ray shows that the legs of the reclining naiad originally extended farther to the right. Her current position bears a striking resemblance to the figure in Wyatt Eaton's *Lassitude* (location unknown), a painting that at one time belonged to Sherman.

MJWD

Provenance: Charles de Kay, New York, by 1879; Stanford White, New York, before 1907; purchased for $350 by Newman E. Montross, New York, from Stanford White Estate Sale, American Art Association, Mendelssohn Hall, New York, no. 20, 11–12 April 1907; purchased for $925 by John Gellatly, New York, from Newman E. Montross Sale, American Art Association, Plaza Hotel, New York, no. 59, 27 February 1919, possibly through Knoedler & Co., New York, as agent; gift of Gellatly to National Museum of American Art, Washington, D.C., 1929.

Notes
1. Sherman, *Ryder,* 56.
2. De Kay, "Modern Colorist," 259.
3. De Kay to Gilder, 29 November 1879, Gilder Archives, Tyringham, Mass. De Kay knew his classical subject matter well. There is a pool of water in the foreground of the composition, suggesting that these women are naiads, or water nymphs; strictly speaking, dryads are woodland nymphs.
4. During the 1920s and late 1930s Sherman published three other paintings and a pencil sketch (*Arcadia, Dance of the Wood Nymphs* [see fig. 140], *Sketch for "Arcadia,"* and *Sylvan Dance*), which he claimed were variations on the theme by Ryder. Most were later acknowledged by Sherman to be forgeries.
5. De Kay, "A Modern Colorist," 259.
6. *Newman E. Montross Estate Sale,* auction cat. (New York: American Art Association, 1919), no. 59 (American Art Auctions and Exhibition Catalogues, Archives of American Art).

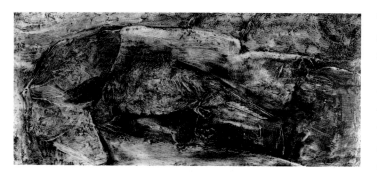

11 *The Dead Bird (The Dead Canary)*

panel; 4¼ x 7⅛ in. (11.4 x 18 cm)
The Phillips Collection, Washington, D.C.
See also figure 58

Nowhere else in art, sculpture or painting, I think, will one find anything more tragically beautiful or more poignantly pathetic than his picture of a dead canary. It is a more touching Elegy upon a dead songbird than one may hope to find in music or in poetry, and it is a matchless piece of drawing and painting besides.[1]

The Dead Bird is among Ryder's best loved paintings. Delicately painted in pale yellow on a wood panel, it is a transitional image probably dating to the late 1870s, when Ryder moved from a concern with nature to literary, allegorical, and symbolic themes.

Ryder's image is far from the tradition of trompe l'oeil dead game birds popularized in Europe and favored by William Harnett and John Haberle, which are presented first as trophies of the hunt, only secondarily referring to lost life. The frail form of Ryder's bird rests like a corpse on a ghostly shroud, its half-opened beak evoking the stilled voice of the songbird. Ryder has scored the thin paint of the bird's feathers with the butt of his brush to capture their ethereal lightness and has built up paint to create the illusion of sinew and bone in the bird's legs. Ridges of paint also describe the curved shape around the bird's head and back, suggesting veins in a leaf-shroud, with the panel itself serving as a bier.

Ryder developed two ways of looking at the world in his paintings, one favoring narrative or dramatic situations and the other presenting simplified, iconic images that appeal to ancient

themes without a specific source. *The Dead Bird* exemplifies the second approach, recalling early motifs yet devoid of any textual reference.

The winter tradition of the hunting of the wren was part of renaissance festivals associated with the feast of Saint Stephen. Adapted from pagan seasonal rites, the image of the small songbird became an icon of Christian sacrifice, complementing the tradition of the sacrificial lamb (cat. 11a). Renaissance lyric poets embraced the theme of the dead songbird as a metaphor for lost love, as in John Skelton's "Sparrow's Dirge," a formal lament over the death of a pet sparrow, Philip:

> When I remember again
> How my Philip was slain,
> Never half the pain
> Was between you twain
> Pyramus and Thisbe,
> As then befell to me.[2]

Pre-Raphaelite painters in England and America presented close-up views of dead birds rendered in loving detail. Victorian painters sometimes depicted funerals for dead birds conducted by children as emblems of lamentation over lost innocence, a motif adopted by J. Alden Weir for his *Children Burying a Bird* (cat. 11b), which is possibly contemporaneous with Ryder's small panel. In his early poem "Out of the Cradle Endlessly Rocking" Walt Whitman used the motif of a songbird that fails to return to her

Cat. 11a. Francisco de Zurbarán, *Agnus Dei (Lamb of God)*, 1635–40, oil on canvas. San Diego Museum of Art, 47.36.

nest as a means of engendering thoughts on love, departed childhood, death, and poetic creativity.[3]

The association of women with songbirds recalls stories of Ryder's infatuation with a singer in the 1890s, which may have influenced such subjects as *The Lorelei* and *Passing Song* (cat. 33, 44). Visually, the frail form of Ryder's bird echoes the figure of Constance, adrift in her boat (cat. 7).[4] Ryder's lifelong empathy with the weak and vulnerable is nowhere more convincingly captured than in this diminutive panel.

ELJ

Provenance: Newman E. Montross, New York, by 1918; purchased by the Phillips Memorial Art Gallery, Washington, D.C., from Montross, 1928.

Notes

1. Sherman, *Painters of America,* 36–37. Also in Sherman, "Some Paintings by Ryder," 155–62.

2. John Skelton, "The Sparrow's Dirge," ca. 1504, *Oxford Book of Sixteenth-Century Verse,* 18.

3. I am grateful to Charles C. Eldredge for bringing this similarity to my attention.

4. Brown, "Ryder's *Joan of Arc:* Damsel in Distress," 48.

12 *Diana*

gilded leather mounted on canvas;
28¾ x 19⅞ in. (73 x 50.5 cm)
The Chrysler Museum, Norfolk, Virginia,
gift of Walter P. Chrysler, Jr., 71.611
See also figure 87

Diana is the only vertical gilded leather painting by Ryder that is not known to have been part of a multipanel screen. The size is nearly identical to *A Stag Drinking* and *A Stag and Two Does* (cat. 70) and may have been one of the stock formats for such work; several Homer Dodge Martin gilded panels are the same dimension, although Ryder's three panels for a screen (cat. 68) are substantially taller. In keeping with the trends in home furnishings after 1876, single decorative panels were sometimes incorporated into firescreens, with elaborately carved frames (cat. 12a).

Diana is seated on an outcropping of rocks near water, her form and drapery recalling the woman (possibly Genevieve of Brabant) in the panel *Woman with a Deer* (cat. 68). The dog at Diana's feet reappears in *King Cophetua and the*

Cat. 11b. J. Alden Weir, *Children Burying a Bird,* 1878, oil on canvas. National Museum of American Art, Smithsonian Institution, Washington, D.C., 1986.1.

Beggar Maid (cat. 25) and in *Joan of Arc* (cat. 23); the latter in fact is nearly identical overall in composition. Unlike many of the women in Ryder's paintings, Diana is not a woman abandoned or unfairly treated; rather, she is the protector of virgins, children, and weak creatures as well as goddess of the hunt.

ELJ

Provenance: Alexander Morten, New York, ca. 1900; purchased for $500 by A. W. Bahr, Montreal, Ridgefield, Connecticut, and New York, from Alexander Morten and Others Estate Sale, American Art Association, Plaza Hotel, New York, no. 66, 29 January 1919; purchased for $1,000 by Dr. John Mayers from Parke-Bernet, New York, sale 1453, no. 65, 14 October 1953; ACA Heritage Galleries, New York, 1966; Adelson Gallery, Boston, 1967; Walter P. Chrysler, Jr., 1967; gift of Chrysler, to the Chrysler Museum, Norfolk, Virginia, 1971.

Cat. 12a. Herter Brothers, New York, Screen, ca. 1880, gilded and painted wood, embroidered silk and embossed leather (?). Collection of Margot Johnson (courtesy of the Metropolitan Museum of Art, New York).

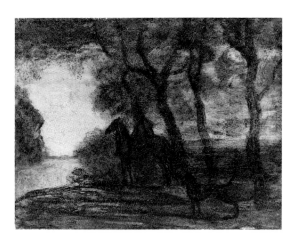

13 **The Equestrian**

canvas; 9 x 12 in. (22.9 x 30.5 cm)
Portland Art Museum, Oregon, bequest of
Winslow B. Ayer, 35.27
See also figure 13

In *The Equestrian* Ryder has painted his friend and fellow artist J. Alden Weir on horseback, accompanied by a hound, in a wooded landscape near a riverbank. Alexander Morten saw *The Equestrian* hanging in Ryder's studio and begged the artist to sell him the work. Ryder refused, eventually giving the painting to Weir. In time, Morten pleaded with Weir to sell him *The Equestrian;* when Weir finally agreed, he turned over the money to Ryder.[1]

The Equestrian is thinly painted for Ryder, resembling his painted sketches in its roughly blocked-in forms, particularly the trees. The overall dark tonality gives the painting a moodiness found in many of Ryder's more heavily worked canvases. An air of expectation and controlled energy pervades *The Equestrian*: the dog stands alert, as if on display, head turned toward Weir, who holds the horse in check. Duncan Phillips remarked on Ryder's ability to transcend mundane subjects, "We did not know that the silhouette of a horseman against the afterglow could in itself suggest a thrilling adventure."[2]

ELJ

Provenance: J. Alden Weir; purchased by Alexander Morten, New York, from Weir, before 1917; purchased for $525 by C. W. Kraushaar, New York, from Alexander Morten and Others Estate Sale, American Art Association, Plaza Hotel, New York, no. 11, 29 January 1919; Holland Galleries, New York; purchased by Macbeth Gallery, New York; purchased for $2,000 by Winslow B. Ayer, Portland, Oregon, 12 December 1919; bequest of Ayer to Portland Art Museum, 1935.

Notes
1. McIntyre to Winslow B. Ayer, 16 January 1920, curatorial files, Portland Art Museum, Oregon.

2. Phillips, "Ryder," 391.

14 *The Flying Dutchman*

canvas mounted on fiberboard; 14¼ x 17¼ in. (36.1 x 43.8 cm)
National Museum of American Art, Smithsonian Institution, Washington, D.C., gift of
John Gellatly, 1929.6.95
See also cover and figure 104

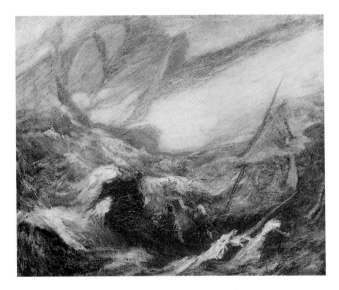

Cat. 14. Photograph from the 1918 memorial exhibition, the Metropolitan Museum of Art, New York.

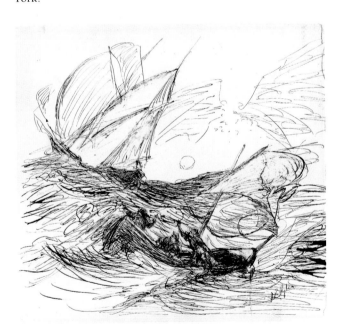

15 *The Flying Dutchman*

paper; 7¼ x 8 in. (18.4 x 20.3 cm)
Memorial Art Gallery of the University of Rochester, New York, given anonymously, 77.150

The Flying Dutchman brings together Ryder's favorite themes of the solitary marine voyage and the search for redemption as narrated in a legend long familiar through plays and novels. *The Phantom Ship,* a novel by Captain Frederick Marryat, was published in 1839 and frequently reprinted; *The Flying Dutchman* was published the same year by Marryat's literary rival, Johnson Neale.[1] Edgar Allan Poe's short story "MS. Found in a Bottle" of 1843 explored the legend from the Dutchman's point of view.[2] *The Flying Dutchman; or, The Phantom Ship: A Nautical Drama* by Edward Fitzball took a droll approach in a three-act play performed by the Brooklyn Academy of Music in 1866.[3] Heinrich Heine recalled seeing a play in Amsterdam in which Vanderdecken, "the Wandering Jew of the Ocean," landed in Scotland after seven years at sea and was befriended by a Scottish nobleman whose daughter became his intended bride.[4]

Richard Wagner's opera *Der Fliegende Holländer* was the most celebrated nineteenth-century setting of the legend and has usually been assumed to be Ryder's source. In America the overture was premiered by the Brooklyn Philharmonia in May 1862, and on 8 November 1876 the first full performance was given at the Philadelphia Academy of Music and reviewed at length in the next day's *New York Times.*[5] On 26 November 1889—two years after the first mention of Ryder's painting—the opera premiered at the Metropolitan Opera in New York, sung in German.[6]

Although Wagner's opera has today eclipsed other versions of the tale, Marryat's novel was still popular in the late 1880s and more likely served as Ryder's inspiration, as it did also for Robert Louis Stevenson in 1887.[7]

Marryat's version of the legend tells of the Dutch ship captain Vanderdecken who boasts that not even the devil could best him. While trying to round the Cape of Good Hope during a violent storm, Vanderdecken swears on a relic of the true cross that no storm should defeat him, although he sail until Judgment Day. The devil accepts Vanderdecken's challenge, condemning him to sail the cape seas against gale-force winds until presented with the relic on which he blasphemed. Vanderdecken's son Philip devotes his life to pursuing the phantom ship, bearing the relic that will set the Dutchman free. Their destinies entwined, father and son must both find redemption through forgiveness of their enemies before Philip can reach his father's ship and Vanderdecken kiss the holy relic, thereby ending the curse. Ryder's painting shows the dramatic moment in which Vanderdecken's son—grown old from decades of searching for his father, his own

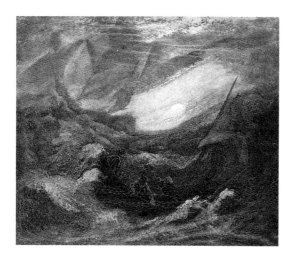

Cat. 14a. Elbridge Kingsley, wood engraving after Ryder, *The Flying Dutchman.* National Museum of American Art, Smithsonian Institution, Washington, D.C., gift of Leonard Baskin, 1969.26.9.

Cat. 14b. Autoradiograph of *The Flying Dutchman.* Conservation Analytical Lab, Smithsonian Institution, Washington, D.C.

vessel in danger of foundering in the gale—glimpses the phantom ship under full sail on the storm-swept horizon.

Wagner's opera omits the character of Philip and any mention of the true cross, substituting the love of a faithful woman for forgiveness as the agent of salvation. Those believing Ryder's painting to derive from Wagner's opera interpret the old man in the foreground ship as Captain Daland, who, as the curtain rises on the opera, finds his ship docked near the Dutchman's after a storm, hears his sad tale, sees his wealth, and offers to introduce the Dutchman to his own daughter, hoping for a match that will bring the Dutchman's riches into the family. Daland's motives for helping the Dutchman are as much mercenary as compassionate; he is not characteristic of Ryder's insistently virtuous protagonists.

No moment in the opera's dramatic action corresponds to the situation depicted by Ryder, in which two ships meet on the high seas. The overture evokes a fierce storm corresponding to that in the painting and so has sometimes been identified as the inspiration for Ryder's work. Marryat's novel, however, describes three occasions when Philip glimpses the phantom ship through terrible storms. By carefully depicting the gesturing figure in the foreground as an old man Ryder makes clear that this is Philip's final, climactic encounter with his father's ghost ship—the encounter that will redeem them both.

Ryder's theme of religious salvation is confirmed by a drawing (cat. 15) of a large-winged presence in the sky at right, recalling the figure of *God* presiding over *Jonah* (cat. 24). Ryder had *Jonah* and *The Flying Dutchman* underway simultaneously in the mid-1880s, and both illustrate redemption themes set as marine dramas. They also apparently once shared many compositional similarities, including tattered sails whipped by winds and a deity in the sky. Ryder altered the two compositions to make them less similar by eliminating the mast and sail in *Jonah* and the winged divinity in *The Flying Dutchman*.

The Rochester drawing of *The Flying Dutchman* is one of only a few surviving drawings from Ryder's hand.[8] Delicate pencil lines underlie rapid penwork, which captures the figures' gestures, swelling waves, and motion of sails in wind. Ryder heavily worked some areas, then scraped the paper and redrew key elements as he sought to clarify his vision. This is a drawing conceived with a painter's eye—lights and darks and masses are well established while contours and academic linework are neglected. The phantom ship's rigging is noteworthy, for although quickly observed, it is fundamentally accurate, with taut lines and rigging anchoring the mast to the hull, convincingly suggesting a ship under full sail.

Elbridge Kingsley engraved *The Flying Dutchman* for an engraver's portfolio promoting the Society of Art in Wood Engraving, published in 1887 (cat. 14a).[9] William I. Homer has suggested that Ryder's drawing of the subject served as a guide for Kingsley's engraving or as a visual document of Ryder's completed painting.[10] Kingsley's descriptions, however, suggest that he worked from the paintings of *The Flying Dutchman* and *Jonah* directly.[11]

Kingsley described Ryder's phantom ship as "simply flying cloud masses sweeping across the picture, just a fantasy of the imagination."[12] Indeed, Ryder painted the ship so thinly that the image does not register on the X-ray against the thicker lead-based substrate. The ghost ship

Detail of cat. 15

does, however, appear in autoradiographs, which also reveal that the man uppermost in the smaller boat has been adjusted, his awkwardly upraised hand covering an earlier version in which the arm was braced on the gunwales (cat. 14b). This gesture was also scraped down and redrawn in the pen drawing.

The Flying Dutchman was first exhibited in 1887 to excellent reviews. The *New York Times* praised its imagination and artistic merits, comparing it favorably in color and romantic interest to Turner's *Slave Ship* (see fig. 108).[13] De Kay declared Ryder's painting "a splendid marine which Turner would have been glad to own."[14] Kingsley commented on the rage for Flying Dutchman images, calling it a "hackneyed subject and made in all degrees of realism by the Marine painters. Mr. Ryder's rendition always held my admiration, and I think for the reason there was no realism about it."[15] Kingsley's reference to the "hackneyed subject" refers not only to literary and operatic versions; in 1887 James Tyler's *Flying Dutchman* (unlocated) hung in the same exhibit as Ryder's painting,[16] and Ryder himself painted another small *Phantom Ship* (unlocated), described by de Kay in 1890.[17] Inspired in part by Turner, Dupré, and the Hague school artists, marine painting as a genre peaked at this time, providing viewers with a plethora of real and spectral galleons.

Although *The Flying Dutchman* belonged to Gellatly by 1897, Sadakichi Hartmann saw it in 1902 in Ryder's studio and called it equal to *Jonah* in composition and thought. "It is a picture as impressive as religion," he wrote, "one of the few that sound the note of sublimity which is, after all, the highest in art."[18] A similar redemption theme surfaces again in Ryder's *With Sloping Mast and Dipping Prow* (cat. 76), inspired by Coleridge's "Rime of the Ancient Mariner." At the moment that the mariner can feel love for his fellow man he is able to pray; in doing so he rids himself of the albatross and finds peace. Like the mariner, the Dutchman stands "in Living Judgment"[19] until he achieves spiritual redemption.

Ryder composed a poem entitled "The Phantom Ship" to accompany the painting, which he sent to Gellatly in 1897 (see Appendix A). Nearly twelve years later, in 1909, he wrote again, "I have tried to improve the verse of the 'Flying Dutchman' hence a slight delay. I think it a little better."[20]

ELJ

Provenance of cat. 14: Cottier & Co., New York, by 1887; James S. Inglis, New York, by 1890; purchased for $800 by John Gellatly from Cottier & Co. by 1897; gift of Gellatly to National Museum of American Art, Washington, D.C., 1929.

Provenance of cat. 15: Louise Fitzpatrick, Elmhurst, New York; Philip Evergood, New York; M. A. Mac-Donald, New York; Robert MacDonald (MacDonald's son); purchased by a private collector, New York, from Robert MacDonald during the 1930s; donated to Memorial Art Gallery, Rochester, New York, 1977.

Notes
1. Frederick Marryat, *The Phantom Ship*, 3 vols. (London: Colburn, 1839). Oliver Warner, *Captain Marryat: A Rediscovery* (London: Constable, 1953), 167.

2. The final version appeared first in *Broadway Magazine* in 1845 (*Selected Poetry and Prose of Poe*, ed. T. O. Mabbott [New York: Modern Library, 1951]).

3. Edward Fitzball, *The Flying Dutchman; or, The Phantom Ship: A Nautical Drama in Three Acts* (London: Cumberland, n.d.). Brooklyn Academy of Music, playbill dated 7 February 1866 (Brooklyn Academy of Music Archives, New York).

4. Richard Wagner apparently based his opera on this account of the legend (Heinrich Heine, *Memoirs of Herr von Schabelwopski* [London: Dent, n.d.], quoted in the brochure notes for "Richard Wagner: The Flying Dutchman" [Angel Records]).

5. Anne Dzamba Sessa, "At Wagner's Shrine: British and American Wagnerians," in *Wagnerism in European Culture and Politics*, ed. David C. Large and William Weber (Ithaca, N.Y.: Cornell University Press, 1984), 249.
 "The Flying Dutchman: First Performance in America," *New York Times*, 9 November 1876, sec. 5, pp. 4–5.

6. Information courtesy of the Metropolitan Opera Archives, New York. Other versions of the opera and its overture were performed as well. For a discussion of Wagner performances during these years see Carmen, "Albert Pinkham Ryder's Two Wagnerian Paintings: *The Flying Dutchman* and *Siegfried and the Rhine Maidens*" (thesis).

7. Robert Louis Stevenson reread *The Phantom Ship* in 1887 in preparation for writing his novel *The Master of Ballantrae*. Stevenson was reading Marryat's book while staying at the Hotel St. Stephen in New York, managed by Ryder's brother.

8. An inscription on the verso of this drawing, written in pencil, reads: "The Flying Dutchman / by Albert P. Ryder / Original owned by / James S. Inglis." Four pencil drawings of windmills are in the collection of the Art Museum, Princeton University; a single large windmill drawing is in a private collection; a pen drawing of *The Story of the Cross,* sometimes attributed to Ryder, is also in the Art Museum, Princeton University (cat. 64a).

9. *Engravings on Wood* (New York: Harper's, 1887). Stephen G. Putnam, who owned Ryder's *Spirit of Autumn* (cat. 61), also contributed two engravings to this book (Putnam to Sherman, 5 November 1937, curatorial files, Columbus Museum of Art, Ohio).

10. Homer, "The Flying Dutchman," 13.

11. Autobiography, 183, Kingsley Papers, Archives of American Art.

12. Ibid., 162.

13. "Third Prize Fund Exhibition," *New York Times,* 2 May 1887.

14. De Kay, "Modern Colorist," 258.

15. Autobiography, 162, 183.

16. *Third Prize Fund Exhibition for the Promotion and Encouragement of American Art,* American Art Association, New York, no. 217, 1887. For a comparison of Ryder's and Tyler's versions of this subject see Speed, *Essays on American Art,* 150.

17. " 'The Phantom Ship' is a small marine owned by Mrs. W. T. Moore of Paris. . . . With all sails set the spectral galleon glides mysteriously between a headland and a low shore with trees out to the calm ocean, over which hangs a bank of clouds with the moon just emerging" (De Kay, "Modern Colorist," 257).

18. Hartmann, "A Visit to Ryder," 1.

19. Marryat, *Phantom Ship,* 1:19.

20. Ryder to Gellatly, 20 July 1909, curatorial files, National Museum of American Art.

16 *The Forest of Arden*

canvas; 19 x 15 in. (48.2 x 38.1 cm)
The Metropolitan Museum of Art, New York, bequest of Stephen Clark, 61.101.977
See also figure 79

Cat. 16. Photograph from the 1918 memorial exhibition, the Metropolitan Museum of Art, New York.

"Where is the forest of Arden? Who knows, and who cares to know!"[1] Ryder's Arden is an idealized land outside geography and time, a sanctuary in which the artist and his inspiration meet. The two figures, be they Rosalind (disguised as a man) and Celia from Shakespeare's *As You Like It* or any pair of lovers, offer entry into a magical realm where lovers, poets, and dreamers find refuge. As a mythic place of inspiration, Ryder's Arden parallels the muses' realm in *The Poet on Pegasus,* Prospero's enchanted isle in *The Tempest,* and the forest glade of *Woman and Staghound* (cat. 48, 66, 77).

The two figures in renaissance dress poised before the landscape effect a transition between the viewer's world and the artist's invented one. This placement suggests the staging of a play

Cat. 16a. Edouard Manet, *La Pêche,* oil on canvas. The Metropolitan Museum of Art, Mr. and Mrs. Richard Bernhard Fund, 57.10.

Cat. 16b. Peter Paul Rubens, *The Park at Steen,* ca. 1632–38, oil on canvas. Kunsthistorisches Museum, Vienna.

before a backdrop, but the figures also recall the costumed couple in *La Pêche* by Edouard Manet (cat. 16a), which in turn pays homage to a composition by Peter Paul Rubens showing the artist with Suzanne Fourment before a park (cat. 16b).

Most critics have considered the landscape to be the protagonist of Ryder's painting—the grand late manifestation of his earliest interest in art. "[This is] one of his most brilliant figure subjects, though, as was often the case with pictures of his, the landscape was made more important than the figures. It is a mellow symphony of tender greens under a lambent sky."[2] Kenneth Hayes Miller included *The Forest of Arden* as the only American picture in his lecture on great art of the world, and Lloyd Goodrich called it "one of the greatest landscapes of the nineteenth century in any country."[3] Just as many of Ryder's

paintings display a square format, the space within *The Forest of Arden* is nearly a cube, with solitary trees anchoring the left and right banks of a meandering stream, which leads the eye calmly from foreground to horizon. A composition of classic stability like *The Temple of the Mind* but tempered by nature's asymmetries, *The Forest of Arden* displays Ryder's love for formal inventions, balanced by his sensitivity to nature.

Ryder began *The Forest of Arden* in about 1888 and labored over it for more than two decades. In the fall of 1897 he wrote about the painting to Sylvia Warner, whose husband, Olin (Ryder's close friend), had died the previous year and toward whom he felt a protective and possibly romantic inclination: "I have every faith that my Forest of Arden, will be fully as beautiful as any preceding work of mine; Bronx Park has helped me wonderfully, and I would have gone out to day for that breezy agitation of nature that is so beautiful. But the rain has spoiled my plans. I sincerely wish the picture was for you."[4] Like so much of Ryder's work of the 1890s and later, *The Forest of Arden* was destined for Dr. Albert T. Sanden. Sanden briefly held possession of the painting in 1908 but soon relinquished it to Ryder for reworking, only regaining it in 1912.[5]

ELJ and EB

Provenance: purchased by Dr. Albert T. Sanden, New Rochelle, New York, by 1892; delivered to Sanden in 1912; purchased by Ferargil Gallery, New York, February 1924; purchased for $16,000 by an "Eastern collector," March 1925; Adah M. Dodsworth, New Jersey, by 1930; Alice A. and Mary E. Dodsworth (sisters); Milch Galleries, New York; consigned to Macbeth Gallery, New York, November 1936; purchased for $9,500 by Stephen C. Clark, 18 November 1936; bequest of Clark to the Metropolitan Museum of Art, New York, 1960.

Notes

1. Sadakichi Hartmann, *Shakespeare in Art* (Boston: Page, 1901), 141.

2. "Ferargil Galleries Acquires Famous Sanden Group of Ryders," unidentified newspaper clipping, 9 February 1924, curatorial files, the Metropolitan Museum of Art.

3. Curatorial files, the Metropolitan Museum of Art.

4. Ryder to Sylvia Warner, 12 October 1897, Warner Family Papers, Archives of American Art.

5. Ryder to Sanden, 9 May 1908, Babcock Galleries.

17 Gay Head

canvas; 7½ x 12½ in. (19 x 31.7 cm)
The Phillips Collection, Washington, D.C.
See also figure 25

Cat. 17. Photograph from the 1918 memorial exhibition, the Metropolitan Museum of Art, New York.

Gay Head, Massachusetts, is at the westernmost tip of Martha's Vineyard and at one time was the site of an Indian reservation.[1] Rather than painting the cliffs, the most prominent feature of Gay Head and most frequently depicted by artists, Ryder chose the view "across Menemsha Bight to Prospect Hill, [with] only the grassy Gay Head meadow in the foreground," providing a vantage point from which one could see across the Elizabeth Islands, to Wood's Hole and to the artist's hometown of New Bedford.[2]

According to Goodrich, *Gay Head* was painted in 1890 and is one of many small landscapes dating from this time in Ryder's career.[3] As with other of his early landscapes, *Gay Head* represents a specific place, carrying familiar overtones for Ryder. As such, it relates to a tradition of view painting, here filtered through memory, that differs from his more famous imaginative works. The foreground meadow, dotted with flowers, contains Ryder's signature, visible in the lower-right corner. The painting's condition is quite good, with only a network of fine cracks disturbing the surface.

Two other paintings by Ryder are very close in composition to *Gay Head: The Canal* (cat. 5) and *Landscape* (cat. 26) repeat the rhythm of softly rolling landscape and interplay of land, water, and sky. The intermediate tonalities of the palette Ryder used in *Gay Head* create a strong link to tonalist painting, characterized by more subdued colors and an aura of longing or nostalgia for a now-distant familiar place.

ELJ

Provenance: Dr. Albert T. Sanden, New York; purchased by Ferargil Gallery, New York, 5 February 1924; purchased by Duncan Phillips, Washington, D.C., 9 October 1924; the Phillips Collection, Washington, D.C.

Notes
1. "Albert P. Ryder: Poe of the Brush," 5.
2. "Across Menemsha Bight": quoted in Lucy Wallbank, "Ryder's Paintings Reflect Cape Cod, New Bedford," *New Bedford Standard-Times,* 17 April 1960.
 Elizabeth Islands: Mrs. Isaac M. Taylor, Chapel Hill, N.C., to Duncan Phillips, Washington, D.C., 3 April 1962, curatorial files, the Phillips Collection.
3. Goodrich notes, curatorial files, the Phillips Collection.

Provenance: C. B. Smith (Ryder's nephew); Macbeth Gallery, New York; Robert C. Vose Galleries, Boston; Hiram Hyde Logan; bequest of Logan to Museum of Fine Arts, Boston, 20 April 1922.

Note
1. Review of the Society of American Artists exhibition, *The World,* 25 March 1883, Sherman scrapbook, Force Papers, Whitney Museum of American Art.

18 *The Golden Hour (Sunset Hour)*

canvas; 7½ x 12½ in. (19 x 32 cm)
Museum of Fine Arts, Boston, bequest of
Hiram Hyde Logan, 22.841
See also figure 32

Nowhere is Ryder's early reputation as a colorist more evident than in a painting like *The Golden Hour,* its sky glowing with the brilliant luminosity the artist prized, its decorative color representing for Ryder the greatest triumph of the old masters he admired. Critical response to his paintings from the 1870s and early 1880s centers on this aspect of his works, one reviewer calling them "little phantasmagories of color."[1] De Kay, entitled the first full-length article on Ryder, "A Modern Colorist." The diminutive size and delicate handling of *Golden Hour* exhibits the gem-like quality often cited by critics.

On peaceful water a sailboat glides, framed by dark foliage; a woman stoops to pick flowers or gather twigs on the left bank; behind her a tall tree is encircled by vines. The setting sun recalls the seascapes of Claude, so highly esteemed for their golden glow. Ryder also loved Corot above all others for the way he brought an "old master glow" into modern painting. Ryder was accustomed to the darkened varnishes that lent warmth to Corot's silvery colors and may have sought such an "antique" effect in *The Golden Hour.*

ELJ

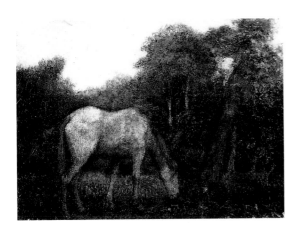

19 *The Grazing Horse*

canvas; 10¼ x 14¼ in. (26 x 36.2 cm)
The Brooklyn Museum, Graham School of Design
Fund, 14.554
See also figure 2

In late 1914 Ryder was asked to authenticate six
paintings recently acquired by the Brooklyn Mu-
seum from Cottier's widow. Witnessed by the
museum's curator, on 12 November 1914 Ryder
signed and dated each painting on the back of
the stretcher; this occasion suggests the growing
awareness of clever forgeries, which began to
appear about 1912.

 The Grazing Horse is thinly painted, the canvas
twill clearly visible under the horse's legs and in
the foliage. Ryder primarily used shades of russet
and brown, the landscape containing touches of
green in the trees on the right. The white horse,
its flanks and legs well modeled, conveys a
strong sense of equine anatomy. Beyond the
large, intertwined trees to the horse's right
strides a man carrying a sack. This small pastor-
ale recalls Ryder's youth in New England, the
horse bringing to mind the stories of Ryder's
fondness for white horses (cat. 74).

 ELJ

Provenance: Daniel Cottier collection, London; pur-
chased by the Brooklyn Museum, Graham School of
Design Fund, from the estate of Marion Field (Mrs.
Daniel) Cottier, 12 November 1914.

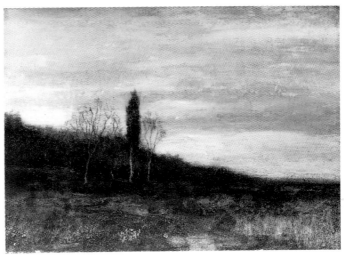

20 *Harlem Lowlands, November*

canvas; 18¼ x 24¼ in. (46.4 x 61.6 cm)
Private collection
See also figure 27

Harlem Lowlands, November depicts a scene along
the Harlem River north of New York, the same
area Ryder painted in *The Bridge* (cat. 3). Dark
russet tones of late fall are animated by touches
of red throughout the foreground; the pale sky
carries the first chill of winter. Ryder's brush-
work is fluid and the paint relatively thinly ap-
plied except in the dense, creamy portions of the
sky.

 The painting was shown at the 1879 Society of
American Artists exhibition held at the Pennsyl-
vania Academy of the Fine Arts in Philadelphia.
It was described by de Kay in 1890 as an early
work, "a landscape from nature, a view on the
lowlands near High Bridge. A simple slope of
woodland runs from the left downward to the
center; the Harlem flats are in the foreground;
above is one of the subtlest, quietest of cloudy
skies."[1] De Kay described Ryder as having started
as a landscape painter, and works like *Near
Litchfield, Connecticut* (cat. 42), dated 1876, con-
firm that he was painting landscapes from nature
during the years he worked on gilded panels for
Cottier. *The Bridge* and *Harlem Lowlands, Novem-
ber* may have been painted during the same pe-
riod, one as an easel painting and the other for
decoration.

October and November were favorite months for the tonalist painters, who sought to capture the subtle values and colors afforded by the half-light of autumn. Ryder came to this idiom relatively early, along with Inness and Homer Dodge Martin. In *Harlem Lowlands, November,* Ryder captured the transition between fall and winter, his palette imparting the evocative, subdued mood shared by many tonalist paintings.

ELJ

Provenance: William Macbeth, New York; George S. Palmer, New York, by 1920; Mrs. J. Reid Johnson; M. Knoedler & Co., New York; Milch Galleries, New York; private collection, 1957.

Note
1. De Kay, "Modern Colorist," 255.

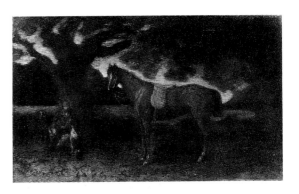

21 *The Hunter's Rest (After the Hunt; Hunter and Dog; Huntsman's Rest)*

canvas; 14½ x 24¼ in. (36.8 x 61.6 cm)
University of Nebraska, Lincoln, Sheldon Memorial Art Gallery, Thomas C. Woods Memorial Collection, Nebraska Art Association

"His horses are as fine as Géricault's and his sheep as fine as Jacques' when he wishes them to be."[1] Sherman's assessment testifies to the high regard in which Ryder was held as an animal painter. Hartmann also praised Ryder's horses, saying that they showed "more draughtsmanship than he ordinarily seems capable of."[2] Frequenting stables and blacksmith shops in New Bedford and New York, Ryder developed an understanding of the subtleties of equine form.[3] In 1882 Ryder visited England and wrote to William R. Meade, "I have just seen the Derby—found it very interesting," and mentioned having gone to Epsom.[4] Ryder attended the spring horse races in New York with Inglis, cheerfully talking horses and art.[5] Ryder experimented with large-scale profiles of horses on two other canvases, which he painted over (see *Autumn Landscape* and *King Cophetua and the Beggar Maid* [cat. 1, 25]).

The X-ray (cat. 21a) reveals a more naturalistic image with greater structure in the forms than can be seen today on the surface. In the X-ray the horse's head, shoulders, and flanks are handled with grace and accuracy and the massive tree has an elemental power. The more natural interface between sky and branches has been altered to conform quite neatly to the shape of the horse, as if to emphasize the "patterning" for

which Ryder was famous in the modernist period. Ryder's laborious layering of paint and the subsequent reinforcement, perhaps by later hands, has softened contours and forms.

Hunter's Rest pays tribute to the tradition of British horse portraiture. Viewed as an expression of rural leisure pursuits, eighteenth-century sporting art reflected the dual interest in improving horse breeds and the passion for the chase. As in traditional equine portraits, Ryder's horse is shown in profile, centered on the canvas, with its head slightly turned. The seated man and hunting dogs are subsidiary elements. There is no quarry or trophy—simply a reflective moment in nature with two of man's best friends.

ELJ

Provenance: Charles de Kay; Louis A. Lehmaier [Lemaire], before 1906; Alexander Morten, New York, by 1913; purchased for $1,625 by Charles Daniel from Mrs. Benjamin Thaw and Others Collections Sale, American Art Association, Plaza Hotel, New York, no. 115, 10 May 1916; Marjorie (Mrs. Alexander) Morten, New York; purchased by Macbeth Gallery, New York, from Morten, 29 September 1917; sold to Vose Gallery, Boston, 8 October 1917 (with two other paintings, *The Castle* [*Gondola*] and *Pirate's Isle* [*Shore Scene*] all for $5,500); Ralph Cudney, Chicago, by 1920; consigned to Babcock Gallery, New York; Milch Gallery, New York; Babcock Gallery, 1943; Mrs. Jacob H. Rand by 1947; purchased for $2,200 from Mrs.

Jacob H. Rand and Others Sale, Parke-Bernet Galleries, New York, no. 68, 6 January 1949; Milch Galleries; Mr. and Mrs. Lawrence A. Fleischman by 1961; purchased by Nebraska Art Association for University of Nebraska, Lincoln, 1961.

Notes
1. Sherman, *Painters of America,* 36.
2. Hartmann, *History of American Art,* 241.
3. "Albert P. Ryder: Poe of the Brush," 5.
4. Ryder to William R. Meade, posted 27 May 1882 from 3 St. James Terrace, Regents Park, London, N.W.
5. Inglis to Wood, 15 June 1895, Wood Papers, Huntington Library.

Cat. 21a. X-ray of *The Hunter's Rest.*

22 In the Stable (Interior of a Stable; The Stable)

canvas mounted on fiberboard; 21 x 32 in.
(53.3 x 81.3 cm)
National Museum of American Art, Smithsonian
Institution, Washington, D.C., gift of
John Gellatly, 1929.6.97
See also figure 8

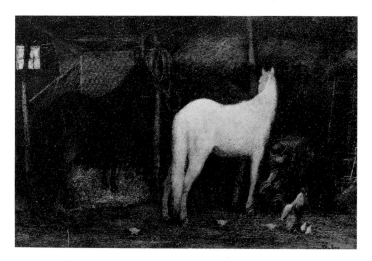

Cat. 22. Photograph from the 1918 memorial exhibition, the Metropolitan Museum of Art, New York.

Cat. 22a. *The Stable*. Vassar College Art Gallery, Poughkeepsie, New York, gift of Mrs. Lloyd Williams in memory of her father, Daniel Cottier, 40.1.12.

Cat. 22b. George Morland, *Horses in a Stable*, 1791, oil on canvas. Victoria and Albert Museum, London, 5061.4.

Cat. 22c. John Henry Dolph, *Interior of a Stable*, 1875, oil on canvas. Private collection (courtesy of Christies, Inc., New York).

In the Stable unites Ryder's passion for horses with his ambition to rival the greatest of the old masters. His largest and most complex stable scene, it is the grand statement of a theme explored in several smaller works (cat. 22a, 63, 74).

Ryder showed a stable interior in an exhibition in 1875, but the unorthodox painting technique and carefully plotted composition of *In the Stable* suggest that this example was painted in the wake of his first trip abroad in 1877, when he visited the Rijksmuseum in Holland. In subject and palette *In the Stable* is distinctly Dutch. The golden age of Dutch art was revived in the nineteenth century through genre scenes by George Morland (cat. 22b) and John Herring, the advancing popularity of the Hague school, and the emphasis on New York's Dutch heritage. Hartmann saw "something of Moreland's [*sic*] stables and Wilkie's handling of interiors" in Ryder's paintings.[1] Rural subjects by artists like Josef Israels, Anton Mauve, and Morland were eagerly sought after by American patrons. John Henry Dolph's *Interior of a Stable* (cat. 22c), painted in 1875, also owes much of its visual character to Dutch prototypes.

Cat. 22d. X-ray of *In the Stable*.

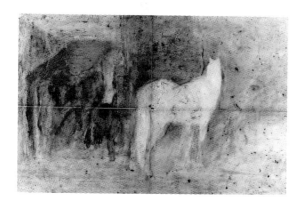

Cat. 22e. Autoradiograph of *In the Stable*.
Conservation Analytical Lab, Smithsonian Institution,
Washington, D.C.

In the Stable is an early instance of Ryder's lifelong search for new ways of handling paint. Experiments with technique formed the basis of much of his art. When William Macbeth purchased *In the Stable* in 1911, Ryder strongly protested his intention of cleaning the painting, fearing damage to the color effects he had worked so hard to achieve (see here "Chaos Bewitched").[2] Macbeth kept the painting as part of his personal collection until his death, loaning it to the Armory Show in 1913.[3]

The deep, translucent browns of *In the Stable* have long been viewed as evidence of bitumen. Recent analysis has proven, however, that there is no bitumen in this painting; rather, the browns are composed of umbers mixed with high levels of slow-drying oils, popular with artists for the depth they gave to dark colors.[4] Different layers of paint have dried at different

rates, resulting in serious traction crackle, repaired by Sheldon and Caroline Keck in 1967.

The X-ray (cat. 22d) reveals a figure standing between the two horses, holding a long-handled tool, possibly a broom—an arrangement Ryder explored in *The Stable* (cat. 22a). Ryder painted a stall divider over the figure, but his form still can be seen in raking light as a raised area. A sleeping dog, also painted out, lay curled behind the bay horse.

An autoradiograph (cat. 22e) indicates that forms were blocked in with an umber paint and that the centrally placed groom once carried a bucket. The contours of the white horse are drawn with thin strokes, the legs clearly articulated.

In the final composition the groom wipes down the legs of the white horse, which turns toward the bay in the adjoining stall, acknowledging a silent bond. The sense of nurturing is reinforced by the rooster, hen, and chicks scurrying across the stable floor.

ELJ

Provenance: C. B. Smith (Ryder's nephew), before 1911; consigned to Macbeth Gallery, New York, 25 October 1911; purchased by Mr. and Mrs. William Macbeth, 1911; purchased for $6,000 by Vose Galleries, Boston, 22 August 1917; purchased by George S. Palmer, New London, Connecticut, 16 February 1918; purchased by John Gellatly through Rehn Galleries, New York, ca. 1919–20; gift of Gellatly to National Museum of American Art, Washington, D.C., 1929.

Notes

1. Hartmann, "An American Painter," 5, Hartmann Papers, University of California Library.

2. Ryder to Macbeth, 6 November 1911, Macbeth Gallery Papers, Archives of American Art.

3. Robert C. Vose, Jr., to William Truettner, 23 December 1970, curatorial files, National Museum of American Art: "Ryder asked Mr. Macbeth never to sell this picture at a low price. William Macbeth esteemed it highly and never sold it. We bought it after his death."

4. Several paint samples of *In the Stable* were analyzed by research scientists at the Conservation Analytical Laboratory, Smithsonian Institution, in 1988; none showed evidence of bitumen, but each revealed high concentrations of oils.

Cat. 23a. Julien Bastien-Lepage, *Joan of Arc,* 1879, oil on canvas. The Metropolitan Museum of Art, New York, 89.21.1.

23 *Joan of Arc*

paper mounted on canvas; 10⅛ x 7⅛ in.
(25.7 x 18.1 cm)
Worcester Art Museum, Massachusetts, bequest of
Theodore T. and Mary G. Ellis, 1940.90
See also figure 88

Called to a destiny that will save a nation, Joan of Arc may have embodied for Ryder selflessness and personal sacrifice, a romantic ideal as well as a historical figure. She is shown as a shepherdess at the moment of her conversion to the cause of God and France. Her responsibility is to her sheep grazing calmly nearby and to her dog, unaware of its master's destiny.

The composition of *Joan of Arc* is very close to that of *Diana* (cat. 12), with sheep substituting for cattails and a shepherdess for a goddess. *Joan of Arc* entered E. B. Greenshields's collection in 1889, through Ryder's dealer Cottier, who had several clients in Montreal. Ryder wrote a poem for *Joan of Arc,* choosing the moment she recognizes her destiny (see Appendix A).

Cat. 23b. X-ray of *Joan of Arc.*

In subject Ryder may have been inspired by Bastien-Lepage's *Joan of Arc* (cat. 23a), shown at the fourth Society of American Artists exhibition of 1882 in New York. J. Alden Weir, a friend of Bastien-Lepage's, had arranged for the painting to come to New York and Boston, where it attracted enormous attention. Hailed as a modern masterwork, *Joan of Arc* was purchased by Erwin Davis and given to the Metropolitan Museum in 1889.

Ryder's *Joan of Arc* has layers of varnish or glaze atop thinly applied paint, adding depth and resonance to Joan's clothing and dog. Thin lines of umber create the contours and folds of her dress. The dog's tongue and Joan's face and outstretched hand appear to have been retouched. Her feet are outlined in red, recalling the similar treatment of the horse's face in *King Cophetua and the Beggar Maid* (cat. 25). An X-ray (cat. 23b) shows no major changes in the composition but reveals Ryder's use of lead-based paint to establish forms.

ELJ

Provenance: purchased by E. B. Greenshields, Montreal, Canada, from Ryder through Daniel Cottier, 1889; W. Scott & Sons, Montreal, after 1906; Vose Galleries, Boston, 15 November 1915; Theodore T. Ellis, Worcester, Massachusetts, 2 August 1918; bequest of Theodore T. and Mary G. Ellis to Worcester Museum of Art, 1940.

24 *Jonah*

canvas mounted on fiberboard; 27¼ x 34⅜ in. (69.2 x 87.3 cm)
National Museum of American Art, Smithsonian Institution, Washington, D.C., gift of John Gellatly, 1929.6.99
See also figures 105–6, 109

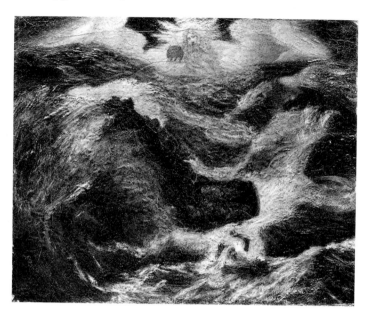

Cat. 24. Photograph from the 1918 memorial exhibition, the Metropolitan Museum of Art, New York.

No other work in Ryder's oeuvre has received more praise or inspired more competition for ownership than *Jonah*. Celebrated by critics as the "only original biblical composition produced since the Italian Renaissance,"[1] this picture marked an important shift in Ryder's art, uniting his favorite themes of damnation and redemption with his love for the sea. The result is a marine painting endowed with great breadth of meaning and historical parallels, in keeping with the demands of the American art market that, at late century, was increasingly attuned to biblical themes.

The painting underwent several permutations before the artist believed that he could "make it felt as true."[2] A useful account of *Jonah*'s evolution comes from the memoirs of Elbridge Kingsley, who engraved the picture for *Century*

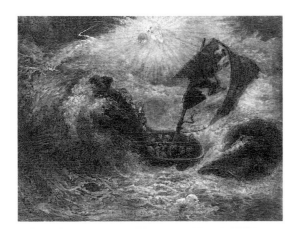

Cat. 24a. Elbridge Kingsley, wood engraving after Ryder, *Jonah*. National Museum of American Art, Smithsonian Institution, Washington, D.C., gift of Leonard Baskin, 1969.26.1.

Magazine in 1890 (cat. 24a) while Ryder was working out the composition. He recalled, "The phases and the changes that this painting went through during my intimacy with the artist were a little short of marvelous. The main points of interest would move all over the canvas, according as the stimulating influences of the color accidents would appeal to Ryder's imagination at the moment."[3]

Kingsley's engraving shows a different arrangement of elements: God's presence is more overwhelming, with a radiant aureole bathing the scene with light; a bolt of lightning strikes from his left; and the boat has a tattered sail. Offsetting these dramatic elements, Jonah seems unaware of the great fish, almost adjacent to the bow of the boat. This version of the painting recalls the imagery in Melville's description of the final confrontation between Captain Ahab and the great white whale in *Moby-Dick,* a novel laden with references to the story of Jonah: "Half smothered in the foam of the whale's insolent tail, and too much of a cripple to swim, [Ahab] thought he could still keep afloat, even in the heart of such a whirlpool as that; helpless Ahab's head was seen, like a tossed bubble which the least chance shock might burst."[4]

An autoradiograph (cat. 24b) reveals some of the elements of the composition as they appear in the engraving, most notably the luminous beams emanating from God. Another autoradiograph (see fig. 109), which records the presence of manganese, a primary component of umber paints, shows the free and forceful brushwork Ryder used to block in his composition before refining the image. The most surprising discovery in this autoradiograph, however, is the presence of a woman's portrait underlying the composition, oriented vertically, her head at left center.

Jonah was already in progress in 1885, when Ryder offered the painting to Thomas B. Clarke.[5] Clarke did not buy the picture, although many have assumed that he did so based on this letter. *Jonah*'s first owner was Richard Haines Halsted, who lent it to the New York Athletic Club for an exhibition in 1890; Halsted was a New York stockbroker whose collection of mostly European paintings reflected the vogue for particular artists and subjects at this time.[6]

Ryder reworked the painting sometime before 1895, when it was acquired by C. E. S. Wood of Portland, Oregon.[7] In 1918, around the time of Ryder's memorial exhibition at the Metropolitan Museum of Art, John Gellatly asked Wood to sell him the painting (see here "Later Critics, New

Cat. 24b. Autoradiograph of *Jonah*. Conservation Analytical Lab, Smithsonian Institution, Washington, D.C.

Patrons"). By late 1919 Gellatly prevailed, but Wood demanded the enormous sum of twenty-two thousand dollars and lectured Gellatly: "Don't you think you are a bit greedy to want *all* the good things or do you proceed by the scripture to him that hath much shall be given? However, I do appreciate your desire to assemble under one roof a commanding group of a Master's masterpieces."[8]

The Old Testament account of Jonah was often used as an analogy for the death and resurrection of Christ in early Christian art, appearing on sarcophagi and in early frescoes. As Ryder's painting postdates his 1882 European tour, he may have been influenced by such works, thus accounting for the sudden appearance of a rare Old Testament subject in American painting. A native precedent exists, however, in La Farge's murals in Trinity Church, completed in 1877, which include a *Jonah* subject in the tower's south wall. The pose of Ryder's Jonah in Kingsley's engraving corresponds to that in La Farge's painting, although La Farge represents the moment when Jonah is thrown up onto land.

The general typology of Ryder's *Jonah* descends from the image of the storm-tossed boat found throughout European paintings from the seventeenth through the nineteenth centuries, which were collected in great number by American patrons in the nineteenth century. Hartmann remarked on the overall importance for Ryder's art of Delacroix's *Christ on Lake Gennesaret* (see fig. 107).[9] At least nine variations of the composition were painted by Delacroix in two principal conceptions: one showing a masted boat with a wind-blown sail and the other showing a mastless boat.[10]

The clouds surrounding God in *Jonah* resemble wings embracing the scene, a motif frequently found in Blake's art. Representations of God in heaven presiding over earthly events are, however, a convention in Western art dating at least to medieval manuscript illuminations.

In 1965 Sheldon and Caroline Keck relined and cleaned the painting, noting that the original support was inscribed: "Prepared by / Edgar Dechaux / New York" and "P / Yonkers." Numerous traction cracks were filled and inpainted and the painting was varnished. In commenting on the inherent instability of the paint film they wrote: "It is doubtful that the structure of the painting will ever dry completely in its depth."[11] Nonetheless, *Jonah* retains many of the qualities of tone and rich color that led early critics to praise Ryder's art as being like precious gems, lacquers, or enamels.

MJWD

Provenance: to Richard Haines Halsted, New York, by 1890; C. E. S. Wood, Portland, Oregon, from Cottier & Co., valued at $3,500, by 1895; purchased for $22,000 by John Gellatly, New York, from Wood, 22 November 1919; gift of Gellatly to National Museum of American Art, Washington, D.C., 1929.

Notes
1. Sherman, *Ryder*, 81.
2. "It's very inspiring to paint a Jonah and make it felt as true: It probably is the reason 'Sah' it is going to you" (Ryder to Wood, 10 January 1895, Wood Papers, Huntington Library).
3. Autobiography, 184, Kingsley Papers, Archives of American Art.
4. Herman Melville, *Moby-Dick, or, The Whale* (1851; reprint, Boston: Houghton Mifflin, 1956), 636.
5. Ryder to Clarke, 9 April [1885], Detroit Artists Association Records, Archives of American Art.
6. A review of this exhibition dwells on *Jonah*, comparing Ryder to Delacroix, Rembrandt, and other European masters. The exhibition of *Jonah* is called "the greatest art event of the year 1889 so far as our native workmen are concerned" (*New York Times*, 2 March 1890, 12). I am grateful to George Gurney for bringing this review to my attention.
 "Mr. Halsted has no very definite taste in paintings, his object being to all appearance the getting together of a little of everything in the way of French and German work, and some examples of American" ("The Halsted Pictures," *New York Times*, 31 December 1886, 5).
7. "My Dear Col. Wood, Inglis has informed me of your desire for the Jonah and your generous interest for the fulfillment of his equally generous thought for me.
 "I am greatly pleased with the fact of the picture becoming yours: it never had a better friend and am most anxious it should retain its charm after possession" (Ryder to Wood, 10 January 1895, Wood Papers, Huntington Library).
8. Copy of Wood to Gellatly, 15 October 1919, Wood Papers, Huntington Library.

9. Hartmann, "An American Painter," 5, Hartmann Papers, University of California Library.

10. One of Ryder's patrons, Sir William Van Horne of Montreal, Canada, owned a Delacroix of the first type, while one of the other type was in the collection of William Ladd of Portland, Oregon, who lent it to the Armory Show in 1913. He probably acquired the canvas through his friend Wood, who acted as an agent for Cottier & Co. on the West Coast. Still another mastless version was owned by H. O. Havemeyer, a prominent New Yorker, who bequeathed the painting to the Metropolitan Museum in 1929 (see fig. 107). Both versions were certainly known to Ryder and compare to early and late stages of *Jonah*.

An article by John Walsh, "Rembrandt's Christ in the Storm on the Sea of Galilee" (*Annual Report,* Isabella Stewart Gardner Museum, Boston, 1986), points to the "zig-zag diagonals of the hull, mast and yard, and the upward spiral of the sail and loose rigging," all found in the early version of *Jonah,* as common pictorial conventions for both Italian and Flemish painting in the seventeenth century.

11. Treatment report, December 1965, Conservation Lab Files, National Museum of American Art.

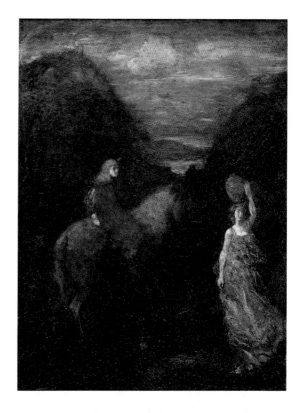

25 *King Cophetua and the Beggar Maid*

canvas mounted on fiberboard; 24½ x 18 in.
(62.2 x 45.7 cm)
National Museum of American Art, Smithsonian
Institution, Washington, D.C., gift of
John Gellatly, 1929.6.99.
See also figure 82

Although it is not known when John Gellatly commissioned *King Cophetua and the Beggar Maid,* by August 1900 he was pressuring Ryder to complete the work.[1] It remained unfinished, however, for more than five years. Charles Fitzpatrick recounts Gellatly's active interest in Ryder's progress throughout this period:

It worried him [Ryder] a great deal. Gellatly would come now about twice a year without any thought of hurrying him, but he liked the picture and naturally longed for possession of it. He had a frame made to order that stood around the room for a few years. How it escaped being broken is a mystery, but Ryder didn't like commissions from anybody.[2]

Ryder wrote to Gellatly in August 1905, attributing his slowness to trouble with his eyes.[3]

The subject for *King Cophetua and the Beggar Maid* derives from an Elizabethan ballad of love between a man and a woman of different classes, included in Thomas Percy's *Reliques of Ancient English Poetry* (1765). Percy printed the ballad from Richard Johnson's "Crown Garland of Goulden Roses" (1612), where it was entitled "A Song of a Beggar and a King." The story describes Cophetua, the king of Africa, who had foresworn women but was so taken by the beauty of a young beggar maid that he married her despite her poverty. Shakespeare alluded to the ballad in *Love's Labour's Lost, Richard III,* and *Romeo and Juliet,* and Tennyson wrote a version called "The Beggar Maid."[4]

King Cophetua and the Beggar Maid was a popular motif in Daniel Cottier's circle. Several stained-glass pieces depicting this subject, probably designed by Matthijs Maris, were auctioned from the gallery's stock in 1913.[5] Cophetua's beggar maid was one of several literary heroines pictured on decorative glass objects by Cottier's artists; others included Calypso, Helen, and Miranda.

The British Pre-Raphaelite Edward Burne-Jones painted *King Cophetua and the Beggar Maid* in about 1861 and again in 1884 (cat. 25a). A central figure in the aesthetic movement, Burne-Jones celebrated the supremacy of beauty over material wealth and temporal authority. Whereas he depicted the king removing his crown, the symbol of his earthly power, Ryder represented a more romantic moment in the tale—the king's first bewitching encounter with the maid.

An X-ray (cat. 25b) indicates the presence of another subject beneath Ryder's painting—a cow, clearly defined in lead white, behind and to the left of the woman. A second underlying image, of a standing reddish horse in a landscape with green grass and blue sky (cat. 25c), was revealed in 1967 when the original support was removed and the ground thinned during the process of transferring the painting to a new support.[6] This horse is oriented horizontally on the canvas, filling the pictorial space; the image also shows in autoradiographs and the X-ray of the painting.

Insofar as *King Cophetua and the Beggar Maid* once included a charming peasant girl with a

Cat. 25a. Edward Burne-Jones, *King Cophetua and the Beggar Maid,* 1884, oil on canvas. The Tate Gallery, London, 01771.

Cat. 25b. X-ray of *King Cophetua and the Beggar Maid.*

Cat. 25c. Image revealed through ground of *King Cophetua and the Beggar Maid* after removal of support.

cow and illustrated a ballad published in Percy's *Reliques*, it parallels Ryder's small *Perrette* (cat. 50).

Perhaps wishing to emulate Rembrandt's warm tones, Ryder used an unstable substance that has darkened the image, which was noted as early as 1918.[7] Figures painted thinly on the surface such as the woman, horse, and dog have been almost entirely obscured. A reddish paint lying on the uppermost layer defines the head of the horse, perhaps an attempt by Ryder or an early restorer to recover faded elements in the work.

King Cophetua and the Beggar Maid apparently underwent little restoration before the 1967 treatment. At that time, the painting was described as having an opaque, mustard-colored substance oozing from surface cracks. In the right and left sides of the background and on the figure of the beggar maid, cracks were as wide as one inch across. The painting was cleaned and transferred and the cracks filled.

SLB

Provenance: commissioned by John Gellatly, New York, before April 1900; purchased for $1,000 by Gellatly through Cottier & Co., New York, 1906–7; gift of Gellatly to National Museum of American Art, Washington, D.C., 1929.

Notes

1. Ryder to Sylvia Warner, 3 August 1900, Warner Family Papers, Archives of American Art.

2. Charles Fitzpatrick, quoted in Taylor, "Ryder Remembered," 3–16, 40.

3. Gellatly Vertical File, National Museum of American Art Library.

4. Shakespeare's *Othello*, from which Ryder took the subject of Desdemona, treats a Moorish king's love for a European maiden (see also *Constance* [cat. 7]).

5. *Illustrated Catalogue of the Artistic Property, Fine Antique and Modern Furniture, Important Flemish Tapestries, Stained Glass, Textiles, and Other Objects of Household Utility and Embellishment of the Well-known House of Cottier and Company of New York*, auction cat. (New York: American Art Association, 1913), nos. 774, 876.

6. Treatment report, October 1967, Conservation Lab Files, National Museum of American Art.

7. An annotated copy of the catalogue of the 1918 Ryder memorial exhibition mentions the dark tonality of the painting (curatorial files, Carnegie Museum of Art, Pittsburgh).

26 Landscape

canvas or paperboard; 9½ x 14 in.
(24.1 x 35.6 cm)
The Metropolitan Museum of Art, New York,
gift of Frederick Kuhne, 52.199

Landscape is densely painted with strong tonal contrasts and local color quite different from other Ryder canvases with their paradigmatic accumulations of layered glazes. It was executed in 1897–98 as a commission for Marian Y. Bloodgood.[1] In a letter to Sylvia Warner in October 1897 Ryder wrote, "My work is going tolerably well and your request to see it is not unheeded, nor Miss Bloodgood's commission."[2] Two letters in 1898 from Ryder to Bloodgood document progress on the painting, one discussing a frame for it, and the other two weeks later reporting: "I came very near finishing the picture to day; I

think I have the little figures capital. It might be my luck to get the quality I am after tomorrow, if so I will bring it up to you tomorrow evening; if not I will take the liberty of calling, to tell you the why and wherefore."[3]

Despite the relatively short time Ryder took to paint this landscape, an X-ray reveals a vague image of horses pulling a cart, their scale too large to have been part of the current setting, which was later painted out. Examinations have not revealed whether the support for this painting is canvas or heavy paperboard.[4] The paint surface has suffered, developing deep cracks and a yellowed appearance.

The painting's unusual appearance prompted Frank Jewett Mather, Jr., to call it "Ryder's greatest landscape," describing its strong affinities with the works of Samuel Palmer, whose eerie, moonlit scenes place him in close company with Blake and John Crome.[5] *Landscape* may once have been quite different, however; an engraving of a Ryder landscape (cat. 26a) was published in 1890—almost ten years before the completion of the Bloodgood commission—showing a nearly identical composition, suggesting that Ryder repainted an earlier canvas, which he did increasingly by the late 1890s. The engraving presents a more naturalistic view, with a few alterations.[6] The scalloped edges of the hedgerow, nearly symmetrical cloud banks, and rows of rocks (sheep?) in the left foreground all suggest a deliberately simplified vision.

ELJ

Provenance: commissioned by Marian Y. Bloodgood, New York, 1898; inherited by Frederick Kuhne (Bloodgood's nephew) with the stipulation that it be given to the Metropolitan Museum of Art, New York; gift of Kuhne to the Metropolitan Museum of Art, 1952.

Notes
1. Marian Y. Bloodgood probably met Ryder through her friend Sylvia Warner, wife of sculptor Olin Warner (Ryder to Sylvia Warner, 21 June 1897, Warner Family Papers, Archives of American Art). Ryder, the Warners, "Minnie" Bloodgood, and other artists from "the original sketch class" vacationed in Point Pleasant, New Jersey, during the summer of 1898.

2. Ryder to Sylvia Warner, 12 October 1897, Warner Family Papers, Archives of American Art.

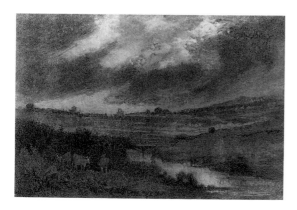

Cat. 26a. Elbridge Kingsley, wood engraving after Ryder, untitled. National Museum of American Art, Smithsonian Institution, Washington, D.C., gift of Leonard Baskin, 1969.26.5.

3. Ryder to Bloodgood, 1 March 1898, the Metropolitan Museum of Art Archives (quoted in Bolger-Burke, *American Paintings in the Metropolitan,* 3:26). Ryder to Bloodgood, 17 March 1898, Sherman scrapbook, Force Papers, Archives of American Art.

4. Bolger-Burke, *American Paintings in the Metropolitan,* 3:27.

5. Mather, *Estimates in Art,* 177–80.

6. The caption for the wood engraving reads: "Landscape, Late Afternoon. / Owned by James S. Inglis" (de Kay, "Modern Colorist," 255). The print shows an arched bridge at center and two cows in the left foreground accompanied by a herdsman. There are none of the white rocks (sheep?) that appear in the painting; also, in *Landscape* Ryder substituted a man leaning on a crutch for the herdsman in the print.

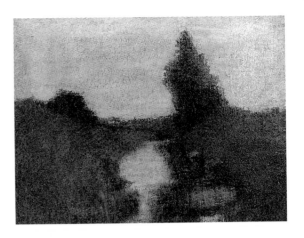

27 *Landscape*

canvas; 9 x 13 in. (22.9 x 33 cm)
Collection of Rita and Daniel Fraad
See also figure 23

Ryder presents a landscape of soft contours and partially resolved forms, emphasizing two-dimensional design. A canal winds into the foreground, linking the image to others in his oeuvre (cat. 5) and to canal scenes by members of the Hague school. Two half-articulated, blocky forms rest on the right bank, their dark shadows balancing the reflected light on the open water, which in turn echoes the shape of the tall tree. Its fresh approach must have appealed to its first owner, Wood, whose discerning eye and artistic taste found much to admire in Ryder's works.

In this early work Ryder had already begun to experiment with the painting process. The coarse canvas weave is seen prominently at the edges of the forms, which take shape from surrounding passages of thicker paint. In places the canvas looks unprimed, so that the colors appear almost as stains. Glazing is sporadic; the overall effect is one of forms dissolving into areas of light and shadow.

ELJ

Provenance: C. E. S. Wood, Portland, Oregon, and Los Gatos, California; Mrs. Kirkham Smith (Wood's daughter), San Rafael, California; Maynard Walker Galleries, New York; Babcock Galleries, New York, 1955; Fraad collection.

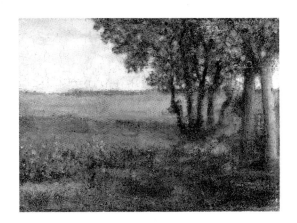

28 *Landscape with Trees*

panel, cradled; 9 x 12 in. (22.9 x 30.5 cm)
Private collection
See also figure 31

The pictorial elements of *Landscape with Trees* are reduced to a minimum—a pair of sturdy trees in the foreground, a stand of graceful saplings in the middle distance. This diagonal axis leads to an open field of greens and grays, animated by touches of the brush. Light floods in from the right, giving solidity to the thick, round trunks and casting long shadows across the sward. Ryder left the canvas weave visible and details vague—the trees, for instance, seem suspended rather than rooted in the ground. It must have been a landscape similar to this that led a critic to call Ryder's work "coarsely finished" when first shown at the National Academy.[1]

According to a label on the verso of the panel, *Landscape with Trees* was once owned by George de Forest Brush, who had been a colleague of Ryder's at the National Academy. While a student, Ryder gave or sold many works to his fellow artists; they saw in such small panels the beginning of a new aesthetic.

The painting is signed and dated at lower right, but the date cannot be securely read.

ELJ

Provenance: George de Forest Brush, New York; Reverend Louis Van Ess; purchased by Alastair Bradley Martin, New York, from E. & A. Milch, Inc., New York, 27 April 1966; private collection.

Note
1. *New York World*, 15 April 1873.

29 *Little Maid of Acadie (Little Maid of Arcady; Flora)*

panel; 9¹⁵⁄₁₆ x 4¾ in. (25 x 11.6 cm)
Collection of Mr. and Mrs. Daniel W. Dietrich II
See also figure 73

This painting, exhibited as *Little Maid of Acadie* in 1897, 1898, and 1899, is related to Longfellow's "Evangeline: A Tale of Acadie" (1847), a romanticized tale about the peaceful and prosperous farmers of Acadia (today's Nova Scotia), who were forced by the British in 1755 to leave their land for new settlements, dividing many families. Evangeline, a bride, is separated from her husband and spends many years searching for him through wild and desolate areas of the North American continent, finding him only when he is at the brink of death. Evangeline parallels other heroines portrayed by Ryder; she is virtuous, lives close to nature, and is made to suffer in love through no misdeed of her own.

"Evangeline" was immensely popular in America, for its dramatic action is set in the New World. Painters like Joseph Rusling Meeker used the subject as an occasion to depict wilderness landscape in *The Acadians in the Achafalaya, "Evangeline,"* 1871 (The Brooklyn Museum). F. O. C. Darley lavishly illustrated an 1883 edition of the poem, presenting the scenes with a wealth of genre detail and pathos.[1] Ryder's version was shown at the National Academy in 1886, suggesting that he capitalized on the popularity of the theme. He presented Evangeline as a young bride with flowers in her hair but wearing a poignant expression. In format *Little Maid of Acadie* resembles *A Country Girl, Passing Song,* and *Perrette* (cat. 8, 44, 50).

In recent years the title has usually been given as either *Flora* or *Little Maid of Arcady,* recasting the heroine as a shepherdess and linking the theme to Ryder's idyllic pastorals. With her flowers and unhappy gaze, the figure also resembles conventional illustrations of Ophelia (cat. 29a–b).

ELJ

Provenance: Herbert Ryston, 1886; William T. Evans, New York, by 1897; purchased for $200 by Frank L. Babbott, Brooklyn, from William T. Evans Collection Sale, American Art Association, Chickering Hall, New York, no. 62, 31 January–2 February 1900; consigned to Macbeth Gallery, New York, 4 April 1934 (as *Flora*); purchased for $660 by S. C. Clark, November 1934; consigned to Macbeth Gallery, 1 February 1937 (as *Flora*); purchased for $950 by Elisabeth W. (Mrs. George A.) Ball, 4 February 1937; purchased by Dr. and Mrs. Irving Levitt, Southfield, Michigan, 1960; purchased by Mr. and Mrs. Daniel W. Dietrich II through Wunderlich Galleries, New York.

Note
1. *Longfellow's Evangeline with Illustrations by F. O. C. Darley* (Boston: Houghton, Mifflin, 1883).

Cat. 29a–b. Plates representing Ophelia (from Sadakichi Hartmann, *Shakespeare in Art* [1901]).

30 *The Lone Horseman*

composition board; 7¹⁵⁄₁₆ x 14½ in.
(20.2 x 36.8 cm)
Guennol Collection

Cat. 30a. Jacob Maris, *The Tow Path,* oil on canvas.
Haags Gemeentemuseum, The Hague, 28.1968.

Ryder's lone horseman quietly follows two cows along a dimly visible path. In mood *The Lone Horseman* resembles Jacob Maris's *Tow Path* (cat. 30a), one of many paintings on a very popular theme. Twilight pastorales recur in Ryder's art, including *The Curfew Hour* (see fig. 118) and *Plodding Homeward* (cat. 30b).

The tree forms have an ethereal quality similar to those found in both *Dancing Dryads* and *The Equestrian* (cat. 10, 13), their trunks painted thinly enough to allow the horizon to show through. According to Goodrich, the trees in *The Lone Horseman* are not apparent in the X-ray; the horseman appears in the X-ray as somewhat amorphous, suggesting that Ryder altered the silhouette several times, building his form with multiple layers.[1] Although *The Lone Horseman* cannot be traced before its ownership by Mrs. Hugh H. Baxter, her family recalls that the painting belonged to her for many years; and the painting's surface and X-ray confirm a structure and method clearly consistent with Ryder's hand.[2]

ELJ

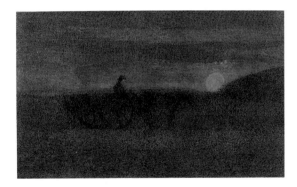

Cat. 30b. Elbridge Kingsley, wood engraving after Ryder, *Plodding Homeward.* National Museum of American Art, Smithsonian Institution, Washington, D.C., gift of Leonard Baskin, 1969.26.8.

Provenance: Mrs. Hugh H. Baxter, New Rochelle, New York, before 1954; purchased by E. & A. Milch & Co., New York, from Baxter Estate Sale, Knoll House, New Rochelle, no. 510, 5–6 October 1954; purchased for Guennol collection, 10 March 1956.

Notes
1. Goodrich notes, Guennol collection.
2. Ibid.

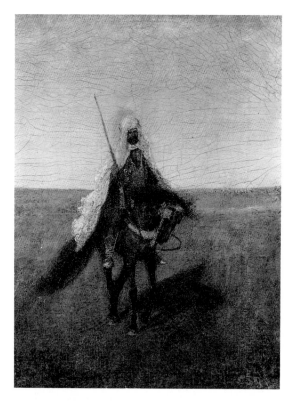

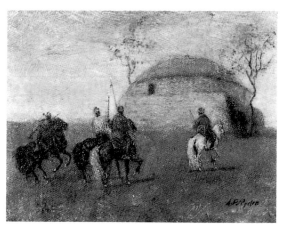

Cat. 31a. *The Mosque in the Desert*. Lyman Allyn Museum, New London, Connecticut, bequest of Miss Alice S. Bishop, 1959.77.

31 *The Lone Scout*

canvas; 12 x 9¼ in. (30.5 x 23 cm)
The Fine Arts Museums of San Francisco, De Young Museum, gift of Mr. and Mrs. John D. Rockefeller III, 1979.7.88
See also figure 19

One of the "oriental" works that Ryder painted during the late 1870s and early 1880s, *The Lone Scout* is a not too distant relation to *The Mosque in the Desert* (cat. 31a). Its subject suggests a work mentioned by de Kay in 1890:

Some years ago, when Mr. Ryder had but lately graduated from the schools of the Academy, he was passing through the street with a little panel in his hand. Suddenly a man stopped him. He was clad in a long Oriental gown, slippers on his feet, a fez on the back of his head. Apologizing in very fair English, he asked the young artist if the picture he had in his hand was not Persian. Very much surprised, Mr. Ryder handed it to him. The Persian examined it with great interest and explained that the color and drawing—it showed a horse and rider—was extraordinarily like those in pictures among his countrymen.[1]

The Lone Scout is richly colored and detailed, with the gear of the horse and the rider's accou-

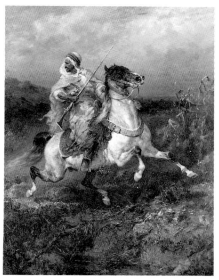

Cat. 31b. Adolf Schreyer, *Arab Warrior*, oil on canvas. Milwaukee Art Museum, gift of the Rene von Schleinitz Foundation, M1962.36.

terments and physical features described with unusual specificity. Of special note is the intricate rendering of the carbine rifle and lacing and stitching of the Arab's boots. The radical foreshortening of the horse, carefully drawn shadow on the ground, and way in which the horse's legs represent motion suggest that Ryder may have worked from a photograph. Tiffany, whose work Ryder collected, brought many photographs back from his trip to the Near East in about 1869.

Beginning around the mid-1870s, Cottier & Co. handled the work of several orientalist painters, including Delacroix, Monticelli, and Schreyer. Ryder's painting bears comparison with works by Schreyer from this period, such as *Arab Warrior* (cat. 31b), one example among many similar representations from the nineteenth century, although Schreyer's portrayal of Arabs is more aggressive and dramatic.

Pentimenti around the head of the rider in *The Lone Scout* reveal that his pose was adjusted. Remnants of varnish can be seen in low areas of the paint surface, indicating that the painting has been cleaned. Overall, it is in good condition.

MJWD

Provenance: Whitman W. Kenyon, Smithtown, New York; purchased for $150 by "R.T." from Whitman W. Kenyon Estate Sale, Anderson Galleries, New York, no. 45, 14–15 December 1926; Babcock Galleries, New York, by 1947; T. Edward Hanley, Bradford, Pennsylvania, by 1959; Robert M. Light before May 1967; Vose Galleries, Boston, May 1967; purchased by John D. Rockefeller III, 1967; gift of Mr. and Mrs. John D. Rockefeller III to Fine Arts Museum, San Francisco, 1979.

Note
1. De Kay, "Modern Colorist," 255. This anecdote is obviously a device to suggest that Ryder's painting is as "oriental" as the "real" Orient, but de Kay's comments are also symptomatic of characterizations of non-white cultures in America during the nineteenth-century (see Said, *Orientalism*).

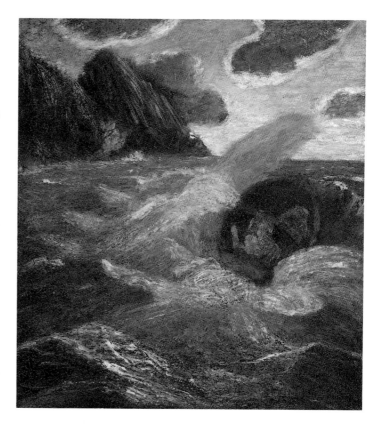

32 Lord Ullin's Daughter (The Sea)

canvas mounted on panel; 20½ x 18⅜ in. (51.2 x 45.8 cm)
National Museum of American Art, Smithsonian Institution, Washington, D.C., gift of John Gellatly, 1929.6.101
See also figure 64

Like *Toilers of the Sea* (cat. 69), this painting shows lovers eloping by boat under a moonlit sky. Gellatly was first to cite a literary reference, linking the painting—exhibited during Ryder's lifetime as *The Sea*—to Thomas Campbell's "Lord Ullin's Daughter." He may have had firsthand knowledge of Ryder's source; in any case, Ryder knew the poem, for he used an illustration of it by Turner as the basis for another composition, *The Lorelei* (cat. 33).

Campbell's poem, set in the Minch, between the Scottish mainland and the Isle of Mull, tells how a chieftain fled with his lady through a stormy sea, trying to escape her wrathful father, but was overcome by waves and drowned. Although the figures in the boat can be only vaguely perceived, autoradiographs (cat. 32a)

Cat. 32a. Autoradiograph of *Lord Ullin's Daughter*. Conservation Analytical Lab, Smithsonian Institution, Washington, D.C.

33 *The Lorelei*

canvas; 22½ x 19¼ in. (57.2 x 48.9 cm)
Guennol Collection
See also figure 77

reveal that one figure is falling backward with his legs flying up and his arms out, knocked off his seat by the wave at left crashing against the boat. In one of his most dramatic compositions Ryder continues the sense of "balance lost" through zigzag rhythms of waves, rocks, and clouds, carrying the eye rapidly to the top of the frame and out of the image.

With its theme of the lovers' journey, Scottish origins, and moonlit marine tempest, *Lord Ullin's Daughter* is a quintessential Ryder theme, lending credence to Gellatly's identification.

EB

Provenance: Cottier & Co., New York; purchased for $500 by John Gellatly, New York, by 1906–7; gift of Gellatly to National Museum of American Art, Washington, D.C., 1929.

Charles Fitzpatrick said that Ryder labored more over his painting of *The Lorelei* than any other work.[1] From the mid-1890s until his death in 1917, this subject haunted the artist, compelling him to strive for the perfect representation of his inner vision. Although he pronounced the painting "finished" in 1896, he continued to rework *The Lorelei* throughout his lifetime.[2]

According to German legend, the Lorelei was an evil seductress, similar to the Greek siren, who lived atop a high rock along the treacherous narrows of the Rhine. With her music, she enchanted passing sailors, who, in striving to reach her, became oblivious to the waters that engulfed them and were sucked below to their deaths.

Heine popularized the Lorelei theme during the mid-nineteenth century with his poem, "Ich weiss nicht was soll es bedeuten." The imagery in Ryder's painting is related to the second and third stanzas of the poem:

The last peak rosily gleaming
Reveals, enthroned in air,

A maiden, lost in dreaming,
Who combs her golden hair.

Combing her hair with a golden
Comb in her rocky bower,
She sings the tune of an olden
Song that has magical power.[3]

Ryder may have been introduced to the work of
Heine through de Kay, who translated Heine's
family letters.[4] Heine's "Lorelei" was translated
and widely published in America and was put to
music by many including Liszt, Mendelssohn,
Schubert, and Schumann. Franz Silcher com-
posed the most popular melody for the verse. It
is quite possible that Ryder was familiar with
Silcher's song, for friends often heard him "sing-
ing the song of Lorelei" while working on the
painting during his night sessions.[5]

The painting was originally intended for Helen
Ladd Corbett, daughter of Portland banker Wil-
liam Ladd and close friend of Wood's. Mrs. Cor-
bett paid Ryder three hundred dollars for *The
Lorelei* but never received it.[6] Ryder's letters re-
garding progress on the painting were directed to
"Brother Wood," who served as intermediary.
Wood periodically urged Ryder to complete the
work, assuring him in November 1902 that "Mrs.
Corbett would gladly save you from cooking or
washing to get the *Lorelei*."[7] After Ryder's death
J. Alden Weir apparently felt that the painting
should have gone to Mrs. Corbett; it went, how-
ever, to Wood instead and remained with the
Wood family until 1957.[8]

The principal cause of Ryder's "fretting and
stewing" was the position of the female figure on
the jagged rock.[9] Ryder's composition resembles
an illustration by Turner for Thomas Campbell's
poem, "Lord Ullin's Daughter" (cat. 33a).[10] Ryder
placed the siren in the general vicinity of Turn-
er's agents of evil, the king and his men; yet he
resituated her on the rock countless times ac-
cording to his whim. On 2 October 1899 Ryder
wrote to Wood, "It was not till this day that I
felt the witching maiden was placed where she
should be."[11] Hartmann's account highlights the
evolution he witnessed over a fifteen-year period:
"How often she has changed since I first became
acquainted with her! She is going through a

Cat. 33a. Robert Wallis, engraving after J. M. W.
Turner, illustration for "Lord Ullin's Daughter" (from
The Poetical Works of Thomas Campbell [1837];
courtesy of Dorinda Evans, Emory University,
Atlanta).

whole cycle of evolution. Now large, now small,
now emerging from the rock, now sinking back
into it, almost vanishing at times, coming forth
again, changing her position, drapery, expres-
sion, color of her hair, a hundred times."[12]

Ryder had "difficult problems" with the piece
from a technical standpoint, most notably in
1898 and 1901. By 1903 he said he had adopted
a treatment for the work.[13] Exactly what this
treatment involved is unknown, but several
friends believed his obsessive reworkings and
unconventional methods resulted in the destruc-
tion of his most powerful images of the Lorelei.
Charles Fitzpatrick said,

He would get it up to what anyone would call fin-
ished, lay it aside and the next time you saw it, it
would be all out, and maybe rubbed down. If we
heard a rasping sound on the floor (and it was always
at night) we knew he was rubbing down the Lorelei.
. . . The picture was finished three times, but he
would not let it go. It was a strange weird moonlight,
and when it was at its best and looked as though he

called it finished, it looked as though it was painted by a man with strange subconscious power.[14]

Louise Fitzpatrick recalled "the last supreme efforts of Ryder's agony when he created . . . a 'little world in itself' ": "I begged him to leave it so. But alas, in the making of the picture, the varnish, the oils, the wax, the heat, and his fear that it would not dry made him dig into it, and then the work of undoing started and it was put aside. He could no longer stand the strain of even speaking about it."[15] Hartmann expressed frustration over Ryder's quest for "hair-splitting perfection" in *The Lorelei,* saying, "Thus Ryder spoils a year's work by the brush daub of a moment."[16]

When the painting passed through Macbeth Gallery in February 1918, Macbeth described it to Wood as "in exceedingly bad condition, . . . lack[ing] the color quality which most collectors of his pictures look for in Ryder's work."[17] Accordingly, Wood had *The Lorelei* sent to Louise Fitzpatrick, requesting that she restore it.[18] In April 1918 she described her restoration:

When it was returned to me I could see that a great deal of the picture had been brought back, but, ah, the "little world of its own" was not there. Just a few touches on the "Lorelei" and on the man in the boat would have brought it back. I carefully made out the form of the "Lorelei" and the man and boat and a few lights on the water right below the rock near the boat in watercolor for safety sake.[19]

Fitzpatrick claimed she removed her retouches when admonished by Weir, who said that he pronounced all restored or retouched Ryders to be fakes.[20] Apparently, Fitzpatrick thereafter returned the work to Wood as she had received it.

In its current state the glazes Ryder used to demarcate the woman's figure have faded to the extent that the "witching maiden" has vanished from the rocks and the surface of the painting has cracked. The work was conserved most recently by Sheldon and Caroline Keck in July 1976.

SLB

Provenance: paid for ($300) by Helen Ladd Corbett, Portland, Oregon, before 1917; in Ryder's studio, March 1917; C. E. S. Wood, Portland, by 1947; purchased by Maynard Walker Galleries, New York, from Wood, 1957; Guennol collection by 1959.

Notes
1. Charles Fitzpatrick, quoted in Taylor, "Ryder Remembered," 3–16, 40.

2. Ryder to Weir, 1896, Weir Papers, Archives of American Art.

3. Lewis Untermeyer, *Poems of Heinrich Heine,* illustrated by Fritz Kridel (New York: Heritage, 1957), 85–86.

4. "Charles de Kay Dies: Novelist, Poet, and Critic," *Herald Tribune,* 23 May 1935. De Kay received his early schooling in Dresden, and in 1894 President Grover Cleveland appointed him general consul to Berlin. His ties to Germany may help explain Ryder's interest in German subjects (see cat. 59).

5. Charles Fitzpatrick, quoted in Taylor, "Ryder Remembered," 5.

6. Louise Fitzpatrick to Wood, 1920, Wood Papers, Huntington Library.

7. Quoted in Young, *Life and Letters of Weir,* 215.

8. Charles Fitzpatrick to Wood, 1920, Wood Papers, Huntington Library. Fitzpatrick expresses Weir's displeasure: "I felt very sad to have hurt Weir's feelings as he had always been a dear . . . friend [to Ryder]. . . . He said, I suppose you have by this time found out that Ryder painted the 'Lorelei' for Mrs. Corbet [*sic*] that it was her who paid 300 Dollars to Ryder. I thought it had been done through you and that you had to make good the money to Mrs. Corbet to have the Lorelei for what she had done for Ryder, just as it was. . . . Only you and I are still left to do the right thing for [Ryder], so let us make him happy by turning the Lorelei over to the one he painted it for; he was truly trying his very best to please her with it some day."

9. Ryder to Warner, 3 April 1900, Warner Family Papers, Archives of American Art.

10. Dorinda Evans cites Diane Chalmers Johnson's observation of this resemblance in "Albert Pinkham Ryder's Use of Visual Sources," *Winterthur Portfolio* 21 (Spring 1986): 36–39.

11. Ryder to Wood, 2 October 1899 [not sent], Katherine Caldwell collection, Berkeley, Calif.

12. Hartmann, "An American Painter," 9, Hartmann Papers, University of California Library.

13. Inglis to Wood, 28 December 1898, Wood Papers, Huntington Library; and Ryder to Harold Bromhead, Cottier & Co., London, 2 August 1901 and 20 March 1903, Sherman scrapbook, Force Papers, Archives of American Art.

14. Charles Fitzpatrick, quoted in Taylor, "Ryder Remembered."

15. Louise Fitzpatrick to Wood, 17 April 1918, Wood Papers, Huntington Library.

16. Hartmann, "An American Painter," 10, Hartmann Papers, University of California Library.

17. Macbeth to Wood, 5 February 1918, Wood Papers, Huntington Library.

18. Wood to Fitzpatrick, 16 March 1918, Wood Papers, Huntington Library.

19. Louise Fitzpatrick to Wood, 17 April 1918, Wood Papers, Huntington Library.

20. Louise Fitzpatrick to Wood, 1918, Wood Papers, Huntington Library.

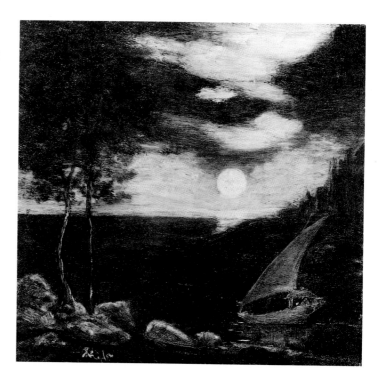

34 *The Lovers' Boat (Moonlight on the Waters; The Smugglers)*

panel; 11⅜ x 12 in. (28.9 x 30.5 cm)
Guennol Collection
See also figure 63

The Lovers' Boat was exhibited in the 1881 Society of American Artists exhibition, accompanied by Ryder's poem of the same name (see Appendix A). A full moon hangs near the horizon, illuminating the night clouds and casting a reflection on the distant water. Between a headland and the near shore a boat glides through a channel. The boat is under sail, its shadowy occupants beneath a canopy in the stern.

Ryder explored the theme of lovers meeting by moonlight in a number of his paintings. *The Lovers* (see fig. 62), linked to the poem "Saint Agnes' Eve" by Tennyson, shows a couple embracing under moonlight; *The Windmill* (cat. 75) sounds the same theme through its alternate title, *Honeymoon*; and *A Sentimental Journey* evokes similar romantic sensibilities (cat. 56). Ryder's poem underscores the role of the moonlight, creating "a scene grand and lovely" in which the

lovers' boat glides, "into the deeper shadows / of sky and land reflected."

In mood, color, and shape *The Lovers' Boat* calls to mind *The Culprit Fay* (cat. 9). Ryder used the square panel of warm, dark wood as part of his palette; the prevailing painted tones are russets and pale yellow. Like the vignette from *The Culprit Fay* of cranes flying in front of the moon, *The Lovers' Boat* has a delicate beauty accentuated by an air of romance. The boat is a variation of one in *Oriental Landscape* (see fig. 44), evoking a time long ago or far away. The tall, willowy trees framing the composition are a legacy of Corot, their delicately brushed foliage a common note in Ryder's work.

ELJ

Provenance: Mary Jane Morgan, New York; Reverend N. W. Conkling, New York, by 1890; purchased for $600 from Sarah B. Conkling Estate Sale, American Art Association, Mendelssohn Hall, New York, lot no. 98 (as *Moonlight*), 9–10 February 1905; E. B. Greenshields, Montreal, Canada; Robert C. Vose Galleries, Boston; Ralph Cudney, Chicago (as *The Smugglers*), by 1920; William T. Cresmer, Chicago; Mrs. Jacob H. Rand, New York; Hirschl & Adler Galleries, New York, 1956; Guennol collection.

35 *Macbeth and the Witches*

canvas; 28¼ x 35¾ in. (72 x 90 cm)
The Phillips Collection, Washington D.C.
See also figure 76

Cat. 35. Photograph from the 1918 memorial exhibition, the Metropolitan Museum of Art, New York.

A canvas entitled *Macbeth on Horseback Meeting Three Witches* was described by de Kay in 1890: "The singularly bold, simple outline of hills, between which an orange full moon is just about to quit the horizon, is as notable as the deep beauty of the sky and the mystery of the dark heath, all the darker because the light floods a winding path which seems to proceed in snaky loops from the sky itself."[1] The painting referred to is a smaller oil (cat. 35a), a first attempt to capture the enchantment of Macbeth's encounter with his destiny. Ryder occasionally began a subject in such a way; Horatio Walker explained, "Ryder did not often make studies for pictures, but rather felt his way as he went along, always with the grand idea uppermost. This is well illustrated here by comparison with the finished work and Macbeth."[2]

In his mature career Ryder painted larger works with grand themes for patrons who were professionals or entrepreneurs with a special interest in his work. *Macbeth and the Witches* went to Dr. Albert T. Sanden, who also acquired *The Race Track*. A patron of American art, Sanden formed an important collection of Ryder's work, which was exhibited on extended loan to the Metropolitan Museum. He also was a benefactor

of the artist as were a small variety of friends and patrons throughout different phases of Ryder's life. Without specifying Sanden by name, Charles Fitzpatrick wrote that Sanden was "a good sport and had plenty of money. He had been giving Ryder so much every month for I don't know how long. . . . [Sanden] was placing his money on the future market. Ryder won out and had all his unfinished pictures left, which looked as though it might wind up into a one man sale."[3]

In 1899 Sylvia Warner wrote to Wood, "[Ryder] has sold his 'Macbeth,' which is only begun, and at a good figure—all of his business-like self."[4] Yet, like John Gellatly, William Van Horne, and C. E. S. Wood, all of whom paid for works in advance in the hope of encouraging Ryder to finish, Sanden would have to wait more than fifteen years before he could take possession of the painting.[5] When Ryder was asked toward the end of his life about the progress of the picture, he reportedly said, "I think the sky is getting interesting."[6]

"This weird vision of a night torn by storms" depicts act 1, scene 3, of Shakespeare's tragedy, when Macbeth and Banquo are crossing the "blasted heath," where a dreary castle looms in the distance.[7] They encounter three witches, harbingers of fate, who greet Macbeth by saying: "All hail, Macbeth, that shalt be king hereafter!"

Cat. 35b. C. Hafften, *Heath Scene* (from Sadakichi Hartmann, *Shakespeare in Art* [1901]; courtesy of Berlin Photographic Company, New York).

Thus said, the virtuous "Thane of Glamis" is swept up by the enchanting prophecy of his rise to power. Ironically, Ryder's major painting for Sanden concerned the tragedy of worldly ambition, "its struggle against a supersensitive conscience, haunted by superstition."[8] In 1915 Sanden was indicted for using the mails to defraud purchasers of his electric belt.[9]

There is an interesting symmetry between this painting and *Siegfried and the Rhine Maidens* (cat. 59). Both works stage the moment in which a heroic male protagonist encounters his tragic future through the prophecy of three bewitching women. The landscapes serve as more than just background; they play a principal role in the narrative, an other-worldly setting of doom and enchantment. The landscape in *Siegfried* is reminiscent of Corot's version of *Macbeth and the Witches* (cat. 59b), which entered the Wallace Collection in London in 1871–72 and was well known through engravings. Hartmann claimed that Ryder used a reproduction of a German painting (cat. 35b) as a source for this subject (see here "Fancy Endowed with Form").

The surface of *Macbeth and the Witches* appears abraded even in early photographs. According to his neighbors, the Fitzpatricks, Ryder sanded the surface in order to work on it further.[10] Sometime in the 1920s, probably following its acquisition by Ferargil Gallery in 1924, the painting was restored. The composition is now extremely dark.

MJWD

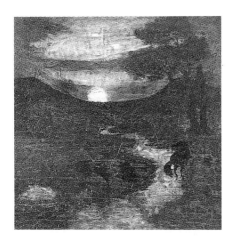

Cat. 35a. *Macbeth and the Witches*. The Art Museum, Princeton University, New Jersey, gift of Alastair Bradley Martin, 57-8.

Provenance: Dr. Albert T. Sanden by 1918; on extended loan from Sanden to the Metropolitan Museum of Art, New York, 1918–24; purchased by Ferargil Gallery, New York, from Sanden estate, February 1924; acquired by the Phillips Memorial Art Gallery, Washington, D.C., from Ferargil Gallery in trade for *Macbeth* (sketch) and *The Barnyard* (cat. 2) in 1940.

Notes

1. De Kay, "Modern Colorist," 257.

2. Certification of authenticity for the Macbeth oil sketch sent by Frederic Newlin Price of Ferargil Gallery to Kleeman Galleries, 23 December 1936. Price wrote in this same letter, "Personally I have no doubt about the beauty and rightness of this Ryder and only a fool or ignoramous [sic] would or could say otherwise" (Ferargil Gallery Papers, Archives of American Art).

3. Charles Fitzpatrick, quoted in Taylor, "Ryder Remembered," 11. About ninety letters survive from Ryder to Sanden from the period 1898–15, and many include references to monthly payments from Sanden (Ryder Records, Babcock Galleries).

4. Wood Papers, Huntington Library. Sylvia Warner wrote in the same letter, "It is a great matter of pride with [Ryder] to prove that he can get along without a go-between, and deal with his clients directly, instead of having to go to Jimmy Inglis for a few dollars at a time."

5. "A. T. Sanden . . . has been waiting for years for Mr. Ryder to complete for him 'Macbeth and the Witches.' . . . 'Macbeth' has been in the studio seven years ("Albert P. Ryder: Poe of the Brush," 5). "Begun probably before 1895; worked on for fifteen to twenty years" (Goodrich, *Ryder* [1959], 116). Walter de S. Beck, however, writes that "*Macbeth and the Witches* had been more than twelve years in the making when the owner claimed it, but it was taken back by the artist and worked upon until his death" ("Ryder: An Appreciation," 40).

6. Quoted in Price to Goodrich, 14 October 1938, Ferargil Gallery Papers, Archives of American Art.

7. Pach, "On Ryder," 125.

8. Hartmann, *Shakespeare in Art,* 222.

9. He was acquitted on this count, but his firm faced further charges of fraud. Sanden tried to nullify an order from the postmaster general, who withheld his mail pending the outcome of the charges against him, but he was unsuccessful. The presiding judge Mayer ruled that "by the use of his power, much money . . . had been saved to unfortunate and foolish people, and long and tedious trials had been averted" (*New York Times,* 8 June 1915, 7).

10. Taped interview between Goodrich and Eleanor Fink, ca. 1980, New York, Juley Photo Archives, National Museum of American Art.

36 *Mending the Harness*

canvas; 19 x 22½ in. (48.4 x 57.2 cm)
National Gallery of Art, Washington, D.C., gift of Samuel A. Lewisohn, 1951.1063
See also figure 9

Cat. 36. Photograph from the 1918 memorial exhibition, the Metropolitan Museum of Art, New York.

37 *Mending the Harness*

panel; 7½ x 8 in. (19 x 20.5 cm)
Hirshhorn Museum and Sculpture Garden, Smithsonian Institution, Washington, D.C., 1966.4434

The subject of the horse-drawn cart was a favorite of painters in America and Europe, beginning with Constable's *Hay Wain*, 1821 (National Gallery, London), and continuing for the next eight decades. Ryder painted several variations on the theme, of which his most complete pictorial treatment is *Mending the Harness* in the National Gallery. In this painting a solitary figure adjusts a shaft on the haycart, his horse standing somewhat stiffly in the traces.

Exhibited at the Corcoran Gallery in December 1908, *Mending the Harness* may have been the painting described by de Kay in 1890 as "A yellow sunny landscape [hanging] in his studio. The foreground contains a raw-boned white horse, a cart, and a laborer in blue overalls. The golden distance of plain, the rolling hills, and the slightly clouded sky are robust and broad."[1]

The canvas is heavily painted, with a weighty, solid cast to all the forms. The X-ray reveals changes Ryder made as the composition developed: a man standing alongside the cart raking hay and a boy crouching in the foreground have both been painted out. Their absence contributes to the sense of timelessness and isolation that permeates the work.

A sketch entitled *Mending the Harness* in the Hirshhorn Museum and Sculpture Garden seems to be a study in which Ryder developed the frontal, center-focused composition. In this small work a relaxed bay horse stands patiently as the driver attends to the harness. Using the butt of his brush to define the horse's legs and harness, Ryder demonstrated a sure hand with foreshortened equine anatomy. In the larger canvas Ryder exchanged the bay for his archetypal white horse, but the loose handling of form apparent in the sketch becomes tighter in the larger work. A second small oil sketch, *Boy Driving a Hay Wagon* (cat. 36a), likely belonged to Mrs. E. N. Ryder (Ryder's sister-in-law); it appears to have been reworked in an effort to reinforce Ryder's forms.[2]

Although scenes of rural labor had long been popular with European artists, interest in these works peaked in America following the Civil War. Postwar disillusionment with Hudson River

Cat. 36a. *Boy Driving a Hay Wagon*. The Fine Arts Museums of San Francisco, gift of Dr. T. Edward and Tullah Hanley, Bradford, Pennsylvania, 69.30.183.

Cat. 36b. Constant Troyon, *A Farmer in His Wagon* (*Un fermier dans sa charette*), oil on canvas. Musée du Mans, Le Mans, 100.293.

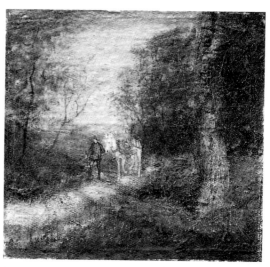

Cat. 36c. *The Wood Road*. Worcester Art Museum, Massachusetts, 1973.74 (photograph from the 1918 memorial exhibition, the Metropolitan Museum of Art, New York).

school landscapes blended with a renewed interest in European culture, encouraging a somewhat belated recognition of Barbizon and Hague school paintings. Opposition to industrialization was among the forces for the popularity of Barbizon subjects with artists and their patrons. Looking for emotional reprieves in idealized rural scenes, patrons eagerly bought subjects that ennobled those who worked the land.

With Millet as spiritual guide, European artists such as Dupré, Israels, and Mauve painted scenes that inspired their American colleagues. Anton Mauve often depicted rural laborers with horse-drawn carts; Constant Troyon's *Farmer in His Wagon* (cat. 36b) provides a similar vision. Wyatt Eaton, Inness, Ryder, and Horatio Walker were among many artists in America who adopted similar subjects. Ryder's tiny *Wood Road* (cat. 36c) depicts a man leading a white pack horse, while his unfinished painting *Harvest* (see fig. 113) presents the popular variation of an oxen-drawn wagon. Gellatly, who purchased *Harvest* in 1898, also owned Louis Paul Dessar's *Load of Brush* (cat. 36d), painted in 1912.

Literature too provided ample sources of pastoral images; Ryder's *Plodding Homeward* (cat.

30b), thematically related to *Mending the Harness*, derives its title from the closing lines of Thomas Grey's "Elegy in a Country Churchyard": "The ploughman homeward plods his weary way, / And leaves the world to darkness and to me."

ELJ

Provenance of cat. 36: purchased by James S. Inglis from Ryder between 1890 and 1907; M. Knoedler & Co., New York, by October 1915; purchased by Adolph Lewisohn, New York, from Knoedler, February 1917; inherited by Samuel A. Lewisohn (Lewisohn's son), 1938; gift of Lewisohn to National Gallery of Art, Washington, D.C., 1951.

Provenance of cat. 37: Ryder until April 1917; Louise Fitzpatrick, Elmhurst, New York, April 1917; Philip Evergood until 1952; purchased by ACA Gallery, New York, from Evergood, 1952; Passedoit Gallery, New York; purchased by Joseph H. Hirshhorn, New York, 6 February 1953; the Hirshhorn Foundation, New York, 1961; Hirshhorn Museum and Sculpture Garden, Smithsonian Institution, 1966.

Notes

1. De Kay, "Modern Colorist," 257.

2. "I sat under a quaint study in browns,—a boy driving a load of hay,—which Mrs. Ryder informed me was one of the first works the painter ever produced" (Cheney, "New Bedford's Painter of Dreams"). According to the curatorial files, M. H. de Young Memorial Museum, San Francisco, *Boy Driving a Hay Wagon* belonged to Ryder's relatives until the 1940s.

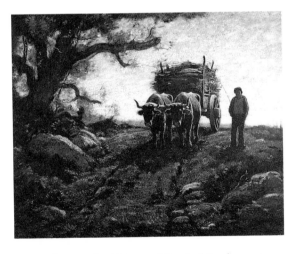

Cat. 36d. Louis Paul Dessar, *A Load of Brush*, 1912, oil on canvas. National Museum of American Art, Smithsonian Institution, Washington, D.C., gift of John Gellatly, 1929.6.25.

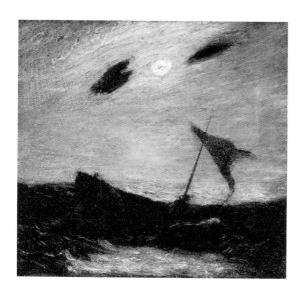

38 *Moonlight*

mahogany panel, cradled; 15⅞ x 17¾ in.
(40.4 x 45 cm)
National Museum of American Art, Smithsonian
Institution, Washington, D.C., gift of
William T. Evans, 1909.10.2
See also figure 96

In 1887 Ryder sailed to England with Captain
John Robinson on the SS *Canada,* during which
crossing he worked on *The Temple of the Mind*
(cat. 67), paid for in advance by Thomas B.
Clarke.[1] Ryder finished the difficult work and
painted *Moonlight* on the verso of the same thick
mahogany panel during the return voyage,
spending considerable time studying the effects
of moonlight on the water.[2] When the ship
docked in New York, Ryder took the panel to
several cabinetmakers, none of whom thought it
could be split without destroying one of the
paintings. He then gave the panel to Clarke, who
had it split successfully by a man who made
meerschaum pipes.[3]

The story documents Ryder's idiosyncratic
working habits and differences of approach.
While *The Temple of the Mind* is heavily laden
with symbolism and dream imagery from Poe,
Moonlight steps beyond specific meanings. It is
thinly painted, the reddish brown clouds merely
varnished on bare panel. The X-ray confirms the
simplicity of the composition and its execution,

factors contributing to the painting's good
condition.

William T. Evans purchased the painting in
1896 but was forced to sell it and much of his
collection in 1900. *Moonlight* moved through at
least two collections until Evans purchased it
again in 1909. In a letter to Richard Rathbun of
the then-new National Gallery of Art (now Na-
tional Museum of American Art), Evans re-
counted the painting's history, including a
cryptic reference to its ownership by an uniden-
tified "Canadian client," from whom Cottier &
Co. acquired the work before reselling it to Ev-
ans.[4] It is possible that *Moonlight* belonged to the
Corbetts of Portland, Oregon, rather than to a
Canadian collector; in 1973 the daughter-in-law
of Mrs. Helen Ladd Corbett identified this paint-
ing as having belonged to her mother-in-law be-
tween 1902 and 1909.[5]

In 1909, when Evans purchased *Moonlight* for
the second time, he received a letter from the
painter Charles Melville Dewey requesting that
Dewey be allowed to undertake the restoration.[6]
In April 1910 Ryder wrote to Evans that he was
pleased with Dewey's work on the painting.[7]
ELJ

Provenance: commissioned for $500 by Thomas B.
Clarke, New York, by April 1885; purchased for $200
by William T. Evans, New York, and Montclair, New
Jersey, from Clarke Sale, Fifth Avenue Art Galleries,
no. 30, January 22, 1896; purchased for $700 by Cot-
tier & Co., New York, from William T. Evans Collec-
tion Sale, Association of American Artists, Chickering
Hall, New York, no. 259, January 31–February 2,
1900; E. F. Milliken, 1900; purchased for $1,500 by
Cottier & Co. from E. F. Milliken Collection Sale,
Association of American Artists, Mendelssohn Hall,
New York, no. 5, 14 February 1902; unknown Cana-
dian client or Mrs. Helen Ladd Corbett, 1902; Cottier
& Co. by 1909; purchased for $1,750 by Evans, 22
October 1909; gift of William T. Evans to National
Museum of American Art, Washington, D.C., 1909.

Notes
1. Robinson, "Reminiscences of Ryder," 180.
2. Ibid.
3. "Albert P. Ryder: Poe of the Brush," 5. The panel is
discussed in a letter from Inglis to Wood, 25 July
1899, Wood Papers, Huntington Library.

4. Evans to Richard Rathbun, 22 October 1909, curatorial files, National Museum of American Art.

5. John F. Porter to William H. Truettner, 1 October 1975, with accompanying transcript of a conversation between Porter and Mrs. Henry Ladd Corbett, 12 March 1973, curatorial files, National Museum of American Art.

6. Dewey to Evans, 8 November 1909, Evans Papers, Archives of American Art.

7. Ryder to Evans, 5 April 1910, Evans Papers, Archives of American Art.

39 *Moonlight Marine*

panel; 11½ x 12 in. (29.2 x 30.5 cm)
The Metropolitan Museum of Art, New York,
Samuel D. Lee Fund, 34.55
See also figure 102

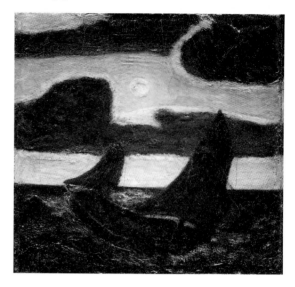

Cat. 39. Photograph before 1918.

The early history of *Moonlight Marine* is difficult to trace. Its heavily worked surface and simplified forms are consistent with paintings made in the late 1890s, such as *Landscape* (cat. 26). The many Ryder images that at one time have borne the title *Moonlight* leave identification of many uncertain. By 1908 this painting belonged to Newman E. Montross, a New York art dealer who formed important collections of nineteenth-century French and American art, and in 1913 he loaned it to the Armory Show. Often exhibited after that date, *Moonlight Marine* has become among the most widely recognized Ryder marines and, along with others, has served as a model for numerous forgeries.

With its strongly patterned composition, the painting was a favorite of critic Roger Fry, who described *Moonlight Marine* in 1908 as endowed with

a quality of paint [that] has the perfection of some precious stone . . . he has wrought the slimy clay of oil pigment to this gem-like resistancy and translucency. The whole effect is that of some uneven

Cat. 39a. X-ray of *Moonlight Marine*.

40 **Moonlight on the Sea (Moonlight at Sea)**

panel, cradled; 11½ x 15⅞ in.
(29.2 x 39.6 cm)
Wichita Art Museum, Kansas, Roland P. Murdock
Collection, M72.47
See also figure 97

enamel, certainly of something that has passed
through fire to give it so unyielding a consistency. . . .
Here, then, is a vision recorded for us so absolutely
that once seen it can never be forgotten. It has the
authoritative, arresting power of genuine inspiration.[1]

Moonlight Marine provides ample evidence of
the darkening and sagging of paint endemic to
some of the artist's better-known late works. An
X-ray (cat. 39a) confirms the extreme density of
the paint and near-total lack of compositional
changes in the painting. As with *Toilers of the
Sea* (cat. 69), the dark areas of the boat, clouds,
and water—probably containing high concentra-
tions of slow-drying oils—have sunk below the
level of the lighter paint, becoming glossy and
visually impenetrable.[2]

ELJ

Provenance: Newman E. Montross, New York by
1908; acquired by Macbeth Gallery, New York, from
Montross estate by December 1933; purchased by the
Metropolitan Museum of Art, New York, 28 March
1934.

Notes
1. Fry, "Art of Ryder," 64.
2. The surface irregularities have been compounded
by the panel itself; autoradiographs revealed tree rings,
indicating that the wood was cut improperly, its
striated surface allowing the paint to sink into the
grooves (Bolger-Burke, *American Paintings in the
Metropolitan*, 3:20).

Moonlight on the Sea records Ryder's turn to
marine painting in the early 1880s. The compo-
sition is straightforward, with the ship's sails
aligned in perfect silhouette against the sky and
hull in profile on the edge of the horizon. The
various colors in the waves, accentuated by lines
made by the butt of the brush, and airy lightness
of the sky enliven the image.

The painting entered the collection of John
Popham of Montreal and then passed into the
prestigious collection of Sir William Van Horne;
the fame of these collectors, and Van Horne's
generosity with reproductions, guaranteed that
this was one of Ryder's best-known images in the
early 1900s. By the time Roger Fry illustrated it in
his article on Ryder as a precursor of modernism,
the straightforward forms had been reinterpreted
as a kind of primitivism: "The simplification of
the forms, the willed awkwardness and *gaucherie*
of the ship's silhouette, gives I know not what of
conviction to our sense of the infinite planes of
wind-swept, moon-illumined air."[1]

EB

Provenance: John Popham, Montreal, Canada; Sir Wil-
liam Van Horne, Montreal, by 1895; Lady Van Horne,

Montreal; purchased for $6,200 by Macbeth Gallery, New York, from William Van Horne Estate Sale, Parke-Bernet Galleries, New York, no. 1 (as *Moonlight at Sea*), 24 January 1946; purchased for $6,450 by Jayne Robertson, Pelham, New York, from Macbeth Gallery, 7 February 1946; Macbeth Gallery; purchased for Wichita Art Museum, Roland P. Murdock Collection, 11 July 1947.

Note
1. Fry, "Art of Ryder," 64.

41 *Moonlit Cove (Moonlight on Beach)*

canvas; 14 x 17 in. (35.5 x 43.2 cm)
The Phillips Collection, Washington, D.C.
See also figure 103

Ryder's *Moonlit Cove,* like *Shore Scene* and *The Smugglers' Cove* (cat. 58, 60), evokes tales of piracy that fueled art and literature alike. In discussing Ryder and his Cape Cod roots Frank Jewett Mather, Jr., noted,

The abundant new ghosts found already installed the spirits of the victims that Captain Kidd slaughtered over his buried treasure. The pines around Tarpaulin Cove have seen the pirates, the British and the Yankee privateers dropping anchor opposite their sweet spring. And the soft, humid air of the Cape entraps more moonlight than any air I know.[1]

Mather's prose captures the eerie mood of *Moonlit Cove,* its strong, rhythmic patterns echoing the motion of the sea, which have been praised: "It is not large save in the matter of handling a fine impression of cliff, sea and clouds. No one has excelled Ryder in just this sort of thing. There is a brooding mystery here lightened by the brilliancy of the flooding light that streams from the moon on the water."[2]

Walter Pach was first to reproduce a picture of *Moonlit Cove* in print, in his article of 1911; *Moonlit Cove,* however, may have been completed by 1890.[3] The painting was exhibited at the Armory Show in 1913 as *Moonlight on Beach.*

Conservation of the painting in 1961 revealed that Ryder had painted over the edges of the canvas, gluing them down to the stretcher. The verso of the canvas was drenched with oil, contributing to the darkening of the image; the coraclelike boat now blends with the dark cliffs behind it, heightening the sense of mystery.[4]

ELJ

Provenance: Alexander Morten, New York, by 1911; Marjorie (Mrs. Alexander) Morten, New York, 1924; purchased by Duncan Phillips, Washington, D.C., from Rehn Galleries, New York; the Phillips Collection, Washington, D.C.

Notes
1. Mather, *Estimates in Art,* 156.
2. "Fifty-two Paintings Shown," *Washington Post,* 12 February 1928.
3. Pach, "On Ryder," 126. Goodrich notes, curatorial files, the Phillips Collection, Washington, D.C.
4. Sheldon and Caroline Keck, treatment report, March 1961, curatorial files, the Phillips Collection.

42 *Near Litchfield, Connecticut*

composition board; 9⅝ x 9⅛ in. (23.6 x 23 cm)
Collection of Robin B. Martin, Washington, D.C.
See also figure 21

An inscription in Ryder's hand on the verso of this small painting reads: "Near Litchfield, Connecticut / Sketch from nature by Albert P. Ryder / 1876 / Presented to C. de Kay / by the artist." The fresh color and handling convey a sense of plein-air execution; the thinness of the paint film, unlike the density of Ryder's later works, contributes to the impression of spontaneity, and the flurry of brushwork reinforces the sense of direct observation.

The X-ray indicates a major alteration in the composition. Whereas the road passing in front of the trees is now empty, in the X-ray the trees are farther to the right, and centered in the painting is a dark mass, which has since been painted out.

Among the influences Ryder encountered while a student at the National Academy and through his association with the Gilder circle was that of William Morris Hunt. His rugged

brushwork and fluid, painterly style echoed the teachings of Couture, with whom Hunt worked in France. Returning from France in 1862, Hunt had an immediate impact on artists like La Farge. Hunt's seminal *Talks on Art,* culled from critiques of his students' works, was published in 1875; his forward-looking ideas quickly made him the American prophet of Barbizon art. The timing could not have been better for Ryder's assimilation of the ideas supporting the rebellion that took shape with the formation of the Society of American Artists in 1878.

The verso of the composition board is primed with an off-white ground. In addition to the inscription, there is an outline pencil sketch of a horse and rider oriented in the opposite direction (cat. 42a). Precisely drawn, the image is foreshortened with great facility. The horse's ears and eye are carefully rendered, and Ryder has experimented with the position of both horse's and rider's legs while leaving the figures incomplete.

In 1906 the *New York Press* observed, "He spent his summers in the country for some years, and in winter prowled around the stables and blacksmith shops of New York, painting horses. He studied drawing at the Academy, but he taught himself color."[1] The strong sense of direct observation in the pencil sketch and painted landscape and the dated inscription help locate more precisely Ryder's interests early in his career.

ELJ

Provenance: Charles de Kay, New York; purchased by Macbeth Gallery, New York, 1913; Alexander Morten, New York, 9 November 1913; purchased for $775 by William Macbeth for W. S. Stimmel from Alexander Morten and Others Estate Sale, American Art Association, Plaza Hotel, New York, no. 27 (as *Late Afternoon,* sketch), 29 January 1914; Adelaide Mitchell, Pittsburgh; Maynard Walker Gallery, New York; Alastair Bradley Martin, 27 June 1956; Robin B. Martin, Washington, D.C.

Note
1. "Albert P. Ryder: Poe of the Brush," 5.

Cat. 42a. Verso of *Near Litchfield, Connecticut.*

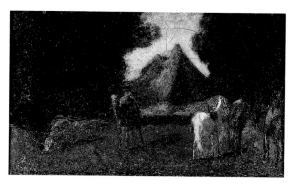

43 *An Oriental Camp (An Oriental Encampment)*

canvas; 7¼ x 12 in. (18.4 x 30.5 cm)
Mead Art Museum, Amherst College, Massachusetts,
gift of George D. Pratt, '93 P.1933.10
See also figure 18

An Oriental Camp was first owned by Newman E.
Montross. "When Mr. Montross bought 'An Ori-
ental Encampment,' the painter had been work-
ing on it for ten years, but he asked a little more
time to finish it. It was three more years before
Mr. Montross got his picture; but this time the
result of thirteen years later was a masterpiece."[1]
An Oriental Camp was lent by Ryder to an exhi-
bition in 1887 at the American Art Galleries;
Montross may have acquired it soon after, sug-
gesting that it was begun in the mid- or late
1870s.

Ryder's oriental subjects preceded his visit to
Tangiers in 1882, so that his representations of
the East depended on impressions culled from
standard descriptions in popular culture and fine
art.[2] Yet *An Oriental Camp* deviates from conven-
tional images of Arab marketplaces and city-
scapes by artists like Gérôme and Tiffany.
Accentuating the fanciful quality of its concep-
tion, the painting is almost a pastoral subject
transposed to the Near East, with camels and
horses instead of cows and sheep.

An early review describes the image more
clearly than it can be seen today:

Mr. Albert Ryder hies him in spirit to the Orient and
paints with his usual depth of color, but with most
unusual attention to definite outlines, some camp of
Arabs in an oasis. The horses are capitally touched in;
the tents loom mysteriously in the background; a
camel stands by itself; a cock and some hens give a
touch of peacefulness; an Arab woman arrives with a
jar balanced on her head.[3]

An X-ray (cat. 43a) taken in 1988 shows two
horses and a woman with a jar at the right,
along with another shadowy horse shape to the
left of the group. Surprisingly, the image of a
classical portico appears at far right with sugges-
tions of water to its left, not unlike several paint-
ings of the Middle East by Frederic E. Church
that were exhibited in New York in the 1870s.
Ryder's only other subject with classical architec-
ture is *The Temple of the Mind* (cat. 67), also a
work of the 1880s.

The painting was cleaned and retouched in
1967. Overall, its current condition is good; the
painting retains some of the rich coloration and
translucency prized by Ryder's patrons.
MJWD

Provenance: purchased by Newman E. Montross, New
York, from Ryder, late 1890s; purchased for $2,400 by
George D. Pratt for A. D. Rudert from Newman E.
Montross Estate Sale, American Art Association, An-
derson Galleries, Inc., New York, no. 50, 20 April
1933; gift of Pratt to Mead Art Museum, Amherst
College, Massachusetts, 21 April 1933.

Notes
1. LaFollette, *Art in America*, 197–98.
2. See *By the Tomb of the Prophet* (cat. 4).
3. "A Rival to the Autumn Academy Exhibition," *New
York Times*, 4 December 1887, 12.

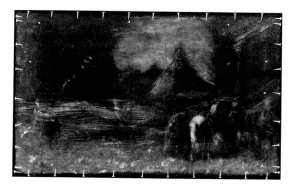

Cat. 43a. X-ray of *An Oriental Camp*.

44 *Passing Song (Melancholy)*

wood; 8½ x 4⅜ in. (21.6 x 11.1 cm)
National Museum of American Art, Smithsonian
Institution, Washington, D.C., gift of
John Gellatly, 1929.6.103
See also figure 78

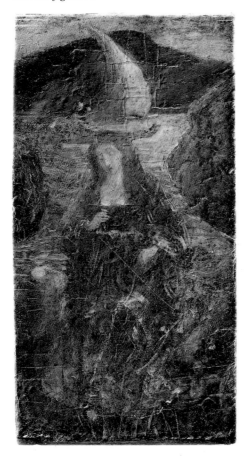

Cat. 44. Photograph from the 1918 memorial
exhibition, the Metropolitan Museum of Art,
New York.

Ryder explained to art critic Sadakichi Hartmann that he intended *Passing Song* to be "like a little volume of poetry."[1] The romantic subject of a pale maiden, singing in vain to attract a passing sailor in a rudderless vessel, inspired the artist to compose verses to accompany the painting (see Appendix A).

Although painted on the tiny surface of a cigar-box lid, *Passing Song* clearly had significance for Ryder, occupying his attention for nearly two decades. The painting was intended for Helena de Kay Gilder (previously a fellow student at the National Academy) by 1887, but she waited more than fifteen years to receive it.[2] Her brother Charles de Kay described changes in the composition: "Among the earlier works is a little woman's figure on a panel, standing with a harp at her feet and the sides of a tent door about her. Originally this picture had a background with a man sailing an enchanted bark. The figure is called 'Melancholy.' "[3] Sometime after 1890 it underwent additional reworkings and was retitled.[4] In the final version the man in an enchanted boat again appeared. The seated woman holds the lyre in her left hand and a white flower in her right hand.

While laboring over *Passing Song* Ryder also worked on *The Lorelei* (cat. 33), showing another woman who lures a boatman with her music, but one with sinister rather than benign intentions. Ryder appears to have struggled with both female figures. He "lost" *The Lorelei* as well as *Passing Song* around 1900 and had them both "underway again" in 1901.[5]

Ryder wrote Helena de Kay Gilder in March 1903, "I have handed to your brother Charles the one time Melancholy; now Passing Song, partly because he wanted it, and partly because Weir seemed so much taken with it, and partly because Bauer [*sic*] on a recent visit was so enthusiastic over it."[6] The artist expressed definite reservations about relinquishing the painting and suggested he would begin another for Gilder if she was not satisfied with *Passing Song*.[7]

In the same letter Ryder quoted his friend Theodore Baur, the German sculptor, as saying "if some one was to take [*Passing Song*] to Ger-

Cat. 44a. X-ray of *Passing Song.*

many . . . they would spend months in speculating as to its meaning; write poetry and essays about it, and altogether be quite mad about it."[8] The central figure may indeed have German antecedents, resembling for instance Dürer's images of the Madonna, with downturned head and ample lap draped in copious folds. Perhaps Dürer's *Melencholia* inspired Ryder's image and first title.

Ryder referred to his treatment of the *Passing Song* as "a kind of revelation for method to introduce in some stage of my future work."[9] This "revelation for method" may have posed problems; the X-ray (cat. 44a) records multiple vertical patches, particularly in the figure, as well as a swirl of brushstrokes in the face and neck.

The landscape elements in the foreground are particularly difficult to read, due to fading and blurring of paints. The paint has dried over the entire surface in swirled masses of colors, reflecting Ryder's layering of one color over another. Despite this, conservators Sheldon and Caroline Keck found the work to be more stable and have less surface alteration than others with similar crackle patterns.[10]

SLB

Provenance: commissioned by Helena de Kay Gilder, New York, before August 1887; to Charles de Kay by March 1903; Helena de Kay Gilder by 1907; Alexander Morten, New York; Marjorie (Mrs. Alexander) Morten, New York, by 1918; purchased for $2,800 by John Gellatly, New York, after 1920; gift of Gellatly to National Museum of American Art, Washington, D.C., 1929.

Notes

1. Hartmann, "A Visit to Ryder," 1–3, and Hartmann, *History of American Art,* 313–14.

2. "[I] will soon be home to make your little picture—all you desire" (Ryder to Helena de Kay Gilder, 26 August 1887, Gilder Archive, Tyringham, Mass.).

3. De Kay, "Modern Colorist," 257.

4. Hartmann recounts that he first met Ryder in the winter of 1893 ("An American Painter," Hartmann Papers, University of California Library). It was during this first encounter at Ryder's studio that Hartmann saw *Passing Song.*

5. Ryder to Bromhead, 2 August 1901, Sherman scrapbook, Force Papers, Archives of American Art.

6. Ryder to Helena de Kay Gilder, 19 March 1903, Gilder Archive, Tyringham, Mass. Presumably, de Kay passed the work on to his sister shortly thereafter.

7. "I have great respect for both gentlemen [Weir and Baur], and have given way to their exquisite taste and feeling. That does not necessarily end the matter as I am willing to try again, if necessary. Hoping that it may be an illustration of what you once so kindly and prettily remarked as to my work, that it was more by the grace of God" (ibid.).

8. Ryder paraphrased Baur's compliment in his letter to Bromhead, 20 March 1903, Sherman scrapbook, Force Papers, Archives of American Art.

9. Ryder to Bromhead, 20 March 1903, Sherman scrapbook, Force Papers, Archives of American Art.

10. Conservation report, July 1967, Conservation Lab Files, National Museum of American Art.

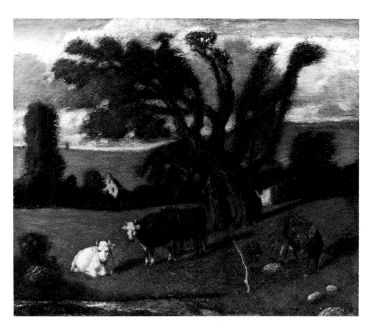

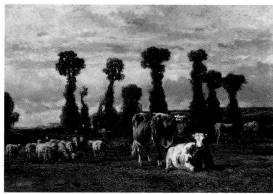

Cat. 45a. Constant Troyon, *Pasture in Normandy,* 1852, oil on panel. The Art Institute of Chicago, Henry Field Memorial Collection, 1894.1069.

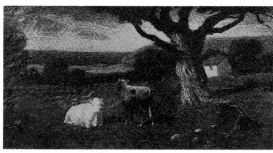

Cat. 45b. *Pastoral.* Unlocated (from *Art in America* 9 [October 1921]).

45 *Pastoral Study (Pastorale)*

canvas mounted on fiberboard; 24 x 29⅜ in.
(60.9 x 74.6 cm)
National Museum of American Art, Smithsonian
Institution, Washington, D.C., gift of
John Gellatly, 1929.6.104
See also figure 71

In an 1897 letter to Wood, Inglis wrote, "Pinky hasn't been seen for a week, for he has sold his large Landscape with the Cows to a man in Brooklyn and is up in the 7th heaven and very, very busy."[1] The purchaser was Henry T. Chapman, Jr., a stockbroker whose collections were well known both through their frequent turnover at auction and display in public exhibitions at private men's clubs in Manhattan.[2] *Pastoral Study* was first exhibited as *Pastorale* in an important show, *Tonal Paintings: Ancient and Modern,* organized at the Lotos Club by Chapman in March 1897, which included works by Europeans (Constable, Dupré, Jacob and Willem Maris, Rubens, van Dyck) and Americans (Davies, Inness, Martin, Minor, Ranger, Tryon). A reviewer commented:

The term tonality is used so glibly by so many writers and lectures on art topics that it is to be feared the general art public is not always entirely certain of its meaning. A study of any or all of the admirable and superior canvases Mr. Chapman has selected would

soon make clear . . . that tone in the simplest sense means that harmonious adjustment and blending of values and colour which gives sentiment, richness and artistic value to a picture.[3]

The reviewer concluded that the American artists were "such students and interpreters of tone in painting as to make them tonalists par excellence." Such words exemplify the important place that Ryder held in the continuing campaign to demonstrate the caliber of American artists as measured against their European counterparts.

The pastoral subject is the pillar of classical landscape painting. Envisioned as a counterpart to pastoral poetry, its pedigree lies in ancient frescoes, which often include bucolic settings as the playground for the gods and their creations. In modern painting the pastorale evolved into the sentimental realism of the Barbizon school, celebrating the moral virtues of peasant life.

Cat. 45c. X-ray of *Pastoral Study*.

Cat. 45d. Autoradiograph of *Pastoral Study*.
Conservation Analytical Lab, Smithsonian Institution,
Washington, D.C.

Ryder's painting manages to accommodate
both aspects of pastoral imagery. Like Troyon's
Pasture in Normandy (cat. 45a), it offers a peace-
ful expanse of land populated by grazing cattle.[4]
Ryder, however, carried the mood of his picture
beyond the transcription of a tranquil pasture;
his trees are more expressive and their limbs
intertwine as if those of metamorphosed lovers
from the pages of pastoral poetry.

In 1921 Frederic Fairchild Sherman published
a smaller version of the composition entitled
Pastoral (cat. 45b), writing that it "conforms sen-
sibly to the facts of nature and is devoid of all
trace of the conscious exercises of artistic license
in construction."[5] The larger *Pastoral Study* he
felt to be unsuccessful because "the tree forms

are too evidently deliberately cut off at the top of
the canvas and create an impression of artificial-
ity."[6] Yet similar tree forms are found in Dutch
painting, which was a strong inspiration to
Ryder.

An X-ray and autoradiograph of *Pastoral Study*
(cat. 45c–d) reveal a very different composition,
with a road winding through the center of the
picture and a horse and rider midway down its
path. The trees at right are not interlocked, and
the configuration of their leaves and branches is
different.

Sheldon and Caroline Keck relined and
cleaned the painting in 1966, finding evidence of
earlier restoration; they filled and inpainted new
traction cracks and varnished the painting. Its
current condition is stable, with strong colors
and few new fissures. At lower left the inscrip-
tion in red, "pastoral study," is still plainly visi-
ble as is Ryder's signature in red faded to brown
at lower right.

MJWD

Provenance: purchased by Henry T. Chapman, Brook-
lyn, from Ryder, March 1897; Cottier & Co., New
York, by 1904; purchased for $1,800 by John Gellatly,
New York, 1904; gift of Gellatly to National Museum
of American Art, Washington, D.C., 1929.

Notes
1. Inglis to Wood, 24 March 1897, Wood Papers,
Huntington Library. The painting should not be con-
fused with another large work, *Landscape with Trees
and Cattle* (National Museum of American Art), said
to have been purchased by Gellatly in 1897 from an
unknown source.
2. Chapman auctioned works in April 1875, 1877,
1880, and 1888 (his largest sale).
 Private galleries of exclusive New York clubs—such
as the Century Association, New York Athletic Club,
New York Engineer's Club, Lotos Club, Manhattan
Club, and Salmagundi Club—were the site of impor-
tant loan exhibitions of European and American paint-
ings, organized by the principal lenders and open to
the public.
3. "Pictures at the Lotos Club," *New York Times*, 27
March 1897, 2.
4. Many suitable comparisons exist, but Constant
Troyon was a leading *animalier* in the nineteenth cen-
tury, and his works often appeared in exhibitions and
private collections that included paintings by Ryder.
5. Sherman, "Four Paintings by Ryder," 267.
6. Ibid.

46 The Pasture

canvas; 12⅛ x 15¼ in. (39.8 x 38.7 cm)
North Carolina Museum of Art, Raleigh, gift of the
North Carolina Art Society, 52.9.26
See also figure 4

65 Summer's Fruitful Pasture

panel; 7¾ x 9⅞ in. (19 x 24.7 cm)
The Brooklyn Museum, Museum Collection Fund,
14.552
See also figure 3

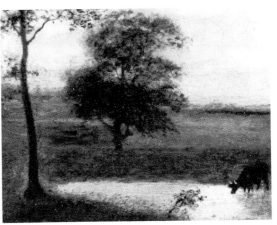

72 The Watering Place

panel, cradled; 8¾ x 11⅜ in. (22 x 28.4 cm)
Private collection
See also figure 22

The Pasture, Summer's Fruitful Pasture, and *The Watering Place* are examples of the rural subjects in the Barbizon tradition that Ryder painted from the mid-1870s through the early 1880s. Broadly painted in horizontal bands of color, *The Watering Place* relies less on detail than on modulation of color for effect.

The Pasture, Summer's Fruitful Pasture, The Watering Place, and a fourth example called *The Red Cow* (see fig. 130), all contain variations of the same animal in different environs. *The Red Cow,* purchased by Charles Lang Freer in 1908, depicts a dark cow near a thatched-roof cottage, while the cow in *The Pasture* stands at the fence line, its tail stilled, its body conveying a sense of expectation as it gazes across the field to a large house. *Summer's Fruitful Pasture* presents a spotted cow in a seemingly endless landscape, the horizon broken only by three stands of trees. In the far distance, between the cow's horns, is the diminutive figure of a man, giving focus to the cow's scrutiny. Ryder has given all his cows a distinct sense of weight and modeling and well-articulated ears, horns, and tail.

ELJ

Provenance of cat. 46: Dr. Dudley Tenney, New York, by 1918; C. W. Kraushaar, New York, by 1920; purchased for $1,150 by Dr. Chester J. Robertson, Pelham Manor, New York, from John F. Kraushaar and Others

Estate Sale, Parke-Bernet, New York, no. 22, 9–10 April 1947; consigned to Macbeth Gallery, New York, 17 October 1951; purchased by North Carolina Art Society for North Carolina Museum of Art, Raleigh, 1952.

Provenance of cat. 65: Daniel Cottier, New York; purchased by the Brooklyn Museum of Art, 14 December 1914.

Provenance of cat. 72: purchased by Daniel Cottier, New York, from Ryder; Mr. and Mrs. Lloyd Williams (Peggy Cottier Williams), New York, before 1912; Macbeth Gallery, New York, by 1912; purchased by Vose Galleries, Boston, 26 October 1912; purchased by Albert E. McVitty, Princeton, New Jersey, July 1917; Albert E. McVitty, Jr.; Vose Galleries; purchased by private collector, 1970.

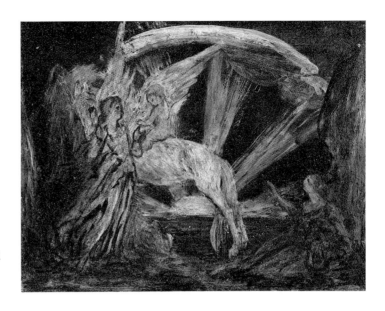

47 *Pegasus*

panel; 7 x 9⅛ in. (17.8 x 23.2 cm)
Hirshhorn Museum and Sculpture Garden, Smithsonian Institution, Washington, D.C., gift of Joseph H. Hirshhorn, 1966.4433
See also figure 91

Ryder's small *Pegasus* sketch prefigures his two finished paintings of the winged horse (cat. 48–49). As he turned to subjects of great personal significance he labored over their compositional structure, searching for the most powerful arrangement of forms.

Pegasus stands like a horse at show, with a winged cherub on his back, a muse in attendance, and another seated behind. Cliffs, sketchily indicated, frame a view to a distant body of water and setting sun, its rays spanning the sky like a cartwheel. Here, Ryder experimented with a profile view of the horse; as his conception developed he exchanged the profile with its narrative overtones for a more iconic, frontal presentation (cat. 48–49).

Along with a reduced facsimile of part of the Parthenon frieze, Ryder kept "a crowd of little Greek figures" and other art objects arranged on his mantelpiece.[1] His dealer James Inglis apparently dealt in antiquities occasionally; in his correspondence with Wood during 1897 the two men arranged to have a small terra-cotta winged Pegasus sent to Wood.[2]

This small painting and three others were left in Louise Fitzpatrick's hands at Ryder's death and only came to light after her death in 1934.[3] The brushwork and palette are entirely characteristic of Ryder. An X-ray of *Pegasus* confirms Ryder's skillful draftsmanship, particularly in the horse, which strongly resembles the horses in his other paintings.

ELJ

Provenance: Ryder until 1917; Louise Fitzpatrick until 1934; Philip Evergood until 1952; Passedoit Gallery, New York; purchased by Joseph H. Hirshhorn, New York, from ACA Gallery, New York, 6 February 1953; gift of Joseph H. Hirshhorn to Hirshhorn Museum and Sculpture Garden, Smithsonian Institution, Washington, D.C., 17 May 1966.

Notes
1. "Albert P. Ryder: Poe of the Brush," 5.
2. Inglis to Wood, n.d. [1897], Wood Papers, Huntington Library.
3. Of the four, three were purchased by Joseph H. Hirshhorn; the fourth is unidentified and unlocated. Evergood discussed his ownership of these paintings in a letter to Goodrich (curatorial files, Hirshhorn Museum and Sculpture Garden, Smithsonian Institution). For a different account see Taylor, "Ryder Remembered," n36.

48 *The Poet on Pegasus Entering the Realm of the Muses (Pegasus)*

panel; 12 x 11⅜ in. (30.5 x 28.4 cm)
Worcester Art Museum, Massachusetts, 1919.33
See also figures 89, 110–11

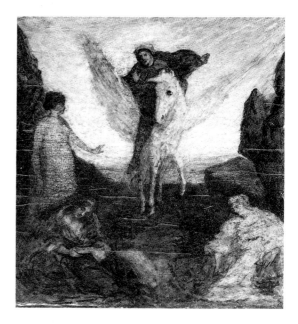

Cat. 48. Photograph from the 1918 memorial exhibition, the Metropolitan Museum of Art, New York.

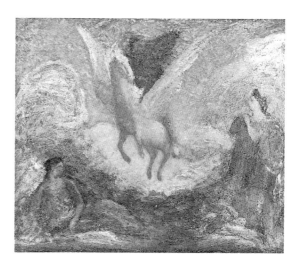

49 *Pegasus Departing (Pegasus)*
canvas mounted on fiberboard; 14¼ x 17¼ in. (36.1 x 43.8 cm)
National Museum of American Art, Smithsonian Institution, Washington, D.C., gift of John Gellatly, 1929.6.105
See also figures 90, 132

"Imitation is not inspiration, and inspiration only can give birth to a work of art."[1] Ryder's statement concerning creativity informs his paintings of Pegasus, the patron of the muses and symbol of creativity. On Mount Helicon, home of the muses, the winged steed struck a hoof against the rocks, causing a stream to gush forth, which became the fount of poetic inspiration. As both poet and painter, Ryder found in Pegasus the quintessential symbol of creativity, which appears in three of his paintings (cat. 47–49).

Ryder began *The Poet on Pegasus Entering the Realm of the Muses* in 1883 for Charles de Kay, completing it in 1887.[2] Although this painting has suffered grievously from cracks and suppurating lower layers of red paint (see fig. 111), it is a compelling vision of the source of poetic and artistic inspiration, painted when Ryder was experiencing the rapid growth of his own creative power. Seated with her book is Calliope, muse of epic poetry and eloquence; accompanying her is Terpsichore, muse of lyric poetry and the dance, shown here with a lyre. Greeting the poet stands a muse without an attribute; she may be Erato, representing love poetry, rounding out the trio of muses associated with the poets.

Pegasus was an important symbol for European and American artists, especially Odilon Redon, who made lithographs based on the myth. In his *Captive Pegasus* of 1889, the artist supplants Bellerophon, whose ability to tame the steed becomes a metaphor for discipline and skill.

The X-ray of the Worcester *Pegasus* (cat. 48a) reveals the original grace of the muses' gestures, which Ryder had altered by the time Kingsley made a wood engraving of the painting, probably by 1890 (cat. 48b). Streaks radiating outward from the center in the X-ray and paint swirls below them suggest a fountain and rippling water; perhaps Ryder once thought to include the spring of inspiration tapped by Pegasus.

A related subject, *Pegasus Departing*, was probably begun on commission for John Gellatly by 1901, when Ryder wrote to Harold Bromhead, "I was so pleased with your sentiments and your correct attitudes toward the combination of Pe-

Cat. 48a. X-ray of *The Poet on Pegasus Entering the Realm of the Muses*.

Cat. 48b. Elbridge Kingsley, wood engraving after Ryder, *The Poet on Pegasus Entering the Realm of the Muses*. National Museum of American Art, Smithsonian Institution, Washington, D.C., gift of Leonard Baskin, 1969.26.4.

Cat. 49a. X-ray of *Pegasus Departing*. Conservation Analytical Lab, Smithsonian Institution, Washington, D.C.

Cat. 49b. Eugène Delacroix, sketch for *Apollo Destroying the Serpent Python,* 1850, oil on canvas. Musées Royaux des Beaux-Arts de Belgique, Brussels.

gasus and those dependent on him."[3] Ryder struggled over *Pegasus Departing* for many years. Its scarred surface bears witness to a difficult birth: partially transferred from its original canvas support onto panel, the painting must have developed serious structural problems to necessitate this early restoration.[4] Much of the original canvas remains, but the paint surface apparently shifted during transfer, causing distortions in the composition. Later restorations blurred Ryder's hand, leaving the forms with a generalized appearance.[5]

The X-ray of *Pegasus Departing* (cat. 49a) graphically demonstrates the violence done to the painting: holes in the canvas and parallel tracks appear where the paint film was scraped. Ryder himself may have been responsible for damage requiring the transfer of the painting onto a sturdier support, for tales surface of his intentional damaging of a painting he did not wish to relinquish.[6] A letter to Gellatly indicates Ryder's difficulties in completing the commission and his unwillingness to be rushed.

During the 1918 memorial exhibition the *New York Times* reviewer compared the two Pegasus paintings, commenting that in the early work (Worcester Art Museum) the formal and sym-

bolic arrival of the mounted poet as messenger left the muses in awe, while the later version (National Museum of American Art) was compelling for what it shared with Blake: the emphasis on the energy generated as Pegasus's wings bore him aloft.[7]

Many have noted that the drawing of the horses in both paintings is weak, not meeting the standard of the horses in Ryder's stable subjects or other terrestrial steeds. The uncertain foreshortening may reflect his attempt to imagine a horse from an unusual point of view or it may represent his recollection of the many European ceiling decorations showing Apollo's horse-drawn chariot, of which the most celebrated is Delacroix's painting on the ceiling of the Louvre (oil sketch, cat. 49b).

ELJ

Provenance of cat. 48: painted for Charles de Kay, dated 1887; Stanford White, New York; purchased for $1,225 by John R. Andrews, Bath, Maine, from Stanford White Estate Sale, American Art Association, Mendelssohn Hall, New York, no. 30, 11–12 April 1907; purchased for $2,500 by Alexander Morten, New York, from J. R. Andrews and Others Collections Sale, American Art Association, New York, no. 111, 27–82 January 1916; Marjorie (Mrs. Alexander) Morten, New York; purchased for $4,400 by Macbeth Gallery, New York, from Alexander Morten and Others Estate Sale, American Art Association, Plaza Hotel, New York, no. 49, 29 January 1919; purchased by Worcester Art Museum, Massachusetts, 1919.

Provenance of cat. 49: Montross Gallery before 1918; John Gellatly, New York, by 1918; gift of Gellatly to National Museum of American Art, Washington, D.C., 1929.

Notes

1. Ryder, "Paragraphs from the Studio of a Recluse," 10–11.

2. The verso is inscribed: "Painted by Albert P. Ryder for Charles de Kay 1887."

3. Ryder to Bromhead, 12 October 1901, Sherman scrapbook, Force Papers, Archives of American Art.

4. Even the earliest extant photographs of this painting show the surface as it appears today, indicating the major damage and restoration occurred before 1918.

5. Sheldon and Caroline Keck in 1968 noted three layers of paint applied after the transfer of the painting onto the panel. During such transfers the entire canvas is usually removed before the painting is adhered to the new support; here, the autoradiograph indicates that part of the canvas was not removed, contributing to the distortion of the images. According to the Kecks, the surface was then "freely repainted" (treatment report, Conservation Lab Files, National Museum of American Art).

6. Hartmann, "An American Painter," 27, Hartmann Papers, University of California Library. See also here "Later Critics, New Patrons" for the study of his attacking a painting with a hairclipper.

7. "Ryder Exhibition at Metropolitan Museum," *New York Times,* 10 March 1918, Magazine section, 12.

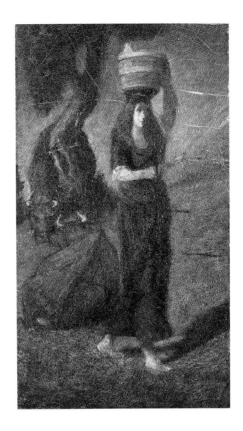

50 **Perrette**

canvas mounted on panel; 12⅞ x 7¾ in.
(32.7 x 19.7 cm)
Smith College Museum of Art, Northampton, Massachusetts, 93:1-1
See also figure 72

Perrette was the first of Ryder's works to enter a museum collection, purchased in 1893 by Laurenus Seelye, first president of Smith College. President Seelye often bought works directly from artists, in consultation with Dwight William Tryon, who may have known Ryder.[1] Ryder had *Perrette* underway by 1890, as de Kay mentioned it in his article of that year; in 1891 the work was exhibited in Chicago and in 1892 was lent by Ryder to an exhibition at the New York Athletic Club.

Ryder's inspiration was La Fontaine's fable "The Dairymaid and the Milk-Can," in which Perrette, a young milkmaid, allows dreams of the money she will make at market transport her imagination far beyond her lowly status. Skipping with joy over the riches she envisions, Perrette trips, spilling her jug of milk, leaving her

with nothing. La Fontaine's version of this popular moral fable closes with the narrator musing,

"Who doesn't build castles in Spain?
Which of us isn't mildly insane?
Picrochole, Pyrrhus, the dairymaid,
Wise men and fools alike, we all daydream
(No pleasure in life is so sweet)."[2]

Ryder's painting has a gravity and beauty far from the comic overtones of La Fontaine's fable, as noted in a review from 1892: "The stride of the vestal virgin, for she is far more august than a mere milkmaid, is really impressive, and the drawing of the cow lying down and 'foreshortened backward,' is really a triumph. And yet there are people who say that Albert Ryder cannot draw!"[3] A second review from the same year praised *Perrette* as being "quite in the vein of Millet," not only for its pastoral image but also for its jewellike coloring.[4] The cows, which de Kay compared to those of Corot, are lightly outlined in umber and bear a strong affinity with Constable's bovine studies. Rich in color, *Perrette* is thickly painted and glazed, lending it great depth and luminosity. The paint is now cracked and wrinkled, particularly in the lower half of the canvas.

Goodrich had the painting X-rayed and noted changes Ryder made as he worked out the composition.[5] Perrette's right arm, now crossing her body, once hung straight by her side, in a pose nearly identical to the beggar maid's in *King Cophetua* (cat. 25). Her skirt was once much shorter and the details of her face and limbs more crisply rendered.

The sinuous rhythms carried through the tree, curved back of the large cow, and Perrette's gait are other examples of Ryder's ability to animate a composition—a point frequently made about his marines. *Perrette* is a classic Ryder subject, bringing together several hallmarks of his art: a country girl, pastoral setting, dreaming, poetry, and a philosophic approach to material wealth.

ELJ

Provenance: purchased by Hillyer Art Gallery, Smith College, Northampton, Massachusetts, 1893.

Notes
1. Curatorial files, Smith College Museum of Art, Northampton, Massachusetts.

2. La Fontaine, *Selected Fables*, bk. 7, fable 10, "The Dairymaid and the Milk-Can" (New York: Viking, 1979).

3. *New York Times,* 21 March 1892.

4. *New York Herald,* 21 March 1892.

5. Goodrich's notes, curatorial files, Smith College Museum of Art.

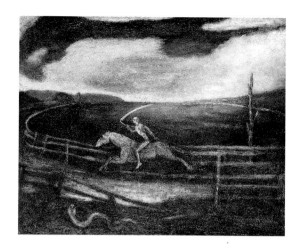

51 *The Race Track (Death on a Pale Horse)*

canvas; 27¾ x 35⅛ in. (70.5 x 89.2 cm)
The Cleveland Museum of Art, purchase through the
J. H. Wade Fund, 28.8
See also figure 86

With its macabre theme, allegorical figures, and
barren landscape, *The Race Track* stands apart
from most of Ryder's art, lacking the undercur-
rent of hope or salvation so often present even in
his darker subjects. An ambiguity permeates the
work, perhaps best perceived in the sky, where
the light is that of neither day nor night. When
asked about this, Ryder's reply was vague: "I
hadn't thought about it."[1]

The Race Track depicts Death as a skeleton
riding a white horse, galloping clockwise around
an elliptical track.[2] The fence surrounding the
track is broken; pacing the horseman on our side
of the fence is a large, undulating snake. One
dead tree and a building on the horizon are the
only points of stability in a composition based
on motion.

The Race Track is first mentioned in 1896,
then again in 1897 by Hartmann describing a
visit to Ryder's studio.[3] The dealer Benjamin Alt-
man encouraged Ryder to paint this subject, but
when Altman saw the painting in 1901, he re-
jected it.[4] Ryder continued to work on it for the
next decade, until it entered the Sanden collec-
tion in 1913.[5] During that time Ryder made sev-
eral changes in the work, described by Roger Fry
in 1908: "Instead of inclining the planes
obliquely, as undoubtedly he had done in earlier

versions on the canvas, Ryder came ultimately to
present them here as broadly spread out. In the
final state of the composition, moreover, he in-
sisted upon dissolving these planes by every
means at his disposal."[6]

Fry's reference to the shift away from oblique
angles is confirmed in the X-ray (cat. 51a). The
white horse, which now resembles the man-
nered, stretched racehorses common to nine-
teenth-century sporting art, once galloped more
naturally, with its hindquarters gathered under
its body.[7] In addition, the horse angled toward
the lower corner of the picture, on a path con-
vergent with the snake. The serpentine curves of
the snake cover an earlier, more streamlined im-
age enhanced by sgraffito, probably achieved
with the butt of the brush.

Fry went on to describe the "vague but not
serious dread of the cloud arabesque and the
admirably thought-out contour of the distant
hill," a rhythm evident in the X-ray.[8] The cloud
shapes originally complemented the undulating
horizon, echoing in reverse the land forms be-
low. After much reworking and restoration, the
sky now is made of alternating bands of light
and dark.

The story inspiring the work was recounted by

Cat. 51a. X-ray of *The Race Track*.

Henry McBride in 1917: Ryder befriended a waiter at his brother's hotel, and when talk turned to racing Ryder tried to discourage the waiter from gambling on horse races. The locally famous Dwyer brothers were boasting about their talented colt, Hanover, and in May entered him in the Brooklyn Handicap.[9] Ryder's friend bet his life savings of five hundred dollars on the horse to win; when Hanover came in third, the waiter committed suicide in despair. Distressed, Ryder wrote, "This fact formed a cloud over my mind that I could not throw off, and 'The Race Track' is the result."[10]

After 1917 most writers who have studied this difficult work recount all or part of the story of the wager. By 1926, when Hartmann discussed the story, it had taken on the aura of a legend. He identified the setting as the "once famous 'chute,' a rocky elevation in the infield" of the old Jerome Park racetrack that momentarily obscured the view of horses and riders from the spectators, commenting that often it was there that so much happened during a brief span in a race.[11]

The Race Track presents life as a horse race, in which the only constant competitor is Death. Critics have described Death as condemned to ride alone, having mown down all others, or as a symbol of jockeys and horses killed in racing spills.[12] The elliptical track has been seen as representing the inevitability of fate.[13] The connection between Death and the snake, however, has often been overlooked. Since biblical times the snake has been used to represent evil and the power of temptation, here moving on a separate but parallel course with Death.

The apocalyptic vision, common since the Middle Ages, often relies on the depiction of Death mounted on a pale horse, wielding a scythe. Frank Jewett Mather, Jr., suggested that Ryder's depiction of Death derives from Pieter Bruegel the Elder's *Triumph of Death,* ca. 1564 (Prado Museum, Madrid).[14] Ryder visited Spain on his tour of Europe in 1882 and could have seen this painting as well as other depictions of this theme; given the changes apparent in the X-ray, however, Ryder's initial concept did not owe the same debt to Bruegel as the current incarna-

Cat. 51b. Benjamin West, *Death on a Pale Horse,* 1817, oil on canvas. Pennsylvania Academy of the Fine Arts, Philadelphia, 1836.1.

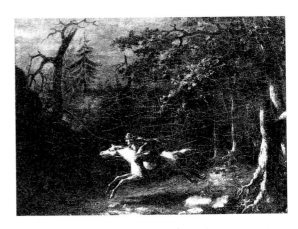

Cat. 51c. John Quidor, *Ichabod Crane Pursued by the Headless Horseman,* oil on canvas. Yale University Art Gallery, New Haven, Connecticut, the Mabel Brady Garvan Collection, 1948.68.

tion. Death as a horseman was a popular image in American painting as well, finding expression in works such as Benjamin West's *Death on a Pale Horse* (cat. 51b) and John Quidor's *Ichabod Crane Pursued by the Headless Horseman* (cat. 51c); in England, Turner gave it a particularly haunting power in a sketch now hanging in the Tate.

Perhaps as significant as all of this for Ryder was the death of his long-time friend Olin Warner in 1896, the year that the painting is first mentioned, from injuries following an accident in Central Park when his bicycle collided with a horse-drawn cab. Letters to Warner's widow and daughters reveal the depth of Ryder's feelings.[15] Ryder's mother died the same year and his brother William in 1898; Daniel Cottier had died

in 1891. Death must have weighed heavily on Ryder's mind during this decade. In this light, Ryder's story of the horse race provides an understandable deflection of attention from personal tragedy to contemplation of death in general.

ELJ

Provenance: purchased for $7,500 by Dr. Albert T. Sanden from Ryder by 10 May 1913; purchased by Ferargil Gallery, New York, February 1924; purchased by the Cleveland Museum of Art, through the J. H. Wade Fund, January 1928.

Notes

1. Comment recounted by Kenneth Hayes Miller, quoted in Goodrich, *Ryder* (1959), 20.

2. Although all American flat races are now run counterclockwise, in 1904–17 races at Belmont were run clockwise, nullifying discussion of reversal and inversion in the horseman's clockwise motion. I am grateful to Jennifer Raisor of the International Museum of the Horse, Lexington, for this information.

3. See here "Genius in Hiding" and Hartmann, "A Visit to Ryder," 1.

4. Fry, "Art of Ryder," 64.

5. Charles Fitzpatrick, quoted in Taylor, "Ryder Remembered," 11. The sale of the painting is recounted in a letter from Weir to Wood, 10 May 1913, Wood Papers, Huntington Library. Correspondence from 1947 in the curatorial files, the Cleveland Museum of Art, also links the painting to Louis A. Lehmaier.

6. Fry, "Art of Ryder," 64–65.

7. Ryder's original horse resembles the lead horse and rider from the west front of the Parthenon frieze; it is tempting to think Ryder may have had this source in mind. A 1906 description of Ryder's studio included the observation: "Over there is an exquisite miniature of the Parthenon frieze" ("Albert P. Ryder: Poe of the Brush," 5).

8. Fry, "Art of Ryder," 64.

9. This race was run in 1888 (Goodrich, *Ryder* [1959]); Baldinger, "Art of Eakins, Homer, and Ryder," 226.

10. "Pictures by Ryder and Others," newspaper review of an exhibition at N. E. Montross Galleries, New York, ca. 1919–23 (photocopy in the Metropolitan Museum of Art Library).

11. Hartmann, "An American Painter," 14, Hartmann Papers, University of California Library.

12. Fry, "Art of Ryder," 64; Hartmann, "An American Painter," 14.

13. Milliken, "The Race Track, or Death on a Pale Horse by Albert Pinkham Ryder," 66, 71.

14. Mather, *Estimates in Art*, ser. 2, 174–75.

15. Warner Family Papers, Archives of American Art.

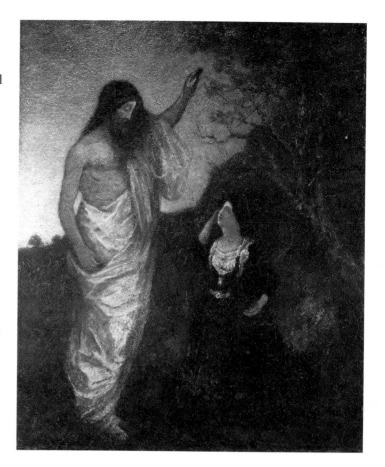

52 *The Resurrection*

canvas; 17⅛ x 14⅛ in. (43.5 x 35.8 cm)
The Phillips Collection, Washington, D.C.
See also figure 92

Recalling a visit to Ryder's studio, Hartmann wrote of seeing "a Christ and Magdalene, apparently undertaken more to express individual sensuousness than Biblical glory."[1] It is more than likely that he was referring to *Resurrection*. Despite its title, which suggests another passage in the scripture, *Resurrection* portrays the same biblical subject as *Christ Appearing to Mary* (cat. 6). The traditional iconography of a resurrection scene includes Christ in glory, emerging from the open tomb, with a crowd of onlookers staring in disbelief. A noted nineteenth-century author explained, however, that the Noli me tangere story became one of the "usual substitutions for the actual scene of the Resurrection. In some instances, the appearance of Christ to the Magdalene—the first revelation of Himself on

His return to earth—was felt to be sufficient setting forth of this irrefutable doctrine."[2]

The painting was known as *Resurrection* as early as 1886, when it was sold from the extensive collection of paintings (mostly European) and oriental objets d'art belonging to Mary Jane Morgan of New York. While American art was poorly represented in Morgan's collection, what few works she did have were praised by de Kay as representing the "wealth, beauty and variety of native art."[3] De Kay touched all bases by calling *Resurrection* "purely native art" that "recalls the Cinque-cento masters" but with a "modern suggestion. . . . Mr. Ryder's work has a strong family likeness to old Dutch and recent French landscape; but also he has the honor to evoke fierce dissensions among painters and amateurs, and so recalls Delacroix and Millet."[4]

Resurrection's composition bears a general likeness to the earlier state of *Christ Appearing to Mary* as revealed in X-rays and autoradiographs (see fig. 115). In both, a downward sloping landscape serves to bond the Magdalen to the earthly realm while Christ towers over her, his aureole linked to the rising sun.

Two sources exist for documenting the changes in composition that *Resurrection* underwent. The first is an anonymous wood engraving (cat. 52a) published in de Kay's article and presumably showing an early conception: Mary is cloaked in religious robes and kneels before a rocky cave; her gestures and facial expression are different; the horizon line and mountain silhouette are changed; Christ's right arm is different and he gestures with only two fingers of his left hand; the aureole around his head is more pronounced; and his drapery is fuller and falls differently about him.

The second source is a 1918 photograph (cat. 52b), showing several changes since the 1890 engraving: the cave has disappeared and a tree grows at right; the folds of Christ's drapery are softer; his right arm has been moved forward to his side, and his left arm is raised higher; the Magdalen wears a Victorian-style dress; her face and hands have been moved and impart a different expression.

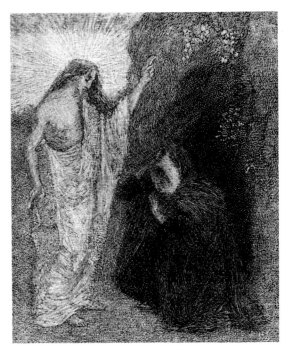

Cat. 52a. Unidentified artist, wood engraving after Ryder, *The Resurrection*.

Such adjustments may have been Ryder's work or that of a restorer. Inglis wrote to Wood in 1893, complaining of Ryder's reworking of the painting: "The Reverend [Ryder] smiled while I applied the caustic remarks to him. . . . He has ruined my Christ Appearing to Mary. I don't go to his studio so as to avoid swearing."[5] In about 1896 Ryder wrote to Weir that he had finished "Christ and Mary," but in 1899 Sylvia Warner mentioned having just seen in Ryder's studio a "*Christ and Mary* that will be a jewel—another small canvas," suggesting that Ryder was still making changes.[6]

Captain John Robinson, on whose ship Ryder sailed to Europe in 1887 and 1896, reported an incident that occurred in Ryder's studio while he was working on a "figure of Mary Magdalene," perhaps this painting:

It appears that one morning another Mary, Mary O'Brien, who used to tidy up for some of the occupants of the rooms of the building, got into Ryder's place; and using her duster vigorously, she smeared Mary Magdalene's face out of all shape—the nose was

quite gone. She was in great distress over this. . . . Ryder was much concerned, not for the spoiled picture, but for Mary O'Brien's distress, so he patted her on the back and said, "Never mind, Mary, it is all right. I can soon put Mary Magdalene's face right again, so don't you bother any more about it."[7]

In subsequent years *Resurrection* was restored, so that today the tree at right, the Magdalen's expression, and Christ's blessing gesture all are different from their appearance in 1918. Duncan Phillips wrote in 1943,

I seem vaguely to remember that Mr. Montross told me that the painting had already been restored but he certainly did not specify in what area and the condition of the painting at that time [1928] was considered good. . . . A few years ago cracks began to reopen and the whole surface of the painting [began] to take on an alarming appearance. Therefore I sent it to the restorer in New York who has been doing our work.[8]

Phillips commented that the X-ray revealed the "technic of Ryder in starting a picture," showing Christ's head in a "softer more or less Old Mas-

terish contour. . . . The rest is a chaos of heavy brush strokes out of which was to emerge his conception."[9]

MJWD

Provenance: purchased by Mary Jane Morgan, New York, from Ryder, 1885; sold for $375 from Mary Jane Morgan Sale, Chickering Hall, New York, no. 168, 3–5 March 1886; purchased by James F. Sutton; to James S. Inglis, New York (but retained by Ryder), by 1892; to Newman E. Montross, New York, by 1905; acquired by the Phillips Collection, Washington, D.C., from Montross, 1928.

Notes

1. Hartmann, *History of American Art,* 1:312.

2. Jameson, *History of Our Lord,* 2:265. Jameson pointed out that as the Resurrection was not "witnessed by mortal eye, it takes no graphic form in Scripture," accounting for the diversity in its visual representations (p. 263).

3. De Kay, "American Gallery," 247. The Morgan collection included only six American artists. In 1887 an anonymous reporter included *Resurrection* on a list of unsold paintings from the Morgan sale: "For some time past, I have been told that certain pictures, supposed to have been sold at the Mary Jane Morgan sale, were being offered in this city, but I refused to believe it. Now a perfectly responsible and trustworthy informant assures me that the following seventeen paintings, supposed to have been knocked down to the highest bonafide bidders, were really bid in for the executor, with the knowledge and consent of the auctioneers, and that they are now on [*sic*] storage at the Lincoln Safe Deposit Warehouse, patiently awaiting a private purchaser" (*The Art Amateur* [June 1887]: 3).

4. Ibid. De Kay's opinion on this painting was not unanimous, for another critic wrote, "Mr. A. P. Ryder's imaginative feeling is poorly expressed in an inartistically composed and absurdly drawn 'Resurrection'" (*New York Times,* 11 February 1886).

5. Inglis to Wood, 10 March 1893, Wood Papers, Huntington Library. The letter must refer to *Resurrection* since *Christ Appearing to Mary* was in the collection of Thomas B. Clarke at this time.

6. Ryder to Weir [1896], Weir Papers, Archives of American Art. Sylvia Warner to Wood, 11 January 1899, Wood Papers, Huntington Library.

7. Robinson, "Reminiscences of Ryder," 176–77.

8. Phillips to Ethelwyn Manning, Frick Art Reference Library, New York, 26 February 1943, curatorial files, the Phillips Collection.

9. Phillips to Ethelwyn Manning, Frick Art Reference Library, New York, 11 March 1943, curatorial files, the Phillips Collection, Washington, D.C.

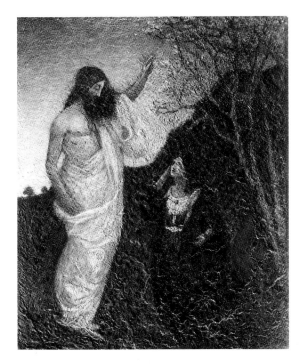

Cat. 52b. Photograph from the 1918 memorial exhibition, the Metropolitan Museum of Art, New York.

53 *Roadside Meeting (Meeting on the Road)*

canvas; 15¹³/₁₆ x 12⁷/₁₆ in. (40.1 x 31.6 cm)
The Butler Institute of American Art, Youngstown,
Ohio, 917-0-106
See also figure 83

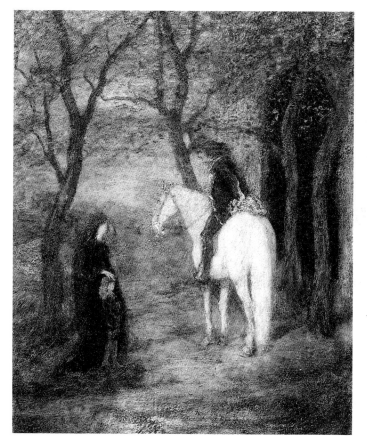

Cat. 53. Photograph from the 1918 memorial exhibition, the
Metropolitan Museum of Art, New York.

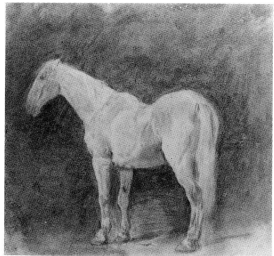

Cat. 53a. *Study of a Horse,* watercolor. Private
collection (courtesy of the Brooklyn Museum,
TL1987.181a).

"The picture by A. P. Ryder, 'Meeting on the
Road,' was a gift from the artist to his mother,
who was very happy and proud in the possession
of it. At her death it came back to Mr. Ryder
with some other things that she wished him to
have."[1] So wrote Louise Fitzpatrick, to whom
Ryder gave the painting before his death. *Road-side Meeting* has a blond tonality, with red high-lights in the trees, figures, and landscape. Ryder
has rendered the figures carefully, especially
those of the man and horse, the brushwork and
color building form in light and shadow.

An X-ray reveals that Ryder had at one time
placed the horizon slightly above the horseman's
head, creating a deeper landscape than the glade
in which the figures now meet. It also shows
that Ryder had once painted the horse with his
neck lowered as if grazing.[2] By lifting the horse's
head Ryder emphasized the immediacy of the
encounter, the action of a grazing horse implying
the passage of time.

Two Horses (see fig. 6) and a watercolor, *Study
of a Horse* (cat. 53a), depict animals nearly iden-tical in build and stance to the white horse in
Roadside Meeting. In each work Ryder convinc-ingly rendered a horse foreshortened as seen
from behind, paying particular attention to the
placement of the animal's legs and distribution of
its weight.

The subject of *Roadside Meeting* is not known;
one possible source is Sir Walter Scott's 1820
novel, *The Monastery,* set in the ruins of Melrose,
Scotland, following the religious wars with En-gland. Ryder painted another work exhibited in
1910 as *The Monastery,* which may also be re-lated to Scott's book.[3] An engraving from an
early edition of Scott's novel illustrates a scene in
which Dame Glendinning is interviewed by the
English soldier Stawarth Bolton (cat. 53b); she
fears that the "heathen soldier" will try to take

Cat. 53b. J. Williamson, *Dame Glendinning's Interview with Stawarth Bolton,* engraving (from Sir Walter Scott, *The Monastery* [1898 edition]).

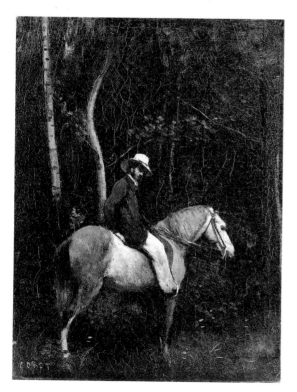

Cat. 53c. Jean-Baptiste Camille Corot, *Monsieur Pivot on Horseback,* ca. 1853, oil on canvas. National Gallery, London.

her children from her. Ryder's painting contains the basic elements of this encounter, placing the scene near a Gothic portal recalling medieval monastic architecture. The woman places her hand on her child's head as they are addressed by the horseman, who wears a nobleman's costume but not armor. Sources may exist in European painting as well, as for instance in a similar mounted horseman by Corot (cat. 53c).

The darkened portal recalls the forest grotto in Ryder's *Christ Appearing to Mary* (cat. 6), suggesting the woman's vulnerability and piety, both important elements of Scott's novel.[4] The meeting also recalls *King Cophetua and the Beggar Maid* (cat. 25), in which a richly dressed man stops his white horse, turning in the saddle to talk to a young woman. Women as victims of misfortune or noble spirits in humble circumstances occur throughout Ryder's oeuvre, confirming his deeply rooted interest in the theme regardless of its source and his propensity for extracting the essence of a narrative without representing it as written.

ELJ

Provenance: Ryder to his mother; back to Ryder after June 1892; Louise Fitzpatrick by 1918; M. Knoedler & Co., New York, October 1915; purchased by Vose Galleries, Boston, 7 September 1917; purchased by Joseph G. Butler, Jr., Youngstown, Ohio, 25 May 1918; the Butler Institute of American Art, Youngstown, 25 May 1918.

Notes
1. Louise Fitzpatrick to Roland Knoedler, September 1917, curatorial files, the Butler Institute of American Art.

2. Curatorial files, the Butler Institute.

3. *A Group of Twenty-four Paintings of the French, Spanish, German, and American Schools Selected from the Cottier Gallery,* ex. cat. (New York, 1910), 56–57, "Purchased from the artist by the late James S. Inglis" (American Art Auction and Exhibition Catalogues, Archives of American Art; the painting is now in the collection of the Parrish Museum, Southampton, New York).

4. The figures of a woman and child recur as a similar motif in *Autumn Landscape* (cat. 1).

54 *Scottish Castle*

composition board; 14 x 10½ in. (35.5 x 26.7 cm)
Collection of Thomas Fidelo, Edinburgh, Scotland
See also figure 68

Scottish Castle surfaced at an auction in Edinburgh, Scotland, in 1985, titled by auctioneers and attributed only as "Scottish School." The painting was consigned by a couple in Paisley, seven miles west of Glasgow. Although lacking any exhibition history or further provenance, this small panel is consistent with Ryder's works in both brushwork and palette. The white-capped waves resemble those in *Jonah* (cat. 24), and the dark brown landscape tones recall those of *The Windmill* (cat. 75). The subject and mood are close to *Macbeth and the Witches* (cat. 35), in which a hilltop castle appears at right. The small size of the panel and thin paint film suggest that it may have served as an oil sketch for *Macbeth*

and the Witches or may have simply been a small study to be sold separately.[1]

An X-ray shows the image faintly, with characteristic dense paint on the moon and looser brushwork corresponding to the turbulent water. Darkened by layers of varnish, the painting is difficult to see unless viewed under intense illumination. The paint at lower right is "alligatored" (surface paint layers have dried more quickly than oily underlayers, causing tensions in the paint film).[2]

Since several references to works by Ryder in early exhibition histories and auctions remain unidentified, it is possible that some of his paintings are misattributed in private collections and museums. Such a discovery in Scotland is not surprising, due to Ryder's myriad connections there and Anglo-Scottish literary interests.[3] His dealers, Daniel Cottier and James Inglis, were Scots; Inglis, in fact, was born in Paisley and had relatives there, suggesting a possible connection with *Scottish Castle*. Cottier & Co. maintained a gallery in London and enjoyed a cooperative arrangement with a dealer in Glasgow, William Craibe Angus, who traveled with Ryder in 1877. William Macbeth, another Scot who owned a New York gallery, once asked why he had to go to England to obtain Ryder's paintings.

The motif of the gloomy castle is prominent in Gothic novels, such as those by Sir Walter Scott. Scott's description of Wolf's Crag Castle in *The Bride of Lammermoor* could almost describe Ryder's painting:

Tall and narrow it stood, glimmering in the moonlight like the sheeted spectre of some huge giant. A wilder or more disconsolate dwelling, it was perhaps difficult to conceive. The sombrous and heavy sound of the billows, successively dashing against the rocky beach at a profound distance beneath, was to the ear what the landscape was to the eye—a symbol of unvaried and monotonous melancholy, not unmingled with horror.[4]

Views of mountaintop castles enveloped in mystery are standard fare in paintings by Scottish and English artists of the eighteenth and nineteenth centuries, such as Alexander Nasmyth, John Thomson of Duddingston, and

Turner.[5] Cottier & Co. marketed a line of stained-glass windows representing views of old Scottish towns such as Aberdeen, Ayr, Dumbarton, and Edinburgh as well as sites like the Castle of Dumbarton or "Old Scotch Castle of Dunnotar."[6] With an eye toward the taste of British patrons in particular, Ryder was no doubt inspired by what obviously was a genre popular with collectors.

MJWD

Provenance: purchased by Thomas Fidelo, Edinburgh, Scotland, from Phillips Auction, Edinburgh, sale 2354, no. 33 (as "Scottish School: A rocky coast by moonlight"), 5 July 1985.

Notes

1. See *Macbeth and the Witches* and *Siegfried and the Rhine Maidens* (cat. 35, 59) for references to other oil sketches.

2. The painting shows evidence of conservation at upper left in the sky. Some inpainting can be seen, most notably in the lower center of the composition.

3. Ryder made trips to the United Kingdom in 1877, 1882, 1887, and 1896. One of his purposes may have been to contact patrons there, for in an undated letter (probably 1882) sent from a London address by Ryder to de Kay, he wrote, "I have got my money from Scotland" (Frick Art Reference Library, New York).

4. Sir Walter Scott, *The Bride of Lammermoor* (1819; London, 1893), 98.

5. Turner helped popularize Scottish themes with his drawings of the Scottish countryside, engraved for *The Provincial Antiquities of Scotland* (1822), with text by Sir Walter Scott.

6. *House of Cottier*.

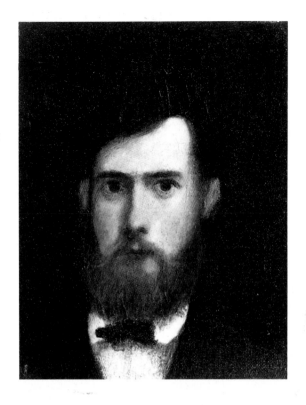

55 *Self-Portrait*

canvas mounted on wood; 6½ x 5 in.
(16.5 x 12.7 cm)
Collection of Mr. and Mrs. Daniel W. Dietrich II
See also figure 1

Ryder painted this self-portrait about 1878, when he was thirty-one years old, giving it to Charles de Kay in 1881.[1] Apart from two small vignettes on a mirror frame (cat. 9), this is the only instance in which Ryder attempted a portrait. Although modest in dimension, it is ambitious in intensity, with staring eyes conveying the sense of "soul" that Ryder admired in portraits by his tutor, William E. Marshall.

In 1902 Wood wrote to Weir, "A letter from that sweet minded philosopher Bishop Ryder came today, telling of things which make my mouth water. A portrait of himself—'A lovely bit of painting,' two 'fine large' landscapes—etc. etc. I'd like to be there to see."[2] No further mention of this self-portrait occurs; if the letter refers to a second self-portrait, Ryder either abandoned this effort or the painting is now lost.

The frontispiece in Frederic Newlin Price's 1932 catalogue purported to be Ryder's self-portrait in his studio, with the painting *Nourmahal* on the wall at upper right. As *Nourmahal* has been proven false this must be considered a case of one forgery incorporating another in order to impart a measure of legitimacy to both (see figs. 141, 144). This forged self-portrait may be identical to the painting mentioned in 1925, which was said to include the image of *The Temple of the Mind* in the upper-right corner; *The Temple of the Mind* and the forged *Nourmahal* both feature classical porticoes and so might have been easily confused.[3]

ELJ

Provenance: presented to Charles de Kay, New York, by Ryder about 1881; consigned to Macbeth Gallery, New York, by Florence (Mrs. Charles) de Kay, valued at $1,500, 15 February 1932; returned to Charles de Kay, 9 March 1933; purchased by Harry Stone Gallery, New York, ca. 1933; Morton R. Goldsmith, Scarsdale, New York, by January 1938; Macbeth Gallery, 23 December 1953; purchased by Lawrence A. Fleischman, Detroit, 30 January 1954; acquired by Mr. and Mrs. Daniel W. Dietrich II after 1961.

Notes
1. Robinson, "Reminiscences of Ryder," 176.
2. Wood to Weir, 10 November 1902 (quoted in Young, *Letters of Weir,* 217).
3. T. H. Russell to T. Durland Van Orden, 29 April 1925: "As for the little self-portrait, which both Mrs. Van Orden and you admired so much the other day, I am in rather an embarrassing position. The Albright Gallery, who is the owner of 'The Temple of the Mind' which appears in the upper right hand corner of the little self-portrait, is very anxious to obtain this small example and has made a very tempting offer" (curatorial files, National Museum of American Art).

56 *A Sentimental Journey (Moonlight Journey)*

canvas; 12 x 10 in. (30.5 x 25 cm)
Canajoharie Library and Art Gallery, New York, 317207
See also figure 61

A Sentimental Journey takes its title from Laurence Sterne's winding narrative of the same name.[1] Rather than a specific moment in Mr. Yorick's amorous adventures, Ryder evokes the magic of carriage travel by moonlight. Horses and harnesses are bathed in gentle rays, casting long shadows beside the road. Giant trees with trunks entwined frame the road, giving way as the coach rounds the bend, seemingly headed for the moon.

Ryder's painting *The Windmill* (cat. 75), alternately entitled *Honeymoon,* conveys a similar anticipation as a farm cart containing a couple drives toward a windmill, their passage illuminated by the moon.[2] The moonlit journey in these paintings conveys a romantic undercurrent, and they are both related to other moonlit trysts, such as *The Lovers* (see fig. 62) and *The Lovers' Boat* (cat. 34) and the more desperate escaping lovers in *Lord Ullin's Daughter* (cat. 32).

ELJ

Provenance: Daniel Cottier, New York; E. B. Green-
shields, Montreal, Canada, 1889; Mrs. E. B. Green-
shields, Montreal; sold for Edward Greenshields
(Greenshields's son) by W. Scott & Sons, Montreal,
and Weitzner, Inc., to Macbeth Gallery, New York,
February 1937; purchased by Bartlett Askill for Cana-
joharie Library and Art Gallery, New York, 22 March
1937.

Notes

1. Laurence Sterne, *A Sentimental Journey through
France and Italy, by Mr. Yorick* (1768; New York:
Dutton, 1927).

2. A label on the stretcher of the painting—affixed
when the work was in the Chester Dale Collection
during the 1930s—identifies it as "The Windmill
(Honeymoon)."

57 *The Shepherdess*

gilded wood; 10⅛ x 6¹³⁄₁₆ in. (25.7 x 17.3 cm)
The Brooklyn Museum, purchased through the
Frederick Loeser Fund, 14.553
See also figure 47

A layer of gold leaf, adhered to the panel by a
pigmented adhesive, appears to underlie the im-
age.[1] On this gilded surface Ryder applied thin,
pale tints, scratching through the paint to create
gold highlights in the foliage of the trees and
elsewhere. The young maiden, sheep, and trees
are drawn with a black calligraphic line; the
dotted brown wash in the foliage at right gives
the work an almost oriental delicacy. Ryder was
undoubtedly influenced by the decorative, eclec-
tic aesthetic of his dealer Daniel Cottier who
specialized in objects for domestic interiors. The
thin paint film, gold leaf, and rococo charm of
the work link it to decorative projects of the late
1870s.

In *The Shepherdess* Ryder combined a decora-
tive aesthetic with a pastoral subject. The theme

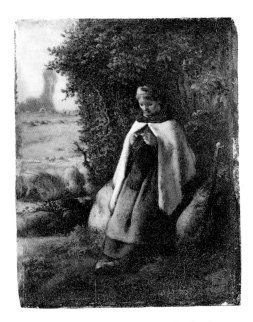

Cat. 57a. Jean-François Millet, *Shepherdess Seated on a Rock,* oil on wood. The Metropolitan Museum of Art, gift of Douglas Dillon, 1983.446.

Cat. 57b. Winslow Homer, *Fresh Air,* 1878, watercolor over charcoal. The Brooklyn Museum, Dick S. Ramsay Fund, 41.1087.

of the shepherdess pervaded nineteenth-century European and American art, reflecting the nostalgia for pre-industrial life and the taste for secular subjects with religious overtones. Cottier himself rendered the subject in stained glass (see fig. 36). Millet's *Shepherdess Seated on a Rock* (cat. 57a), which entered a New York collection in 1879, is one of many similar works from the Barbizon school. William Morris Hunt's *Belated Kid,* 1857 (Corcoran Gallery of Art), and Winslow Homer's *Fresh Air* (cat. 57b) show American adaptations of the theme. Ryder painted shepherdesses at least three times, emphasizing their purity and closeness to nature.[2]

In April 1887 Ryder's small panel was included in the *Third Prize Fund Exhibition for the Promotion and Encouragement of American Art.* The painting was one of six from the collection of Daniel Cottier's widow that Ryder signed and dated on the verso on 12 November 1914; all six entered the collection of the Brooklyn Museum on 14 December 1914 and were exhibited there in November 1917.

SLB

Provenance: Cottier & Co., New York, by April 1887; purchased by the Brooklyn Museum from Mrs. Daniel Cottier through the Frederick Loeser Fund, 14 December 1914.

Notes
1. Conversation with Ken Moser, conservator, the Brooklyn Museum, 25 July 1988.
2. See *Florizel and Perdita* (see fig. 81) and *Joan of Arc* (cat. 23). Another Ryder painting of a shepherdess (unlocated) is mentioned in a letter from Mrs. Spingarn to Bryson Burroughs of the Metropolitan Museum, 6 March 1918 (the Metropolitan Museum of Art Archives).

58 *Shore Scene (Pirate's Island; Pirate's Isle)*

gilded leather, mounted on canvas; 9½ x 27¼ in.
(24.1 x 69.2 cm)
Georgia Museum of Art, the University of Georgia,
Athens, Eva Underhill Holbrook Memorial Collection
of American Art, gift of Alfred H. Holbrook, 45.78
See also figure 46

60 *The Smugglers' Cove*

gilded leather; 10⅛ x 27¾ in.
(25.7 x 70.5 cm)
The Metropolitan Museum of Art, New York,
Rogers Fund, 09.58.2
See also figure 45

Both *Shore Scene* and *The Smugglers' Cove* are
decorative panels, probably made in the 1870s as
a pair to be fitted into furniture (see cat. 3),
although it is not known if they were ever
mounted. Both were owned by James Inglis until
his death in 1909, when they were sold as indi-
vidual paintings.

With the inception of the grand tour in the
eighteenth century, the vogue for tales and im-
ages of distant places increased steadily. Travel
guides and travelers' recollections warned of the
perils of the journey to Italy through stories of
coaches accosted by bandits in alpine passes and
ships beset by pirates lurking in offshore coves.
The Neapolitan coastline, in particular, was stud-
ded with cliffs and coves inhabited by pirates.
Responding to the tales, artists across Europe
painted mementos of journeys made or envi-
sioned, and shipwrecks, smugglers' coves, and

pirate raids became standard themes for a public
familiar with such subjects from literature.

Although Italy provided the impetus for this
genre, each country gave it a particular twist; by
the nineteenth century tales of piracy along the
Scottish coast inspired Robert Louis Stevenson to
write some of his most compelling prose.[1] Amer-
ican collectors acknowledged the vogue for this
romantic side of life at sea, and American paint-
ers filled exhibitions with subjects of seagoing
adventure. Domesticated versions of ocean-going
furniture—ships' chests and captains' desks
among them—provided ample opportunities for
the addition of decorative panels bearing such
subjects.

Shore Scene is an eventide homecoming, as
two men and a dog return from a ship beached
near shore. Headed for a thatched cottage nestled
behind a spit of land, each man carries a loaded
sack. In *The Smugglers' Cove* a ship is unloaded
while one man scrapes its keel. The tide is out,
and a harnessed horse stands patiently near the
shore. Two houses have been built deep into the
recesses of the cove, the one on the left made
from an upturned ship's keel.[2] A third horizontal
panel, *Sunset: Marine* (see fig. 43), is similar in
arrangement of forms, depicting a headland close
to shore along which a small clipper ship sails.[3]

Where the paint is thinly applied on *Shore
Scene* the gilding is visible; the surface of the
work, however, has been extensively retouched.[4]
The paint layer on *The Smugglers' Cove* obscures
the gold leaf to such an extent that its presence
was confirmed only through autoradiography in
1978.[5] As with all of Ryder's leather panels, the
support has become brittle over time. Curiously,
Shore Scene reveals canvas weave along the lower
edge of the panel and leather texture everywhere
else. If the painting was removed from a piece of
furniture and damaged in the process, it is possi-
ble that the painting was then relined with can-
vas, showing through where the leather had been
torn. *The Smugglers' Cove* contains one oddity, a
rectangular patch roughly six-by-eight inches,
centered on the panel, which appears slightly

raised from the rest of the surface, as though something lies beneath the pigment.

ELJ

Provenance of cat. 58: James S. Inglis, New York; purchased by Alexander Morten, New York, for $430 from James S. Inglis of Cottier & Co. Estate Sale, American Art Galleries, Mendelssohn Hall, New York, no. 75, 12 March 1909; consigned by Marjorie (Mrs. Alexander) Morten, New York, to Macbeth Gallery, New York, 29 September 1917; purchased by Vose Galleries, Boston, 5 October 1917 (with *The Gondola* and *The Hunter's Rest,* all three for $5,500); purchased by George H. Webster, Haverhill, Massachusetts, 21 February 1919; purchased by Milch Galleries, New York, from Mr. Platt (or Pratt), Springfield, Massachusetts; purchased by Alfred H. Holbrook, ca. 1943–44, from Milch Galleries; gift of Holbrook to Georgia Museum of Art, the University of Georgia, Athens, 1945.

Provenance of cat. 60: James S. Inglis, New York; purchased by the Metropolitan Museum of Art, New York, Rogers Fund, from James S. Inglis of Cottier & Co. Estate Sale, American Art Association, Mendelssohn Hall, New York, no. 59, 12 March 1909.

Notes

1. Stevenson's *Treasure Island* (1883), *Kidnapped* (1886), and *The Master of Ballantrae* (1889) are all tales of piracy and adventure at sea. As early as 1822 Sir Walter Scott wrote *The Pirate,* set in Scotland, although pirates figure in the tale only peripherally.

2. Curatorial files, the Metropolitan Museum of Art.

3. *Sunset: Marine* (8¾ x 26 in.) was owned by Ralph M. Coe, Cleveland, and is now unlocated.

4. Curatorial files, Georgia Art Museum, the University of Georgia.

5. Bolger-Burke, *American Paintings in the Metropolitan,* 3:10. Both *Shore Scene* and *The Smugglers' Cove* are discussed in detail in this volume.

59 *Siegfried and the Rhine Maidens*

canvas; 19⅞ x 20½ in. (50.5 x 52 cm)
National Gallery of Art, Washington, D.C.,
Andrew W. Mellon Collection, 1946.1.1
See also figure 75

Some have claimed that Ryder had a "devotion to Wagnerian opera,"[1] but it is probably more accurate to say that he attended the opera occasionally with his friend Inglis, a true music devotee who subscribed to a box at the Metropolitan Opera.[2] In addition to this painting, based on a scene from *Die Götterdämmerung,* it is possible, although not at all certain, that *The Flying Dutchman* (cat. 15) may have been based on a Wagnerian opera. Certainly, the composer's work enjoyed widespread popularity in nineteenth-century America, and Ryder's painting can be viewed in terms of this phenomenon.[3]

The story of the painting *Siegfried and the Rhine Maidens* is related by Elliot Daingerfield, as told to him by Ryder: "He said, 'I had been to hear the opera and went home about twelve o'clock and began this picture. I worked for forty-eight hours without sleep or food, and the picture was the result.' "[4] This statement has been thought to mean that Ryder finished the picture in two days. A small landscape sketch (cat. 59a) survives, however, that is related to the painting, indicating that Ryder probably first worked out the general patterns, contrasts, and

masses in the landscape and then began the larger composition once these details had been decided.[5] This sketch, along with the evidence in the painting itself of long labor and built-up paint film, suggests that much more than two days was required to complete the painting. By 1891 the completed large painting was exhibited at the New York Athletic Club; thus, Ryder may have taken as long as three years to complete *Siegfried*.

The scene from *Die Götterdämmerung* that made such a strong impression on Ryder was the first scene of the third act, in which Siegfried is enchanted by the Rhine Maidens, who cry out for the golden ring worn on his finger.[6] Just as he has resolved to give in to their desires, Siegfried recoils as the Rhine Maidens tell of the curse hidden in his ring and prophesy his death. His is a tragic triumph as he stands ready to face his destiny.

Ryder's choice of this scene reflects the critics' judgment that it was among the opera's most exciting moments. Following the New York premiere in 1888, one wrote, "The third act from beginning to end is indescribably beautiful. It is hardly too much to say that it surpasses everything else in opera. . . . The whole of the scene between the three maidens and Siegfried is simply bewitching in its sensuous and poetic beauty."[7] Hartmann used identical praise for Ryder's painting, commented that in *Siegfried and the Rhine Maidens* Ryder has shown how he could "flood a picture with sensuous, bewitching poetry."[8]

A critic, reviewing the 1902 Society of American Artists twenty-fourth annual exhibition in New York, wrote, "Such a picture as this recalls no other that one has seen, being at once so fantastic, voluptuous, and tranquil."[9] It was shown again in the 1904 *Comparative Exhibition of Native and Foreign Art*. In 1910 it was in Berlin at *Die Ausstellung der amerikanische Kunst*. The painting of Wagner's knight-hero was long owned by Sir William Van Horne, who was himself in 1894 made an Honorary Knight Commander of the Order of Saint Michael and Saint George; in the words of a friend, "no one was

Cat. 59a. *Landscape Sketch.* Collection of Berta Walker, New York (courtesy of Peter A. Juley & Son Collection, National Museum of American Art, Smithsonian Institution, Washington, D.C.).

Cat. 59b. Jean-Baptiste Camille Corot, *Macbeth and the Witches*, 1858–59, oil on canvas. The Wallace Collection, London (courtesy of the Trustees of the Wallace Collection).

more courtly than he was, when he chose to be courtly, and no one was ever more chivalrous to women than he was at all times."[10]

The forms of sky and landscape, bathed in an eerie, almost artificial yellow light, sweep outward with furious energy. Elliot Daingerfield cherished its almost musical rhythms, and Frank Jewett Mather, Jr., wrote: "It has steely coruscations worthy of a Greco, and in mere pattern is consummate; it conveys most energetically its sense of doom."[11]

While no reproductions of the set designs from the New York performances of *Die Götterdämmerung* survive, a comparison of the painting to stage sets for the opera at Bayreuth in 1876 (reused in Kassel in 1890) show that Ryder's design echoes stage conventions to some extent, which may themselves be derived from painting.[12] Aspects of Ryder's *Siegfried* are similar to Corot's painting *Macbeth and the Witches* (cat. 59b), a subject Ryder was undertaking himself at this time (cat. 35).

Early photographs of the painting reveal that extensive cracks had developed in the composition before 1905 and that they had been repaired by 1907, possibly by Ryder.[13] The photograph from the 1918 memorial exhibition catalogue shows that the condition of the painting had worsened. In 1946, after its purchase by the National Gallery, the painting was relined and cleaned, with old restorations and stains removed and traction cracks repaired.[14] Compared to many of Ryder's works, the painting is quite stable, and its light and color remain bewitching.
MJWD

Provenance: Richard Haines Halsted, New York, by 1891; Sir William Van Horne, Montreal, Canada, by 1895; Lady Van Horne, Montreal, September 1915; purchased for $23,500 by Chester Dale, Chicago, from William Van Horne Estate Sale, Parke-Bernet, New York, no. 18, 24 January 1946; purchased by National Gallery of Art, Washington, D.C., from Dale, ca. April 1946.

Notes
1. Beck, "Ryder: An Appreciation," 42. His is the first embellishment of Ryder's interest in music, repeated by subsequent writers.

2. Inglis seems not to have been devoted to Wagner, however, writing to Wood on 12 December 1893: "Nice opera now and beautiful singers—no sauerkraut as [Olin] Warner says—all French and Italian" (Wood Papers, Huntington Library).

3. For a different approach see Johns, "Ryder: Thoughts on His Subject Matter," 164–71. Arguing more generally for the far-reaching effects of social Darwinism in nineteenth-century American culture, Johns interprets a number of Ryder's paintings as emblematic of a changing world view.

4. Daingerfield, "Ryder: Artist and Dreamer," 380. *Die Götterdämmerung* had its New York premiere at the Metropolitan Opera on 25 January 1888 and was performed several times in February (see Paul E. Eisler, *The Metropolitan Opera: The First Twenty-Five Years, 1883–1908* [Croton-on-Hudson, N.Y.: North River, 1984], especially 150–52.

5. The sketch is currently owned by Berta Walker in New York. See Horatio Walker's comments on Ryder's use of sketches in the entry for *Macbeth and the Witches* (cat. 35).

6. " 'Rhinegold! Rhinegold!' And so their plaintive, beautiful trio runs on, with its liquid melody and limpid harmony, until we would gladly plunge into the depths with them like any doomed sailor into his mermaid's arms. It is the old enchantment, the familiar pull backwards into irresponsible bliss, the perennial unconscious fantasy of return to the mother's embrace. It is hard to believe that such a promise of delight can conceal such a lure of danger" (Robert Donington, *Wagner's "Ring" and Its Symbols* [London: Faber & Faber, 1963], 232).

7. *New York Times,* 26 January 1888, 5.

8. Hartmann, "A Visit to Ryder," 8.

9. *International Studio,* 1902, Sherman scrapbook, Force Papers, Archives of American Art.

10. James Mavor, *My Eyes on the Street of the World* (London, 1923), 2:233.

11. Daingerfield, "Ryder: Artist and Dreamer," 380. Mather, *Estimates in Art,* 173.

12. Oswald Bauer, *Richard Wagner: The Stage Designs and Productions from the Premieres to the Present* (New York: Rizzoli, 1983), 239–45.

13. Goodrich notes, conservation files, National Gallery of Art.

14. Treatment report, October–November 1946, conservation files, National Gallery of Art.

60 **The Smugglers' Cove** (see cat. 58)

61 **Spirit of Autumn**

panel; 8½ x 5¼ in. (21.6 x 13.3 cm)
Columbus Museum of Art, Ohio, bequest of
Frederick W. Schumacher, [57] 47.68

Painted on a wooden cigar-box panel, *Spirit of Autumn* was completed around 1875, while Ryder was a student at the National Academy. Ryder painted it for fellow student Stephen G. Putnam, in gratitude for his having helped nurse Ryder through an attack of typhoid fever. According to Putnam, Ryder refused to accept payment for the painting. Putnam persisted, and in a compromise, Ryder signed the panel before accepting five dollars for it.[1]

Spirit of Autumn portrays a woman standing before a tree, reminiscent of standing, silent figures by Corot and Millet. Ryder articulated the rough texture of the tree trunk, going back into the wet paint with the butt of his brush to create

the pattern of the bark. The seasonal title here and in *Spring* (cat. 62) may have allegorical meaning. Described as containing "elegiac overtones" in which mood supplants narrative, Ryder's painting is linked to the tonalist tradition prevalent at the time.[2]

Spirit of Autumn was stolen briefly from the museum in November 1957 and was recovered in April 1958.[3]

ELJ

Provenance: Stephen G. Putnam, New York, 1875; purchased by Frederic Fairchild Sherman from Putnam, 9 February 1920; Julia Munson (Mrs. Frederick) Sherman, New York; purchased by Jacob Schwartz, Brookline, Massachusetts, from Sherman, 1944; purchased by Frederick W. Schumacher from Parke-Bernet Galleries, New York, no. 32, 26 February 1947; bequest of Schumacher to Columbus Museum of Art, Ohio, 1957.

Notes
1. Letter from Stephen G. Putnam to Frederic Fairchild Sherman, 5 November 1937, and Goodrich notes, both in the curatorial files, Columbus Museum of Art.

2. D.F.H., "Albert Pinkham Ryder," in *The Frederick W. Schumacher Collection,* ed. Katherine Paris (Columbus, Ohio: Columbus Gallery of Fine Arts, 1976), 27.

3. News releases, 4 November 1957 and 2 April 1958, curatorial files, Columbus Museum of Art.

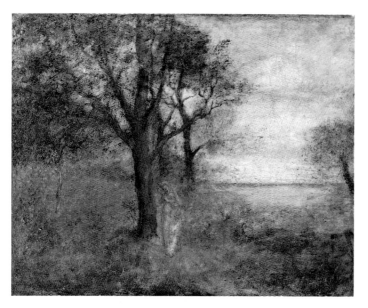

62 *Spring (Landscape, Spirit of Dawn; Spirit of Spring; Springtide)*

canvas; 14¼ x 18¾ in. (36 x 47.5 cm)
The Toledo Museum of Art, gift of Florence Scott
Libbey, 23.3134
See also figure 29

Among Ryder's earliest offerings to the Society of American Artists exhibitions was *Spring,* shown in 1879 and well reviewed in the *New York Times.*[1] In 1880 William Brownell began a series of articles entitled "The Younger Painters of America," in which he traced the evolution of the Society of American Artists, claiming as their province the exploration of feeling over form.[2] Brownell illustrated *Spring*—apparently the first time a painting by Ryder was reproduced; he noted Ryder's struggle with figures but cautioned, "If he should suddenly realize their shortcomings in these respects and attempt to correct them out of hand, we should fear for their poetic feeling, their engaging color, and their softness and tenderness; even to lose their fragmentariness would, one feels, be risky."[3] Through such comments, Ryder's work became emblematic of the new art current.

The engraving in Brownell's article confirms that Ryder did not alter the painting after 1880, although many details are faint today, indicating some fading. The woman appears to hold a small child who reaches across her body to her raised right hand. The area just below may once have included a hat or basket of flowers hanging over her arm. The figure is as much allegorical as real—Botticelli's *Primavera* recast through Corot.

Curiously, the relatively thin paint film, which appears to have many glazes, is substantially thicker along the left edge of the canvas, as if the painting were stored resting on its left edge while the varnish was still wet.

ELJ

Provenance: purchased by James W. Ellsworth, New York, from Ryder by 1890 (as *Springtide*); M. Knoedler & Co., New York, February 1923 (as *Landscape, Spirit of Dawn*); Chester H. Johnson, Chicago, April 1923; Florence Scott Libbey; gift of Libbey to the Toledo Museum of Art, 1923.

Notes
1. "The American Artists: Varnishing Day of the Second Exhibition," *New York Times,* 8 March 1879 (for the text of the review see here "A New Society for Art").
2. Brownell, "The Younger Painters of America—First Paper," 7.
3. Ibid., 10.

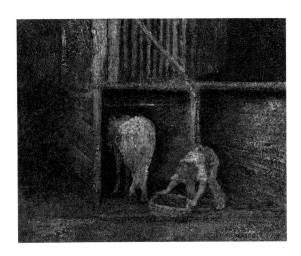

63 The Stable

canvas; 8 x 10 in. (20.3 x 25.4 cm)
The Corcoran Gallery of Art, Washington, D.C., gift of
Mabel Stevens Smithers, 1949, the Francis Sydney
Smithers Memorial, 49.51
See also figure 7

The Stable may have been the painting Ryder
exhibited in 1875 at Cottier & Co., described as
a stable interior "suggestive of promise."[1] Exhib-
ited in 1882, this painting garnered favorable
reviews:

The creature stands with drooping head and relaxed
muscles, the very incarnation of weariness. The golden
straw of the stall is of a color that lights up the whole
rather sombre stable interior, and on one of those chill
November days gives the beholder a pleasurable sensa-
tion of warmth. The picture is painted in Mr. Ryder's
individual and striking manner, and has a depth of
tone and subtlety of expression not to be fathomed at
the first glance.[2]

Owned initially by Stanford White, *The Stable*
brings together Ryder's love of horses and early
interest in genre subjects. The stable architecture
is similar to the setting of *Two Horses* (see fig.
6), and the foreshortening of the animal is con-
vincingly rendered. A reviewer noted in 1914
that Ryder's short, directional brushstrokes create
form from "little spots and blots of paint [mak-
ing a] mysterious appeal to the imagination" and
continued, "Quiet and unpretentious, what hu-
man quality gives the simple design the power
that tells us that the artist has felt more deeply
and conceived more largely than his neighbors?"[3]

Ryder painted a still smaller stable scene (cat.
22a), with a groom sweeping behind the bay
horse similar to *In the Stable* (cat. 22). Both
small oil sketches may have been used as com-
positional studies for the larger work—Ryder's
way of studying a subject without using the
more traditional method of multiple composi-
tional drawings.

ELJ

Provenance: Stanford White, New York; purchased for
$325 by James G. Shepherd, Scranton, Pennsylvania,
and New York, from Stanford White Estate Sale,
American Art Association, Mendelssohn Hall, New
York, no. 22 (as *In the Stable*), 11 April 1907; Macbeth
Gallery, New York, June 1913; purchased for $750 by
Mr. and Mrs. Francis Sydney Smithers, New York, 6
April 1914; Mabel Stevens (Mrs. Francis Sydney)
Smithers; gift of Smithers to the Corcoran Gallery of
Art, Washington, D.C., 1949.

Notes
1. *Boston Saturday Evening Gazette*, n.d., Gilder Pa-
pers, New York Public Library.

2. "The American Art Association's Exhibit," *Boston
Daily Evening Transcript*, 25 November 1882, 10:3–4.

3. "Group of Paintings by American Artists," *New
York Evening Post*, 4 April 1914, curatorial files, the
Corcoran Gallery of Art, Washington, D.C.

64 *The Story of the Cross*

canvas mounted on panel; 14 x 11⅜ in.
(35.5 x 28.9 cm)
Guennol Collection
See also figures 94, 112

The Story of the Cross was heralded in 1890 by
de Kay as "represent[ing] an age when Christianity had vanished from most communities but still
lingered among the shepherds. . . . The color was
as remarkable as the idea, which plainly aims at
the present confusion in Christendom."[1] Its color
today remains exceptional, almost supernatural,
producing an effect not unlike the glow of a
medieval icon. The woman and child have the
awkward posture and flattened quality of Sienese
"primitive" madonnas by Duccio and Cimabue,
to whom Ryder was compared by early critics.
The painting may represent his effort to reclaim
the severe spirituality of an earlier age.

Ryder worked and reworked the composition,
at one point bringing it "almost to a finish, when

it was ruined by being transferred to another
canvas."[2] In correspondence from 1892–93 Inglis
complained to Wood about Ryder's slow progress:

The Story has now got the length of being a full
fledged lie—though it is done and has been in our
place for over two weeks now. . . . [I] haven't let it go
back, though [Ryder] wants it just to put a little
finishing touch on it—after all it is quite beautiful and
has made him "lots" of friends. Of course there is no
end of queer things about it, but it's art and no
mistake.[3]

Ryder also wrote to Wood, saying, "I am having
a frame, the best that Wilmarth can make, chosen by Mr. Inglis who is wonderful in making
combinations into effect, made for the Story of
the Cross, as a little expression of kindness to
you and Mrs. Wood. Picture and frame will be
sent to you as soon as Cottier['s] is finished."[4]
Judging from such remarks, the painting was
destined to be Wood's but exactly when he received it is not certain, and it eventually came
into the possession of Helen Ladd Corbett, a
friend of Wood's.[5]

A tightly rendered pen drawing of the composition exists (cat. 64a), which has been interpreted as a guide prepared by Ryder for an
engraver; the constrained penwork and fancy lettering of the signature suggest that it may be a
copy of the composition by another hand.

The Story of the Cross was interpreted by a
later critic as a "charmingly sympathetic representation from which one gathers a new understanding of the poetry of the Gospels,"[6] and yet
it is unlike Ryder's other religious paintings,
which rely on biblical stories. It parallels the
iconography of the flight into Egypt;[7] as a secularized version of the Holy Family, it is related
to other veiled or secularized religious themes in
nineteenth-century American art, especially the
Madonna and child. Such religious associations
also underlie the rural subjects of Barbizon
painting.

Wayside crosses or shrines had political ramifications in France during the early nineteenth
century.[8] While European in origin, stemming

Cat. 64a. *The Story of the Cross.* The Art Museum, Princeton University, New Jersey, gift of Frank Jewett Mather, Jr., 48-1789.

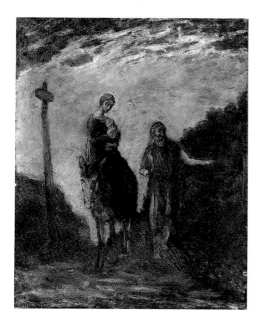

Cat. 64b. *Flight into Egypt.* Unlocated (courtesy of Peter A. Juley & Son Collection, National Museum of American Art, Smithsonian Institution, Washington, D.C.).

from works by Rembrandt and other seventeenth-century artists, scenes of peasants worshiping at wayside shrines were symbols of religious piety early in American art, as in Samuel Morse's *Chapel of the Virgin at Subiaco,* 1830 (Virginia Museum of Fine Arts, Richmond). In the late nineteenth century such scenes were found in works of the Barbizon school but also in modernist paintings such as Gauguin's *Yellow Christ,* 1889 (Albright-Knox Art Gallery, Buffalo). The subject emerged in works by American painters such as Elliot Daingerfield, Alexander Schilling, and Horatio Walker (see fig. 143) as well as Ryder.

Some confusion has existed as to whether *The Story of the Cross* was begun as *Flight into Egypt* or whether two separate works existed, the latter now lost. Writing in 1926, Hartmann recalled a "humorous incident" in Ryder's studio involving a slide on a work identified as *The Flight into Egypt.*[9] In 1897 Ryder mentioned having begun a *Flight into Egypt*—this comment coming well after the "pending" departure of *The Story of the Cross* is mentioned, suggesting that he had begun a new composition.[10]

A *Flight into Egypt* (cat. 64b), now unlocated, was lent by Louise Fitzpatrick to the Ryder 1918 memorial exhibition. Concerning this picture, Fitzpatrick wrote to Wood in 1917: "I will show you a picture that Mr. Ryder gave me when I was ill last year. I hope that I will never have to part with it. It is not much more than a sketch, a shepherd pointing to a wayside crucifix; one of the things he did not finish, perhaps you remember it?"[11] This painting has a curiously illogical composition, with the cross on the left, while the figures focus their attention toward the right; it should be considered with caution.[12]

The Story of the Cross was conserved twice by Sheldon and Caroline Keck, in June 1957 and March 1966. In the first treatment the paint was found to emit a strong odor of linseed oil when the lining was removed and the stretcher was heavily stained with oil. The adhesive securing the lining canvas was determined to be a mixture of varnish resin and oil paint, which had been irregularly applied and was full of air pockets— probably Ryder's own work. When the reverse of

the original canvas was revealed, a tear was found in lower center, suggesting that the canvas was relined before Ryder finished the painting, supporting de Kay's remarks in 1890.

Despite efforts to stabilize the composition, wet underlayers of paint continued to flow and cause wrinkling of the paint film, and the painting was returned in 1966 for more work.

MJWD

Provenance: Helen Ladd Corbett, Portland, Oregon, by 1907; to C. E. S. Wood, Portland, 1918, from Corbett; R. C. & N. M. Vose, Boston, 1920; inherited by Sara Bard Field (Mrs. Wood), ca. 22 January 1944; purchased by Maynard Walker Galleries, New York, 1956; purchased by Alastair Bradley Martin, New York, 17 March 1956.

Notes

1. De Kay, "Modern Colorist," 258. De Kay's reference to the "present confusion in Christendom" may refer to the move away from organized religion in the late nineteenth century, evident in the proliferation of independent religious societies, continuing debates on Charles Darwin's theories, and agnostic effects of socialism (thanks to Dr. Minnock, chairman of the Department of Religious Studies, Catholic University, Washington, D.C., for his insights).

2. De Kay, "Modern Colorist," 258.

3. Inglis to Wood, 23 May 1893, Wood Papers, Huntington Library.

4. Ryder to Wood, n.d., Wood Papers, Huntington Library. George Gurney has dated the letter to the period October 1892–May 1893, based on internal evidence.

5. On 11 January 1899 Sylvia Warner wrote to Wood that Ryder's "picture for Mrs. Corbett has advanced very perceptibly, but there may be others that would give her more delight" (Wood Papers, Huntington Library). Corbett later gave the picture to Wood (see Wood's handwritten notes on a letter from Robert C. Vose, 2 October 1918, Wood Papers, Huntington Library).

6. Sherman, *Ryder*, 50.

7. The Flight into Egypt and other biblical stories describing suffering are generally taken to presage the suffering of Christ. The red robe, worn by the woman, is traditionally interpreted as a symbol of the Passion. Cypress trees, at left in the painting, are a symbol of death—underscoring the theme of the Crucifix, to which the peasant points (see Anna Jameson, *Legends of the Madonna as Represented in the Fine Arts* [London: Longmas, Green, 1885], 228–37).

8. "On the return of the Bourbons, the restoration of the wayside crosses, which had been destroyed in the Revolution, was proposed. It was found in Finistère alone it would cost no less than 1,500,000 francs. Hence the project was dropped as being too expensive" (William Wood Seymour, *The Cross in Tradition, History, and Art* [London: Putnam's, 1898], 327–28). Wayside crosses were distributed throughout Europe, with many located in alpine passes. Ryder might well have encountered these while traveling through the Alps on his trip to Europe in 1882.

9. Hartmann, "An American Painter," 8, Hartmann Papers, University of California Library.

10. "I have a picture Flight into Egypt begun for you already; but of course you shall have the say as to what you would like" (Ryder to Sylvia Warner, 2 June 1897, Warner Family Papers, Archives of American Art). She eventually chose a different picture, a six-by-ten-inch panel of a seated shepherdess, which she sold through Kenneth Hayes Miller in 1917. This information is in a June 1941 notation by Rosalie Warner on a letter from Kenneth Hayes Miller to Sylvia Warner, 4 June 1917, Warner Family Papers, Archives of American Art.

11. Fitzpatrick to Wood, 9 December 1917, Wood Papers, Huntington Library.

12. Still another related composition appeared in the 1918 memorial exhibition under the title *The Way of the Cross*, lent by Charles M. Dewey and presently in the collection of the Addison Gallery, Andover, Mass.

65　*Summer's Fruitful Pasture* (see cat. 46)

66　*The Tempest*

canvas; 27¾ x 35 in. (70.5 x 88.9 cm)
The Detroit Institute of Arts, purchase through Dexter
M. Ferry, Jr., Fund, 50.19
See also figure 80

The Tempest seems to want but little; but Oh, how much that little may be; however I really believe if anything happened to me, if the blue of the sky in upper left hand corner was matched it would be about as valuable as finished. . . . My fault is: I cannot some way, go at a picture cold; I have to have a feeling for it.[1]

Thus Ryder kept at bay his patron Wood for more than twenty years. Ryder began work on *The Tempest* in 1892, and after 1896 Wood paid for it, hoping to convince Ryder to finish.[2] Although Wood meant well by the gesture, it backfired, putting unwelcome pressure on Ryder to complete a work he described as being invested with his whole life.[3]

The history of *The Tempest* provides a commentary on the gradual weakening of Ryder's conception through reworking. In 1918 Wood described how it once equaled *Jonah*:

"The Tempest" I have not seen for at least fifteen years. It was paid for fully that length of time ago and was then, to my mind, one of the greatest of his canvases, equal to the "Jonah," the essential thing being the clearing away of the stormy sky with the

creamy rifts of light, and the majestic sea beating over the rocks and the wreck of the vessel, and against these masses of subtle transparent greys, blues, and green of clouds, sky and sea, Prospero and Miranda glowed like jewels in the foreground, his amethyst-colored robe and her emerald-green dress, with Caliban a dull orange grey hidden in the cleft at their feet, Ariel floating in the clouds. I tried several times to get the picture in this state and Weir tried for me and Mrs. Fitzpatrick, but we all found if we could get it at all, which was doubtful, it would only be by tearing out his heart, and on my later visits to New York he would never even let me see it, telling me to wait until next time. It is too bad that this wonderful bit of color and conception as majestic as Shakespeare's is lost to the world, but after all it was his right.[4]

After Ryder's death Weir came across the work in Ryder's studio, where the painting had been for almost twenty-six years.

The Shakespeare play that was Ryder's source takes place on an island where a magician works his art; Prospero is both magus and poet, a congenial subject for Ryder. Prospero calls up the storm that threatens the king's ship; the spirit Ariel then guides the delegation safely to shore, its crew charmed asleep. Ryder brings the three island dwellers—Prospero, his daughter Miranda, and the primitive Caliban—together during the storm, collapsing the major elements of the play into a single scene. An early reviewer described Ryder's painting as exploring "in itself the contending spirits of storm, without reference to the play."[5]

Ryder's loose interpretation of his literary sources and several of his compositional elements are paralleled in a painting by John Runciman of another Shakespearean subject, *King Lear in the Storm* (cat. 66a), which Ryder could have seen in the collection of David Laing while he traveled with the Scottish art dealer William Craibe Angus in 1877.[6] When Runciman painted *Lear* in 1767, it was considered "unique at this period" for giving the sense of the play and not illustrating a specific passage.[7] Both Runciman's *Lear* and Ryder's *Tempest* present a storm-swept coast and dramatic sky with figures and headland in a similar arrangement and with Ryder's Caliban echoing Runciman's foreground rocks.

The X-ray (cat. 66b) provides a glimpse of the

Cat. 66a. John Runciman, *King Lear in the Storm*, 1767, oil on wood. National Gallery of Scotland, Edinburgh.

Cat. 66b. X-ray of *The Tempest*.

power invested in *The Tempest*: the sharply split cloud masses, jagged streaks of lightning, and waves whipped into whitecaps give energy and drama to the painting. The figures of Prospero and Miranda are beautifully defined.[8] Repainting has blurred the edges and softened the forms. "A remote, almost invisible Ariel slanting out of the cloud" no longer appears even in the X-ray; lightly painted atop an area of lead white, he is now a true spirit of the air.

In 1918, after rescuing it from Ryder's studio, Weir took *The Tempest* to the Macbeth Gallery, and then on Wood's instructions to Louise Fitzpatrick to be restored.[9] In a letter to Robert C. Vose, Wood commented, "As Weir told me there was nothing left of the picture but the composition, all had gone into blackness, I thought it would do no harm to let her have her way."[10] Charles Melville Dewey also petitioned to be allowed to do the restoration, reminding Wood that he was "an artist of some repute, and a life long friend of Ryder and the Administrator of his Estate."[11] Louise Fitzpatrick did restore *The Tempest,* likely working as much from memory as from what remained of Ryder's conception. In 1920 she wrote to Wood, asking why he never commented on her work.[12]

Marsden Hartley offered the most eloquent postscript to *The Tempest*'s history, describing the creative chaos of its development and subsequent decay, recalling

amazing and fatal abrasions in matters of technique, for Ryder had run a hot poker through the thickest part of the sky, and these jags were filled with new paint whitish of course of which he was to build eventually by tonal processes the sense of jags of lightning as it cuts through the dark densities of cloud bodies in a summer storm. The rest of the surface of this picture was all scum, as was the Macbeth and the Racetrack one also, and they were not to be recognized after they had been through the hands of the picture restorer, not until after Ryder's death did one learn what was really his first pictorial intention, and the varnish that was applied for protective purposes, gave them a museum finish which was not at all natural to them when they were seen in his own rooms. These scums that were added by dust and abuse, were doubtless part of the process, as if he had reasoned that nature herself must have a hand in it too.[13]

ELJ

Provenance: paid for by C. E. S. Wood, between 1896 and 1903, delivered to Wood in 1918; purchased for $7,000 by Macbeth Gallery, New York, from John List Crawford and Other Collections Sale, Parke Bernet, New York, cat. 58, 20–21 February, 1946; purchased for $7,350 by Dr. Chester J. Robertson, Pelham Manor, New York; consigned by Robertson to Macbeth Gallery, 9 September 1948; purchased by the Detroit Institute of Arts through Dexter M. Ferry, Jr., Fund, 1950.

Notes

1. Ryder to Wood, 9 February 1906, Love Papers, Archives of American Art.

2. "For the Tempest he wonders if $1250 +/− will be too much for you—He is to be rich & yet is to present you with a large picture. How he gets rich he don't say" (Inglis to Wood, 19 April 1892, Wood Papers, Huntington Library). See also Charles Fitzpatrick, quoted in Taylor, "Ryder Remembered," 12.

3. "Ryder is here and asks me to say that now his whole life is to be in 'The Tempest' and it will be ready for you soon—also that he feels now more power and is to outdo himself" (Inglis to Wood, 9 July 1896, Wood Papers, Huntington Library).

4. Wood to Robert C. Vose, 9 August 1918, Wood Papers, Huntington Library.

5. See here "Genius in Hiding."

6. In 1879 the painting entered the collection of the National Gallery of Scotland, Edinburgh, and was placed on public view (Dr. Lindsay M. Errington, assistant keeper of British art, National Gallery of Scotland, to Elizabeth Broun, 26 October 1987, curatorial files, National Museum of American Art).

7. W. M. Merchant, *Journal of the Warburg and Courtauld Institutes* 18 (1954): 385; and *Shakespeare and the Artist* (1959) chap. 12 (information from Errington).

8. Ryder affirmed the importance of paint as conveyor of emotion: "A daub of white will serve as a robe to Miranda if one feels the shrinking timidity of the young maiden as the heavens pour down upon her their vials of wrath" ("Paragraphs from the Studio of a Recluse," 11).

9. Wood to Macbeth, 16 March 1918, Wood Papers, Huntington Library.

10. Wood to Vose, 9 August 1918, Wood Papers, Huntington Library.

11. Dewey to Wood, 2 April 1918, Wood Papers, Huntington Library.

12. Louise Fitzpatrick to Wood, 1920, Wood Papers, Huntington Library.

13. Hartley, "Ryder: Spangle of Existence," in *Hartley: On Art,* 264.

67 *The Temple of the Mind*

panel, cradled; 17¾ x 16 in. (45 x 40.6 cm)
Albright-Knox Gallery of Art, Buffalo, gift of
R. B. Angus, 1918.1
See also figure 95

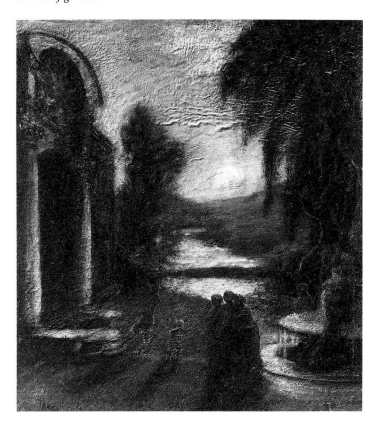

Cat. 67. Photograph from 1918 memorial exhibition, the Metropolitan Museum of Art, New York.

In 1907 Ryder penned a long description of *The Temple of the Mind* in response to an inquiry from Professor John Pickard:

The theme is Poe's Haunted Palace. . . . The finer attributes of the mind are pictured by the three graces who stand in the center of the picture: where their shadows from the moonlight fall toward the spectator. They are waiting for a weeping love to join them. On the left is a Temple where a cloven footed faun dances up the steps, snapping his fingers in fiendish glee at having dethroned the erstwhile ruling graces: on the right a splashing fountain.

 I saw the picture in the Cottier gallery after the sale: it seemed to have a chrystalline [*sic*] purity: if so it is of course a new quality.[1]

Although Ryder identified Poe as his source, *The Temple of the Mind* does not illustrate a specific passage from "The Haunted Palace," the poem purportedly written by the fictional character Roderick Usher in Poe's short story "The Fall of the House of Usher." Poe summarized his own intent when he stated "I mean to imply a mind haunted by phantoms—a disordered brain"; in this spirit, Ryder supplied his own conception.[2]

In Poe's story, a narrator recounts Usher's gradual descent into madness and the final days of his life, using the cracked and disintegrating palace as a symbol of Usher's state of mind. Poe's description of Usher could almost serve for Ryder; hypersensitive, nervous, living in cluttered rooms, a painter and poet, prone to strange diets and clothes, unable to tolerate bright light, Usher is painfully aware of his deteriorating condition. The stories about Ryder describe a similar if less gloomy temperament, perhaps explaining his fascination with the tale.

Ryder painted *The Temple of the Mind* during his ocean crossing to England in 1887.[3] John Robinson recalled finding him stretched out on the floor of his cabin at work on the painting, which he completed before the return trip, when he painted another composition on the reverse (cat. 38). Originally, Ryder placed a bridge on the right side of the picture, leading away from the temple. Walter Pach explained that Ryder considered the bridge a symbol of a rite of passage—a journey that once undertaken could not be reversed. Ryder discovered that the horizontal structure did not suit the composition and replaced it with a fountain, modeling it on one he had seen in Florence.[4]

The Temple of the Mind is evidence of Ryder's desire to address more complex themes during the mid- and late 1880s. In a letter to Thomas B. Clarke, he called it one of "the two chief efforts of my ambition," the other being *Christ Appearing to Mary* (cat. 6), also in Clarke's collection.[5]

When *The Temple of the Mind* was exhibited in Chicago in 1888, a reviewer praised it as reminiscent of the masters: "The canvas is not barely covered with color, it is laid on in successive layers until the painting resembles an enamel, in places it is corrugated. The work of Ryder, like the poetry of Browning, requires study before it can be appreciated."[6]

While *The Temple of the Mind* hung in the 1918 memorial exhibition at the Metropolitan Museum, Miss C. B. Sage, director of the Albright Art Gallery, wrote to R. B. Angus requesting it for a show in Buffalo, and Angus responded that he would donate the painting to the gallery.[7] Within days, collector John Gellatly discovered this plan and asked that the painting be sold instead to him, offering ten of his paintings to the Albright Art Gallery and fifteen thousand dollars to Angus's favorite war charities, but the gallery elected to keep the painting.[8]

Kingsley's 1890 engraving of *The Temple of the Mind* (cat. 67a) takes a few liberties, extending the composition on all four sides and rounding the top border. The painting has faded and deteriorated with time; in the 1930s Harold Bromhead lamented the changes.[9] The 1918 photograph records its earlier appearance.

Temples are common metaphors in the literary works of Baudelaire, Emerson, and Swedenborg;

Cat. 67a. Elbridge Kingsley, wood engraving after Ryder, *The Temple of the Mind*. National Museum of American Art, Smithsonian Institution, Washington, D.C., gift of Leonard Baskin, 1969.26.7.

they also appear frequently in paintings by Claude, Corot, and Turner. Goodrich found similarities between Corot's *Dance of Cupids*, 1866, and *The Temple of the Mind*.[10] Turner's *Fountain of Indolence* (Tate Gallery, London), based on James Thomson's poem "The Castle of Indolence" (1748), presents a somewhat similar disposition of forms.

ELJ

Provenance: commissioned for $500 by Thomas B. Clarke by April 1885; purchased for $2,250 by Cottier & Co., New York, from Thomas B. Clarke Collection Sale, American Art Association, Chickering Hall, New York, no. 39, 14–17 February 1899; purchased by R. B. Angus, Montreal, Canada, from James S. Inglis by 25 July 1899; gift of Angus to Albright-Knox Gallery of Art, Buffalo, 1918.

Notes

1. Weller, "Letter by Ryder," 101–2. John Pickard mailed letters to living artists requesting information concerning their art and lives; of the artists who responded, Ryder submitted "by far the longest and most interesting letter."

2. Poe to Griswold (letters, 83–84), quoted in *Edgar Allan Poe: Representative Selections*, ed. Margaret Alterton and Hardin Craig (New York: American Book Company, 1935), 498.

3. Ryder to Helena de Kay Gilder, on SS *Canada* stationery, 26 August 1887, "Just off Dover . . . I am here quite unexpectedly: all the ships are too crowded in fact it is impossible to get a berth for any money . . . and will soon be home" (Gilder Archive, Tyringham, Mass.).

4. Pach, "On Ryder," 128.

5. Ryder to Thomas B. Clarke, April 1885 (quoted in Goodrich, *Ryder* [1959], 24–25).

6. *Chicago Journal*, 26 May 1888.

7. C. B. Sage to Angus, 28 February 1918. The complete correspondence between the Albright, Angus, and Gellatly is in the curatorial file, Albright-Knox Gallery of Art, Buffalo, New York.

8. Gellatly to Mrs. Quinton, Albright Art Gallery, 9 March 1918 (courtesy of Albright-Knox Gallery of Art). The paintings offered were: *The Golden Age (Eve)* by La Farge; *Girl and Easter Lilies, Giverny, Le Débâcle*, and *A Winter Landscape* by Theodore Robinson; *The Canal, Harvest, Pegasus*, and *The Sea (Lord Ullin's Daughter)* by Ryder; and *Girl in White* by Thayer (see here "Later Critics, Early Patrons).

9. Sherman, "Notes on Ryder," 167ff.

10. Goodrich, "Ryder's Background," 39. This Corot was on view in the *Pedestal Fund Exhibition*, New York, in December 1883.

68 **Three Panels for a Screen:** *Children Frightened by a Rabbit; Woman with a Deer; Children Playing with a Rabbit*

gilded leather mounted on canvas; each panel
38½ x 20¼ in. (97.7 x 51.4 cm)
National Museum of American Art, Smithsonian Institution, Washington, D.C., gift of
John Gellatly, 1929.6.106a–c
See also figure 39

This three-panel screen was one of several decorative commissions made during Ryder's association with Daniel Cottier.[1] Painted on gilded leather, the panels were originally set into a hinged screen commissioned as a wedding present for Helen Josephine Mellen and William C. Banning. Presumably completed around the time of the wedding in 1876, the screen remained in the Banning family until 1923, when it was sold to John Gellatly.[2] According to Gellatly's assistant, Ralph Seymour, the panels were removed from the screen and mounted individually in gilded frames designed by E. & A. Milch in 1928.[3]

Ryder has been described as the "first American artist of any stature to experiment with the screen format."[4] This three-panel example resembles Japanese lacquer work in its contrasting black and gold; it also includes flora common to Chinese and Japanese objects.[5] The rocky grotto unifies the scene visually, creating the effect of a triptych found in oriental screens and prints.

The panels likely comprised the upper part of a tall screen, the lower portion of carved wood

or covered with cloth or embroidery, or it may have served as a firescreen, preventing drafts from the flue during the summer.

The subject of the screen derives from the story of Genevieve of Brabant, virtuous wife of Count Palatine Siegfried. While Siegfried was away the master of the palace attempted to seduce the pregnant Genevieve. She refused him and he denounced her to her husband, who ordered Genevieve executed. A sympathetic servant hid her in a forest, where she gave birth to a son, who survived on the milk of a deer. Years later Siegfried discovered them while hunting and learned of her innocence; he restored his wife and son to their proper station, but Genevieve survived only a fortnight.

The story became popular in the seventeenth century with northern European audiences; all but forgotten today, it was a favorite of nineteenth-century German painters Moritz von Schwind and Ludwig Richter (see fig. 40). It was also painted in America by George Bensell (see fig. 41). Ryder's penchant for depicting abandoned women lends credence to this source, although he deviated from tradition in showing two children rather than one.

The introduction in the West of Japanese screens created ripples in home fashions; Clarence Cook's *House Beautiful* reproduced and discussed Japanese screens, applauding their decorative and functional place in the home.[6] Disparate influences formed the American market for screens and decorative furnishings, which firms like Cottier & Co. filled. The orientalizing style of Ryder's three-panel screen reflects the taste for eastern wares.

Cracks in the leather reveal the powdery texture of the support; where the dry upper layer of paint has contracted, a red translucent lower layer glows like stained glass over the gilded leather below. Advances in contemporary stained glass find their painterly equivalent in Ryder's screen panels, which were often likened to jewels.[7]

ELJ

Provenance: Helen Mellen (Mrs. William C.) Banning, 1876–78; Kendall Banning; purchased for $2,700 by John Gellatly, New York, 5 July 1923; gift of Gellatly to National Museum of American Art, Washington, D.C., 1929.

Notes
1. "Ryder is doing a good deal of decorative work for Cottier and others" (Wyatt Eaton to Richard Watson Gilder, 23 September 1879, Gilder Papers, scrapbook no. 2, New York Public Library).

2. Kendall Banning to Mr. Grant, ca. 1923, typescript, curatorial files, National Museum of American Art.

3. Ralph Seymour, typescribed notes, ca. 1932, curatorial files, National Museum of American Art.

4. Michael Komanecky and Virginia Fabbri Butera, *The Folding Image*, ex. cat. (New Haven, Conn.: Yale University Art Gallery, 1984), 101.

5. Evans, "Ryder's Visual Sources," 32. Evans identifies these plants as camellias and peonies (left panel); chrysanthemums, Chinese bellflowers, primroses (center panel); persimmon trees and irises (right panel).

6. Clarence Cook, *The House Beautiful: Essays on Beds and Tables, Stools and Candlesticks* [New York: Scribner, Armstrong, 1878], 181–82; fig. 67.

7. See "The World's Work," *Scribner's Monthly* 21, no. 3 (January 1881): 486.

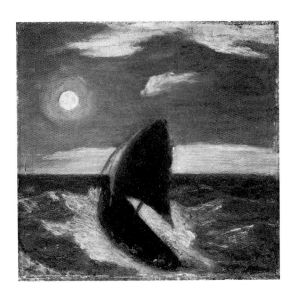

69 *Toilers of the Sea*

panel; 11½ x 12 in. (29.2 x 30.5 cm)
The Metropolitan Museum of Art, New York,
George A. Hearn Fund, 15.32
See also figure 100

Toilers of the Sea is accompanied by a short
verse, probably written by Ryder: " 'Neath the
shifting skies, / O'er the billowy foam, / The
hardy fisher flies / To his island home." The
painting acquired its present title at exhibition in
1884, its source being Victor Hugo's novel *Toil-
ers of the Sea*, written in 1866 and translated into
English the same year.

A tale of unrequited love, Hugo's *Toilers of the
Sea* is set on the island of Guernsey, where the
fisherman Gilliatt falls in love with Deruchette,
the niece of a steamer captain. The girl is prom-
ised to the man who can salvage her uncle's
sabotaged boat engines; Gilliatt vows to win the
woman he loves. His task pits him against the
forces of the sea, but he overcomes the challenge
only to find Deruchette betrothed to another.
Gilliatt gallantly forgoes his claim and helps the
lovers elope before returning to the rocky shore,
to await his death with the rising tide.

In later life Ryder came to resemble such ro-
mantic heroes as Gilliatt, a loner and dreamer,
negligent of his surroundings and drawn to
moonlit walks, turning "more and more towards
the face of nature, and further and further from
the need of social converse."[1]

The steeply angled boat crashing against the
waves in *Toilers of the Sea* recurs in *Lord Ullin's
Daughter* (cat. 32), which presents a similar
theme of lovers eloping by sea.

Attached to the painting's stretcher is a label
for the 1884 Providence Art Club exhibit, al-
though the work does not appear in the cata-
logue. It is also likely that *Toilers of the Sea* was
exhibited at the Society of American Artists exhi-
bition in 1884, when two untitled marines, both
lent by T. C. Williams (possibly a misprint of I.
T. Williams), were shown there and a verse by
Ryder was printed in the catalogue. Reviews
from 1884 describe a "wild, ghostly fisherman
flying over the billowy and foaming malachite."

Ryder built up *Toilers of the Sea* from dense
layers of paint, which have now drifted toward
the bottom of the panel, lipping over the frame
rabbet. The dark areas of boat and water have
sunk below the level of the surrounding paint
and taken on a shiny, viscous appearance ob-
scuring all detail, including the people in the
boat. The strong patterning of Ryder's composi-
tion is accentuated by this deterioration, which
has further simplified Ryder's forms.

Toilers of the Sea was acquired by the Metro-
politan Museum in 1915 and frequently exhib-

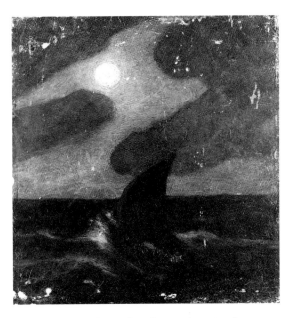

Cat. 69a. Formerly attributed to Ryder, *Moonlit
Marine*. Yale University Art Gallery, New Haven,
Connecticut, gift of Robert G. McIntyre, 1950.55.

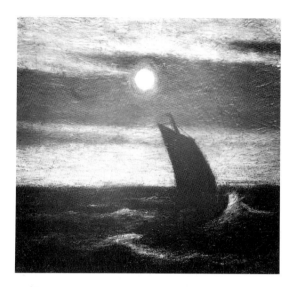

Cat. 69b. Unknown imitator of Ryder, *Outward Bound*. The Corcoran Gallery of Art, Washington, D.C., bequest of James Parmelee, 41.20.

ited there; considered to be one of Ryder's most expressive paintings, it provided the model for numerous forgeries (cat. 69a–b).

ELJ

Provenance: Ichabod T. Williams, New York (perhaps by 1884); Ichabod T. Williams Estate Sale, American Art Association, Plaza Hotel, New York, no. 73, 2–3 February 1915; purchased by the Metropolitan Museum of Art, New York, 1915.

Note
1. Victor Hugo, *Toilers of the Sea* (quoted in Bolger-Burke, *American Paintings in the Metropolitan,* 3:16). The entry on *Toilers of the Sea* discusses affinities between Hugo's work and Ryder's.

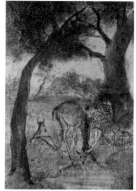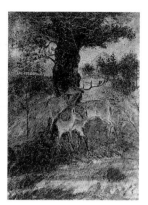

70 Two Panels for a Screen: *A Stag Drinking* and *A Stag and Two Does (Idylls; Pastoral Fancy)*

gilded leather on canvas mounted on board; each panel 27 x 19 in. (68.5 x 48.2 cm)
Private collection
See also figure 37

This pair of screen panels is similar in technique to the three-panel screen (cat. 68), and it is likely they were painted during the 1870s along with Ryder's other decorative works (cat. 3, 9, 12, 57–58, 60). Originally part of a three-panel screen, these two paintings flanked a center panel by Homer Dodge Martin, *Beech Tree near a Pool* (unlocated).[1] The screen belonged to William Mackay Laffan, a collector of paintings and porcelain in New York, but by 1915 the screen had been dismantled and each panel offered separately for sale.[2] The following year the Holland Galleries asked Ryder to authenticate and sign the back of both panels.[3]

The left panel depicts a stag drinking from a pool flanked by two oak trees, set in a golden landscape with a small round hill in the background. In the right panel a stag, facing left, and two does are pictured in a similar landscape. Descriptions of the center panel indicate that the three panels read as a continuous image.

The influence of oriental screens is evident; his light, calligraphic brushwork may also owe a debt to oriental ink paintings and porcelain (see fig. 38). The Philadelphia Centennial brought into focus the "china mania" that had gripped many American art collectors, William Laffan

and John Braun among them.[4] The père david's deer of China that frequently grace oriental ware resemble Ryder's deer, delicately outlined in dark, opaque paint. Ryder's decorative works have long been compared to oriental lacquers, medieval enamels, stained glass, and Persian tiles.

ELJ

Provenance: William Mackay Laffan, New York; purchased for $725 by Cottier & Co. from William Mackay Laffan Collection Estate Sale, Association of American Artists, Mendelssohn Hall, New York, no. 15, 20 January 1911; Cottier & Co. Sale, Metropolitan Art Association, Anderson Galleries, New York, nos. 155, 159, 12 March 1915; Holland Galleries, New York; John F. Braun, Philadelphia, 7 April 1916; consigned to Macbeth Gallery, New York, 12 November 1935; John F. Braun Sale, Kende Galleries & Gimbel Bros., New York, no. 66, 16 January 1942; George B. Berger, Denver, by May 1946; Mrs. Laurene Walker (Mrs. John) Berger; private collection.

Notes
1. *The Objects of Art and Antiquity Collected by the Late William M. Laffan,* auction cat. (New York: American Art Galleries, 1911), no. 15, describes the center panel: "On the left, behind a small pool, a thick beech tree with reddish foliage of which only the lower part is visible. In the foreground and to the right reddish-brown shrubbery, and behind the tree a sloping hill. Bluish sky with yellow clouds on the horizon in the lower part" (American Art and Exhibition Catalogues, Archives of American Art).

2. William Laffan wrote at least four articles on the Tile Club: three for *Scribner's Monthly* in 1879 (two with Earl Shinn) and another in 1882 for *Century Magazine* (*In Pursuit of Beauty: Americans and the Aesthetic Movement,* ex. cat. [New York: Metropolitan Museum of Art, 1986], 337 n. 5).

3. Letter from Holland Galleries, New York, 5 April 1916 (courtesy of the present owners).

4. *In Pursuit of Beauty,* especially 199–201. A great many of Ryder's patrons owned Dutch, French, and American paintings and oriental ceramics; the Cottier sale of 1915 featured examples of furniture decorated with oriental motifs or mimicking lacquer wares.

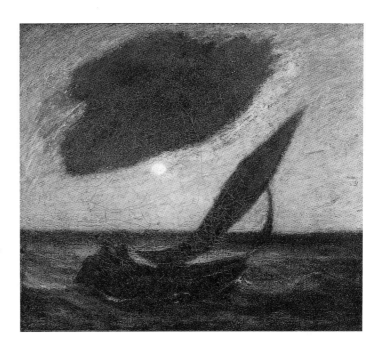

71 *Under a Cloud*

canvas; 20 x 24 in. (50.8 x 61 cm)
The Metropolitan Museum of Art, New York, bequest of Mrs. T. Durland Van Orden, 1989

Under a Cloud is the largest of Ryder's pure marine paintings, apparently conceived without a literary text. It is said to have been purchased from Ryder by Sanden in 1892. In the 1890s Ryder's gemlike colors and glazes gave way to stronger tonal contrasts. The accentuated light and dark shapes in this painting create the kind of two-dimensional compositional patterns that the early modernist painters prized in Ryder's art.

An X-ray (cat. 71a) shows Ryder's characteristic free brushwork in the sky and sea, blocked in with a dense creamy white paint clearly visible in the cracks of the painting. This dense paint surrounds a vacant area coinciding with the position of the boat's sail, which is rendered in less dense pigments that do not appear on the film.

In several respects the composition revealed in the X-ray differs from that seen today and in the first known photograph, made in 1918. In the X-ray, moonlight radiates through the night sky and is brilliantly reflected on the waves in the middle distance. A dark shape along the bottom

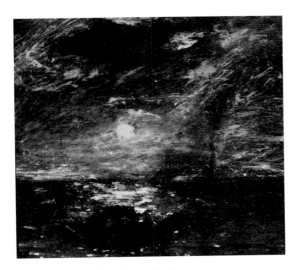

Cat. 71a. X-ray of *Under a Cloud*.

Although *Under a Cloud* is said to have been sold by Ryder to Sanden in 1892, it was not exhibited before the 1918 memorial exhibition. After Ferargil Gallery purchased the Sanden collection in 1924, Horatio Walker, a Canadian artist who had known Ryder, was engaged to clean this marine. A disturbance in the paint film, in the shape of a large circle, can be seen on the surface but does not appear in the X-ray.

EB

Provenance: purchased by Dr. Albert T. Sanden, New Rochelle, New York, from Ryder, perhaps in 1892; purchased by Ferargil Gallery, New York, 5 February 1924; purchased by Dr. and Mrs. T. Durland Van Orden, April 1925; gift of Mrs. T. Durland Van Orden to the Metropolitan Museum of Art, New York, 1989.

edge appears to be a canopied boat gliding through the foreground. Highlights in the sky surround an irregularly shaped cloud at upper left. Although an X-ray records only very heavy elements and so gives an incomplete view, this film suggests that *Under a Cloud* once presented a more pictorial appearance with quasi-naturalistic light effects and deep space.

The boat that now appears in the painting is similar to that in *With Sloping Mast and Dipping Prow* (cat. 76), but elongated in an exaggeratedly expressive shape, with a decorative curvature of the sail. The two sailors are dark shadows, rendered without modeling or detail. The boat and passengers have been moved to the middle distance, obscuring the dramatic effects of moonlight on water and collapsing the deep space. The cloud was extended considerably to appear as an unnaturally large mass, becoming a symbolic device rather than a romantic nature motif.

These several changes in design suggest either that Ryder reworked the composition himself or that a restorer substantially reinterpreted the image, working before 1918. The changes are consistent with the view of Ryder's art that prevailed after the Armory Show, when he was hailed as a proto-modernist master of two-dimensional design.

72　**The Watering Place** (see cat. 46)

73　**Weir's Orchard**

canvas; 17⅛ x 21 in. (43.3 x 53.3 cm)
Wadsworth Atheneum, Hartford, the Ella Gallup
Sumner and Mary Catlin Sumner Collection, 1970.71
See also figure 133

Cat. 73. Photograph from the 1918 memorial
exhibition, the Metropolitan Museum of Art, New
York.

Ryder and fellow artist J. Alden Weir developed
a close friendship in their student days in New
York, and from the 1890s Ryder was a frequent
visitor to Weir's farm near Branchville, Connecti-
cut. Following a lengthy illness in the spring of
1897, Ryder retired to Weir's farm to recuperate,
writing to Weir of the experience:

I have never seen the beauty of spring before; which is
something I have lived and suffered for. The landscape
and the air are full of promise. That eloquent little
fruit tree that we looked at together, like a spirit
among the more earthly colors, is already losing its
fairy blossoms, showing the lesson of life; how alert
we must be if we would have its gifts and values.[1]

After visiting Branchville in November 1902,
Ryder wrote to Wood that he was working on
two "fine, large" landscapes and a self-portrait.[2]
Weir's Orchard, among Ryder's largest pure land-
scapes, may be one of those he worked on that
fall, when he was painting several canvases for

Cat. 73a. Adolphe Monticelli, *Summer Day,* ca. 1867,
oil on wood panel. The Portland Art Museum,
Oregon, bequest of Winslow B. Ayer.

Dr. Albert T. Sanden, who loaned this painting
to the memorial exhibition in 1918.

In mood and handling *Weir's Orchard* resem-
bles the pastoral landscapes of Adolphe Monti-
celli, such as *Summer Day* (cat. 73a).

ELJ

Provenance: Dr. Albert T. Sanden, New Rochelle, New
York; Ferargil Gallery, New York, 5 February 1924;
Macbeth Gallery, New York, May 1927; Babcock Gal-
leries, New York, by 1932; T. Edward Hanley, Brad-
ford, Pennsylvania; Mrs. T. Edward Hanley; Mr. James
Welch, Canton, Ohio; purchased by Wadsworth Athe-
neum, Hartford, 1971.

Notes
1. Ryder to Weir, 5 May 1897 (quoted in Young, *Life
and Letters of Weir,* 189).
2. Wood to Weir, 10 November 1902 (quoted ibid.,
217).

74 *The White Horse*

canvas mounted on panel; 8⅛ x 10 in.
(20.4 x 25.2 cm)
The Art Museum, Princeton University, New Jersey,
57.9

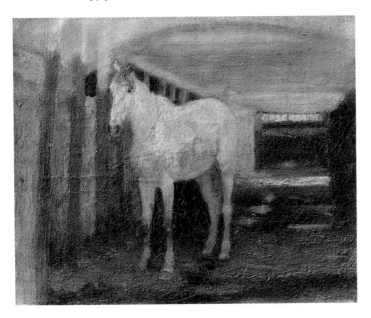

Cat. 74. Photograph from the 1918 memorial exhibition, the
Metropolitan Museum of Art, New York.

Ryder's lifelong interest in horses derives from
his childhood, when the family owned a white
horse named Charley.[1] His father delivered fuel
in New Bedford, probably by horse-drawn cart,
and after moving to New York, Ryder frequented
the carbarns in which were stabled the city's
horses, observing and drawing the animals.[2] The
verso of this work has a note that it was made at
the carbarn at Thirty-third Street and Fourth
Avenue. A somewhat similar watercolor of a
swaybacked horse confirms Ryder's ability to
grasp and articulate the animal's complicated
form (cat. 53a).

In 1874 *Old Omnibus Horse* was exhibited at
the Brooklyn Art Association, and in 1879 *Market Horse* appeared in the Society of American
Artists Exhibition—either of which might refer
to the painting now known as *The White Horse*.
De Kay may have mentioned this work in 1890,
saying, "One drab interior of a stable with an old

heavy fetlocked horse hangs in his studio."[3] Its
appearance in Ryder's studio dovetails with de
Kay's description of *Mending the Harness* (cat.
36), for which it may have served as a study.

ELJ

Provenance: Walter P. Fearon, New York, after 1890;
N. E. Montross, New York, by 1909; purchased for
$1,400 by C. W. Kraushaar Galleries, New York, from
E. Montross Collection Sale, American Art Association, Plaza Hotel, New York, no. 62, 27 February
1919; C. W. Kraushaar; George J. Dyer, New York, by
1932; Alastair Bradley Martin; the Art Museum,
Princeton University, New Jersey, by 1957.

Notes
1. When Ryder's sea-faring brother returned home after a voyage, he "would dance around the house out
in the yard to the stable grabbing his old white horse
Charley by the neck and kissing him. This white horse
was indelibly impressed on his mind from boyhood"
(Charles Fitzpatrick, quoted in Taylor, "Ryder Remembered," 12).
2. Hyde, "Ryder as I Knew Him," 596.
3. De Kay, "Modern Colorist," 257.

75 *The Windmill (Honeymoon)*

canvas; 15⅝ x 13¾ in. (39.7 x 34.9 cm)
Collection of Robin B. Martin, Washington, D.C.
See also figure 65

Cat. 75. Photograph from the 1918 memorial exhibition, the Metropolitan Museum of Art, New York.

The Windmill is one of several paintings that Ryder made for Sanden, with whom Ryder felt an affinity of temperament.[1] Like *A Sentimental Journey* (cat. 56), it shows a midnight lovers' tryst under moonlight, but here the subject is not drawn from literature but from memories of Ryder's childhood in Massachusetts. In 1906 it was described as a "picture of the old windmill at West Falmouth, Massachusetts; the only one of the old New England windmills which still grinds corn as it has done for more than a century past."[2] The artist grew up nearby and had relatives at Falmouth; it was there that he spent summers while a student at the National Academy in the early 1870s and first experimented with a synthetic approach to painting.

Several pencil drawings of windmills are known (private collection; the Art Museum, Princeton University), which may be studies for this painting; some include color notes in Ryder's hand. A watercolor of a similar monumental windmill in an open landscape (cat. 75a) is one of only a few watercolors known by Ryder, for whom this spontaneous technique was probably not congenial. The small painting *Old Mill by Moonlight* uses the arms of the mill in silhouette to interrupt horizontal patterns of light (cat. 75b). Together with Ryder's several canal subjects, these windmill images suggest the influence of the picturesque rural scenes favored by the Hague school artists and early Dutch masters.

The condition of the painting today offers insight into Ryder's working method. The lower-

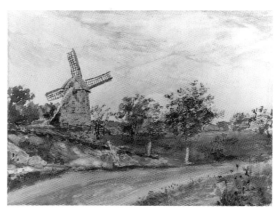

Cat. 75a. *Landscape with Windmill.* Private collection (courtesy of the Brooklyn Museum, TL1987.181b).

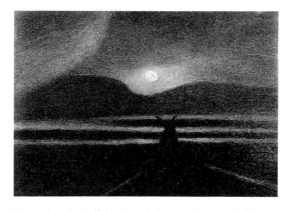

Cat. 75b. *Old Mill by Moonlight.* Jan Krugier Gallery, New York (photograph before restoration; courtesy of Peter A. Juley & Son Collection, National Museum of American Art, Smithsonian Institution, Washington, D.C.).

left landscape area shows alligatoring. The effect of moonlight filtered through dark clouds in the sky was achieved by mingling light and dark paints on the canvas, so that where the paint film has cracked a cross-section of alternating layers of blues and whites is visible. The brightest touches of color are at right, where a strong, very thin green indicates grass and a bright, thin red defines one of the horses; these colors and all details of figures and farm cart can be seen clearly only under strong light.

EB

Provenance: begun for Dr. Albert T. Sanden, New York, by 1900; on loan from Sanden to the Metropolitan Museum of Art, New York, 1918–24; purchased (along with numerous others) by Ferargil Gallery, New York, May 1924; purchased by a Connecticut collector; Mrs. D. H. Reese; purchased by Chester Dale; Guennol collection; Robin B. Martin, Washington, D.C.

Notes
1. Progress on the painting is mentioned in several letters from Ryder to Sanden (Ryder Records, Babcock Galleries).
2. "Ryder: Poe of the Brush."

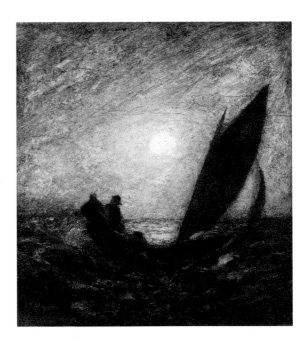

76 *With Sloping Mast and Dipping Prow (Moonlight)*

canvas mounted on fiberboard; 12 x 12 in. (30.4 x 30.4 cm)
National Museum of American Art, Smithsonian Institution, Washington, D.C., gift of John Gellatly, 1929.6.102
See also figure 101

The style of this painting is consistent with Ryder's works of the early 1880s; there are frequent exhibition references beginning in 1883 to one or more paintings called *Moonlight,* some of which may refer to this example. By 1905, however, it was owned by William T. Evans, who lent it for exhibition under the title *With Sloping Mast and Dipping Prow,* taken from Coleridge's "Rime of the Ancient Mariner."

The boat and figures in this painting resemble those in the foreground of *The Flying Dutchman* (cat. 15), which is also linked thematically with Coleridge's poem. The mariner is haunted by his wanton killing of an albatross, and, doomed by his action, the ship and crew are pursued by a skeleton ship manned by a specter-woman and Death, her mate. Only when the mariner is able to feel love can he pray and thus be rescued, but his penance is to wander the earth, searching for those who must hear his tale and be taught love

and reverence for living things. Ryder's painting takes its mood from the narrative but not Coleridge's ominous message.

The painting underwent extensive restoration and overpainting sometime before 1918, probably to mask damage incurred when it was transferred to a new support. The most notable alteration is in the horizon, which now appears to represent a calm sea but which is curiously higher at the left of the boat than in the center distance. The X-ray (cat. 76a) confirms disturbances in the paint in this area and suggests that, originally, a large swell rose up at the left, echoing the curve of the boat and animating the now-static composition with gentle rocking curves.[1]

Despite such changes, Ryder's hand is clear in the blue, green, and white paints swirled together on the canvas rather than premixed on the palette and in the carefully built up layers of small, directional brushstrokes.

William T. Evans frequently loaned the painting for exhibition until he sold it in 1913; it was donated to the National Museum of American Art (then National Gallery of Art) in 1929, where it was consistently displayed after that time. This public accessibility may account for the many marine forgeries that resemble it in composition.

ELJ

Provenance: Daniel Cottier, New York; R. T. Hamilton Bruce, Edinburgh, Scotland; R. T. Hamilton Bruce Estate Sale, Christies, London (as *Moonlight*), 16 May 1903; William T. Evans, New York and Montclair, New Jersey, 1905; purchased for $3,050 by George S. Palmer, New London, Connecticut, from William T. Evans Collection Sale, New York, Plaza Hotel, 31 March–2 April 1913, no. 38; purchased for $6,000, by John Gellatly, New York, from Palmer, 1920; gift of Gellatly to National Museum of American Art, Washington, D.C., 1929.

Note
1. Removal of much overpaint in 1965 revealed an abraded surface and the earlier damage (treatment report, August 1965, Conservation Lab Files, National Museum of American Art).

Cat. 76a. X-ray of *With Sloping Mast and Dipping Prow*.

77 **Woman and Staghound (Geraldine)**

gilded wood; 12 x 6½ in. (30 x 16.3 cm)
New Britain Museum of American Art, Connecticut,
purchased through the Harriet Russell Stanley Fund,
1946.26
See also figure 70

Woman and Staghound is probably the painting shown by Ryder in the 1883 *National Academy of Design Autumn Exhibition* under the title *Landscape and Figures,* which drew the attention of reviewers:

The high varnish and peculiar finish makes the picture look like a piece of old Italian enamel. The rich color in which this artist excels is not wanting here, in the soft, gold-brown earth, the trees, the warm sky and the deep-red dress of the single figure of a woman. The weak point in the picture is this figure. . . . The rich attire is regal, but the face and pose would suit a drawing of a Salem witch.[1]

Another writer called the piece a "fastidious morsel of color . . . in which the figure does not look inspired, but the sky and the landscape make one long to look beyond the frame on both sides and see what poetic strand that is of which Mr. Ryder gives such tantalizing glimpses."[2]

By 1885 the painting entered the collection of Mary Jane Morgan and was described in 1886 by de Kay in glowing terms as a "charmingly naif 'Chatelaine with Greyhound,' by Ryder, which has delicious depth of tone and quaint originality of composition, tenderness of sky, otherworld glamour over the landscape."[3]

Ryder's dealer Daniel Cottier purchased the work at Morgan's estate sale in March 1886 and offered it to C. E. S. Wood for three hundred dollars in 1889. In a long and eloquent letter to Olin Warner, Wood described his struggle to appreciate the painting.[4]

Wood lent the painting to the *Portland Art Association Summer Exhibition* of 1909, where it was displayed as *Geraldine.* Wood also indicated in a letter to Robert C. Vose, 9 August 1918, that "I have a small upright panel, a woman in a wonderful red gown, caressing a white greyhound, 'Geraldine.' "[5]

Geraldine is associated in English literature with Lady Elizabeth Fitzgerald, the subject of a poem by Sir Henry Howard, earl of Surrey, titled "A Description and Praise of His Love Geraldine" (1587).[6] Lady Elizabeth was for Surrey the equivalent of Petrarch's Laura or Dante's Beatrice—the unattainable object of desire and impetus for noble thoughts and deeds.

Cat. 77a. Gavin Hamilton, *Elizabeth Gunning, Duchess of Hamilton*, ca. 1752–55. Hamilton Collection, Lennoxlove, Scotland.

In his portrayal of a richly dressed woman posed with a hound in a landscape Ryder borrowed from conventions of British portraiture, exemplified by Gavin Hamilton's portrait of *Elizabeth Gunning, Duchess of Hamilton* (cat. 77a). The late nineteenth century witnessed a revival of such conventions, as seen in Edward Percy Moran's pastoral scene *Young Girl and Dog* (cat. 77b) and in Will Low's picture of a seated woman in archaic costume with a greyhound, *Reverie—In the Time of the First Empire* (cat. 77c), which received considerable attention in the 1876 Salon and in 1877 at the National Academy.[7] Fête galante painting was revived in Ryder's day by Monticelli, whose images such as *The Greyhounds* (see fig. 57) presented elegantly attired Parisian women accompanied by dogs in wooded landscapes. De Kay, in identifying Ryder's painting as "Chatelaine with Greyhound," evoked the world of Monticelli's paintings, often shown at Cottier's.[8]

The extremely thick glaze covering the surface of *Woman and Staghound* may have been tinted with pigments to give added richness to the painting; the forms of the painting are barely

Cat. 77b. Edward Percy Moran, *Young Girl and Dog*, 1890, oil on canvas. National Museum of American Art, Smithsonian Institution, Washington, D.C., bequest of Alfred Duane Pell, 1939.4.1.

Cat. 77c. Engraving after Will H. Low, *Reverie—In the Time of the First Empire* (painting location unknown; from Will H. Low, *Chronicle of Friendships* [1908]).

discernable through the encrusted surface. Gold leaf may underlie the paint film, although laboratory tests are required to confirm these decorative embellishments. It appears that the painting has never been restored, making this an excellent case study for Ryder's painting technique.

SLB

Provenance: Mary Jane Morgan, New York, by 1885; purchased for $225 by Cottier & Co., New York, from Mary Jane Morgan Sale, Chickering Hall, New York, no. 86 (as *Landscape and Figure*), 3–5 March 1886; C. E. S. Wood by 1889; purchased by New Britain Museum of Art, Connecticut, 1946.

Notes

1. "The Autumn Exhibition of the National Academy," *Boston Daily Evening Transcript,* 22 October 1883, 3–4.

2. *New York Times,* 4 November 1883.

3. De Kay, "American Gallery," 291.

4. Wood to Warner, 17 March 1889, Warner Family Papers, Archives of American Art (for the text of the letter see here "Later Critics, New Patrons").

5. See also Vose to Wood, 2 October 1918, with comments in margins written by Wood about "Geraldine," Wood Papers, Huntington Library.

6. Surrey's poems were published by Richard Tottel in *Songes and Sonettes Written by the Ryght Honorable Lord Henry Haward, Late Earle of Surrey,* reprinted by P. Collier in *Seven English Poetical Miscellanies* (1867). Other publications include an 1815–16 edition of poems by Surrey and his friend Wyatt, issued by Dr. G. F. Nott, and the Aldine edition, edited by J. Yeowell, of 1866.

7. The painting was also illustrated in Brownell, "The Younger Painters of America—Second Paper," 331.

8. "An Impressionist's Work: The Pictures of Monticelli, Curious Works of Art at Cottier's," *New York Times,* 20 May 1879, 8. Cottier exhibited Monticellis in 1878 as well; see *Fine Oil Paintings and Water-Color Drawings by the Great Modern Classic Painters (Imported by Cottier & Company)* (New York: Leavitt, 1878) (American Art Auction Catalogues, Archives of American Art).

Poems and Verses Composed by Albert Pinkham Ryder

Ryder sometimes exhibited his paintings with verses of his own composition attached to the frame or quoted in the catalogue. He also composed poems unrelated to paintings, which he copied to send to friends on special occasions. Variations in wording and punctuation suggest that he made these gift copies from memory. A few of Ryder's poems were published during his lifetime; the first publication of each is noted. The texts should not be taken as definitive, however; Ryder complained that "with the exception of the Century Magazine I have never had a poem faithfully rendered."[1]

An obituary in the *New Bedford Sunday Standard-Times* commented that Ryder was writing a long prose work "of strange beauty" at the time of his death, but this has not been found.

Wherever possible, the texts reproduced here have been taken from manuscripts in Ryder's hand; his punctuation, or lack of it, has been maintained.

Note
1. Ryder to Gellatly, 8 June 1897, Gellatly Vertical File, National Museum of American Art.

Verses Accompanying Paintings at Public Exhibition
With *Dancing Dryads* (cat. 10), exhibited 1881:

> In the morning, ashen-hued,
> Came nymphs dancing through the wood.

With *The Lovers' Boat* (cat. 34), exhibited 1881:

> In splendor rare, the moon,
> In full-orbed splendor,
> On sea and darkness making light,
> While windy spaces and night,
> In all vastness, did make,
> With cattled hill and lake,
> A scene grand and lovely.
> Then, gliding above the
> Dark water, a lover's boat,
> In quiet beauty, did float
> Upon the scene, mingling shadows
> Into the deeper shadows
> Of sky and land reflected.

With *Toilers of the Sea* (cat. 69), exhibited 1884:

'Neath the shifting skies,
O'er the billowy foam,
The hardy fisher flies
To his island home.

Other Poems Related to Paintings

Joan of Arc [cat. 23]

On a rude mossy throne
Made by nature in the stone
Joan sits, and her eyes far away
Rest upon the mountains gray
And far beyond the moving clouds
That wrap the sky in vap'rous shrouds
Visions she sees
And voices come to her on the breeze
With a nation's trouble she's opprest
And noble thoughts inspire her breast
Ah gentle maid and can it be
Thou wils't do more than chivalry
And thy weak arm shall guide the blow
And hurl the invading conqueror low
Who knows what God knows
His hand he never shows
Yet miracles with less are wrought
Even with a thought.

From a manuscript in Ryder's hand, inscribed "For Rosalie Warner / With the very best wishes of Albert P. Ryder" (Warner Family Papers); published with minor changes in French, "Painter of Dreams," 9.

The Passing Song [cat. 44]

By a deep flowing river
There's a maiden pale
And her ruby lips quiver
A song on the gale
A wild note of longing
entrancing to hear
A wild song of longing
Falls sad on the ear.

Adown the same river
A youth floats along
And the lifting waves shiver
As he echoes her song
Nearer still nearer
His frail bark doth glide
Will he shape his course to her
And remain by her side
Alas there is no rudder
To the ship that he sails
The maiden doth shudder
Blow seaward the gales
Sweeter and fainter the song cometh back
And her brain it will bother
And her heart it will rack
And then she'll grow paler
With this fond memory
Paler and pale
And then she will die

From a manuscript in Ryder's hand (Love Papers, Archives of American Art). The poem was published in Hartmann, *History of American Art,* 314–15, broken into four-line verses and punctuated.

The Phantom Ship (for *The Flying Dutchman* [cat. 15])

Who hath seen the Phantom Ship,
Her lordly rise and lowly dip,
Careering o'er the lonesome main
No port shall know her keel again.

But how about that hopeless soul
Doomed forever on that ship to roll,
Doth grief claim her despairing own
And reason hath it ever flown
Or in the loneliness around
Is a sort of joy found
And one wild ecstasy into another flow
As onward that fateful ship doth go.
But no, Hark! Help! Help! Vanderdecken cries,
Help! Help! on the ship it flies;
Ah, woe is in that awful sight,
The sailor finds there eternal night,

'Neath the waters he shall ever sleep,

And Ocean will the secret keep.

From a manuscript in Ryder's hand, dated 8 June 1897 and entitled "The Phantom Ship" (the Metropolitan Museum of Art Archives); published as "The Flying Dutchman" in Metropolitan Museum of Art, *Loan Exhibition of the Works of Albert P. Ryder.*

Poems Not Explicitly Related to Any Painting

The Awakening

When Phoebe in the eastern ray
Fades early in the morning
With faintest tinge the breaking day
So tenderly adorning

The restless herds demand their care
And musically lowing
Sniff scented gales of fragrant air
From dewy pastures [flowing]

Then on the rosy morning high
The hamlet smoke ascends
A curling tinge upon the sky
A charm to nature lends

At intervals a note is heard
A hail to the budding dawn
Another and another bird
Chirp a welcome to the morn

Tremulously the world awakes
To a harmony of trills
Till one eager bird slakes
Its burning soul in gushing rills

Of song, so loud, so clear,
So joyously profound
That aught else far and near
Seems lost or mute in this firmament of sound.

From a typescript copy of Ryder's handwritten poem inscribed to Mrs. Albert T. Sanden, included with Ryder's letter to Dr. Sanden (Ryder Records, Babcock Galleries).

Lines addressed to a maiden by request

I look upon thy youth fair maiden,
I look upon thy youth, and fancy laden,
Would that I a fairy were
That with magic wand I could deter
All evil chance, and spare thy coming years,
All unwrought by rain of tears,
With a rainbow bright.
That thy feet, made joyously light,
May tread thy glowing arc of day.

May such sorrows as all must feel,
Come to thee as tears that steal,
In sleep, from the peaceful hideaway,
Leaving no trace in the morning ray,
As an opal, from the dark,
 Shines still brighter rays.

From a manuscript in Ryder's hand, included as part of a letter in the form of a prose-poem dedicated to Olin Warner, dated Christmas 1875 (Warner Family Papers, Archives of American Art). The "maiden" who requested the lines is not known.

An Orchid

Oh beauteous flower
Angel of the floral kind
How shall I praise thee?
Sustained on thy arbor stem
Thous imbibs't the air
And dost radiate it to a hue;
Breath of my love
A poet's ecstasy
I see thee as man
First saw thee
A cool light in all the wood
Displayed in thy element
Born without a seed
Symbol of immortality.

Ascribed to Ryder, from a manuscript in Louise Fitzpatrick's hand (1918 memorial exhibition archive, the Metropolitan Museum of Art Archives).

The Spirit of the Flowers

What radiant passing is this
That gilds the sphere with summer bliss
And calls a race of gentle wonders
All born in beauteous splendors
To gem the warm zone of the world,
And as in tender sheen unfurled
Raying with sweet light the earth
All lovely, like the tender birth
Of dawn in early rays or light
Or lustrous or luminous and bright
As stars or moon or milky way of night.

Tis the spirit of the flowers
Soul of the sunny hours
Her lightened way winging
Birds and insects singing
Her graceful weight scarce bending
The slender vine that's lending
Support to her.
To breathe within the petal of the flower
Its perfume sweet of her
Fragrant breath—
 Sweet spirit of the sunny air
Sweet radiant fair.

Shall our entranced delight
In thy delicious [?] joys sigh for a good night
Thou wilt say when November's gloomy
wings smother the fading springs
That nurse thy lovely flowers
Or wilt thou come again
When weeping April sends her rain
Fairy messenger to call
The blushing forms all
Spring like a throne of joy
To seat thy reign.

Yes thou wilt come again
And crowding butterflies
Shall claim thee for kindred
And yield glowing obedience
To thy fairy reign.

From a manuscript in Ryder's hand (Love Papers, Archives of American Art).

Untitled

From afar, from afar
From brass trumpets of war
Comes adown the gale
 An echoing wail
Passing on a summer zephyr by
Coming again never
Out into the infinite sky
Like a dying shriek into eternity.

 Nearer comes, nearer comes
A roll of drums
 While a fife's shrilly cry
Dies: passes by to die
 Into immensity.

 See way up the street
The tramping [?] of their feet
 A dark mass swaying
Bands playing
 A Dirge
 A Dirge
 A Dirge.

Nearer coming nearer coming
 With mournful drumming
Arms trailing
 Fifes wailing
 Steel gleaming
Sunlight streaming
 A dark mass swaying
 Bands playing
 A Dirge.

Drawing near drawing near
Falls the silent tear
Runs through the frame a chill
 As they climb the hill.

Now bursts the awful chime
As they advance in line
 Shoulder to shoulder
 As they sway together
 As they vibrate together

And the rustling of their feet
Through the stony street

Gives an impressive chill
Moving with perfect drill
Beats the throbbing heart
As they pass in part
To their beating drum
And their shrieking fife

Gives our blood a start
As they come as they come
With departed fife
And beat of muffled drum.

Then wail the shrieking fife
Roll the muffled drum
Halpine's in the higher life
His remains come

Their impressive tread
Wakes a responsive dread
As their rustling feet
Beat the dusty street

Like withered leaves across moors
In chill November hours
Rustle their muffled tread
O'er the street so dread

They pass beneath the hill
With their perfect drill
Leaving us a chill
As when water still

Closes o'er a corpse
On the dread sea
And the burier walks
Close again to me

Now bursts the awful chime
As they pass away in line
Swaying together
Vibrating together

Now sounds the awful music
Strains the ear not to lose it
Sound it loud and high
Into the infinite sky

Roll the muffled drum
Wail the shrieking fife

Halpine's in his home
Only his remains come

To the grave To the grave
Halpine brave has gone
With the sound of fife and drum
And veterans every one

And we hold the breath
In the presence of death
And we hold the breath
For men who faced death
Veterans every one.

Now burst the awful chime
As they pass in line
Shoulder to shoulder
As they sway together
As they vibrate together.

With music weird and strange
As sounds that range
Along the billowy shore
When storm rules the hour
Alas! Alas!
As they pass
As they pass.

Wakes within the brain
Ah so dull a pain
Wakes within the frame
Both a chill and pain
Ah so dull a pain

And we hold the breath
For men who face death
On the hill and plain
In the bullets' rain

They seem not honourers of death
With their awful tread
But to carry a victim slain
Leaving us such pain
As they pass
As they pass

With sorrow in their hearts
A funeral step their parts

With bowed head
 And muffled tread

With air profound
 Shadows clinging to the ground
 Arms gleaming
 Sunlight streaming

With music weird and strange
 As sounds that range
Along the billowy shore
 When storm rules the hour—
 They have passed
 They have passed.

From a manuscript in Ryder's hand (Love Papers, Archives of American Art).

Untitled

They lived the life of angels;
For they worshipped each other as angels.

 From their coming steps, and their going steps are as the progress of flowers and they respired the aroma of their odors: each sought to forestall the other in little acts of tenderness and with the intuitiveness of inspiration which is love they penetrated to the wishes of the inner soul and delighted by the wonder of their perceptions.

 Morning superceded morning, one day another day, varied only by increasing love increasing tenderness.

 Her steps were too pure to touch the dust, he lifted her in and out of conveyances, and over obstacles that destroy the grace and harmony of woman's movements, and each day she seemed lighter because he grew stronger great and beautiful breathing and living in this their exquisite atmosphere of the affections.

From a manuscript in Ryder's hand, signed, accompanied by a letter to Rosalie Warner, dated 14 November 1912, "on the eve of [her] approaching marriage" (Warner Family Papers, Archives of American Art).

Untitled

Vapor from the mountain
stream that lightly floats away

Lightly o'er the meadow land
Wailing o'er the shelving strand

Hides it in some shady dell
Or in some caverned well
Ah tell me who can tell

The mist soft molded to the cape
Rises lightly on the morning air
And shifts with every breeze its varying shape
But ever graceful and ever fair

The thought fits to the parent mind
And lightly floats away
But varies to each 'centric kind
That grasp it on its way

Passed beyond recall the thought
Makes forward free as air
On what eternal mission fraught
Its end, Oh tell me where?

From a manuscript in Ryder's hand, sent by Louise Fitzpatrick to C. E. S. Wood in 1917 after Ryder's death (Wood Papers, Huntington Library). A manuscript of the poem in Fitzpatrick's hand is in the 1918 memorial exhibition archive, the Metropolitan Museum of Art Archives.

Untitled (*Pastoral*)

These tended flocks and pastures green
Although the sun falls fair along, seem
Far brighter in my memory beam
For then I stray in love and song
 Ah well the day
 And happy dreams

And well I know these sylvan bowers
That range so wide around
These scented gales of fragrant flowers
Remind of hallowed ground
 For in other days
 There were pleasant hours

But now alas, no more can be
Our wanderings in the sunny gleams
Ah then what sorrow else, for me
Than vented grief in tearful streams
 The long day
 So sad to be.

Where yon tree in sunlight stands
There us'd to be our trysting place
There met our hearts in trembling hands
 Eyes fell the day
 That kissed the summer lands

But now alas no more shall know
Familiar paths our lingering feet
Alas! Alas! tears shall flow
For memories now but ghostly sweet
 This weary day
 Has griefs enough.

Just over yonder there the place
A sad bower of willow trees
Where leafy memories to call her face
Light hover on the summer breeze
 The live long day
 in the lonely place

And when in reverie appears
Her face with same sweet smile of old
Then ah then I lay me down in tears
And sigh for cold death to fold
In embrace of years
 This weary day
 Has gloomy fears

And when And when sad beguiling
I wake from dreams to conscious day resume
Then ah then as her spirit smiling
I would resolve in dreams away
 In dreams away
 I would resolve in dreams away.

From a manuscript in Ryder's hand (Love Papers, Archives of American Art). A verse fragment appears on the second sheet: "Open with thy music dawn / Let the trees speak a prelude / Of the coming day / While many a graceful form."

Untitled (perhaps related to *The Shepherdess* [cat. 57])

One
Clear shepherdess of all the rest
Leading their flocks through
Driving snow or morning dew
To the hill's fair crest;
In beauteous grace seemeth all the view.

So is there always one,
One gem or purest ray to find,
One moon, one sun,
One year of nobler mind.

From Braddock, "Poems of Ryder," 85. Braddock says a manuscript for this poem in Bryson Burroughs's hand was discovered by Lloyd Goodrich in the material gathered for the 1918 Ryder memorial exhibition at the Metropolitan Museum of Art. No manuscript is now in the archive for that exhibition.

Voice of the Forest

Oh ye beautiful trees of the forest;
Grandest and most eloquent daughters
Of fertile Mother Earth.
When first ye spring from her,
An infant's puny foot
Could spurn ye to the ground,
So insignificant ye are.
Yet ye spread your huge limbs,
Mightier than the brawny giants of Gath,
 How strong,
 How beautiful,
How wonderful ye are.
Yet ye talk only in whispers,
Uttering sighs continually
Like melancholy lovers,
Yet I understand thy language
Oh voices of sympathy
I will draw near to thee
For thou can'st not to me,
And embrace thy rugged stems
In all the transports of affection.

Stoop and kiss my brow
With thy cooling leaves
Oh ye beautiful creations of the forest.

From a printed copy that appeared in the *New York Evening Sun*, 6 May 1909 (Evans Papers, Archives of American Art). Lines 16–17 are written out by Ryder to correct errors in printing. The printed copy says, "These lines were inspired by a gale at Yarmouth Port, Mass., and the harmonies it tore from the trees."

Voice of the Night Wind

The wind, the wind, the wind,
[The breath of balmy, balmy evening,]
That am I that am I
My unseen wanderings
Who can pursue, who comprehend?
Soft as a panther treads
When moving for its prey,
I fly over beds of sweet roses
And violets pale,
Till disturbed within their slumbers,
They bend from my gay caress,
Only to lift their heads again
And send the aroma of sweet perfumes
To call me yet more
Ere I pass away.

For I am the wind, the wind, the wind,
[As fickle as lightning, swift as light.]
I'll away, I'll away and seize upon the giants of
 the forest
And shake them to their roots
And make them tremble to their sap.

For I'm the wind, the wind, the wind!
I'll away, I'll away to where maidens
Are sighing for fond lovers,

And softly coo and woo
And whisper in their ears
[With sigh answering sighs,]
Making their hearts throb
Their bosoms rise
Till I seem hardly from without
Almost within the voice
Of their soul's illusion.
What lover would not give his all for this
To kiss those rosy cheeks
Those dewy lids, that luscious mouth
So wantonly to lift those woven tresses
And breathe upon those rounded bosoms

But I'm the wind, the wind, the wind
I'll away, I'll away to gloomy pools profound
And stir the silence
Of their reflective depths
With rippling laughter
At my wanton freaks.
[For I'm the wind, the wind, the wind,]
And my fantastic wanderings
Who can pursue, who comprehend?

From a manuscript in Ryder's hand (Love Papers, Archives of American Art). The poem was printed in de Kay, "Modern Colorist," 250–59, and in the catalogue of the Metropolitan Museum of Art 1918 memorial exhibition. Lines in brackets are included in these published versions but not in Ryder's handwritten manuscript. There are several other minor variations in wording between the manuscript and published versions.

Exhibition History 1873–1917

It is widely believed that Ryder was almost unknown to the art public during his lifetime and that recognition arrived only after his death in 1917 and the memorial exhibition at the Metropolitan Museum of Art the following year. Yet his paintings were included in more than one hundred group exhibitions during his lifetime, in many cities in northeastern United States as well as Chicago; Washington, D.C.; Toledo; Portland, Oregon; Charleston; Montreal; and Berlin. In the late 1880s Ryder ceased submitting his own work for exhibition, but by this time his paintings had been purchased by important collectors, who frequently sent them to public exhibitions in museums, commercial galleries, and private clubs.

This lifetime exhibition record was compiled from published catalogues, museum records, archival sources, and contemporary reviews. It is surely not complete; many Ryder paintings, for instance, were shown in the gallery of his dealer Daniel Cottier, with no permanent record.

Information is given as recorded in the sources, including location, date, and title of exhibition; title and catalogue number of painting;

lender; and price of works offered for sale. Many paintings in the early exhibition record have been lost or have changed titles and therefore can no longer be securely matched with surviving works. Where reviews or descriptions permit a probable identification, this is suggested in brackets along with the corresponding catalogue number in this book. For a work without a catalogue entry, the present location of the work or a reference to its illustration in this book is given in brackets when known.

The paintings publicly exhibited during Ryder's lifetime are usually assumed to be authentic, since he or his close associates would have removed from view works falsely attributed to his name. Forgeries did appear as early as 1912, however, and in Ryder's declining years it is possible that such works were exhibited unchallenged.

Especially in early catalogue records, there are occasional misprints leading to the confusion of A. P. Ryder with another painter, P. P. (Platt Powell) Ryder, whose romantic, literary titles are often similar. Where it has been determined (usually through residence addresses) that paint-

ings by P. P. Ryder have been wrongly attributed to A. P. Ryder, these listings have been omitted.

1873
National Academy of Design, New York, *Forty-eighth Annual Exhibition*, ca. 1 April–ca. 15 May
 Clearing Away, no. 8, lent by the artist
Brooklyn Art Association, *Fall Exhibition*, 8–20 December
 Landscape, no. 200

1874
Brooklyn Art Association, *Spring Exhibition*, 27 April–9 May
 November Landscape, no. 150; *Landscape near Chelsea, VT*, no. 369
Brooklyn Art Association, *Fall Exhibition*, 30 November–20 December
 Landscape, no. 209, $50; *Old Omnibus Horse*, no. 210, $50

1875
Cottier & Co., New York, 29 April
 Interior [cat. 22]

1876
National Academy of Design, *Fifty-first Annual Exhibition*, ca. 1 April–ca. 15 May
 Cattle Piece, no. 163, lent by W. D. Ryder

1878
Kurtz Gallery, New York, *Society of American Artists First Exhibition*, 6 March–5 April
 Landscape, lent by the artist

1879
Kurtz Gallery, *Society of American Artists Second Exhibition*, 10–29 March
 Market Horse, no. 19, not for sale; *The Chase*, no. 97, lent by J. S. Inglis; *Landscape with Figures*, no. 102, for sale; *In the Wood*, no. 107, lent by J. S. Inglis [*The Sisters*, The Saint Louis Art Museum]; *Spring*, no. 146, for sale [cat. 62]
Pennsylvania Academy of the Fine Arts, Philadelphia, *Society of American Artists Fifteenth Annual Exhibition of the Pennsylvania Academy of the Fine Arts*, April–May
 Harlem Lowlands, November, no. 188 [cat. 20]; *In the Boyhood of the Year*, no. 271
Cottier & Co., *Exhibition of Paintings by Monticelli*, August–September
 The Culprit Fay [cat. 9][1]

1880
Art Gallery, 845 Broadway, New York, *Society of American Artists Third Exhibition*, 17 March–16 April
 Chill November, no. 16; *Moonlight*, no. 57 [*Moonrise (?)*, the Brooklyn Museum]; *Two Lovers*, no. 59, lent by I. T. Williams [fig. 62]; *Nourmahal*, no. 60; *An Eastern Scene*, no. 89 [cat. 4]; *Study*, no. 133
Saint Botolph Club, New York, May
 Unidentified works[2]

1881
New York Society of American Artists Fourth Annual Exhibition, 28 March–29 April
 Moonlight, no. 52, accompanied by short poem, lent by Rev. N. W. Conkling [cat. 34]
National Academy of Design, *Fifty-sixth Annual Exhibition*, ca. 1 April–ca. 15 May
 Landscape and Figures, no. 666, lent by the artist, $250 [cat. 10]

1882
National Academy of Design, *Fifty-seventh Annual Exhibition*, 27 March–13 May
 Pool and Horseman, no. 67, lent by Erwin Davis [*The Pond*, Walker Art Center, Minneapolis]
American Art Gallery, New York, *Society of American Artists Fifth Annual Exhibition*, 6 April–6 May
 Curfew Hour, no. 90, lent by Mrs. J. H. de Kay, not for sale [fig. 118]; *Homeward Plodding*, no. 91, lent by Mrs. J. H. de Kay, not for sale [*Plodding Homeward*, Hunter Museum of Art, Chattanooga]
Providence Art Club, Rhode Island, *Third Annual Exhibition*, 17 April–13 May
 Horse Market, $200
The Metropolitan Museum of Art, New York, *Loan Collection of Paintings and Sculpture in the West Galleries and the Grand Hall*, May–October
 Dutch Landscape, no. 93, lent by W. C. Banning
American Art Association, New York, November
 Cart Horse in Stable [cat. 63][3]
The Metropolitan Museum of Art, *Loan Collection of Paintings and Sculpture in the West Galleries and the Grand Hall*, November–April 1883
 "The Curfew Tolls the Knell of Parting Day," no. 113 [fig. 118]

1883
American Art Gallery, *Society of American Artists Sixth Annual Exhibition*, 26 March–28 April
 Landscape, no. 101, lent by Mrs. E. M. Whiting; *Moonlight*, no. 102, lent by Mrs. E. M. Whiting, Boston
National Academy of Design, *Fifty-eighth Annual Exhibition*, 2 April–12 May
 Landscape, lent by the artist, $250
Society of American Artists Sixth Annual Exhibition, 7 May–3 June
 Landscape, lent by Mrs. E. M. Whiting; *Moonlight*, lent by Mrs. E. M. Whiting
The Metropolitan Museum of Art, *Loan Collection of Paintings and Sculpture in the West Galleries*, May–October
 A Market Horse, no. 184
National Academy of Design, *Autumn Exhibition*, 22 October–17 November
 Landscape and Figures
American Art Galleries, New York, *The Private Collection of Paintings by Exclusively American Artists, Owned by Thomas B. Clarke*, 28 December–12 January 1884
 Landscape, no. 108

1884

Providence Art Club Fifth Annual Exhibition
 Toilers of the Sea [cat. 69][4]
National Academy of Design, *Fifty-ninth Annual Exhibition*, 7 April–17 May
 The Waste of Waters Is Their Field, no. 191, lent by
 Daniel Cottier [The Brooklyn Museum]
National Academy of Design, *Society of American Artists Seventh Annual Exhibition*, 26 May–21 June
 Marine, lent by T. C. Williams [cat. 69]
Interstate Industrial Exposition of Chicago Twelfth Annual Exhibition, 3 September–18 October
 Marine, lent by T. C. Williams [cat. 69]

1885

American Art Galleries, *First Prize Fund Exhibition*, 20 April
 The Old Mill, no. 70

1886

National Academy of Design, *Sixty-first Annual Exhibition*, 5 April–15 May
 Little Maid of Arcady, lent by Herbert Ryston [cat. 29]
The Metropolitan Museum of Art, *Society of American Artists Eighth Exhibition*, May–October
 Moonlight, no. 92
American Art Galleries, *Fall Exhibition*
 Stable Interior, no. 163 [cat. 22 (?)]
National Academy of Design, *Autumn Exhibition*, 22 November–18 December
 Smugglers

1887

Yandell Gallery, New York, *Society of American Artists Ninth Exhibition*
 Moonlight
American Art Galleries, *Third Prize Fund Exhibition for the Promotion and Encouragement of American Art*, April
 The Flying Dutchman, no. 185, lent by Cottier &
 Co. [cat. 14]; *The Shepherdess*, no. 186 [cat. 57]
American Art Galleries, New York, *Fall Exhibition*
 Oriental Camp, no. 220 [cat. 43]
National Academy of Design, *Autumn Exhibition*, 21 November–17 December
 Figure Composition, no. 77, lent by the artist, $500

1888

New York Athletic Club Second Annual Art Loan Exhibition, 4 February–?
 The Temple of the Mind, no. 41, lent by Thomas B.
 Clarke [cat. 67]
National Academy of Design, *Sixty-third Annual Exhibition*, 2 April–12 May
 Christ Appearing to Mary, no. 444, lent by Thomas
 B. Clarke [cat. 6]
Art Institute of Chicago First Annual Exhibition of American Oil Paintings, 28 May–30 June
 The Temple of the Mind, lent by Thomas B. Clarke
 [cat. 67]

Art Association of Montreal Loan Exhibition of Oil Paintings and Water Colour Drawings, November
 The Flying Dutchman, no. 85, lent by Cottier & Co.
 [cat. 14]

1889

Art Institute of Chicago Second Annual Exhibition of American Oil Paintings, 30 May–30 June
 Christ Appearing to Mary, lent by Thomas B. Clarke
 [cat. 6]

1890

New York Athletic Club
 Jonah, lent by R. H. Halsted [cat. 24][5]
Art Institute of Chicago, *Art Collections Owned by James W. Ellsworth*, May
 Spirit of Spring, no. 84 [cat. 62]

1891

Art Association of Montreal Loan Exhibition of Oil Paintings and Water Colour Drawings
 A Sentimental Journey, no. 87, lent by E. B. Green-
 shields [cat. 56]
New York Athletic Club Fifth Annual Loan Exhibition
 Jonah, lent by R. H. Halsted [cat. 24]; *Siegfried and
 the Rhine Maidens*, lent by R. H. Halsted [cat. 60]
Pennsylvania Academy of the Fine Arts, *Thomas B. Clarke Collection of American Pictures*, 15 October–28 November
 Christ Appearing to Mary, no. 166 [cat. 6]; *The
 Temple of the Mind*, no. 167 [cat. 67]
Chicago Art Institute, *Fourth Annual Exhibition of American Oil Paintings and Sculpture*, 26 October–29 November
 Pirette [sic], no. 316 [cat. 50]

1892

National Academy of Design, *New York Columbian Celebration of the Discovery of America*
 Temple of the Mind, no. 63, lent by T. B. Clarke
 [cat. 67]
Portland Art Association, Oregon, *Art Loan Exhibition at the Marquam Hall*, January
 Guinevere, no. 60, lent by C. E. S. Wood
New York Athletic Club Sixth Annual Loan Exhibition: A Collection of American Paintings by American Artists, 15 September–28 October
 Perette [sic], no. 57, lent by Smith College, North-
 hampton, Massachusetts [cat. 50]

1893

Thomas B. Clarke Art House, New York, *First Annual Summer Exhibition of the Art House [Exhibition of the Collection of Thomas B. Clarke]*, June 1893
 Moonlight [cat. 38]

1894

Pennsylvania Academy of the Fine Arts, *Sixty-fourth Annual Exhibition*, 17 December–23 February 1895
 Moonlight

1895

Pennsylvania Academy of the Fine Arts, *Sixty-fifth Annual Exhibition*
> *Flying Dutchman* [cat. 15]

William T. Evans Residence, New York, *American Paintings—Collection of Mr. William T. Evans*, March
> *Moonlight*, no. 130 [cat. 38]; *The Sisters*, no. 131; *Launce and His Dog*

Art Association of Montreal *Eighteenth Loan Exhibition*, 18 November
> *"Siegfried,"* no. 70, lent by Sir William Van Horne [cat. 59]; *Moonlight on the Sea*, no. 71, lent by Sir William Van Horne [cat. 40]

The Lotos Club, New York, *American Landscape Painters, Arranged by William T. Evans*, 26 December
> *The Flying Dutchman*, no. 37, lent by James Inglis [cat. 15]

1897

The Lotos Club, *Tonal Paintings: Ancient and Modern*, 27 March
> *Pastorale*, no. 22, lent by Henry T. Chapman [cat. 45]

The Brooklyn Museum, *Opening Exhibition*, 2 June–?
> *Moonlight*, no. 333, lent by William T. Evans [cat. 38]; *The Little Maid of Acadie*, no. 334, lent by William T. Evans [cat. 29]; *Pastoral Scene*, no. 533, lent by Henry T. Chapman, Jr. [cat. 45]

The Lotos Club, *Exhibition of the Work of American Figure Painters*, 18 December
> *Christ Appearing unto Mary*, no. 31, lent by Messrs. Cottier & Co. [cat. 6]; *Launce and His Dog*

1898

The Lotos Club[6]
> *Launce and His Dog; The Sisters*

Art Association of Montreal *Twentieth Loan Exhibition*, 25 January–8 February
> *Constance*, no. 67, lent by William C. Van Horne [cat. 7]

William T. Evans Residence, New York, *American Paintings—Collection of Mr. William T. Evans*, February
> *Moonlight*, no. 153 [cat. 38]; *The Sisters*, no. 154; *Launce and His Dog*, no. 155; *Little Maid of Acadie*, no. 156 [cat. 29]; *Charity*, no. 157 [*The Sisters*, The Saint Louis Art Museum]

1899

The Lotos Club, *Exhibition of American Landscapes and Marines*, 25 March–?
> *Moonlight*, no. 28, lent by William T. Evans [cat. 38]

Carnegie Institute, Pittsburgh, *Fourth Annual Exhibition*, 2 November–1 January 1900
> *Moonlight*, no. 201, lent by William T. Evans [cat. 38]; *The Little Maid of Acadie*, no. 202, lent by William T. Evans [cat. 29]

1900

American Art Galleries, *The William T. Evans Collection*, 24 January–2 February
> *Moonlight*, no. 259 [cat. 38]

1901

Art Association of Montreal Catalogue of the Second Loan Exhibition of Paintings, 21–26 February
> *Temple of the Mind*, no. 17, lent by R. B. Angus, Esq. [cat. 67]

Pan American Exposition, Buffalo, May–November
> *Siegfried and the Rhine Maidens*, no. 436, lent by William Van Horne, silver medal awarded [cat. 59]; *Temple of the Mind*, no. 495, lent by R. B. Angus [cat. 67]

South Carolina Interstate and West Indian Exposition, Department of Fine Arts, Charleston, 1 December–1 June 1902
> Unidentified works

1902

Pennsylvania Academy of the Fine Arts, *Seventy-first Annual Exhibition*, 20 January–1 March
> *Siegfried and the Rhine Maidens*, no. 16, lent by William Van Horne [cat. 59]

Portland Art Association, Oregon, *Loan Exhibition*, March
> *Ophelia*, no. 38, lent by C. E. Ladd

Fine Arts Building, New York, *Society of American Artists Twenty-fourth Annual Exhibition*, 28 March–4 May
> *Siegfried*, no. 237, lent by William Van Horne [cat. 59]

1903

Art Association of Montreal *Twenty-sixth Loan Exhibition*, 22–31 January
> *Constance*, no. 46, lent by Sir William Van Horne [cat. 7]

The Lotos Club, *Exhibition of American Paintings from the Collection of Dr. Alexander C. Humphreys*, 28 March–?
> *Twilight*, no. 34

William T. Evans Residence, Wentworth Manor, Montclair, New Jersey, *American Paintings—Collection of William T. Evans*, April
> *Autumn*, no. 141

1904

American Fine Arts Society Galleries, New York, *Society of American Collectors Comparative Exhibition of Native and Foreign Art*
> *The Flying Dutchman*, no. 17, lent by John Gellatly [cat. 15]; *Siegfried*, no. 145, lent by Sir William Van Horne [cat. 59]; *Custance*, no. 146, lent by Sir William Van Horne [cat. 7]

William T. Evans Residence, New Jersey, *American Paintings—Collection of William T. Evans*, July
> *Autumn*, no. 161

1905

Art Association of Montreal Twenty-eighth Loan Exhibition, 23 January–4 February
 The Temple of the Mind, no. 32, lent by R. B. Angus [cat. 67]
Lewis and Clark Centennial Exposition, Department of the Fine Arts, Portland, Oregon, 1 June–15 October
 Resurrection, no. 152, lent by N. E. Montross [cat. 52]
William T. Evans Residence, New Jersey, *American Paintings—Collection of William T. Evans*, 28 October
 Autumn, no. 144; *"With Sloping Mast and Dipping Prow,"* no. 145 [cat. 76]
The Lotos Club, *December Exhibition*
 Macbeth and the Witches, lent by J. Harson Rhoades [cat. 35a]

1906

Portland Art Association, Oregon, *Loan Exhibition of Paintings*, 26 February–17 March
 Christ Appearing to Mary Magdalen, no. 30 [cat. 6]; *Desdemona*, no. 31 [fig. 84]
The Lotos Club, *Exhibition of Paintings from the Collection of William T. Evans*, 31 March–?
 "With Sloping Mast and Dipping Prow," no. 60 [cat. 76]
William T. Evans Residence, *American Paintings—Collection of William T. Evans*, 25 April
 Autumn, no. 150; *"With Sloping Mast and Dipping Prow,"* no. 151 [cat. 76]
National Arts Club, New York, *Opening Exhibition—American Paintings from the Collection of Mr. William T. Evans*, 8–18 November
 "With Sloping Mast and Dipping Prow," no. 47 [cat. 76]

1907

Pennsylvania Academy of the Fine Arts, *102d Annual Exhibition*, 21 January–24 February
 Resurrection [cat. 52]
The Lotos Club, *American Paintings from the Collection of Dr. Alexander Humphreys*, 30 March–?
 Twilight, no. 63
Cottier & Co., *A Group of Twenty-four Paintings* [or *Nine Representative Canvases by Albert Pinkham Ryder*], 28 December–11 January 1908
 The Curfew Hour, lent by Charles de Kay [fig. 118]

1908

The Corcoran Gallery, Washington, D.C., *Biennial Exhibition, 1908–9*
 Mending the Harness, lent by Knoedler [cat. 36]
William T. Evans Residence, New Jersey, *American Paintings—Collection of William T. Evans*, November
 Autumn, no. 123; *"With Sloping Mast and Dipping Prow,"* no. 124 [cat. 76]

1909

Worcester Art Museum, Massachusetts, *Twelfth Annual Summer Exhibition of Oil Paintings by Contemporary American Artists*
 Unidentified works

The Engineers' Club, New York, *Loan Exhibition of Paintings by American Artists*, 24 April–3 May
 "With Sloping Mast and Dipping Prow" [cat. 76]
Carnegie Institute, *Thirteenth Annual Exhibition*, 29 April–13 June
 The White Horse, no. 239, lent by Messrs. Cottier & Co. [cat. 74]
Portland Art Association, Oregon, *Loan Exhibition of Paintings*, Summer
 Christ Appearing to Mary Magdalen, no. 53, lent by William M. Ladd [cat. 6]; *Jonah*, no. 56, lent by C. E. S. Wood [cat. 24]; *Story of the Cross*, no. 62, lent by C. E. S. Wood [cat. 64]; *Geraldine*, no. 63, lent by C. E. S. Wood [cat. 77]; *Desdemona*, no. 64, lent by Charles E. Ladd [fig. 84]; *Landscape*, no. 73, lent by C. E. S. Wood [cat. 27]; *Christ and Peter*, no. 132

1910

Königliche Akademie der Kunst, Berlin, *Die Ausstellung amerikanische Kunst*
 Siegfried and the Rhine Maidens, no. 72, lent by William Van Horne [cat. 59]
The Newark Museum Association, *Exhibition of Paintings Lent by William T. Evans*
 "With Sloping Mast and Dipping Prow," no. 33 [cat. 76]
Worcester Art Museum, *Thirteenth Annual Exhibition of Oil Paintings by Contemporary American Artists*
 The White Horse, lent by Walter P. Fearon [cat. 74]
Cottier & Co., 1–24 March
 The Curfew Tolls the Knell of Parting Day, lent by Charles de Kay [fig. 118]; *Mending the Harness*, lent by James S. Inglis [cat. 36]; *The Monastery*, lent by James S. Inglis [The Parrish Art Museum, Southampton, New York]
The National Gallery of Art [now National Museum of American Art], Washington, D.C., *Exhibition on the Occasion of the Opening of the National Gallery of Art*, 17–? March
 Moonlight, no. 43, lent by William T. Evans [cat. 38]

1911

Exposition International, Rome[7]
 Unidentified works
William T. Evans Residence, New Jersey, *American Paintings—Collection of William T. Evans*, February
 Autumn, no. 127; *Sunset Glow, The Old Red Cow*, no. 128 [The Brooklyn Museum]; *"With Sloping Mast and Dipping Prow,"* no. 129 [cat. 76]
The Lotos Club, *Exhibition of Paintings by Living American Artists*, 30 March–6 April
 With Sloping Mast and Dipping Prow, no. 27, lent by William T. Evans [cat. 76]

1912

Toledo Museum of Art, *Inaugural Exhibition*, 17 January–12 February
 Mending the Harness, no. 81, lent by Walter P. Fearon, Esq. [cat. 36]

Worcester Art Museum, *Fifteenth Annual Exhibition of Oil Paintings by American Artists*, 7 June–15 September
> *Constance*, lent by William Van Horne [cat. 7]

The Lotos Club, *Exhibition of Paintings from the Collection of William T. Evans*, 7 December
> "*With Sloping Mast and Dipping Prow*," no. 45 [cat. 76]

Art Association of Montreal, *Inaugural Loan Exhibition in Connection with the Opening of the New Building of the Art Association*, 9 December
> *The Temple*, no. 161, lent by William Van Horne [cat. 67]; *Siegfried and the Rhine Maidens*, no. 162, lent by William Van Horne [cat. 59]

1913

The Lotos Club, *Exhibition of Paintings of the Romantic Movement by Artists of the French, Dutch, English, and American Schools*, 16 February–?
> "*With Sloping Mast and Dipping Prow*," no. 45, lent by William T. Evans [cat. 76]

Armory Sixty-ninth Infantry, New York, *International Exhibition of Modern Art, Association of American Painters and Sculptors* [The Armory Show], 17 February–15 March
> *A Pastoral Study*, no. 962, lent by John Gellatly [cat. 45]; *Moonlight Marine*, no. 963, lent by N. E. Montross [cat. 39]; *Moonlight on Beach*, no. 964 [cat. 41]; *Diana*, no. 965, lent by Alexander Morten [cat. 12]; *Hunter and Dog*, no. 966, lent by Alexander Morten [cat. 21]; *Interior of a Stable*, no. 967, lent by Mrs. William Macbeth [cat. 22]; *Saint Agnes Eve*, no. 1079 [fig. 62], lent by Mrs. Lloyd Williams; *Pegasus*, no. 1080, lent by J. R. Andrews [cat. 48]; *Resurrection*, no. 1081, lent by N. E. Montross [cat. 52]; *At the Ford*, no. 1082, lent by N. E. Montross [David B. Findlay]

Art Institute of Chicago, *International Exhibition of Modern Art, Association of American Painters and Sculptors*, 24 March–16 April
> *Pegasus*, no. 363, lent by J. R. Andrews [cat. 48]; *Diana*, no. 364 [cat. 12]; *Hunter and Dog*, no. 365, lent by Alexander Morten [cat. 21]; *Interior of a Stable*, no. 366, lent by William Macbeth [cat. 22]

1914

Macbeth Gallery, New York, *Exhibition*, March–April
> Unidentified works

Toledo Museum of Art, *Exhibition of Paintings Lent by Dr. A. C. Humphreys*
> *Twilight*, no. 131

1915

Minneapolis Institute of Arts Inaugural Exhibition, 7 January–7 February
> *The Stable*, no. 277a, lent by William Macbeth [cat. 22]

1917

The Brooklyn Museum, *An Historical Exhibition of Paintings to Celebrate the Opening of the Catskill Aqueduct*, 1–29 November
> *Autumn's Golden Pathway*, no. 65, owned by the Brooklyn Museum [Cincinnati Art Museum]; *Evening Glow, The Old Red Cow*, no. 66, owned by the Brooklyn Museum [The Brooklyn Museum]; *The Grazing Horse*, no. 67, owned by the Brooklyn Museum [cat. 19]; *Moonrise*, no. 68, owned by the Brooklyn Museum [The Brooklyn Museum]; *The Sheepfold*, no. 69, owned by the Brooklyn Museum [The Brooklyn Museum]; *The Shepherdess*, no. 70, owned by the Brooklyn Museum [cat. 57]; *Summer's Fruitful Pasture*, no. 71, owned by the Brooklyn Museum [cat. 65]; *The Waste of Waters Is Their Field*, no. 72, owned by the Brooklyn Museum [The Brooklyn Museum]; *Horse in Stall*, no. 73, lent by Mr. Augustus Healy

Notes

1. Ryder's painting *The Culprit Fay* is described as hanging at the same time as the Monticelli exhibition at Cottier & Co. ("The Cottier Gallery—Monticelli and His Friend Diaz—Dreams of the Orient—A Tapestry in Paint," *New York Times*, 1 September 1879, 5).

2. Cited in "Art Notes," *Boston Daily Evening Transcript*, 21 May 1880, sec. 4, pp. 4–5.

3. The painting is described in *Boston Daily Evening Transcript*, 25 November 1882, sec. 10, pp. 3–4.

4. The Providence Art Club does not record Ryder's inclusion in this exhibition, but the work has a label on it from the show.

5. De Kay, "Modern Colorist," 258.

6. Cited in *New York Times*, 17 December 1898.

7. Cited in *The Index of Twentieth-Century Artists, 1933–1937* (New York: Arno, 1934), n.p.

Bibliography

Books and Exhibition Catalogues

Albert Pinkham Ryder. New York: Macbeth Gallery, 1946.

Association of American Painters and Sculptors, Inc. *International Exhibition of Modern Art [The Armory Show].* New York: Vreeland, 1913. Supplement and errata sheet contain information on Ryder entries.

Bolger-Burke, Doreen. *American Paintings in the Metropolitan Museum of Art,* vol. 3. New York: Metropolitan Museum of Art, 1980.

———. *J. Alden Weir: An American Impressionist.* Newark: American Art Journal and University of Delaware Press Books, 1983.

Boughton, Alice. *Photographing the Famous.* New York: Avondale, 1928.

Burroughs, Alan. *Limners and Likenesses: Three Centuries of American Painting.* Boston: Harvard University Press, 1936.

Caffin, Charles. *The Story of American Painting.* 1907.

Catalogue of American and European Paintings in the Gellatly Collection. 4th ed. Washington, D.C.: National Collection of Fine Arts, Smithsonian Institution, 1954.

Celebration. Pittsburgh: Carnegie Institute, 1974.

Cheney, Sheldon. *The Story of Modern Art.* New York: Viking, 1941.

Cortissoz, Royal. "Poets in Paint." In *American Artists.* New York and London: Scribner's, 1923.

Craven, Thomas. "Ryder: An American Master." In *Men of Art.* New York: Simon & Schuster, 1931.

Davidson, Abraham A. *The Eccentrics and Other American Visionary Painters.* New York: Dutton, 1978.

Dorra, Henri. *The American Muse.* New York: Viking, 1961.

———, and Lloyd Goodrich. *Albert Pinkham Ryder.* Washington, D.C.: Corcoran Gallery of Art, 1961.

Eldredge, Charles C. *American Imagination and Symbolist Painting.* New York: Gray Art Gallery and Study Center, New York University, 1979.

Faunce, Sarah. "Paintings by Albert Pinkham Ryder." In *The Guennol Collection.* Edited by Ida Ely Rubin, vol. 2. New York: Metropolitan Museum of Art, 1982.

Goodrich, Lloyd. *Albert P. Ryder: Centenary Exhibition.* New York: Whitney Museum of American Art, 1947.

———. *Albert P. Ryder.* New York: Braziller, 1959.

———. *A Selection of Paintings by Albert Pinkham Ryder and Albert Bierstadt.* New Bedford, Mass.: Swain School of Design, 1960.

Greenberg, Clement. "Review of an Exhibition of Albert Pinkham Ryder." In *Clement Greenberg: The Collected Essays and Criticism.* Vol. 2. Chicago: University of Chicago Press, 1986.

Hartley, Marsden. "Albert P. Ryder." In *Adventures in the Arts.* New York: Boni & Liveright, 1921.

———. "Albert Pinkham Ryder: The Spangle of Existence" (1936). In *Marsden Hartley: On Art.* Edited by Gail R. Scott. New York: Horizon, 1982.

Hartmann, Sadakichi. *A History of American Art.* 2 vols. 1902. Rev. ed. New York: Tudor, 1934.

Hilu, Virginia, ed. *Beloved Prophet: The Love Letters of Kahlil Gibran and Mary Haskell.* London: Barrie & Jenkins, 1972.

Karlstrom, Paul J. *Louis Michel Eilshemius.* New York: Abrams, 1978.

LaFollette, Suzanne. *Art in America.* New York and London: Harper, 1929.

Landgren, Marchal E. *Robert Loftin Newman: 1827–1912.* Washington, D.C.: Smithsonian Institution Press for the National Collection of Fine Arts, 1974.

Larkin, Oliver W. *Art and Life in America.* New York: Rinehart, 1949.

Mather, Frank Jewett, Jr. "Albert Pinkham Ryder." In *Estimates in Art,* 2d ser. New York: Holt, 1931.

———, et al. "Early Visionaries, 1860–1900." In *The Pageant of America.* New Haven, Conn.: Yale University Press, 1927.

The Metropolitan Museum of Art. *Loan Exhibition of the Works of Albert P. Ryder.* Introduction by Bryson Burroughs. New York: DeVinne Press, 1918. Introduction reprinted as "Albert Pinkham Ryder," *Arts Magazine* (*Arts Weekly*) 16 (May 1930): 638.

Millet, J. B., ed. *Julian Alden Weir: An Appreciation of His Life and Works.* New York: Dutton, 1922.

Monroe, Harriet. *A Poet's Life.* 1938. Reprint. New York: AMS Press, 1971.

Morris, Harrison S. *Confessions in Art.* New York: Sears, 1930.

Museum of Modern Art. *Sixth Loan Exhibition: Winslow Homer, Albert P. Ryder, Thomas Eakins.* New York: Museum of Modern Art, 1930.

———. *Art in Our Time: An Exhibition to Celebrate the Tenth Anniversary.* New York: Museum of Modern Art, 1939.

———. *Feininger/Hartley.* New York: Museum of Modern Art, 1944. Contains Marsden Hartley's notes on painting, ca. 1909.

Novak, Barbara. "Albert Pinkham Ryder: Even with a Thought." In *American Painting of the Nineteenth Century.* New York: Praeger, 1969.

Phillips, Duncan. "Julian Alden Weir." In *Julian Alden Weir: An Appreciation of His Life and Works.* The Phillips Publication Number One. New York: Dutton, 1922.

Price, F. Newlin. *Ryder: A Study of Appreciation.* New York: Rudge, 1932.

Roosval, Johnny. "Albert Pinkham Ryder: Det Amerikanska Måleriets Store Romantiker, Anteckningar från en studieresa av Johnny Roosval." *Tidskrift för Konstvetenskap,* och Konsthistoriska Sällskapets Publikation. Reprinted from an unnamed and undated publication in the Brooklyn Museum, pp. 113–22.

Rosenblum, Robert. *Modern Painting and the Northern Romantic Tradition: Friedrich to Rothko.* London: Thames & Hudson, 1975.

Rosenfeld, Paul. *Port of New York: Essays on Fourteen American Moderns.* New York: Harcourt, Brace, 1924.

Ross, Barbara T. *American Drawings in the Art Museum, Princeton University.* Princeton, N.J.: Princeton University Press, 1971.

Rothenstein, John. *Brave Day, Hideous Night.* London: Hamish Hamilton, 1966.

———. *Summer's Lease.* Vols. 1–2. London: Hamish Hamilton, 1966.

Shapley, John, ed. *Index of Twentieth-Century Artists, 1933–1937.* Vol. 1, no. 5. New York: Research Institute of the College Art Association, February 1934.

Sherman, Frederic Fairchild. *Landscape and Figure Painters of America.* New York: Privately printed, 1917.

———. *Albert Pinkham Ryder.* New York: Privately printed, 1920.

Society of Art Collectors. *Comparative Exhibition of Native and Foreign Art.* New York: American Fine Arts Society, 1904.

Speed, John Gilmer. "A Painter of Marine Subjects." In *Essays on American Art and Artists.* Temple Court, N.Y.: Eastern Art League, 1896.

Stein, Roger B. *Seascape and the American Imagination.* New York: Whitney Museum of American Art, 1975.

Teller, Walter M., ed. "Albert Pinkham Ryder." In *Twelve Works of Naive Genius.* New York: Harcourt, Brace, Jovanovich, 1972. Contains Philip Evergood essay "The Master's Faithful Disciple" (1950).

Wilmerding, John. *American Marine Painting.* New York: Abrams, 1987.

Wood, C. E. S. "A Letter." In *Julian Alden Weir: An Appreciation of His Life and Works.* The Phillips Publication Number One. New York: Dutton, 1922.

Young, Dorothy Weir. *The Life and Letters of J. Alden Weir.* New York: Kennedy Graphics and Da Capo Press, 1971.

Articles

"Albert Pinkham Ryder, 'Poet Artist,' Dead." Newspaper clipping, 29 March 1917.

"Albert P. Ryder: A Poe of the Brush." *New York Press,* 16 December 1906, 5.

"Albert P. Ryder Dead." Newspaper clipping, 29 March 1917.

"Albert P. Ryder, Died March 28, 1917." *American Art News* 15, no. 25 (31 March 1917): 4.

"Albert P. Ryder of Art Fame Is Dead." *New York Sun,* 29 March 1917.

"Albert Ryder's Mystic Art." *Current Literature* 45 (September 1908): 289–93.

Alper, M. Victor. "American Mythologies in Painting." *Arts Magazine* 46 (Summer 1976): 5–6.

Andreae, Christopher. "Two Sides of Albert Pinkham Ryder." *Christian Science Monitor,* 7 June 1973.

Andrews, Wayne, and Garnett McCoy. "Realists and Mystics." *Art in America* 53, no. 4 (August–September 1965): 54–67.

"A. P. Ryder Dies; Great Native Painter." *New York Evening Journal,* 28 March 1917.

Ashton, Dore. "Art East—The Symbolist Legacy—I and II." *Arts and Architecture* 81 (September, December 1964): 10:37; 6:35–36.

Baldinger, Wallace S. "Art of Eakins, Homer, and Ryder: A Social Reevaluation." *Art Quarterly* 9, no. 3 (1946): 213–33.

Barker, Virgil. "Albert Pinkham Ryder." *Creative Art* 5 (December 1929): 839–42.

Beck, Walter de S. "Albert Pinkham Ryder: An Appreciation." *International Studio* 70, no. 277 (supp. April 1920): 37–46.

Boime, Albert. "The Literary World of Albert Pinkham Ryder." *Gazette des Beaux-Arts,* 6th ser., 33 (January 1948): 47–56.

———. "Newman, Ryder, Couture, and Hero-Worship in Art History." *American Art Journal* 3, no. 2 (Fall 1971): 5–22

———. "Newman and Ryder: A Collaboration." *ArtNews* 73 (January 1974): 61–2.

Breuning, Margaret. "Genius of Ryder, American Mystic, Reviewed by Whitney Museum." *Art Digest* 22, no. 3 (1 November 1947): 9, 34–35.

Brown, Gaye L. "Albert Pinkham Ryder's *Joan of Arc:* The Damsel in Distress." *Worcester Art Museum Journal* 3 (1979–80): 37–51.

Brownell, William C. "The Younger Painters of America—First Paper." *Scribner's Monthly* 20, no. 1 (May 1880): 1–15.

———. "The Younger Painters of America—Second Paper." *Scribner's Monthly* 20, no. 3 (July 1880): 321–35.

———. "The Younger Painters of America III." *Scribner's Monthly* 22, no. 3 (July 1881): 321–34.

Brumbaugh, Thomas B. "The American Nineteenth Century, Part Three: The Gellatly Legacy." *ArtNews* 67 (September 1968): 48–51, 58–60.

———. "Albert Pinkham Ryder to John Gellatly: A Correspondence." *Gazette des Beaux-Arts,* 6th ser., 8 (December 1972): 361–70.

Burroughs, Clyde. "New Acquisitions." *Bulletin of the Detroit Institute of Arts* 6 (1926): 85–87.

———. "Paintings by Homer and Ryder." *Bulletin of the Detroit Institute of Arts* 14 (1934): 8–10.

Caffin, Charles. "International Still Stirs the Public" and "The American Section Still Reflects the Nationalistic Motive." *New York American,* 10 March 1913, 8.

Campbell, Elwyn G. "Artists of This Vicinity" (1979). Lecture presented at the Roundabout Club in 1921 and Fairhaven Club in 1922, Fairhaven, Mass.

Cheney, David M. "New Bedford's Painter of Dreams." *New Bedford Standard-Times,* 10 June 1917, 17.

Coates, Robert M. "The Art Galleries: Mainly Memorabilia." *New Yorker* (1 November 1947): 80–83.

Cortissoz, Royal. "The Visions of a Man of Genius." *New York Tribune,* 10 March 1918.

Cotter, M. J., et al. "A Study of the Materials and Techniques Used by Some Nineteenth-Century American Oil Painters by Means of Neutron Activation Autoradiography." In *Applicazione dei metodi nucleari del campo delle opere d'arte.* Rome: Academia Nazionale dei Lincei, 1976, 163–203.

Craven, Thomas. "An American Master." *American Mercury* 12 (December 1927): 490–97.

———. "Pinkie Ryder: America's Master Painter." *Wisdom* (March 1956): 66–69.

"The Critic's Albert P. Ryder." *Art Collector* (1 December 1898): 37.

Daingerfield, Elliott. "Albert Pinkham Ryder: Artist and Dreamer." *Scribner's Magazine* 63 (March 1918): 380–84.

de Kay, Charles. "An American Gallery." *Magazine of Art* 9 (1886): 291.

———. [Henry Eckford, pseud.]. "A Modern Colorist." *Century Magazine* 40 (June 1890): 250-59.

———. "The Private Collection of W. T. Evans." *New York Times Illustrated Magazine,* 21 August 1898, 12–14.

———. "Great American Paintings." *New York Times Illustrated Magazine,* 5 February 1899, 7–9.

———. "Lessons of the Comparative Art Exhibition." *New York Times Magazine,* 20 November 1904, sec. 2, p. 1.

Dorra, Henri. "Ryder and Romantic Painting." *Art in America* 48, no. 4 (Winter 1960): 22–33.

Dougherty, Paul. "The Comparative Exhibition of Foreign and American Art." *Brush and Pencil* 15 (January 1905): 45–51.

Downes, William Howe, and Frank Torrey Robinson. "Later American Masters." *New England Magazine,* n.s. 14, no. 2 (April 1896): 131–51.

Eager, Gerald. "The Iconography of the Boat in Nineteenth-Century American Painting." *Arts Journal* 35, no. 3 (Spring 1976): 229–30.

Eckford, Henry. *See* de Kay, Charles

"Enriching U.S. Museums, Part IV: Romantic Landscapes to Walker Art Center." *ArtNews* 46 (August 1947): 20.

Evergood, Philip. "The Master's Faithful Disciple" (1950). Quoted in Kendall Taylor, "Ryder Remembered," *Archives of American Art Journal* 24, no. 3 (1984): 3–16, 40.

Fitzpatrick, Charles. "Albert Pinkham Ryder" (1917). Quoted in Kendall Taylor, "Ryder Remembered," *Archives of American Art Journal* 24, no. 3 (1984): 3–16, 40.

"Form and Moonlight: The Art of Albert Ryder." *MD Magazine* 25, no. 6 (June 1981): 120–28.

French, Joseph Lewis. "A Painter of Dreams." *Broadway Magazine* 14 (September 1905): 3–9. Precedes Ryder's "Paragraphs of a Recluse."

Fry, Roger E. "The Art of Albert P. Ryder." *Burlington Magazine* 13 (April 1908): 63–64.

"Genius in Hiding." *Chicago Times-Herald* (24 March 1896).

Gerdts, William H. "The Square Format and Proto-modernism in American Painting." *Arts Magazine* 50 (June 1976): 70–75.

Gibbs, Josephine. "Ryder, America's Great Romantic, Found That 'Something Beyond'." *Art Digest* 20, no. 13 (1 April 1946): 5, 30–31.

————. "Ryder's Siegfried Becomes National Treasure." *Art Digest* 20 (1 April 1946): 5, 29.

Goodrich, Lloyd. "Realism and Romanticism in Homer, Eakins, and Ryder." *Art Quarterly* 12, no. 1 (1949): 17–29.

————. "New Light in the Mystery of Ryder's Background." *ArtNews* 60 (April 1961): 39–41 + .

————. "Ryder Rediscovered." *Art in America* 56 (November 1968): 32–45.

"A Great Collection: Native and Foreign Pictures at the Fine Arts Building." *New York Daily Tribune*, 15 November 1904, 7.

Hartley, Marsden. "Albert P. Ryder." *Seven Arts* 2 (May 1917): 93–96.

Hartmann, Sadakichi. "A Visit to Albert Pinkham Ryder." *ArtNews* 1 (March 1897): 1–3. Reprinted in *Sadakichi Hartmann Newsletter* 2, no. 3 [Winter 1971]: 4–5.

————. "Eremites of the Brush." *American Mercury* 11, no. 41 (June 1927): 192–96.

————. "Albert Pinkham Ryder." *Magazine of Art* 31 (September 1938): 500–503, 550–51.

Hendy, Philip. "Two Unconventional Painters." *Boston Museum Bulletin* 31 (April 1933): 31–32.

"Homer, Ryder, and Eakins Figure in a Great Modern Show." *Art Digest* 4 (15 May 1930): 9.

Homer, William I. "A Group of Paintings and Drawings by Ryder." *Princeton Museum Record* 18, no. 1 (1959): 17–33.

————. "Ryder in Washington." *Burlington Magazine* 103, no. 699 (June 1961): 280–83.

————. "*The Flying Dutchman*: A Drawing by Albert Pinkham Ryder." *Porticus* 9 (1986): 10–15.

Hyde, William H. "Albert Ryder as I Knew Him." *Arts Magazine* 16 (May 1930): 596–99.

J.M.T. "The American Artists' Exhibition." *Art Amateur* 11 (July 1884): 30.

Johns, Elizabeth. "Albert Pinkham Ryder: Some Thoughts on His Subject Matter." *Arts Magazine* 54 (November 1979): 164–71.

————. "Arthur B. Davies and Albert Pinkham Ryder: The 'Fix' of the Art Historian." *Arts Magazine* 56 (January 1982): 70–74.

Judson, Jeanne. "A Recluse of the Sake of His Art Was the Late Albert P. Ryder." *New York Sun*, 29 April 1917, 5.

Katz, Leslie. "The Emblems of A. P. Ryder." *Arts Magazine* 35 (September 1961): 50–55.

Kernan, Michael. "Sliding Ryder." *Washington Post*, 12 January 1969, sec. H, pp. 1, 6.

Kuspit, Donald. "Albert Ryder's Expressiveness." *Jarbuch für Amerikastudien* 8 (1963): 219–25.

Lane, James W. "A View of Two Native Romantics, Newman and Ryder: Recluses of the Brown Decades in America." *ArtNews* 38 (11 November 1939): 9, 16.

Lathrop, George Parsons. "The Progress of Art in New York." *Harper's Magazine* 86 (April 1893): 740–52.

Louchheim, Aline B. "Ryder: The Best American Painter's Largest Show Seen by Marsden Hartley Walt

Kuhn, Yasuo Kuniyoshi, Reginald Marsh, Kenneth Hayes Miller." *ArtNews* 46 (November 1947): 28–31.

McBride, Henry. "News and Comment in the World of Art." *New York Sun*, 1 April 1917, 12.

Mangravite, Peppino. "The American Painter and His Environment." *American Magazine of Art* 28, no. 4 (April 1935): 198–203.

Mather, Frank Jewett, Jr. "The Romantic Spirit in American Art." *Nation* 104 (12 April 1917): 427.

————. "Albert Pinkham Ryder's Beginnings." *Art in America* 9, no. 3 (April 1921): 119–27.

"Metaphysical Haunt." *New Yorker* 33 (2 March 1957): 24–25.

Meyer, Annie Nathan. "Comparative Exhibition of American and Foreign Art." *Harper's Weekly* 48 (3 December 1904): 1841–44, 1857.

M.F. "Portraits at the Museum of Modern Art." *Magazine of Art* 36, no. 1 (January 1943).

Milliken, William M. "*The Race Track*, or *Death on a Pale Horse* by Albert Pinkham Ryder." *Cleveland Museum of Art Bulletin* 15 (March 1928): 65–71.

Minton, Lee, and Everette A. James. "The James M. Cowan Collection of American Paintings in the Parthenon, Nashville, Tennessee." *Antiques* 118, no. 5 (November 1980): 988–97.

M.M. "Exhibitions." *International Studio* 96 (June 1930): 70.

"The Most Imaginative Painter This Country Has Yet Produced." *Current Opinion* 62 (May 1917): 350–51.

Mumford, Lewis. "The Brown Decades: Art." *Scribner's Monthly* 90 (October 1931): 369–72.

————. "The Art Galleries—A Synopsis of Ryder." *New Yorker* (1947): 69.

New Bedford Morning Mercury, 31 March 1917, 4.

O'Connor, John, Jr. "Albert Pinkham Ryder: A Great Artist Enters the Permanent Collection." *Carnegie Magazine* 16 (February 1943): 268–71.

"One Day in the Gallery: Society of American Artists." *New York Times*, 26 March 1880, 5.

"Our Art Beside Europe's." *New York Times*, 15 November 1904, 8.

"Our Veritable Old Masters." *Literary Digest* 105 (7 June 1930): 19–20.

Pach, Walter. "The Field of Art: On Albert Pinkham Ryder." *Scribner's Monthly* 49 (January 1911): 125–28.

Phillips, Duncan. "Albert Ryder." *American Magazine of Art* 7, no. 10 (August 1916): 387–91.

"Pictures at the New York Athletic Club." *New York Times*, 6 February 1888.

Pincus-Witten, Robert. "On Target: Symbolist Roots of American Abstraction." *Arts Magazine* 50 (April 1976): 84–91.

"A Poet's Painter." *Literary Digest* 54 (21 April 1917): 1164–65.

Price, F. Newlin. "Albert Pinkham Ryder." *International Studio* 81 (July 1925): 282–88.

Q.R. "The Solitary in Art." *Christian Science Monitor*, 1 April 1918.

"Realists and Mystics." *Art in America* 53, no. 4 (August–September 1965): 54–67.

"A Remarkable Exhibition." *New York Evening Post,* 29 April 1875, 2.

Robinson, John. "Personal Reminiscences of Albert Pinkham Ryder." *Art in America* 13 (June 1925): 176–87.

Rosenfeld, Paul. "American Painting." *Dial* 71 (December 1921): 649–70.

R.W. "Paintings by Albert P. Ryder (1847–1917) and Odilon Redon (1840–1916)." *Bulletin of the Worcester Art Museum* 10, no. 3 (October 1919): 46–51.

Ryder, Albert Pinkham. "Paragraphs from the Studio of a Recluse." *Broadway Magazine* 14 (September 1905): 10–11.

"Ryder Exhibition at Metropolitan Museum." *New York Times Magazine,* 10 March 1918.

"Ryder's Mysticism Given Magnificent Showing at the Kleeman Galleries." *Art Digest* 10 (15 November 1935): 10.

Sargeant, Winthrop. "Nocturnal Genius: In a Junk-Filled Tenement Albert Ryder Painted a Beautiful World He Imagined." *Life* 30 (26 February 1951): 86–91.

Schnakenberg, H. E. "Albert Pinkham Ryder." *Arts* (*Arts Weekly*) 6 (November 1924): 271–75.

Schnier, Jacques. "The Symbol of the Ship in Art, Myth, and Dreams." *Psychoanalytic Review* 38, no. 1 (January 1951): 53–65.

Schwartz, Sanford. "Northern Seascape." *Art in America* 64 (January 1976): 72–76.

Seymour, Ralph, and Arthur Stanley Riggs. "The Gellatly Collection." *Art and Archeology* 35 (1934): 109–25, 144.

Sherman, Frederic Fairchild. "Some Paintings by Albert Pinkham Ryder." *Art in America* 5 (April 1917): 155–62.

———. "The Marines of Albert Pinkham Ryder." *Art in America* 8 (December 1919): 28–32.

———. "Albert P. Ryder's *Jonah.*" *Art in America* 8, no. 2 (February 1920): 81–82.

———. "Unpublished Paintings by Albert Pinkham Ryder." *Art in America* 8 (April 1920): 129–37.

———. "Four Paintings by Albert Pinkham Ryder." *Art in America* 9 (October 1921): 260–68.

———. "Two Marines by Albert P. Ryder." *Art in America* 12 (October 1924): 296–300.

———. "Two Unpublished Paintings by Albert Pinkham Ryder." *Art in America* 14 (December 1925): 23–25.

———. "Albert Pinkham Ryder's Poetic Fancies." *Art in America* 15, no. 1 (December 1926): 40–44.

———. "Some Paintings Erroneously Attributed to Albert Pinkham Ryder." *Art in America* 24 (October 1936): 160–61.

———. "Some Paintings Erroneously Attributed to Albert Pinkham Ryder." *Art in America* 25 (April 1937): 87–89.

———. "Notes on the Art of Albert P. Ryder." *Art in America* 25 (October 1937): 167–73.

———. "Some Likenesses of Albert Pinkham Ryder." *Art in America* 26 (January 1938): 32–35.

Smith, David Loeffler. "Romanticism and the American Tradition." *American Artist* 26 (March 1962): 28–32.

Soby, James Thrall. "Iron Lungs for Genius." *Saturday Review of Literature* (24 January 1948): 36–37.

"The Society of American Artists." *New York Sun,* 1 June 1884, 7.

"The Society of American Artists." *Scribner's Monthly* (June 1879): 311–12.

Stein, Leo. "Albert Ryder." *New Republic* 14 (27 April 1918): 385–86.

Stuart, Evelyn Marie. "The Cresmer Collection of American Masterpieces." *Fine Arts Journal* 36 (September 1918): 2–23.

Swift, Samuel. "Americanism in Art." *Brush and Pencil* 15 (January 1905): 51–57.

Taylor, Kendall. "Ryder Remembered." *Archives of American Art Journal* 24, no. 3 (1984): 3–16, 40. Includes Philip Evergood reminiscences and Charles Fitzpatrick memoir.

"Three Americans: Ryder, Eilshemius, Lawson—Ferargil Galleries." *Parnassus* 12 (1940): 40.

Vaughan, Malcolm. "The Dreamlike World of Albert Ryder." *Reader's Digest* (November 1958): 144–46.

Wallbank, Lucy M. "Fifty Years Ago; Ryder's Paintings Exhibited." *New Bedford Sunday Standard-Times* (May 1971).

Weller, Allen. "An Unpublished Letter by Albert Pinkham Ryder." *Art in America* 27 (April 1937): 101–2.

Wright, Willard Huntington. "An Abundance of Modern Art." *Forum* 55, no. 3 (March 1916): 318–34.

Unpublished Sources

Archives of American Art, Smithsonian Institution

American Art Association Papers, reels 422–25: auction and exhibition records.

American Art Auction and Exhibition Catalogues, numerous reels: cross-index compiled by the Archives of American Art, microfilmed from archives, libraries, museums.

Carnegie Museum Papers, separately indexed: exhibition histories, correspondence with artists, exhibition catalogues relating to the Carnegie Institute.

Clarke, Thomas B., Papers, reel D10.

Cole, Thomas Casilear, Papers, not microfilmed: comments on the 1932 Ferargil Gallery exhibition.

Detroit Artists Association Records, reel D10: artists' correspondence, including letters from and about Ryder.

Eastwood, Evelyn, Papers, reel 653: Ryder typescript by Eastwood, "Notes from an Interview with Albert Lorey Groll at 222 West Fifty-ninth Street, New York City, September 14, 1946."

Evans, William T., Papers, mostly not microfilmed: copies of correspondence with Ryder and others, papers concerning Evans's collection.

Evergood, Philip, Papers, reel D181: Charles Fitzpatrick's reminiscences of Ryder.

Ferargil Gallery Papers, reels 777–91, 1028–32, D321 and papers not microfilmed: exhibition histories, sales records, correspondence with Ryder's patrons and others.

Force, Juliana, Papers, Whitney Museum of American Art, reel N615: Frederic Fairchild Sherman's scrapbook on Ryder (annotated by Sherman and Lloyd Goodrich), early photographs, letters, articles on Ryder.

Gilder, Richard Watson, Papers, reel 285, restricted: diaries, correspondence, poems, art by Helena de Kay and Richard Watson Gilder.

Jaccaci, August F., Papers, reels D118, D124, D126: annotated inventory of the R. B. Angus and William Van Horne Collections, miscellaneous correspondence with Van Horne and others.

Kelly, James Edward, Papers, reel 1876: reminiscences of Ryder.

Kingsley, Elbridge, Papers, reel 119: unpublished autobiography, discussing Kingsley's engravings of Ryder's paintings.

Lahey, Richard, Papers, reel 378: Kenneth Hayes Miller's comments on Ryder.

Levy, Florence Nightingale, Papers, reel D44: individual files on major patrons and artists, including exhibition reviews, biographical clippings, notes from personal visits to collectors.

Love, Harold O., Papers, reel D181: miscellaneous papers concerning Ryder.

Macbeth Gallery Papers, reels NMc1–81, N132, 2820–23, 3091–92: sales records, early photographs, letters.

Miller, Kenneth Hayes, Papers, reel N583: correspondence with Ryder, Marsden Hartley, and others, papers from 1906–51.

Montross Gallery Papers, reel N133: correspondence related to Ryder, sales and exhibition histories.

New York Public Library Papers, reels N47, N50, N99: auction catalogues, correspondence, lists, records on patrons and galleries.

Price, Frederic Newlin, Papers, reels D42, N68-14, N68-15: correspondence with Ryder's patrons and others, including Horatio Walker.

Shaw, Edwin, Papers, reel 1125: scrapbooks of American artists, correspondence, papers related to Shaw's collection.

Sherman, Frederic Fairchild, and Julia Munson Sherman Papers, not microfilmed: correspondence with Harold W. Bromhead and other dealers and patrons of Ryder, individual files on American artists, including Ryder.

Vose Galleries of Boston, Inc., Papers, reel 2380, N138: sales records, exhibition histories, letters, early photographs of paintings.

Vose, Robert C., Gallery Papers, reel B1: miscellaneous files on artists and art, scrapbook of articles, 1886–1900.

Warner, Olin L., Family Papers, reel 270 and not microfilmed: correspondence with Ryder, J. Alden Weir, C. E. S. Wood, other colleagues.

Weir, Julian Alden, Papers, reels 125–26: correspondence with Ryder and with others about Ryder.

Whitney Museum of American Art, Lloyd Goodrich Papers, reels N619–24, restricted [not consulted]: research on Ryder to 1960.

Wood, Sara Bard Field, Papers, reel D10: correspondence between Charles de Kay and Ryder, correspondence from Ryder to Thomas B. Clarke concerning *Jonah*.

Other Archival Collections

Albright-Knox Art Gallery, Buffalo: correspondence pertaining to Ryder's patrons R. B. Angus and John Gellatly.

Babcock Galleries, New York, Albert Pinkham Ryder Records, compiled by Carmine Dalesio, 1902–59: exhibition, provenance, miscellaneous historical notes and records on paintings by, or attributed to, Ryder; early photographs of Ryder paintings and copies of Ryder's correspondence with Dr. Albert T. Sanden.

The Brooklyn Museum: X-rays and condition reports and records of paintings attributed to Ryder, examined by Sheldon Keck and Lloyd Goodrich.

Conservation Analytical Laboratory, Smithsonian Institution, Washington, D.C.: autoradiographs of several Ryder paintings.

Frick Art Reference Library, New York: photo files and annotated auction catalogues.

Gilder, Helena de Kay, and Richard Watson Gilder Archive, Tyringham, Mass.: letters from Ryder, letters and journals pertaining to Ryder and his acquaintances and to the founding of the Society of American Artists. (Archive is intended to join the Gilder Archive at the New York Public Library.)

Henry E. Huntington Library, San Marino, Calif., Charles Erskine Scott Wood Papers: letters, photos, other documents by and about Ryder, especially Wood's correspondence with Louise Fitzpatrick, John Gellatly, James Inglis.

Keck, Sheldon and Caroline, Archive, Cooperstown, N.Y.: examination and treatment reports on approximately fifty paintings attributed to Ryder.

The Metropolitan Museum of Art, New York, Archives and Library: files of correspondence with lenders and other documents pertaining to the 1918 Ryder memorial exhibition; copy of Sadakichi Hartmann manuscripts on Ryder.

National Academy of Design Archives, New York [not consulted]: records pertaining to Ryder's schooling and acceptance as an academician.

National Museum of American Art, Smithsonian Institution, Washington, D.C., Albert Pinkham Ryder research notes: copies of documents from many sources, notes on Ryder paintings and patrons, copies of publications; Peter A. Juley & Son Collection: early photographs of paintings attributed to Ryder; Pre-1877 Art Exhibition Catalogue Index: exhibition lists prior to the Philadelphia Centennial; Gellatly Vertical File: copies of letters by and about Ryder;

Conservation Lab Files: radiographs and treatment reports on paintings attributed to Ryder.

New Bedford Free Public Library, Mass.: genealogies and local histories.

New York Public Library, Richard Watson Gilder Papers: includes two scrapbooks; Helena de Kay Gilder Archives: auction and exhibition catalogues, periodicals.

New York State Surrogate Court, Borough of Manhattan: probate file on Ryder (document conferring administration of Ryder's estate to Charles Melville Dewey).

University of California Library, Riverside, Sadakichi Hartmann Papers: includes "The Story of an American Painter," an unpublished manuscript by Hartmann on Ryder (typescript in the Metropolitan Museum of Art Library).

University of Delaware, Newark, restricted [not consulted], Albert P. Ryder Archive, compiled by Lloyd Goodrich and William I. Homer: original documents, letters, reminiscences by or about Ryder, early photographs, notes on examined paintings, other research. [Portions to be made available in spring 1989.]

Theses and Seminar Papers

Bienenstock, Jennifer A. Martin. "The Formation and Early Years of the Society of American Artists, 1877–1884." Ph.D. diss., City University of New York, 1983.

Braddock, Richard. "The Poems of Albert Pinkham Ryder, Studied in Relation to His Person and His Paintings." Master's thesis, Columbia University, 1947.

Carman, Sharon Dale. "Albert Pinkham Ryder's Two Wagnerian Paintings: *The Flying Dutchman* and *Siegfried and the Rhine Maidens*." Master's thesis, University of Maryland, 1988.

Hobler, Margaret H. "In Search of Daniel Cottier, Artistic Entrepreneur, 1838–1891." Master's thesis, Hunter College, 1987.

Johnson, Diane Chalmers. "Art, Nature, and Imagination in the Paintings of Albert Pinkham Ryder: Visual Sources." Paper presented at the 1983 College Art Association Annual Meeting, Toronto, Canada.

Phelan, Alice D. "Albert Pinkham Ryder: A Search for the Influences on His Art and Life in the Artists of His Time." Master's thesis, Hunter College, 1969.

Somma, Thomas. "Subject and Meaning in Albert Pinkham Ryder's Marine Paintings." Graduate seminar paper, University of Delaware, 1984.

Steindecker, Oliver. "Albert Pinkham Ryder." Master's thesis, Hunter College, 1984.

Storr, Annie V. F. "Albert Pinkham Ryder and His Religious Paintings." Graduate seminar paper, University of Delaware, 1984.

White, Peter. "Thomas Hart Benton, Jackson Pollock, and the Influence of Albert Pinkham Ryder." Graduate seminar paper, University of Delaware, 1984.

Zalesch, Saul E. "The Collectors and Friends of Albert Pinkham Ryder." Graduate seminar paper, University of Delaware, 1984.

Index

Subjects and Names

Titled works of art here listed are those other than Ryder's. For a list of Ryder's works discussed and illustrated in this volume see Ryder's Works, which follows. **Boldface** page references indicate that the subject matter or work is illustrated on that page.

Ryder's Works Mentioned or Illustrated

Titled works of art and poetry here listed are by Ryder. **Boldface** page references indicate that the work is illustrated on that page. This list does not include all paintings by Ryder but only those discussed or pictured in this volume.

Photography Credits

Photographs were supplied by the owners of the works of art. The following photographers are acknowledged. David Allison: cat. 28; courtesy of Babcock Gallery: cat. 8, 34; E. Irving Blomstrann, New Britain, Conn.: cat. 7a, 77; Richard W. Caspole: fig. 145; Geoffrey Clements: figs. 44, 74, 149, 159, cat. 9, 34; Thomas Feist: fig. 148; Ellen Grossman: figs. 2, 47; Paul Haner, Worcester Art Museum, Mass.: fig. 111; Helga Photo Studio, Upper Montclair, N.J.: fig. 50; Peter A. Juley & Son Collection, National Museum of American Art, Smithsonian Institution, Washington, D.C.: figs. 144, 150, cat. 22a, 59a, 75b; Michael McKelvey: fig. 46; Richard Margolis, Rochester N.Y.: cat. 15; Alfred A. Monner, Portland, Oreg.: fig. 13; courtesy of Walter Rosenblum: figs. 23, 27; Schwartz: fig. 98; Tom Scott, Edinburgh: cat. 77a; Steven Sloman, New York: figs. 168–69; courtesy of Spanierman Gallery, New York: fig. 48, cat. 9; David Stansbury, Springfield, Mass.: fig. 72; Herbert P. Vose: fig. 28; Waggaman/Ward, Del Mar, Calif.: cat. 11a; Wunderlich & Company, Inc., New York: fig. 73.